The Culture of the High Renaissance

ANCIENTS AND MODERNS
IN SIXTEENTH-CENTURY ROME

Ingrid D. Rowland

CAMBRIDGE
UNIVERSITY PRESS

PUBLISHED BY THE PRESS SYNDICATE OF THE UNIVERSITY OF CAMBRIDGE
The Pitt Building, Trumpington Street, Cambridge, United Kingdom

CAMBRIDGE UNIVERSITY PRESS
The Edinburgh Building, Cambridge CB2 2RU, UK
40 West 20th Street, New York, NY 10011-4211, USA
10 Stamford Road, Oakleigh, Melbourne 3166, Australia
Ruiz de Alarcón 13, 28014 Madrid, Spain
Dock House, The Waterfront, Cape Town 8001, South Africa

http://www.cambridge.org

First published 1998
Reprinted 1999
First paperback edition 2000

Printed in the United States of America

Typeface Bembo 10.5/13 pt. *System* Penta™ [RP]

A catalog record for this book is available from the British Library

Library of Congress Cataloging in Publication data
Rowland, Ingrid D. (Ingrid Drake)
The culture of the High Renaissance : ancients and moderns in
sixteenth-century Rome / Ingrid D. Rowland.
p. cm.
Includes bibliographical references and index.
1. Rome (Italy) – Civilization – 16th century. 2. Rome (Italy) –
Civilization – Classical influences. 3. Renaissance – Italy – Rome.
4. Arts, Italian – Italy – Rome. I. Title.
945'.06—dc21 95-29765

ISBN 0 521 58145 1 hardback
ISBN 0 521 79441 2 paperback

The Culture of the High Renaissance

ANCIENTS AND MODERNS
IN SIXTEENTH-CENTURY ROME

Between 1480 and 1520, a concentration of talented artists, including Melozzo da Forli, Bramante, Pinturicchio, Raphael, and Michelangelo, arrived in Rome and produced some of the most enduring works of art ever created. This period, now called the High Renaissance, is generally considered to be one of the high points of Western civilization. How did it come about, and what were the forces that converged to spark such an explosion of creative activity? In this study, Ingrid Rowland examines the culture, society, and intellectual norms that generated the High Renaissance. Fueled by a volatile mix of economic development, scholarly longing for the glories of ancient civilization, and religious ferment, the High Renaissance, Rowland posits, was also a period in which artists, patrons, and scholars sought "new methods for doing new things." This interdisciplinary study assesses the intellectual paradigm shift that occurred at the turn of the fifteenth century. It also finds and explains the connections between ideas, people, and the art works they created by looking at economics, art, contemporary understanding of classical antiquity, and social conventions.

Ingrid Rowland is Associate Professor of Art History at the University of Chicago. A fellow of the American Academy in Rome and Villa I Tatti, she has edited *The Correspondence of Agostino Chigi* and has recently completed a new translation of Vitruvius's *Ten Books of Architecture* (forthcoming). She contributes regularly to *The New York Review of Books*.

To my parents

F. Sherwood Rowland
Joan Lundberg Rowland

Contents

Figures

Acknowledgments

It is a daunting task to thank one's friends with so fallible a thing as a book; it can never do them sufficient justice. What feeble justice this book renders is largely due to the interventions of my readers, Thomas Howe, Charles Stinger, Marcia Hall, Paul Barolsky, and Sheryl Reiss. I owe them my thanks for their infinite patience, bibliographical acuity, and sheer good faith; insofar as a mass of recalcitrant material has been licked into shape like Horace's bear cub, it is their doing. The infelicities and errors that remain, as they know better than anyone, are all my own. I also owe a special debt to the American Academy in Rome for a fellowship in 1981–2 and for unstinting support before and since. The staffs of the Handschriftenabteilung of the Bayerische Staatsbibliothek, Munich; the Manuscript Room of the British Library in London; the Bodleian Library in Oxford; the Biblioteca Hertziana, Biblioteca Casanatense, Biblioteca Lancisiana, Biblioteca Angelica, and Archivio di Stato in Rome; the Biblioteca Nazionale Centrale in Florence; the Biblioteca Comunale in Volterra; the Newberry Library in Chicago; and the Houghton Library at Harvard University have shown every courtesy always, making the Republic of Letters a palpably real country the world over. The Biblioteca Apostolica Vaticana, its former prefect, Father Leonard Boyle, and its staff made the work recorded here possible, and I cannot thank them enough for that.

During research for the book, I have also had the benefit of fellowships (not to mention outstanding support, logistical and spiritual) from the Villa I Tatti, Florence (under Walter Kaiser's directorate) and the Chicago Humanities Institute of the University of Chicago (under Norma Field), as well as financial sustenance from the Charles A. Dana Foundation and the Division of Humanities of the University of Chicago.

In addition, my thanks to all of you who have leavened these labors over the years: Maureen Pelta, Phyllis Bober, Julia Gaisser, Tina Waldeier Bizzarro, Jim Hankins, Jeff Dean, Walter Stephens, Tony Grafton, Joe Connors, Christiane Joost-Gaugier, Cynthia Pyle, Diana Robin, Kenneth Gouwens, Peter Hicks, Dario Ianneci, Andrew Morrogh, Paul Gwynne, Michael Dewar, Katherine Gill, John O'Malley, Ron Witt, Nelson Minnich, John Beldon Scott, Giovanni Cipriani, Eve Borsook, Walter Kaiser, Christof Thoenes, Carolyn Valone, Maria Conelli, Daniela Gionta, Rossella Bianchi, Concetta Bianca, Paola Guerrini, Massimo Ceresa, Mary Quinlan-McGrath, Paul Gehl, Andrew Butterfield, and all the Vat Rats I may have neglected to mention by name.

Beatrice Rehl is a phenomenon among editors, and it has been a privilege to work with her. Thanks also to the perspicacious help of my copy editor, Christie Lerch, and my production editor, Holly Johnson. The final writing of this volume owes a palpable debt to Robert Silvers and Jed Perl, whose standards for the writer's craft, as exigent as those of the humanists, still leave room for the play of the spirit. Mario Pereird cheerfully rescued proofs and index from many an infelicity.

Tragically, a book this long in the making means that a number of friends must be thanked posthumously: John D'Amico, Kyle M. Phillips, Jr., Edwin Miller, S.J., Felix Gilbert, and Marc Worsdale chief among them.

For their unfailing sustenance, I should like to dedicate this book to my parents.

Introduction

[È] sempre suto non altrimenti periculoso trovare modi ed ordini
nuovi che si fusse cercare acque e terre incognite.

It has always been just as dangerous to find new ways and orders
of doing things as to go in search of new lands and seas.

> Machiavelli, Preface to
> *Discourses on the First Decade of Titus Livius*

Paradoxically, Italy's jolt into the modern era began with a long, pene-
trating look into the past. The fifteenth- and sixteenth-century thinkers
who hailed a rebirth of ancient values in their own time did so knowing
that their own era was irrevocably distinct from antiquity; indeed, all but
the most fanatical wanted their Renaissance to stay in the heady realms
of fiction. For the world that generated the antiquarian movement known
as "humanism" was a world of rapidly developing commerce, commerce
that depended absolutely on modern inventions, modern navigation, and
modern mathematics. At the same time, the shapers of that modern world
also felt the need to have it incorporate the best elements of their fore-
bears' existence. With a rationality born perhaps of commercial training,
they probed the past for its systems, what they called "modi e ordini"
(ways and orders) or "ragione" (method), hoping to recover the abstract
principles that would give their own achievements enduring value. No-
where was this paradoxical search for higher principles more intense than
in papal Rome. The suggestive atmosphere of the city, with its endless
layers of civilization, inspired the officials of the late fifteenth- and early
sixteenth-century papacy, self-consciously charged with carrying out
God's mission on earth, to believe that in their lifetimes for once hu-
manity could muster the political means, the historical wisdom, and the

living talent necessary to create "new ways and orders" of lasting validity, enfolding the best of all that had gone before in a truly catholic embrace.

This is the story of that concerted attempt to derive a new order for the future from scrutiny of the past. The search for systems was not itself systematic, nor did the seekers share the same idea of their goal. It was a fiction, after all, often a personal fiction. Nonetheless, a common theme unites many of the disparate activities that went into the creation of Renaissance Rome. And the paradoxical quest for a new order, by its very oxymoronic challenge, invited ingenious responses.

On occasion – most notably, perhaps, in the visual arts – this utopian project actually succeeded, producing such expressive innovations as the conscious gradations of style (*modi*) that appear in the painting of Raphael and Michelangelo, and the "orders" of classical architecture, devised in antiquity but first described as orders in sixteenth-century Rome. Yet the same search for new ways and orders also made itself felt in the world of finance, as when banker Agostino Chigi tried, like a nineteenth-century industrialist, to establish an international economic monopoly on a single commodity. Chigi's vision took form because at the same time his pope, Julius II, was working toward another international goal: asserting a universal church that would far exceed the ancient Roman empire in scope. Indeed, Julius II was the pope who felt the synthetic drive of his epoch more powerfully than any other; the papacy of his successor Leo X provided some reflective respite from the momentum of Julius's headlong pontificate, but it also began to reveal the fragility inherent in any synthesis of old and new.

In other respects, papal Rome's pursuit of "modi e ordini nuovi" failed; the formulation of aesthetic standards for Latin and vernacular literature froze, in the hands of elegant but rigid critics like Pietro Bembo, into a triumph of superficial polish over compelling content, while papal efforts to foster new ways and orders for a reformed and truly universal religion resulted instead in violent schism.

Three characters who figure prominently in these pages have been, for various reasons, relatively little known to contemporary readers except from a handful of anecdotes. Yet each contributed significantly if not indispensably to the formulation of papal Rome's new order. The clerical, antiquarian strain of the formula is exemplified by the papal librarian and orator Tommaso ("Fedro") Inghirami, its forward-looking, practical side by the great merchant Agostino Chigi, and, acting as a bridge between the two, we find, alongside such a well-known figure as Raphael, the

less well-known but no less significant Angelo Colocci, humanist, publisher, and aspiring historian of science. The various aspects of their lives and their various intertwinings, social, financial, and intellectual, are set out here in roughly chronological order.

Tommaso Inghirami was one of papal Rome's most able rhetoricians, brimming with enthusiasm for the city's creative ferment, an accomplished actor for whom the "modi e ordini" of rhetorical theory spilled over into the visual spheres of theater and art. Inghirami was also one of the very last people in sixteenth-century Italy for whom oratory, rather than print, was the most effective instrument of mass communication, and as a result the full impact of his evanescent but undeniable genius is irretrievably lost. What we see instead is the result of his absence after his death in 1516: the comparative lack of inspiration among *litterati* when artists and architects are achieving inspired new syntheses of past and present.

Banker Agostino Chigi transcended the boundaries of social class and intellectual discipline, a merchant magnate whose economic practices were as innovative as his sponsorship of the arts. He collected antiquities, promoted vernacular literature, and reserved special attention for scientific study of mathematics and astronomy. His respect for the ancient history of Italy coincided with his intense involvement in the most recent developments of politics and finance. By all contemporary accounts, his was a formidable mind, one whose impact on his contemporaries may have been as powerful as it is hard to trace from the surviving evidence, with one notable exception: the works of art and architecture he commissioned from Baldassare Peruzzi, Sodoma, Sebastiano del Piombo, and Raphael.

No resident of papal Rome may have been more instrumental in articulating the various new ways and orders of thought and creation, or in applying them across every boundary of social class and scholarly discipline, than the genteel humanist Angelo Colocci. Trained as a classical scholar, he threw himself into study of the ancient world while keeping close watch on the present. As he honed his skill in Latin, he eagerly tracked the development of Romance vernacular, not only in Italy but in Spain, Portugal, and Provence; he was an incurable universalist. A collector of ancient statues and inscriptions, he used these monuments of the past to further his study of current exchange rates and contemporary mathematics and to unlock the secrets of how God had ordered the world from the time of the Creation. A scholar of refined critical sensibilities,

he worked closely with the "illiterate" artist Raphael (a description meaning only that Raphael had no training in Latin) to advance the theoretical underpinnings and professional practice of architecture in their own day. Few of Colocci's contemporaries could have understood the idea of Rome's renewal with greater depth of learning or breadth of imagination.

Our knowledge of papal Rome, as with any city, is conditioned by where we live and whom we know. The importance of print to literate culture ever since the mid–sixteenth century and the greater availability of printed sources to scholars has shaped our image of the early sixteenth-century city according to the lines drawn by printed accounts: guidebooks like Francesco Albertini's pamphlet of 1510, the *Opusculum de mirabilibus antiquae et novae Urbis Romae*, or Andrea Fulvio's erudite topographical study, the *Antiquaria Urbis* of 1527; essays on manners, like Baldassare Castiglione's *Book of the Courtier*, the letters of the papal secretary Pietro Bembo. These sources tend to emphasize the print-conscious papacy of Leo X (1513–21) at the expense of that pope's immediate predecessors, Alexander VI (1492–1503) and Julius II (1503–13), for whom, more than half a century after Gutenberg, manuscripts and public speaking were still the primary means of important communication. Among manuscripts, those that are easily legible and in good condition are more likely to be used than those whose decipherment takes time; manuscript material that has been edited in print is more likely still to figure in modern discussions. Largely unpublished writers like Angelo Colocci, Egidio da Viterbo, and Tommaso Inghirami have tended to play a nebulous or subordinate role in our analysis of situations where Matteo Bandello, Pietro Aretino, or Paolo Giovio can supply a printed source of information, yet in fact the unpublished writers may have had a greater influence on what was thought, said, and done at the time. A diarist like Marin Sanuto, though he wrote copiously on papal Rome and has long been edited in print, supplies undigested reams of anecdotal information, whereas the analytical pronouncements of Castiglione's *Courtier*, Bembo's *Asolani*, or Paolo Cortesi's *De cardinalatu* have already done the work of digestion, and it is tempting simply to adopt their viewpoint when we look at Rome in their day.

When the manuscript record is difficult to read and at best only vaguely allusive, as is the case with Angelo Colocci and Agostino Chigi, their entry into the historical record depends on time-consuming research, like that of Samy Lattés and Vittorio Fanelli on Colocci and that of Giuseppe Cugnoni and Felix Gilbert on Chigi. Just as unprepossessing, and just as

demanding of hard labor, are the notarial documents of the Roman bu-
reaucracy, with their formulaic legal language and their prosaic focus on
the tangible minutiae of life. Charles Stinger, Peter Partner, John Shear-
man, Christoph Frommel, Christof Thoenes, and Richard Sherr provide
sterling examples of the way in which such modest remnants of the curial
administration can be brought to bear, with great interpretive insight, on
the re-creation of works of art, architecture, and music. These authors
have made papal Rome a more physically concrete place as well as a real,
functioning city.

The present work makes extensive use of unpublished sources, some
previously unread, like many of Chigi's letters, along with those that are
better known but always subject to rereading, like Colocci's tangled and
difficult notes on measure. Inevitably, familiarity with specific personal-
ities affects the way we look at papal Rome, much as the recent removal
of several centuries' encrusted grime has given us not only a new view
of the Sistine Chapel of Michelangelo and the Stanze Vaticane of Raphael
but also a particular sense of intimacy with those artists. So too Paolo
Cortesi opened up a new Rome to the late John D'Amico, just as Egidio
da Viterbo has shed his own distinctive light on the same period for John
O'Malley, Clare O'Reilly, Francis X. Martin, and Annamaria Voci; in
turn, these researchers have given us new points of view through their
scholarly work. From Agostino Chigi's vantage, we may find that Julius
II is a far more interesting intellectual leader as pope than Leo X, because
he combines ideological commitment and ready action with fiscal pru-
dence. Tommaso Inghirami reinforces the same sense that the "Golden
Age of the High Renaissance" flourished under the combative Julius
rather than under his successor, despite Leo's flawless Medici pedigree.
(Angelo Colocci, on the other hand, opted vocally for Leo.)

Tastes also change, and our viewpoints with them. Well into the twen-
tieth century, scholars believed firmly in the essential paganism of the
papal humanists and thought it part of their duty to decry such hypocrisy
with full-throated indignation. As often, a masterful manipulator of print
may have been behind it all: Erasmus, whose *Ciceronianus* of 1525 and
Julius exclusus de caelo of 1513 both present damning portraits of papal
Rome. In the same vein, Ludwig von Pastor, in his monumental *History
of the Popes*, seasons his priceless manuscript evidence and painstaking
analysis with a protracted sermon on the difference between the Christian
Renaissance and the "pagan pseudo-Renaissance"; Pastor's tirade may be
a fascinating episode in the history of scholarship, but it is factual non-

sense. (It must be said, however, that the Vatican Library in which the Freiherr von Pastor did his research was a far cry from the ecumenical haven that the Vatican Library has become today, and perhaps only to-day's Vatican Library has made it possible to empathize with the expansive spirit that allowed Christian, Jew, and humanist to live side by side for a brief time in papal Rome of the early sixteenth century.)

Based as it is on a wide variety of sources, the present study remains anecdotal and highly personal, all the more so because what unites most of its protagonists with its author, and indeed with virtually every person cited in these pages, whether scholar, writer, artist, pope, parasite, whether ancient, Renaissance, or modern, is an irrational but nonetheless compelling passion for Rome. A schoolboy's graffito on the wall of his long-ruined classroom (razed in 531 A.D. to make room for the Basilica of Santa Maria Maggiore) says it all in a succinct little palindrome: ROMA SUMMUS AMOR. Not one of us may have understood the schoolboy's sentiment in quite the same way as the others, but we share it, just the same.

Initiation

Voi ch' ascoltate in rime sparse il suono
De que' suspiri ond' io nutriva il core
In sul primo giovenil errore
Quando ero in part' altr' om de quel che sono . . .

All ye who hear the sound in scattered verse
Of sighs like those on which I fed my heart
In my first wanderings of errant youth
When I was still another man in part . . .

Francesco Petrarca, *Canzioniere* (1.1–4)

ROMAN RUINS

Sometime around 1490, a bright teenager named Angelo Colocci appeared in Rome with his uncle Francesco. They hailed from Iesi, a small city-state on the eastern coastal slopes of the March of Ancona, where the Colocci family had prospered for generations.[1] Yet however pretty their hill town, and however important their family had been to its fortunes, neither uncle nor nephew had any plan to stay there. Francesco Colocci, a scholar of Latin, had already spent his life as a diplomat at the court of Naples, a city to be reckoned with both politically and culturally in the mid–fifteenth century; its ruling dynasty of Aragonese kings kept a vast territory under control, while attracting scholars and artists from Spain as well as Italy. Angelo Colocci (1474–1549), though still a very young man, had already shown his learned uncle's talent for scholarship and conversation, and so, in the 1480s, barely out of grammar school, he set out with Francesco Colocci to try his fortune in a great courtly city such as Rome.[2] Even among some of Italy's most sophisticated intellects, the youth's ability stood out.

Quickly, therefore, Angelo Colocci of Iesi joined the figurative nation that his contemporaries called the *Res publica litterarum*, the "Republic of Letters." If only symbolically, the Republic of Letters provided a permanent home for a group of men (and a handful of women) whose lives often took them wandering in perpetuity. Latin served as its universal language, transcending every political, social, and regional division within the international community of peripatetic scholars. But Angelo Colocci, as it happened, never wandered far. He found Rome, and Rome, with its ancient monuments, its religious shrines, and the bustle of a modern city, bewitched him at once.

Rome also gave him and his studies a sense of purpose; the popes of the late fifteenth century took the magnificence of the past as a standing challenge to create a no less glorious present in the name of the universal Christian Church. Colocci absorbed the city's sense of excitement; though he returned to Iesi in 1494 to settle his inheritance on the death of his father (his mother had died when he was three), by 1498 or so Angelo Colocci was back in Rome, there to remain for most of the rest of his life. He was to immerse himself with equal energy in the antiquarian past, the here-and-now of politics and finance, and the eternity of religion. Only Rome made such a life seem not only possible but necessary, for only in Rome did past, present, and eternity mesh together so naturally.

Time had dealt harshly with the city of the Caesars (Fig. 1). Sacked by Alaric and the Visigoths in A.D. 410 and preyed upon thereafter by generations of medieval armies, vast expanses of land within Rome's ancient city walls now lay desolate, except for the shells of abandoned buildings rising among fields and garden plots. The Roman Forum had become the "Cow Pasture" (Campo Vaccino); the Capitoline Hill, site of the ancient city's greatest temple, was now "Goat Hill" (Monte Caprino); the erstwhile palace of the emperors comprised part of a tract named the "disabitato" (the desert). Set behind a bastion, the fourth-century Basilica of Saint Peter's and its surrounding settlement, the Borgo, commanded a bend in the left bank of the Tiber, safe behind the hulking remains of the Emperor Hadrian's red-brick and concrete mausoleum, remodeled by medieval popes into a forbidding fortress, the Castel Sant' Angelo. The mausoleum's access bridge, the Pons Aelius, still led straight across the river, now carrying a street called the Via Papalis (Papal Way) into the very heart of fifteenth-century Rome. What had once been the flats of the Tiber's floodplain, the ancient Campus Martius, now formed

the nucleus of the papal city, a settlement stretching from the bankers' quarter just across the river from the Vatican to the various bases of the city's proverbial Seven Hills.

For centuries, this flood-prone terrain had been divided among several families of feudal landholders, the infamous "barons," each of them ensconced within a sprawling palazzo in a different section of town. Most of the popes in the Middle Ages had been supplied by two such baronial families – the Colonna, with most of their feudal holdings lying to the south of Rome, and the Orsini, with vast lands to the north. Other families, the "black nobles," had never produced a pope, but their cardinals and warriors had managed virtually every conclave and every meeting of the city government; their gangs of liveried thugs were as dangerous as the *viri strenui*, the "strongmen," who hung about the portals of the Palazzo Orsini on Monte Giordano (a hill built up from the crumbled remains of the Palazzo Orsini's previous incarnations) or the equally imposing Palazzo Colonna. By the end of the fifteenth century, Rome had yet to complete the transition from a baronial city to a papal city, although the College of Cardinals, hoping to keep the barons in their place, had begun routinely to choose popes from non-Roman families, and often families of no previous political consequence whatsoever.[3]

A walk through the mud and slops of a Roman street could still be a dangerous venture, when it led through baronial turf. On the most tranquil day a stroll through the city meant threading an obstacle course of soldiers, rattling carts of wine, grain, and vegetables, street vendors, prostitutes, pilgrim tourists, and endless entourages: cardinals riding to the hunt amid a retinue of yapping dogs; bankers in cavalcade on their expensive horses; popes, priests, and the faithful in solemn procession. Near Monte Giordano, Piazza Savelli, or Piazza Colonna, however, a jacket of the wrong color, the wrong badge on a hat, a swagger too jaunty, or the wrong company could bring on an attack by the neighborhood baron's toughs, the *bravi*. The meandering Tiber always flowed close by, ready to cancel the evidence, as it had once concealed many a murder in ancient Rome and carried off the carnage from the arenas.

The ruins of that ancient Rome, however, lay almost entirely outside the city's fifteenth-century focal points. Nobles, churchmen, artists, and scholars favored them instead as sites for their suburban garden plots, some of them quite extensive. The wrecked baths and palaces, like the wreckage of the Forum, had created strange artificial landscapes where a profusion of plants throve on the compost of rotting Roman mortar (Fig.

2). These gardens were known as *vigne* (vineyards: singular *vigna*), because no such refuge could be complete without a grape arbor to provide shade in summer and wine in fall. Unfortunately, however, the ruins also lay open to looting by collectors and by the builders who reused ancient brick, marble, and travertine in modern buildings. Lime burners fed ancient statues, inscriptions, and structural marble into their kilns to produce quicklime for the building industry as well as whitewash for walls. They worked virtually undeterred well into the sixteenth century.[4]

Yet the owners of Roman *vigne* also knew exactly how evocative their arbors could be. Reading ancient Latin poetry aloud to one another, archly quoting clever remarks passed down from antiquity, they imagined themselves back in the Rome of the Caesars. At the same time, artists pored over ancient columns, statues, stuccoes, and frescoes in search of new ideas and of communion with colleagues long dead. Wriggling down holes in the ground into half-buried buildings with candles, pens, paper, and lunch in hand, they sketched for hours in the shifty subterranean light.[5]

THE ROMAN ACADEMY

The artists were not the only motley crew to be found jostling one another in the catacombs or in artificial caverns of Roman brick. The liveliest, or at least the most dramatic, haunters of the ruins belonged to a peculiar club into which Angelo Colocci was soon to be ritually inducted – the "Roman Academy," led by an eccentric professor of rhetoric, Giulio Sanseverino (1427–1498), who had assumed the three-part Latinate name "Julius Pomponius Laetus" – the last of which, the cognomen, typically described some distinctive personal characteristic. "Laetus" was no exception; it meant "happy." In Italian, Julius Pomponius Laetus was known as Pomponio Leto, and as Leto he is usually identified today.[6]

The Roman Academy's membership was almost exclusively male (Leto's daughter Nigella provided the chief exception) and exclusively "literate," that is, educated in Latin. As a group, we may call them "humanists," people who had undergone the course of classical studies known in their own day as humane letters, *studia humanitatis*.

Rather than a prescribed curriculum or the subject of a university degree, humanism was more precisely an outlook on education. Humanists drew their inspiration from the Greek and Roman past rather than their more immediate medieval heritage, and they looked to that

remote past as a guide to their own conduct in the present. Theirs began as a movement outside the university system, for the university and its curriculum were themselves medieval inventions. Gradually, over the course of the fifteenth century, humanist curricula and humanist faculty began to appear in universities, but a scholar like Angelo Colocci, instructed largely by private tutors, could enter the first rank of humanist *litterati* without any university training whatsoever, his literary ability stimulated as much by the company he kept as by a course of formal instruction. In Colocci's case, it was his analytical approach to literature and his careful attention to rhetoric that identified him as a humanist, but his interests also included science, mathematics, surveying, and architecture.

For Colocci and his friends, these intellectual interests also involved strong emotional ties, beginning with profound loyalty to the first humanist, Francesco Petrarca, the fourteenth-century writer who composed letters to the ancients and collected Roman coins but also addressed lyrical sonnets in Italian vernacular to his beloved Laura. In fact, a well-thumbed little manuscript of Petrarch's vernacular poetry provides some of the only definite dates in Angelo Colocci's early life (Fig. 3); on its rear flyleaf, Niccolò Colocci, Angelo's father, recorded his family's births, marriages, and deaths, much as American pioneers were one day to annotate their family Bible.[7] On the first page of the same manuscript, Niccolò Colocci inscribed the name of his wife Ypolita, his personal incarnation of Petrarch's Laura and dead, like Petrarch's Laura, at a tragically early age. After Niccolò's death in 1494, this little Petrarch manuscript continued to act as the repository for some of Angelo Colocci's own most important records. Humanism, to the Colocci family, was apparently a whole way of life.

Unlike modern classicists, humanists were defined by their intellectual orientation rather than their type of employment; indeed, humanists might also be doctors, lawyers, notaries, or architects, but professionals in these specialized fields were not necessarily humanists. Accordingly, the humanist members of the Roman Academy held a variety of jobs in the Church hierarchy or in the secular world. Pomponio Leto, as the bastard son of a southern Italian nobleman, had set out young to seek a fortune he could not count on by inheritance. In 1465, at the somewhat advanced age of thirty-seven, he began teaching Latin rhetoric at the University of Rome, the Studium Urbis. The job did not pay particularly well, but it offered Leto other advantages. Unlike professors in other cities, he could

approach the ancient Latin authors through the study of their physical world as well as their written texts. Unlike the better-paid humanists who worked as bureaucrats in the curial court, Leto could also devote the whole of his imaginative life to the workings of the ancient city rather than its modern problems. An obsessive character, he had good reason to be happy.

Leto's love for the ancient city must have been infectious. Although he was a strange-looking little man and had a pronounced stutter, his small black eyes lit up when he turned his attention to Rome, his deep voice lost its hesitation, and by all accounts he held his listeners spell-bound. He inspired outright adoration from his students, while his friends gravitated to his irrepressible good cheer. His friend Paolo Cortesi reported that "he was as merry [*laetus*] as could be, with his playful exuberance," alluding affectionately to Leto's Latin cognomen. [8]

Within a year or two of his arrival at the Studium Urbis, Leto had gathered a group of like-minded colleagues about him who shared his ambition to revive the cultural splendor of ancient Rome. They entered upon their utopian project in what they considered a thoroughly modern spirit, one that emphasized scrutinizing both ancient monuments and ancient texts with a critical eye, first observing them closely and then comparing them with one another. Ancient coins and inscriptions sometimes provided new information about people previously known only from historical accounts, and sometimes such archaeological information even proved the historians wrong. Over the centuries, Roman civilization had generated a wide variety of spellings and letter forms; Leto began to compare them and try to put them in chronological order, separating the writing of educated ancients from that of the barely literate, contemporaries of Cicero from contemporaries of Constantine. He and his friends examined individual manuscripts of the same text to detect places where scribes had disagreed with one another or had made mistakes, for no two manuscripts of any text are ever exactly alike. In their own way, therefore, misinformation, variant spellings, and strange grammar provided as much insight into the past as the most hallowed traditions; these oddities, after all, had been the work of real people whose Rome seemed ever closer to the Rome of Leto's academy.

Finally, critical method meant assigning value to sources, preferring either the testimony of a coin or a classical author's conflicting account but not both, choosing one manuscript reading over another, praising one kind of language as good, another as less good. By paying such close

attention to the achievements of the past, the members of the Roman Academy hoped to impart a spark of ancient genius to their own work. Their close investigation of ancient Latin usage aimed to set standards for improved Latin usage at the curial court; their methods for assessing classical texts applied equally well to manuscripts of the Bible and the Church Fathers. Most of Leto's fellow academics, employees of the Church in one way or another, freely acknowledged their Christian faith and regarded the religion's development and triumph over persecution as ancient Rome's transcendent glory. Crawling through the catacombs by candlelight, they carved their names into the soft pumice walls of those ancient tunnels and relived the earliest days of Christian community.

As individuals, the members of the Academy set to work on various scholarly projects, gathering and recording ancient inscriptions, editing ancient texts, and reviewing Roman history. Their collective assemblies, however, took on a more exotic air. They had chosen to call themselves the "Roman Academy" as a way of paying homage to Plato's famous school in the sacred grove of Akademos, implicitly suggesting that fifteenth-century Rome might bid fair to become a new Athens. They signaled their initiation as "brothers" (*fratres*) or "clubmen" (*sodales*), by taking antique names and speaking a Latin they hoped to have stripped of all its medieval words and mannerisms. Their heads wreathed in laurel, they reenacted ancient Roman festivals among the ruins or feasted within the catacombs.[9] In the ruined baths, basilicas, and the imperial palace on the Palatine Hill, the brothers of the Roman Academy delivered orations and recited poems whose professions of ardent friendship sometimes became openly erotic; the example of Plato once again provided them with their guide.

At the same time, however, the Academy also provided Rome's humanists with their own equivalent to the artisans' guilds, for their chief bond, their mastery of Latin, was also their chief professional skill, and a skill much in demand for drafting the documents of the universal Church. Since the early fifteenth century, curial officials, inspired by the humanist movement, had begun to favor the consciously artful Latin of the classical authors over the drily precise Latin of the legal codes and the scholastic Latin of philosophy and theology. Roman rhetoric, they had discovered, was no matter of empty speeches in florid language. Already by the time of Cicero it had evolved into a hardheaded art of persuasion, developed by a nation of lawyers to meet conditions that varied over the centuries from republican government to civil war to imperial autocracy. Whatever

the governmental system in effect at the time, an ancient Roman orator's years of training pointed unwaveringly to a single end: to ensure his ability to win cases in court. The price of such a victory was high; it might come after a six- or seven-hour speech, delivered entirely from memory and dedicated to reviewing the evidence of the case in the most painless way possible.[10]

At more than a millennium's remove, the exacting standards, the flexibility, and the proven effectiveness of rhetorical training still worked for fifteenth-century humanists, themselves subjected, like ancient Roman lawyers, to a spectrum of shifting governments. Rather than the laconic slogans of modern advertising, their oratorical art favored an allusive, indirect way of driving home a point. When fifteenth-century speakers brought up the gods, goddesses, heroes, and historical paragons of ancient literature, they used these figures just as the Greeks and Romans themselves had used them: to gossip without naming names, to reaffirm universal truths, to give advice without giving offense, to disguise specific political points as universal generalities.

The drive to purge Latin of its medieval vocabulary also marked a rebellion against its development into a bureaucratic and technical language. Medieval Latin was the Latin of laws, contracts, and of traditional university education. Medieval theology and philosophy had acquired pinpoint precision, but precision could also sound excruciatingly dull. Humanist universities and humanist thinkers demanded instead that humanity's most lofty thoughts convey something of that loftiness in their mode of expression. As Paolo Cortesi put it, "philosophy should have an appearance that is literate and artful, and that is based upon the beauty of nature."[11] The Roman Academy took the restoration of beautiful Latin as a primary mission, and it was easy to wax eloquent among toppled columns and the crumbling shells of once-soaring vaults. All the while, though, the *sodales* kept careful watch on their own conditions of employment; by enforcing rigorous standards of performance among themselves, they sought to improve the status of their group as a whole.

Once Leto's movement began to involve significant numbers of curial officials, the reigning pope, a dourly practical Venetian named Paul II, decided to give the Roman Academy a closer look. In 1464, to save money and improve efficiency, he supervised an overhaul of the curial staff, cutting a large number of positions for letter writers, secretaries, and the like, most of them highly educated and all of them ambitious. Many were members of the Roman Academy. Furthermore (as will be ex-

plained in Chapter 3), many of the fired curialists had made substantial down payments in order to obtain their offices, yet the pope showed no intention of returning those down payments when he eliminated their jobs – these amounted, after all, to an immense source of capital for the papacy. Accustomed to making their living by words, the indignant humanists trained their talents against their former employer.

The most vocal of these complainers also happened to be one of Pomponio Leto's closest associates, a scrappy Lombard named Bartolommeo Sacchi, who went by the name of "Platina," the Latinized form of his hometown (Piadena, near Cremona).[12] Originally trained as a soldier, Platina never lost either his military bearing or his propensity to fight. He complained in an interview with the pope that dissolving the curial staff was illegal, to which the pontiff is said to have replied, "As if you didn't know that the law is whatever [I] keep in [my] heart . . . I am the pope."[13]

Refused a second interview, Platina, after languishing for three weeks in the papal waiting room, put his pen to work instead, as he reports himself:

> So I wrote him a letter in these words: "If you thought it permissible in the present case to rob us of our proper and legitimate acquisitions, then it ought to be permissible for us to protest the injury and the undeserved ignominy brought upon us. Rejected by you, the victims of such egregious contumely, we shall broadcast the information to kings and princes, exhorting them to summon you to a council in which you will be forced to provide an account of why you robbed us of our legitimate possessions.[14]

The threat of a Church council was a serious one in 1464; the memory of the Great Schism and the papacy's seventy-year removal to Avignon were still fresh in every Roman's mind. Platina's insolent tone (and some scurrilous poems about the pope that had been tacked up on the gates of Vatican City) earned him four months in the dungeons of the Castel Sant' Angelo.

Four years later, the pope may still have regarded the Roman Academy with the kind of suspicion that modern industrialists reserve for labor unions on the verge of striking, with the difference that, as he said himself, he and his desires were law, because he was the pope. He claimed to have found proof that members of the Academy had mounted a conspiracy against his own life, in addition to practicing heathen rites and sodomy among themselves.[15] Allegedly acting to preserve the public peace, the

papal guard began rounding up humanists in February 1468 and casting them into prison. If the former mausoleum of Hadrian, that most enlightened of ancient emperors, was an ironically appropriate place to house such ardent neo-Romans, its medieval castellans had long since turned the imperial sepulcher into a grim warren of lightless cells, all set deep within layers of impenetrable Roman concrete.

The exact reasons for Paul II's sudden scare in 1468 remain as elusive as the real doings of the Roman Academy. When the arrests began, in February 1468, Platina was among the first to be clapped into Castel Sant' Angelo, where he and about twenty fellow *sodales* then faced interrogation at the hands of the papal torturers.[16] These succeeded, despite their brutal methods, in extracting no information of substance.

Leto, whether he had sensed the pope's antagonism beforehand or was simply looking for a more lucrative job, had moved to Venice the year before, in 1467, but the pope, a Venetian native, had been able to procure Leto's arrest there on a sodomy charge, for molesting a local boy.[17] That trial, like the inquiries in Rome, proved inconclusive. Gradually Paul came to realize that he could not run Rome without his curial staff; his letters, bulls, and briefs required the expertise of trained writers, the best of whom were, beyond doubt, the humanists of the Roman Academy.[18] Still lacking any evidence of a humanist conspiracy against him, the pontiff, without making any public admissions, slowly lifted the persecution. Over the space of several months – though sometimes after having spent a year or more in prison – all the *sodales* were released, free, if they dared, to resume their business. Those who had fled the city trickled back, Leto among them. By 1471, the pope was dead, supposedly of natural causes.

Pope Paul's successor, Sixtus IV, restored the curial bureaucracy to its previous size, reinstating the positions that Paul had cut. The new pope, formerly Cardinal Francesco Della Rovere, was himself a distinguished scholar, a Franciscan who had specialized in the scholastic-dominated field of theology but who also appreciated the humanist view of the ancient classics. He made a point during his reign of encouraging both the Roman Academy and its individual members.[19] In 1475 he appointed Platina librarian of the newly reorganized Vatican Library. In 1477, Sixtus commanded that the Roman Academy reconvene under direct papal sponsorship. Wisely the pontiff also ordered Leto's group to charter itself as a religious confraternity, helping to dispel any lingering suspicion of paganism; the charter was ratified in the spring of 1478. Within the space

of ten years, what had begun as a free association of like-minded "brothers" had become an institution.

The Roman Academy continued to perceive no conflict between the classical and Christian worlds; its patron saints, Victor, Genesius, and Fortunatus, shared their feast day, April 20, with the traditional anniversary of Rome's founding by Romulus in 753 B.C.[20] (Two thousand years before, Plato's own academy had acted just as Pope Sixtus advised in order to avoid fourth-century Athenian political intrigue; the philosophical school was officially recognized as a religious club charged with maintaining the shrine of the hero Akademos.)

By the time Angelo Colocci arrived on the scene in the late 1490s, the Roman Academy, in all its different capacities (part institute for advanced study, part guild for curial humanists, part society for creative anachronism), had become the club to which, as a young humanist, he most aspired to belong. A sixtyish Leto was still firmly in charge of the proceedings, able to boast by now of substantial achievements among his *sodales*: his own revision of the biographies of the Roman emperors, known as the "Scriptores historiae augustae"; Platina's companion series on the lives of the popes (in which Paul II was suitably skewered); a huge collection of inscriptions; and extensive topographical studies of the ancient city and its fourteen regions. Still, revived rituals remained a central focus of Academy life. Colocci's first taste of those rituals came with his own initiation into the Roman Academy, here described by his seventeenth-century biographer, Federico Ubaldini:

> He also took up the invitation of Pomponio Leto to exchange his given name for one that had a flavor of ancient Rome, the hostility of Paul II not having been enough to put a stop to the practice, and he called himself "A. Colotius Bassus." He made this change of name with formal ceremonies, wreathing his head in laurel and with the approval of the academics, signing into the membership book alongside the others, having earlier given evidence of his qualification by reciting a composition. Later he was received at a solemn banquet, while the academics, singing verses in his praise, greeted him with the new name, nor would they ever address him except by that name; neither would they let themselves be seen at their meetings except crowned in laurel.[21]

Colocci's academic name tells us something more about him and his proverbial sense of humor. "Bassus," for all its superb classical pedigree, means "Shorty."

HUMANISTS

The *sodales* who drafted Colocci into the ranks of the Roman Academy were a varied lot. Aside from the perennial Leto, they belonged largely to the second generation of Roman academicians, no longer the embattled stalwarts of 1468 but the pampered elite of a government-sanctioned think tank–cum–dining society. Pope Sixtus IV, in addition to requesting an official, papally sponsored revival of the Roman Academy, had also set an improving hand to the places where his humanists were most likely to work: the university and the curial bureaucracy. At the university he was best known for his dilatory payment of professors' salaries, but his changes to the Curia had far-reaching effects. Not only had he restored the reduced curial staff to its previous size, but also, more significantly, he made every one of its offices a venal appointment, obtainable only on the payment of a large sum. (The system is explained in more detail in Chapter 3.) The sale of offices quickly transformed the Roman Academy from a cell of intellectuals to a conclave of entrepreneurs.

By and large, these enterprising *sodales* came from outside Rome, usually, like Colocci and Leto, from well-placed families in provincial cities; these were the men most likely to have amassed enough money to enter the curial marketplace. When they met together as Academics, however, they exchanged their roles in the Church hierarchy for a hierarchy inspired by the civic institutions of ancient Rome. There are only sporadic references to the Academy's offices and the people who held them, but these scattered glimpses reveal the thoroughgoing extent of the group's antiquarianism by participation. From the variety of offices recorded, it seems possible that each *sodalis* took on a role within the club that was as tailored to his personality as his academic name, and just as vividly neopagan in a social milieu where neopaganism sat comfortably within a Christian context.

Pomponio Leto, as the Academy's ringleader, bore the portentous title of "Pontifex Maximus," a designation reserved in the Roman Empire for the chief religious officer of the state but in later times appropriated by the pope (hence "Supreme Pontiff"). Perhaps Pope Paul II was disturbed by rumored references to Leto's "pontificate," but the interrogations of 1468 had revealed beyond doubt that Leto, at least, had no intention of becoming a pagan antipope or any other sort of political figure. The bygone days of imperial Rome remained the sole focus of his interest. Sixtus IV, more attuned to the attitudes of the Roman humanists, realized

that imperial Rome was the period of Roman history to which the papal monarchy might most advantageously be compared, and he encouraged Leto, Platina, and their fellow humanists to draw parallels between his own papacy and the imperium of the Caesars.

Leto's dauphin, the man who held the Academy together over the turn of the century, was a Tuscan humanist from San Gimignano named Paolo Cortesi (1471–1510).[22] Educated first at home and later in Pisa, he had come to Rome as a teenager to study at the university under Leto and the philologist Giovanni Sulpizio da Veroli. When the veteran academician (and Vatican librarian) Platina died in 1481, he also left vacant a post as papal scriptor, a venal office that Cortesi's father promptly secured for the ten-year-old Paolo as the first step toward an illustrious career in the Curia. (The actual duties of these positions, discussed in more detail in Chapter 3, were often farmed out to competent but less wealthy subordinates.) Indeed, Cortesi quickly revealed himself as smart and ambitious, a far more clever operator than either of his teachers at the university. By 1490, still in his teens, he had composed his first scholarly work, *On Learned Men* (De hominibus doctis), a critical analysis of the works of fifteenth-century Italian *litterati*. Dedicated to Lorenzo de' Medici, the essay was already far removed in spirit from the tight camaraderie of Medicean Florence. Papal Rome was a stern place, whose roiling intrigues and massive ruins tended to foster thoughts of eternity, and Cortesi's "learned men," carefully restricted to members of a previous generation, looked out on a larger and older world than the one created around Lorenzo.

With Lorenzo's house tutor Angelo Poliziano (1449–1494), Cortesi maintained an admiring rivalry; he probably hoped to become the kind of cultural arbiter for Rome that Poliziano had become in the Medici court. *De hominibus doctis* was only his first step toward what he hoped would be a glittering scholarly trajectory. In the early 1490s, he began to amass papers for a manual on Latin style, sending some examples off to Poliziano for approval, and was surprised when his hero snapped back a testy reply. Searching for another project, Cortesi toyed briefly with the idea of writing a book of advice to princes, a popular genre often used to attract the attention of an important patron among the Roman barons or among the lords at one of the Italian courts. He changed plans after a conversation with a patron of another kind, the rich, indolent, and piercingly intelligent Cardinal Ascanio Sforza. What, opined Ascanio, could be more trite than yet another "mirror for princes"? (The cardinal's own

brother, Lodovico ["Il Moro"] Sforza, lord of Milan, had seen more than his share of them.) A treatise on the papacy, he suggested, might be more to the point. Cortesi took the advice, setting to work on a treatise he called *De cardinalatu* (On the cardinalate), a Bible-sized guidebook to proper behavior for the ambitious man in modern Rome, reserving a special chapter for the papacy and some vivid descriptive passages for Cardinal Ascanio. Designed as a showcase for Cortesi's good manners and good Latin style, the project was cut short by the author's death in 1510; he was not yet forty. Later in the same year, his brother Lattanzio cobbled together the extant drafts for the book and published them, in an effort to advance Paolo's posthumous reputation, but the text, clearly unfinished, exerted little influence on contemporaries.[23] Cortesi's career nonetheless illustrates how, for one *sodalis*, and a *sodalis* more articulate than many, the antiquarian Rome of Pomponio Leto gave way to the gamesmanship of contemporary society.[24]

The Maffei brothers of Volterra provided a transition between the earliest membership of the Roman Academy and the young bloods, like Colocci, who had been born in the 1470s and moved to Rome in the 1490s or later. (In most respects Cortesi, despite his relative youth, also belonged to this earlier generation.) Raffaele Maffei (1451–1522), lean and serious, had become a papal scriptor, like Paolo Cortesi, at an early age (seventeen), in the eventful year of 1468. He cut short a promising Church career to marry sometime before 1490, probably without much regret; Roman worldliness always made him uneasy. He took care that his daughter grew up in the provincial security of Volterra, and as the years passed he himself spent more and more time there with his family, maintaining contact with Rome by means of mountainous correspondence. Much of his scholarly energy went into his one-volume encyclopedia, the *Commentaria Urbana*, an outstanding example of the universal compendium, a literary form as characteristic of the age as the mirror for princes. As might be expected of a digest designed to address all that was fit to know, the *Commentaria Urbana* treated the standard subjects of the university curriculum but also took up the Roman humanists' preoccupations, ancient coins, inscriptions (including two Etruscan inscriptions), and the fine points of Latin usage. Maffei's title suggested, moreover, that universal knowledge, like antiquity, was somehow inextricably bound up with Rome.

During the process of writing, both Paolo Cortesi and Raffaele Maffei discovered that the Tuscan hinterland was a better place to produce their

imposing books than the distracting, intoxicating atmosphere of Rome. Their devotion to their scholarly work ultimately curtailed their worldly careers. It was Raffaele's outgoing younger brother Mario (1463–1537) who rose high in the Curia and in its social circles, and he did so at the expense of any lasting scholarship. Without his brother's edgy intellectuality, the younger Maffei moved much more easily in the Roman social milieu, a social ease he shared with Angelo Colocci, with whom he quickly became friends. Maffei proved particularly effective as a patron of architecture, ably smoothing communication among patrons, architects, and craftsmen, a skill in which Colocci would also became adept.

The Academy's title "master of the horse" fell to a protégé of the Maffei family, the colorful young humanist Tommaso Inghirami (1470–1516).[25] Another native of Volterra in Tuscany, he was so close to Mario Maffei that the latter's mother called them "the twins" and claimed in jest to have given birth to them both at once.[26] Thrust into exile with his family at the age of three, Inghirami arrived in Rome in 1483, after having spent his childhood in Florence in the ambit of Lorenzo de' Medici. At thirteen, he began to study rhetoric under Pomponio Leto at the University of Rome, where his class included the brilliant young humanist (and future pope) Alessandro Farnese. Inghirami's own gifts must have been, if anything, more conspicuous. They went on public display in 1486 when Cardinal Raffaele Riario used the piazza in front of his palace near the Campo de' Fiori to present a full-scale revival of an ancient Roman tragedy, Seneca's *Phaedra*, or, as the players themselves called it in those days, *Hippolytus*.[27] Leto's colleague Giovanni Sulpizio supervised construction of the outdoor stage according to the prescriptions of the ancient architectural writer Vitruvius; a scenic medieval tower just behind the stage was pressed into service as the royal palace of Athens. Young Inghirami took to the boards in the role of the Athenian queen Phaedra, fatally enamored of her stepson Hippolytus, launching anguished soliloquies from the royal turret, much as Juliet was later to do from her balcony at the Globe. Inghirami family legend had it that when part of a set collapsed during one of the queen's soliloquies, Tommaso pressed on undeterred, improvising new lines in Latin verse until the errant scenery could be hauled back into place.[28] By the time the play ended, he had secured his reputation as the greatest actor in Rome.

Despite the fact that the nickname "Phaedra" (more often Italianized as "Fedra") clung to him for the rest of his life, Inghirami inscribed himself in the Roman Academy's ledger by the masculine form "Phaedrus," to

honor the Athenian youth who features in two of Plato's most beautiful Socratic dialogues, the *Phaedrus* and the *Symposium*. He distinctly preferred to be called "Phaedrus," in Italian, or "Fedro," but the memory of his performances in front of the Palazzo Riario was impossible to efface. As one of Rome's supreme examples of that entertaining capriciousness contemporaries termed *bizzarria*, Inghirami continued to answer to the feminine "Fedra."

The consummate actor, predictably, developed into a consummate orator; his only rival in Rome was the Augustinian preacher Egidio da Viterbo. Pronouncedly wall-eyed, Inghirami grew bald and enormously fat as he matured but remained as compelling a figure as he had been in his attractive youth: his sparkling wit, his histrionic skills, and his flamboyance had no parallel. His responsibilities as master of the horse are utterly unclear, although he always managed a stable of sorts: a troupe of professional actors. Despite his extroverted personality, Inghirami also immersed himself in books; he was to serve two popes as librarian of the Vatican Library. Because of this scholarly bent and his similar age, he took an early interest in Colocci and the latter's researches, eventually procuring for the younger humanist one of his most valuable manuscripts.

Another *sodalis*, Andrea Fulvio of Palestrina (ca. 1470–1527), had, like Inghirami, studied with Leto and become his devoted disciple. A quietly modest man, he had little in the way of a personal fortune. Typical of men in that position, he worked as a private tutor and later took up a post in one of the city-run neighborhood (*rione*) schools.[29] Like many a humanist of modest income, he gravitated toward the circle of one more wealthy. Fulvio chose fortunately in Alessandro Farnese (1468–1549), who suddenly found himself appointed cardinal in 1493; Pope Alexander VI had just taken Farnese's sister Giulia ("la Bella") as his most recent mistress.[30]

Among the Roman academics, Inghirami, Fulvio, Cardinal Alessandro, and Colocci all knew Greek, some better than others, but all of them deferred to the erudition of a humanist from Pistoia, Scipione Forteguerri, who had translated his surname into Greek to become Carteromachus ("Strong in Battle"). "Messer Scipio" owed some of his cachet to his skill and some to the fact that he had studied with a native Greek-speaker, the great Constantine Lascaris. He had also devised a peculiar method for reading books that he called "tabulation"; he drew up tables of word lists in a book's margins or on separate papers as a way of remembering its contents.[31] Colocci, at least, found tabulation an easier skill to master than

Greek and eventually tabulated his way through a wide swath of literature – ancient, medieval, and contemporary (Fig. 4).

Despite the fact that many of its members came from elsewhere in Italy, the Roman Academy was also open to Romans, like the noble but impoverished Evangelista Maddaleni Capodiferro, who sheltered for much of his life under the sponsorship of the Colonna family. Ironically, his academic name, "Faustus" (Italian "Fausto"), meant "Lucky," but perhaps he was lucky, after all, to have found so powerful a patron as Cardinal Giovanni Colonna.

Poverty, indeed, could send a *sodalis* into a precarious state of dependency. Both Fedro Inghirami and Angelo Colocci therefore reserved special solicitude for companions in delicate circumstances, like the elderly schoolmaster Pacifico Massimi of Ascoli (d. 1506).[32] What inspired their loyalty to Massimi is difficult to fathom from any remaining evidence. An accomplished pornographer, he also composed vernacular verse, some of it directed ungratefully against Colocci, with whom the destitute old teacher took up lodging during the last years of his life. His diatribes against his host make a striking exception to the praises Colocci received from his many other friends. But the old man from Ascoli, in invective as in all else, never bothered to mince words:[33]

> So, shall I tell you the truth, and all of the things on my conscience?
> You're not the kind of man I once had believed you must be.
> You keep one thing in your mind and one on your lips, and your actions
> Don't correspond to your words; you say this while doing that.
> Easily from your words you give the impression of mildness,
> But in the end your face and your thoughts don't quite come out the same.
> Friendly of face, you seem to promise a wonderful something,
> But like a scorpion you keep a nasty sting on your tail.
> You inspire fury in me that equals an enemy's hatred,
> Barking my name at me as if from the mouth of a dog.

It was more usual to hear *sodales* address one another with extravagant affection, as when clubman Evangelista ("Faustus") Capodiferro wrote to Tommaso ("Phaedrus") Inghirami, who had sailed off to Sicily on a diplomatic expedition with Cardinal Giovanni Colonna,

> What a long wait it's been, ah, my Phaedrus, I waste away waiting
> It wasn't mine to hope for a shorter span to my pain . . .

> Waiting, I die; and though hope helps, still, this kind of hoping
> Ought be called despair, for it's hope that walks with a limp.[34]

Elsewhere he compares the shackles of his affection for Inghirami with
the leashes of his patron's hunting dogs:

> Those massive collars are for the necks of Molossian mastiffs;
> These reliable leashes rein in roistering dogs.
> Yet I am shackled by ties that leave all these chains overpowered:
> Phaedrus and love made my bonds; anyone might make the
> rest.[35]

Such erotic overtones were as integral to the dealings of the fifteenth-
century Roman Academy as they once had been to the Academy of Plato
or to the group of fifteenth-century Florentine intellectuals gathered
around Marsilio Ficino; as Capodiferro's verses suggest, Pomponio Leto's
club for Roman humanists gave rise to some intensely emotional friend-
ships, if nothing else. Leto, Inghirami, and Massimi, in particular, were
all accused at one time or another of aggressive homosexuality; this
charge, if prosecuted as sodomy, could lead to death at the stake.[36] Their
reputation, and its potential risk, comes especially clear in a letter written
to Machiavelli in the summer of 1501 by a young Florentine visitor to
Rome, Agostino Vespucci. Here the predatory habits of the Roman
Academy are mentioned along with the execution of a noblewoman who
has been burned at the stake for abusing one of her maids sexually:

> It's around noontime, and I'm dying of the heat here in Rome, and
> because I can't sleep I'm jotting down these few lines, encouraged as
> well by Raffaello Pulci, who has been having his fun with the Muses.
> He is always in among four prostitutes along with Sante Londiano, and
> he said to me that he worries that because he has a certain reputation
> for being a poet, and that the Roman Academy wants to induct him,
> he does not want to run any risk of being molested, because Pacifico
> is here, and Phaedro, and some other poets, who, if they did not find
> shelter with this or that cardinal, would already have been burned at
> the stake! Furthermore, in these last few days a woman was burned
> alive, one of very high rank, a Venetian, for having molested a girl of
> eleven or twelve, whom she kept in her house, and she did other things
> to her that I won't mention, because they are too depraved, rather like
> the things that the Emperor Nero did.[37]

Vespucci suggests that Fedro and Pacifico have escaped prosecution
for sodomy because they are protected by various cardinals. However,

the case of the convicted noblewoman shows that an accompanying factor carried crucial weight in court: coercion of a helpless dependent. If the Roman Academy pursued Plato's ideal of love between males, it did so among members of a voluntary association composed of social peers. Fedro and Pacifico could always have contended that they consorted only with willing companions, and the charismatic Inghirami, at least, would probably have been telling the truth.

Leto's own sodomy charge, of course, had been brought for political reasons during Paul II's persecution of the Roman Academy. After 1468, the Platonic bonds that united the members of the Roman Academy were to remain largely safe from external pressure until the onset of the Reformation. With his pontificate, Sixtus IV (despite his also having founded the Spanish Inquisition and appointed Tomás de Torquemada to head it) had ushered in a period of relative tolerance in Italy that lasted in some respects until the convening of the Council of Trent (1545–63).

ROMAN SOCIETY

The Roman Academy was only the most famous, the most persecuted, and the most elaborately ritualized of the Roman social clubs in the late fifteenth century. In its other aspect as a religious sodality, too, it fit into a larger social picture, for religious confraternities provided an important focus for curialists to whom the practice of Christian charity was integral to a career in the Christian capital. The elite Confraternity of Santo Spirito, dating back to the papacy of Innocent III, was refounded by Pope Sixtus IV in 1478 to provide support for the newly rebuilt hospital of the same name. Headquartered at the entrance to the Borgo Vaticano, the rejuvenated congregation opened its rolls to highly placed churchmen and the most well-heeled of the curial bankers, as well as to any important foreign visitors to Rome.[38]

The Confraternity of the Santissimo Salvatore (Most Holy Savior), likewise of medieval date, made formal the popular devotion to an image of Christ from the Chapel of the Sancta Sanctorum at the Basilica of Saint John Lateran. Every August 15, on the Feast of the Assumption of the Virgin, the lay brothers of the confraternity paraded their image through the remains of the Forum, where it "met" an image of the Virgin Mary, likewise marched out in state from her ancient Basilica of Santa Maria Maggiore (by the Confraternity of the Gonfalone, discussed below).[39] During the rest of the year the Confraternity of the Most Holy Savior,

among other charitable works, acted as board of trustees for two private colleges. Both of these institutions were founded in the later fifteenth century by cardinals intent on offering higher education to impoverished but promising students. Cardinal Domenico Capranica's Collegio Capranica, originally housed in his own palace, was chartered in 1456 and began admitting students in 1460. Transferred in 1478 to the nearby Convent of Santa Maria in Aquiro, in the same Piazza Capranica, it still carries on its original mission, though now at the level of high school.

With similar intent to help the talented poor, Cardinal Stefano Nardini founded his Collegio Nardini in the 1480s at the church of San Tommaso in Parione, calling for administrative help on the Confraternity of the Most Holy Savior, now seasoned with twenty years of experience at trusteeship for the Collegio Capranica. By 1486, the lay brothers had turned from a distantly benevolent board of governors into so actively intrusive a body that the Capranica faculty lodged an official complaint with the pope.[40]

On a more private scale, the lay brothers of San Giovanni Decollato, clad in black hoods, issued forth from their oratory beneath the ancient Roman execution ground, the Tarpeian Rock, to pray for the condemned criminals of their own day before their executions.[41] Across town, likewise hooded to preserve their anonymity, members of the Brotherhood of the Blessed Sacrament and the Five Wounds of Christ, founded under the papacy of Alexander VI and housed in the Church of San Lorenzo in Damaso, rushed to the bedsides of the dying to offer the comforts of religion. In 1519, the Arch-Confraternity of San Girolamo della Carità would be founded on a site only two blocks away to perform similar services for what had become Rome's most fashionable neighborhood in the late fifteenth and early sixteenth centuries.[42]

Religious clubs also attracted the enterprising women whom this male-dominated city seemed to breed in abundance; Roman women had substantial rights to hold property in their own names, and they managed their possessions with considerable independence. Women's religious sodalities ranged from the prayer groups of the pious laywomen called *pinzochere* to well-heeled associations through which propertied women disposed of their wealth in good works.[43] If prostitution abounded in a city where so many men were forbidden by their profession to marry, so too did organizations designed to win women away from prostitution, like the Convertite della Maddalena, near Piazza San Silvestro, and the already mentioned Confraternity of San Girolamo della Carità. Hoping

to save girls from such a life, organizations like the Confraternity of Maria Santissima Annunziata, founded in 1460 by the Dominican theologian Juan de Torquemada, distributed dowries to poor girls from their confraternal chapel in the Church of Santa Maria sopra Minerva.[44] The endowment charters of many other private chapels in Rome carried the same stipulation.[45] They did not prevent the prostitutes from becoming the most numerous single professional group in the city, even after syphilis made its appearance in the 1490s.

The epidemic advent of syphilis then spurred the construction of a new specialized hospital, the ominously named San Giacomo degli Incurabili, sustained, like other such organizations, by a confraternity named for the hospital's patron saint. Nearby, along the riverside, the Confraternity of Saints Roch and Martin (Ss. Rocco e Martino) kept a hospice for sailors.[46]

Some religious groups served a more cultural bent in an age when monasteries and convents maintained an active musical life and the visual arts played a central role in the expression of religious faith. The Roman painters' guild was incorporated for the first time in 1474 as a confraternity devoted to Saint Luke, the evangelist who was reputed to have been the first person to paint a portrait of the Virgin Mary and her son; the Confraternity of Saint Luke developed in the later sixteenth century into the renowned Accademia di San Luca.[47] Art of a different sort was honored by the bakers' guild, the Confraternity of Our Lady of Loreto, which commissioned an impressive church near the Forum of Trajan in 1501.[48] The goldsmiths' guild, too, financed an appropriately jewel-like church, Sant' Eligio degli Orefici, in 1514.[49] Beginning in 1490, passion plays were produced in the Colosseum under the auspices of the confraternity known as the "Gonfalone" after the banner (*gonfalone*) they carried in procession. Founded in 1242, and still important today as a force in Roman cultural life, this association's official name was "La Compagnia de' Raccomandati di Madonna Santissima Maria" (The Protégés of the Most Holy Madonna Mary).[50] Like the confreres who pursued their works of charity in hooded anonymity, these pious and substantial citizens took the parts of the Passion story as a way of effacing their own identities in an act of devotion, convinced (wrongly, as it happens) that they played out their reenactment on a site where early Christians had once been martyred.[51]

Cultural associations of a less overtly religious nature formed around the houses or *vigne* of influential individuals, both lay and clerical.

Throughout the 1490s and the first few years of the sixteenth century, a small academy of sorts met at the house of Paolo Cortesi, whose personal interests went beyond the antiquarian researches of the Roman Academy and whose personal ambition required a salon of his own. With one eye cocked toward Florence, he presided over discussions of Italian vernacular and sessions of poetry set to music, as well as forays into the perennial question of Latin style that he might also hash over with friends in the Academy. The imprint of Cortesi's elegant tastes did much to shape the aesthetic preferences of Rome in his day.

But the real nerve centers of Roman social life were the showy palazzi of the cardinals and the dynastic abodes of the barons whom they were busily trying to replace.[52] Sometimes the same piazza held both, as did Piazza Capranica during the lifetime of Cardinal Domenico Capranica, churchman and baron in one, or the Piazza Santissimi Apostoli, deep in Colonna territory. Throughout the fifteenth century, the venerable Church of Santissimi Apostoli housed a small university sponsored by the Franciscan order. When the Franciscan Sixtus IV became pope, the piazza in front of the church began to play host not only to the baronial family itself but to some of the pope's various nephews. His favorite, Cardinal Pietro Riario, had begun to rebuild the palazzo opposite the church; Riario's formidable rival and cousin, Cardinal Giuliano Della Rovere, himself a Franciscan monk, took up residence to the left side of the basilica in a severely elegant new building.[53] To the right of the church lived the Colonna themselves in the amoebic sprawl of their ancient house. Cardinal Giovanni Colonna devised exclusive dinner parties at which verse, both Latin and vernacular, was performed to music; in a more public vein, Pietro Riario sponsored open-air spectacles in the piazza. Cardinal Giuliano, in the meantime, amassed a spectacular collection of ancient statues, including the dapper Apollo Belvedere.[54]

It was the friends of the Neapolitan Cardinal Oliviero Carafa, who foregathered in his house on Piazza Navona, who first began to dress a battered old Roman statue group of heroes from Homer's *Iliad* – a noseless Menelaus holding the headless, limbless trunk of the dead Patroclus – in fanciful costume on Saint Mark's Day, praising this singular apparition in verse as "Mastro Pasquino" and giving rise to a still unbroken tradition of social commentary, the pasquinade (Fig. 5), a poetic form in which the statue himself speaks his mind in verse on events of the day.[55] In 1501, Cardinal Carafa enshrined the talking statue on a pedestal,

the better to display his costumes and the cranky poems affixed to his raddled surface at every opportunity. The cardinal's house is gone, but Pasquino continues to pique Roman consciences; he spent much of the 1980s with a spray-painted feminist graffito on his pedestal that read "Pasquina."

At the opposite end of the Piazza Navona, Pietro Mellini held court in the garden of his ancestral home, surmounted by a medieval tower, the Tor Millina; Cardinal Adriano Castellesi, ensconced somewhere in between the two, liked the location enough to avoid ever taking up residence in his stylish travertine palazzo near the Vatican. Angelo Colocci himself eventually attracted his own group of *sodales*, entertaining them in Pomponio Leto's garden or, after 1513, in his own new literary retreat by the Trevi Fountain.

When writing to Machiavelli in the summer of 1501, Agostino Vespucci had noted with some bemusement that the gatherings in Roman *vigne* included accomplished prostitutes as a matter of course. Much in demand in this city of celibate men, they were well on their way to becoming institutionalized under the euphemistic term *cortigiane*, "ladies of the court."[56] As if to gloss over a horrific reality, their male contemporaries (who exploited them ruthlessly) tended to wax poetic over the courtesans' intellectual accomplishments, but even the choosy Latinist "Matremma non vole" (My Mamma doesn't want me to) was a far cry from the truly intellectual women in Rome. Genuine humanists like Nigella Laeta, herself the daughter and wife of humanists, shared all the educational advantages that had come with their fathers' comfortable social position, to say nothing of a personage like Nigella's younger contemporary Vittoria Colonna, born into the great Roman baronial family.[57] Courtesans, by contrast, were bred of grim circumstances, the attractive daughters of prostitutes or dirt-poor workers, girls who usually received at best a training in vernacular literature, unless their mothers too had been in the business. Furthermore, while a Nigella Laeta could spend her days redacting Latin manuscripts, a Matremma non vole was called upon most of the time to perform very different, and no less time-consuming, services. Ladies of the court feature prominently in the topical verse that Colocci and his friends composed in Latin and vernacular, convenient objects both of love poems and of scurrilous invective. Colocci himself claimed to have loved only a few women in his life, and never happily. Although he certainly maintained a liaison with a married

woman at one point in his life, he seems, by and large, to have steered clear of expensive entanglement with professionals. Many of his friends were not so prudent.

If the relationships between men and women in papal Rome often boiled down to a financial transaction, whether to engage a courtesan for the evening or a suitable wife " 'til death do us part," voluntary associations among male *litterati* also intertwined the social and the mercenary in the form we know as patronage. Drawing on the patriarchal Roman family as its model, patronage as a social institution harked back to the days of the Roman Republic, the first period in Roman history to generate vast differences in individual wealth.[58] Ever afterward, the city's wheels had turned on a delicate interlocking system of wealthy sponsors, *patrones* – literally, "big daddies" – and an extended family of poorer *clientes* – "listeners" – who used their various kinds of ingenuity to tap the sources of conspicuous wealth.

Patronage in ancient Roman times, at least as the word is understood in English, actually ran the gamut from friendship among equals to work for hire. Literature and political favors, especially, might pass between social equals without thought of immediate recompense; so too completed works of art might be exchanged among patrician collectors of comparable status. The more the exchange of money or the practice of a manual art entered directly into the picture, the more carefully the Romans distinguished the status of the patrons who commissioned projects from that of the subordinates who carried out the desired work: hence painters, sculptors, copyists, architects, and goldsmiths were all considered craftsmen of inferior social rank. Political patronage ranged, by the same token, from alliances among fellow senators through more unequal relationships with protégés, lieutenants, or agents, down to the mercenary but necessary transactions to procure hired thugs.

Throughout the Middle Ages and into the fifteenth and sixteenth centuries, Roman society continued to gravitate around powerful families, although as society changed the nature of patronage changed as well. The advent of Christianity, and then of a celibate clergy, meant that Rome's barons shared dominion over the city with the cardinals and their households, which were also called *famiglie* (families). Patrons of these later times were more likely than their ancient Roman equivalents to offer formal salaried positions to artists, musicians, and even to *litterati* (or at least the evidence for salaries is far easier to establish). Italian scholars also take pains to divide what their English-speaking colleagues call "patronage"

into two separate categories, separating the dispensing of political favors, which they call *clientelismo*, from the sponsorship of art, music, and literature, which they call *mecenatismo* (after Maecenas, the great literary patron and friend of the Emperor Augustus). Still, *clientelismo* and *mecenatismo* were not necessarily separable in any given case: artists like Raphael and Sebastiano del Piombo were rewarded with well-paying administrative offices in gratitude for their talent as painters, and the holders of many a political appointment, like Machiavelli, Guicciardini, or Pietro Bembo, nurtured aspirations as writers. Patronage was a complicated business, as variable and elusive as the people whose constantly shifting relationships the term attempts to describe.

In ancient Rome and ever after, despite the favorable environment it provided for flatterers and parasites, patronage also fostered genuine bonds of friendship together with the staples of culture: art, music, literature, and scholarship. Through the generosity of an Alessandro Farnese or an Angelo Colocci, people of more modest talents or modest income, like an Andrea Fulvio or a Pacifico Massimi, could still take an active part in the Republic of Letters. The patronage of a Raffaele Riario could translate Pomponio Leto's lectures on ancient drama and Sulpizio da Veroli's research on ancient architecture into a real performance like the Seneca of 1496 and launch a young talent like Tommaso Inghirami in the process. Furthermore, the ties of patronage consistently extended the attentions of the humanists outside their Latinate realm to the vernacular worlds of finance and the arts.[59]

In the Rome of the cardinals, as in the Rome of the senators, patronal "families" persisted as the city's basic social system, and any successful resident had necessarily learned to live within the confines of this peculiar network.[60] Pope Sixtus IV and his dynasty proved particularly adept at maneuvering their family ties, both figurative and literal, and they may serve as an example of the prevailing social phenomenon of their age.

SIXTUS IV AND HIS NEPHEWS

A telling portrait of the pope and his relatives once adorned the entrance wall of the Vatican Library, frescoed in 1477 by the talented Umbrian artist Melozzo da Forlì (Fig. 6). (It has now been detached for exhibit in the Picture Gallery of the Vatican Museums.) Aside from its explicit testimony to the pope's grand plans for the city of Rome, *Sixtus IV Organizes the Vatican Library and Appoints Platina Its Librarian, 1475*, turns a gimlet

eye on the personalities of the papal nephews Sixtus had invited to his court, shown dutifully assembled around their powerful uncle.[61] On the far right, the enthroned pope is attended by his great-nephew Raffaele Sansoni Riario, a youth of eighteen in 1475, clad in the black habit of the Augustinian order; in December 1477 he would be elevated to cardinal. On his knees facing the pope, a large-boned scholar in sober blue robes points downward toward a fictive marble plaque with a Latin inscription; the gesture is enough to reveal that his outfit has been enlivened by a bit of lace at the cuff of his shirt.[62] This is Bartolommeo Platina, great friend of Pomponio Leto, biographer of popes, precipitating cause of the Roman Academy's troubles in 1468, and, thanks to Sixtus, the newly minted Vatican librarian. The elegiac verses to which he points are his own, and they praise Sixtus not only for providing the library with lavish new quarters in the Vatican Palace but also for a variety of urban renewal projects: repairing the aqueduct of the Aqua Virgo, as well as port facilities, city walls, bridges, and houses:

> With churches and palace restored, and the streets, fora, city walls,
> bridges,
> Now that the Aqua Virgo at Trevi is back in repair,
> Now you may open our age-old port for the shippers' convenience,
> And girdle the Vatican grounds, Sixtus, with a new wall.
> Still, Rome owes you more than this: where a library languished in
> squalor,
> Now it is visible in a setting befitting its fame.[63]

In a striking position just off the center of the fresco, Giuliano Della Rovere, a vigorous thirty-four, forms, along with Platina, its undeniable focal point.[64] Although admittedly not a scholar, Cardinal Giuliano seems to have assumed the library as a particular responsibility, and for this reason it is he and Platina who are the most significant figures to the fresco's original context on a wall of the library suite.

Two other nephews, clad in fur-lined velvet and wearing ponderous ornamental chains around their necks, stand off to the left, laymen who had been given secular duties in the papal government. The stocky, lantern-jawed man in red is Cardinal Giuliano's brother, Giovanni Della Rovere, recently named prefect of Rome. The willowy blonde with the exhausted, protruding eyes is the prickly and wayward Girolamo Riario (whose sister was Raffaele Riario's mother). Violent and indolent, Girolamo spent his life as a military commander, settling about 1477 in the

papal fiefdom of Imola, together with his formidable wife, Caterina Sforza. Neither Girolamo Riario nor the prefect, as Giovanni was called, had any involvement with the Vatican Library; they are present in the fresco simply to complete the pope's family circle. They look out beyond the viewer, interacting with none of the other figures in the composition; indeed, Platina and Cardinal Giuliano show them their backs.

Melozzo focuses attention instead on the quartet gathered around the papal throne. The pointing Platina looks meaningfully at his patron, Pope Sixtus, while the pope himself returns a sharp glance over the entire scene. His piercing expression serves as a reminder that the former Francesco Della Rovere was an unusually intelligent man who had risen from obscurity to become a famous theologian before he was elected pope.[65] The pontifical library, founded by Pope Nicholas V in the early 1450s, had served him well; in 1475, he returned the favor in style. Above the heads of pope and librarian, Raffaele Riario and Giuliano Della Rovere glare past one another with studied indifference. Even if he were not clad in crimson and ermine, Giuliano would still dwarf his younger cousin physically; he seems to be moving forward with an almost menacing aggressiveness. The expression in the cardinal's eyes already affords more than a hint of the incandescent bullheadedness for which Pope Julius became famous; his other great portraitist, Raphael, always averted that terrifying gaze. Raffaele Riario, who stubbornly holds his ground, looks exceedingly uncomfortable.

Giuliano Della Rovere and Raffaele Riario, despite their rivalry and their difference in age, were really two of a kind. Even after the death of their uncle the pope, they continued to dominate Rome as patrons in both senses of the word, that is, as powerful political figures and as sponsors of the arts.

RAFFAELE RIARIO (1460–1521)

There was always something theatrical about Raffaele Riario; the very way he carries himself in Raphael's portrait of him in *The Mass of Bolsena* (Fig. 40, discussed in Chapter 6) reveals his sense of drama.[66] His patronage of the arts was no exception. The famous 1486 production of Seneca's *Phaedra* took place in front of Riario's residence near the Campo de' Fiori, paying homage to the cardinal's generosity, but also paying homage to the site itself. The streets in this area of Rome follow a peculiar semicircular route; their surrounding buildings have been erected on the foun-

dations of the ancient city's first permanent theater, dedicated by Pompey in 55 B.C. As the first Roman playhouse to be built of permanent materials rather than a temporary wooden frame, Pompey's Theater spared no expense: its massive auditorium boasted room for 18,000 spectators, while an adjoining tract, laid out in gardens and porticoes, offered protection in case of rain.[67] So elegant was the theater that the Senate often met on its grounds for deliberations, including the occasion on the Ides of March, 44 B.C., when Brutus and a conspiracy of senators assassinated Julius Caesar.

If Riario displayed slightly more restraint than Pompey in his sponsorship of drama – he subsidized only a temporary stage rather than a permanent theater – the production of 1486 nonetheless showed keen attention to the theatrical conventions of Pompey's time, at least as they were understood by the two university professors who were responsible for the performance, Pomponio Leto and Giovanni Sulpizio da Veroli. Guided by the stage directions included in the texts of plays by Plautus, Terence, and Seneca, the pair also studied the prescriptions for Greek and Roman theaters laid out by the ancient architect Vitruvius, who was, conveniently enough, a contemporary of Pompey, Caesar, Cicero, and Augustus.

Thus, because Vitruvius specified that a Roman stage should be 5 feet high, this was the height of the platform on which the teenaged Fedro Inghirami made his triumphal appearance. Because Vitruvius praised the invention of painted sets on revolving drums (*periaktoi*) to facilitate rapid changes of scene, Riario duly provided them for his production; it may have been one of these *periaktoi* that collapsed behind the unflappable Queen Phaedra.

Riario's chief adviser for the project, Giovanni Sulpizio da Veroli, hoped that the play's success would inspire the cardinal to follow Pompey's lead to its logical conclusion and supply Christian Rome with its own permanent theater. For theater, Sulpizio declared, would act as a stimulant to youthful imaginations; the old Rome would live again in the heart of the new. One of those youthful imaginations, as Sulpizio well knew, belonged to Riario himself; despite his influence in the Vatican, he was still only twenty-eight years old.

The Seneca production and its impressive temporary theater provided a single instance of how Rome's intellectual community had begun to work in earnest in the revived style of the ancients. But Riario was also passionately interested in the creation of more permanent architecture in

the ancient style. He first manifested this interest by sponsoring the publication of important treatises on building, both ancient and contemporary, beginning, in 1482, with the publication of Leone Battista Alberti's "On Building" (*De re aedificatoria*).[68] This ambitious work, the first systematic treatment of the new classical style in architecture, had been drafted in Rome about 1450, when Alberti worked in the Curia of Pope Nicholas V. Appropriately, Riario also funded the first printed edition of the ancient writer on whose work Alberti had modeled his treatise, the *De architectura* of Vitruvius.

This printed Vitruvius, dedicated to the cardinal, came, like his theatrical productions, straight from the ambience of the Roman Academy. Once again the guiding spirit was Giovanni Sulpizio da Veroli. The preface to Sulpizio's edition of Vitruvius explains something about why he chose to undertake the work of editing and why Riario in particular was so appropriate a sponsor for his endeavor:

> Whatever care and enthusiasm, sleepless nights and labor I have put into emending and publishing Vitruvius, whatever utility I have afforded, and whatever praise I might earn I dedicate to you, Raffaele Riario, most worthy chamberlain of the Roman Church, secure refuge of scholars, fosterer of talent, hope of the public, patron of the people, goodwill's delight, lively image of every virtue. To whom could I have better done so than to him to whom I am devoted, and by whom I know myself to be preferred and Vitruvius to be held a favorite? To whom, indeed, would that very architect have addressed himself more gladly than to that man who delights so greatly in reading his work, and who, if he should live so long, will make frequent use of his teachings in the construction of great buildings, in whom we lodge firm hope that you shall build lawcourts, palaces, villas, churches, porticoes, fortifications, but theaters first of all? For it was you who outfitted, and beautifully, a stage erected to the height of 5 feet in the middle of the piazza for that tragedy which we first produced to inspire the youth to act and sing. This same tragedy was later performed in Castel Sant' Angelo with Pope Innocent attending, and then in your house . . . You first displayed a painted stage set when the Pomponians performed their comedy; hence the whole city eagerly expects you to build a theater.[69]

Editing Vitruvius, as Sulpizio well knew, was no easy task. Centuries of copying had riddled every medieval manuscript of any classical text with inevitable errors, but *De architectura* posed special difficulties because

of the book's highly technical content. Terms appeared there that appeared nowhere else in preserved Latin literature, as most Roman authors had paid no attention whatsoever to such mundane features of their life as digging cisterns, laying water pipes, or preparing wattle-and-daub walls for painting. The Arcadian shepherds of Virgil and Horace never evaluated either the chemical composition or the durability of the trees under which they sheltered to play the panpipes and talk of love, nor did Cicero detail the kinds of moldings that went into the well-made doorframe. Greek terms that Vitruvius himself must have recorded in Greek had been transformed by generations of Greekless scribes to something that looked more like tortured Cyrillic, while many of the Roman numerals by which the architect supplied dimensions had dropped a stroke or two in transit across the millennia, "xviii" turned by attrition into "xvii." The later books, in particular, used a repertory of ancient symbols for weights and measures whose configuration and meaning had long since gone into eclipse. The eleven illustrations announced in the text itself had disappeared by the ninth century, the age of the oldest known manuscript.[70] As a result, by the fifteenth century as brilliant a man as Leone Battista Alberti felt that he had neither the time nor the expertise to straighten out the philological tangle of Vitruvius, and so he wrote his own *De re aedificatoria* in emulation of an author he felt he barely understood:

> Certainly it pained me that so many and such illustrious written records should have succumbed to the injuries of time and human agency, so that we have but a single survivor of that great shipwreck: Vitruvius, a writer learned beyond doubt, but so affected by time and so fragmentary that in many places much has been left out and in many others one would wish to have more. It so happens that he did not compose in a polished manner; he speaks in such a way that the Latins would have regarded him as Greek, while the Greeks might guess that he spoke in Latin. The work itself, held out for scrutiny, bears witness that it was neither Latin nor Greek, so that to us it would be the same if he had never written at all, writing as he has in a manner we do not understand.[71]

Because of these nagging problems, Sulpizio's edition of Vitruvius lacked two important features of the original Latin text: the Greek and the illustrations. His publication left blanks in the text where attentive readers could fill in the missing Greek passages to the best of their ability, while the lack of illustrations could at least be said to make for a cheaper

edition. Sulpizio recognized the deficiencies of his edition in an open letter to his readers in which, with scrupulous self-effacement, he addressed them as potential collaborators:

> I took on the task [of editing Vitruvius] so that, as far as my other business permitted me, I could supply a printed text that was correct enough to leave only a small amount of additional work to an interested reader . . . Where the Greek is obscure or clearly corrupt I will do the best I can in the meantime to discover better readings by collating [existing texts]; I will not pass them over in silence. Because we have not been able to find exemplars for the illustrated figures and they are difficult to understand and laborious to execute, spaces for them have been reserved in the margins, so that when they are eventually published by our efforts or those of someone else they may be pasted into their proper places. In the meantime, all the readers into whose hands these volumes come are implored to lend us their help, so that we may have this author in a correct version, perfect in every part.[72]

The stopgap text, despite its yawning blanks, was a useful publication, for Sulpizio was a conscientious scholar who knew ancient Rome well. He navigated through the problematic text by keeping as closely as he could to what he found in the manuscripts, trying his best to make sense of what he read. The result was a "conservative" redaction that represented the manuscripts accurately and contained a minimum of guesswork. Riario's circle hailed it, justifiably, as an important step toward producing a new architecture designed to capture all the elegance of the ancients yet adapting that elegance to give new shape to a Rome that had become the capital of Christendom. As Sulpizio observed in his preface to Riario, "Prudent reformers have already embarked upon designing with forethought, eurythmy, and symmetry." "Eurythmy" and "symmetry" were explicitly Vitruvian terms, referring to the strict range of proportions that governed both the dimensions of individual compositional elements in the classical system (eurythmy) and the design of the work as a whole (symmetry). *Consilium* (forethought) is the specific contribution of late fifteenth-century builders to the formulation of their new style. With budgets on a scale much reduced from the boundless resources of imperial Rome, the proponents of the new style had to proceed sensibly. Prudent planning rather than outrageous expenditure continued to govern Rome's architectural revival for another twenty years.

The construction of the Palazzo Riario followed close on Sulpizio's

Vitruvius text to offer living proof of the ancient author's currency. Sulpizio, of course, had hoped that his edition would prod Riario specifically into constructing a theater for the use of the university:

> We need a theater. What could you build that would be more delightful to us and to our descendants? Although those that followed upon Pompey's were smaller and less ornate than his, which was marble and of immense capacity, they were still the source of great reputation for their builders. How many other types of building remain of which no complete examples survive but whose ruins you could repair or rebuild anew?[73]

Raffaele Riario, chief financial officer for the papal state, must have seen that a theater was likely to seem a frivolous expense. In 1485, he had already bought a plot of land near his palazzo in the Campo de' Fiori where he planned to erect a building for which he would in part restore something old, in part build something entirely new, and undertake the whole enterprise with "forethought, eurythmy, and symmetry" as well as a firm grasp of late fifteenth-century Rome as it really was. He began to build an urban palazzo, one that stood near the site of the Theater of Pompey but also occupied a site of venerable Christian heritage, for here in Late Antiquity had stood the palace of Pope Saint Damasus, the wealthy Roman convert whose eponymous basilica, San Lorenzo in Damaso, still survived as a modest, slightly dilapidated structure. Riario's plans for his new residence (Fig. 7) changed over the twenty-five years of its construction, but they always included incorporating the church, installing an audience hall (all that remained of Sulpizio's hopes for a theater), and erecting a façade that for its time was megalomaniacal in its scale.[74] Its construction was to occupy the next twenty-five years of his life. Remarkable for its expense, its ancient materials (largely quarried from the Colosseum), and its new classicizing design, the new Palazzo Riario was also significant, at least according to Riario's admiring friend, Paolo Cortesi, for its site near the Theater of Pompey.

The lines of the Palazzo Riario's broad façade clearly echo those of the Colosseum, from which a good deal of its travertine veneer was looted. But the same pattern of travertine-faced arcades interspersed by engaged columns was visible as well on the extensively preserved Theater of Marcellus, only slightly smaller (capacity 15,000) and slightly later in date (13 or 11 B.C.) than Pompey's more ruinous edifice, known in Ria-

rio's day as the "Colosseo dei Savelli," after the baronial family who lived within it.

But the Palazzo Riario's theatrical façade went deeper in its meaning than the visual echo its round-headed windows and rhythmic pilasters made of the play of columns and arches across the surfaces of these auditoria from ancient Rome. The new building's magnificence, as well as the choice and outlay of its rooms, served to implant the idea that one important function of a great Roman palazzo was to act as a kind of theater for its patron. A variety of settings within the building served to display the powerful cardinal with all the pomp attendant on his many offices. Its fabric engulfed entire the Early Christian basilica of San Lorenzo in Damaso; in addition to a great hall, it also included a formal arcaded court for receiving visitors.

As Paolo Cortesi makes clear, Riario's palazzo was indeed a theater, one into which people came, as Ovid had put it in ancient Roman times, "both to see and to be seen":

> When Raphael Riario (a cardinal who sparkled with brilliant intelligence and an avid explorer of human nature) had drawn up the plans for his magnificent house by the Theater of Pompey according to the principles of good design, he often said that he wished he had built a more spacious audience hall, in order to have more time to develop an impression of his visitors from watching the way they moved as they approached him.[75]

When Paolo Cortesi referred to Riario's palace as "drawn up . . . according to the principles of good design," he made a conscious paraphrase of Vitruvius; in effect, he implied that the architect of the Palazzo Riario had designed the building not only by looking at the Colosseum and the Theater of Marcellus but also by applying the theoretical principles laid down by ancient Greece and Rome's sole surviving architectural writer. Certainly the timing was right; 1486, the probable year of publication for the Vitruvius, was not only the year of the Seneca production but also the year of Raffaele Riario's great gambling victory over Franceschetto Cibò, which netted him an initial 60,000 ducats to fund construction. (By the time the building was finished a quarter-century later, it had cost him about twice that much.)

Thus, in a sense, Giovanni Sulpizio got his theater.[76] But rather than a building dedicated to what many Romans, ancient and contemporary,

might have regarded as idle pleasure, the Palazzo Riario, as soon as it was functional, was a building that went straight to work. Riario took his official duties seriously, and his palazzo provided him with a serviceable base of operations. Indeed, upon his own forced retirement in 1517 it was to be pressed into service as the seat of the Papal Chancellery, supplanting the Palazzo Borgia (which was subsequently known as the Cancelleria Vecchia); as a result, Palazzo Riario has now been known for nearly five hundred years as the Palazzo della Cancelleria. Characteristically, Raffaele Riario, rather than erecting a monument to his own vainglory, gave Rome a building that embodied the principles of architectural reformation in the spirit of "forethought, eurythmy, and symmetry" by coupling its beauty with practical use.

CARDINAL GIULIANO DELLA ROVERE
(1441–1513)

Like his younger cousin Raffaele Riario, Cardinal Giuliano Della Rovere followed his papal uncle's lead in sponsoring extensive building projects. He erected his own palazzo deep in Colonna territory, next to the Basilica of the Most Holy Apostles (Santissimi Apostoli), across from the palace once owned by his cousin Pietro Riario.[77] The stuccoed building is stern and modest by comparison with Raffaele Riario's travertine-faced splendor; it was also completed much earlier. The Palazzo Della Rovere retains the medieval feature of a high tower, a detail which Riario eliminated during later renovations of the Palazzo della Cancelleria. Cardinal Giuliano's garden, however, was a humanist's delight, filled with antique statues, among which the most famous was the life-sized marble now known as the Apollo Belvedere, an image whose effete demeanor and indolently bemused expression must have contrasted remarkably with the cardinal's relentless stride, dark coloring, and blazing glance. As bishop of Ostia, Cardinal Giuliano repaired the Roman port's little cathedral church of Saint Aurea, transforming it into a small jewel of the new classical architecture by evoking the exterior of a delicately articulated ancient Roman tomb on the Appian Way, the tomb of Annia Regilla.[78] She had been the wife of a second-century Roman philanthropist of Greek descent, Herodes Atticus, and the sophisticated restraint of her monument provided an evocative model for Ostia's Christian shrine to an ancient Roman woman who had died for another creed, the virgin martyr Aurea.

However, Cardinal Giuliano focused most of his attention on the port

itself, charging the architect Baccio Pontelli to erect a new castle at the Tiber's mouth.[79] Pirates were still a sufficient threat to make this, rather than the episcopal palace, the cardinal's preferred residence; his apartment in the castle was outfitted with a bathtub, the latest in neo-Roman luxury, supplied by spigots with hot and cold running water. From its battlements, he could watch the ships come and go as he had once done as a boy in Savona. Unlike many of his cardinal contemporaries, Giuliano cared little for hunting, but he loved to sit by the seaside and fish. These may have been the only times in his life when he held still.

Alexandria on the Tiber
(1492–1503)

Nimirum mortuus es in vinclis.

No wonder you died in a straitjacket.

Marginalium in a copy of Annius of
Viterbo, *Antiquitates*

THE BORGIA PAPACY: ALEXANDER VI
(1492–1503)

Cardinals and their patronage may have created the fabric of the city, but
to make a real career in papal Rome, aspiring scholars like Angelo Colocci
needed to refine one skill above all others: pleasing that cardinal of car-
dinals, the pope. Up until the formation of the Italian Republic in 1870,
Roman curialists were notorious for their unctuous flexibility; with dis-
passionate dedication, they had perfected the wily arts by which to flatter
a succession of old men whose reigns were normally shorter than those
of hereditary monarchs. Some of these popes were powerful, some were
puppets of the Curia. Many of them had been inveterate rivals as cardinals;
to maintain a rough balance of power, the College of Cardinals often
made sure that a pope was succeeded at the next conclave by his worst
enemy. Yet whether he was active in his own right or only a figurehead,
the pope always held the sole key to survival within the Vatican. The
curial staff, perforce, adapted or found itself replaced. Angelo Colocci, as
it happened, was compelled to cut his teeth as a curialist at a particularly
challenging time, for he took the first steps of his career in the Rome of
the Borgias.[1]

The Borgia family's terrifying reputation rests partly on fact and partly
on the careful posthumous efforts of the Borgia pope's successor (and

bitter enemy) Julius II. From the moment of his election, Alexander VI (1492–1503) presided over a Rome that was violent, unstable, and largely at the mercy of remote political powers: France invaded in 1494; Spain, the pope's birthplace, pressured him relentlessly for favors; and, chafing on the margins of the action, the Holy Roman Empire of Maximilian I scanned the map for a larger place in European politics. Within this precarious world, the former Rodrigo Borgia moved as best he could, according to a set of ethical standards that had yet to be found unacceptable by Church and society. Priestly celibacy still meant nothing more than not being married; papal revenues came from the sale of indulgences (documents granting a reduction from time spent in Purgatory); and a prime duty of a pope was to take care of his family. Yet whatever its flaws, and they were egregious, the rough-and-tumble Rome of Alexander VI was an exciting place to live, a place where a scholar like Angelo Colocci could hope to find a niche that was financially rewarding and not too dangerous.

As Machiavelli would say with the Borgias in mind, it is no good thing to state one's real political motives openly; the important art in statecraft is to maintain appearances: "Everyone sees what you seem to be, but few notice what you are."[2] To mask extreme vulnerability throughout the fifteenth century, the papacy had resorted to presenting itself to the world in an elaborate symbolic language, constantly drawing parallels between the growth of early Christianity within the Roman empire and the expansion of Christian Rome in the fifteenth century, as well as emphasizing the role of Rome in a world newly expanded by exploration. Somewhere between wishful thinking, a propaganda campaign, and a master plan, the idea of Rome's Christian renewal, the *instauratio Romae*, was rehearsed throughout the fifteenth century in public oratory, public art, public music, finally to lodge securely in many Christians' private thoughts. This ideal of the Eternal City could stand as free from temporal turmoil as Augustine's City of God, or it could serve equally well as the battle cry of papal assault troops. Often it did both at once. Developing this idea of eternal Rome, in turn, became the special province of humanist scholars, who could provide apposite allusions from the past, resurrect appropriate heroes to inspire every occasion, and do so with the professional cogency they were beginning to gain from the study of ancient Roman rhetoric.

Rodrigo Borgia, who had spent nearly thirty years running the papal financial office, who connived at politics in the fearsome company of his son Cesare and the latter's adviser Niccolò Machiavelli, was also, and not

incidentally, a master of classicizing rhetoric in every medium, using word and image alike to state his own aims for the papacy without stating them explicitly. He was not the only master in Rome of such subtle arts: as a young cardinal, Rodrigo Borgia had watched Pope Sixtus IV and his ravenous nephews employ the same symbolic language to pursue the same set of aims for Rome – stability, international influence, religious coherence – along with notoriety for themselves. Alexander VI followed a growing papal tradition when he used art, music, and oratory to present Rome's claim to have headed the Church throughout universal history, just as he followed tradition when he appended, in scarcely less epic terms, the Borgia family's claim to the papacy.

The ancient world was crucial to this rhetorical scheme because it lent Rome an aura of special importance, but for several centuries, ever since the growth of capitalism had begun to change the structure of medieval society, antiquity had served another purpose as well: knowledge of the classics furnished an approximate measure of a person's level of education, and hence provided a rough guide to intelligence and social position. In the fifteenth century, when popes were more and more deliberately selected among cardinals of proven ability and obscure family, education proved an ever more important factor in their selection. The seasoned Vatican watcher Paolo Cortesi noted as much in 1510:

> Not without reason, erudition has always been a direct way into the cardinalate; certainly within our fathers' memory, Nicholas V, born in obscure state, was proclaimed cardinal without opposition from any quarter, on account of his knowledge in many different areas. A road no less narrow suddenly opened wide for that most learned of men, Pius II. Nor was it for any reason other than his treatise on the Blood of Christ that Sixtus IV was able to reach the College of Cardinals.[3]

Furthermore, Cortesi argued, churchmen distinguished by erudition were the best qualified to evaluate their fellow men:

> Now because a cardinal's greatest concern is care for the human race, it is taken as given that those who excel in the depth of their learning and the dignity of their knowledge understand this well, and that they will easily be able to evaluate the natures of their inferiors and know how to govern the people by means of their knowledge, when to order them forward and when to hold them back, which is a cardinal's particular power.[4]

Learned himself, Cortesi tended to equate knowledge (which he called *scientia*) with erudition in the classics. So did the majority of his contem-

poraries at the Roman court. Once outfitted with knowledge, a cardinal, he suggested, must also display an array of virtues, prudence supreme among them, acting as an automatic brake to the more expansive attributes of a great man, two-edged traits like liberality, which might verge on profligacy, or magnificence, which might degenerate into vainglory, and glory, a virtue which Cortesi quite specifically defined as the tempered pride that properly accompanies a good reputation, not that haughty arrogance called *superbia*.[5] In short, patronage provided cardinals and popes with a theater for their virtues.

As for knowledge, although Alexander VI was not a theologian on the order of Sixtus IV, he was nonetheless an intelligent, worldly man. As for liberality and magnificence, he tended to extremes of enthusiasm. His primary fault, in many of his contemporaries' eyes, was not his state of erudition but the misfortune of having been born in Spain; foreign birth, to their eyes, made his emotions all the more uncontrollable, his nepotism all the more pernicious, and his political maneuverings all the more suspect. "People of [the Spanish] race," wrote Paolo Cortesi, who knew the Borgias well,

> are ambitious, suave, curious, greedy, argumentative, stubborn, profligate, suspicious, clever, and they are usually said to be the most like Italians of all barbarians; this is why Pico [Giovanni Pico della Mirandola], the most learned of all Italians, used to say that the difference between Spaniards and Italians was the difference between people who make discoveries and people who turn their ideas into reality . . . To the one race, that of the Spaniards, is given a quick spirit of inquiry; in the other, the Italian, there occurs a more healthy judgment in creating things.[6]

Faced with this kind of prejudice in his adopted city, Alexander focused a fair amount of his own imaginative energy on proving Spain's claim to civilized culture. His search for a way to bring Spain into the purview of Rome's classical fantasy led him to undertake some of the first archaeological investigations of modern times; he made soundings among the ruins of the magnificent dream villa built at Tivoli by the enlightened Spanish-born Roman emperor, Hadrian. But Spanish patriotism also led the pope farther afield in search of worthy ancestors. Snubbed by Italians who proudly traced their own Roman origins, he looked toward other ancient peoples for potential forebears and found his roots in Egypt.

THE "NEW ALEXANDRIA" AND THE BORGIA
APARTMENTS IN THE VATICAN

When Alexander VI took possession of the Vatican Palace, he ordered a whole program of new construction, flinging a new bastion around the Castel Sant' Angelo and beefing up the fortifications around the palace itself. In addition, he charged a prominent Umbrian artist, Bernardino di Betto, alias "Pinturicchio" (the Little Painter) with making fresco decorations for his apartments.[7] Pinturicchio was an avid student of ancient painting *in situ*; his graffito has been found on the walls of Nero's Golden House, whose painted vaults had become an attraction ever since their discovery sometime in the 1470s.[8] Coupled with Pinturicchio's mastery of the traditional painterly methods handed down by the guild system, this firsthand contact with ancient art suggested a wealth of new artistic ideas, making him one of the most innovative painters in Italy at the end of the fifteenth century.[9] The pope wanted more than elegant decorations, however; his apartments, an important reception area, were the starting point from which he hoped to launch the image of his papacy.

Most of the themes developed in Pinturicchio's frescoes, designed between 1493 and 1495, were already standard fare for the humanist-inspired artists of fifteenth-century Italy, designed to present the view that Christianity fulfilled a plan that God had already worked out from the beginning of time.[10] On a series of large lunettes, the "little painter" portrayed the lives of the saints in rich reds, blues, and golds with raised decorations in gilt stucco, in a vain effort to provide the rambunctious Borgias with object lessons in Christian virtue. Other lunettes held personified virtues and personifications of the liberal arts, referring in a hopeful vein to the status of the arts and sciences under Alexander's papacy.

Another room's lunettes show Hebrew prophets flanked by pagan sibyls, a popular theme in the late fifteenth and early sixteenth century; in 1512, Michelangelo reprised it for the Sistine Chapel ceiling. Just as the Christian church had been created by Jews and Gentiles together, so too both prophets and sibyls had predicted the birth of a miraculous savior to their respective peoples; this variegated prophetic tradition, the humanists firmly believed, was how God had been able to prepare the whole world in advance for the coming of the Messiah. Bent on the eternal human quest after God, other religions had thus anticipated Christian Revelation in significant respects. Among these other religions, the Greeks and the Romans themselves had singled out such ancient peoples

as the Persians, the Babylonians, and, above all, the Egyptians as possessors of profound wisdom about divine matters. These wisdom traditions were enshrined in the fifteenth century as "primeval theology" – *prisca theologia* – and were believed to survive only in fragmentary records, like Plato's reports of Atlantis in his dialogues *Critias* and *Timaeus*, and, most significant of all, in a series of Greek texts called the *Corpus hermeticum*.[11]

The texts of the *Corpus hermeticum* claimed as their author the Egyptian god Thoth, whom they equated with the Greek god Hermes and to whom they awarded the honorific title "thrice great," Trismegistos.[12] In dialogue form, they spelled out various possible ways by which individuals could obtain knowledge of God; to fifteenth-century readers, they seemed to anticipate the doctrines of Christian mysticism with remarkable exactitude. Scholars debated whether Hermes Trismegistus lived in Egypt before or after Moses, noting that Moses himself was described in the Bible as privy to Egyptian wisdom lore, but they agreed without dissent that the Hermetic corpus was very, very old.[13] In 1463, the Florentine Neoplatonist Marsilio Ficino dropped work on his translations of Plato to translate two Hermetic dialogues for his dying patron Cosimo de' Medici, and neither man doubted for a moment that Marsilio was doing the right thing. It would not be until 1614 that a perspicacious Frenchman named Isaac Casaubon took a close look at Hermes Trismegistus and pronounced his texts a set of gnostic-inspired pastiches of late Roman date, composed long after the development of Christianity and still longer after Moses.[14]

But in the years just before 1500, fortified by their faith in Hermes Trismegistus and confident of his divine inspiration, humanists could look upon such ancient Egyptian cults as those of Isis and Osiris with appreciation, taking them too as examples of *prisca theologia*, ancient wisdom's God-given anticipations of the Christian message. The documented popularity of Egyptian cults in ancient Rome proved how carefully God had prepared the hallowed ground where Saint Peter would one day establish the Church. The Egyptian themes that appeared so frequently in ancient Roman art bore further witness to Rome's eternal destiny beyond the temporal spread of its ancient empire.[15] Furthermore, a firsthand account of Roman faith in Egyptian cults was available to fifteenth-century readers, the second-century allegorical novel by Apuleius of Madaura known as the *Metamorphoses*, or the *Golden Ass*. This redoubtably enchanting story recounts the misadventures of a silly young man who, in punishment for an inadvertent act of sacrilege, is turned into a donkey, until one day

he meets a procession in honor of Isis. When he looks the goddess in the face, he is restored to a more sensible, and infinitely more pious, version of his original humanity. In the humanists' eyes, Apuleius's beneficent Egyptian goddess foreshadowed the still greater beneficence of the Virgin Mary, who could be counted upon to redeem equally silly souls with equal compassion. A long and famous interlude in the novel tells of the romance between Cupid (or Eros) and Psyche; the protagonists' names show plainly that Apuleius has spun the tale to show how Love brings immortality to the human soul (*psychê* in Greek). In fact, the *Golden Ass* succeeds brilliantly at doing what the Roman Academy also aimed to do so many centuries later: it still brings the ancient world palpably alive as it amuses, titillates, instructs, and bears witness to the author's enduring religious faith.

One aspect of the Isis cult held special relevance for the Borgia family: the veneration of a sacred bull, the Apis, believed by the ancient Egyptians to be an incarnation of Osiris. Because the Borgia coat of arms featured a bull, the suite of rooms that Pinturicchio prepared for Alexander VI happily asserted, over and over again, that this heraldic animal was none other than the Apis, itself proof of the papal family's ancient Egyptian heritage. At least on a symbolic level, the Spanish pope, far from being a "barbarian" (to use Paolo Cortesi's words), might therefore boast of an ancestral line that went back long before the foundation of Rome, back to a time when most Italians lived like wild beasts in the woods. This carefully Egyptianized Borgia bull forms a recurrent theme for the pope's apartments, from a frieze of sculpted stone high on the wall of one room to a whole vault devoted to the story of the Apis (about which more will be said shortly).

Pinturicchio might have received basic information about Isis, Osiris, Hermes Trismegistus, and the Apis bull from conversation with any number of humanists in Rome. The ancient sources from which they learned about Egypt were illustrious: aside from the hermetic corpus and the *Golden Ass* of Apuleius, there were the *Histories* of Herodotus, Plutarch's essay *On Isis and Osiris*, and the first book of the *Library* by the Sicilian Greek historian Diodorus Siculus, to name only the most extensive accounts.[16] All these texts had originally been written in Greek; all had been translated into Latin and thus made generally available in a flush of humanist scholarship during the later fifteenth century. When humanists, on the strength of readings such as these, collaborated with artists to sing the praises of a patron in pictorial imagery, they tried to give the scattered

details of their factual knowledge about the ancient world an overarching theme with direct application to their employer. In the apartments of Pope Alexander VI, the chosen theme is simple and effective: Rome under his reign is presented as a new Alexandria.

Famous for its library, Alexandria was also the native city of Saint Catherine, the Ptolemaic princess who held her own in theological arguments with the pagan sages who had studied the wisdom enshrined in the papyrus scrolls of the city's great library but were not, like her, also inspired directly by God. In Alexandria, the city he had founded, Alexander the Great was buried in a pyramid, like an Egyptian pharaoh; there too, under the blazing Egyptian sun, the head librarian Eratosthenes measured the circumference of the earth. In Alexandria, Claudius Ptolemy wrote the astronomical treatise known to later ages by its Arabic name, the *Almagest*; there Cleopatra seduced Julius Caesar and later Marc Antony but failed to seduce Augustus. The Alexandrian lighthouse on the island of Pharos was once one of the Seven Wonders of the ancient world; ever afterward it retained its symbolism as a beacon to sages as well as to sailors. Along with Athens, and perhaps even more insistently than Athens, Alexandria had stood for ancient Romans as the epitome of civilization, a city in the most profound sense of the word.

None of these associations is lost in the Borgia apartments. To begin with, they lie directly above the suite of rooms that contained the Vatican Library until the late sixteenth century. The frescoed walls are liberally embossed with gilded stucco ornaments that evoke both the sun of Egypt and the plenteous gold of Nubia. To enhance the Egyptian atmosphere, there are pyramids, astronomers, Early Christian anchorites, and over them all loom the Borgia symbols: the bull, the radiant crown, and the wavy beacon of light. In the thirty-odd years before the election of Alexander VI, the Florentine humanist Marsilio Ficino had gradually transformed the solar symbolism of Neoplatonic philosophy into a powerful image of the Christian God, noting the parallels between this Neoplatonic imagery, the solar imagery of Hermes Trismegistus, and the biblical association of God with light (as in Genesis 1 and especially in the Gospel of John).[17] It is precisely the same combination of Hermetic *prisca theologia*, Ficinian solar imagery, and Christian doctrine that gives the blazing gold of the Borgia apartments its theological point and confirms, through the appropriateness of his family arms, Alexander VI's suitability to high office.

Three rooms in the Borgia suite specifically commemorate this kind

of syncretism by having representatives of pagan, Hebrew, and Christian wisdom wave bannerlike scrolls proclaiming the tenets of Christian faith underneath gilt stucco and frescoed ceilings replete with the Borgia arms; the prophets and sibyls of the Sala delle Sibille, the most intimate of these rooms, have already been noted earlier in their connection to *prisca theologia*. The Hall of the Sibyls was the room into which the pope's small bedroom opened, and, in effect, these were the first images he saw each day as he rose to perform his public duties.[18] The lunettes of the neighboring Sala del Credo (another relatively private room, where the pope met his "family" of servants) show the Apostles and the Hebrew prophets lofting the words of the Apostles' Creed, the most succinct statement of Christian belief in the Bible and a reminder that Pinturicchio's frescoes were designed to promote a vision of Christianity to which the institutional Church and the papacy were absolutely fundamental.

The lunettes in the last of the pope's more private decorated rooms, the Hall of the Liberal Arts, contain enthroned images of the subjects covered by the medieval educational curriculum – the trivium (grammar, rhetoric, arithmetic) and the quadrivium (dialectic, philosophy, astronomy, and geometry). The hall, which was once located right above the Vatican Library, probably served as Alexander's study. In the collection of ancient authors housed in the rooms below, the vanished library of Alexandria might be said to have lived on, but the Vatican's many biblical and patristic texts ensured that the modern version of Alexandria acknowledged its fulfillment in Christian wisdom. Between the lunettes, eight compartments contain astrological signs; seven bear images of the planets, in their familiar guise as the gods for whom they are named: Mercury, Venus, Mars, Jupiter, Saturn, Apollo (the Sun), and Diana (the Moon). In the eighth compartment a beautifully precise picture of an armillary sphere suggests that, like Claudius Ptolemy's Alexandria, Alexander Borgia's Rome is a place of astrological significance.

The public rooms of the apartments are decorated in a much more sumptuous fashion and present a far more complex pattern of imagery. In order to drive the Borgia Apartments' syncretic point home with the greatest force, the most detailed Egyptian stories appear on the ceiling of what is now the most elaborate room in the entire suite, the Hall of the Saints, the room where the pope robed before going to give audience. The most conspicuous lunette shows Saint Catherine of Alexandria debating theology among the elders of her great city; the golden-haired, slightly pasty-faced saint has long been taken as a portrait of Lucrezia

Borgia. Behind her, a massive replica of the Arch of Constantine forces the analogy between Alexandria, the original site of the debate, and Rome, the site of the model for this painted triumphal arch, inscribed "to the cultivator of peace." Constantine's arch commemorates his victory at the Battle of the Milvian Bridge, when he called upon the God of the Christians to bring him success; to the Christians of late fifteenth-century Rome, it was both one of the earliest and one of the most powerful episodes in their religion's triumph over the world's largest empire, just as the argumentative young saint in the foreground foreshadows Christianity's triumph over Alexandrian learning.

Egypt is again the setting for the first lunette to the right of Saint Catherine, which depicts a visit between Saint Anthony and Saint Paul the Hermit, two of the very first Christian monks to withdraw to the Egyptian desert. Another visit, that between Mary and her cousin Elizabeth, completes the wall. The rest of the room is devoted to martyr saints like Catherine: Saint Sebastian, Saint Barbara, and Saint Susanna.

Above these eminently Christian scenes, a whole Egyptian pageant plays out on the stuccoed ceiling. Divided into two vaults separated by an arch, the ceiling compartments tell the tale of Osiris, Isis, and the Apis bull, while the archivolt details the exploits of Hermes, the Greek god who was associated with the writings of Hermes Trismegistus (Fig. 8). According to Plutarch's essay *On Isis and Osiris*, the latter had first brought many of civilization's greatest benefits to Egypt: agriculture, the tending of animals, the gathering of fruit, and the making of liquor, both wine and beer. One vault of the Sala dei Santi shows the Egyptian god dispensing these fourfold benefits to humanity.

The other vault tells of Osiris's death and resurrection as the Apis bull, beginning with his ambush and murder by his evil half-brother Typhon. Nearly disguised by the protagonists' elegant poses, Osiris's dismembered limbs lie scattered on the ground.[19] His son Horus runs away from the scene of the crime, clutching a white dog, which represents another of Osiris's sons, the jackal god Anubis. In the next section of the vault, Isis, Osiris's widow, has reassembled her husband's body and given it proper burial in a gilt, bejeweled pyramid. Opposite the scene of the murder, Osiris emerges from his pyramid, embodied in a glorious golden bull, the Apis (which, Herodotus assures his readers, was really a black bull with a white blaze on his muzzle). In a final scene, an image of the Apis is borne in state, a patent precursor to the Borgia bull.

The octagonal panels of the dividing arch in the Sala dei Santi present

a more light-hearted intermezzo to this intense Egyptian drama. Drawing primarily upon Ovid's *Metamorphoses*, they recount the story of Jupiter and Io, the lady who turned into a cow; the whole tale develops the recurrent theme of Borgia beef in a feminine key. The first octagon shows the flirtation between Jupiter and Io, the unsuspecting maiden. The subsequent panel shows Jupiter's formidable consort Juno giving the Father of the Gods a severe cross-examination; he has already transformed Io, for her own protection, into a cow, who gazes with bovine simplicity over her lover's shoulder. To keep his ladylove safe, Jupiter put Io, still a cow, under the care of hundred-eyed Argus, a monster whose name probably meant "watchdog" in primeval Greek. Pinturicchio's Argus, the focus of a third octagon, is a speckled delight, shown being lulled to sleep by Mercury's divine lullaby on the panpipes; it is just like clever Juno to have engaged the services of the cleverest of the gods to help torment her husband's mistress. Here, the musical god deliberately evokes the idea of Hermes Trismegistus, who (in his Egyptian identity as Thoth) invented letters and music (Fig. 9). The final octagon of the story shows Mercury killing the hundred-eyed monster, leaving Io to wander the world en route to her final home in Greece. But Greece is not the focus in the Borgia apartments; instead of showing the further adventures of Io and Mercury/Hermes Trismegistus, the archivolt's crowning octagon shows Isis enthroned, ruling as queen of Egypt after her husband's death. In effect, Isis and Io provide the female equivalents of Osiris and Apis in this Borgia symbolism.

The neighboring Sala dei Misteri della Fede, where the cardinals robed before papal audiences, displays the seven great mysteries of Christianity known as the Seven Joys of the Virgin: the Annunciation, the Nativity, the Adoration of the Magi, the Resurrection, the Ascension, Pentecost, and Mary's Assumption.[20] The Magi in particular, wise men whose immersion in *prisca theologia* enabled them to recognize the Messiah, provide a further connection among ancient creeds and Christian Revelation. As ever, the importance of the institutional Church in this formulation is emphasized in the miracle of Pentecost, the moment that marked the transformation of the disciples into Apostles and the effective birth of the Church organization; the official papacy is no less evident in the fine portrait of Pope Alexander himself adoring the resurrected Christ. His pose follows a longstanding pictorial convention in which the patron who endowed the painting or mosaic can be seen off to one side, adoring the holy figure that is the work's real focus. However, unlike the tiny donors

of medieval tradition, this vicar of Christ is just as large as the Lord he represents on earth, and considerably more real.

On days when there were papal audiences, the pope would have robed just next door in the Hall of the Saints, after which the company would have moved in state into the assembly hall, or Sala dei Pontefici. Not surprisingly, it is here among the members of the college that elected him that Alexander made his strongest pictorial statement of purpose as pope.[21] The parallel between the death and resurrection of Osiris and the death and resurrection of Christ was self-evident to late fifteenth-century humanists; the implied connection between the Apis bull and the Borgia bull also implied connections between Christ and His vicar the pope, implications reinforced in the Sala dei Misteri della Fede when the specific mystery at which Alexander bears witness is the mystery of the Resurrection.

All of these signs and symbols must have reached their climax in the decoration of the great assembly hall, the Sala dei Pontefici. There, however, on June 29, 1500, the feast day of Saints Peter and Paul, lightning blasted the Apostolic Palace during a papal audience, destroying the room above the hall itself and killing two young curialists on the spot.[22] Debris and bodies crashed down through Pinturicchio's painted vault; a piece of ceiling struck the pope on the head. He recovered; the room's designs did not. Their symbolic charge could never compare with the force of a lightning bolt so ominously timed and placed.

Still, Pinturicchio's frescoes show that humanists in the 1490s were profoundly interested in the outer edges of the classical world, particularly in reputedly wise but elusive cultures such as those of Babylon, Persia, and Egypt. The same interest explains why a pope named Alexander might attempt, at least rhetorically, to compare life in a vulnerable Italian city-state with the glories of Alexandria.

THE FORGERIES OF GIOVANNI NANNI
(ANNIUS OF VITERBO)

Nor did Egypt exhaust Pope Alexander's interest in the more far-flung corners of the ancient world. His Spanish patriotism as well as his curiosity about ancient peoples together prompted him to fall victim to one of the great charlatans of his age, a Dominican monk and forger of Etruscan antiquities named Giovanni Nanni, of Viterbo.[23]

Nanni had spent most of his career as a preaching monk in Genoa,

where he had written a fiery call for a Crusade against the Turk (*De futuris Christianorum triumphis*) and whipped up the citizens of Genoa to resist the Milanese in 1478.[24] He fell ill with a brain abscess in the late 1480s and then, with remarkable "scientific" detachment, transformed his misfortune into a test case for a disputed matter of Christian theology. Praying for a cure to the Virgin Immaculate, at a time when his order was busily attempting to refute the doctrine of the Immaculate Conception, he took the bursting of his abscess as divine confirmation that the Dominicans were wrong. Shortly thereafter, still feeble and suddenly controversial, he was sent out to pasture in his native Viterbo.[25]

The resourceful friar was not yet ready for a quiet retirement. From the time of his arrival in Viterbo and through the year 1493, he began to report a series of remarkable discoveries he had made, both as a lifelong book hunter and as a newly active amateur archaeologist in the area around Viterbo. He claimed as well to have studied the Talmud with three Viterbese rabbis, who, he said, enabled him to knit together his manuscript findings with the results of his excavations and reach startling new conclusions about the history of Italy.[26]

In fact, his narrow escape from death and his newfound leisure had stimulated Giovanni Nanni to devise a monumental hoax, apparently hoping once again to attract attention to himself as a scholar and a visionary. From the beginning, using his forgeries as a pretext, he seems to have courted the Borgia pope with particular attention; he later added Ferdinand and Isabella of Spain to his list of illustrious targets. The reasons why he decided to become a forger remain elusive, although for so successful a forger ambition must certainly have been an important factor. That hometown Italian patriotism known as *campanilismo* (literally, devotion to the bell tower of one's local church) also played its part: Viterbo had a long Etruscan heritage, about which fifteenth-century antiquarians could extract precious little information from Greek and Roman historians. Loyal Italians had been embroidering their local history since time immemorial, and in one sense Nanni's inventions differed from those of other chroniclers only in scale.

It is also possible that the Virgin Immaculate had done only a partial job of healing Nanni's abscessed brain; one early sixteenth-century reader of his great book scrawled in the margin, "This man went insane twice and died in chains" – chains were the equivalent, in 1502, of a straitjacket. The irate note continues, "and now he teaches all of Viterbo his art of going crazy."[27] The outlines of that art follow in the next few paragraphs.

Unless otherwise noted, every statement they contain is false, part of Giovanni Nanni's great but persuasive lie.

While in Genoa, Nanni recalled, he had come across two manuscripts, one in the possession of his old friend William of Mantua and the other owned by an itinerant Armenian named George. Both men had seen little value in their old books and had therefore gladly sold them to their friend the monk. It was only by comparing their uncannily complementary contents that anyone, even Nanni himself, could have understood the full scope of the information they contained. Without knowing it, George the Armenian had been carrying around, albeit in a miserable medieval Latin translation, one of the great lost books of antiquity: the *Annals* of Berosus the Chaldaean, librarian at Babylon in the time of Moses, a sage to whom Latin authors like Pliny and Vitruvius had referred with awe. The same manuscript also contained, probably in a version by the same translator, a version of the list of the Egyptian kings compiled in Greek by a Hellenized Egyptian named Manetho, revised in light of what Berosus had to say about primeval history.

If William of Mantua's manuscript supplied less exotic authors than Berosus, the "pious Chaldee," and Manetho, the Grecophile Egyptian, it could nonetheless boast ancient books that had previously numbered among those presumed in the Middle Ages to be lost, texts such as the Latin histories of Fabius Pictor, Marcus Porcius Cato, Archilochus (the Greek lyric poet), and a previously unknown personage from ancient Persia named Metasthenes. The revelations of these Greek and Roman authors further confirmed the information contained in Berosus, whose sources extended back beyond Noah and the Flood to the time of Adam, the first person to invent writing.

What these texts revealed included the following information. Before taking to the ark with his family and the animals, Noah had carved a digest of human wisdom on a pillar of stone intended to survive the ravages of the Flood, and so it had; Berosus had actually seen this antediluvian column and summarized the contents of its inscription in his book. Once disembarked on Mount Ararat, Noah and his wife (with the help of their three sons and their three daughters-in-law) had quickly gone about creating a new generation of children to people the earth. One hundred years after the floodwaters receded, with repopulation well under way, Noah and the three antediluvian sons who had joined him on the Ark – Ham, Shem, and Japheth – had taken a tour of the world.

In the course of the journey, the patriarch gave each son a continent to colonize: Ham took Africa, Shem received Asia, and Japheth was assigned Europe. These assignments carried out, Noah voyaged alone in a raft up the river Tiber, stopping on the bank just opposite the future site of Rome and then hiking north for a day or so. Under the shadow of Mount Cimino and its forbidding woods, he stopped to found a new city, "Vetulonia," a settlement which eventually changed its name to "Etruria" and, long afterward, to "Viterbo." Ten years after his arrival in Italy, Noah returned to the Holy Land and his mighty work of repopulation. Meanwhile, the descendants who ruled in his wake were such paragons of justice that these early days of Etruria gave rise to the Greek and Roman myths of a Golden Age. The Vetulonians spoke in Hebrew or Aramaic and wrote, like the Hebrews, from right to left. Their language, which came to be called "Etruscan," was thus a form of Hebrew, and the Etruscans' ancient reputation for piety was natural; they were directly descended from the patriarchs of Israel.

Noah was also the inventor of wine, and from the Hebrew word for wine, *yayin*, he took a new name, "Janus," by which he became known to the Greeks and Romans as the most ancient of the Etruscan gods. This ancient Etruscan wisdom was cross-pollinated with the wisdom of Egypt when Noah's African-born grandson, Hercules, crossed the Mediterranean to rule Vetulonia upon the death of King Gomer, a postdiluvian son of the great Hebrew patriarch and winemaker.

Years later, the Egyptian deities Isis and Osiris came to Vetulonia/Viterbo as well; there, at the wedding banquet of King Iasius Ianigena and Queen Cybele, Isis baked the first bread. Both the wine and bread of the Christian Eucharist, in other words, had their origins in Viterbo.

Nanni's revelations might have seemed more incredible had they not been backed up by archaeological "evidence": magic tablets, some in Greek, some written in Etruscan on alabaster that glowed from within, and some in Egyptian hieroglyphs. One "Egyptian" tablet still survives in the Museo Civico of Viterbo, a pastiche in which a twelfth-century marble lunette depicting a lush grapevine has been set in a square panel and flanked by two fifteenth-century carved heads.[28] The museum also preserves two alabaster roundels, both inscribed in chiseled letters rather than magic ink. One contains (or, rather, purports to contain) a decree issued by Desiderius, king of the Lombards, shortly before his defeat by Charlemagne in 774, in which he bestows the name "Viterbo" on the

former Vetulonia. The other, in rudimentary Greek, commemorates the visit of Isis and her lasting contribution to Italian cuisine.

It was inevitable that news of archaeological finds like these, especially with their close biblical connections, would reach the ears of the pope. In the autumn in 1493, Alexander VI came up to Viterbo for a hunting expedition, which may always have included plans to examine Giovanni Nanni's fabulous antiquities. But hunting came first, as it often did for Renaissance churchmen. In an area called Monte Cipollara (Onion Hill), the papal entourage flushed a hare, which suddenly disappeared down a hole that led right into an Etruscan tomb – a real one. Out came several sarcophagi of volcanic stone and two inscriptions; a careless attendant dropped a third. With great pomp, the treasures were borne into the Governor's Palace in Viterbo.[29] And thus Giovanni Nanni, perhaps for the first time in his life, was presented with Etruscan artifacts he had not made himself.

He made a masterful attempt to read them, not so much in the heat of the moment, when he dashed off a little pamphlet called the *Borgiana lucubratio* (Borgian Study), as later, when he studied the texts with care (Fig. 10). He may never have known that they were simply the epitaphs for Arnth Sauturinies, son of Larth and Fulni, dead at thirty-eight, and fifteen-year-old Shetre Ceisui, daughter of Shetra Ceisu and his wife Ramtha Calisnei, but on the other hand he may have suspected something of the sort; he had certainly figured out that the word "avil(s)" meant "year(s)" and that our so-called Roman numerals must originally have been devised by the Etruscans. Furthermore, the shameless old forger correctly identified what looked like the letter O as the Greek letter theta, enabling him to read the word "larthial" in the phrase "son of Larth" and, still more impressive, to argue, again correctly, that the suffix *-ial* marked the possessive case.[30] Ironically, the first steps toward the accurate decipherment of Etruscan belong beyond question to the mad monk from Viterbo.

None of this, of course, is what he told the pope. Instead, he identified the reclining figures on the sarcophagus lids as the wedding party, 751 years after the Flood, of the Etruscan king Iasius Ianigena and the great mother Cybele, the couple for whose festivities Isis had done her primeval baking. In his commentary on the find, the Dominican noted that just as the wedding couple prefigured the successes of another royal pair, Ferdinand and Isabella, so too the discovery itself was a marvelous omen for the success of the Borgia papacy.

Like the riotous crowd in Genoa a decade before, the pope melted before Nanni's blandishments. He invited the monk to Rome. In 1499, Alexander VI entrusted Giovanni Nanni with the exalted position of "master of the sacred palace" – chief preacher to the pope. By then the wily old friar had exchanged his unexciting name, the Italian version of "John Johnson," for a new Etruscan surname, "Annius." It was as "Iohannes Annius of Viterbo" that he became an international figure, especially through his publication, in 1498, of the rediscovered manuscript works of Berosus et al., flanked by two essays in which he discussed his archaeological finds and attempted to tie up all the loose ends of his elaborate argument. These *Commentaries of Friar Johannes Annius of Viterbo about Works of Different Authors Speaking about Antiquities* (Commentaria Fratris Joannis Annii Viterbiensis super Opera Diversorum Auctorum de Antiquitatibus Loquentium), usually known for short as the *Antiquitates*, thus became available to the Latin-reading public at a time when antiquarian research was all the vogue in Rome (Fig. 11).

From its Gothic print, to its format of text surrounded by commentary, to its single crude woodcut illustration (a medieval-looking map of Rome), the *Antiquitates*, printed in Rome by the German bookseller Eucharius Silber, seems to belong to another and much older world than the neo-Roman elegance of humanist printers like Aldus Manutius, whose work is treated later in the present chapter.[31] Silber's typeface recalls that of the Gutenberg Bible – and for good reason. Annius, whose hoax attempted to subvert biblical chronology, needed to inspire the kind of confidence accorded to the Holy Scripture in order to be believed. His book's visual format, therefore, showed unmistakable signs of deceitful premeditation. What is more, his strategy worked.

Annius of Viterbo succeeded so well as a forger because he manipulated scholarly method with such devilish mastery. Not only did he exploit the connotations of print; he also set up newly rigorous standards for evaluating the authenticity of ancient texts and made certain that his own work was seen to pass his self-devised tests. He also used his evident creativity to establish methods for working with the often anecdotal evidence presented by ancient authors and ancient monuments to draw a larger picture of remote or bygone (or utterly fictitious) worlds.[32]

A tantalizing theory holds Annius of Viterbo responsible for the neo-Egyptian decorative program of the Borgia Apartments; certainly his forged texts had a great deal to say about Egyptian chronology and the

way it harmonized with Etruscan history.[33] There is nothing specifically Annian about Pinturicchio's designs, however; Plutarch and Ovid would have sufficed to inspire his choice of imagery. Furthermore, during the time that Pinturicchio was actually painting the papal suite, the devious monk was still resident in Viterbo.

Even if he had no role in the Borgia Apartments, the forger from Viterbo remained a clever exploiter of patrons. Upon his arrival in Rome (or perhaps before), Annius had acquired a new set of sponsors in Ferdinand and Isabella of Spain, presumably through the mediation of the pope and the Spanish ambassador Garcilaso de la Vega, who must have represented the *Borgiana lucubratio* to Their Most Catholic Majesties in a favorable light. Accordingly, the published *Antiquitates* also have a good deal to say about the illustrious heritage of Spain, as well as the glory of Noah's Etruria.

LOVE AMONG THE RUINS: THE *HYPNEROTOMACHIA POLIPHILI* OF 1499

Still, the Rome of Alexander VI was a city in which the pope's attempts to create a new Alexandria seemed less urgent than his efforts to provide for his restive children. The eldest, Juan, had been fished dead from the Tiber a year before, in July 1497; rumors blamed the murder on the pope's second son, Cesare Borgia. Though groundless, the gossip said something about this ruthless, talented youth, then busily trying to rid himself of a cardinalate foisted upon him by his father and bent instead on acquiring secular power. Lucrezia, the papal daughter, found her father's machinations still more oppressive; he had married her off to three husbands already. She escaped when she could to the solitude of a convent, but the respite was only temporary. Whenever the pope left Rome, it was she who was put in charge of the Apostolic Palace.

All of these affairs Colocci may have known only from a distance. His first contacts in Rome seem mostly to have included the humanists who clustered at the lower end of the Vatican's hierarchy, people, in other words, very much like himself. Remarkably, his surviving papers show no sign that he sought either a baron or a cardinal as his special patron; he gravitated instead to the Neapolitan humanists in Rome (old friends of his uncle Francesco), and this group may have afforded him enough illustrious or amusing company to keep him content. An orphan with a

considerable private fortune, he may have required little else than what he had to get his start, presuming correctly that his skills and his outgoing personality would quickly supply the rest.

Palazzo Borgia, the center of the Curia's financial operations, must have acted as the center of Colocci's working life. His friends and he probably lived nearby, but their obligatory *vigne* were scattered widely across the deserted tracts still contained within the perimeter of the city's ancient walls. In Campo de' Fiori, the German printer Eucharius Silber was keeping his bookshop stocked with copies of Annius of Viterbo's *Antiquitates;* there were more than twenty rival booksellers competing in the neighborhood for custom among well-heeled young humanists, cardinals, and intellectually inclined merchants.[34] The Jewish quarter lay nearby, and there Colocci seems to have begun his career as a collector of antiquities, buying ancient Roman weights from the tailors and weavers who used them to iron their fabrics.

Colocci's early life in Rome is hard to reconstruct, because he embellished its details as time went on, presenting himself as still more precocious than he surely had been, a close friend of the great at an improbably early age.[35] If we are to gain any idea about his first impressions of Rome or the Roman Academy, we can only approach them obliquely. As it happens, the grandeur of the ruins and the excitement of life at the Roman Academy figure in a contemporary novel that seems to have left a lasting impression on the young humanist.

That novel, the curiously titled *Hypnerotomachia Poliphili,* was published in Venice by Aldus Manutius in 1499.[36] At the time of its publication, Angelo Colocci had been permanently settled in Rome for about a year, perhaps already ensconced in Pomponio Leto's house and garden, for Leto, after more than thirty years at the University of Rome, died in 1498 at the age of seventy, apparently bequeathing his property to Colocci, a person he must have regarded as a devoted antiquarian. The *Hypnerotomachia* of Aldus Manutius, with its large quarto format, a typeface modeled on ancient Roman inscriptions, and its Greek-based title, took direct aim at a reader like Angelo Colocci, a model customer who could both afford its stiff price and understand its difficult prose.

The identity of the novel's putative author, "Francesco Colonna," is disputed today; both a Venetian monk and a Roman prince of that name have been proposed, but the name may be a pseudonym. Along with his identity, his familiarity with the ruins of Rome has been called into question as well.[37] Beyond question, however, his book found an audience

of devoted readers in its own day, readers for whom its pages conjured up the ancient world as a dream, a mystic initiation, a romance couched in a rapture of strange words. Angelo Colocci certainly knew the book well and at some point must have loved it dearly, an experience as closely linked to his first years in Rome as popular songs (*frottole*) like "The Cricket" of Josquin des Prez or the *strambotti* (improvised vernacular songs) of Serafino Ciminelli, who seems to have been a favorite musician of Colocci's in the last years of the fifteenth century. (See Chapter Four.)

Written in Italian vernacular (albeit a very peculiar vernacular, which strives to sound like Latin), illustrated with elegant woodcuts, set in a new Roman typeface on expansive quarto pages, the *Hypnerotomachia Poliphili* was a stylish book designed to attract the most stylish of late fifteenth-century readers; it remains one of the most hauntingly beautiful objects ever to leave the printing press. There is hardly a better visual record to be found of the way in which a late fifteenth-century humanist might have experienced the ruins of antiquity.

Like so much of the humanists' enterprise, the *Hypnerotomachia* used the past to help create the outlines for a more glorious present. It was written in modern vernacular rather than ancient Latin; its typeface was new, carved specially for the occasion. It included experiments with punctuation, such as the use of the recently invented semicolon. Furthermore, the illustrations and the text were carefully laid out to complement one another in order to suggest new forms, "modi ed ordini nuovi," of expression, inspired by the ancient world but not one with it, applicable at once and alike to the written text, the graven letter, and the drawn image.

And yet, despite its portentously classical title – *Poliphilo's Dream about Love's Struggle* – and its lofty ambitions, the *Hypnerotomachia* made no attempt to hide its real identity as a steamy novel. "Erotic" emerges loud and clear from the strange compound title, as suggestively in fifteenth-century Italian as in modern English. But then, allegories of the late fifteenth and early sixteenth century, whether literary or artistic, often combined an exalted philosophical or religious message with flat-out eroticism, taking their cue from the biblical Song of Songs.

The plot of the *Hypnerotomachia* traces the wanderings of a humanist who, rather like Dante, loses his way in a wood, only to emerge in a marvelous world of ancient creatures, verdant nature, and monumental buildings, some ruined, some intact (Fig. 12). Nymphs gambol forth at every turn, keeping the hero in a nearly constant state of erotic excitement,

whose details he seldom spares his readers. Reliably, however, the story's comely sprites always provide Polifilo with an ancient building to explore or a titillating ritual to undergo before he can draw any nearer. The most provocative of his temptresses finally reveals herself as his long-lost lover Polia, with whom, after any number of delays, he sails away in Cupid's boat to the Island of Venus, where they are betrothed in an endless series of ancient ceremonies. Their last rituals performed, the couple settles at long last into a rapturous embrace, when, suddenly, "along with the delicious sleep which she snatched swiftly from my eyes, she pushed away in rapid flight, saying: 'Poliphilo, my dear lover, goodbye.' "[38] The book ends with her epitaph: "a flower so withered never comes back to life."[39] Polia, it seems, is dead, and has been dead for some time.

The names "Polia" and "Polifilo" must offer some key to this odd little story. "Polifilo" may mean "much-loving" (*polyphilos*) or perhaps "lover of Polia" (*poliphilos*). The closest cognates to Polia's name in Greek are *polios*, the word for "gray-haired," and *Polias*, "civic," the epithet for city goddesses, or perhaps her name means "multiplicity" from *polus*, "much." Surrounded as she is by ancient gods and ancient buildings, Polia looks less like a real woman dead before her time than like an embodiment of antiquity itself, or, more specifically, of ancient wisdom. The object of endless longing, she slips away every time Poliphilo comes close to embracing her, just as ancient Rome both tempted and eluded Pomponio Leto and his fellow Academics. Furthermore, Polia's surroundings – the obelisks, statues, columns, and evanescent nymphs – are presented as more palpably real to her lover than Polia herself; obsessed with the idea of her, he fails to recognize her when they actually meet at the beginning of the book. Tellingly, the long full title of the *Hypnerotomachia* distills Poliphilo's experience as the antiquarian's eternal dilemma – to answer the eternal questions, Which is more real, the ruins, or the ephemeral beings who explore them? Are we the dream, or is antiquity?

> POLIPHILO'S HYPNEROTOMACHIA WHERE HE TEACHES THAT ALL THINGS HUMAN ARE NO MORE THAN A DREAM. AND ALONG THE WAY COMMEMORATES MANY THINGS THAT ARE CERTAINLY WORTH THE KNOWING.[40]

For Poliphilo, the ancient world exerts a pull just as magnetic as sexual passion; in his own experience, the two are often inseparable. Fertility cults abound in his antique dreamland, from the phallic deity Priapus to the sleeping nymph who is called the "Mother of All." The humanist

hero, exploring every cranny of his dream world, burns with the curiosity that Saint Augustine once defined as "concupiscence of the eyes," terming himself a "scholar, inflamed with desire to understand the fecund intellect and the sharp insights of the perspicacious [ancients]." Poliphilo reads the contours of ancient buildings with the same loving attention and panting desire that he reserves for his elusive Polia. She, for her part, knows how to use that desire for antiquity to put off his physical advances; her elaborate language may also keep him at bay:

> my perceptive Polia, aware of the indiscreet condition of my blinding Love, in order to devise some way to mortify that importunate excitation and to cut it short, came to my aid as my only breath of life, saying cheerfully, "Poliphilo, my love, I am hardly unaware that you take the greatest pleasure in looking at antiquities. Now, while we are awaiting Lord Cupid, you have abundant time to admire at your leisure these deserted buildings, collapsed by devouring and destructive age, consumed by fire, or shattered by burden of years, and to contemplate the fragments that remain, so worthy of veneration" . . . Then, utterly impatient to contemplate these along with all the other remarkable works I had seen, anxious and avid, rising from our pleasant seat . . . I hurried off.[41]

In 1513, some fourteen years after the first printing of the *Hypnerotomachia*, Angelo Colocci centered the layout of his new *vigna* near the Trevi Fountain on a sculpted nymph who re-created the novel's bas-relief of the sleeping Mother of All.[42] Poliphilo describes his dream statue in a characteristic mix of quickened sensuality and plodding antiquarian thoroughness. She has been cunningly crafted to spray hot water from one breast and cold water from another, the jet of hot water arching harmlessly over the head of anyone who bends forward for a cool drink (a feature Colocci's assemblage was not able to duplicate) (Fig. 13):

> Now the craftsman had created this statue with such definition that I truly doubt that Praxiteles could have made its like with that Venus, the one that Nicomedes, king of the Cnidians, spent the entire state treasury to buy, as rumor has it, and he created her to be so charmingly beautiful that men, inflamed by sacrilegious desire for her, tried to rape the statue . . . , but I decided that no image could ever have been as perfect as this . . . It was almost reasonable for me to suspect that a living being had been turned to stone in this place and thus petrified . . . Under this wondrous sculpture, amid the channels and moldings of the flat fascia, I saw inscribed this mysterious saying in magnificent

Attic characters: ΠΑΝΤΩΝ ΤΟΚΑΔΙ (to the Mother of All). For which reason I would not be able to decide whether the daytime and pressing thirst which I had borne since morning provoked me to drink [from that fountain], or rather the lovely suggestion of the work of art, the frigidity of which warned me that the stone lied.[43]

Whether the lifelike stone sculpture lied or not, it must have spoken directly to Colocci's own sense of the immanent Roman past: Why else would he have commissioned a similar sculpted nymph, complete with forged antique inscription, to preside over his own wonderland of antiquities?

Regrettably, for most modern readers, the sense of breathless wonder that suffuses the novel's woodcuts usually goes missing from its text. For an audience steeped in Latin literature, the language of the *Hypnerotomachia* was intended to imbue Italian vernacular with the flavor of antiquity by heaping on latinate adjectives. Unfortunately the author often tends to do so with repetitive regularity, one adjective for every noun, predictably ornamental, as Homer's epithets never were: "The voluptuous pleasantness of the ordered verdant orchards and well-watered gardens, living springs with rushing rivulets coursing through marble conduits contained and enclosed by incredible skill, dewy plants, ever-fresh and flowering and sweet summer breezes and spring-bearing winds with shifting choirs of little birds."[44]

Interspersed are references to Polia's "succulent tongue, fluttery as a viper," her "savory and tiny mouth, spiracle of perfumed breezes and musky spirit and cool breath," and nymphs with legs the color of ivory, for which the infelicitous adjective of choice is "elephantine."[45] Yet by means of this ponderous machinery, the prose of the *Hypnerotomachia* pleads convincingly that for late fifteenth-century readers, the Latin language itself still possessed latent magic; here was the real key to unlock the powers of perception that had been known to the ancients and lost to subsequent ages. Poliphilo will not claim to apprehend classical beauty until he can put that beauty into an appropriate verbal description:

I marveled above all at a gorgeous gate, as stupendous and of such incredible workmanship and as elegant in every lineament as one could ever contrive and refine; beyond doubt I felt that I lacked sufficient knowledge to describe it perfectly and in detail, especially because in our age the vernacular, proper, and native words peculiar to the art of building have been buried and extinguished with all real men. O execrable and sacrilegious barbarism, how rapaciously you have invaded

the most noble part of that treasury and shrine of the Latin language, and shamelessly offended art, once so esteemed, and now obscured by cursed ignorance; together with ravening, insatiable, and perfidious greed it has blinded that highest part of what made Rome the supreme and expansive empress.[46]

In Poliphilo's humanist creed, therefore, Rome owed her imperial sovereignty as much to her supremacy in art and letters as to her pugnacious legions.[47] The humanists of the Roman Academy likewise insisted that a renewed papal Rome could rule only by recovering the full expressive capacities of art and language.

Ironically, however powerfully the *Hypnerotomachia*'s scrupulous descriptions of pyramids, obelisks, and classical portals reveal a close reading of ancient writers like Vitruvius and moderns like the lexicographer Niccolò Perotti or the humanist-artist Leone Battista Alberti, they also reveal only a limited comprehension of some basic architectural concepts. If the identification of Ionic capitals as Doric in the following passage is not a typographical or scribal error, the author of the *Hypnerotomachia* lacks an accurate grasp of some of the most elementary features of classical architecture. In the rest of the description, certainly, the rhythmic incantation of ancient technical terms, some quite banal, serves more to create word magic than to convey useful information:

> In front of this magnificent gate . . . there were two rows of columns with the exquisite interval of the araeostyle interjected according to the proper requirements from one column to another. The first row or order on each side began symmetrically at the margins, that is the extreme edge of the pavement of the metope, that is the façade of the great portal. And between one columniation and the other there was a space of fifteen steps; of these columns some, indeed most, were still to be seen intact, with Doric, that is cushion capitals, with coils, that is shell-like spirals outside the ringed echinuses with astragals pendant below on either side, one-third part projecting above the base, that is, of the capital, which had the thickness of a semidiameter of a column.[48]

Fifteen years later, an older Angelo Colocci would have had the experience and the critical sophistication to decry the inaccuracies of this passage and the *Hypnerotomachia*'s other attempts at archaeology, but not in 1499. Only a handful of people had yet acquired the factual knowledge needed to do so.[49] Instead, the ancient world and its surviving ruins still lay open in every aspect to exploration, to the gathering of facts, and to

the first glimmerings of insight. Because of its innocence, the novel's style stops just of short of pomposity, and because the passion it describes for the bygone glories of antiquity is so genuine it continues to exert its own peculiar charm, sustained always by the suggestive beauty of its woodcuts and its elegant new Roman typeface.

Although his ancient dream world is predominantly Greco-Roman, Poliphilo also devotes special attention to the Egyptians and the Hebrews. As in Rome itself, especially the Rome of the Borgias, pyramids and obelisks comprise an integral part of antiquity's ruins, and Poliphilo spends a certain amount of his dream adventure in deciphering "Egyptian" hieroglyphs (Fig. 14). Hidden treasure lies behind doors inscribed in Arabic, Hebrew, Greek, and Latin.[50] However little the *Hypnerotomachia*'s author and readers may have known about certain aspects of classical antiquity, they were eager to place the Greeks and Romans within a much wider ancient world and to profit from every vestige of ancient wisdom.

If the *Hypnerotomachia*'s author, illustrator, and place and date of composition all remain the subject of lively debate, one of the few certainties about the novel regards the immediate circumstances of its publication. In 1499, another kind of "Love's struggle," quite different from the one recounted in Poliphilo's dream, was raging at the Venetian printing house of the book's distinguished editor (an expatriate Roman), Aldus Manutius. After a little over four years of operation, Aldus's ambition to specialize in printed editions of ancient Greek texts had revealed itself as too narrow; with that restricted focus, he would never sell enough books to make a living. In a stark departure from his usual practice, therefore, he printed the *Hypnerotomachia*, under the sponsorship of a wealthy benefactor, a Venetian humanist with a position in the Roman curial court named Leonardo Grassi.[51] Thus the book's romantic evocation of antiquity, its explicit eroticism, and its attractive format were all designed to sell, thereby paving the way for further Aldine editions in Greek.

On the whole, however, the *Hypnerotomachia* did not prove a financial success. If surviving marginal notes are any indication (and they usually are), many early sixteenth-century readers who went so far as to purchase the book grew bored with it after reading a few of the opening chapters. (The flyleaf to one Vatican copy heads readers off at the pass: "It's a boring novel of sorts.")[52] Yet for a few people, Angelo Colocci among them, the book struck a deep chord. Because these select few were also rich, educated, and demonstrably persistent (at least as readers), they ensured

that the *Hypnerotomachia* and its images enjoyed a long afterlife in the Italian imagination.[53]

In the meantime, Aldus's concession to the laws of Mammon marked neither the first nor the last time that the dreams of humanists would have to make their peace with the laws of the marketplace. Initiated into the mysteries of Roman antiquity, Angelo Colocci himself was soon to be initiated as well into the financial mysteries of the contemporary city.

❧ *Chapter Three* ❧

The Curial Marketplace

Non sono sí povero.

I'm not that hard up.

Agostino Chigi

THE CURIAL ADMINISTRATION

When Angelo Colocci settled in Rome once and for all in 1498, he did so with the hope that he could find a foothold in the city's foremost business – running the Church. With lands stretching from Bologna in the north to Naples in the south, the pope wielded one of the great temporal powers on the Italian peninsula, and as a temporal power the Papal States had become deeply embroiled in the political struggles of Europe. Consequently the papacy had the authority to raise armies and levy taxes, like any other state; it also continued to claim its traditional income from tithes, "Peter's pence," and from the sale of indulgences. Regulating this influx and outflow of money, goods, and services fell to the Apostolic Chamber, the financial office of the Church, headed by a cardinal chamberlain who supervised the activities of a raft of bankers, scribes, and notaries, as well as an internal judiciary. In that busy office, rendering unto Caesar the things that were Caesar's merged completely with rendering unto God the things that were God's.[1]

Through the office of general administration, the Apostolic Chancellery (Cancelleria), the pope assigned bishoprics, including those of the all-important "cardinal" (or "hinge") bishops, who, as the College of Cardinals, formed the governing body of the Church, deciding on questions of dogma, liturgy, music, and moral life. Beatifications and canonizations were processed in the Chancellery along a paper trail, and here

too all of the papal bulls, briefs, and letters were redacted, in a tortuous series of steps that was designed to root out forgeries as well as to create jobs. Over this buzzing bureaucratic hive presided the "cardinal vice-chancellor" (the office of chancellor having fallen by the wayside sometime in the Middle Ages). Aside from the pope, there was no more powerful official in Rome. Many a former vice-chancellor, fortified by his experience, eventually became pope in his own right; Rodrigo Borgia was a famous example.[2]

The papal judiciary, usually called the "Sacra Rota" (Holy Wheel), decided most of the minor legal questions that arose in the course of Church administration. The Rota was headed by twelve judges called "auditors," all with law degrees; many of them became the most famous jurists of their day. However, lower-degree appointments in the offices of the Rota, such as notary, were open to any literate candidate. Renaissance Italy was a litigious place, and while the auditors were busy adjudicating contracts for papal business, collecting bad debts, and guiding people through the legal process of petitioning the pope, their subordinates drew healthy salaries by creating the paperwork that kept the Holy Wheel turning.

Both the temporal and the spiritual sides of Church life had been profoundly affected by the humanist movement; in Rome, as elsewhere in Italy, the legal precision of medieval Latin had given way, in both document and sermon, to the emotive appeal of classical rhetoric. There were comfortable places for humanists within many of the existing structures of society.[3] Thus, whether they were in or out of clerical orders, young men with Angelo Colocci's literary education faced a bewildering array of possibilities for gainful work in papal Rome. Most of these aspiring youths had probably received some training as well in business arithmetic, *abbaco*, which, like Latin, was taught in specialized elementary schools by hardworking, underpaid teachers.[4] Angelo Colocci had certainly been trained in *abbaco*, and his subsequent career (detailed in Chapter 5) shows that he made the most of it.

The search for work might begin in a banking house as a highly placed chamberlain or a lowly cashier or within the Curia itself, where positions were up for sale from a specialized branch of the Cancelleria called the "Dataria." An initial payment (a steep one) secured a candidate's right to the position. The clerical work itself could be expected to produce a certain annual income, as there was a scale of set fees for performing various tasks, but most officeholders hoped to relinquish their post after

a few years, reselling it at a higher price. With the extra money they could then purchase another office, preferably one with more prestige and a higher annual income. In effect, the Dataria ran a kind of brokerage as well as the Vatican's personnel department.

When Colocci first arrived in Rome in the 1480s, the Cancelleria made its headquarters in the palazzo that had been built by the order of the cardinal vice-chancellor, Rodrigo Borgia, who was eventually to serve in this powerful position for thirty-five years (1457–92). When Borgia became Pope Alexander VI in 1492, the Cancelleria retained its headquarters in the Palazzo Borgia; it was rumored that the both the building and the office of cardinal vice-chancellor had been included in the bribe that Borgia offered Cardinal Ascanio Sforza in exchange for his support at the conclave.[5] (The building itself is now known as the Cancelleria Vecchia or Palazzo Sforza-Cesarini; its nineteenth-century façade masks a beautifully preserved fifteenth-century courtyard.) The Cancelleria remained there because its location next to the bankers' quarter was convenient, and besides, the pope still liked to keep close watch on the administration he had run for most of his life. Cardinal Ascanio Sforza, Borgia's successor, also lasted a relatively long time in the vice-chancellorship: thirteen years, until his death in 1505. He did not, however, take nearly as active a role in the running of the Chancellery as had his predecessor; he much preferred to go hunting.

The papal financial office, the Apostolic Chamber, enjoyed a period of comparable stability with the election as chamberlain of Cardinal Raffaele Sansoni Riario in 1483; he was to vacate his post only in 1517, at the age of seventy.[6] Both Borgia and Riario had owed their initial appointments to high places as young men to the fact each had an uncle who became pope, but their ability to stay for decades in positions of such responsibility attests to their personal competence. A shrewd, ambitious politician and a surprisingly competent administrator, Riario served out his thirty-four years as chamberlain with particular success under the papacy of his cousin and rival Pope Julius II.

Riario's mastery of the Roman social scene was legendary. We have already seen how, after a spectacular gambling win at the expense of another former papal nephew, the dissolute Franceschetto Cibò, he sank the proceeds into building a massive palazzo not far from the Cancelleria, acquiring the facing for the two most conspicuous sides of its avant-garde classical exterior by quarrying travertine blocks from the Colosseum. His ability to turn gambling cash into rock-solid assets did no harm to his

control over the Apostolic Chamber, nor did it harm the Roman economy. With its massive scale and classical rhythms, the Palazzo Riario set the tone for future construction in the city and represented an important step in the rise of the building trade to its eventual position as Rome's chief industry.[7]

BANKERS AND HUMANISTS

Because the papacy was so intimately connected with temporal government and matters of finance, it is not surprising to find that there were three basic types of curialists who worked together under the watchful eyes of the cardinal chamberlain and the cardinal vice-chancellor, sometimes so closely that their positions overlapped: the humanists, who drafted the papacy's documents; the merchant bankers, who handled its money; and the lawyers, who interpreted canon law, civil law, and contracts. Trained in "letters," the lawyers and humanists, many of them the sons of aristocrats who had been able to provide them the time and money for schooling, could lay claim to a higher social status than merchant bankers, who had traditionally been sent to work as apprentices at the time in their lives when budding humanists were sent off to tutors or to the university. In practice, however, the Roman Curia tended to level these social differences as the old baronial order gave way to a new entrepreneurial age. By the mid–fifteenth century, many of the merchant bankers who competed to lease the Apostolic Chamber's concessions for taxes and customs duties had been tutored in letters as well as *abbaco*. They knew the legal niceties of business contracts as thoroughly as did the lawyers with whom they worked. As international businessmen, they had arrived at the very top rank of their profession. Proud and wealthy, they were as willing as any aristocrats to invest in their children's education, just as their parents had invested in theirs.[8] Furthermore, because of their close webs of trade contacts, merchant bankers were frequently entrusted with ambassadorial duties, for which some training in letters was essential. By the seventeenth century, banking families supplied most of the cardinals and popes of baroque Rome, the old feudal distinctions between barons and traders virtually erased.[9]

Both bankers and humanists bought positions on the curial staff as investments; like stocks, these positions brought a certain "dividend" of steady income, and with luck could be resold at a higher price. The fluctuating but steady inflation in the prices of such positions throughout

the fifteenth and early sixteenth centuries shows that speculating in offices was, by and large, an extremely lucrative activity.[10] The market in curial positions was mobile, and had to stay mobile in order to generate profits. Some purchasers of office actually worked at their curial jobs, others delegated them to hired agents, and some held their posts in name only, by arrangement with the Apostolic Chamber. These nominal positions really amounted to glorified loans to the papacy. Assigned in theory to competent candidates with good recommendations, curial positions might be secured in Rome by the services of a broker; they were also distributed to cronies and relatives with casual regularity. Given the universal venality of its offices and the wide variety of people who did or did not work at them, the curial bureaucracy was lucky that it worked at all. The secret to what success it enjoyed may well lie in the chance it afforded to enterprising spirits for social and financial mobility, as the rigid structures of feudal society broke down to create the modern world.

Archival records show that among the privileged handful of men who accumulated multiple offices in the Curia in the fifteenth and sixteenth centuries, humanists and merchants stood side by side; indeed, the sons of merchants, like the future cardinal Girolamo Ghinucci or the short-lived brothers Angelo and Lorenzo Chigi, entered the ranks of the humanists *tout court*. Remarkably, despite the very different directions their careers were always to take and the very different reasons for which they invested in the curial market, Angelo Colocci, the quintessential humanist scholar, amassed virtually the same collection of multiple offices, and at virtually the same time, as Rome's most conspicuous merchant banker, Agostino Chigi. Nor was the Cancelleria the only place in the fluid environment of papal Rome where their destinies were to cross.

AGOSTINO CHIGI (1466–1520) AND THE EDUCATED MERCHANT

Eventually, in his own way, Agostino Chigi was to become as integral to the formation of Rome's cultural life as Angelo Colocci and his humanist cohorts. Chigi began, however, in the bankers' quarter of Parione, just across the river from the Castel Sant' Angelo. From the time that he formed his first company in 1487, when he had barely attained the legal age of consent, twenty-one, he used the title "Mercator senensis Romanam curiam sequens" (Sienese merchant following the Roman Curia),

and it was within the tight community of other Rome-based Sienese merchants that he was expected to make his career.[11]

Once a formidable player in the European cloth industry, by the fifteenth century Siena had become increasingly reliant instead on its merchant bankers, who tendered loans, exchanged currencies, traded commodities, and farmed taxes with bewildering versatility. The Tuscan presence in Roman finance had long been a strong one, with Florentines and Sienese vying for supremacy within a group that also included merchant bankers from Lucca, Arezzo, and still smaller towns like Volterra, Pescia, and Pistoia. With offices in the Roman Curia, these peripatetic financiers, continually shuttling back and forth between Tuscany and the Vatican, competed to farm taxes and customs duties not only in their own republics but also in Rome, its vassal states (such as Bologna or Ancona), and in the papal lands just north of Rome known as the Patrimony of Saint Peter.[12] These merchant firms were family concerns, employing an extensive network of relatives at every level of operations, from ship's boy to cashier to traveling agent to the grand *paterfamilias* who kept the master ledger. They normally did business by entering into short-term partnerships with another firm or firms, sometimes only for the purpose of a single transaction, sometimes for a more permanent arrangement. Certain families tended to do business with one another, sharing notaries, agents in other cities, and cargo ships. Arranged marriages, secured (like every other business transaction) by a notarized contract, served further to cement these already existing financial partnerships and to expand the work force of relatives, a situation that favored large numbers of children and a community that could be close-knit almost to the point of suffocation; suicides were not uncommon.[13]

Agostino Chigi's grandfather, another Agostino, had been the first of his family to open an office in Rome, in the 1440s. A generation later, Mariano Chigi, son of this Agostino and father of the other, emerged as one of Siena's most prominent citizens, a city councilman for eighteen years and an ambassador for several missions.[14] The flourishing state of Mariano's business ventures had led him to groom no fewer than three of his five surviving sons to manage the various branches of his bank: Agostino, the eldest, was to head the branch in Rome, Francesco, the second, the Viterbo branch, and Gismondo, the youngest, was to be his father's successor in Siena. The two remaining sons, Angelo and Lorenzo, went to Rome with training both in mercantile practice and letters, help-

ing in the Banco Chigi, studying the classics, and beginning the long process of speculation in curial offices.

At this level in the world of finance, advanced education was essential. The significance of Latin letters to an ambitious merchant like Mariano Chigi was twofold, both moral and cultural. Long before the humanist movement came into its own, the medieval communes of Italy, created by merchant capitalists, relied upon the ancient Latin authors for moral instruction at the elementary level; further literary education was designed to inculcate a sense of civic responsibility modeled on Cicero and on Christian writers. By the fourteenth century, advanced literary education already included the study of Latin rhetoric as well.[15] For the most influential members of these communes, therefore, Latin language and culture served in a fundamental sense to define the terms of good citizenship.

The development of humanism in the fifteenth century placed a somewhat different slant on this basic Latin education, imposing a new set of standards for high culture that were based on the mastery of ancient style, not only for Latinity but for public behavior and for the visual arts. Although the connection between instruction in Latin and instruction in morals remained as firm as ever, the humanist curriculum emphasized that the solid moral teachings of Cicero could no longer be considered apart from the elegance of his diction. Aesthetic sensitivity became an integral part of erudition.[16]

In practical terms, this meant that the sons and daughters of an enterprising merchant family spent two years (sometime between the ages of six and ten) learning elementary reading and writing with a grammar-school teacher, who could be either male or female. From this stage onward, girls were educated at home. Boys, on the other hand, devoted about two more years to instruction under the tutelage of a *maestro dell' abbaco*, whether their ultimate destination was further literary education or direct entry into business. (A more detailed discussion of *abbaco* follows in Chapter 5.) After learning arithmetic and elementary geometry in the *scuola d'abbaco*, the boys, now in their teens, might next be turned over to a Latin master for instruction in letters; here they received the polish that distinguished a humanist, or at least an educated man, from the rest of society. Their apprenticeship in a banking house might be delayed as a result, but the potential rewards of their humanistic learning more than compensated, for a successful merchant was also expected to become a patron of the arts. In any case, an aspiring merchant banker was unable to draw up contracts in his own name before the age of twenty-one.

Letters and *abbaco*, curricula originally aimed at somewhat different strata of society, also employed different forms of script. Just by their outward appearance, the archival records of Renaissance Rome tell a great deal about the kind of men who peopled the curial staff and about the men and women they dealt with.

Merchants, opting for convenience as their chief criterion, favored a looping cursive script full of ligatures and abbreviations, what they called, in Italian, *scrittura mercantesca*. Bankers lived by their business correspondence; through letters they learned of market conditions in the rest of their world, cemented ties with their partners, and held their agents to their assigned tasks. Notaries, drawing up formulaic contracts, employed "chancery cursive" (*cancelleresca*), a script that also made extensive use of ligatures and abbreviations and could be, if anything, more illegible than the hand of a harried merchant. Agostino Chigi's elegant *mercantesca*, for example, was sometimes supremely unintelligible, and he knew it; for much of his career, he kept a Tuscan notary named Cristofano Pagni close at hand, to play the lute and to draft documents in the distinctive script, not of the notaries, as might be expected, but of the humanists (Fig. 15).

Italian humanists like the lute-playing Pagni regarded writing, as they did every other aspect of life, from the standpoint of style. Along with his other antiquarian activities, Petrarch was one of the first scholars to scan old manuscripts for the letter forms of ancient Rome. He finally adopted a script that was used in the tenth and eleventh centuries, Caroline minuscule, in the belief that he was writing in the very style of an ancient Roman. Other early humanists – Poggio Bracciolini, Niccolò Niccoli, and Coluccio Salutati – followed suit. By this collective act of will, they invented the italic calligraphy that eventually became standard for educated penmanship in the later fifteenth century; Poggio's formal script, in particular, set the norm for scribes and typesetters alike.[17] As models for their capital letters, the humanists looked to ancient Roman inscriptions, gradually refining their standards for the well-turned majuscule by reducing the letter forms to geometric formulas.[18] As humanistic script came to define the form of the printed page in the late fifteenth and early sixteenth century, mercantile cursive became less and less common even among the merchant classes. In circles like the Chigi family, men of Mariano's generation, roughly spanning the middle to late fifteenth century, wrote in mercantile cursive no matter what their level of education. A generation later, Agostino worked in mercantile script

(which he evidently had learned from his father), whereas his ambitious colleague Filippo Sergardi and his refined sister-in-law Sulpizia Petrucci had both chosen to adopt a humanistic hand. Without exception, their sons and daughters learned to write in standard "Roman" letters. (For their grandchildren, born in the sixteenth century, when printed writing manuals had begun to spread Roman letter forms into the lower classes, the written mark of gentle breeding once again became elaborate calligraphy rather than the widespread, clear Roman script.)

In the earliest days of movable type, the high value placed on good penmanship did constant battle with the sheer volume of writing that a busy professional, whether merchant, notary, or humanist, needed to produce. For every scrupulous calligrapher like the professional scribe Ludovico degli Arrighi, the artist Raphael, the notary Cristofano Pagni, or the scholar-architect Fra Giocondo da Verona, there was a rough-and-ready Mariano Chigi scrawling in mercantile cursive or Angelo Colocci in careless Roman letters, dropping ink from coarsely trimmed pens, or a fluidly illegible Agostino Chigi, every vowel the same tight, efficient loop. Spelling, no less than script, was a matter of intensely personal choice, not to mention endless learned arguments among the humanists. Reading, writing, and arithmetic, therefore, meant protracted personal encounters with scripts as well as writers, and humanistic study in particular immersed its adepts in a whole world of variegated books.

After a general course of study, Agostino Chigi, destined for the higher reaches of curial finance, served an apprenticeship with a man who had long experience both with business on the highest level and with this complicated world of letters. His mentor was named Stefano Ghinucci, a fellow Sienese merchant banker and a close associate of Mariano Chigi, who, like Mariano, had always maintained numerous contacts in Rome.[19] Significantly, however, "Messer Stefano" was best known in his day for the depth of his learning, especially in the field of history.[20] He had been a compatible friend from their youth to the literarily inclined Mariano Chigi, and, like Mariano, nourished high aspirations for his own sons in Rome.[21] As Agostino Chigi served out his apprenticeship, one of Ghinucci's sons, Girolamo, began a Church career that ultimately led him to membership in the College of Cardinals. Agostino Chigi's brothers, Lorenzo and Angelo, had embarked upon a similar route themselves when they met their untimely deaths.[22]

Agostino Chigi (Fig. 16), however, seems to have posed a problem, both for his father and for the social categories within which Mariano

and his contemporaries operated. In an age where education determined social mobility, Agostino, patently ambitious and just as patently intelligent, refused to study, although he seems to have absorbed the moralism of early Latin training to lasting effect; his letters reveal a sententious turn of mind and an acute, if self-centered, awareness of right and wrong.[23] It may be a lasting tribute to his formative association with Stefano Ghinucci that Chigi, the reluctant humanist, retained a taste for reading history throughout his life.

Yet if letters bored him, *abbaco* and its applications did not; a descendant reports that from the beginning Agostino was "ravenous to increase his family wealth."[24] For a ravenous young merchant, the first step toward riches was entry into the world of tax farming, leasing concessions from the Apostolic Chamber to collect taxes on commodities such as salt, meat, or wine. An aspiring tax farmer pledged to pay over a certain flat sum from his revenues to the chamber but was allowed to keep whatever he could exact in excess of that amount. By leasing the right to collect customs duties at the borders of the Papal States, he could hope to earn money on the same general principle. From arrangements such as these the Renaissance papacy derived the greatest part of its income in the fifteenth and early sixteenth century.[25]

For Agostino Chigi, the influence of his father and Stefano Ghinucci had been instrumental in securing his first leases, but the ambitious young banker had also caught the eye of Rome's most influential merchant house (owned by fellow Sienese): the Heirs of Ambrogio Spannocchi.[26] From the reign of Pope Pius II (1458–64), various members of the Spannocchi bank had also served many terms in the highest financial position in the Apostolic Chamber, that of Depositor General, general overseer of all the papal revenues. Under the pontificate of Alexander VI, who had known the firm well from his tenure as cardinal vice-chancellor, they were once again in office.

Through his association with the Spannocchi firm, Agostino Chigi expanded his network of contacts to include the Spanish-dominated Kingdom of Naples. Something about his association with this international bank, or with the international atmosphere of the curia, or with the whole idea of a universal church seems to have lent him an exceptional overview of his profession, for, just as the fifteenth century drew to a close and the Borgia pope declared a jubilee year, Agostino Chigi, a mature man of thirty-four, divined his personal path through the curial labyrinth. Among his investments, there was one international market

that depended at a crucial juncture upon a single scarce commodity, and it was a commodity that he stood a good chance to control.

That international market was the cloth trade; in Chigi's day, the entire structure of the European economy depended in significant measure upon the production and processing of wool. Extending from the Cotswolds to Constantinople, the wool industry in turn depended for crucial parts of the dyeing process on alum, a mineral found in only a very few places around the Mediterranean.[27] Until the mid–fifteenth century, the most important source of this crystal was Asia Minor, but the fall of Constantinople to the Ottoman Turks in 1453 had disrupted the structure of the trade network and made the development of European alum sources desirable for panicked Christian merchants. In 1460, as if by divine Providence (and many Europeans acknowledged God's hand outright), huge deposits of alum came to light at Tolfa in Italy, a rugged mountainous area one day's journey north of Rome, deep in the sparsely settled papal territory known as the Patrimony of Saint Peter. Other fields of some significance also lay on the Italian peninsula, all within easy reach of Tolfa: Massa, Monteritondo, and Piombino along the Tuscan seaboard, and Agnano north of Naples. In the late fifteenth century, Tolfa was managed by the papacy, which leased out the mines to curial financiers, including the Medici. Massa and Monteritondo were leased in a similar arrangement by the commune of Siena, Piombino fell under the jurisdiction of its own communal government, and Agnano was owned by the Neapolitan humanist Jacopo Sannazaro and his brother.[28] This diffuse series of leasing arrangements meant that the alum business in late fifteenth-century Italy was a piecemeal operation; although the Tuscan communes, the papacy, and the Kingdom of Naples each enjoyed extensive trade networks of their own, neither the networks nor the mining and processing of alum had advanced beyond the stage of small-scale, modestly profitable local industries.

Connected by one tie or another with all these alum-rich localities, Agostino Chigi spotted a way to use his connections to advantage. In 1501, using the Spannocchi bank's solid reputation as an added guarantee for his own solvency, he made a series of daring but consistent investments: in a 3:2 partnership with the bank, he bought up the leases to the alum works of Tolfa, Massa, Monteritondo, and Agnano, all within that single year. At the end of his buying spree he was close to obtaining a monopoly on marketing alum in Europe. Did he reveal this plan overtly to his Spannocchi partners or keep it to himself? It is clear from Agostino's

letters to his father that Mariano Chigi, at least, had no sense of the direction in which the Roman branch of the Chigi bank was now inexorably headed. Instead, father and son quarreled bitterly about the size of the alum investment, as a series of Agostino's letters shows:

> About the alum works, I've seen what you've written me, and it will be difficult to accommodate you . . . You have heavy expenditures, and I thought the opposite: for all my not having a family, it's quite true that I have expenditures myself and extremely heavy ones, and you can be sure that I spend more in one year than you do in four, and these holdings of mine don't bring in any return except for the [alum] industry . . . I see you headed down a road that had better make you happy, because I don't know how to do my business so hurriedly nor with such diligence, and I trust in God that when the day comes He'll show me the best way.[29]

The scale of the younger Chigi's business had clearly surpassed that of his father, whose persistent attention to minor transactions Agostino blasted in another missive: "You're making a big mistake if you think I can tend to a lawsuit of 100 lousy ducats [*ducati tignosi*], because I pass up my own [cases] that bring in thousands to avoid having to litigate."[30]

Chigi's attempt to garner a monopoly on alum production never met with more than partial success; though by 1501 he had obtained virtual control over all the alum operations in Italy, two important fields, one at Cartagena in Spain and the age-old sources in Asia Minor, lay outside his purview. Furthermore, he held his properties in partnership with the Spannocchi firm. Within two years, however, a set of fortuitous circumstances forever altered Chigi's situation, especially his relationship with the Spannocchi bank. In early October 1503, Pope Alexander and Cesare Borgia returned from a dinner party in the *vigna* of Cardinal Adriano Castellesi complaining of stomach pains. By the next week the pope was dead, and syphilitic Cesare would never again be quite the same either.

The most traumatic event for a curial banking house at its apogee, like the Heirs of Ambrogio Spannocchi, was a change of popes; it was highly unlikely that the favorites of one pontiff would enjoy the same privileges under his successor. Nonetheless, as depositors general of the Apostolic Chamber under the Borgia papacy, the Heirs of Ambrogio Spannocchi had good reason to expect that they would be reappointed when Alexander VI was succeeded in the October conclave of 1503 by a Sienese pope, Pius III Piccolomini. They invested lavishly in trappings for the

new pontiff's ceremonial installation, confident that they would eventually recoup their outlay in lucrative tax-farming contracts with the Apostolic Chamber. Twenty-six days later, this pope too was dead. Within two days of its convening, the second conclave of 1503 brought forth a quite different personage: Cardinal Giuliano Della Rovere, a native of Savona in the northern Italian region of Liguria, who took the name Julius II. Predictably, the new pope designated a group of fellow Ligurians, from the Genoese firm of the Sauli, to serve as depositors general. Short of cash, abruptly cut off from their expected source of funds, the Spannocchi firm declared bankruptcy.[31]

Agostino Chigi had been more clever than his partners at hedging his financial bets. Cardinal Della Rovere's lust for the papacy had been anything but secret for well over a decade. A longtime enemy of the Borgias, he had rushed back from nine years of self-imposed exile to press his candidacy in the October conclave of 1503, hoping to profit from the Spanish pope's unpopularity. Controversial himself, he had watched his fellow cardinals elect Pius as an elderly, feeble interim candidate – too feeble, as it turned out, to give the College the breathing space it had wanted. In December's conclave, Cardinal Della Rovere took no more chances. When he bribed his way to election, he did so with the help of loans from Agostino Chigi. Partners in political action, now and ever afterward, they were destined as well to become close friends.

Chigi, as we have already noted, had leased his alum fields by sharing the investment with the Spannocchi firm in the ratio of 3 to 2; in 1501 he had needed their capital and their reputation to make his own bids stick. Upon their sudden collapse in 1503, however, he swiftly claimed their share of the alum leases as his own, giving him full control of the operation. Giulio Spannocchi, sole head of his family firm since the death of his brother Antonio earlier that same tumultuous year, protested immediately against Chigi's takeover. He had assumed that he would receive temporary help from his partner in the form of a friendly negotiated settlement; this was the usual way in which a consortium handled a partner's bankruptcy. Spannocchi railed at Chigi in a letter of January 5, 1504, "If you hadn't been so opportunistic [*vantaggioso*], things between us might have been negotiated, even if it were to have been with some loss to myself."[32] The fallen magnate might as well have been writing from another world, for the cooperative virtues that ran the Sienese mercantile consortium had no place in Agostino Chigi's design, and neither did a negotiated settlement with the Heirs of Ambrogio Spannocchi. On the

contrary, Chigi recognized all too well that his former partners were also his chief rivals for supremacy in Rome's financial world. (Not for nothing had he spent part of 1499 on the road with Cesare Borgia and Machiavelli.) The temporary elimination of the Spannocchi bank gave him freedom to act in the European market on his own terms, and act he did.

In the midst of his Tolfa transactions of 1501, still taking in customs duties on livestock in Siena and the Patrimony of Saint Peter, salt tax in the March of Ancona, and profits from receiving jewels in pawn from prelates and aristocrats, Chigi also purchased his first known curial post, that of papal abbreviator.[33] Within the hierarchy of the Cancelleria, this was a supervisory position; an "abbreviator," as the name suggests, after receiving a draft from an apostolic scriptor, distilled the text of a papal decree to its essentials, earning a set fee every time he did so. There were seventy-two of these positions available when Chigi bought in, each to be had for about 1,500 ducats.[34] Sometime shortly afterward, he added a second position to his portfolio, scriptor of apostolic letters. The 101 members of the College of Scriptors wrote the texts of the pope's decrees and correspondence, under the supervision of the abbreviators and higher Chancellery officials such as the apostolic secretaries. Theirs was an entry-level position, which at the beginning of the sixteenth century normally cost slightly over 2,000 ducats. With the same amount of money, Chigi could have hired a private army for several months, engaged ten humanists or fifty artillery experts for a year, commissioned a first-rate marble tomb, or squandered everything on a single dinner party with a cardinal or two. In the course of his eventful life, he was to do them all, but for the moment he concentrated on the curial marketplace.[35]

On December 16, 1505, Agostino Chigi took on the far more prestigious post of apostolic secretary; at roughly 3,000 ducats, it was also considerably more expensive than the scriptorship, and there were only thirty places to be had.[36] To illustrate how thoroughly bankers and humanists mixed at this level of the Chancellery, we might note that Girolamo Ghinucci, the son of Chigi's mentor Messer Stefano, bought a secretariat two days later as a significant step toward his eventual cardinal's hat.[37] Apostolic secretaries served directly under the pope, drafting the relatively informal papal proclamations known as "briefs" (*breves*), though their brevity had more to do with their comparatively short road through the Chancellery than with the length of their contents. (An official proclamation was known as a "bull" from the papal seal, or *bulla*, that was affixed to it.) Ambitious secretaries often used the texts of their briefs as

an opportunity to show off their Latin style, hoping to attract attention and higher office. Both Girolamo Ghinucci and Angelo Colocci were to do so successfully. In the case of Agostino Chigi, the apostolic secretariat was almost certainly honorary; in effect, the position marked receipt of a loan to the papacy, and Chigi delegated the actual work, at a reduced salary, to one of his employees.

This is not to say, however, that Chigi was an absentee administrator. As a papal banker and a standing ambassador from Siena to the Holy See, he generated his own share of the pope's paperwork. The financial health of the papacy was intimately connected with Chigi's financial health, especially after he had pulled free from the Spannocchi; the Chancellery's bulls and briefs sometimes also directly concerned his own business. The extent of his personal involvement in his purchased offices can be gauged by the fact that once he acquired them he held them until his death – a bad idea if he were merely speculating on them for profit, but a good idea if he were using them to keep control of his place in Vatican affairs.

In 1507, Chigi bought a position as notary of the Apostolic Chamber, the branch of the papal administration that governed his tax concessions and the alum operations at Tolfa.[38] He installed his trusted associate Cristofano Pagni in the office, and from Pagni's notarial papers we can see that a substantial portion of his duties in this capacity actually involved redacting alum contracts for the Heirs of Mariano Chigi.

By 1509 (probably in 1507 or so) Agostino had enhanced his several venal offices by buying the noble title of "count palatine." Although the Chigi family were considered *gentiluomini* (gentlemen) in the merchant oligarchy of Siena, his lineage was not likely to impress the feudal lords of northern Italy or the Kingdom of Naples. For these arrogant courtiers, a venal title was better than none at all; many feudal lords stood in perpetual need of money and hence accorded a certain grudging respect to those who had it.

The pattern of Chigi's investments and his degree of participation in their management suggests that he wnated to exert an unusual amount of control over the economic policy of the Curia. He had resorted to more direct means as well, tendering loans to the Borgias during the papacy of Alexander VI and then to Julius II before, during, and after the second conclave of 1503. Despite his privileged dealings with the Della Rovere pope, he seems to have made no attempt to procure the prestigious post of depositor general to the Apostolic Chamber, leaving it in-

stead to the Sauli bank of Genoa. The fate of the Spannocchi in the depositor generalship may well have given him pause.

ANGELO COLOCCI ENTERS THE CURIA

Next to this aggressive and devious figure, Angelo Colocci – though he too was an outstandingly successful speculator in curial office – led a retiring life. For the humanist from Iesi, entrée into the Camera Apostolica probably served more as a source of steady income and a venue for making connections among humanists than it did as a chance to shape papal policy. He probably began his investments in 1498, shortly after he returned for good to Rome from Iesi, where he had gone in 1494 upon the death of his father. Orphaned and not yet of legal age, Colocci had spent about four years in his birthplace settling his family affairs (and growing old enough to do so legally in his own name).[39] His initial outlays for curial office may well have come from his inheritance.

Whereas Chigi seems to have retained his offices tenaciously once he had acquired them, Colocci shifted his investments, a sign that he was playing the Curia as a speculator while also rising legitimately through its ranks. Like Chigi, he began investing at the relatively high level of abbreviator, a sign that each man from the outset was unusually wealthy and well connected. Unlike Chigi, however, Colocci worked in person at his curial tasks, for this astute businessman was also intent on making his name as a humanist. In 1499, Colocci shifted from the position of "assistant vice-chancellor," or *abbreviator praesidentiae majoris*, to "curial abbreviator," *abbreviator de curia*; in practical terms, he turned from reviewing the texts of papal bulls to supervising the internal memos of the curia.[40] Like Chigi, he followed his tenure as abbreviator with the purchase of a position as scriptor; this he did in 1504, and about the same time he took an additional position as registrar of apostolic letters, a position that entailed entering the pope's correspondence into a master ledger. Before 1511 he had become master registrar.

Colocci's stint as apostolic notary lasted only two years, from 1509 to 1511; by 1510 he had become a solicitor of apostolic briefs, and by 1511 he too had reached the coveted position of apostolic secretary. He took this secretarial position seriously, and it turned out to claim a good deal of his time. He had a reason for his diligence, however: his great dream

may already have been to win the coveted post of domestic secretary, or personal aide to the pope, but for that honor he would have to wait.

Along with his purchase of offices, Colocci had also begun to invest substantially in real estate, another traditional source of income in papal Rome, and one regarded by contemporaries (perhaps misguidedly) as especially secure. Pomponio Leto's house (unless it was a bequest from his late mentor) may have been one such acquisition. There were many others to follow.

At a certain point, however, just as Agostino Chigi avoided the post of depositor general, Angelo Colocci set distinct limits on his curial ambition. He avoided taking holy orders, eliminating his chance to rise within the ecclesiastical hierarchy to a position as canon or bishop. Unlike Fedro Inghirami, whose service as a canon of Saint Peter's allowed him to flaunt some of the most voluminous scarlet robes ever fashioned for a priest, Colocci chose instead to marry a Roman aristocrat, Girolama Bufalini, and to wear the sober dress of a man about town. Cleverly, and without a doubt deliberately, Colocci had stopped his climb at the point where the expenditures and risk of a church career mounted most steeply. Not only were bishoprics expensive to buy; they were often bound up in elaborate arrangements that made their actual income a fraction of what it seemed to be on paper. The title of cardinal might cost more than 10,000 ducats for the initial down payment, to say nothing of the living expenses incurred if a "prince of the Church" were to live up to his title as patron, statesman, and head of an official family. By dealing only in the lower offices and by pocketing his wife's substantial dowry, Colocci had reached a point of stable economic well-being by the first decade of the sixteenth century.[41]

The cause to which Angelo Colocci sacrificed his ecclesiastical career (at least for a while) was that of humanistic study. With Leto's example before him and a great deal more disposable money than his mentor had ever enjoyed, he embarked on an enthusiastic program of what his twentieth-century cohorts might call "support for the arts." He was not a great patron; neither, though, would he ever need to serve a powerful man as client. Instead, with more freedom than most of his contemporaries, Colocci created both his career and his position as a sponsor of the arts through a network of relationships among equals, in other words, of carefully maintained friendships. His measured investments, probably insufficient to cover the cost of the open-air dramas mounted by a Raffaele Riario or the banquets of an Agostino Chigi, nonetheless earned enough

to allow him to devote both his attention and his income to his true passions: assembling manuscripts, books, and antiquities. These too would have been sound investments if Colocci had nourished any intention of selling them, but, like his mentor Pomponio Leto, he arranged them instead as a permanent resource for his friends. In effect, Colocci endowed a small, privately run museum and library on the model of two grander public institutions that had been opened to the learned community by Pope Sixtus IV: the Capitoline Museum and the Vatican Library.[42] To judge from the state of some of his surviving manuscripts, Colocci's library kept fairly relaxed rules about eating and drinking around the books, not to mention scribbling in their margins. As for the antiquities, in the clean air of sixteenth-century Rome their worst enemies were the builders and lime burners rather than the exhaust fumes that threaten them today; enclosed within the walls of his various gardens, his manuscripts, monuments, and printed books were safe, at least for the time being.

In some respects, however, this rarefied scholar's attempts to influence the renovation of Rome (and of papal policy) were no less ambitious than those of Agostino Chigi. Like Agostino Chigi, Angelo Colocci was at heart an entrepreneur, one who reserved his best attentions as a speculator to the area where he commanded the greatest skill. While Agostino Chigi marketed alum to Europe, Angelo Colocci marketed culture.

Chapter Four

The Cultural Marketplace

Oymè che può habitar fra tante insidie
Fra tanta servitù: fra tanta inopia
Fra tanta falsità: fra tante invidie
Speso ho gli anni mei qui sì gran copia.

Who could survive all these cabals and ambuscades
In helplessness like this, in such servility.
In such hypocrisy, in such petty escapades
I've spent my life, my youth, and my senility.

Serafino Ciminelli, "L'Aquilano"

CONNECTIONS

The curial marketplace in Rome also gave rise to a cultural marketplace where talented individuals bargained their skills for goods and services, much as many of them bargained for curial offices at the same time. The spheres of finance and culture overlapped, and in papal Rome both spheres also bore continually on the conduct of the Church.

Social connections provided the universal cement, beginning with the microcosms that swirled around the households of cardinals, barons, high prelates, and wealthy bankers. Entry into these sanctums, or into the Roman Academy and the other local academies, depended invariably on the proper introductions; thus the necessary intermediary for Angelo Colocci had been his uncle Francesco. All of these relationships, however, whether contractual or consensual – whether they involved peers, patron, and client, or something in between – could change as rapidly as the fortunes of the curial marketplace.

Because many humanists were born rich, they could pursue learning,

like Colocci, in their own right. The less fortunate were forced to find a position in the entourage of a patron. Here they kept company with other hired personnel at various levels of the social hierarchy. For example, Agostino Chigi's close associate Cristofano Pagni came from a large, fairly important family in the small Tuscan town of Pescia. His father Roberto had moved down to Rome, perhaps in the 1460s, where he educated his several sons in letters and sent them out to work. A succession of Pagni brothers carried out the duties of notary to the Apostolic Chamber without any of them having purchased the office in his own name. Before succeeding his brother Filippo at this post in 1504, Cristofano kept records for the Chigi bank and drafted a good deal of Agostino's correspondence, saw to the great merchant's mail whenever he was out of town, and played the lute. He was able to save enough from these years of labor to purchase a retirement home in the pretty town of Asciano near Siena.[1]

Cristofano Pagni's lute serves as a reminder that education in letters must often have included instruction in music. Humanist poetry was often sung solo to the lute or by a chorus; Pagni, Colocci, and their peers took the figurative "singing" of Roman poets (as in Virgil's "I sing of arms and the man") at face value.

In the patronage systems of the fifteenth and sixteenth centuries, as in the patronage systems of the ancient city, the old Roman art of *ambitio* – literally "making the rounds" – still reigned as the strategy of choice. The humanist Evangelista Maddaleni Capodiferro, known to his companions in the Roman Academy as "Fausto" (Lucky) has left ample evidence of how to make the rounds successfully. Lucky seems to have spent his early adulthood acting as a factotum for Cardinal Giovanni Colonna, not unlike Cristofano Pagni's position with Chigi. Fausto disbursed small sums of money to the various employees of the cardinal's household, arranged the table settings and menus of the cardinal's important dinner parties, and, as a humanist certified by membership in the Roman Academy, composed learned verse to be performed on such occasions. A notebook that records both expenses and Fausto's Latin poetry also tells how he went about looking for a new patron at the time of Cardinal Giovanni's death:

> Sunday, which was the first of October, 1508, I paid a visit to the Right Reverend Monsignor de' Medici, that is, Giovanni, and I asked his Right Reverend Holiness, because of my Right Reverend Monsignor Colonna having died, and my having made a choice of his own

Right Reverend Holiness, who is so superbly literate, whether it might please him to accept me among his servants and the members of his household. And his Right Reverend Holiness with a gracious countenance did receive me as his familiar, among many and most gracious words and offers. (He was later made pope and was Leo X.)[2]

Fausto was himself considered a Roman noble; when he volunteered to become Giovanni de' Medici's "servant," his offer was only rhetorical, and Cardinal Giovanni recognized it as such. Instead, as the report reveals, Fausto took up a position as "familiaris"; in fiction, at least, he became a member of the celibate cardinal's official family, just as he had been a fictive member of the Colonna family before 1508.

MANNERS

For a sycophant like Fausto Capodiferro the correct use of titles was essential to success, but the elaborate etiquette of titles comprised only a small element in the intricately choreographed regulations that governed one person's contact with another in Rome's complex hierarchy of church and state. Who rose and who sat, who rushed to meet whom and how far they rushed, who kissed whom on the hands and who on the mouth: every gesture could be fraught with significance, especially for a habitually dependent person like Fausto or the punctilious masters of ceremonies whose job it was to work out daily schedules for the pope.[3]

Even mortal insults could be hurled with elegant formality, as in the duel Fausto records on the first page of his logbook – a fight, for reasons unknown, between another local nobleman, Mario degli Astalli, and a knight in the service of Cesare Borgia, probably a Spaniard, Messer ("Sir") Antonio Vendectino:

> On Tuesday, the eighteenth of July 1503, Mario degli Astalli and Messer Antonio Vendectino fought one another on the field of combat. Their dispute was this: Messer Antonio bore a grudge against Marcello, Mario's brother, and one day when Messer Antonio got into a discussion with Mario, he said that said Marcello, in his opinion, was not a man. Mario replied that he had already proven his manhood, and he said this because Marcello had assaulted Messer Antonio in the past and chased him away. Then Messer Antonio said, "Now I have you here, and I want to prove to you that in my opinion Marcello is not a man." Mario replied that he would rather maintain that [Messer

Antonio] lied through his throat. Messer Antonio chose the field of combat, which belonged to His Invincible Excellency Cesare [Borgia], duke of Valentinois. Mario chose the weapons, these for defense: helmet without visor and with neckpiece, and these for offense: long-handled maces and daggers.

And thus on the aforementioned day they faced off, and struck one another some four blows with said maces. When Mario wanted to strike a blow with all his strength and missed, he began to lose his balance, and then Messer Antonio closed in on him, and giving him a shove he threw him to the ground with ease, and then he was on him with all his body, and tormenting his left eye with his fingers for some time and punching him he said, "Give up, you Jew, give up." Mario, enduring with supreme constancy, got his hands on [Messer Antonio's] neckpiece and thus pulled him off, and then flipped him over with a sudden twist of his back, and without saying a word he took some handfuls of earth and stuffed them in his mouth, choking him by the throat and tormenting his testicles to get a better grip and to reach for his dagger. Then Messer Antonio said, several times, "I give up, I give up, I give up." Thus he was given over to [Mario] as his prisoner, and [Mario] gave him over to the duke, to the prince [Cesare Borgia's younger brother Jofré, prince of Squillace], and to Don Michele [Coroglio, Cesare Borgia's captain of the guard]. Then the prince and Don Michele requested that the two of them be good brothers to one another, and thus they made each of them kiss one another on the mouth. (The duke was not present, unless he was in disguise.) The spoils from said Messer Antonio were hung up at Santa Maria del Popolo.

In this let us praise Mario for spirit in fighting, patience in suffering, strength in overcoming, prudence in winning, liberality in making [Messer Antonio] prisoner, piety in accepting him as a brother, humanity in not vaunting over his victory, and religion in rendering thanks to Almighty God.[4]

This brutal little vignette presents a vivid picture of the Rome in which a Fausto Capodiferro might prefer instead to live his safely protected life of clientage. The ritualized exchange of insults before and during combat must have taken on an added shiver of suspense with the arrival of Cesare Borgia's brother and his closest henchman. Indeed, Mario degli Astalli may have hoped that these notoriously cruel strongmen would toy further with Messer Antonio, and so they did – but with supreme disdain, they did so by forcing a humiliating peace between both combatants.

Cesare Borgia, if he was present, remained still more aloof, concealed

by a disguise. By 1503 his handsome face had been disfigured by syphilitic chancres, and he often preferred to hide it in the daytime. But that restless soul also had other reasons to resort to traveling incognito. In the social choreography of papal Rome, dress and grooming provided quick clues to status and occupation; like titles, they worked as distant signals by which to gauge the course of closer personal contact. To a remarkable extent, clothing for the professions and the Jews was actually regulated by law, while the papal masters of ceremonies complained constantly that no one in their decadent age knew how to dress properly to meet the pope. In the case of Cesare Borgia, dressing in the brocades and slashed velvets to fit his status meant simultaneously confining him to the ceremonial demands of being the acknowledged son of a reigning pope as well as the duke of Valentinois and the pope's chief military adviser. It meant kisses, cavalcades, and ritual exchanges of greetings along a well-marked route. Cesare Borgia, defrocked cardinal, absentee husband, and footloose general, hated confinement of any kind.

Looking back at nineteenth-century New York, Edith Wharton perceptively drew the line between wealth and its lack on the basis of "cleanliness and comfort."[5] The same distinction also held true for papal Rome, for one unexpected result of the humanist movement was a revival of bathing as an institution.[6] A clean Roman was probably a wealthy Roman; the working people hovered continually at the level of bare subsistence, with sporadic food and one suit of clothes. Once simple distinctions had been made between repair and disrepair, washed and unwashed, in effect at the point dividing the poor laboring *plebs* from the *mediocres*, the middle class, Rome's sartorial code suddenly became much more complex.

Fausto Capodiferro, as a Roman aristocrat, would have been permitted such luxuries as gold chains, fur linings, velvets, and bright colors, especially as a young man. The peacock splendor of secular dandies competed openly with the crimson, furs, and laces that draped the prelates of the Church, substituting the charm of close-fitting tights, glimpses of embroidered linen through slashed overgarments, and well-stuffed codpieces for the churchmen's vast displays of expensive cloth. Older men hid their spreading physiques and stiffer movements under clothing of more muted hues, like the grays and blacks that dominate Raphael's virtuoso portrait of his friend Baldassare Castiglione, an elegant Mantuan count who also disguises his balding pate with a luxuriant hat (Fig. 17).

Merchants and scholars were expected to dress soberly in blacks,

browns, or blues, the wealthier among them, like the nobles, confronting the dank Roman winters of the Little Ice Age through a lining of fur.[7] Needless to say, these restrictions did nothing to damper the urge of ambitious merchants to make a display of themselves in public; the difference between Agostino Chigi's black brocaded silks from Damascus and the woolens of his cashiers was probably apparent to the most untrained eye. So too is a slightly less opulent banker's reliance on his sheer physical beauty in Raphael's portrait of the young Bindo Altoviti. Like the highest prelates and the titled peers, these resplendent moneymen moved through town in cavalcades, "keeping their place" only when they made way for a king, pope, or cardinal.

The women with whom such men kept company were effectively divided into two categories: "family" members and courtesans. Aside from widows and nuns, who were swathed in cumbersome, dark outfits, even the most chaste of women wore gowns that drew pointed attention to their bodies. In homage to the humanist movement, artists might represent them as half-clad classical goddesses without damaging their reputation for modesty. The second decade of the sixteenth century brought a sudden passion for Turkish turbans; even the Virgin Mary has been outfitted in the latest style in Raphael's *Madonna of the Chair* of 1514. More conventionally, the portrait known as *La Fornarina* combines a similar Turkish turban with a come-hither glance in the image of a woman whose nudity, perfunctorily swathed in a diaphanous veil, is more voluptuous than heroic. Longstanding tradition has identified her as Raphael's lover, the baker's daughter (*fornarina*) from Trastevere with whom he was reportedly locked up in Agostino Chigi's villa. She is dressed, however, in the style of another profession. It seems at least as likely that the work, with its ostentatious signature on the sitter's armband, may be one of the many portraits of courtesans generated by the Raphael workshop.[8]

When not clad in gossamer for Raphael portraits, courtesans still dressed more garishly and more suggestively than other women in Rome, their hair frequently dyed blonde on a regimen of lemon juice and exposure to the sun. (When not working, they sat on their laundry terraces wearing special straw hats without crowns; these were designed to keep their skin white as their hair, spread about the wide brims, baked to a golden tone.) On occasion, they took to the streets in men's clothing, soliciting the custom of passersby.

Writing toward the end of the sixteenth century, Thomas Randolph,

the English metaphysical poet, left a vivid picture of the Renaissance scholar's inherent frustration with life at court in precisely these terms of colored clothing: "As once in blacke I disrespected walkt / Where glittering courtiers in their Tissues stalkt."[9] With courtly tissues went courtly morals. Randolph's poem ends with his discovery that the woman he has followed into a secluded garden is a transvestite.

SERAFINO'S SUBVERSIVE ART: THE LIFE OF
SERAFINO CIMINELLI (D. 1500)

Cesare Borgia and the demi-monde were not the only denizens of Rome to bridle openly at the city's dress codes and the social distinctions they expressed. In the 1490s a scrappy little musician from the mountains of the Abruzzi launched a personal protest against every kind of courtly snobbery, one of the first of his age to insist that talent, not birth, should determine social status. His name was Serafino Ciminelli, but he was usually called "Serafino Aquilano," after his native town, L'Aquila.[10]

Professional musicians did not enjoy particularly elevated status; unless they were humanist amateurs, they were regarded as craftsmen. Frequently they were taken into a patron's household as "familiares," a term that identified members of an extended official family running the gamut from slaves and servants to blood relatives or close friends.[11] Thanks to the classical myth of Orpheus, the Greek bard who drew the wild beasts to him with the strains of his lyre, musicians in fifteenth- and sixteenth-century Italy were often compelled to double as dog handlers. On special occasions a household might hire extra musicians for a single event; performers engaged on this basis were normally paid a pitiful sum.

By conventional Roman standards, Serafino Aquilano sat well below the high end of this professional spectrum. In technical terms he was illiterate, for he composed and sang only in Italian vernacular. But how he must have sung! From 1493 to 1496, he was taken into the Roman "family" of the powerful Milanese cardinal vice-chancellor Ascanio Maria Sforza, whose house musicians also included the brilliant (and "literate") Fleming Josquin Des Prez. While Josquin composed elaborate polyphonic masses for the Sistine Chapel and for Cardinal Ascanio (as well as more casual pieces), Serafino improvised ditties on his lute.[12]

Surviving reports suggest that the key to Serafino's appeal to his contemporaries lay in his skill as a song stylist. Modern literary critics have

found it difficult to reconcile his legendary popularity with the quality of his preserved poetry, forgetting that they are dealing almost exclusively with lyrics, bare words that were always meant to be words set to music; it is not absolutely clear, unfortunately, that any of Serafino's tunes survive. As a result, what we are now able to read is always less than half a sample of what his art was all about.

In some ways, too, Serafino's artistic iconoclasm was so pure that it still hurts, for he created much of his poetry by perverting the forms of the Petrarchan love sonnet, and this at a time when a copy of Petrarch's *Rime*, like the Petrarch manuscript that Angelo Colocci inherited from his father, might well be considered the most important book in the house. Some of Serafino's most severe modern critics, particularly in Italy, still resent his barbs against the father of humanism.

Beyond the sonnets of his own vastly influential *Rime sparse*, Petrarch spawned a movement, *Petrarchismo*; already by the fifteenth century, let alone the sixteenth, any humanist of merit felt compelled at some time in life to compose love sonnets in the Petrarchan vein. The task was harder than it looked. Like his ancient Roman predecessor, Tibullus, Petrarch used a deceptively simple vocabulary with iron discipline. If the poems' outward form was easy to imitate, it was exceedingly hard to imitate well. By the late fifteenth century, the number of Lauras, Phyllises, Amaryllises, Clorindas, and sweet Endymions who had been enshrined in tedious Italian verse made up a veritable nation.

Serafino differed from other *Petrarchisti* in his ability to use conventional forms with limitless imagination and an utter lack of reverence. The restriction imposed by the rules of the sonnet and by his musical settings only served to add shape to his work, to prove the cleverness of his rhymes by their crazy perfection. In the midst of so many pale imitations of poor Petrarch, Serafino's ditties must have stood out to bracing effect:

> I don't know what you want: your brain's frenetical:
> You smile at me and then you turn to snarling.
> First you believe in me: then you're heretical.
> You're angry now: and later you're a darling.
> You run from me as if I'm paralytical,
> And then I'll be a prize beyond regarding.
> Love me, or shut me out and lock the door:
> Don't give me peace today and then make war.[13]

Serafino also seems to have initiated the practice of writing sonnets in the form of a dialogue, usually between lover and Death, reducing the interventions of each to curt syllables:

> Death?
>> Yes?
>>> I want you.
>>>> Here I am beside you.
> Now take me.
>> Why?
>>> My pain's past toleration.
> I can't.
>> You can't?
>>> Not in this situation . . .
> But why?
>> Because there's not a heart inside you.
> How?
>> Where would you have left it lying, stupid?
> Ha ha! I know too well – the cause is Cupid –
> So now what?
>> Make him give it back, or try –
> Unless you get a life, you'll never die.[14]

On the basis of his musico-literary rebellion and the popularity it brought him, Serafino also staged a one-man rebellion against the patronage system, especially as that system was embodied in his own sponsor, Cardinal Ascanio Sforza. A fellow poet, Vincenzo Calmeta, recalled that:

He lived in the house of a Bolognese Knight of Jerusalem named Nestor Malvezzo for as long as he belonged in the service of Cardinal Ascanio Sforza, with whom he stuck it out for three years with tremendous resentment and irritation. For, despite the difference in their natures, the cardinal (like most princes, and not without justification) expected that Serafino would adapt to his own habits, but talent of that sort can never endure control, and [Serafino] would not accept it. Thus the patron, with all his authority, and the client, with his lazy disposition, were forever at each other's throats.

Now among the many incompatibilities, one stood out beyond all the others, and that was hunting, to which the cardinal was so addicted that he neglected every other responsibility, while Serafino was so averse to it that to hear the very mention of it offended him. Every

day the cardinal continued to rebuke him and to hold him in low esteem, treating him with more familiarity, in truth, than befitted the dignity of such a prince and prelate, and certainly not in a manner compatible with so wayward a spirit . . . Now he began to bewail his unhappiness and to attack the cardinal secretly in bitter and humorous sonnets, . . . as when he attached a sonnet to the collar of a dog, when he ridiculed the courtiers' ill-spent carousing 'til dawn, when he lampooned the cardinal's pomposity and greed . . . to the point that as he continued with these satires and attacks, with all their cleverness and point, the less Cardinal Ascanio appreciated him, and the more his reputation spread throughout Rome.[15]

Avid hunter that he was, Cardinal Ascanio kept a huge kennel; Serafino's trick of tying a scurrilous poem to one of the cardinal's dogs and sending it out into the Roman streets was easy to arrange and successful enough for him to repeat the feat more than once. The most clever of these sonnets, found on the collar of an aging hound, also gives one of the period's better glimpses into the life of a humanist or a musician in Rome:

> Ow-ooo! Ow-ooo! I never learned to speak,
> But hear me out, let mercy be the judge.
> A little compensation's all I seek
> For all the time I've wasted as a drudge.
> Bu bu, bu bu, bu bu, I'll sink my teeth
> In anyone who knocks me from my throne,
> For good and faithful service can be shown
> In every wound I've suffered in the breach.
> Don't take me now for what I used to be;
> A weak physique won't sap my good advice.
> Now more than ever, you can count on me,
> And yet, my lord, I think you realize
> A bottom-dwelling life's all I foresee
> (A rude surprise).
> If curial life is how you earn your keep,
> The truth is that you'll die a hapless heap.[16]

Despite Serafino's provocations, Cardinal Ascanio continued to employ him, and if he berated his wayward musician daily, he was also responsible for the most important change ever to take place in Serafino's musical life. On a trip to the cardinal's native Milan, at the court of Leonardo da Vinci's great patron, Ludovico Sforza ("Il Moro") (Cardinal

Ascanio's brother), the wild man from the Abruzzi met a new art form. Calmeta describes the contact as follows:

> When Serafino was in Milan he became friends with a notable Nea-politan gentleman named Andrea Coscia, a soldier of Duke Ludovico Sforza, who sang very pleasingly to the lute, and among the other types of music, a sonata in which he performs *strambotti* by Chariteo with great sweetness. Now Serafino not only adopted the musical form, adding more polish to it, but began to compose his own *strambotti* with such passion and diligence that he achieved his greatest fame and had his greatest success in that style.[17]

A *strambotto* is an improvised vernacular verse with eight eleven-syllable iambic lines. ("I don't know what you want" and "Death? Yes? I want you" are two such *strambotti*.) The form's real novelty seems to have lain in its musical setting.[18] Against a background of sharp chordal rhythms bowed on the *lira da braccio* (a seven-stringed viol with five strings on the fingerboard and two drones), the *strambottista* declaimed his lyrics, the cleverer the better. Strong rhythm and a repeating series of chords provided a reliably firm structure for almost endless variation, much as the blues progression has served twentieth-century musicians. In another essay, Calmeta, no mean *strambottista* himself, gives a more specific de-scription of their practice: "Chariteo [another prized *strambottista*] and Serafino . . . have striven to accompany their rhymes with easy and simple music, that the excellence of their witty and sententious words might be better understood, for they have the judgment of a discerning jeweler, who, wanting to display the finest and whitest pearl, will not wrap it in a golden cloth, but in some black silk, that it might show up better."[19]

In other words, *strambotti* were popular music, in every sense of the word, and like popular music they owed a good deal of charm to their immediacy. As evanescent as a passing mood, they were seldom com-mitted to musical notation. Just as modern churchgoers in England are expected to recall their hymns, tunes and all, from books that print only the words to the verses, Serafino's public would have conjured up the whole melodic setting of a *strambotto* from the bare record of its lyrics.

As Calmeta reports, the mania for these Neapolitan *strambotti* had en-veloped Milan in a new passion for vernacular verse; another of the north-ern city's most clever *strambottisti* would turn out to be an architect from Urbino, Donato Bramante. Because of their satirical tone, their vernacular language, and the seductive novelty of their accompanying music, *stram-*

botti seem to have had a universal appeal regardless of the listeners' social class. Serafino, clever improviser and expressive performer, poured both his creative power and his resentments into a medium that throve on the charged tension between refined art and popular sentiment.

It was his triumph as a *strambottista* that made Serafino resolve to break with Cardinal Ascanio once and for all. He prepared a final sally, now emerging out into the open with his attack, choosing as his occasion a Carnival dinner party back in Rome in the presence of a distinguished guest, Cardinal Giovanni Colonna. Calmeta may well have been on the spot to hear the performance:

> As Carnival drew near, already planning to leave the cardinal, he com-
> posed the eclogue that begins, "Tell me Menander, etc.," imitating
> Jacopo Sannazaro, who in those days held the championship for bu-
> colic verse, and in it under a clever cover he attacked the greed and
> other detestable vices of the Roman court. And when he performed
> it with the approval of Cardinal Giovanni Colonna, he drew to himself
> still greater admiration. Afterward, when he had left the service of
> Ascanio, he wandered about Rome for several months without having
> any particular patron, most of the time tagging along with me like a
> brother.[20]

Like his perverted Petrarchan sonnets and his *strambotti*, Serafino's bu-colic is long on cleverness and short on reverence – for the poetic form, for conventional poetic content, or for living masters of the poetic art – not to mention for Cardinal Ascanio. The shepherd protagonist of this offending eclogue, Menander, sounds far more like the Leporello of *Don Giovanni* in his "nott' e giorno faticar" than like the good, and ponder-ously serious, neo-Virgilian Arcadians who populated the contemporary bucolics of Jacopo Sannazaro, Pietro Corsi, or Fausto Capodiferro:

> Who could survive all these cabals and ambuscades
> In helplessness like this, in such servility.
> In such hypocrisy, in such petty escapades
> I've spent my life, my youth, and my senility.
> In snow, and rain, in beating sun's brutality,
> You'd say that I'd been born in Ethiopia.[21]

A still more provocative sally followed shortly thereafter from the mouth of a fellow shepherd:

> These patrons, fat on blood from other folk,
> Should tumble into some enormous ditch.

> The higher they stand, the farther down they'll pitch,
> Like Carthage, once so lofty and so rich,
> Or high and mighty Troy, gone up in smoke.[22]

Calmeta's narration makes clear, nonetheless, that the eclogue, hilariously clever, had no effect whatsoever on Serafino's position within Cardinal Ascanio's official family. (Perhaps the lean prelate felt immune from the charge of fattening on others' blood.) In order to leave the cardinal's service, the outrageous *strambottista* finally had to quit of his own volition. He quickly learned that a career outside the patronage system could be still more brutal than a career within it. Living on and off the streets, Serafino was stabbed in the throat by a thug in the service of the dissolute Franceschetto Cibò (the same Franceschetto whose gambling loss supplied a down payment for the palazzo of Raffaele Riario):

> And having found out by experience that the prelates of Rome were more likely to offer a benign ear to hear his compositions than a compassionate hand to help him with his needs, he decided to try his luck again in service. And reconciled once again with Cardinal Ascanio he returned to his service, where, with greater respect and improved conditions, he was given enough to live on with honor.[23]

No less restless than before, Serafino spent the remainder of his life moving from city to city throughout central and northern Italy, but always under the protection of one patron or another. Calmeta's biography provides a sharply observed portrait of a true free spirit, rebellious in every respect, from his unprepossessing physical appearance to his subversive art:

> Serafino was of less than average height, with limbs more robust than delicate, and although he was somewhat large-boned, he was not only strong but also more agile than one might have expected. His hair was black, long, and worn loose; his skin brown in color. His eyes were black and lively, and everything he did was filled with his enthusiasm. In his jokes, witticisms, and clever sayings he was charming, but more likely to be licentious than urbane. He was so avid for popular acclaim that he applied his talents to everything that might draw the admiration of the crowds. He performed various memory games with cards and names, played ball, and other activities which, no less than his compositions, made him celebrated and famous among the populace. In performing his poems he was so passionate, and intertwined words and

music with such perception, that he moved the very souls of his listeners, no matter whether they were learned, or middle-class, or plebeian, or women. Although he competed with many poets, he was never of a suspicious nature, or argumentative. In company, he was extremely affable, despite the fact that he had some boorish habits, more by nature than by design. In his dress, because of his limited means and his natural laziness, he went about for a time in a wretched state; nonetheless, such was his success that this abject appearance was attributed by the populace to a philosophical choice rather than to his laziness. Toward the end, when his ambition and his fame increased, and he had better means to do so, he applied himself to better grooming and better dress. Love was also a potent reason for this. His poems never had a particular beloved as their object, because everywhere he went he found a lover rather than paying rent for lodging. In eating, he was not temperate; in fact he was rather greedy . . . All his thoughts went to having a great name and acclaim in his lifetime, even if his reputation were to live only among the middle and lower classes. In achieving this he had remarkable success.[24]

When he died in Rome of a quartan fever in 1500, Serafino was buried in great pomp in the Church of Santa Maria del Popolo, his funeral expenses underwritten by Agostino Chigi, then only a promising banker who boasted close connections with Serafino's last patron, Cesare Borgia.[25] Four years later, an anthology of poems in Latin, vernacular, and Greek commemorated this "illiterate" musician's popularity among the "literate" elite of Italy.[26]

As a cultural phenomenon, Serafino had aimed his appeal to a broad audience and found it receptive – sometimes, as in the case of Cardinal Ascanio, in spite of itself. Both his appeal to a wider public and his demand for respect were to become increasingly important forces in the cultural life of sixteenth-century Rome. After his death, he would find one of his staunchest advocates in a very different kind of man – the courtly scholar Angelo Colocci.

The humanists who flocked to Serafino's funeral and published a booklet of poems in his praise reflected the growing importance within their own circle of vernacular literature – as well as their emerging awareness of the power of print. One of Serafino's favorite Roman haunts had been the cultural circle that met in the house of the prelate Paolo Cortesi, where *strambotti* were soon to become as standard an entertainment as learned exercises in neo-Latin. Calmeta's biography suddenly shifts its

tone when it passes from the down-to-earth Serafino, whom we meet again on his return from the trip to Milan, to Cortesi's august salon: his style becomes downright pompous:

> [Serafino] returned to Rome together with the cardinal, and when he visited his usual companions he not only seemed like a new man but had brought back a new way of singing, and the *strambotti*, lofted on high, afforded him no small admiration throughout Rome. Also in Rome, in those days, our Academy flourished in the house of Paolo Cortesi, a young man held in high regard in court for his learning, his noble birth, and his affability; in fact, you could have called it not a house, but a workshop of eloquence, or a receptacle of every outstanding virtue. Every day a great multitude of lofty spirits assembled there: the Venetian Gianlorenzo Pietrogravina, bishop of Montepiloso, Agapyto Gerardino, Manillo, Cornelio, and many other learned men, in whose shadow others, younger in age, who nonetheless desired to embrace the virtues, gathered to spend time and enjoy themselves. Among the vernacular poets the "ardors" of Bernardo [Accolti] Aretino were held in highest regard – nor were our own little snatches held in small esteem. Now Serafino, who had more contact with me than with any other living person, decided to frequent this academy, which was the cause of no small delight to that most august consortium. Soon he took part in the demanding contests of those other *litterati*, thanks to the harmony of his music and the acuity of his *strambotti*.[27]

However, aristocratic humanist patrons like Cortesi were not the only important force in the development of vernacular lyric, nor, in fact, of neo-Latin lyric. In his letter to Niccolò Machiavelli of July 16, 1501, the young Florentine humanist Agostino Vespucci specified that his friend Raffaello Pulci performed for wealthy merchants:

> Raffaello Pulci . . . is enjoying himself with the Muses. He often recites impromptu poems in the gardens of these great masters and merchants . . . Pulcio is enjoying himself, and he is always in the company of four prostitutes along with Sante Londiano . . . Now said Raffaello confirms that in having to while away the hours in gardens among the ladies and others like himself who "rouse the silent muse" with their lyre, they delight each other and have their fun. But, good God, what meals they eat, from what I hear, and how much wine they guzzle after they've played the poet! . . . They have players of various instruments, and with those ladies they dance and leap like the Salii – or, I should say, like Bacchants. I'm jealous of them, champing at my chain

here in my room, which is right under the roof, hot, and often plays host to a tarantula or two. I'm dying of the heat, and can hardly stand this summer.[28]

Agostino Chigi was one such merchant host, and by sponsoring Serafino's funeral, he clearly hoped to assert himself as an important patron of vernacular in its new heyday. Because of his own connections with Cesare Borgia, Serafino's last sponsor, Chigi had probably had the opportunity to employ the singer when alive as well as honoring him after his death. The ambitious banker also maintained connections with Paolo Cortesi's circle through his chamberlain, Cornelio Benigno, that same "Cornelio" whom Calmeta lists among Cortesi's friends, and a man who, like Chigi's notary Cristofano Pagni and the aristocratic factotum Fausto Capodiferro, had to accommodate his humanist undertakings to the work of making a living day-to-day.

THE VERNACULAR PRESS

At the same time, among the younger men who gathered at Paolo Cortesi's house to "embrace the virtues," Angelo Colocci, who shared that Academy's passion for vernacular literature, began to envision what might happen if such literature went to press.

Colocci's first known venture into the editorial world dates from 1498, when he underwrote and edited an anthology called *Bombyx* by the vernacular poet Lodovico Lazzarelli.[29] In 1503, however, he began what looks like a concerted publishing campaign. He began, significantly, with an anthology of Serafino Aquilano's lyrics, prefaced by a long "Apologia" in which he asserted the poet's claim to be considered an artist of the first rank.[30] At the same time, the "Apologia" also served as a preface to Colocci's own activity as an editor during the next few years: by January 1510 he had brought out a total of seven editions of vernacular verse.[31]

In some cases these editions seem to pay homage to old friends, but Colocci's intent in publishing Serafino was far more ambitious. He saw the poet's lightning career as proof of an emerging new standard for vernacular literature and argued forcefully that such literature could not begin and end with Dante and Petrarch, or with their medieval discretion

Those people who are always looking for the knot in the reed protest . . . that he has made little effort to imitate Petrarch or Dante Alighieri

. . . I shall say only this: it is neither a safe nor a good thing always to step in other people's footprints.

He seems to fall a good deal beneath the lofty level of Petrarch, and this happens because, when he wanted to ease the description of love's anxieties – just as he displays the emotions more openly – then those feelings that Petrarch kept closed in his fist he preferred to extend in the palm of his hand. Nor can we claim that from time to time swollen veins and overly taut nerves do not appear on the surface – but he said he made up for them by charm.[32]

The point of Serafino's new style, Colocci insisted, was its unprecedented capacity to unlock the emotions through a combination of words and music – unprecedented, at least, in modern times; it was a capacity he dignified with the word *modo*, a method that, presumably, others might follow. The ancients, he was certain, had known all about this kind of expressivity:

[Critics] will grant [Serafino] a unique style of diction, but he tried to harmonize the words with the lute in order to impress them more deeply on the souls of the audience, to inflame them at one moment and release them at another, just the way Gracchus used his lyre to the same effect at sessions of the Senate. I predict that just as Terpander will never lack for praise for having joined his voice to the music of his lyre, or Dardanus to that of the pipes, so Serafino is to be celebrated more than anyone else before him for giving us a way [*modo*] both to express the passions of love in verse and to impress [them on our hearers].[33]

Serafino also came in for criticism from "the ranks of the stupid" and "puerile intellects," Colocci reported, because he sang of lofty matters to women. The "Apologia" argues instead that these subjects are thoroughly appropriate for "women of rare discernment" (*raro iudicio*):

They say, still more stubbornly, that it was inappropriate for a lutenist not only to have spoken of natural phenomena but also to have raised his consideration toward matters of destiny and of fate, singing about these matters in the hearing of women. Virgil's Iopas and the other bards of antiquity will refute that objection on his behalf, for they sang to Queen Dido about the course of the stars, the labors of the sun and the moon, not to mention our own Serafino, who offered his words

to women of rare discernment; it was no effort for him to make his words delightful to ladies and to gentlemen.[34]

From the little we know about her, Colocci's wife Girolama Bufalini had the kind of lively intelligence that "raro iudicio" implies.[35] The humanist himself was among those who acknowledged the importance of women to the development of language and literature; he listed as important contributors to vernacular the kings of France, who "wrote in their native idiom, sonnets in our Masses, hymns, the lullabies of women from my region, entertainment at banquets, comedies, farces, sacred representations; wet nurses in their cradle songs and lullabies sing these things, mothers, women's prayers."[36]

Power to communicate was one fundamental element in the aesthetic creed that Angelo Colocci laid out in his "Apologia" for Serafino Aquilano. The other essential, equally evident in the passage just quoted, was synthesis, as in Serafino's exploration of the common musical ground between voice and lute and, more radically, between spoken word and musical note. The same search for synthesis, Colocci suggested in his "Apologia," governed Serafino's relationship with his predecessors. The same critics who accused the poet of failing to imitate Dante and Petrarch sufficiently

> will reply that in various places he has imitated now one and now the other, to which we'll say that he has chosen expert guides . . . To these sorts of objections we shall only cite that saying of Afranius, the writer of historical tragedies; when some suggested that he had borrowed liberally from the comic poet Menander, he answered, "I confess without a tremor of shame to having borrowed not only from Menander, but indeed from all the Greeks and Romans who have said anything useful to my purpose, or have said it better than I could myself." I persuade myself, then, that an example such as this should suffice to excuse those flowers which our Serafino has plucked from various gardens to create his garland, just as Virgil, too, and countless other writers have brought forth their copious vintage from more than one cluster of grapes.[37]

Colocci believed that a similar synthetic process was occurring in his own time with the very form of the Italian language. It had grown up from the ruins of the Roman empire; with the courtly lyrics of the troubadours, with Dante and Petrarch, it had come fully into its own:

As the Roman empire faltered and the Christian faith rose up and grew stronger, the poets who believed in Christ were the first who began to give form to lyric poetry in Latin and vernacular with their holy hymns, with their prayers, with their moral songs, and in their footsteps the noble knights and amorous ladies, with practice, made such a beginning that one hopes soon to be able to outdo both the Greeks and the Latins.[38]

Colocci also felt strongly that the qualities of Latin and vernacular differed starkly: "psalms, the Mass, the Office, and laws are not put into vernacular because they lose their force without brevity and majesty."[39] By the same token, "We who compose in the common language of Italy seek to imitate not Latin but the common language."[40] However deeply the *Hypnerotomachia Poliphili* impressed him with its antiquarian visions, he must have felt that its ponderously Latinate Italian failed where Serafino's outrageous *strambotti* succeeded, in bringing people together.

Angelo Colocci's editorial efforts embodied his vision of what he called a "common" vernacular, one that would encompass the dialects of the entire peninsula rather than the single, if influential, region of Tuscany. Serafino Aquilano, born in the Abruzzi and educated in Naples, provided him with a superb example of this new language, which he termed *lingua cortigiana*, "the language of the courts," emotive, expressive, and universal.

To Colocci's mind, moreover, the center of development for this new, distinctly non-Tuscan *lingua cortigiana* could not be Florence. It could only, in fact, be Rome, the home of the universal Church and a magnet for new ideas of every type. In one of his earliest personal notebooks (more accurately a scratch pad), he wrote,

Dante [writes] about a common courtly language. Say that today it is more apparent what that common language is, because it is the language of the Roman Curia. And I say that what is common to all of Sicily is what is spoken by those who frequent the courts of Ferdinand and Frederick. In the Venetian region the common language is that which is celebrated in Venice, or Ferrara, or Mantua. The common language of the Lombards is that of Milan. But the common language in Rome is composed of all of these, where there is the universal Curia, or, if you like, from these individual courts a single universal court has come into being among learned men, whose consensus has become the common spoken language.[41]

As his remarks show, Angelo Colocci sensed, better than many of his contemporaries, that there was more in the making in papal Rome than

a new version of spoken Italian, or even of Italian sung to music. The city was beginning to generate a comprehensive new aesthetic sense. For at the same time, largely through the efforts of another versatile *strambottista*, the painter and architect Donato Bramante (1444–1514), a similar effort toward creating a "common language composed of all of these" was occurring in the visual arts.

"MR. PERSPECTIVE": THE CASE OF DONATO BRAMANTE

Like Serafino, Bramante, born in Urbino (not far from Angelo Colocci's Iesi), sprang to artistic maturity in Milan. Like Serafino, too, he exerted immense influence on his contemporaries without any proficiency in Latin. His linguistic limitations did not apply, however, to the formal language of art; from the beginning, he absorbed his visual surroundings – ancient, medieval, and modern – with an analytical eye. Just as Serafino understood on a profound level what the relationship should be between words and music, so Bramante penetrated the mysteries of classical art, learning how to communicate substance along with style.

Like Serafino, too, Bramante was instrumental in effecting change on a social level. As we have noted, artists, like musicians, were generally considered craftsmen; the original guild affiliation of painters, for example, had been with the pharmacists. The great architect Brunelleschi trained as a goldsmith and continued to belong to the goldsmiths' guild. Like craftsmen's work, the work of artists and architects was secured by notarized contract, usually for no great price. At the same time, however, these putative craftsmen were charged with producing intricately allusive pictorial versions of mythological and religious themes; Pinturicchio's work for the Borgia Apartments provides an example on the highest end of the scale. Bramante was among those who insisted that artists too had the humanists' gift for intellectual penetration. He did this more by his stately example than by special pleading.

The first indication of Bramante's presence in Rome may well be an anonymous vernacular poem, *Roman Antiquities in Perspective* (Le Antiquarie prospettiche romane), published in Rome as a cheap four-page booklet sometime between 1499 and 1500.[42] Dedicated to Leonardo da Vinci, the poem is a more sophisticated work than it seems to be at first. On the surface its anonymous author, "Prospettico melanese depictore" (Mr. Perspective, a painter from Milan), presents himself as a kind of city

bumpkin who has composed a guidebook to the wonders of Rome in an awkward version of *terza rima*, the poetic meter of Dante's *Divine Comedy*. With an opening hymn to Apollo and divine wisdom, he states his purpose, rather too cleverly for a real rube:

> O hidden power of virtue intellective,
>> Supply these arid lips with irrigation;
>> Deep-seated justice, help Mr. Perspective,
> In order that I give some recreation
>> To those who put their faith in nature's strictures
>> And do my part to spread Rome's reputation,
> Her sacred temples, sculpted stones, and pictures –
>> Some pagan, every one a ruination,
>> To make the very walls weep with compassion.[43]

Mr. Perspective thus promises to provide comedy more comic and less divine than that of his illustrious predecessor. Passing through Rome along the traditional pilgrim routes, he notes the sights to be seen, ancient and modern, with a special emphasis on antique works of art. Finally, with sketch pad and picnic basket, he ventures deep into the "grottoes" formed by the subterranean ruins of Nero's Golden House, where the fanciful remains of ancient painting had given rise to a new tourist attraction and a new term, *grottesche* (grotesques):

> There's not a heart so hard it's not bewailing
>> The spacious halls, the broken walls and bodies
>> Of Rome, once so triumphantly prevailing –
> They all are caverns now, and crumbling grottoes
>> Of stucco, bas-reliefs, and sometimes painting –
>> The work of Cimabue, Apelles, Giotto,
> They're full of artists now in every season . . .
> We crawl along the dirt upon our bellies
>> With bread, prosciutto, apples, and some *vino*,
>> Becoming more bizarre than the *grottesche*.
> Our faithful guide is one Master Pinzino,
>> Who makes us black our eyes and bump our faces,
>> Poking like chimney sweeps in hidden places.[44]

The ironic self-awareness of this description, like that of several other passages, suggests a considerably finer mind at work than the pamphlet's bumptious verses and outrageous rhymes care to let on. For example, a new word, *ventresche*, has been coined to rhyme with *grottesche*. Perhaps,

however, the jocular Bramante has left a conspicuous clue to his author-ship. Addressing Leonardo, Mr. Perspective says:

> To you, my heart's most pleasant bosom buddy,
> Dear Vinci, don't believe that it's from sin
> Of laziness I've time to write and study –
> I'm soaked in leisure right through to my skin.[45]

concluding that he longs more avidly to see his brilliant Florentine friend again than he longs to see the very day of Resurrection: "che *bramo* vederte più che 'l giuditio" (emphasis added). *Bramo* (I long) is not an uncommon verb, but it is a strong one; it carries overtones of ravenous appetite or passionate wishfulness, and it is the verb of which *bramante* is the participle. Certainly the word's placement at the beginning of the poem is striking. In any case, "Bramante" was an appropriate nickname for the new arrival in Rome, even if he had inherited it from his father – he harbored a ravenous genius, but only Rome would eventually reveal its full scope.

The personal circumstances of Mr. Perspective about 1500, "soaked in leisure right through to my skin," also sound a good deal like those of Bramante at the turn of the century, at least according to that diligent mid–sixteenth century biographer of artists, Giorgio Vasari:

> Having brought a certain amount of money with him from Milan and earned more doing a few works in Rome, [Bramante] spent it with great economy, wanting to live by his own means without having to take on work, in order to measure all the ancient buildings of Rome at his leisure. And once he had applied himself to the project, he wan-dered around the city alone, lost in his thoughts, and in not much time he measured all the buildings there were in that city and out in the countryside, and he did the same as far south as Naples, and anywhere else he knew that there were ancient buildings. He measured what was to be seen at Tivoli and at Hadrian's Villa, and, as we shall recount shortly, he reaped great benefit from having done so.[46]

The woodcut frontispiece to the *Antiquarie prospettiche romane* (Fig. 18), no less tongue in cheek than the text, is a mock-heroic portrait of a naked, billiard-ball–bald Mr. Perspective drawing figures on the ground with his compass while holding aloft an armillary sphere in front of the Colosseum and a second columned building, possibly the Temple of Antoninus and Faustina in the Roman Forum.[47] This combination of attributes fits well with the character sketch of Bramante by a sixteenth-century memoirist,

Sabba Castiglione, who describes him as "a man of great talent, a cosmographer, vernacular poet, an excellent painter, . . . a pupil of Mantegna, and a great perspective artist, . . . a protégé of Piero della Francesca."[48]

The pose itself was be quoted closely several years later in a painting by Bramante's distant relative and close protégé Raphael, whose *School of Athens* depicts the great geometer Euclid, appropriately enough, as an ancient *prospectivo*, compass once again spread on the ground, knee once again bent dramatically, the armillary sphere evoked by a starry globe in the hand of a nearby astronomer. Raphael's figure has sometimes been identified as a portrait of Bramante himself.[49]

The *Antiquarie prospettiche romane* was not the work of a retiring soul nor of a craftsman resigned to keeping his subordinate place in the social hierarchy. Like Serafino's barbed *strambotti*, it was after something that had not quite existed before. When thoroughgoing humanists like Angelo Colocci took to the vigorous defense of the likes of Serafino and experimented themselves with the power of the printing press, the very emphasis of humanism seemed to be shifting from the revival of ancient Rome among a handful of highly educated friends to a new set of aesthetic standards – *modi e ordini* – for the culture at large. But there was more involved in Bramante's own creative activity than a shift in the nature of humanism. His mentor Piero della Francesca, his friend Leonardo da Vinci, and such varied personalities in Rome as Angelo Colocci and Agostino Chigi all recognized the importance of an area of thought that lay well outside the purview of humanism: astronomy, mathematics, and technology: the culture of the abacus.

Chapter Five

Tabulation

Deus enim immensus.

For God is beyond measure.

<div style="text-align: right">Angelo Colocci (Vat. Lat. 3906, 42v)</div>

Natura duce et examinatione comite.

With nature as leader and inquiry as companion.

<div style="text-align: right">Angelo Colocci, paraphrasing Cicero
(Vat. Lat. 3904, 154r, 306r)</div>

FIBONACCI (LEONARDO DA PISA, 12TH–13TH C.)

The humanist movement arose in Italy at a time when the growth of merchant capitalism had already brought about significant changes in the medieval social fabric. Landed lords had watched the growth of a new merchant class, whose members had settled together in towns where the lords were less and less welcome. As Italian traders scattered throughout the Mediterranean, they and their native cities grew increasingly wealthy and powerful, and increasingly inclined toward republican self-government. By the twelfth century, maritime republics like Pisa, Genoa, Amalfi, and Venice launched immense fleets of merchant ships; inland cities like Florence and Siena throve on overland trade and kept careful watch on outlets to the coast. For the proudly self-made citizens of these capitalist communes, a revived interest in Greek and Roman antiquity provided an alternative set of values to the feudal ideals of courtly chivalry. Thus, long before Petrarch, the merchant class in many Italian city-states

had adopted Cicero and the Roman Republic as models for behavior, morals, governmental philosophy, and stylish living.[1]

At the same time, an equally important development was gradually taking place in these merchants' economic lives. It had begun in 1202, when a Pisan merchant named Leonardo, son of Bonaccio Fibonacci, wrote a Latin treatise about methods of computation that he had seen in use among his Arab colleagues during his long stay on the coast of Algeria at the Pisan outpost of Bougea.[2] He called his work "Liber abaci" (Book of the Abacus) despite the fact that it was really about something else: a new kind of numeration (the numerals 1 through 9) that he himself called "the nine figures of the Indians."[3] There was a tenth figure, too, the zero, which he called "zemenias," and it was that apparent nullity that made all the difference. Roman numerals per se expressed only a rough relationship between the value of a numeral and its place, whereas sequence was of crucial significance. There is a one's column of sorts in numbers like xvi and xviii, and an important difference between xl and lx, but the value of Roman numerals is not absolutely related either to the place or to the actual number of digits but rather to their order.

Roman numerals (like the Etruscan numerals from which they developed and the Greek numerals that also used letters to denote the digits) were difficult to use for rapid calculation, and for this reason these ancient Mediterranean civilizations developed a quick calculating device divided into columns that denoted powers of ten. At its simplest, the device was a sand-covered board (*abax*, in Greek; hence *abacus* in Latin) with pebble counters (*calces*, in Latin; hence "calculation"); elaborate wooden and bronze models with decorated tokens later became fashionable.[4] A skilled operator could work an abacus with immense speed; Hindu-Arabic numerals offered no improvement over that. What they offered from the first, however, was greater consistency between the columnar system of the abacus and the form of the written numbers in which records were kept.[5]

In 1228, a thoroughly revised version of Fibonacci's "Liber abaci" increased the work's accessibility to merchant readers. Nonetheless, the new system took full hold only after several centuries of transition; merchants have always combined their taste for enterprise with a healthy dose of conservative caution. Europe's definitive shift to Hindu-Arabic numeration occurred only in the sixteenth century; a German woodcut of Lady Arithmetic from 1517 makes it clear that she was associated both with written computations and with the counting board (Fig. 19).[6] In

Italy too, where Fibonacci's compatriots had changed over fairly quickly to the nine figures of the Indians, a late fifteenth-century merchant could still sketch himself equipped with a counting stick as well as a slate bearing a series of Hindu-Arabic calculations (Fig. 20).[7]

The information presented in Fibonacci's treatise was largely practical; after instructing his readers in the nine figures and *zemenias*, he devoted the rest of its fifteen books to exercises drawn from the kind of situations his readers might actually face. The sequence of story problems is exhaustive, for it is designed to anticipate every possible set of circumstances in the mercantile life: from calculating areas and volumes (including the geometry involved), it moves on to the more complex operations of loading ships, bartering one commodity for another (e.g., "Trading Pepper for Ginger"), buying on time, buying in partnership (e.g., "Three men form a company," "Four men form a company"), or calculating exchange rates, as when "Three gentlemen from Genoa find a Byzantine gentleman's purse."

However, Fibonacci also endowed his work with a strong theoretical framework. The fifteenth book of the "Liber abaci" addresses algebra with a sophistication that was to go unchallenged in Italy until the end of the fifteenth century.[8] The famous numerical series that now bears his name (1, 1, 2, 3, 5, 8, . . . : each successive number is the sum of the two preceding numbers) appears in a story problem about breeding rabbits. It is difficult to decide how much Fibonacci himself was aware of the extent to which this series recurs in nature, as it does, for example, in the compartments of the nautilus shell or in the centers of daisies, but few historians of mathematics deny him at least the benefit of the doubt.[9] What emerges without controversy from the "rabbit problem" is Fibonacci the gifted teacher:

HOW MANY PAIRS OF RABBITS WILL BE BRED IN ONE YEAR FROM ONE PAIR

In order to find out how many pairs of rabbits would be bred in a year, a certain person put a pair of rabbits in a certain place which was surrounded on all sides by a wall. The nature of the rabbits was such that they produced another pair every month; these would breed in the second month from their own birth. Because the first pair bred in the first month, doubling itself, there will be two pairs within one month. Of these, one pair, the original, breeds in the second month, and thus at the end of the second month there are three pairs. Of these, two become pregnant in the next month and breed two pairs of rabbits

in the third month, and thus there will be five pairs by the end of that same month. . . . [Leonardo proceeds through the sequence 8, 13, 21, 34, 55, 89, 144, 233, 377.] For you can see here in the margin [the manuscript supplies the sequence in the left margin of the page] how we performed the operation: we joined the first number to the second, that is, 1 to 2, and the second to the third, and the third to the fourth, and the fourth to the fifth, and so on, until we join the tenth to the eleventh, that is 144 to 233, and we will have the sum of the rabbits, that is, 377, and you can proceed by the same order to an infinite number of months.[10]

With its Latin prose and hefty bulk, Leonardo da Pisa's "Liber abaci" was designed to function as an encyclopedia rather than a handbook, and it was also designed (successfully) to become a classic.[11] Until the sixteenth century, it remained the standard text on mathematics, and the initials "L.P." were enough to identify "Leonardus Pisanus," just as "The Philosopher" could only mean Aristotle.

The "Liber abaci" was written in a style meant to be of value to scholars as well as to professionals; it appealed, that is, to the privileged few who had been educated at the university or by private tutors, but also to that much larger group of merchants who lived by their correspondence and by their skill in arithmetic and geometry. Italian merchant communes were already beginning to develop specialized schools (some private, some endowed at public expense) where they could train their children in the mercantile arts.[12] These institutions were called "abacus schools" (*scuole di abbaco*), and at one point early in their history they must in fact have taught students how to use the abacus. Thanks to the steady incursion of the nine figures of the Indians, however, the word *abbaco* eventually came to mean "calculation" in a more generalized sense, the equivalent of " 'rithmetic" in the proverbial three R's of elementary education in English.[13] From a fair number of still-preserved textbooks, we can see that fifteenth-century students of *abbaco* learned elementary Euclidean geometry and the four arithmetical operations; long division was considered especially difficult. They also learned the "rule of three," the usual method for calculating exchange rates; it involved setting up proportions among three terms to determine the value of a fourth.[14]

ALGORISM AND *ABBACO*

In addition, the advent in Italy of the Hindu-Arabic numerals brought with it a market for two new kinds of mathematical treatises, both based

on Arab models: the university-level theoretical texts called "algorisms" (after the eighth-century Arab mathematician al-Khwarizmi, author of an early example of such a treatise) and "abacus books," *libri di abbaco* (also known simply as *abbaci*). Because algorisms were aimed at a university population, they were written in Latin and provided only theoretical principles rather than exercises and problems.[15] They normally ran to about ten pages in length.

Abbaci, by contrast, were practical manuals. Their structure and content generally followed the precedent, if not the scale, of Leonardo da Pisa's "Liber abaci," itself based upon Arab models. Because they aimed at a merchant clientele more than the lettered elite, *abbaci* were usually written in vernacular, and for the same reason they were filled with various kinds of problems and tables. They averaged about a hundred pages in length. Fibonacci's "Liber abaci," especially in its last chapter on algebra, contains enough theoretical material to qualify as an algorism, though it also contains an abundance of the practical information that made its title the generic name for these more modest successors.

Most of these other *libri di abbaco* were humble in their scope and were not composed for wide dissemination; they were often created for individuals, whether by a client, a relative, or a professional book dealer. As a result, their collections of story problems retain a great deal of circumstantial detail about the author's (and the customer's) immediate milieu; they probably have more value now as social documents than they do for their mathematical content.[16] Many of these extant *abbaci* are too well crafted and survive in too good a condition to have been used by schoolboys. Their relatively fine execution and their method of presenting problems together with their solutions suggest rather that they may have served fledgling merchants as reference works about various kinds of problem solving rather than serving as textbooks for the abacus schools.[17] Nonetheless, these little volumes cover the subjects taught in the *scuola di abbaco*, and this means that most of them deal with elementary Euclidean geometry as well as numbers.[18] Other *abbaci* show the depredations of their young owners all too well; there is no question that a battered text like Angelo Colocci's modest fifteenth-century *abbaco*, Vat. Lat. 4829, with its marginalia and practice penmanship, had done time at hard labor in abacus school before it entered the humanist's collection (Fig. 21).

Libri di abbaco reached their peak of production in the fifteenth century; the great majority seem to have been written in Tuscany, especially Florence, where they seem to have become a special tradition among that

city's merchant class.[19] Like other forms of Florentine literature – the advice books known as *ricordanze*, in particular – they seem to have been addressed to young men by their elders, the rough equivalent of the watches and dictionaries given to more modern graduates as a badge of induction into adulthood.[20]

The fifteenth century also bred an increasing interest in pure mathematics, and not only on the part of active merchants. Both artists and humanists could also speak the language of geometry and numbers, and as early as 1435 Leone Battista Alberti's vernacular essay *Della pittura* made certain that both groups had immediate access to the perspective geometry invented a few years earlier by Filippo Brunelleschi. Like humanism, *prospettiva* developed into a philosophy of aesthetics as well as a series of techniques. It was to become as integral to fifteenth-century visual life as the revival of antiquity, if not more so. As a result, *prospettiva* also promoted the intellectual stature of cerebral artists like Andrea Mantegna, Piero della Francesca, and Leonardo da Vinci, not to mention that tongue-in-cheek character "Prospettico Melanese depictore," whom we encountered in Chapter 4.[21]

FRA LUCA PACIOLI (D. CA. 1514)

The widespread interest in mathematics and perspective also created the niche for a late fifteenth-century personage who was to have a great influence on Angelo Colocci (among many others), Fra Luca Pacioli. We know Fra Luca best from his remarkable portrait by Jacopo de' Barbari in the Capodimonte Museum in Naples (Fig. 22).[22] The gray-clad monk stands at his desk, pointing with his compasses at an open book. His ethereal thoughts may be guessed at from the delicacy of the glass-and-wire polyhedron suspended to his right.[23] To his left a young aristocrat, probably a student (or perhaps the artist), looks out at the viewer in marked contrast to the raptly abstracted gaze of Pacioli himself. A thick, closed quarto volume, inscribed "Li[ber] R[everendi] Luc[ae] Burg[ensis]" in Roman capitals and positioned to Pacioli's left, is almost certainly a copy of his important work, the *Summa de arithmetica* of 1494.[24] Fra Luca points with his left hand to another text that lies open. With his right hand, he fixes a pointer upon a figure drawn in chalk upon a slate. This writing tablet is labeled "Euclides" in Roman capitals, and, as Margaret Daly Davis first pointed out, the text of the open book is by Euclid too. In fact, Pacioli (surely on his own suggestion) has been portrayed as

if he were in the midst of a lesson from book 13 of Euclid's *Elements*, where the Greek geometer describes how to inscribe an equilateral triangle within a circle.[25] The printed Euclid is open not only to this problem but to a theorem involving the golden section, the subject of Pacioli's next ambitious book.[26] The painting emphasizes Pacioli's skill as a teacher,[27] while the selection of texts surrounding him implies his familiarity with Greek geometry, Latin letters, and the problems of *abbaco* – in short, with every aspect of mathematics, the theoretical as well as the practical, the lofty reaches of the Greek and Latin authors as well as the Italian vernacular culture for which he composed many of his works.

In 1480, or thereabout, Pacioli composed his own version of a *libro di abbaco*, the "Opera de arithmetica." A manuscript version of the work, probably copied shortly after the composition of the original text, is preserved in the Vatican Library (Vat. Lat. 3129, Fig. 23). Typically, the language of this comparatively long abacus book is vernacular, and although its scribe was apparently a Franciscan monk (of Pacioli's own order), the friar's hand is a mercantile cursive. Like any other *abbaco*, Pacioli's "Opera" treats such practical matters as exchange rates, triangulation, weights and measures, percentages, and calculating shares in companies, and it does so in the characteristic script of the merchant class. Pacioli makes calculations exclusively in Hindu-Arabic numerals, with exhaustive emphasis on the usual challenges of his own day: long division, the rule of three, and the computation of areas and volumes. He and his contemporaries could manage second-degree or quadratic equations (formulas involving squares and square roots) with some facility, but for all practical purposes cubic equations remained beyond the capabilities of his mathematics.

The "Opera di arithmetica" was only a beginning for Fra Luca Pacioli; his real ambitions were revealed in a treatise on the scale of Fibonacci's "Liber abaci"; entitled *Summa de arithmetica, geometria, proportioni et proportionalità*, it went to press in Venice in 1494.[28] The *Summa*, as its name implies, was designed to be an encyclopedia of mathematics, immense in its ambition and its bulk. Along with his own work, Pacioli engulfed in the volume, without acknowledgment, two works by other authors. One was the set of geometric problems from an unpublished "Trattato di abaco" by Fra Luca's own teacher, Piero della Francesca, whose skill at geometry and draftsmanship was unsurpassed. (Fra Luca did, however, streamline Piero's prose.)[29] The second was Giorgio Chiarini's handy reference table of fifteenth-century tariffs for Italian traders.[30]

Pacioli was also a shrewd marketer; in order to make his tome attractive to merchant customers as well as the Latin-educated *litterati*, he wrote it in vernacular. But he did not talk down to his readers. The most advanced merchants of the late fifteenth century had moved inexorably from simple calculation into the domain of Hindu-Arabic algebras, and one of the significant contributions of Pacioli's book was its discussion not only of second-degree equations (involving squares and square roots) but also cubes, cube roots, biquadratic equations, and even fifth-degree equations, not to mention the sophisticated geometries he had "borrowed" from his mentor Piero.

At the same time, however, Pacioli's *Summa* addressed subjects dear to the humanists' tradition: geometry (a subject also treated occasionally by ambitious *libri di abbaco*), perspective, and proportion. In order to attract a humanistically educated reading public as well as learned merchants, Pacioli outfitted the printed editions of his works with his own Latin prefaces and Latin rubrics that added a certain classicizing tone to the vernacular text. Again, his instincts were unerring. Higher mathematics based on the computational techniques and the algebras developed by the *abbaco* tradition had developed its cachet within the educated class (termed by the Florentine biographer Antonio Manetti "good men" [*uomini da bene*]), and the market opened by Luca Pacioli's *Summa* at the end of the fifteenth century was well prepared for Gerolamo Cardano's mathematical books by the middle of the sixteenth.[31]

ABBACO AND HUMANISM

Angelo Colocci was among those humanists for whom Luca Pacioli's *Summa* was a profoundly influential work.[32] His own abiding interest in *abbaco* can still be seen from his personal library, whose volumes on "abacus" range from well-thrashed textbooks to elegant showpieces, including some strange hybrids of classical learning and merchant bravura. One of the small works in his collection, for example, shows at firsthand how an enterprising merchant might keep up his Latin: it is an undated *abbaco*, probably composed in Rome in the late fifteenth century (or early sixteenth), by the Florentine merchant Papinio Cavalcanti (Fig. 24).[33] In its mathematical content, the pamphlet cannot be distinguished from any other work on *abbaco*. Its Latin text, however, is a rarity within the genre, and Cavalcanti explains at the end of his brief treatise why he has chosen

to write in this language rather than the vernacular.[34] He is a merchant just beyond the stage of apprenticeship – still, in his own words, an adolescent – and for all his life he has longed to study Latin. He has managed to find time to learn the language outside his duties in the firm and would like to keep up his mastery of the language, despite the charges of presumption he might conceivably incur:

> Let us put an end to these first lessons, and let it be a fortunate and happy one. Yet a bit of fear arises lest a place be seen for this book among learned and eloquent men, especially because we have not yet come to the finish of our fourth year of study, and I dare, as the adolescent I am, to treat mathematical disciplines that Latin scholars ought to treat, and also because for this reason we may have introduced words that will seem utterly barbarous . . . Shortly after I had left Florence for here, and before, such a desire to learn Roman letters had come over me that I dedicated my efforts to that discipline for three years. During that time I have been in business, the last two years with my father, and the first two with Paolo Massimi, a fellow citizen. . . .[35]

Transcribed in an elegant humanistic hand, which may be Cavalcanti's own, the book bespeaks that time of transition when merchants like Agostino Chigi and merchants' children like Girolamo Ghinucci were rising to the pinnacle of Roman society. Cavalcanti testifies with disarming immediacy to the pull that Rome's monuments and ancient traditions exerted on them as well as on the humanists among whom they worked.

At the same time, mathematics and the natural world attracted the interest of those whose training lay more explicitly in the realm of Latin letters. In the following verse description of a Roman garden party (held sometime between 1512 and 1524), we overhear Angelo Colocci and his friends holding forth on what the poem's author, a visiting German humanist who had adopted the Latin name "Caius Silvanus," can only call "the order of things" (ordo rerum), a rubric so broad that it seems to include Bible study, incarnation theology, astronomy, meteorology, surveying, and geometry. The remarkable feature of this gathering is the breadth of interest that the assembled litterati show in the sciences, or what they themselves might have called "natural philosophy." It is a pronounced change from the literary regime of the Roman Academy under Pomponio Leto and Paolo Cortesi, a change for which Colocci himself bore significant responsibility. Of the scholars whose character sketches make

up the poem, Colocci most resembles the last mentioned, the man who determines "distances between the borders of cities":

> Happy, the crowd of experts comes together,
> Sprinkling light and elegant conversation
> With addresses that show their depth of learning.
> Tables heaped with food stand in lengthy series
> As they calm their parching thirst with Lyaeus
> Previously mixed with Albula's waters [i.e., wine diluted with
> Tiber water]
> Hunger they subdue with the help of Ceres [bread],
> As each one tells tales worthy of his station.
> There the deathless sacred band of the choir
> Sings sweet measures to the tune of the lyre;
> Nor will bolts of lightning or passing seasons
> Ever mar them with the rot of the ages.
> This one, passed beyond the orbs of Olympus
> In his thoughts, discloses the sacred Scriptures,
> He reveals the reasons why this world's Author
> Wanted to take on a human appearance.
> Here another speaks of the starry orbits:
> How, because of their dizzying rotation,
> Moon, the glory of shadowed night, meets Phoebus'
> Rays and gleams with brotherly fire forever,
> Through what intervals she works out her phases,
> And the signs by which she heralds the weather,
> Rain, clear skies, or winds that rage through the ether.
> Next the extent of level earth is considered,
> Distances between the borders of cities,
> And the extent of land and ocean's circumference.
> Forth they bring the deepest secrets of Nature;
> Each discourses in turn on natural order [*de rerum ordine*]
> With what learning – Jupiter! – yet how clearly.[36]

These were people, in other words, for whom a Luca Pacioli, a Leonardo da Vinci, or a Bramante had a definite, and considerable, value.

ANGELO COLOCCI ON MEASURE, NUMBER, AND WEIGHT

Roman contemporaries of Caius Silvanus would have been well aware that Angelo Colocci's interest in the world of mathematics took a highly

specific turn. In the spirit of Pomponio Leto's Roman Academy and originally, perhaps, under its auspices, he had taken on an antiquarian project, the study of ancient weights and measures. On the surface, it may have looked like an undertaking roughly equivalent to Bartolommeo Platina's *Lives of the Popes*, Leto's own revision of the *Scriptores historiae Augustae*, or especially Raffaele Maffei's *Commentaria Urbana* – that is, an ambitious, time-consuming project that was destined to result in at least one impressive tome where Colocci's mastery of Latin would shine forth in all its glory. Furthermore, the enterprise allowed Colocci to buy antiquities selectively, tailoring his collection to a specific purpose.

There was only one drawback to the scheme, and that was Colocci's own nature. Broadly curious and an irrepressible enthusiast, he simply could not concentrate on the ancient world with Leto's singlemindedness; he persisted in thinking about his own. He expanded his project to include weights and measures in the modern world, drafting repeated outlines and assembling vast troves of woefully disorganized notes. After fifty years of research, he had drafted an outline, reproduced here (Fig. 25 and Table 1), as well as the skeleton of a preface and part of a chapter on geography, all the while earning an international reputation for his expertise on the length of the Roman foot.[37] A lifetime of learned parties, editing, publishing, and curial duties had taken their toll. Nonetheless, these surviving fragments of a lifetime's work reveal a great deal about their author and about an intellectual world that ranged well outside the bounds of humanism.

Angelo Colocci himself recalled that he began his project when he started to collect ancient weights. Made of basalt or bronze, these antiquities were small, unattractive, and therefore cheap. As a young humanist beginning his career in Rome, he could buy nearly as many as he wanted, and by learning how they worked he could come just as close to the physical world of the ancients as any collector of coins, statues, columns, or inscriptions. By restoring meaning to these ancient weights, moreover, he gave them new value, just as elder scholars of his day, like Pomponio Leto and the Dominican monk Fra Giocondo, had greatly enhanced the value – and the inherent interest – of ancient inscriptions, thanks to their collecting and research a decade or two before. Local junk vendors must have learned to recognize Angelo Colocci and his peculiar tastes, as the following tale drawn from part of his skeleton preface suggests:

Table 1. (cont.)

Priscian[9] Numbers from epitaphs

Fra Luca
Problems Number of cities
 Number of peoples
 Number of stars
 Number of every single thing

III. Weight
 1. The *siliqua*[10]
 2. Medicine
 3. Roman revenue taxes, tribute, census
 4. Contemporary revenues
 5. Conversion of units of weight from antiquity to contemporary units
 6. The difficulties with weights; when you draw lighter currency, when
 heavier, what falls under the heading of weights, what of measures
 7. Contemporary tariffs, including conversion tables
The corollary of the work and grammar

[1] Measurement of distances was called *podismus* (a term that presupposes measuring in feet), and finding a credible dimension for the Roman foot was Colocci's chief claim to antiquarian fame. His sources were the archaeological collection we have already considered and the treatise "De podismo" by the second-century A.D. *agrimensor* Marcus Junius Nipsus, of which Colocci had several copies, including Vat. Lat. 3132, 3893, 3894, 3895, 4498, 5237, 5394.

[2] Colocci's source for this section would have been his fine collection of copies of the *Corpus agrimensorum*, once including the Codex Arcerianus now in Wolfenbüttel.

[3] The basic sources were Frontinus, "De aqueductis" (copy in Vat. Lat. 4498), Vitruvius, *De architectura*, and personal observation.

[3] By *elementa*, Colocci means the Ptolemaic *climata*, our "latitudes." This part of the treatise had been substantially completed as his essay "De elementorum situ," Vat. Lat. 3353, 268r–289r, with notes on 289v.

[5] The notes for this section of the treatise are probably those drawn from Ptolemy and preserved in Vat. Lat. 3353, 290r–297r, with notes on 297r–298r.

[6] The source for these dimensions was "Publius Victor"; one copy is preserved in Vat. Lat. 3353, 312v–314v. For Colocci's studies of Publius Victor, see Chapter 7 of the present volume.

[7] "De mensura orbis terrae" is the name of an anonymous treatise preserved in Vat. Lat. 3353, 349r–370r.

[8] See Vat. Lat. 4807 and 4811 for copies of Portulanus, "De navigantibus."

[9] A sixth-century Latin grammarian, author of the "Institutiones grammaticae," who also wrote a treatise called "De figuris numerorum," dedicated to the consul Symmachus (cos. 485). The reference here is clearly to the latter work.

[10] A basic unit of weight, equal to one-sixth of a scruple and one-twenty-fourth of a *solidus*.

At the beginning I wondered what kind of stones those might be that religious people displayed on altars or as votive offerings. In the first place, they were nearly all of one color, as if they were from the same stone, and their hardness was immense. There were chains and hooks in some, and I could easily surmise that this was some sort of instrument devised for measuring or some other purpose.

I also saw many stones of this kind in tailors' shops, in the houses of nobles and of weavers, which Roman workers use in place of a cylinder to iron what has been sewn together when one piece of fabric is sewn to another, for they are, as I said, extremely hard and polished carefully and precisely. I observed that they were not only similar in color but also in shape, for all of them are absolutely round except for what is removed from the top and bottom, which is enough for them to rest on either surface.

Drawn onward by this same curiosity, I chose some that seemed to be of approximately equal size, and when they had been hung on a balance I discovered that they were equal in dimension and weight. When I tested more and more [stones], I found that they were instruments used for weighing things.

On some Q.AQVIL. was inscribed, on others L. TITIVS. "Hey, look at this," a certain dealer in antiquities said to me. "Hey, mister" (for he knew that I investigated antiquities and was a buyer), "Do you want to buy this ball of brass?" I bought it gladly, and on its upper surface were inscribed two silver letters, that is, A.A. Immediately I got the idea that this might weigh 1 pound, and having examined my other stone weights, ounces and pounds, I discovered that it was a standard pound, and immediately I cried out in the words of Archimedes, "I've got it! I've got it!" [i.e. "Eureka!"]

Made all the more enthusiastic because of this, I scoured nearly the entire city shopping for stones, sparing neither labor nor expense. I weighed all the ones that were in churches, and nearly all of them corresponded in some ratio to my smallest weights and to my middle-sized ones.[38]

The outline of Colocci's book, reproduced here in Figure 25, probably was written in the 1530s, when he had greatly expanded the scope of his researches, but elsewhere he says that he worked at it especially hard during the reign of Leo X (1513–21).[39] This outline shows that his basic organizing principle came straight from the Bible, from a passage in the apocryphal book called the Wisdom of Solomon that he and his contemporaries loved to quote. Addressing God, the passage declares, "omnia mensura et numero et pondere disposuisti" (You have set out everything

in terms of measure and number and weight) (*Wisdom* 11:21).[40] The same passage gave Colocci the title for his uncompleted masterwork, *On Measures, Numbers, and Weights* (De Meusuris, numeris et ponderibus). The pervasive presence of Wisdom 11:21 in the humanist's researches shows that by pursuing the study of weights and measures Angelo Colocci had really set about discovering how God had organized the world, and so he admits in one of his many notes to himself: "For Heaven and the elements and all the things contained in them have measure, number, and weight. We investigate many of these things broadly in order to derive some sort of formula about them, just as it pleased my Romans to do."[41]

Colocci's driving purpose had two important repercussions on the direction of his work. First of all, in considering number, he had to reconcile his interest in *abbaco* and mathematics with a radically different strain in contemporary mathematical thought, although it was one that had found special favor among the humanists. This was numerology, a discipline that focused its attention upon the intrinsic characteristics of numbers, such as their names, their factors, and a whole series of putative individual qualities, and which had particular vogue among the Christian Neoplatonists who followed in the wake of Marsilio Ficino.

NUMBER

Numerology had a strong ancient pedigree, one that the ancient Greeks and Romans themselves traced back to Pythagoras in the sixth century B.C., and that Pythagoras allegedly traced back to the Egyptians. Certainly, ancient mathematics had always regarded the names of the numbers with particular interest; Greek mathematicians also classified integers in geometric terms, as squares, triangles, and the like, as well as assigning each of them some particular personality.[42] In some medieval arithmetics, this legacy persisted so strongly that the Arabic names of the integers and the numerals themselves were simply regarded as further numerological properties rather than as practical tools for calculation.

Angelo Colocci recorded an example of this peculiar medieval legacy in his notes, a mnemonic verse apparently composed in the twelfth century by Gerardus of Cremona, a Toledo-based Dominican who translated a remarkable amount of Arabic scholarly work into Latin.[43] To help his students commit the Hindu-Arabic numerals, their essential qualities, and their visual forms to memory, Gerardus devised a set of Latin hexameter

verses about the numbers, each preceded by its Hindu-Arabic cipher. (In the meantime, ironically, both he and they continued to make their calculations in Roman numerals with the help of the abacus.) The origin of the medieval names that attached themselves to the numbers is still a mystery. These names also varied widely among different authors; Gerardus, for example, supplies two alternative names for 9.[44] Still, Colocci himself thought Gerardus's information of sufficient importance that he copied the verse in his own hand:

1. *Igin* takes up its name in the primeval order,
2. Look, soon *Andras* arrives to vindicate second place.
3. After these numbers then *Ormis* is first and still a prime.
4. *Arbas*, following next, stands for 2 times 2.
5. *Quimas* stands for 5, and so its name was created
 [the name sounds like its Latin equivalent, *quinque*];
6. *Calcus*, holding sixth place, exults in its perfect gift
 [six was the Pythagoreans' perfect number];
7. *Zemis* glitters in state, beaming in sevenfold honor,
8. *Themenias* a single order expressing the blest
 [8 was the traditional number of the Resurrection].
9. Then follows *Sipos equi*, otherwise called "the wheel."
9. Three times *Celentis* beats out the rhythm of 3 in its name.[45]

Gerardus of Cremona was a contemporary of Leonardo Fibonacci; in their shared passion to transmit the wisdom of the Arabs to the Latin-speaking world, both men show how irresistible the attraction of Islamic civilization had become to the intellectual and the mercantile life of medieval Europe. The same people who recited mystical mnemonics about the nine figures of the Indians would come to use those nine signs for computation, gradually supplanting numerology with *abbaco* and supplanting *abbaco* in turn with symbolic algebra and higher mathematics.[46] The process was a gradual one, and by the time of Angelo Colocci it was still far from complete.[47]

Among Colocci's own manuscripts, the most conspicuous backward step in the transition from numerology to calculation is a treatise on number entitled "De numeris," composed sometime before 1527 (probably between 1510 and 1520) by the humanist Marco Fabio Calvo of Ravenna (Fig. 26). Calvo was a close friend of Colocci's, and, like many of Colocci's friends, was a pronounced eccentric. As a habitué of the Apostolic Court and the Vatican Library, he professed a great interest in science, and indeed he is best known for his translations of two ancient

works with significant scientific content, his Latin translation from the Greek of Hippocrates was printed in 1521, and at the behest of Raphael he drafted a vernacular version of *De architectura*, by the ancient Roman architectural writer Vitruvius, around 1516.[48]

Calvo shared Angelo Colocci's interest in number, weights, and measures. To his Hippocrates, he appended a translation (again from Greek to Latin) of an essay on weights and measures composed by a Late Antique medical writer named Africanus, an essay that Angelo Colocci cites in his notes with great interest. Calvo's own interest in science, however, seems to have remained rooted in the Greco-Roman past. His treatise "De numeris," written in Latin, covers the same ground as an *abbaco*, but rather than following in the wake of Fibonacci and the Arabs, it teaches its readers to perform arithmetical operations by means of Roman numerals and the specialized ancient symbols for weights and measures – in other words, it revives the modes of calculation that had been out of style for generations among financiers like the Chigi, Spannocchi, and Ghinucci. True to the rest of its backward-looking contents, "De numeris" further leavens its text with a healthy dose of Platonic numerology. Either Calvo wrote this odd unpublished work to aid Colocci's researches on his collection of ancient weights and measures, or he wrote it in a spirit that was flatly anachronistic. He was capable of either.

Calvo's mathematical anachronism was not the only such exercise to emerge from the curial court. He and many of his fellow humanists in Rome were still more intently engaged in ever more trenchant attempts to conform the Vatican's official language to the Latin of Cicero, erasing all the vocabularies and usage that had evolved over the subsequent centuries. Calvo himself took a close interest in this ongoing debate over the standards for Latin style, becoming one of the most tenacious champions of strict Republican purity. He grew especially punctilious – not to say odd – about his orthography; he boasted, for example, that not a single word in his immense translation of Hippocrates ended with the letter *d*, since he believed that Cicero's Latin too had opted for *aput* rather than *apud*, *at* rather than *ad*. It is not surprising, under the circumstances, that his work on numbers, like his operations on the Latin language, pursued the quixotic aim of restoring wholesale the mathematics of the ancients. Calvo and his deliberate reversion to the past represented an extreme form of humanist antiquarianism, one for which Colocci himself harbored little real sympathy (though he and Raphael kept watch on the old man's personal welfare). Yet the very fact that Colocci's own projected treatise

on number, weights, and measures quickly changed its focus from the ancient world to a general overview shows that, like such contemporaries as Luca Pacioli, Leonardo da Vinci, or Donato Bramante, he intended to deal with the world as it was.

In the meantime Colocci had also absorbed lessons on Platonic numerology from Marsilio Ficino's chief acolyte in Rome, the Augustinian preacher Egidio da Viterbo, who had adopted the Florentine model of Neoplatonic thought with infectious enthusiasm. In his sermons, his writings, and his private conversation, the charismatic Egidio was a walking font of number lore; he grew so obsessed with the Holy Trinity that he chose for himself a coat of arms with three crosses, and it is not surprising that Colocci's notes cite him as an expert on the number 3.[49] At the same time, like Colocci, Egidio da Viterbo could live quite comfortably in the contemporary world while he engaged in these abstruse speculations about theology or about the ancients. His Neoplatonism, as Chapter 6 will show, was always, in its own way, firmly rooted in the here and now.

ANGELO COLOCCI ON THE CREATION

The second problem Colocci set himself by expanding the scope of his treatise on weights and measures was a more involved one. By deliberately taking on the subject of God's organization of the world, he recognized that he had entered into the realm of theology. He therefore decided at some point to dedicate a second treatise to the larger religious considerations brought up by his study of number, weights, and measures. He intended to call his second treatise, which never developed beyond the barest outlines, "On the World's Creator" (De opifice mundi).[50]

In this work Colocci planned to testify to his deep religious faith through an analysis of the way in which God had imparted order to the creation – how, that is, a single omnipotent deity had come to organize a complex world in terms of measure, number, and weight. Shifting back and forth between dogma and quantitative data, he thus combined what we might recognize as a scientific attitude toward the phenomena of nature with an equally strong belief in the divine mandate of the institutional Church. Far from being a callous careerist, Colocci reveals that he undertook his duties in the Curia with real devotion, and that he undertook his life of study in the same reverent spirit: "Iamblichus [the Neoplatonic philosopher] says that our minds move in measure and harmony, and that human nature inclines toward knowledge and contem-

plation. I say that human nature is not only a beholder of the divine creation but a contemplator."[51]

The spirit that moved Nicolaus Copernicus (1473–1543) to formulate his heliocentric system was not very different. Only a year older than Colocci, he too had been educated in Italy, and conceivably their paths may have crossed in Rome in 1511. The Polish mathematician and the humanist from Iesi shared many attitudes, including their unquestioning Christian faith, their belief that the natural world showed the orderly hand of God, and their rhetorical mode of thinking and writing.[52] Copernicus's treatise *On the Orbits* (De revolutionibus), justified the position of the sun at the center of his system in terms that Colocci would have found eminently suitable (although he might have been less pleased by Copernicus's conclusion):

> In the middle of all sits Sun enthroned. In this most beautiful temple could we place this luminary in any better position from which he can illuminate the whole at once? He is rightly called the Lamp, the Mind, the Ruler of the Universe; Hermes Trismegistus names him the visible God, Sophocles' Electra calls him the All-Seeing. So the Sun sits as upon a royal throne ruling his children, the planets, which circle about him.[53]

At heart, however, Copernicus was always a mathematician, and his revolutionary ideas about the structure of the cosmos sprang from his calculations of planetary motion. His work, whatever its own defects, points up the extent to which Colocci's scientific researches always remained those of a dilettante, for the Italian scholar was far more acutely attuned to words than numbers. Angelo Colocci's notes, with their nearly total absence of calculations, show that his interest in mathematics stayed at the level of superficial enthusiasm, and so, as a result, did his forays into cosmology.

In those brief jottings where Colocci seems to have assembled the premises for his treatise on the Creator, he first sought his answers in the words of the ancients rather than in empirical data. (Copernicus, by contrast, presumably used Hermes Trismegistus and Sophocles to back up his calculations.) Colocci's projected title, "De opifice mundi," paraphrased the title of an ancient work, *De opificio mundi* (On the creation of the world), composed by Philo of Alexandria in the first century A.D. and recently translated into Latin for the Vatican Library. Not only did Colocci's title deliberately echo a newly fashionable ancient text but it also raised some knotty old philosophical questions, for by using the word

mundus to denote the world, he had chosen a loaded term for the title of his study. On a basic level, *mundus* was the Latin translation for the Greek *kosmos*, but in the early sixteenth century the nature of that cosmos was very much up for debate. In particular, neither his contemporaries nor the ancients had ever managed to agree on whether this "world" was the same thing as the "universe" (*universum*) or only a part of it.

Most natural philosophers taught that the universe was made up of matter and the void; the problem was to decide whether the world was exclusively material – and therefore distinct from the void, and hence only one component part of the universe – or whether the void was itself a part of the world. Was there one world, or were there many in the universe? Were the world and the universe finite or infinite?

In his notes, Colocci listed those ancient philosophers who had maintained that the world and the universe were one finite whole and those who asserted instead that the world was only one small part of an infinite universe, to conclude that for him at least the world and the universe were one and the same:

MYSELF ON THE WORLD

Pythagoras was first to call the assemblage of all things "the world [*kosmos*], for which reason it is no surprise that he perceived in it the elegance of things and their *management* [both meanings of *kosmos* in Greek].

Thales and his followers agreed that the *world was one.*

Democritus, Epicurus, and *Metrodorus* and their students [said that there were] innumerable worlds in an infinity which through its whole complex spread outward into immensity.

Empedocles said that the orbit of the sun was the boundary of the world, and that this was the [dividing] line of its circumference.

Seleucus said that the world could not be bounded.

Diogenes that the universe could not be bounded, but the world was finite.

The Stoics say that everything-that-exists [*omnia existentia*] is not the same as the universe. *Everything* means the infinite plus the void [*inane*]. The universe lacks the void.

The world therefore is one, and the universe and the world are the same.[54]

On the basis of his view that the universe and the world are one and the same, Colocci could then assert that the Creator he intended to honor in his treatise was truly the Creator of the universe, a creation "set out

in terms of number, measure, and weight." To Colocci's mind, therefore, Scripture taught unequivocally that the universe was both finite and measurable.

THE MEASURABLE UNIVERSE

Colocci found confirmation that the universe is measurable in the writings of that very Philo of Alexandria to whom his study was to have paid homage. As a Jew, resident in the cosmopolitan Egypt of Roman times, Philo was steeped in Platonic numerology as well as Jewish letter mysticism and felt no qualms about trying to link the two together. His work on the Creation took the form of a line-by-line commentary on the Book of Genesis that attempted to harmonize Plato's thought with Philo's own Hebrew tradition. In a clear if mannered Greek, he therefore eagerly assimilated the geometry and numerology of the creation myth in Plato's *Timaeus* with the seven days of the biblical Creation, to conclude that Egyptian-bred Moses was the supreme Platonic philosopher. This kind of eclecticism typified the early days of the Roman empire in its attempt to unify its vast diversity of languages, customs, and peoples.[55] It is the same strain of eclectic thought that we see in the writings of Philo's contemporary Saint Paul, and despite doctrinal differences Philo continued to be much cited by the early Fathers of the Christian Church, Jerome and Ambrose in particular.

Fifteenth-century Italy, as the Borgia Apartments attest, was fertile soil for Philo's type of syncretic thought. Beginning in 1478, Pope Sixtus IV had sponsored a Latin translation of Philo's complete works to make them more widely available to readers in the Vatican Library; "De opificio mundi," part of volume 2, was ready in 1481.[56]

Oddly enough, however, for all his emphasis on mystic gnosis and perfect numbers, Philo's chief effect on Colocci was anything but mystical; instead, Colocci used the Alexandrian philosopher to reinforce his own contention that, in theory at least, one should be able to measure the divine universe:

PHILO SAYS: GOD IS INTELLIGIBLE AND INCORPOREAL, INDE-PENDENT OF ALL NUMBERS.

I say, following Philo:

And if His parts are corporeal and body [i.e., matter] *is measurable or falls under the category of measure*, then the universe, particularly be-

cause it is the greatest body of all bodies, and because in a former time it carried the sum of all other bodies in its womb as if they were its own, for this very fact it [the universe] has to be divine, and we can arrive at measuring it if we progress from small units to the measurement of the world.[57]

One wonders what Philo would have made of it all.

Colocci found further support for his finite and measurable universe in another Genesis commentary, the *Genesis Letter by Letter* (De Genesi ad litteram) of Saint Augustine, where a substantial passage, devoted to the close consideration of Wisdom 11:21, concludes that all of the creation, and hence the universe, possesses quantity (and hence cannot be infinite): "He disposed all things in terms of number, measure, weight"; Augustine says, "that is, all things which He made have number, weight, and measure."[58] In one of his notebooks, Colocci interspersed long citations from this section of *De Genesi* with his own comments, as in the following passage, where he focuses his thoughts on the ancient Romans: "I say that therefore the heavens and the elements and all things that are in them have measure, number, and weight. About these we have tried to produce a kind of formula, like my Romans."[59] Elsewhere in his notes, Colocci makes a still more specific claim that the universe is finite. Again, he is addressing reminders to himself as he plans one of his prefaces:

> Say that all things are finite and measurable, except the maker of the world. For all things are bounded by measure or by soul except for God. For God is immense [that is, "God is beyond measure"].
> But according to the Stoics, out of admiration for His works, we ought to measure God. Therefore one must begin like this: from the measure of the globe and other things which are in it, and from them we will know just how immense God is.[60]

It was perhaps inevitable that a man who aimed at taking the measure of God eventually turned his thoughts to quantifying other sorts of apparent intangibles in the terms laid out by the Bible. If the universe possessed measure, it should also possess weight. Fortified by this scriptural certainty, Colocci wrote: "I say that Heaven is weightless once it has been emptied of the gods" and "Dreams have weight, and so do portents of the future."[61]

For so devout a Christian as Colocci to be referring to "the gods" sounds like the outright paganism that was once attributed to the hu-

manists by piously indignant nineteenth-century scholars, but in fact the usage has both its biblical basis and its place in Renaissance intellectual history. Colocci had been an attentive reader of Marsilio Ficino, whose Neoplatonic writings freely referred to the divine minds that helped to govern the universe as "the gods." Colocci, like most of Ficino's other contemporaries, simply understood him to mean the angels. Indeed Egidio da Viterbo, who was both Colocci's friend and Ficino's protégé, made the far bolder assertion that the gods of the ancient world had been guardian angels at work in the service of *prisca theologia*.[62] Inasmuch as they were creations of God, Colocci logically concluded that the divine minds or angels must also possess number, measure, and weight in their own right. Nor was he alone in his belief. It is no accident that a Scholastic treatise, Giles of Rome's "On the Measure of the Angels" (De mensura angelorum), went to press in the early sixteenth century.[63]

This was the same world of belief in which Copernicus published his revision of the cosmos, *De revolutionibus*, which appeared late in Colocci's lifetime (1543). Furthermore, Copernicus surely exemplifies exactly the kind of intelligent, educated, progressive reader that Colocci would have had in mind for his great study of numbers, weights, and measures, as well as for his work on the maker of the universe. Colocci understood the publishing business well enough to recognize the potential represented by the printed book. He nourished great respect for the readers who bought the thousand-page folio edition of Raffaele Maffei's *Commentaria Urbana*, the scarcely smaller heft of Luca Pacioli's *Summa de arithmetica*, and the Nuremberg physician Hartmann Schedel's monumental universal history of 1493, the *Liber chronicarum* (usually known now as the Nuremberg Chronicle).[64] In 1503, for the same well-heeled and universally curious readers, Gregor Reisch prepared the first of many editions of his encyclopedia *Margarita philosophica* intending, as he stated in his preface, to supply the professional man with quick access to every branch of knowledge.[65] In France, the royal secretary Guillaume Budé had set to work on his own monumental study of weights and measures, inspired by one of Angelo Colocci's own mentors, the Dominican monk Fra Giocondo da Verona – monk, architect, and superb classical scholar.

Budé's *De asse* (On the pound), first published by the Parisian printer Josse Bade (Iodocus Badius) in 1516, probably best represents the kind of work Colocci must have been hoping one day to produce, with one

salient difference. Budé was a scholar first and foremost, who studied and wrote for the love of learning.[66] Angelo Colocci, by contrast, clearly intended to use his writings to bear witness to his Christian faith, mustering his own equivalent of Budé's encyclopedic breadth to argue a cogent case for the preordination of the Church in the scheme of creation. It was Colocci, not Budé, who wrote that the ancient Greek unit of measure the *orguia*, or fathom (the measure, fingertip to fingertip, of a human armspread), was an image of the Crucifixion: "You tell [again Colocci reminds himself] how Christ our Lord spread wide his arms so that he would create a broader unit of measure with his outstretched hands."[67] This apostolic zeal is one indication of the depth to which Rome's rhetorical culture and its emphasis on the triumphant restoration of her ancient splendors, the *instauratio Romae*, had penetrated the thinking of the people who, like Colocci, spent their lives working for the popes. This mighty evangelizing purpose may also, of course, have been one of the factors involved in guaranteeing that Colocci's masterwork remained only a sketch whereas Budé's compendium, a proven success in Paris, showed up in 1522 on the list of the house of Aldus Manutius, not quite a quarter century after their publication of the *Hypnerotomachia Poliphili*.

Colocci looked wistfully on Budé's international success, knowing that he had only himself to blame for not achieving something similar. Furthermore, he knew that he could always have put out a smaller study, like the little handbook on weights and measures, *De sestertio*, published by the busy Venetian businessman Leonardo da Porto in 1511. Yet another passage in Colocci's skeleton preface muses, probably about 1520: "For these twenty years I have tried, with the help of my enthusiasm, to publish something for the common good, because I have spent more of my time, if the truth be known, on proving the soundness of my first principles than on writing the book." "Two extremely learned men wrote after me, as is known to nearly all Romans and Italians, but each of them published their volumes before I did, first L. Portius and later Budaeus."[68] There was one area of endeavor, however, for which Colocci and his inchoate masterwork did receive international recognition, notably in the works of da Porto and Budé: his research on the Roman foot. To this successful investigation he brought all his training as a humanist in the analysis of Latin literature, his knowledge of mathematics, and his instincts as a collector.

THE ROMAN FOOT

In Colocci's own day, probably thanks to the cloth trade, the foot had
largely been replaced by longer units of measure; whether that unit it-
self was literally called an "arm" (*braccio*), as it was in Florence and Ven-
ice, or an "ell," as in Flanders, or a "reed" (*canna*), as in Rome, its
length ranged from that of a human forearm to our modern rod.[69] The
foot and its multiples, the "pace" and the "mile" (from *mille passuum* [a
thousand paces]) persisted, however, in Italian place names like Quarto
Miglio (Fourth Mile) or Sesto (Sixth) Fiorentino, settlements that had
grown up alongside the milestones that marked off the proverbial roads
that led to Rome. Some of those ancient Roman milestones can still be
seen standing in the twentieth century; there were many more to be
seen in the fifteenth and sixteenth. Furthermore, foot rulers were
sometimes sculpted on the gravestones of ancient Roman architects.
Colocci himself eventually made a specialty of collecting these and re-
lated images. The most impressive piece in his collection was the
gravestone of the architect Agathangelus, now gathered with several
other pieces from Colocci's garden in a special room at the Capitoline
Museum in Rome: "Among my monuments in the garden by the
Aqua Virgo there was the funeral monument of Agathangelus the ar-
chitect, and in the stone on its left side were carved architects' tools,
and there was also a 1-foot measure."[70]

Colocci had one of his servants make a copy of this measure and test
its length against that of various Roman monuments. The most impor-
tant of these, in his opinion, was an unfinished ancient column that had
been preserved in the Lateran Palace with a mason's mark intact; he
had guessed earlier that the mark inscribed on its surface signified a 10-
foot column. His discovery that the foot of Agathangelus indeed
proved to be one-tenth the length of the Lateran column brought him
double gratification. Not only had his guess about the mason's mark
proven correct, but also, more touchingly, he had learned that Aga-
thangelus, an architect to the marrow, had carefully commissioned a
gravestone with a full-scale working image of the foot ruler by which
he had made his living (Fig. 27). In all of Colocci's studies, his sense of
personal contact with the ancients was vividly immediate – not always
the case with some of his pedantic colleagues. (Calvo springs immedi-
ately to mind.)

Colocci acquired a second relief image of a foot ruler around 1514, thanks to the sharp eye of Fra Giocondo:

> And because Giocondo, the monk of Verona, alerted me that in the Piazza Giudea on the façade of the most humble sort of barbershop there was a stone which he regarded as certainly of the same dimensions [as the foot on the Agathangelus tomb]. Well, more swiftly than light I had bought that stone at a pretty price and discovered it to be equal to the tool of Agathangelus. Once again I cried the cry of Archimedes, "Eureka! Eureka!"[71]

In the flyleaf of a mathematical book that he eventually inherited from Fra Giocondo, Colocci once again recalled his purchase of this relief from the barbershop in the Jewish quarter (not yet the Ghetto), still gloating: "A stone above the door of a barbershop in the region of Arenula in one of the smaller piazzas came my way, and among [my stones] there was not only a correspondence among all the units I have mentioned but [on this one] there were also palms, digits, half digits, square and round measures represented."[72]

Still, despite an equivalence within a few millimeters of one another, neither of these sculpted foot measures nor the dimensions Colocci could derive from other monuments (like the column in the Lateran Palace) were precisely equal to any other; the two reliefs, after all, were funerary images rather than actual surveying tools, and most of the other evidence showed certain signs of age. But long before he had any idea that there might be an archaeological record to deal with, Colocci had begun to chase down the dimensions of the Roman foot from literary evidence, especially from the collection of ancient Roman surveying treatises that has been called the *Surveyor's Anthology* (Corpus agrimensorum) ever since Late Antiquity. Colocci himself simply called this collection *the Surveyors* (Agrimensores). In its present state, the *Corpus* seems to have been largely assembled sometime in the fourth century A.D., with additions inserted right up to the time of the oldest preserved manuscripts, which date from the early sixth century. The writers whose works it includes seem mostly to have worked for the imperial service in the second and third centuries, A.D., approximately from the time of the emperor Hadrian, under whose reign the Roman empire reached its greatest physical extent, to the age of the Severans, when vast cities like Timgad and Lepcis Magna were still being laid out according to Roman standards of urban planning.

THE *CORPUS AGRIMENSORUM* AND THE
ANCIENT ART OF SURVEYING

These professional surveyors used the Roman foot to lay out the plans of cities, to calculate the distances between towns, and to establish the boundaries of provinces. They computed the areas of terrain ranging from the flats of the Nile Delta to the craggy Alps and Apennines. Because of the intricate technical content they were intended to transmit to posterity, their treatises were illustrated, and the illustrations were passed down along with the texts by medieval copyists, usually with considerable care. Scholars now believe that in effect these drawings have been passed down to us directly from antiquity.[73] Angelo Colocci thought so as well.

Among his extensive collection of manuscripts containing these surveying texts, one manuscript stood out, a sixth-century Italian parchment book that still holds pride of place as the oldest known copy of the *Agrimensores*.[74] Colocci acquired this book thanks to the sharp eyes of his friend Fedro Inghirami, who, in the course of a trip to Milan and Vigevano in 1496, had spotted it in the monastery of Bobbio near Pavia and had it spirited to Rome sometime before 1506.[75] Now known as the "Codex Arcerianus" (after a seventeenth-century owner, Johannes Arcerius), the book was destined to pass as well through the hands of Erasmus before it reached its present resting place in Wolfenbüttel.[76]

The manuscript itself is written in broad uncial letters and is filled with color illustrations of boundary stones, properties, cities, roads, rivers, and swamps, as well as diagrams of the cosmos. The areas to be surveyed are shown in plan from a bird's-eye view, so that their dimensions can be reproduced accurately. Mountains, cities, buildings, and boundary stones, by contrast, are shown receding into space according to the technique that Vitruvius called "scene drawing" (*scaenographia*). This *scaenographia* is not the one-point perspective of the fifteenth and sixteenth centuries but rather the Roman technique of varying viewpoints. Likewise, swamps and seas are shown in plan, but the creatures that live within them are shown upright, sometimes in schematic elevation and sometimes with the modeling of *scaenographia*. The vignettes of cities, in particular, would have reminded Colocci and his friends of the similar schematic images of cities that they could see on ancient Roman coins, derived, evidently, from the same set of ancient Roman artistic conventions.[77]

In addition to what he called his "ancient codex" (*codex antiquissimus*),

Colocci also collected other manuscripts of the surveyors' texts, including copies he ordered made from old-looking manuscripts in Germany and Venice (Fig. 28).[78] He assumed, like modern classical scholars, that because these older codices were closer in time to the original Roman papyrus scrolls of the text they must also have suffered from fewer errors by copyists.

These *Agrimensores* appealed to Colocci's background in *abbaco* as well as to his humanist training. Like the writers of abacus texts, they combined a certain theoretical sophistication with practical utility. Without the help of Arab mathematics, they had evolved techniques for measuring the areas of complicated shapes or up-and-down topography, problems related to the geometric exercises set by Piero della Francesca and Luca Pacioli in the latter's *Summa de arithmetica*. Colocci himself was quite interested, at least in theory, in problems that combined geometry and calculation in this way. Bound in with one copy of the *Agrimensores* is an unpublished fifteenth- or early sixteenth-century treatise on perspective for painters by one Girolamo Sechadinari; its title, "On Painterly Perspective" (De prospectiva pingendi), is identical to the one chosen for a similar unpublished work by Piero della Francesca.[79]

Of all the surveyors, Colocci seems to have reserved special interest for the work of the second-century writer Marcus Junius Nipsus, whose contribution to the anthology has to do with techniques for measuring linear distance. *Podismus* (footing) is the ancient writer's term for this activity, and the treatise is accordingly called "On Footing" (De podismo).[80] Successful *podismus* depended, of course, upon adopting an accurate value for the foot, and with the help of Nipsus, Angelo Colocci hoped to derive a value for the Roman foot that would harmonize perfectly with the placement of the Roman milestones whose positions he knew in the countryside around the city.

He also badgered his friends about what Caius Silvanus's poem had called "measuring distances between the borders of cities." When Colocci remarks, in the following passage from his notes, that he and his friends "fell into a conversation about the universe and how it is divided up," one suspects that they "fell" only after a certain amount of pushing from their host:

> When we were in Rome in my Sallustian gardens and concentrating on dinner, we fell into a conversation about the universe and how it is divided up, and according to what scheme our ancestors had divided the globe and measured it out in miles and *stades*. Then F. threw a

scruple in among all of us: What was the *order* of the *stade* that both the Greeks and the Latins used, and by which they measured out length? And everyone affirmed that a *stade* legitimately consisted of 1,000 paces, a pace of [the manuscript is blank] feet, yet everyone expressed doubt about what the measure of the foot might be and how many digits, how many cubits, how many palms.[81]

By virtue of its tangible, practical content and its oddly vivid illustrations, the *Surveyors* afforded something very close to a direct link with the ancient Roman world; readers of the surviving manuscripts could almost see the world through ancient Roman eyes. As a trained humanist, Colocci could also sympathize directly with these surveyors' rhetorical approach to writing about their trade. In the high-flown prefaces that were ancient Rome's mark of "serious" work, the *Agrimensores* traced a direct link between their science of measurement and the very place of human society within the structure of the universe. Diligent civil servants, to a man, they assigned pride of place within this cosmic structure to the Roman empire in whose name they carried out their duties. Nor was antiquarian lore out of place; the surveyor known as "Hyginus Gromaticus" traced his art back to the Etruscans and their practices of divination, proving that theirs was a native Italic art rather than an invention of the Egyptians or the Greeks: "Among all the rites or acts of measurement, the establishment of borders is handed down as the preeminent, for it has a heavenly origin and a perpetual continuity . . . for boundaries are established on the same principles as the world, inasmuch as the main streets [*decumani*] are oriented along the course of the sun and the cross streets [*cardines*] along the polar axis."[82]

Another surveyor, Agennius Urbicus, put his work "On Property Disputes" (De controversiis agrorum) into a similarly grand cosmic structure:

When asked what property is and where it is, we are brought back to the order of the world and to its parts. Now the world, as the Stoics have decided, is understood to be one, but its nature and size are left up to geometric investigations. The nature of the [four] elements of the earth is balanced in this way: one part of this earth shines by day, one part is obscured by night. It is divided . . . into four parts . . . From these premises the state of the [earth's] regions is known hypothetically, [those] within which the lands of the Roman empire fling wide their spacious borders [and those as yet unexplored].[83]

On such lofty premises the imperial surveyors proceed to detail how to lay out the cities, roads, and landholdings of the Roman state while also predicting the existence and the climatic conditions of the Southern Hemisphere long before they explored it in person. Angelo Colocci's particular interest in Roman-style large-scale surveying is attested by the fact that the only extended essay he ever completed for his projected masterwork on measure was a discussion of what Ptolemy had called the "climates" of the earth – our "latitudes" (Fig. 29). Colocci called his essay "De elementorum situ" (On the location of the elements).[84] Like the surveyor Agennius Urbicus, just quoted, Angelo Colocci seems to have subscribed to the belief that the earth is a mixture of four elements (earth, air, water, and fire), combined in differing proportions depending on their placement on the surface of the globe.[85] The voyages of exploration made during the late fifteenth and early sixteenth century seemed only to confirm the existence of lands in the Southern and Western Hemispheres that Agennius Urbicus had already claimed to know hypothetically (*argumentaliter*).

In a more down-to-earth sense, the *Agrimensores* also provided later ages with a guidebook through the physical world of the ancient city of Rome, much as the Roman historians provided a guide through its human events. Just as the humanists of Pomponio Leto's Roman Academy had been intent upon using ancient monuments, especially inscriptions, to bolster their researches into Roman history, Colocci, as Leto's spiritual successor, shows what was to happen next. Thanks to the efforts of Leto and his cohorts, he and the other Roman *litterati* had become quite sophisticated in their monumental setting by the second decade of the early sixteenth century; they were now capable of examining the physical legacy of ancient Rome in its own right, reading its buildings, roads, and aqueducts nearly as well as its inscriptions or texts.

One living source for this newly sophisticated outlook, which was not by any means restricted to Rome itself, is not hard to find. Both Colocci in Rome and Guillaume Budé in Paris undertook their study of weights and measures under the influence of the Veronese monk Fra Giovanni Giocondo (ca. 1433–1515), whose enterprises over a long, peripatetic lifetime had included the study of philology, mathematics, and metrology, as well as the practice of architecture.[86] The universal scope that Budé attained for *De asse* and that Colocci projected for "De numeris, mensuris, et ponderibus" both reflect the universal interests of their teacher. If Colocci owed one of his prized images of the Roman foot to Giocondo's

sharp eyes, ever on the hunt for ancient inscriptions, the relationship between the two men also emerges from the books that Giocondo bequeathed to Colocci upon his death in 1516 and whose margins Colocci then filled with his ubiquitous scrawl.[87]

FRA GIOCONDO'S VITRUVIUS OF 1511

Giocondo had also done his contemporaries the incalculable favor of producing a definitive edition of Vitruvius's *De architectura libri decem*, the sole treatise on architecture to survive from the ancient world. Vitruvius provided an indispensable complement to any study of ancient Rome's physical legacy, and hence especially to the study of measure. Furthermore, like the writers of the *Corpus agrimensorum*, and to an infinitely greater degree, he endeavored to put the study of his own discipline within a universal context, not only that of the world of learning but that of the universe as a whole.

Colocci was enthralled by Vitruvius, who, he said, had first inspired him to look into the proportions of columns.[88] His copy of Giocondo's printed Vitruvius of 1511 is one of the most manhandled books of his surviving collection (Fig. 30).[89] He tabulated its text at least three times himself and finally paid a scribe to produce an attractive folio *tabula*.[90] The reasons for his interest are not hard to find; Vitruvius succeeded in combining huge ambition with specific detail. Furthermore, as Colocci noted, Vitruvius had a healthy respect for the importance of measure. The signal importance of Vitruvius for the researches of humanists like Giocondo and Colocci lay in the way in which the ancient architect connected measure with proportion, and thereby with beauty. For on the most basic level, like the *agrimensores* after him, Vitruvius derived proportional harmony from the construction of the universe, implicit in his image of nature as an architect: "Now the cosmos is the all-encompassing concept of everything in nature, and also the firmament, which is formed of the constellations and the courses of the stars. This revolves ceaselessly around the earth and sea at the extreme hinges of the axis. For thus the power of nature has acted as architect."[91] On a smaller scale, Vitruvius likened architectural proportion to the scale and harmony of the human body in a passage repeatedly cited in the Renaissance:

If Nature has composed the human body so that its elements correspond to its measurements as a whole, then the ancients seem to have

had reason to decide that bringing their works to full completion like-wise required a correspondence between the measure of individual elements and the appearance of the work as a whole. Therefore, when they were handing down proportional sequences for every type of work, they did so especially for the sacred dwellings of the gods, as the successes and failures of those works tend to remain forever.[92]

Vitruvius wrote his treatise virtually at the birth of the Roman empire to sing the praises of Rome and the Roman way of life. For a very different but no less compelling vision of Rome, Angelo Colocci hoped to write something comparable. He did not do so, but, as we shall find in Chapter 7, he came closer than his abortive prefaces, scattered notes, and grandiose plans might lead us to think. The catalyst was Vitruvius, but before looking at those Vitruvian studies we need to examine the larger intellectual climate in which they were conceived.

✖ *Chapter Six* ✖

Sweating Toward Parnassus (1503–1513)

Magnus ab integro saeclorum nascitur ordo.

The great order of the ages has come whole into being.

<div align="right">Virgil, Fourth Eclogue</div>

Sudandum est ut monte parnasum pervenies.

You have to sweat to reach Mount Parnassus.

<div align="right">Tommaso Fedro Inghirami,
Vat. Lat. 2742, 102r</div>

JULIUS II (1503–1513)

For an important formative period of Angelo Colocci's life, we know remarkably little about what he was doing or thinking; much of the documentary evidence was probably destroyed in the Sack of Rome in 1527, when his houses were ransacked by marauding bands of mercenary troops from the army of Charles V. His surviving reminiscences seldom ranged over the fifteen years during which he first struggled to make his career. He must have been extremely busy; more than just a struggling curialist, he became a struggling curialist for that ferociously energetic pope, Julius II. Whether he packed up, like Agostino Chigi, to travel with the mobile court that accompanied Julius on his two military expeditions of 1506 and 1510–11 or stayed back in Rome to watch the city's sudden burst of new construction, he would have had his hands full with putting the irascible pope's briefs and bulls into temperate language.

For Julius (Fig. 31), Rome's renewal was neither a rhetorical trope nor an antiquarian ideal: it was a task to be realized at once. He saw his work as pope in practical terms: he wanted his own lines of command over

Christendom, especially over the Papal States, to be absolutely clear. To further this end, he mustered every available means of communication to get the point across: not only his proclamations and his diplomatic corps but also persuasive orators like Egidio da Viterbo and Fedro Inghirami, the painted images of Michelangelo and Raphael, the megalomaniac architecture of Bramante, and, if all else failed, his Swiss shock troops. He kept careful track of the money trails in the Apostolic Chamber, taking advice on occasion from one of the only figures in the city who shared his ruthless ambition in equal measure, Agostino Chigi. At the same time, he recognized that the Church itself was ripe for reform and showed particular favor toward the reforming Augustinian friar Egidio da Viterbo. The pope, the banker, and the theologian made an odd combination of personalities and tastes, but in their various meetings they applied their disparate viewpoints to the same goal: recovering the authority of the Roman Church.[1] Theirs was the manic world in which Angelo Colocci performed his duties as one wheel in the papal juggernaut.

Julius first focused his political activity on regaining control over the papacy's vassal states, especially Perugia and Bologna, which had both come under the rule of independent warlords. In 1506, he shocked his contemporaries by deciding that he would personally lead a military expedition to reclaim these territories and invited all the able-bodied cardinals to join him on the road. Those who did were flanked by a traveling court that included bankers, notaries, secretaries, and scriptors, as well as their own households of servants. Nor did Julius neglect the ceremonial aspect of his office; the Sistine Chapel choir also made the trip.[2]

Among the contingent of bankers, Agostino Chigi played an important role; one report has it that when Julius fell ill en route, Chigi and the doctor were his preferred bedside company.[3] Chigi had his own reasons for keeping close to the pope; as a merchant "following the Roman Curia," as we have seen, he leased many of his tax and customs concessions from the Apostolic Chamber, including the alum mines at Tolfa. These, by the time of the papal expedition, had made him phenomenally rich. More important still, Julius recognized the potential income to be realized for the papacy by a monopoly on alum. He added a clever new weapon to Chigi's economic arsenal: with the excuse that buying alum from the Turks was buying from the infidel, he threatened to excommunicate anyone who dared buy from Chigi's Levantine competitors.[4] Henry VII of England was caught in the act, although Julius stopped short of excommunicating the king; ironically, another offender turned out to

be one of Chigi's own agents, Francesco Tommasi, arrested in 1507 for buying Turkish alum in Lyons; he had been acquiring it for resale at a higher price by the Banco Chigi.[5]

Closer to home, Chigi's connections with Siena – personal, political, and economic – ensured that buffer state's continued loyalty to Rome, a factor that proved especially comforting during the papal reconquest of nearby Perugia in 1506. Always, however, Chigi was looking beyond immediate circumstances to see a larger picture, sifting the information supplied him in letters from a network of agents scattered from London to Constantinople, assessing the economic impact of the pope's political plans. When Julius mounted his second military expedition in 1510–11, Chigi took a central role in the planning, the execution, and the negotiations afterward.[6]

Against this roiling background of history, with its infinite number of obstacles large and small to realizing Julius's vision of the Church, against the intricate economic webs woven on the pope's behalf by Agostino Chigi and the other curial merchants, the art, architecture, and oratory sponsored by Julius II stand out in all their clarity. These were the media through which Julius proclaimed what he was about in the most essential terms. The pope had more than a driving mission: he had taste. He had been refining it for years as a cardinal, competing with his cousin Raffaele Riario, another patron of rare discernment, and both of them had taken their initial impetus, and perhaps their whole approach to formulating the public messages of patronage, from the vast unrealized projects of their uncle, Sixtus IV. However touchy their relationship could be, the family ties that bound the two cardinals together were far more profound than their differences. When Cardinal Giuliano exiled himself from Rome for the nine years between 1494 and 1503, Riario's animated participation in Roman cultural life kept alive the contacts that helped set the stage for many of Julius's projects as pope.[7] As chamberlain of the Apostolic Chamber, Raffaele Riario also helped Julius keep the Vatican's financial house in rare good order.

SERMONS AND PREACHERS

In addition to his important position as chamberlain of the Apostolic Chamber, Raffaele Riario was also cardinal protector of the Augustinian order, a role which brought him into contact with a significant and suitably theatrical development in ecclesiastical life. In the 1480s the Augus-

tinians had introduced a new oratorical style, first practiced by the order's prior general, Mariano da Genazzano, and continued – some said shamelessly imitated – by his successor Egidio da Viterbo. These bearded friars in their stark black habits looked like the very picture of monastic asceticism until they opened their mouths; then all the florid luxuriance of humanist-inspired rhetoric poured forth.[8]

Ever since the development of the mendicant orders in the Middle Ages, public sermons had become an important form of mass communication, particularly in Italy, where the Roman rhetorical tradition lived on in the lively conversations and animated gestures still to be found in every piazza of every city. Unlike the stern predictions of hellfire and damnation that thundered in later centuries from Puritan pulpits, the sermons of these mendicant preachers could be extremely entertaining, filled with sudden exclamations ("Do you hear me, you sleeping woman? Look, there are two women, both sleeping, one using the other as a pillow!"), show-and-tell (relics of the saints were especially popular), and exuberant gestures.[9] Unlike the down-to-earth Franciscans or the intellectual Dominicans with their scholastic precision, the Augustinians leaned toward the mysticism of their traditional founder, that Late Antique writer and staunch Neoplatonist, Augustine of Hippo. In the late fifteenth century, when Marsilio Ficino had given new currency to Plato's ideas about a transcendent reality surpassing the phenomenal world, the Augustinian preachers found a newly appreciative audience.

Fra Mariano da Genazzano was quick to exploit the situation. One hearer, the exacting Tuscan humanist Angelo Poliziano, described him in action as follows:

> I heard a harmonious voice, apt words, elevating and pious sentiments. He paced the development of his subject, and I found nothing incongruous, nothing superfluous, nothing bombastic. His proofs convinced me, his illustrations delighted me, and I was enraptured by the music of his pronunciation. When he chose to joke, I laughed; when he pressed home a point, I was left no option, I surrendered; I was overcome. When he treated of delicate emotions, I wept; when he was aroused and threatened, I grew terrified and wished I had not come. In short, he varied his illustrations and voice according to his thoughts, and by his gestures supported and heightened the effect of his words.[10]

Paolo Cortesi was less impressed:

> No less [deplorable] are those kinds of eloquence in which there is a brightness that is all makeup and no dignity. That was how Mariano

da Genazzano's daily homilies seemed to me when I was a young man; they were so loaded down with the struggle for excessive artifice and too many acrobatics of the pen that they removed authority from the subject and faith from the sermon.[11]

Mariano's protégé, Egidio da Viterbo, absorbed form, content, and technique from the mentor with whom he had been closely associated for years.[12] Egidio's listeners affirmed that his sermons were a sensual delight, "deliciae."[13] He "sweetened their tempers" and "caressed their ears" with his oratory, and after some twenty years of itinerant preaching he was considered one of the supreme masters of persuasion in his own time, for every size and level of audience.[14] The papal secretary Jacopo Sadoleto would write,

> When he talks, there is no difference between learned men and idiots, an old man cannot be distinguished from an adolescent, a man from a woman, a prince from the lowest of men; rather, we have seen the spirits of every one of his hearers carried along with equal force, wherever it pleases [Egidio] to drive them. This is the power of his oratory, this the river of his choice words, and the weight of his excellent observations is borne on this.[15]

Nor was Sadoleto's an isolated opinion. Paolo Cortesi put it this way:

> What can I say about Egidio da Viterbo? Who else among the multitudes seems so uniquely born to persuade, to win over the minds of the Italians, whose speech is so seasoned with the salt of literary elegance, so that all the sap of content is present in the supreme harmony of his words, and it flows so gently and rhythmically with the pitch and variety of his voice that one seems to hear sounds like that of a plucked lute?[16]

It is somewhat difficult to appreciate that eloquence from the bare texts of Egidio's sermons. As with the *strambotti* of Serafino Aquilano, we have the words without the performance. The Augustinian's urbane eloquence and his contrived rhetorical effects provide no clue at all to the startlingly changeable cadences of his voice, his brilliant black eyes, or his fervor, the very qualities of presence that allowed Sadoleto to report that "in his sacred orations, his eloquence invariably has turned the minds of men toward divine and wonderful things just as he decides; it restrains those who are over-excited and lights up the languid, or, better, inflames them toward the desire for Virtue, Justice, and Temperance, toward the love of Almighty God and devotion to holy religion."[17]

Egidio also became important as a promoter of Neoplatonic thought, not so much for his skills as a philosopher – both Ficino and Pico della Mirandola were by far his superiors on that account – but rather for the vividness with which he could picture those ideas in sermons, in writing, or in conversation. He offers repeated proof of this gift in a large theological tractate he composed during the reign of Julius II. (He had worked on it from 1506 to 1513.) Designed as a teaching text that would introduce Christian Neoplatonism to Augustinian novices, it followed the order of the Church's standard theological textbook, the twelfth-century *Sentences* (Sententiae) of Peter Lombard, a sterling example of scholastic prose in which Aristotle and his empirical way of thinking reigned supreme. Egidio called his own work "Sentences According to the Mind of Plato" (Sententiae ad mentem Platonis), alerting his readers that he would be attempting to reconcile Lombard's traditional scholastic theology with the new Neoplatonic Christianity of Marsilio Ficino, creating a bridge between Plato and Aristotle, the Middle Ages and the Renaissance, scholastic precision and humanist expressivity.[18]

Under Ficino's influence, the "Sententiae ad mentem Platonis" devoted a great deal of attention to explaining how the phenomenal world is separated from the pure reality of God by intermediate levels of reality. In Egidio's scheme, which he adapted not only from Ficino but also from Augustine (appropriately enough for an Augustinian monk), these orders of reality were three: *vestigium*, the "footprint" or "trace" of God; *imago*, the "image" of God; and *essentia*, Godhead itself. An *imago* he defined as an outright likeness: in Genesis 1, for example, Adam and Eve are made in the "image and likeness" of God. In concrete terms, Egidio said that the *imagines* of God were two: the angels and the human soul. Like God, these were bodiless and immortal; unlike God they were many rather than one, and unlike God's, their powers were limited. Most unusually, he insisted that the gods of the pagan pantheon had been *imagines* – guardian angels to the classical heroes. Myths, like other repositories of ancient wisdom, showed God's hand at work through time; they too helped to make up *prisca theologia*:

> [Augustine] taught about the excellence of [the angels] through the help of whom men will necessarily come to know and love God. This is why Plato states in the *Critias* that the gods were given the sphere of Earth in order to care for mortals. Homer also alludes to this fact, when he sets Minerva over Ulysses as guide, and Virgil when he sets Venus over Aeneas; by their help and interest, it is possible for [the

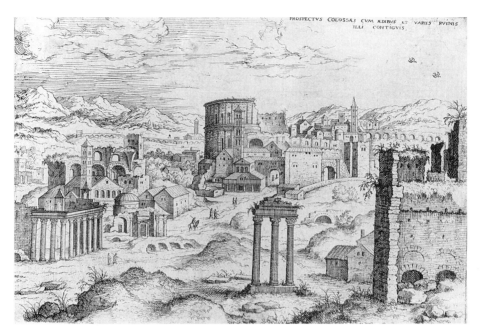

Figure 1. View of the Roman Forum, 1560s. Engraving by Hieronymus Cock. Courtesy of the University of Chicago Libraries.

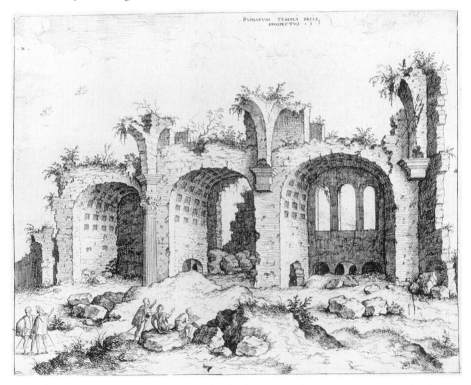

Figure 2. View of the Basilica of Maxentius in the Roman Forum, 1560s. Engraving by Hieronymus Cock. Courtesy of the University of Chicago Libraries.

Figure 3. Colocci family records in the flyleaf of Petrarch, *Rime sparse*, including the birth notice of Angelo Colocci (fourth entry from top). Fifteenth-century manuscript copy belonging to the family of Angelo Colocci. Biblioteca Apostolica Vaticana, Vat. Lat. 4787. Courtesy of the Biblioteca Apostolica Vaticana.

Figure 4. Tabulation. Pliny, "Historia naturalis," "tabulated" by Marco Fabio Calvo (margins) and Angelo Colocci (bottom of page). Biblioteca Apostolica Vaticana, Stampati R.I.II.999. Courtesy of the Biblioteca Apostolica Vaticana.

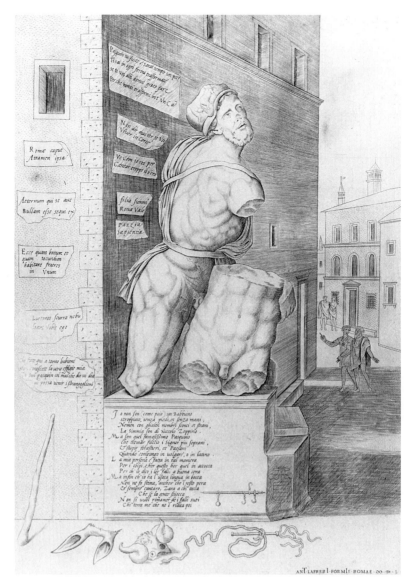

Figure 5. Pasquino. Engraving by Antoine Lafréry. Courtesy of the University of Chicago Libraries.

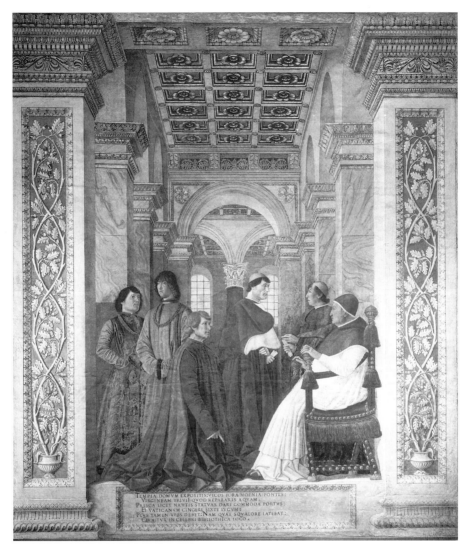

Figure 6. Melozzo da Forlì, *Sixtus IV Reorganizes the Vatican Library and Appoints Platina Its Librarian, 1475.* Painted 1476 or 1477. Fresco, formerly on the wall of the Vatican Library, now in the Pinacoteca Vaticana. Courtesy of the Musei Vaticani.

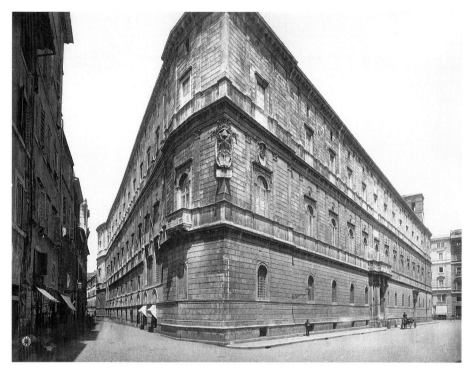

Figure 7. Palazzo Riario (Palazzo della Cancelleria, or Cancelleria Nuova). 1485–1511. Courtesy of Art Resource.

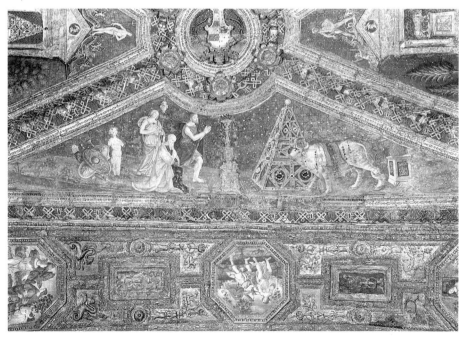

Figure 8. Pinturicchio, *Exploits of Osiris.* 1493–5. Appartamento Borgia, Sala dei Santi. Courtesy of the Musei Vaticani.

Figure 9. Pinturicchio, *Hermes and Argus*. 1493–5. Appartamento Borgia, Sala dei Santi. Courtesy of the Musei Vaticani.

Sup_ delubro Cybelis Etruscis lrs

ᚺᎸ᎔Ǝᗱ ∨ᗱ⌐Ǝᐸ ᐸᎬ⌐ᗱ∨ ᗰᎬᎤᎸᚺ
ᐸᎬᎸ᎔Ǝᐸ : ᐸᎬ᎔⌐ᎤᎬᗰ
ᐸᎸ⌐ᐸ ᐳᎥᎻᎸᐸ : ᐳᎸᎻᎥᐸ ᐸᎽᎸ⌐ᐳ
∨Ⅹ ᐸᎽᎸ᎔Ᏸᴙ

Latinis lrs

BELYV MEOS ITI
MEOS IEY YEB
BTILY YPITIB RTIPIB
ATILY XV

Latinis verbis

DIVA DOMO HOSPITA ISIS
HOSPITIO PRIMO EXCEPTA FVIT
IN DOMO PVELLÆ YPITÆ PATERNA
REGIS PITI PATRIS
ANNO XV.

Federico Patetta
Ms n°. 40.

Figure 10. "Tabula Cybellaria," Etruscan inscription discovered in 1493. Sixteenth-century Italian transcript, now in the Bodleian Library, MS Lat. class.e.29, 2r. Courtesy of the Bodleian Library.

& Palefatus scribunt/& Eusebius refert/fuisse nouimus triennio ante regnum Lau
medontis patris Priami/cum uxor prima ob Zelotipiam Armoniæ recedens ą Cad
mo illi certamen intulit:ut etiā Xenophon & plures retulerint∙Quare Samorraces
ut reliqui Greci falso aiunt/hunc Cadmū fuisse filium Agenoris egyptii/cuius cog/
natus fuit Dardanus Dardaniæ conditor∙ Nam ante hunc annū condita erat Dar∕
dania nō minus annis uno & uiginti supra ducentos: neqʒ hac etate alius Cadmus
& phenix inueniantˉ ᵭ Amyntoris nō Agenoris egyptii filii∙ Itaqʒ teste Manetho∕
ne in Syros & Grecos/Cadmum & Phenicem:fuerunt Egyptii Agenoris filii Cad∕
mus & Phenix qui a mari rubro iussu patris profecti : alter apud Sydonē Phenix:
alter apud Greciæ Thebas regnauit anno∙xxxvii∙Amenophis : tertioqʒ post anno
pulsus fuit : ut tam Manethon ᵭ Eusebius de temporibus scribunt∙ Quare raptus
Europæ paulo ante hunc annū obtigit:& nō post exactos nonaginta annos: ut Eu∕
sebius de temporibus pro Greca incerta historia notat∙

**Post Ꝃenophim cepta est dy∕
nastia Larthū ut in Ꝭtalia:quę
dynastia durauit annis solari∕
bus.c.rciiii.Ḩorum Larthum
in Egypto primus fuit Ꝫetus:
qui regnauit ānis.lv.cuius an∕
no octauo in Dardania regna∕
uit Tros: in Tuscia uero anno
bui⁹.rrxiii. regnauit annis.x∕
rrviii.Ꝟeiben⁹ex familia Ꝟei
tuloniæ.**

Hoc nomen Larthes nō propriū
est/sed cōmune dignitatis uoca
bulū/sicut Augustus & Pharao∙
In triumphalibus Etruscis inue∕
nimus per aspiratione scriptum
Larth/& Larthi∙ Erant enim in
Dynastia siue potentatu Etrurię
xii∙Lucumones in Vetulonia re∕
sidentes∙xii∙reges : quibus unus
perat:ut Seruius auctor est super
viii∙Eneidos∙Hic supremᵒLarth
uocabulo Etrusco idest regū ma∕
ximus dicebatur/ nō solum quia
ceteris preerat/uer ̄u etiā quia an∕
niuersarie ceteris duodecim reuo
catis ipse per uitam totam perse∕
uerabat∙ Hoc pacto potētatus &
Dynastia plurium regum in Egypto cepit: quibus primus prefuit Zetus Larthes
Nō hic Zetus fuit qui pepulit Cadmum/ut supra retulit∙ Nam iste fuit egyptius :
ille uero Grecus∙ De horū temporibus Eusebius & Manethon paria sentiūt∙Tros
iste fuit filius Erictonii & nepos Dardani qui in Dardania partem urbis maximā
fundauit: atqʒ a se Troiam dixit: ut Eusebius de temporibns & ceteri conscribunt:
sed de alio Larthe Magueo & temporibus tam Larthum Thusciæ ᵭ Dardanię:in tē
poribus Archiloci & historiç Etruscę supprimit Berosus:ut qui nouitius historicus
& externus∙ Nomen uero Veibennum quod a latinis Vibennum per sineresim in
primo/Varronis de lingua latina scriptum reperio/sicut & Veiturgiā & Veiterbum
per sineresim dicimus Viturgiā & Viterbum: pfecto Etruscū est nomen qd solū Ve
tuloniatibus conuenit∙Nam ben fililius apud orientales atqʒ Arameos & Hebreos
filius dicitur∙ Hinc Veibennus siue Vebennus Veiorum filius & conciuis dicitur∙

Z ii

(marginal handwritten notes: "Larthes", "Augustus/pharao", "Dynastia", "lucumones / xii", "Larth regi / maximus", "Zetus Larth")

Figure 11. Page from Annius of Viterbo, "Commentaria Fratris Joannis Annii Viterbiensis super opera diversorum auctorum de antiquitatibus loquentium." Copy belonging to Egidio da Viterbo, with marginal notes by Egidio and others. Rome: Eucharius Silber, 1498. Biblioteca Apostolica Vaticana, Incunabulum II.275, 154r. Courtesy of the Biblioteca Apostolica Vaticana.

& cū blandicelle parole tanta obſeruantia digna di laudatiſſima commé
datione integramente exponendo narrato, & me compendioſaméte in-
ſtituto al ſpatioſo & harenulato litore di piaceuoli plémyruli irruenti re
lixo, oue era il deſtructo & deſerto tempio perueniſſimo.

Figure 12. Poliphilo among the ruins. Francesco Colonna, *Hypnerotomachia Po-*
liphili. Copy belonging to Fabio Chigi, later Pope Alexander VII, with autograph
annotations. Venice: Aldus Manutius, 1499. Biblioteca Apostolica Vaticana,
Stampati Chigi II.610. Courtesy of the Biblioteca Apostolica Vaticana.

figura della
statua rehominata

Π Α Ν Τ Ω Ν Τ Ο Κ Α Δ Ι

Per laquale cosa io non saperei definire, fila diuturna & tanta acre fe-
te pridiana tolerata ad bere trahendo me prouocaffe, ouero il belliffimo
fuscitabulo dello inftruméto. La frigiditate dil quale, inditio mi dede che
la petra mentiua. Circuncirca dunque di quefto placido loco, & per gli
loquaci riuuli fioriuano il Vaticinio, Lilii conuallii, & la floréte Lyfima
chia, & il odorofo Calamo, & la Cedouaria, Apio, & hydrolapato, & di
affai altre appretiate herbe aquicole & nobili fiori, Et il canaliculo pofcia

c

Figure 13. Fountain Nymph. Francesco Colonna, *Hypnerotomachia Poliphili*. Copy belonging
to Fabio Chigi, later Pope Alexander VII, with autograph annotations. Venice: Aldus Manutius,
1499. Biblioteca Apostolica Vaticana, Stampati Chigi II.610. Courtesy of the Biblioteca Apos-
tolica Vaticana.

numifmati in circo. Vno facello cum patefacta pòrta, cum una ara i me-
dio. Nouiffimamente erano dui perpendiculi. Lequale figure i latino cu
fi le interpretai.

DIVO IVLIO CAESARI SEMP. AVG. TOTIVS ORB.
GVBERNAT. OB ANIMI CLEMENT. ET LIBERALI
TATEM AEGYPTII COMMVNIA ERE. S. EREXERE.

Similmente in qualūque fron
te del recenfito fuppofito qua-
drato, quale la prima circulata
li'[...] figura, tale unaltra fe pftaua a li
[...] nea & ordie della prima a la de
xtra planitie dūque mirai an-
cora tali eleganti hieroglyphi,
primo uno uiperato caduceo.
Alla ima parte dilla uirga dil-
quale, & de qui, & deli, uidi u-
na formica che fe crefceua i ele
phanto. Verfo la fupernate æ-
qualmente dui elephāti decref
ceuano in formice. Tra quefti
nel mediaftimo era uno uafo PACE, AC CONCORDIA PAR-
cum foco, & dal altro lato una VAER ESCRESCVNT, DISCOR
conchula cum aqua. cufi io li DIA MAXIMAE DECRESCVNT.
interpretai. Pace, ac concordia
paruæ res crefcūt, difcordia ma
ximæ decrefcunt.

Figure 14. Hieroglyphs. Francesco Colonna, *Hypnerotomachia Poliphili*. Copy be-
longing to Fabio Chigi, later Pope Alexander VII, with autograph annotations.
Venice: Aldus Manutius, 1499. Biblioteca Apostolica Vaticana, Stampati Chigi
II.610. Courtesy of the Biblioteca Apostolica Vaticana.

Figure 15. Humanistic script (Cristofano Pagni) and mercantile cursive (Agostino Chigi). Letter of Agostino Chigi to his brother Sigismondo Chigi, August 15, 1510. Biblioteca Apostolica Vaticana, MS Chigi R.V.c, 45r. Courtesy of Biblioteca Apostolica Vaticana.

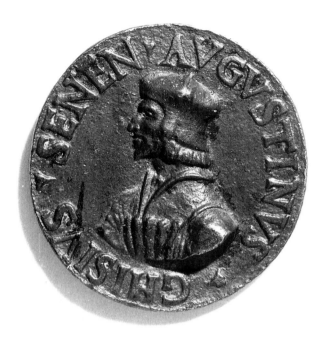

Figure 16. Agostino Chigi. Portrait medallion, probably ca. 1513. Courtesy of the Biblioteca Apostolica Vaticana.

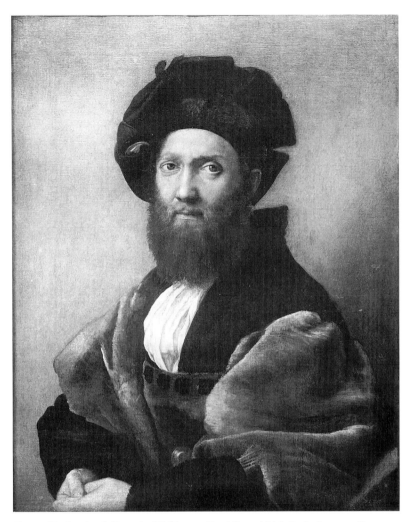

Figure 17. Raphael, *Portrait of Baldassare Castiglione.* 1516. Paris, Louvre. Courtesy of Alinari.

Figure 18. "Mr. Perspective." Frontispiece, Donato Bramante (?), *Antiquarie prospettiche romane*. Ca. 1500. Courtesy of the Biblioteca Casanatense.

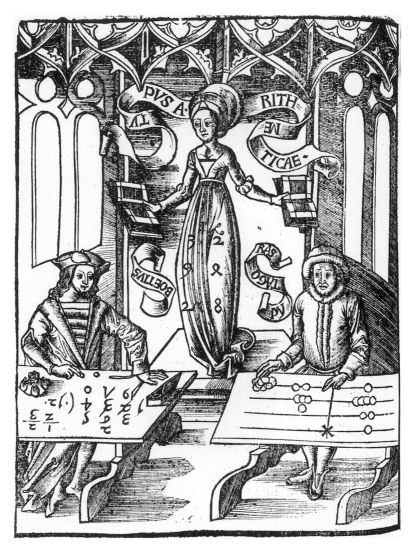

Figure 19. Arithmetic between paper calculations and abacus (*Typus arithmeticae*). Gregor Reisch, *Margarita philosophica*. Basel: Michael Furterius, 1516, k v 3v. First printed 1503. Newberry Library, Wing ZP 38.F985. Courtesy of Newberry Library.

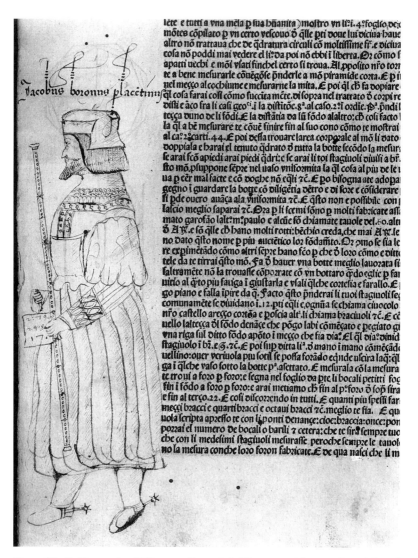

Iacobus boronus placentinus

lete e tutti a vna mela p̄ sua bn̄anita) mostro vn li?i. 4?foglio,de?
montes copilato p̄ vn certo vescouo o̊ q̄lle p̄ti dote lui diciua haue
altro nō trattaua che de q̄dratura circuli cō moltissime fī?e diciua
cosa nō poddi mai vedere el li?da poi nō ebbi i liberta.Or cōmo f
apārti vechi e mōi vsati finchel certo si troua.Al̄ppolito nr̄o to?ī
te a bene mesurarle cōu̇egōse p̄nderle a mō piramide co?ta.E p̄ iī
nel meçço alcochiume e mesurarne la mita.E poi q̄l cb̄ fa dopiare
q̄l cosa farai cosi cōmo succira mcte.di sopza nel trattato o̊ co?pi re
distī e aco fra li cāsi geo?i.i la distitōe.8ª.al caso.2?ī ordie.p̄?.p̄ndi l
teçça duno de li fōdi.e la distātia da lū fōdo alaltro:cb̄ cosi facto l
la q̄l a bē mesurare te cōue finire fin al suo cono cōmo te mostrai
al ca?2?carti.44.E poi dessa trouare larea co?pozale al mō li dato
doppiala e barai el tenuto q̄drato o̊ rutta la botte secōdo la mesur
se arai fcō apiedi arai piedi q̄dri:e se arai li toi stagiuoli diuisi a bī
sto mō.psuppone sēpze nel vaso vniformita la q̄l cosa al piu o̊ le t
ua p̄ cēr mal facte e cō doghe nō eq̄li ?c̄.E po bisogna ate adopa
gegno i guardare la botte cō diligētia dētro e di foze e cōsiderare
si pde ouero auāça ala vniformita ?c̄.E q̄sto non e possibile con ı
lascio meglio saparai ?c̄.Oza p̄ li scemi sōno p̄ molti fabzicate assī
mato garofao lalt?m?paulo e alcūe fō chiamate tauole del.o.aln
o̊ A p̄?.e fō q̄lle cb̄ bano molti rotti:bechio creda,che mai A p̄?le
nō dato q̄sto nome p̄ piu auctētico lo? fōdamēto.Or ōmo se fia le
re expimētādo cōmo altri sēpze bano fēo p̄ che o̊ lozo cōmo e ditto
tele da te tirrai q̄sto mō.Fa o̊ bauer vna botte meglio lauozata fī
saltramēte nō la trouasse cōpozate cō vn bottaro q̄ do eglie p̄ far
uirlo al q̄to piu fatiga i giustarla e vsali q̄lche coztesia e farallo.E ı
go piano e falla ipire da q̄.Facto q̄sto p̄nderai li tuoi stagiuoli sē
comunamēte se diuidano i.12.p̄ti eq̄li e,ognia se chiama ciuocolo
nr̄o castello areçço coztēa e poscia alt?li chiama bzaciuoli ?c̄.E cō
nello laiteçça o̊l fōdo denāçe che pōgo labi cōmēçato e pegiato gı
vna riga sul ditto fōdo apōto i meçço che fia dia?El q̄l dia?ouind
stagiuolo i bī.e G.?c̄.E poi sup ditta li?.o̊ mano i mano cōmēçadu
uellino:ouer veruola piu sotil se possa fozādo eq̄nde uscira laq̄:q̄l
ga i q̄lche vaso sotto la botte p̄?asettato.E mesurala cō la mesura
te troui a fozo p̄ fozo:e segna nel foglio da p̄te li bocali petitti foç
fin i fōdo a fozo p̄ fozo?o̊ fin al p̄?fozo o̊ sōp stra
e fin al terço.22.E cosi discozzendo in tutti.E quanti piu spessi far
meçci bzacci e quarti bzacci e octaui bzacci ?c̄.meglio te fia. E qu
uola scripta apzesso te cō li?pōti denāçe:cioe:bzaccia:once:pon
pozzai el numero de bocali o barili ?z cetera:che te sir̄s sēpze tuo
che con li medesimi stagiuoli mesurasse peroche sēpze le tanolē
no la mesura conche lozo fozon fabzicate.E de qua nasci che li m

Figure 20. Self-portrait of Giacomo Boroni da Piacenza with counting stick and sheet of calculations. Marginalium in his copy of Luca Pacioli, *Summa de arithmetica*. Venice: Paganinus de Paganinis, 1494. Newberry Library, Incunabulum f5168, pt. II, 74v. Courtesy of Newberry Library.

Figure 21. Schoolboy's *abbaco*. Probably late fifteenth century. Once owned by Angelo Colocci. Biblioteca Apostolica Vaticana, Vat. Lat. 4829, 90v–91r. Courtesy of the Biblioteca Apostolica Vaticana.

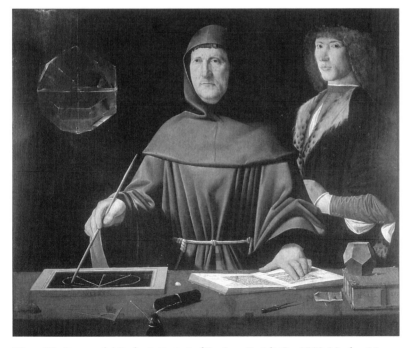

Figure 22. Jacopo de' Barbari, *Portrait of Fra Luca Pacioli*. Ca. 1500. Naples, Museo Nazionale di Capodimonte. Courtesy of Art Resource.

Figure 23. Luca Pacioli, "Opera de arithmetica." Manuscript. 1480s. Vatican Library, Vat. Lat. 3129, 268r. Courtesy of the Biblioteca Apostolica Vaticana.

Figure 24. Papinio Cavalcanti, "De numerandi disciplina." Manuscript. Early sixteenth century, once owned by Angelo Colocci. Vatican Library, Vat. Lat. 3896, 112r. Courtesy of the Biblioteca Apostolica Vaticana.

Figure 25. First page of Outline for Angelo Colocci, "De numeris, ponderibus, et mensuris." Autograph, probably after 1527. Vatican Library, Vat. Lat. 3906, 71r. Courtesy of the Biblioteca Apostolica Vaticana.

Figure 26. Marco Fabio Calvo, "De numeris." Manuscript, early sixteenth century, once owned by Angelo Colocci. Vatican Library, Vat. Lat. 3896, 95r. Courtesy of the Biblioteca Apostolica Vaticana.

ℂ Ibidem. *quadr.*

DIS MAN.

· COSSVTIAE
ARESCVSAE . F .
CN . COSSVTIVS
AGAᖷ*N*GELVS
CONIVGI
· SVAE ⊕ BENE
MENTI
VIXIT ANNIS
XXXX.V

ⅭIS MAN.

CN . COSSVTIVS
CLADVS
CN . COSSVTIVS
AGATHANGELVS
FRATRI · SVO
ISDEM LIBERTO
BENEMERENTI.F·
VIXIT ANNIS
XXX.V·

Figure 27. Tombstone of Agathangelus, an ancient Roman architect. From Angelo Colocci's copy of Jacopo Mazzocchi, "Epigrammata Urbis Romae," 1521. Vatican Library, Vat. Lat. 8492, 109v. Courtesy of the Biblioteca Apostolica Vaticana.

Figure 28. "Corpus agrimensorum." Manuscript copy of a medieval exemplar made by Basilio Zanchi for Angelo Colocci, ca. 1520. Vatican Library, Vat. Lat. 3132, 23r. Courtesy of the Biblioteca Apostolica Vaticana.

Figure 29. Angelo Colocci, "De elementorum situ." Manuscript, early sixteenth century, once owned by Colocci. Vatican Library, Vat. Lat. 3353, 152v. Courtesy of the Biblioteca Apostolica Vaticana.

De quinque ædium ſpetiebus. Caput. I I.

S pés át ædiũ ſũt q̃nq̃,quæ ea ſũt uocabula:Pycnoſtylos,ideſt crebris colũ/
nis,Syſtylos,pauloremiſſiorib°,diaſtylos,ampli° patétib°,Rãri° q̃ oportet
iterſe diduĉtis,areoſtylos,Euſtylos iteruallog̃ iuſta diſtributióe.Ergo py/

Item ſyſtylos eſt,in quo duarum colũnarũ craſſitudo in intercolũnio po/
terit collocari,& ſpiræg̃ plinthides æque magnæ ſint eo ſpatio,quod fue/
rit iter duas plinthides,quéadmodũ eſt fortunæ equeſtris ad theatrum la/
pideum,& reliquæ,quæ eiſdem rationibus ſunt compoſitæ.

at Intercolũ
nia. quibus
uni° & dimi
diate colũne
craſſitudo in
terpoſita eſt.

D

Figure 31. Raphael. Portrait of Julius II. *The Expulsion of Heliodorus* (detail). 1512. Fresco, Apostolic Palace, Stanza di Eliodoro. Courtesy of Art Resource.

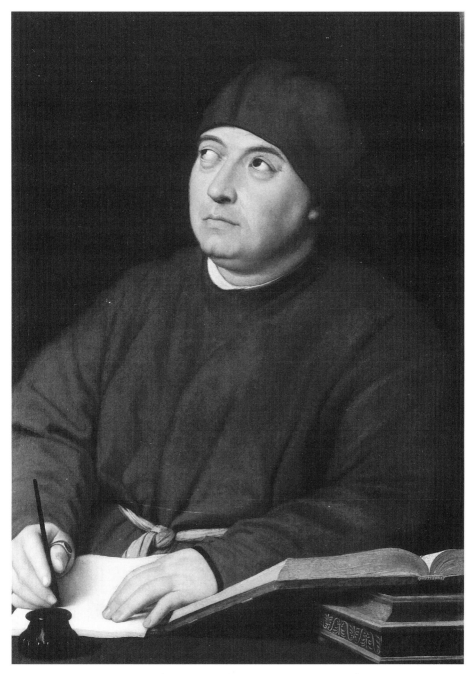

Figure 32. Raphael, *Portrait of Tommaso Fedro Inghirami as a Canon of Saint Peter's.* 1510 or slightly later. Florence, Galleria Nazionale Palatina (Palazzo Pitti). Courtesy of Art Resource.

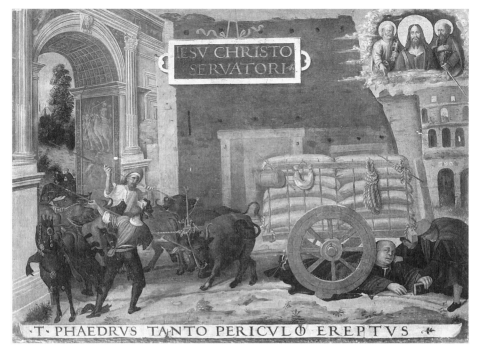

Figure 33. Ex-voto of Tommaso Fedro Inghirami. 1508. Rome, Museo del Chiostro di San Giovanni Laterano. Courtesy of the Musei Vaticani.

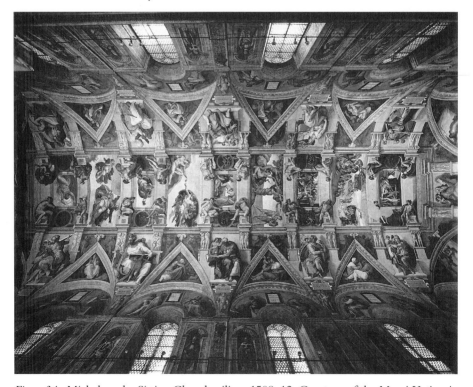

Figure 34. Michelangelo, Sistine Chapel ceiling. 1508–12. Courtesy of the Musei Vaticani.

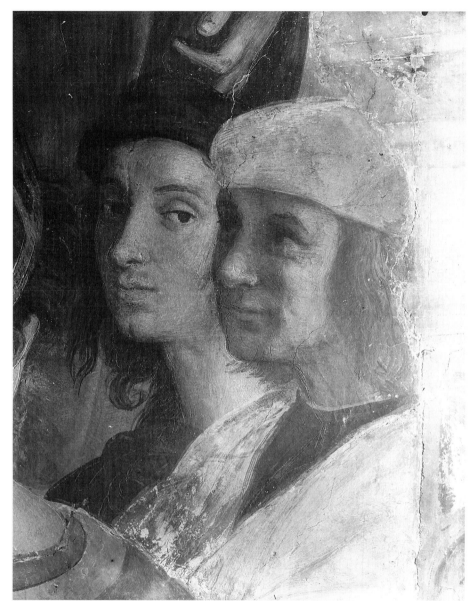

Figure 35. Self-portrait of Raphael. *School of Athens* (detail). 1509–11. Apostolic Palace, Stanza della Segnatura. Courtesy of the Musei Vaticani. Raphael is the young man on the left.

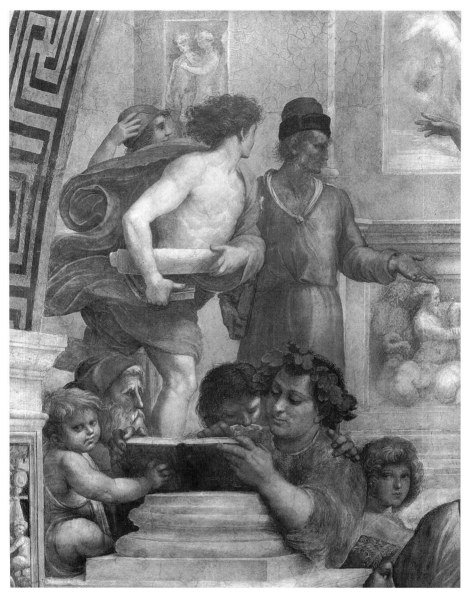

Figure 36. Tommaso Fedro Inghirami as Epicurus(?). Raphael, *School of Athens* (detail). 1509–11. Apostolic Palace, Stanza della Segnatura. Courtesy of the Musei Vaticani.

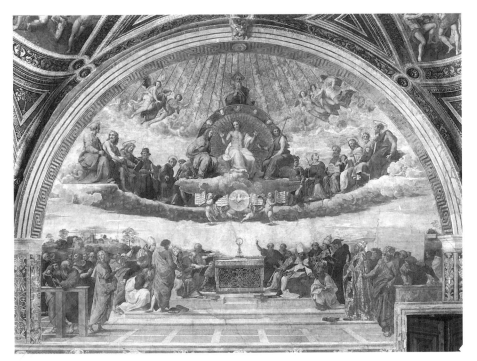

Figure 37. Raphael, *Disputa del Sacramento*. 1508. Apostolic Palace, Stanza della Segnatura. Courtesy of the Musei Vaticani.

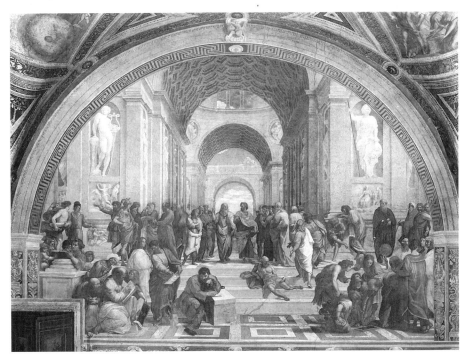

Figure 38. Raphael, *School of Athens*. 1509–11. Apostolic Palace, Stanza della Segnatura. Courtesy of the Musei Vaticani.

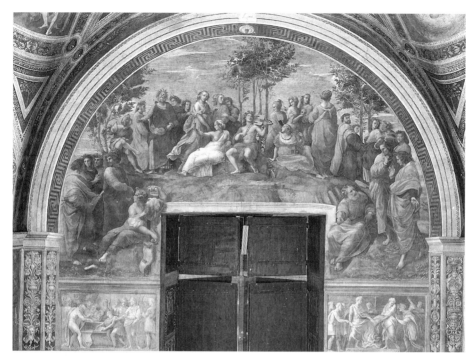

Figure 39. Raphael, *Parnassus*. 1511. Apostolic Palace, Stanza della Segnatura. Courtesy of the Musei Vaticani.

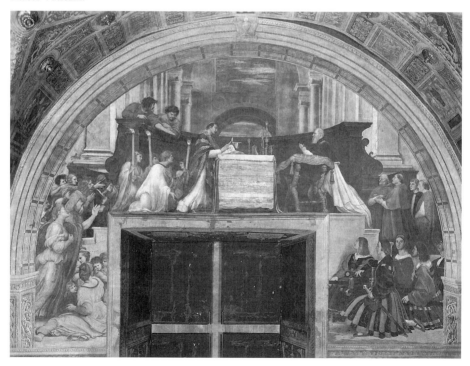

Figure 40. Raphael, *The Mass of Bolsena*. 1512. Apostolic Palace, Stanza dell' Incendio. Courtesy of Art Resource.

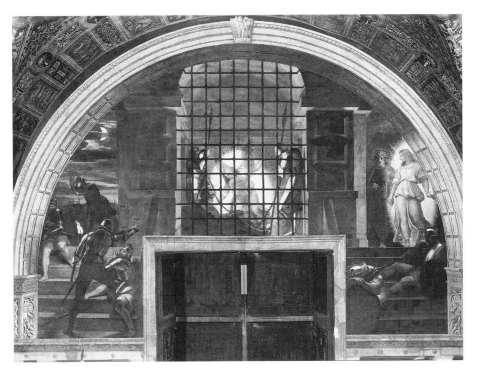

Figure 41. Raphael, *The Liberation of Saint Peter.* 1512. Apostolic Palace, Stanza dell' Incendio. Courtesy of Art Resource.

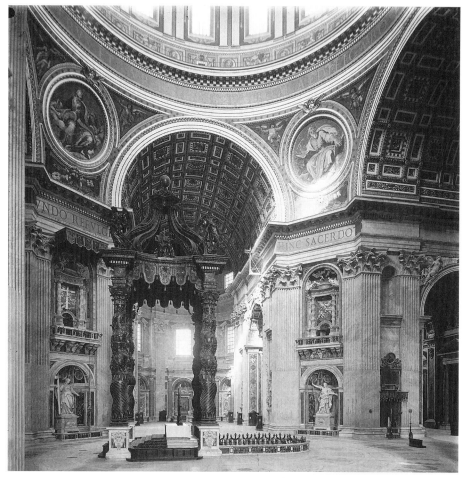

Figure 42. Saint Peter's Basilica (interior), showing canted pilasters designed by Donato Bramante for Julius II. Courtesy of the Istituto Centrale per il Catalogo e la Documentazione, Rome.

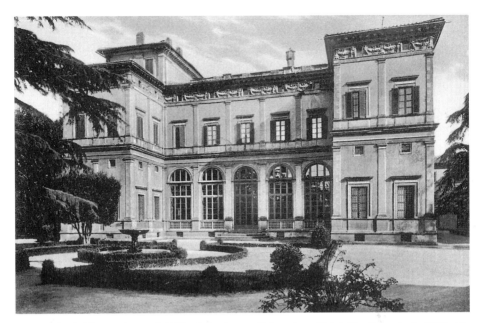

Figure 43. Baldassare Peruzzi, Villa Suburbana of Agostino Chigi (La Farnesina). 1509–11. Courtesy of the Accademia Nazionale dei Lincei, Rome.

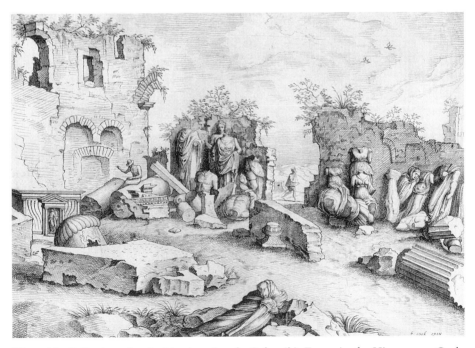

Figure 44. Collection of antiquities (not Angelo Colocci's). Engraving by Hieronymus Cock. 1530s. Courtesy of the University of Chicago Libraries.

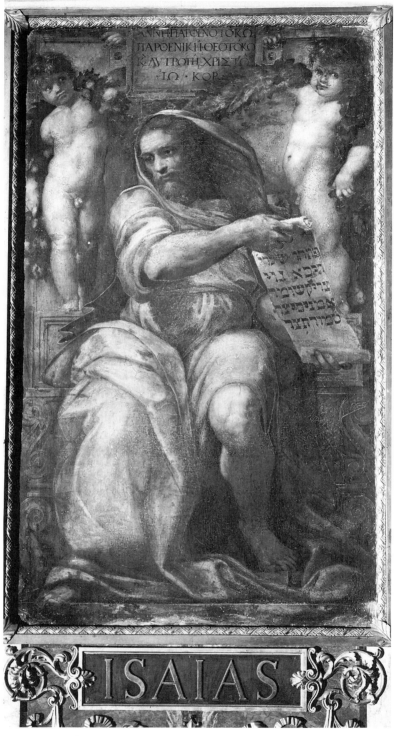

Figure 45. Raphael, *Isaiah*. Fresco for the Göritz Chapel, Sant' Agostino, Rome. 1512. Courtesy of Art Resource.

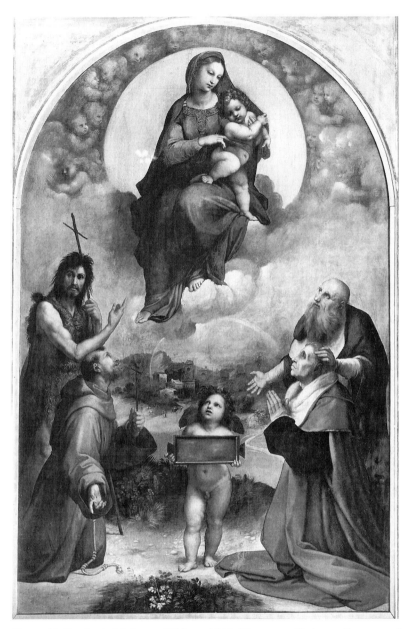

Figure 46. Raphael, *Madonna of Foligno*. 1512. Pinacoteca Vaticana. Courtesy of
Art Resource.

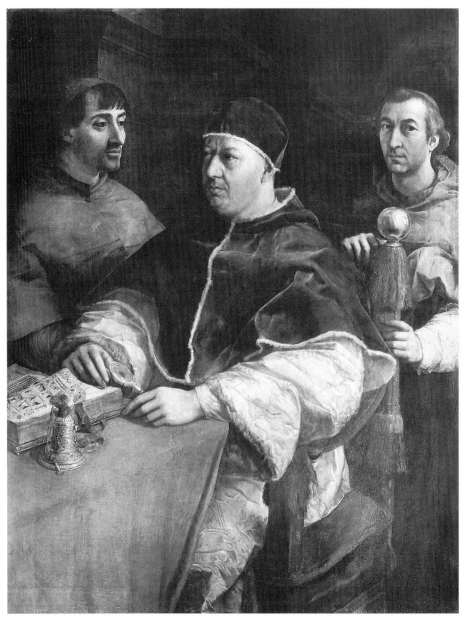

Figure 47. Raphael, *Portrait of Pope Leo X with Cardinals Giulio de' Medici and Luigi de' Rossi.* 1517. Florence, Galleria Palatina. Courtesy of Art Resource.

Secōdo

Figure 48. Page from Fabio Calvo's translation of Vitruvius, *De architectura libri decem*, executed for Raphael about 1516. Hand of Angelo Colocci, with marginal notes by Angelo Colocci and Raphael. Munich, Bayerische Staatsbibliothek, MS It. 37, 60r. Courtesy of the Bayerische Staatsbibliothek.

particulæ sunt eius numeri, Mathematici uero contra disputantes ea re
perfectum esse dixerût numerum, qui sex dicitur, ᵱ is numerus habet par/
titiones eorum rationibus sex numero conuenientes, sic sextantem vnum,
trientem duo, semissem tria, bessem, quem λ/μοιρον dicunt, quatuor, quin⁵
tarium, quem πεντάμοιρον dicunt, quinᵱ, perfectâm sex, Cum ad suppu/
tationem crescat, supra sex adiecto asse ἔφεκτον, cum facta sunt octo, quod
est tertia adiecta) tertiarium, qui ἔπι ἥ/τος dicitur, dimidia adiecta cum fa/
cta sunt nouem, sesquialterum qui ἡμιόλιος appellatur, duabus partibus
additis & decussi facto, besalterum, quem ἔπι λ/μοιρον vocitant, in vnde/
cim numero quod adiecti sunt quinᵱ quintarium, quod ἔπι πεντάμοι/
ρον dicunt, Duodecim autem ᵱ ex duobus simplicibus numeris est effectus
λ/πλασίωρα, Non minus etiam quod pes hominis altitudinis sextam ha
bet parte, ita ét ex eo quod perficitur pedû numero, corpus his sex altitu/
dinis terminando eum perfectum constituerunt, cubitumᵱ animaduerte/
runt ex sex palmis constare digitisᵱ vigintiquatuor, Ex eo etiam uidentur
ciuitates græcorum fecisse, vti quemadmodum cubitus est sex palmorum,
ita in drachma quoᵱ eo numero vterentur, Illæ enim aereos signatos (vti
asses) ex æquo sex quos obolos appellant, quadrantesᵱ oboloru, quæ alii
dichalca nonnulli trichalca dicût, pro digitis vigintiquatuor in drachma
constituerunt, Nostri autem primo decem fecerunt antiquum numerum,
& in denario denos æreos asses côstituerunt, & ea re compositio nummi ad
hodiernum diem denarii nomen retinet, etiamᵱ quartam eius partem qᵈ
efficiebatur ex duobus assibus & tertio semisse sestertium uocitauerunt,
Postea, quoniam animaduerterût utrosᵱ numeros esse perfectos & sex, &
decem, vtrosᵱ in vnum coniecerunt, & fecerunt perfectissimum decussis
sexis, Huius autem rei authorem inuenerût pede, E cubito enim cum dem/
pti sunt palmi duo relinquitur pes quatuor palmorum, Palmus autem ha
bet quatuor digitos, ita efficitur vti, habeat pes sexdecim digitos, & totidê
asses æracius denarius. Ergo si conuenit ex articulis hominis numerum
inuentum esse, & ex membris separatis ad vniuersam corporis speciem ra/
tæ partis commensus fieri responsum, relinquitur vt suscipiamus eos, qui
etiâ ædes deorum immortalium constituentes ita membra operum ordi/
nauerunt, vt proportionibus & symmetriis separatæ atᵱ vuiuersæ conue/
nientes efficerentur eorum distributiones. Aedium autem principia sût,
e quibus constat figurarum aspectus: & primum in antis quod græce ναὼς
ἐν παραςάςι dicitur, deinde prostylos, amphiprostylos, peripteros, pseu
dodipteros, dipteros, hypethros, Hoæ exprimunt formatióes, his rónib°.
In antis erit ædes, cum hébit in fronte antas parietû, qui cellâ circûcludût,
& iter antas in medio colûnas duas supraᵱ fastigiû symmetria ea colloca/
tum, quæ in hoc libro fuerit perscripta, Huius autem exemplar erit ad tres
fortunas, ex tribus, quod est proxime portam collinam.

Figure 50. Page from incomplete copy of Fabio Calvo's vernacular translation of Vitruvius, *De architectura libri decem*, with revisions by Angelo Colocci and indications for illustrations by Raphael. Hand of Angelo Colocci, perhaps early 1520. Munich, Bayerische Staatsbibliothek, MS It. 37a, 36r. Courtesy of the Bayerische Staatsbibliothek.

Figure 51. The first mention of the classical "orders," in Raphael's prefatory letter to a set of drawings for Pope Leo X. Draft in the hand of Angelo Colocci, written with his close collaboration, about 1519 or early 1520. Munich, Staatsbibliothek, MS It. 37b, 87v. Courtesy of the Bayerische Staatsbibliothek.

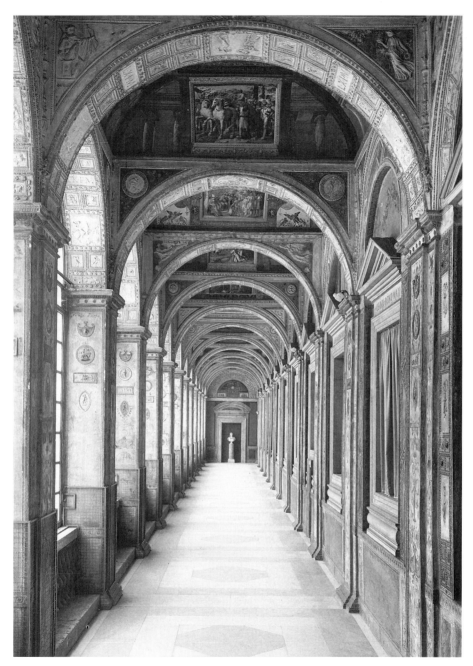

Figure 52. Raphael, Logge Vaticane. 1518. Apostolic Palace. Courtesy of Art Resource.

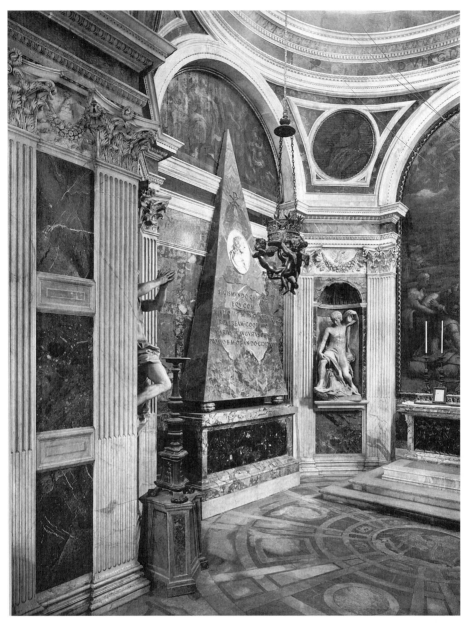

Figure 53. Raphael, Chigi Chapel, Santa Maria del Popolo. Unfinished. Courtesy of Alinari / Art Resource.

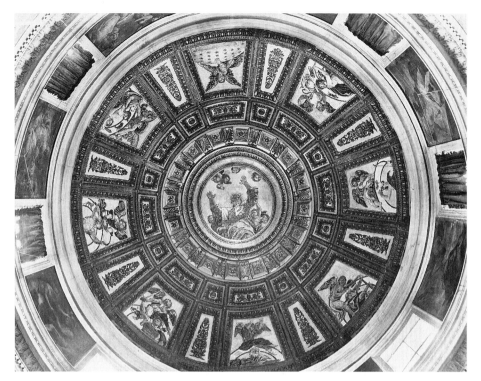

Figure 54. Raphael, Chigi Chapel, dome. Completed 1517. Rome, Santa Maria del Popolo. Courtesy of Alinari/Art Resource.

Figure 55. Raphael and assistants, *Loggia of Cupid and Psyche* (detail): genius figures with attributes of the gods. Fresco, 1518. Rome, Villa Suburbana of Agostino Chigi (Villa Farnesina). Photo by Kyle M. Phillips III.

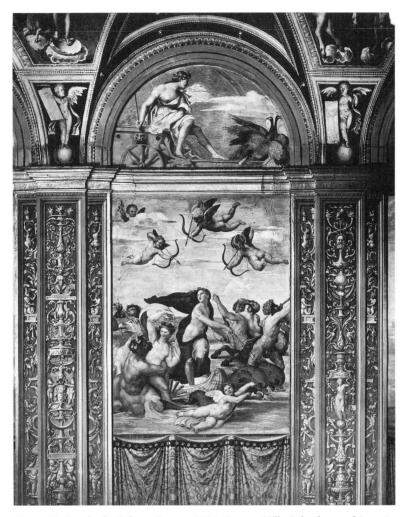

Figure 56. Raphael, *Galatea*. Fresco, 1514. Rome, Villa Suburbana of Agostino Chigi (Villa Farnesina). Courtesy of Art Resource.

heroes] to avoid danger, and [the goddesses] will in the meantime have prepared the highest glory for them.[19]

He assigned Augustine's term *vestigium* to any phenomenon that bore a less exact likeness to God, any "trace" that proved the divine presence in the material world through its possession of three particular qualities: that familiar triad of Wisdom 11:21, measure, number, and weight.[20] The distinctively divine characteristics of *vestigium*, the divine trace, therefore, could always be quantified: they included beauty, harmony, and order, such as might be found in the dimensions of a well-proportioned building or a beautiful body, but also in a well-regulated government, a harmonious religious order, or a peaceful world: "For when the beauty and order of this world are seen, immediately it occurs [to us] that there is an author – either of all this world, or at least, certainly, of its order – who is the parent of all things, or the rector and administrator of nature."[21]

Egidio was a great conciliator by temperament, with particular sympathy for the Jews.[22] Gradually, especially after 1512, his Neoplatonism gave way to a burning interest in the Jewish mystical tradition called the Kabbalah, and over the years his thought became increasingly abstruse.[23] Always, however, he was a good friend, as well as an inspiration, to the humanists of Rome, including, as we know, Angelo Colocci.

If Egidio da Viterbo moved within Riario's circles for much of his career (succeeding Riario in 1517 as cardinal protector of the Augustinian order), he became still more closely linked to Pope Julius himself. As a Franciscan, Julius too had been brought up in a preaching tradition, and this background may well explain his initial interest in sacred oratory. As pope, however, he promoted an eloquence that transcended not only the individual styles of the preaching orders but the very division between layman and cleric, striving to produce a universal language by which to proclaim the universal Church.

Egidio da Viterbo's reforming zeal meshed well with the pope's plans for a renewed Rome and a renewed papacy; both men combined an interest in abstract ideas with a strong practical streak, and both seemed to possess stamina and optimism to an almost otherworldly degree. But then, they both believed implicitly that they were doing God's work.

In 1506, Julius appointed Egidio da Viterbo as acting vicar general of his order, giving him a mandate to eliminate corruption in Augustinian monasteries and to return the order to a more authentic adherence to its rule. In 1507 this promotion was made permanent; Egidio da Viterbo

was confirmed as prior general by his fellow Augustinians, becoming the successor in every sense to Mariano da Genazzano. He now had a 22,000-man monastic order as a field of action.[24]

Egidio's preaching duties may only have increased as a result of his elevation. On many important occasions during Julius's papacy, it was this voluble Augustinian who outlined the pope's plans in a public address, exploiting his peculiar gift for bringing abstract theology down to the realm of immediate action. As usual in an age of allusive rhetoric, he performed this magic by making elaborate references to other times and other places rather than by delivering a set of straightforward pronouncements. When Julius instructed Egidio to preach a sermon on Crusade for Pentecost of 1509, he used the preacher's skill to rouse enthusiasm for the Church Militant without specifying the papal armies' exact objectives.[25] On a fund-raising trip to Tuscany in November 1511, the versatile Augustinian delivered a sermon in which, reportedly, "having proposed some terms of arithmetic, and then of a circular line, which he referred to God, he moved along through a brief sermon, genuinely enticing the people, promising them that on the next day he would announce some matters more specifically pertinent to [themselves]."[26] Apparently, in other words, he used numerology and geometry (probably borrowing from Plato) to describe God's transcendent reality and somehow brought this discourse around to Pope Julius's need for money. Usually he compared current events to events in the Bible, using the prophetic books especially to guide his listeners in their own future behavior. Sometimes he slipped into outright panegyric; in 1506, called upon by Julius to address the citizens of Perugia just after their official return to the papal fold, he heaped the pope with praises rather than delivering one of his stirring calls to action. Julius was not amused.[27]

What moved the crowds must have been Egidio's flights of fancy; his orations might transport his hearers to the corners of the New World, to Madagascar, or to the outer reaches of the firmament. Egidio da Viterbo lived in a world of ceaseless wonders, as tangible as last year's figs still on the tree after a mild winter (like the figs he once waved from the pulpit, while paraphrasing the Song of Songs), or as intangible as a circular God.[28]

Egidio's penchant for the mysterious and the picturesque emerged in more than his travelers' tales or his Neoplatonic theology. A native son of Viterbo, he had quickly fallen under the sway of another famously persuasive preacher from his hometown, the Dominican forger Giovanni Nanni, alias Annius, whose revisionist views on Noah, Egypt, Hercules,

and the Etruscans had seduced the young Augustinian completely. All through the first three decades of the sixteenth century, the revelations of "Berosus the Chaldaean" and his merry company of factitious texts were to come to life again in Egidio's sermons, finding their way, along with the ascending levels of reality, into Julian Rome's larger imaginative life.[29]

It was Egidio da Viterbo who spelled out all the ways in which the pope had become the successor of Noah–Janus, in a series of forced etymologies and free associations that were widely accepted as valid in his own day. Thus, for example, the ancient Roman Janus had protected bridges, and one of the pope's traditional titles, Pontifex Maximus, meant "supreme bridge builder"; this continuity was proof enough, in Egidio's eyes, that the Church had a Janus figure in charge. As god of doors, Janus had been known as *claviger* (keybearer), and so, as keeper of Saint Peter's symbolic keys (which imparted the power to loose and bind on heaven and earth), was the pope. Just as the doors of the Temple of Janus were ceremoniously closed in times of peace, so, too, a fundamental message of the Church was the "peace which passeth all understanding." The Mons Vaticanus itself was a spur of Rome's proverbial eighth hill across the Tiber, named Janiculum after Janus, the primeval Etruscan god. For Egidio da Viterbo, thanks to the efforts of his countryman Annius, the Janiculum was also where Noah–Janus had once presided over the idyllic life of the Golden Age; furthermore, he could assume with confidence that his contemporaries agreed with him. Writing to his friend Antonio Zoccolo about the pope's various efforts to enforce papal primacy, Egidio exclaimed, "Hail, throne of Janus, now truly the Janiculum!", knowing that Zoccolo would interpret the outburst to mean that Julius and his aggressive policies were swiftly ushering in a new Christian Golden Age.[30] Behind the prelate's complex, allusive language lay a disarmingly sincere faith that God's plan was unfolding as it must.

Furthermore, Egidio's musings were models of contemporary scholarly method, striking a clever harmony between the philology of Annius of Viterbo, the archaeology of Pomponio Leto, and the philosophy of Marsilio Ficino. Annius of Viterbo, as we have seen, promoted his forgeries successfully by setting newly sophisticated standards for the authentication and analysis of ancient texts.[31] At the same time, Pomponio Leto had taken great strides in setting standards for the evaluation of material evidence from the ancient world, leading him on occasion to prefer the testimony of coins and inscriptions to the written assertions of ancient

authors.[32] Ficino had set his own textual and empirical researches into a larger philosophical framework, guided by Plato's insistence upon a transcendent supernatural world. From his own position at the forefront of Roman intellectual life, Egidio da Viterbo used archaeological remains and archaeological method to bolster more traditional methods of preacherly exegesis to make plain the intricate series of links between Noah's Etruria and the Vatican of Julius II.

As Egidio saw it, ancient coins, both Roman and Etruscan, offered mute proof of the timeless connection between the Rome of Noah–Janus and the Rome of the papacy. The earliest Roman coins (from the second century B.C.) were large disks of cast bronze, bearing a Janus head on the obverse and an image of a ship on the reverse. Prized by collectors of the fifteenth and sixteenth centuries, they bore a certain resemblance to a still older type of cast Etruscan coin, minted in Volterra in the fourth century B.C. and likewise prized by early collectors. These Etruscan issues also bore an image of Janus on the obverse, while the reverse, in Etruscan letters, displayed the Etruscan version of the name "Volterra," "Velathri." Because Annius of Viterbo had "proven" that Etruscan was actually Aramaic, these heavy bronze coins seemed to be written in the very language of the patriarchs and were thought to bear portentous sayings rather than the name of the city where they had been minted. In a discourse delivered before Pope Julius in 1507, Egidio da Viterbo showed his own familiarity with this early Italic coinage, tying its imagery together with the fabulous histories of Annius to conclude that the course of the papacy had been prefigured in the ancient past:

> Long before . . . they say that Janus ruled on the other bank of the Tiber according to the golden customs of Etruria . . . Why did divine Providence bring it about that the image of a ship was minted in bronze together with that of Janus, unless the Etruscan throne of Janus, which you yourself occupy, long accustomed to divinely favored customs, were not destined for dedication according to divinely favored laws to the Christian ship, and destined to bring the holy laws of Christ, the divinely favored King, to the uttermost ends of the earth?[33]

Remarkably, Julius – impatient, intransigent, and filled with deep skepticism about human nature – listened to assertions such as this and believed them.[34] His acceptance of his role as new Noah, new Janus, Pontifex Maximus and *claviger* were to have profound effects on the cultural life of Rome under his pontificate.

TOMASO "FEDRO" INGHIRAMI (1470–1516)

Julius's other prize orator was, if anything, more dramatic: "Fedro" In-
ghirami, another Riario protégé – a fatter, older version of the pretty
youth who had held the stage so stoutly as Seneca's Phaedra. Despite his
tremendous girth and his wall-eyed gaze, Fedro, in scripted dramas as in
life, remained Rome's greatest actor, and an orator equaled only by Egi-
dio da Viterbo for dramatic eloquence.[35] When Andrea Fulvio called him
"great Fedro," he may have meant the term "great" in both senses, but
the predominant sense was that of Inghirami's authority.[36] This grandeur
also impressed Raphael, who painted a portrait of Fedro with delicate
regard sometime around 1510. By then Inghirami had obtained the right
to wear the red robes that distinguished a canon of Saint Peter's Basilica.
He had also been granted official title to an office he had already held *de
facto* for some five years, librarian of the Vatican Library.[37] Raphael shows
his friend lost in a rapture, pen in one large hand, the other caressing a
Vatican manuscript, his divergent eyes turned heavenward, so that a phys-
ical defect has been transformed into a crucial element of the sitter's spir-
itual portrait (Fig. 32). No less than blind Homer, Fedro seems to be
gifted with second sight.

A quite different portrait of Inghirami survives in the Basilica of Saint
John Lateran, where he served as canon for several years (Fig. 33). In
1508, as Fedro was riding from his *vigna* near the Arch of Titus in the
Roman Forum, he fell off his mule and was run over by a grain cart.
Like many more humble Romans, then and now, he commissioned a
little votive painting of thanks for his survival. Dressed in the black robes
of a canon of the Lateran Basilica, he can be seen riding on his mule in
the picture's background, attended by two young friends.[38] A jaunty red
hat on his head, manuscript in hand, he seems to be the very picture of
a successful humanist consulting the ancient authors amid the ruins of
Rome. Something, though, is wrong with the picture; Fedro's right hand
stretches forth in a sweeping gesture as a flicker of consternation passes
over his broad face. His mule, in fact, has been surrounded by a herd of
jet-black oxen. In the foreground of the picture, chaos reigns; the stam-
peding cattle jostle one another through the Arch of Titus, while the
grain cart's drivers can barely control either their vehicle or their fright-
ened animals. One ox turns back to look at Fedro, almost apologetically,
but the other cattle and their drivers are caught up in their own confusion.
The foremost driver is armed with a sinister short sword, as if he doubles

as a brigand; the wild-eyed beasts, dark as midnight, charge below the famous reliefs on the arch showing the looted treasures of the Temple of Jerusalem borne to Rome as Roman spoils.[39] To the right, a fallen Fedro, his robes pinioned by the wayward cart, looks out from beneath its carriage as one of its wheels crushes his hat. But he has fallen in style: his disheveled robe reveals soft boots adorned with golden spurs, and one of his chubby hands is sporting a large gold ring with a jeweled bezel. The artist portrays him without an ounce of flattery: Fedro's starting eyes are filled with tears, his balding head is grizzled, and the ministrations of his handsome young friends cannot keep him from crying out his prayer for deliverance. In a penumbra in the painting's upper right-hand corner, above the ruins of the Colosseum, the humanist's anguished prayer has already been received by a celestial committee of three. The stiffly frontal Jesus Christ appears as he does on the Lateran's most holy image, the icon of Christ the Savior from the part of the Lateran Palace known as the Holy of Holies (Sancta Sanctorum). This was the image that paraded forth every August 15 to "meet" the icon of the Virgin Mary in the Roman Forum (see Chapter 3); it was said not to have been made by human hands (Greek *acheiropoiêtos*; hence Italian *achiropita*). As canon of the Lateran, Fedro was devoted to its care, and it is logical that the Lateran Christ would be the intercessor to whom he would pray. To the iconic Christ's side stand Rome's two patron saints, Peter and Paul, gesticulating vividly toward the ground, but the miracle has already occurred. Thanks to this divine intervention, as the ex-voto's caption says, "Thomas Phaedrus, snatched from such great danger," lived to make his little painted offering "to Jesus Christ the Savior." He has been saved for a higher destiny; indeed, the detail of his crushed hat may reflect the fact that he would soon exchange his position as canon of the Lateran for the more prestigious canon's office at Saint Peter's. It is difficult to believe that many of Fedra's contemporaries could have borne so uncompromising a portrait of themselves as that of the sprawled figure who forms the focus of this ex-voto. It suggests that a more flattering detail may also be drawn straight from life: the downed Fedro is still tenaciously clutching his manuscript. The Vatican Library could hardly have been put into more instinctively conscientious hands.

The Volterran's oratorical style, like his ex-voto, could only be described as unique. It is important to remember that no less a judge than Erasmus regarded Inghirami as "inventive and authoritative," when we read accounts of performances such as his oration on the death of Christ,

for Good Friday, April 5, 1504.⁴⁰ Under the azure vaults of the Sistine
Chapel, studded with gilt stars, the pope and the College of Cardinals
arrayed before him, Fedro began his account of the Passion as if he were
Perry Mason expostulating before a jury: "Holy Father, to you I report
a terrible crime, and, since the birth of humankind, one unheard of even
amongst the most far-flung barbarians who dwell beyond every reach of
humanity, dared, done, and perpetrated by the most pious of nations."⁴¹
Only gradually did his listeners realize that the crime to which he called
such urgent attention had been committed one and a half millennia ear-
lier, in distant Palestine. And Fedro had just begun to warm up; the
oration reached its climax with a dramatic apostrophe to Pope Julius that
must have exploited a real crucifix on the chapel's wall: "Look, Holy
Father, He stretches out His arms to embrace you. Look, He inclines His
head to offer you a kiss . . . Tears prevent me from speaking further."⁴²
Whereupon, true to his word, Fedro fell silent.

For a pointedly political speech, such as the oration that Julius ordered
him to deliver "in Praise of Ferdinand, the Most Catholic King of Spain
on the Occasion of the Capture of the Kingdom of Bougea in Africa" in
the spring of 1509, Fedro moved from a stately beginning to a gripping
account of the battle itself. Julius regarded the Spanish conquest of Muslim
Bougea as a victory of the Church over the infidel and wanted all Chris-
tians to share his view. Furthermore, when the pope called for a solemn
Te Deum to celebrate the occasion, his ulterior motive was to stimulate
support for his own impending military expeditions in northern Italy.
Inghirami brought the distant battle home by narrating the action in the
present tense, fixing on vivid details that imbued the remote place and
foreign soldiers with familiar signs of life. Furthermore, he called the
Spanish troops "nostri" (our own):

> The king, along with the greater part of the troops (there are more
> than ten thousand foot and as many cavalry) occupies the hill over-
> looking the city. In the meantime siege engines have been arrayed
> along the walls, not only blocking access by land but even making the
> ships' position perilous. All at once, a huge onslaught of every kind of
> missile flies from the walls: arrows, grenades, pellets, stones come on
> as thickly as a cloud of hail. At a single instant two hundred siege
> engines slam down on the close-packed soldiers.⁴³

The give and take of battle rages for several pages of manuscript; it must
have taken up ten minutes or more of Fedro's oration when he delivered

it. Suddenly the garrison of Bougea hesitates, and Inghirami brings his audience to a still higher emotional pitch:

> But this did not happen because of human strategies. Not alone did the strength of the Western world take action in that place and at that time, not alone did the stout men of Spain do combat, not alone did the Iberians draw their battle line. The [enemy] shrank back at a greater sight than that of a human figure. Jesus Christ Himself, the Omnipotent God who wages war against the impious and lawless nations, Jesus, I say, fought them Himself, smote them Himself, scattered them Himself. For who made it come to pass that none of the missiles cast forth in that dense multitude reached their target? Jesus.[44]

A surviving description of Fedro's oratorical style, written posthumously by his friend Janus Parrhasius, shows certain similarities with Sadoleto's description of Egidio da Viterbo at work; the prize papal orators strove consciously to meet a common standard of apostolic fervor and sterling latinity. Not surprisingly, in an age before amplification, they are remembered for their voices, for the discipline with which they controlled them as well as their native attractiveness. Egidio, in Sadoleto's opinion, had a "warmth and power in speaking, a liveliness of voice . . . in which [he] had such skill that he first soothed the spirits of every bystander with the utmost gentleness and then moved them with the greatest forcefulness to the opposite extreme."[45] Fedro seems to have been still more extravagant a performer, an actor to the core. Less elaborately allusive than Egidio, his oratory moves more evidently from a limpid flow of elegant words to vivid peaks of emotion, falling off abruptly for dramatic effect. Those same qualities were contagious enough to show forth in descriptions of him, like this eulogy from his friend Janus Parrhasius: "Alas! that voice of Thomas Phaedrus, delightfully resonant, is silent now, the persuasiveness of his articulate tongue, that drove his listeners' minds through every emotion and restored the Roman eloquence that had been lost since the time of the Goths. Where is he now, matching his gestures with his statements? Where is the pure integrity of his Latin speech?"[46]

This prize orator must have begun his association with the Vatican Library in 1505 or so, although his exact position there is not always clear; by 1508, he was drawing a salary from the pope but had not yet been officially awarded the position of *bibliotecarius*, or head librarian. That

would only come in 1510, with the death of the previous librarian (a Della Rovere relative who had been little more than a figurehead).[47] Deoclecio Redig de Campos has suggested that Inghirami might have worked in the interim as curator for the private library of Julius II, an ad hoc position whose exact duties are therefore nearly impossible to trace.[48] However, the librarians of rulers such as Federigo da Montefeltro not only acquired and commissioned books but also read aloud to their patrons. Julius's private librarian may well have been expected to do the same, in which case Fedro's intellectual intimacy with the pope may have been unmatched. One can only imagine what those readings might have been like, what with Fedro's taste for the dramatic and Julius's tendency to flail his cane when excited.

Inghirami's position in the library was a plum within the papal patronage system. A lifelong appointment, it stood outside the Curia's crowded roster of venal offices and afforded him privileged contact with the pope, as well as the solace of that incomparable collection of books. His was the dream job of many a humanist, and those who failed to obtain it could become quite bitter about the loss. Angelo Poliziano, the chief humanist in the court of Lorenzo de' Medici, applied twice from Florence, in 1483 and 1488, and was turned down both times. It is telling that he saw the real center of intellectual life in a Roman library rather than in Medicean Tuscany, and his disappointment at being passed over may have been profound.[49]

Angelo Colocci may have coveted Fedro's position too; his friendship with Inghirami seems to have suffered some strain in its later years, when he composed a set of poems lampooning Fedro's bulk. It is also true, however, that Colocci only began daring to borrow books from the Vatican Library in 1510, the year of his friend's official elevation to the position of head librarian.[50]

Inghirami's ascendancy in the Julian court did not stop with the librarianship; in 1512, Julius appointed him secretary to the Fifth Lateran Council, where his resonant voice could make the council's proclamations heard to the back of the immense Lateran Basilica. Eventually Inghirami would also be charged with delivering the funeral oration for Julius at the dying pope's request, proof of the fidelity with which "Great Fedro" had promoted Julius's image with his oratory. The funeral oration itself was in many respects the crowning achievement of this promotional effort; it showed, in addition, how automatically Fedro and his hearers

accepted a religious doctrine that paid homage to *prisca theologia* and to Ficinian Neoplatonism, and how frankly Fedro approved the pope's eagerness to enforce papal primacy in the most literal terms:

> Good God! What talent was equal to his, what prudence, what experience at the ruling and administration of empire? What strength could match that of his lofty, unbreakable spirit? He had no rest, no sleep, no joy until he had beaten back the rebellion of one and all, called their will to obey back into compliance, extinguished tyrannies, and abolished civil dissensions and internecine hatreds – not by force of arms, but by his counsel and his authority.[51]

Fedro's bellicose eulogy was perfectly appropriate to the keeper of the Vatican Library under Julius II. From the beginning, as its full title, Biblioteca *Apostolica* Vaticana suggests, the papal library had been (and still is) conceived of as a means of spreading the Christian Gospel through the promotion of knowledge: in the words of Sixtus IV's bull *Ad decorem*, of 1475, "for the enhancing of the Church Militant, for the increase of the Catholic faith, and for the convenience and honor of the learned and studious."[52] To the popes of the fifteenth century, the collected wisdom of their forebears served to reinforce the universal validity of Church doctrine, based on the combined wisdom of the Old Testament, Greco-Roman antiquity, and the exotic lore of *prisca theologia*.[53]

The Vatican Library's original collections thus included far more than Bibles, the writings of the Church Fathers, and scholastic theologians. Works by ancient Greek and Roman authors stood alongside the "Egyptian" prophecies of Hermes Trismegistus and Philo of Alexandria's commentaries on the Bible, and all of them were well used by the humanists in the library's first decades of operation.[54]

The library was an important focus for Julius II long before he became pope. When his uncle Sixtus IV entrusted the running of the Vatican Library to Platina in 1475, he also seems to have assigned Cardinal Giuliano Della Rovere some conspicuous role in promoting the institution itself, a role that can now only be surmised from Melozzo da Forlì's fresco and a smaller fresco in the Ospedale di Santo Spirito, where again the cardinal and the librarian stand in tandem to guide the pope through his new, beautified facility.[55] Thirty years later, as pope in his own right, Julius had not forgotten the library's apostolic purpose, nor, evidently, did Fedro Inghirami. And in 1508, another papal orator for the Julian

court, Battista Casali, made similarly sweeping claims for the importance of the Vatican Library to the Church Militant.

BATTISTA CASALI AND THE SCHOOL
OF ATHENS

Battista Casali (1473–1525), a rumpled, long-haired academic, with an academic's tendency to rebel against such restrictions on his self-expression as appropriate clothing or protocol, had been a professor since 1496 at the *Studium Urbis*. Despite his eccentricities, he made fairly regular public appearances as a preacher under Popes Julius II and Leo X.[56]

On January 1, 1508, Battista Casali delivered an oration in the Sistine Chapel *coram papa*, that is, in the presence of Julius himself, to celebrate the Feast of the Circumcision. Christian males in early sixteenth-century Rome did not undergo circumcision; hence, most of Casali's homily sought to raise the practice from a specific initiation rite for Jewish males to a metaphor for the sense of self-limitation and self-sacrifice that marked the Christian concept of humility. At the very end of his speech, however, Casali turned to an image of the Vatican Library as a new Athens:

> Once . . . the beauty [of Athens] inspired a contest between the gods, there, where humanity, learning, religion, first-fruits, jurisprudence, and laws are thought to have arisen and been distributed to every land, where the Athenaeum and so many other gymnasia were to be found, where so many princes of learning trained her youth and schooled them in virtue, fortitude, temperance, and justice – all of this collapsed in the whirlwind of the Mohammedan war machine.
>
> But . . . just as [your uncle, Sixtus IV], as it were, laid the foundations of learning, you set the cornice upon it. There is the pontifical library which he erected, in which he has, as it were, brought over Athens herself; gathering what books he could from the shipwreck, he established a very image of the Academy. You, now, Julius II, Supreme Pontiff, have founded a new Athens when you summon up that prostrated world of letters as if raising it from the dead, and you command, amid threats of suspended work, that Athens, her stadiums, her theaters, her Athenaeum, be restored.
>
> This is why, Blessed Father, you achieve what your soldiers shall never conquer by arms, shackling your adversaries with bonds of learning, learning with which, as with a sponge, you will erase all the errors

of the world and circumcise the ancient roots of evil at their base with a sickle of adamant.[57]

To Casali, then, the Vatican Library and the learning contained within it were the single most effective Crusade that Julius might mount. Just as Melozzo da Forlì's fresco of Sixtus IV organizing the Vatican Library and Platina's accompanying elegy put the library into a larger scheme of urban renewal, so too the Vatican Library under Julius remained a powerfully aggressive institution, an active stimulus to the cultural ferment of papal Rome.

An anecdote related by Michelangelo's biographer Ascanio Condivi has sometimes been used to call Julius's intellectual interests into question: in 1506, at the height of Julius's first papal military campaign, Michelangelo arrived in Bologna to produce an immense bronze statue of the pope. The Florentine artist asked his sitter whether he would like to be shown holding a book. Julius replied, "Better show me with a sword, because I'm no scholar."[58] Condivi's Italian says, "Che io non so lettere" (because I don't know letters). Strictly speaking, the phrase means: "I'm not a classical scholar"; an unabashed intellectual like Leonardo da Vinci made virtually the same statement about himself as an "uomo sanza lettere" and so did Donato Bramante. The words do not mean that either Julius or Leonardo regarded himself as an ignoramus, however slyly Condivi may be hoping to suggest something of the sort. Rather, in the midst of a military expedition, the anecdote reveals a good deal about Julius's priorities, and about his forthright nature. As the nephew of a famous theologian, the pope certainly knew what scholarship was, as well as his own limitations in the matter, but his own lack of pretension does not translate automatically into lack of appreciation or lack of interest. His personal library was large enough to merit a caretaker, Fedro Inghirami, and a haughty intellectual like Pietro Bembo could find it much preferable to the Vatican proper as a place to work. (Michelangelo, incidentally, cast the statue of Pope Julius with a sword *and* a book.)

Indeed, like yet another famously "unlettered" contemporary, Agostino Chigi, Julius understood the value of letters without necessarily participating in them himself, just as he understood the communicative powers of oratory, music, art, and architecture without himself being a great speaker, a composer, a painter, a sculptor, or a builder. Julius was a pope, and as pope he well recognized the power of these various media

to advance his own apostolic enterprise. Gruff, with barely a shred of diplomacy in him, Julius was nonetheless possessed by a positive furor to communicate; the wildly waving cane for which he became notorious punctuated the moments in which his frenzy to share his thoughts overcame his power of articulate speech.

More tractable than the chaotic world he strove to shape to his will, works of the imagination could lay out his ideas as he envisioned them; revealingly, one of his favorites was a stained-glass window commissioned in 1507, portraying the king of France on his knees before the pope – an event that never happened in reality but that had happened in Julius's dreams more than once.[59]

ENTER MICHELANGELO

As cardinal, Giuliano Della Rovere had commissioned Antonio del Pollaiuolo's spectacular bronze tomb for Sixtus IV, which represents the deceased pope lying on a catafalque decorated with personifications of the liberal arts.[60] A man of strong opinions about art, Julius wasted no time as pope in ordering his own funerary monument, again engaging a Florentine artist to undertake the task.

In many respects, Michelangelo Buonarroti followed directly in the Tuscan tradition of Pollaiuolo: like most of their Florentine compatriots, they favored lean, muscular human figures with clearly drawn contours, based on their close observation of Etruscan and Roman bronzes as well as the paintings on the Greek vases that so often were recovered from Etruscan tombs.[61] Michelangelo, moreover, had spent his youth in the household of Lorenzo de' Medici, absorbing Neoplatonic philosophy and an interest in vernacular poetry but maintaining his distance from Lorenzo's effete, courtly artistic taste. Indeed, the expulsion of the Medici from Florence in 1494 and the subsequent reestablishment of a Florentine republic must have first inspired him to give full play to his muscular classical style, modeling his own work on the ancients just as the Republic modeled its revamping of the city's civic institutions on the Republican era of ancient Rome. But the early years of the Florentine republic were turbulent, when the city gave way to the apocalyptic preachings of the demagogic Dominican friar Girolamo Savonarola. In 1496, Michelangelo made a prudent artistic pilgrimage to the Eternal City, where Raffaele Riario challenged him to create something as wonderful as the ancient statues in Riario's collection.[62] The eventual result was his *Bacchus*, which

did not, apparently, meet the cardinal's standards. But another Roman commission was in the offing; by late 1497 or early 1498, Michelangelo was in Tuscany again, to select the gleaming block of Carrara marble from which he would carve his *Pietà* for the French cardinal Jean Villiers de Fezenac. It must have been this magnificent statue, with its Roman monumentality and Christian pathos – not to mention its silken finish – that gave Pope Julius, that discerning collector of ancient sculpture, a vision of what he might eventually want for himself.[63]

Julius first intended to have his burial place in what had been his titular church as cardinal, San Pietro in Vincoli. Quickly, however, the mercurial pope changed his mind; by 1505 he had decided that he would be interred instead in the Vatican, where he would raze Saint Peter's Basilica and replace it with an entirely new building. Michelangelo, momentarily startled by the change in plans, was still more startled to learn that Julius also had a new project in mind for his favorite sculptor: a new frescoed ceiling for the Sistine Chapel. Although Michelangelo protested that he was no painter, Julius insisted to the contrary, with what must now be admired as extraordinary insight.

THE SISTINE CHAPEL CEILING (1508–1512)

Michelangelo finally succumbed to the pope's persuasion in 1508. He was to finish, with a bad crick in his neck and a frazzled temper, in 1512.[64] Like Pinturicchio's frescoes for the Borgia Apartments, and like the earlier fresco cycle commissioned by Sixtus IV for the Sistine Chapel walls, the Sistine Chapel ceiling used visual images to set the Church within the scheme of universal history, but the difference in scale between Michelangelo's work and that of his forerunners was epochal. The Sistine Chapel walls, which had surely been conceived in the 1480s according to a plan devised by Pope Sixtus himself, traced parallel lives of Moses and Christ, showing how every aspect of the life of Moses among the Egyptians and Hebrews prefigured some aspect of the life of Christ and the Church.[65] The finding of Moses in the bulrushes prefigured the Nativity; Christ's baptism was prefigured by the circumcision of Moses' son; and, most emphatically for the whole scheme, Moses' handing down the Law foreshadowed Christ's handing over the keys of authority to Saint Peter.

To save time and to encourage better work through competition, Sixtus engaged a team of artists to carry out the decoration of his chapel,

including Luca Signorelli, Sandro Botticelli, Cosimo Rosselli, and Domenico Ghirlandaio. The most conspicuous scenes, however, as well as the altarpiece with the *Assumption of the Virgin*, were all assigned to the Umbrian whirlwind Pietro Perugino. Without doubt, the scheme's centerpiece, and the fresco on which Perugino lavished the greatest care, was the *Transfer of the Keys* in the center of the right-hand wall, a tribute to the papacy's founding moment. (In later years, the painting was believed to bring good luck in the conclave to the cardinal whose cell was placed beneath it, and they jostled for the assignment. In 1503, that lucky cardinal was Giuliano Della Rovere.)

Above the large biblical scenes from the Old and New Testaments, a series of life-sized portraits of popes drove home the point that the Sistine was a papal chapel, and that its walls looked down upon the living continuation of a long sacred tradition. Sixtus, careful scholar that he was, took care that each painting bore a label, so that the identity of each pontiff would be clear and each biblical scene would yield up the significance he intended it to have. The ceiling itself was an image of heaven, painted deep blue and studded with gilt stars. Although such decoration was standard, it was expensive: good blue was made from ground lapis lazuli, and the gold of the stars was real.

Julius II and Michelangelo first envisioned a continuation of the chapel's basic theme and its basic pictorial structure: twelve Apostles, six on a side, would look down from the ceiling's fictive heaven as saintly forerunners to the range of painted popes.[66] Sixtus IV had seen his evangelizing mission as one of his most important duties, a commitment that is expressed in his labels for the Sistine Chapel wall paintings as well as in the charter he drafted for the Apostolic Vatican Library. In the hands of such an artist and such a patron as Michelangelo and Pope Julius, however, this simple if compelling structure was bound to complicate. In the end, Michelangelo traced the role of the Church and its apostolic mission back, not to the days of the Gospels but to the beginning of time, to the moment when God first began to dispose the world in number, measure, and weight by creating heaven and earth, and he traced the first papacy back beyond the lawgiver Moses to the world's primordial lawgiver, keybearer, and lord of the Janiculum – Noah.

Michelangelo's ceiling arrayed fictive panels showing events from the Creation to the Flood among huge figures of prophets, sibyls, and Jewish patriarchs, set where the Apostles had once been intended to reign (Fig.

34). If the subjects themselves were familiar, their presentation was anything but. For a pope who claimed to be no scholar, the sculptor, who claimed to be no painter, proved that he could build up layers of paint (and ideas) as commandingly as he could chisel away layers of stone. The imposing painted architectural framework with which Michelangelo arched over the chapel's cavernous interior almost seemed to embody the structure of the Church itself.

Both the scenes of the Creation and the emphasis on Noah, like the prophets and sibyls, find their echoes throughout early sixteenth century Rome.[67] These were years in which both Angelo Colocci and Egidio da Viterbo, for example, expended a great amount of mental energy wondering how a single God could create a multiplicitous world, discussing exactly where and when measure, number, and weight had entered the creation, concluding, as does the chapel ceiling, that the exact moment must have been with the first division of the creation from the Creator. Along with number, measure, and weight, God at the same instant had also created order, for order, as philosophers and theologians agreed, could not exist without sequence and priority.[68] In that first act of God was contained the whole idea of a hierarchical Church in a multifarious world.

After the creation of heaven and earth, Michelangelo's purple-clad God whirls around to separate light from darkness and then to create the sun and moon. He divides the land from the waters and then moves on to create Adam, who can barely muster the energy to receive the breath of life from a God who contains all the rest of creation in the fold of his capacious cloak. (The "bosom" of the King James Bible really means the fold of a garment.) Eve's creation follows next, then the temptation in the Garden of Eden and the human couple's expulsion. The story of the Creation ends with humanity's fall from grace, the moment for which Christ and the Church were meant to atone.

As for Noah, he is shown three times, and not in chronological order, first making sacrifice after having landed the Ark on Mount Ararat, then gathering the animals and embarking them on the Ark, and finally as a digger of vineyards who is one day discovered drunk in his tent by his three sons. The scene of sacrifice parallels the strongly sacrificial language of Eucharistic liturgy, while wine also refers back to the earliest prefiguration of the Eucharist. They frame the image of the Ark, which is an old Christian image for the Church itself. These points of reference are

not unusual, nor are they meant to be. But in 1512, these ancient images took on added urgency in light of Annius of Viterbo's still-convincing "proofs" that Noah, the proverbially just man, the promoter of religion, and the inventor of viticulture, was also Janus, lord of Etruria. As Michelangelo brushed the patriarch's figure onto the Sistine Chapel ceiling, Egidio da Viterbo was exclaiming, "Hail, Vatican, now truly the Janiculum!" to his friend Antonio Zoccolo. It might be a fitting caption for the ceiling as a whole.

In their symbolic import, Michelangelo's prophets and sibyls, like his biblical scenes, differ only in their muscular grandeur from those in the Borgia Apartments; they mean virtually the same thing.[69] And yet, they seem to mean much more, for the Sistine Chapel ceiling marks a drastic change in color, in spatial sense, and in sheer majesty from the art executed for previous popes. Furthermore, Michelangelo had organized a complex series of themes into an astoundingly intricate system in which each of these themes had its own specific place in the larger order, as well as its own specific mode of representation: fictive panels across the center of the vault contain scenes from the Creation, the stories of Adam and Eve, and the life of Noah; the lunettes along the walls were peopled by Hebrew patriarchs, colossal prophets and Sibyls perched above the windows, while fictive bronze plaques, fictive stone cupids and terrifyingly lifelike nude youths add still more layers to the assemblage. Michelangelo, a Ficinian from his youth, must have seen the world in Neoplatonic fashion, as a series of levels of reality, but it was his genius to give those levels a systematic arrangement in the varying orders and styles of expression that organize the separate parts of the Sistine ceiling within a greater whole.[70] Like Egidio da Viterbo's *vestigium* and *imago*, Michelangelo's ceiling makes the layered Neoplatonic view of the world something that anyone can begin to grasp.

Julius was beside himself with impatience to see his ceiling finished. Much as Michelangelo grew to resent the intrusions of the burly old man with the flailing cane, he must have understood what was driving Julius forward, for he captured it in his epic frescoes: not only a set of ideas but their coordination toward a single end, the Church Triumphant. The Sistine Chapel's final design still enshrined Julius's commitment to an apostolic faith, but rather than presenting a faith conceived in the first century of the Roman empire, Michelangelo showed a faith begotten at the beginning of time.

THE *STANZE* OF RAPHAEL

The same apostolic drive showed forth from Raphael's brush in the papal apartments, now called the "Chambers," or *Stanze*.

By November 1505, Julius had decided to decorate his own apartments in the Vatican Palace rather than continue to live in the papal suite that Pinturicchio had frescoed for Alexander VI.[71] The rooms directly upstairs, formerly used by Cesare Borgia and by some of Alexander's favorite cardinals, provided an easy solution; their walls were bare, and their access to the rest of the Apostolic Palace was virtually identical to that of the Borgia Apartments. The pope settled there definitively in November 1507, redux from his first military campaign.[72] Originally Julius had engaged a team of painters to work on his quarters, an expedient that would have allowed him to complete the redecoration quickly, but in the end he awarded the whole assignment exclusively to Raphael, who had quickly revealed himself as something of a boy wonder.[73] Just as Michelangelo's early work may have reminded Julius of Pollaiuolo, Raphael's must have evoked memories of the art of his Umbrian teachers: Perugino, the chief painter of the Sistine Chapel walls and of its altarpiece, and Pinturicchio, another favorite of the Della Rovere family. Yet, as with Michelangelo, the pope obtained not the continuation of a traditional style he obviously liked but startling novelty.

Newly arrived in Rome in 1508, thanks to some string pulling by his relative Bramante, Raphael began to work in the room that housed Julius's private library (today called the "Stanza della Segnatura," because it was later the home of the Signatura Gratiae, a papal tribunal).[74] Its collection of books was choice, and its working environment singularly pleasant; as we have seen, the aesthete Pietro Bembo much preferred it to the regular Vatican Library.

The curial humanist Paolo Giovio reported that this "upper library" and a neighboring chamber were executed "to the specifications of Julius II."[75] Certainly, after four years spent looking at the gilded portrait of Alexander VI in pious prayer, Julius was ready to look at something else; in the two rooms that Raphael painted during Julius's papacy, there are four images of him during the various stages of his reign. Had he not died before the suite was completed, there might have been several more. Yet the most important portrait in the Stanze is a figurative one, for Raphael, like Michelangelo, was able to give remarkably concrete form to Julius's vision of the Church.[76]

The imagery of the Stanza della Segnatura also bears a close relationship to themes developed in some of Fedro Inghirami's unpublished writings. If this was Julius's library and Fedro was its librarian, it is not surprising that he and Raphael were thinking about the same ideas; Julius charged each of them in his own way to convey his visions to the Christian flocks. Both, furthermore, were outgoing men who loved a good chat, and it is hard to believe that either of them would have kept entirely quiet on trips into and out of the pope's library. An amazing number of books populate the frescoes of the Stanza della Segnatura, and very few of them are being read by silent scholars sitting alone; they are being passed around, declaimed aloud, spied on over shoulders, all of them public treasures that serve as the subjects for animated conversations, just as their real counterparts in the Vatican libraries must have done (and still do). Raphael himself appears in the right-hand corner of the fresco known as *The School of Athens* (Fig. 35), and the fat Epicurus in the foreground of the opposite corner, engrossed in a book while a handsome colleague peers over his shoulder, might, with his playful smirk and his carefully downcast eyes, present the Platonic form of "Phaedrus" Inghirami (Fig. 36).[77]

In their general organization the frescoes of the Stanza della Segnatura represent the four divisions into which several contemporary humanistic libraries, including the Vatican Library of Nicholas V, had organized their holdings: Theology, Philosophy, Letters (or Poetry), and Jurisprudence.[78] Within the room itself, these divisions are labeled as such by Latin inscriptions on the ceiling above each wall. Theology is shown in an image now called *The Dispute over the Sacrament* (Disputa del Sacramento; Fig. 37). In fact, however, there is no argument: in this fresco, the whole Church, composed of Hebrew prophets, Christian martyrs, popes, theologians, and wayward mortals, is arrayed (with a few stubborn exceptions) to adore the elevated Host, which also coincides with the vanishing point of the painting's perspective structure.[79] Above, Christ in Glory shows his stigmata, proof that before his Resurrection he had taken on human form and died, and a reminder that his body and blood are believed to be present at the liturgy of the Eucharist. Among the four doctors of the Church ranged around the sacramental altar, Pope Gregory the Great is a portrait of Julius, hale and beardless in the early stages of his papacy.[80]

The library's holdings in philosophy are shown as an idealized *School of Athens* (Fig. 38), where the great thinkers of antiquity (and a few more

recent contributors) gather to discuss the nature of God and humanity, led by Plato, carrying a copy of his cosmological dialogue *Timaeus*, and Aristotle, clutching his *Ethics*. These are the champions of *prisca theologia*, whose insights into the nature of God allowed Christianity its quick conquest.[81]

In the *Parnassus*, letters are symbolized by a conclave on the sacred mount, home of Apollo and the Muses (Fig. 39).[82] (Fedro notes in one of his scholarly works that the poets were the first of all mortals to praise God.)[83] The mountain peak cleverly arches over a problematic aspect of the wall, which contains a large window. Half rapt in contemplation, Apollo, his lyre modernized as a sixteenth-century *viola da braccio*, fiddles among a company that includes the nine Muses, ancient Greeks, ancient Romans, Dante, Petrarch, and contemporary Italians.[84] Blind Homer declaims to Virgil and Dante as a sultry Sappho clutches a papyrus scroll bearing her name. One of the Parnassian figures is allegedly a portrait of Angelo Colocci's best friend, the Ferrarese poet Antonio Tebaldeo; Colocci himself had not produced enough verse to qualify for a position on the Muses' mount, and he never would. He may, nonetheless, have made his own contribution to formulating the image by hosting many of the learned gatherings that made this Parnassus conceivable. He counted among his prize antiquities an ancient bronze votive tablet dedicated to Apollo and the nymph Clatra, a treasure probably discovered in the *vigna* that had passed to him from Pomponio Leto.[85] Thus one of the chief haunts of the Roman Academy, on sound archaeological evidence, seemed to be sacred to the god of Parnassus. So too, according to long humanist tradition, did the Vatican Hill itself.[86] The humanists themselves insisted continually in verse that the quality of their own poems furnished decisive proof that Apollo and his Muses still governed Roman creative life, and Raphael, as an aspiring poet himself, proved only too willing to enshrine the idea in vibrant color.

The fourth wall fresco, only partially completed, represents canon and civil law in the form of two great codes: to the left side of the window, the Emperor Justinian receives the Pandects from the Byzantine jurist Trebonianus, while to the right Pope Gregory IX receives the Decretals from Saint Raymond of Peñafort.[87] These two rulers and their jurisconsults appear beneath a composite image of Justice (as she is presented in Plato's *Republic*, an ineffable combination of prudence, temperance, and strength). Julius appears again in this room as Pope Gregory, now bearded and noticeably more frail.

Raphael's paintings, therefore, like Michelangelo's Sistine ceiling, present certain immediately recognizable figures from classical antiquity and Church history. In the Rome of Julius II, however, these familiar figures often took on added meanings that were highly specific to the papacy and its aspirations; they were marshaled, in other words, in particular combinations to further particular ideas. They retained their conventional meanings: Minerva still denoted wisdom, Socrates was still the restless questioner, King David was both the divinely anointed ruler and the divinely inspired poet, but the precise significance of wisdom, or restless inquiry, or divine kingship depended significantly upon their combination and ultimately reflected the pope's own careful attention to the imagery of his reign.

The people who would see the frescoes of the Stanza della Segnatura, or, better, of Julius's library, were his closest intimates or high officials. The images were meant to speak to this select group with enough clarity to convey a message and enough riddling to entertain them. Thus Raphael left his compositions for the room somewhat open-ended, with people rushing in from somewhere else, gestures that signify something we cannot quite understand, rays of golden light, packed with cherubim, pouring down upon the assembled ranks of the *Disputa* from a source beyond the plane of the picture itself, as inaccessible to human eyes as a Neoplatonist would claim that God's reality is inaccessible to human reason.

In the world outside the Vatican, Pope Julius moved from taking stock of the awesome institution of the papacy and turned quickly to action. So too did Raphael's decorative program for the pope's apartments. In 1512, the artist turned his attention to the room adjoining Julius's library; it probably served as an audience hall.[88] The chamber is now called the "Stanza di Eliodoro," after one of Raphael's frescoes: Heliodorus, a corrupt Greek official appointed by King Seleucus of Antioch to act as treasurer of the Temple in Jerusalem, is being flogged away from the sacred precinct by wingless angels. The coins he has purloined from the Temple treasury clatter to the pavement as Heliodorus cowers in a tortuous crawl. As the High Priest of the Temple prays on unperturbed, Julius II enters on a litter from the left side of the painting, beholding God's agents at work. It is hard not to associate the punishment of a greedy Temple treasurer with an admonition about the state of Julius's own Apostolic Chamber.[89]

Only two other walls of the Stanza di Eliodoro were completed in Julius's lifetime, and they too show God's active intervention in matters

of religion. *The Mass of Bolsena* (Fig. 40) commemorates a miracle said to have occurred in a small city north of Rome. In 1262, a German priest, returning from a pilgrimage to Rome, was tortured by doubt as to whether the communion wafer could really turn into the body and blood of Christ. At Bolsena, he was suddenly called upon to serve Mass to the pope. During the liturgy, the Host, imprinted with the image of the crucified Christ, began to bleed. The blood stained the liturgical linen with an indelible blot, and it assuaged the priest's doubts. The citizens of Bolsena instituted the feast of Corpus Domini to honor the miracle, and then, as happened so often in the Middle Ages, the city began squabbling with its neighbor Orvieto over possession of the bloody cloth.[90] Julius himself was particularly devoted to this prized local relic. Raphael's fresco, by choosing to commemorate the event, helps to reinforce the Eucharistic message of the *Disputa*, but whereas the earlier painting functions almost as an icon, laying out the doctrine of the Eucharist from God, through Christ, through the Host, through the priesthood, all the way to ordinary people, the *Mass of Bolsena* commemorates an empirical demonstration that the liturgy of communion is real. Transubstantiation had only recently been declared dogma, and the whole matter of Christ's Incarnation was of particular interest to theologians of the early sixteenth century. They had already begun to apply a way of thinking that would eventually be defined as scientific, and they were finding that such analysis often gave disturbing results.[91]

It is the frail but still imposing figure of Julius himself that we see in the guise of the medieval pope, worn out by his recent military campaigns and several near-fatal bouts of illness. Raphael has turned the emblematic miracle into a searing personal portrait. Now that Melozzo da Forlì's aggressive cardinal has turned into an elderly Supreme Pontiff, his eyes are no longer a drill trained on his rivals but a window into the mysteries of the faith he has been charged to embody; he took that charge so personally that he once reacted to some favorable news by crowing "Julius and the Church!" (Giulio e Chiesa!) for the rest of the day.[92] In *The Mass of Bolsena*, the restless, pugnacious old man shows the pensive side that was as important to the direction of his papacy as his indomitable will. And yet, if the miracle of Bolsena offered physical "proof" that the ceremony of the Eucharist transformed wine and water into the literal flesh and blood of Christ, Raphael's image of Julius, with his still-strapping frame, seems to suggest that the Church itself has a no less physical reality.

Below him, to the right, Raffaele Riario cuts a striking figure – portly,

black-haired, and eminently self-possessed – and just below the cardinal kneels a marvelous complement of velvet-clad Swiss guards, presumably including some of the soldiers who had fought so valiantly for Julius in northern Italy.

The fresco on the opposite wall shows Saint Peter's liberation by an angel from the dread Mamertine prison in the Roman Forum (Fig. 41).[93] Raphael has illuminated this dramatic nighttime miracle by the pale silver light of a full moon and the angel's blinding golden nimbus, a kind of magic circle into which Peter's hand and arm are pulled in an angelic clutch. Here, Julius did not have to be shown as a spectator; as pope, he was the living vicar of Saint Peter. As with the Mass of Bolsena, Raphael's fresco has enshrined a relic for which the pope reserved particular devotion, the fetters that had bound Saint Peter in prison, prize relic of his erstwhile titular Church of San Pietro in Vincoli (St. Peter in Chains).[94] In silhouette, the chains provide a central focus for Raphael's painting.

CLAVIGER REGNI COELORUM

Shortly before Raphael painted the *Liberation of Saint Peter*, a musician for the Sistine Chapel (possibly Heinrich Isaac) furnished a motet for the saint's feast day on June 29. The piece was composed early in Julius's reign, certainly before 1507. Its words give some idea of what Saint Peter meant to this pope and how closely Julius identified with him:

> O keybearer [*claviger*] of the kingdom of heaven and prince of
> Apostles,
> Deign to pray to pious Jesus Christ our Lord on our behalf
> So that by the vows of your prayers the filth of our guilt may
> be washed away
> And so that the prince of all princes may award us entrance
> into the heavenly paradise after death, the athlete [of virtue],
> most powerful Peter;
> So that by the strength of your prayers the filth of our guilt
> may be washed away.
> Pray for us to your Lord and Master,
> Who handed over the keys to the Kingdom and the care of his
> flocks
> Who committed the reins of heaven and earth to Peter
> So that he might open the doors for those who were shut in
> and loose the chains of those in bondage.

He ordered that your own chains, Peter, be loosed,
[He] who charged you to loose the knots of this world,
Who committed the reins of heaven and earth to Peter
So that he might loose the chains of those in bondage.
By the merits of our Shepherd and saving prayer,
Eternal Shepherd, free us from the debt of our sins. Amen.[95]

Performed from the side balcony of the Sistine Chapel, the sung words of "O claviger regni coelorum" echoed the imagery of the wall fresco situated almost directly over the heads of the choir, Perugino's stately *Transfer of the Keys* of 1483 (the very fresco that had brought Cardinal Giuliano such luck at the conclave that elected him pope). Thus, as a painted Christ handed over the keys of the Kingdom of God to Saint Peter, the choir saluted the saint (and, by extension, Julius) as *claviger*. As a piece of music, however, "O claviger regni coelorum" shows the kind of architectonic structure and complex interweaving of motifs that would soon distinguish Michelangelo's ceiling, gently arching overhead; both were created, after all, at the same time and for the same pope's vision of muscular Christianity. But like an oration of Fedro Inghirami, the motet ends with a flourish, a catchy coda in triple time that drives home the pope's real power over Christendom: his ability to intercede with heaven: "By the merits of our Shepherd and saving prayer, / Eternal Shepherd, free us from the debt of our sins." The motet's last word, *libera* (free us) reflects back again on Saint Peter's miraculously broken chains, another topical reference to the former cardinal of San Pietro in Vincoli.

Together with the papal music and the papal oratory, the frescoes of Michelangelo and Raphael bore glowing witness to "Giulio e Chiesa." But the real boon companion of the pope's ambitions was the architect with the nickname that meant "ravenous" – Donato Bramante. Almost from the moment of Julius's election, the two of them had begun planning to remake Rome.

SAINT PETER'S AND THE BELVEDERE

The pope and his architect had had virtually no time to get acquainted. When Julius arrived in Rome in 1503, he had been out of the city for nine years. Donato Bramante had been in Rome for three, intent on his studies of the ruins and only beginning to think again about taking major commissions. However, Julius must have known about this studious builder from sources in the city, and some of those sources were powerful

indeed: cardinals like Giovanni Colonna, Oliviero Carafa, Adriano Cas-
tellesi, Ascanio Sforza, and, of course, Raffaele Riario. Bramante had
already begun to give tangible proof of his talents for design (notably in
the cloister he had designed for Cardinal Carafa in Santa Maria della Pace),
and he was also stimulating company; not only did he compose *strambotti*,
which were then at their apogee of popularity, but he also recited Dante
with such imposing authority that Julius sometimes called him in just to
hear excerpts from the *Divine Comedy*. Furthermore, he shared the pope's
passion for ancient statues, and it may have been statues, in fact, that first
brought them together.[96]

Quickly, however, they forged a deep bond. Between them they
hatched a plan to overturn the old city of Rome and remake it in a new
apostolic image, beginning with Saint Peter's Basilica and the Vatican
Palace.[97] The original structure of the great basilica, consecrated in 326,
had been erected by the Emperor Constantine, who exploited the con-
crete foundations of the Circus of Nero to define both the course of the
basilica's walls and its colossal dimensions. Since the mid–fifteenth cen-
tury, popes had considered making large-scale repairs to the venerable
structure, but Julius and Bramante decided simply to raze it and build it
anew. To finance the project, Julius intended to count on the Apostolic
Chamber, especially on the huge revenues that were coming in from a
banker from Augsburg "following the Roman Curia," Johann Jakob
Fugger. Fugger coordinated the sale of indulgences in Germany: through
his agency, pious burghers grown rich on the cloth trade could purchase
Church-sanctioned reductions from the time they would have to spend
in Purgatory before becoming pure enough to enter the Earthly Paradise
(a term normally estimated at about a thousand years). For this and other
enterprises, Johann Jakob earned the nickname "der Reiche" (the Rich).
His only rival for the title might have been Agostino Chigi, but Chigi,
for whom rich was never quite enough, went by "Il Magnifico."

In 1506, Julius II declared the old Saint Peter's structurally unsound
and began to dismantle it. He laid the cornerstone of the new basilica on
April 18 of that year.[98] While Bramante gradually removed the old roof,
leaving the ancient naves (and the faithful) exposed to the elements, the
Sistine Chapel took over some of the basilica's liturgical functions. Not
always, however; Julius, who had a high tolerance for discomfort, hardly
seemed to notice the drawbacks of open-air Masses. In 1512, on the
blustery June 29 feast day of Saints Peter and Paul, the cardinals began
celebrating Mass, robes flapping about them, in what was left of Saint

Peter's. Suddenly, in midservice, they had had enough; they rose as a body and took cover in the Sistine Chapel. And when one of those cardinals, Giovanni de' Medici, had succeeded Julius as pope, he instructed Bramante to erect a temporary shelter over Saint Peter's altar, so that he and his companions could tend to their spiritual duties in comfort.[99]

In the meantime, the die of demolition cast, Bramante struggled over the design of the new Saint Peter's; more than the commission of a lifetime, the project was to make a statement about the place of their own age in the course of universal history.[100] In the new basilica, architecture, painting, sculpture, oratory, liturgy, music, and incense would fill the senses of pilgrims, Romans, and curialists alike with a hint of the celestial world to come. The very forms of the building were to symbolize the Christian renewal of the city's ancient glory: exterior columns in the style known as Roman Doric, interior columns modeled on those of the Pantheon, and a scale worthy of ancient emperors (Fig. 42). Bramante declared that he wanted to place the dome of the Pantheon over the Baths of Caracalla, and he came very close to doing exactly that. Beneath the projected dome's vast expanse, in the right-hand crossing, was to stand Julius's tomb, which Michelangelo, who had recently delivered himself of his sublime *Pietà*, was engaged to design.

At first Bramante had planned to change the orientation of the church, to focus its porch on the immense Egyptian obelisk that had once adorned the central spine of the ancient Roman circus and had withstood upright the passage of the Middle Ages. A symbol of ancient Egyptian sun worship, and thus a tangible link to the *prisca theologia* of Hermes Trismegistus, its transferral to Rome symbolized the vast power of the Roman empire.[101] The bronze ball on its summit was rumored to contain the ashes of Julius Caesar, a figure of great symbolic importance to Pope Julius, who must have chosen his own pontifical name with the parallel in mind.[102] Certainly that supposed fact occurred to every humanist in Rome at one time or another, as when Egidio da Viterbo (not without some gloating) describes the pope's response to Bramante's grand design:

> Bramante, who was the first among architects at the time, tried to persuade Julius to shift the Apostle's tomb to a more convenient part of the church, and that the church façade should no longer be turned eastward as it now faces, but to the south, so that the obelisk would greet the people ascending into the church in the great church court-

yard. Julius said no to this, declaring that sacred shrines should be stationary, and he prohibited moving what should not be moved. Bramante again pressed the point, promising that the result would be extremely beneficial if this most august church of Julius the pope would have the monument of Julius Caesar (as the populace believe) at the vestibule of the very entrance to the church itself. He did it for the sake of religion, so that all who entered the church to perform devotions could not make their entrance without being thunderstruck at the sight of the immense new structure. It was hard to move stones when they still clung to the mountainside, but once they had been moved they were easily brought down to lower levels; people too remained immovable when they were unaffected by feelings, but once stimulated by emotions they would readily prostrate themselves before churches and altars. He himself would assume responsibility for transferring the tomb, he would move nothing but promised that he would transfer the whole tomb with its surrounding floor with the least stress possible. Julius persisted no less vehemently in his opinion; he would allow nothing of the old church site to be turned, nothing taken from the old tomb of the first pope. He himself would decide what was appropriate for Caesar's obelisk, but he, for one, was not going to put sacred matters before profane, religion before splendor, and piety before ornaments.[103]

Bramante had already earned the nickname "ruinante" in Milan, but it stuck to him in Rome all the more firmly for his having helped to destroy one of the chief shrines of Christendom, and, in fact, Egidio da Viterbo told the obelisk story to illustrate what he regarded as the architect's insatiable hubris.

But Saint Peter's was only the beginning. Julius also wanted a new wing for the Vatican Palace, with a stairway that could accommodate horses. He wanted a covered walkway to the papal villa, the Belvedere, where he had been busily stowing his own collection of statues among those amassed by previous popes.[104] They eventually included the Laocoön, extracted from the ruins of Nero's Golden House in 1506; Julius's personal treasure, the Apollo Belvedere; images of the rivers Nile and Tiber taken from the ruins of the Temple of Isis at the foot of the Campidoglio; a River Tigris; a Hercules and Antaeus; and, as of 1512, a sleeping Ariadne, with a snake armlet that induced Julius and his contemporaries to believe that she was the dying Cleopatra, her arm encircled by the asp whose bite was now slowly poisoning her. (Having

read their Plutarch, they knew that the Egyptian queen had pressed the serpent to her arm rather than her breast; all the same, her dress has slipped cunningly to reveal the latter.)

Bramante did an elegant job of combining the two extreme ends of the papal properties. Next to Saint Peter's Basilica, he outfitted the Apostolic Palace with a three-story loggia that faced the city, providing the pope with splendid views of Rome from an open edifice as tall and graceful as the Imperial Roman porch near the Circus Maximus that was known as the Septizodium.[105] At the opposite end of the papal complex, Julius got his horse-friendly spiral ramp up to the Belvedere, again in classical style: the ramp's supporting columns run through an ascending sequence of different column types, from Tuscan to Corinthian. In between, multi-storeyed loggias linked the Belvedere to the Apostolic Palace, surrounding what would for a brief period become an enclosed garden of imperial proportions, laid out on three separate levels. In the lowermost of these three courtyards, Bramante finally created what Sulpizio da Veroli had begged of Raffaele Riario nearly twenty years earlier: a theater. The Teatro del Belvedere was an outdoor structure, like the theaters of the ancients, with a flight of stairs at its far end that doubled as seating; spectators could also look down on the entertainments from the apartments of the Apostolic Palace.

Though Julius, as a collector of Niles and Cleopatras, cannot be regarded as hostile to Egypt, he rejected Bramante's plan to adorn one of the new palace's long connecting corridors with playful hieroglyphs:

> The fancy took Bramante to make, in a frieze on the outer façade of the Belvedere, some letters after the manner of ancient hieroglyphs, representing the name of the pope and his own, in order to show his ingenuity; and he had begun thus: "Julius II. Pont[ifex] Max[imus], having caused a head in profile of Julius Caesar to be made, and a bridge with two arches, which signified 'Julius II. Pont.,' and an obelisk from the Circus Maximus to represent 'Max.' At which the pope laughed, and caused him to make letters in the ancient manner, one *braccio* in height, which are still there to this day, saying that he had copied this folly from a door in Viterbo. There one Mastro Francesco, an architect, had placed his name, carved in the architrave, and represented by a Saint Francis [Francesco], an arch [*arco*], a roof [*tetto*], and a tower [*torre*], which interpreted in his own way, denoted "Maestro Francesco Architettore."[106]

In 1951, Ernst Gombrich surmised that Julius disliked this proposal for hieroglyphs because he associated them with Viterbo and, by extension, with the wily Annius and that scholar's presumed role in designing the Borgia Apartments.[107] A great deal of subsequent scholarship now shows that Annius and his forgeries still enjoyed reverent credit in Julian Rome, and that the nefarious Dominican's connections with the Borgia Apartments are not as strong as was once believed. Besides, Vasari's story, as we have it in his Life of Bramante, suggests more emphatically that Julius rejected the scheme because he thought it silly and unintelligible. However promising hieroglyphs might seem in theory as an example of a universally understandable language, in fact Latin worked better. To this day, the connecting passage boasts the foot-high stone Roman letters that Vasari describes as Julius's preference. They say, IVLIVS II PONT. MAX. LIGVRVM VI PATRIA SAONENSIS SIXTI IIII NEPOS VIAM HANC STRVXIT PONTIFICVM COMMODITATI (Julius II built this road for the comfort of popes).[108] The sentiments, if not the language, were still worthy of Ramses the Great.

THE UNIVERSAL LANGUAGE

The incident of Bramante, Julius, and the hieroglyphs neatly illustrates a larger theme in Julius's patronage: his own clear vision of what he wanted to communicate (in brief, "Giulio e Chiesa!"), and how. When he admonished Michelangelo to portray him with a sword rather than a book in 1506, he was implicitly demanding accuracy, and Michelangelo, in finally showing the pope with both, complied with that demand in the deepest sense; he knew that Julius had an intellect, and a refined one at that.

This refinement shows up unmistakably when we look at the pope's taste in oratory. The allusive, recondite Egidio da Viterbo and the flamboyantly emotional Fedro Inghirami both emphasized, in quite different ways, an elegant classical style that formed a living linguistic bridge between the ancient world and contemporary Christianity. Just as Angelo Colocci believed that Roman vernacular should become the universal Italian language, so, still more emphatically, the classical Latin of the apostolic court was designed to work as a universal language of Christianity.

The episode of Bramante and the hieroglyphs further suggests that Julius intended to foster a universal language that was natural rather than

invented, a *koinê* like the simplified "common" Greek of the New Testament rather than an artificial Esperanto, and that he regarded the classical Latin of his day as just such a language. And as his interactions with Michelangelo and Bramante show, he set the same demands for clarity and universality – and dignity, which Bramante's hieroglyphs clearly lacked – in his patronage of art. The paintings and sculptures that Julius commissioned expended little effort on complex iconography, unlike the hermetic allegories that, for example, Botticelli and Luca Signorelli executed for Lorenzo de' Medici. Instead, they lent their most inspired efforts to formulating the systems, the "modi e ordini," by which they might put their content across, on devising their visual version of rhetoric.

Fedro Inghirami claims to have quoted Horace's line "ut pictura poesis" often, as the most concise expression in classical literature of the idea that the principles governing effective art and oratory are closely related. In his own commentary on the Horatian *Ars poetica*, Inghirami observed:

> [Horace] does well to compare poetry to painting, because the poet is nothing but a speaking painter and the painter a mute poet. Each portrays the movements of man and beast . . .
>
> Rightly he ranks arrangement and order just after the attractiveness of the entire work . . . Nature has nothing more important than order; if it is taken away, all these things perish of necessity and revert to their old confusion and primordial chaos. If you create a statue and arrange its limbs at random, you create a monster. A poem that lacks order slips and tumbles. Builders assemble stone and sand, because if these are not available they can create nothing of merit. If they put a bedroom in place of the front hall, they not only disturb the individual rooms but indeed the whole house. So a poet may think great thoughts and collect divine inventions, but if these are not put in their proper place in the overall order, the ideas slip away, and unless he ties them together he simply makes a heap of things.[109]

To a certain extent, of course, Fedro's statements are clichés, not only of his own time but also of the ancient world: Vitruvius argued the same points about the necessity for arrangement and order at far greater length in his *De architectura*. But Fedro and his contemporaries took these clichés to heart, because they knew that the ancients had done so with spectacular results in art and oratory. They aimed to achieve no less in their own time, and Julius was there waving his cane to flail them on.

Vitruvius, indeed, was emphatically back in style in Julian Rome: a lavish new folio printed edition emerged from the Venetian press of Gio-

vanni Tridino on May 22, 1511, edited by the scholar-architect Fra Giovanni Giocondo, whose influence on Angelo Colocci has been discussed in Chapter 5.[110] Well versed in mathematics as well as a first-rate philologist, Giocondo had spent a good part of his youth in Rome. He was one of the few people of any era who have had the necessary training to attempt a comprehensive edition of Vitruvius's treatise, and in Venice he also had access to a wide selection of Vitruvius manuscripts on which to base his text. He was also, therefore, among the first to recognize that Vitruvius, writing for the Emperor Augustus in about 23 B.C., was really creating a planning manual for empire rather than a book about architecture narrowly conceived. Among the proper concerns of his profession, Vitruvius numbered liberal education, city planning, waterworks, astronomy, labor-saving devices and siege engines, along with designing and constructing every type of building. Furthermore, he did so for a bilingual culture (Greek and Latin) that already stretched in his day from Britain to Egypt.

For his edition of 1511, Fra Giocondo boldly faced the problems to which Sulpizio da Veroli's edition of 1486 had made only a tentative response. He recovered the Greek poems about water springs that were missing or mutilated in the existing Vitruvius manuscripts by hunting down the same passages in a Byzantine poetry anthology owned by the Medici. He took the enormous trouble to illustrate nearly every page of his large folio edition with woodcuts, probably by his own hand. For these illustrations he drew in part upon his own observations, but he also made use of a rich parallel tradition of manuscript illustrations for certain aspects of the Vitruvian text (Fig. 30). The *Agrimensores*, for example, proved as useful to him as to Angelo Colocci because of their venerable pictures; so too did manuscripts of writers on siege warfare; like the *Surveyors*, these texts preserved drawings whose traditions reached back into antiquity.[111] In addition, Giocondo made bold changes, based on his own guesswork, to the Latin text itself, assuming that medieval scribes had misunderstood and hence mistranscribed the ancient author's real words. Many of these so-called emendations are still accepted today as what Vitruvius actually must have written (though some now look like the wildest hypotheses).[112] Unlike Sulpizio's, his was anything but a conservative text; to reach back to the ancients, Giocondo let his imagination range widely and freely, trusting his instincts for building, language, and the aesthetic principles that governed them both.

Fra Giocondo addressed his book's letter of dedication to Pope Julius

II, explaining exactly why the treatise of an ancient Roman architect should be made accessible in so spectacular an edition to a wide public: like the emperor Augustus, to whom Vitruvius had addressed his *De architectura*, Julius as pope had made building one of his supreme concerns.[113] The Julian building program's implicit parallel between Rome as Imperial capital and Rome as Christian capital was here made explicit. With the help of the newly clarified text of the ancient writer, the rebuilt Rome of Julius could proceed from a clarified understanding of what ancient Rome, the Rome inhabited by the Apostles Peter and Paul, had actually been.

In fact, both Fra Giocondo's printed book and the Saint Peter's project that inspired its letter of dedication were faithful reflections of parallel activities by Giocondo and Bramante, respectively bent on examining the textual and the physical legacy of ancient Rome. While Giocondo worked in Venice on Vitruvius's Latin, Bramante went to work in Rome on the surviving remains of Roman architecture, hoping to discover how the Romans had thought about the process of design.[114] The colossal imperial baths whetted his appetite for sheer scale; the Pantheon showed him how harmonious composition could succeed in pulling a massive building down to human scale. His eventual plans for Saint Peter's never attained the Pantheon's powerful sense of a single unified space surrounded by a single structure; they always look rather like the attempts of contemporary Netherlandish painters to envision mountains when they have only seen rocks. Inspired by the fragments of imperial Rome, Bramante sought tirelessly for the connective logic by which he could put the fragments back together again. He never quite found the overarching plan that would pull the great basilica into a single coherent whole, but in two other projects of no less epic scale he began to see his way.

GARDEN CITY ON THE TIBER

Between the imposing new works at the Vatican and Sixtus IV's graceful Ponte Sisto, Julius II and Bramante dreamt of creating a kind of city within the city, a garden city along the Tiber.[115] Two long, straight boulevards, one on either side of the river, would form the axes, each flanked by spacious palaces in the new classical style. The orderly gardens of the riverside properties would run right down to the banks of the Tiber, so that the river itself would be transformed into a third, graceful thorough-

fare, a haven for boaters and amateur fishermen (Pope Julius, an avid angler, surely to be included among them). This idyllic marriage of land and water would be punctuated every so often by grandiose churches, and halfway along the magnificent passage would loom another of Bramante's other great constructions for Julius, a central headquarters for the papal bureaucracy: Rota, Chancellery, and Apostolic Chamber, all concentrated in a single place rather than scattered throughout the city.[116] In honor of the lawcourts of the Rota, this landmark was to be called the Palazzo dei Tribunali, standing fortresslike as an image of papal justice (and an obvious counterpoint to the Castel Sant' Angelo, into whose fortifications Alexander VI had sunk so much money).

Neither Julius nor Bramante could possibly have lived long enough to see his urban dream happen in its entirety, but its backbone of streets remains. By 1509, the twin thoroughfares had been laid out, their surrounding properties divided into large lots to ensure that only the best sort of people could buy them. The Via Giulia, named after the pope, ran through the bankers' quarter, more or less parallel to the Via Papalis, the chief route through town. On the opposite side of the river, the Via della Lungara, previously surrounded mostly by *vigne*, linked the populous quarter of Trastevere with the Borgo Vaticano, Vatican City. The magnificent sweep of Bramante's plan is still to be seen in the same streets today; even now, their striking straightness transforms the palazzi along them into an urban stage set. Remarkably, quite a few of the original riverside palazzi also survive, including the one that belonged to Agostino Chigi.

THE TRIUMPH OF AGOSTINO CHIGI

By 1509, Agostino Chigi had extended his tentacles well into the political realm. In that year he met with the Venetian ambassador, Alvise Pisani, to discuss prospects for an alliance between Venice and Rome; it would mean that Venice would have to give up its claims to the cities of Imola and Faenza, nominally papal vassals, but it would also mean that the pope would protect Venice against the French and the Holy Roman Empire, both of which were ready to strike at the fat lands of the Venetian *terra ferma*.[117] Chigi had his own reasons to negotiate; Venice restricted access to the upper Adriatic to her own ships, thus interfering with the way in which Chigi hoped to market his alum: independently. Since 1508 he had been governor of the Sienese port of Porto Ercole; for all practical

purposes he used it as the private headquarters for his alum business, which had taken on the dimensions of a small city.[118]

Pisani behaved with haughty disdain, however, as did his fellow ambassadors in Rome; the alliance with Venice fell through, and Julius put the Venetians under interdict.[119] The papacy joined with France and the Hapsburg emperor Maximilian I to sign a pact in the city of Cambrai, on the strength of which the newly constituted League of Cambrai declared war on the Venetians. After a resounding Venetian defeat at Agnadello in 1509, Julius suddenly changed his position, offering the lagoon city a separate peace (with some stringent economic concessions). Now he resolved to expel the French from Italy, an enterprise that involved removing their influence from Genoa, Milan, and Ferrara, as well as keeping them away from Venice. In the summer of 1510, after consultations that included meetings with Chigi and with Egidio da Viterbo as well as those with his usual diplomatic staff, the pope decided once again to go to war, emphasizing his authority over Bologna by making it the headquarters for his campaign.[120] His stated target was Ferrara, a papal vassal state that had become all too friendly with France. At the same time, another papal force set out to take back Genoa.

Chigi was all in favor of the campaign; Ferrara offered salt at a cheaper price than that available from the papal salt beds at Comacchio, and the drain on the papal coffers was significant.[121] When Julius marched north in the autumn of 1510, Chigi was in his entourage, remaining in Bologna as the pope laid siege to Imola in the bitter winter of that year. By February 1511, Chigi had moved to Venice, acting as Julius's agent while that city continued to battle the allied forces of the two foreign monarchs. Chigi took advantage of Venice's military vulnerability to press for shipping rights in the Adriatic and high prices for his alum. In return, he offered the Venetian republic a loan from his own funds to pay for mercenary troops, and an alliance with the papacy. Chigi's profile during his Venetian sojourn was high; he attended supposedly sealed meetings of the Venetian city councils and openly flouted the stringent wartime sumptuary laws that had been in force since the outbreak of the war in 1509.[122]

When he returned from Venice in August 1511, Chigi had taken a significant part in the negotiations that led to a Holy League in 1512 between Venice and the Papal States; he also brought a pledge of 30,000 ducats in coins and jewels from the Venetian state treasury, a new set of alum contracts, a painter, and a very young mistress. He could finally take

possession of his new house on the Via della Lungara, which had been ready for a month or so before his arrival. Julius, back from the north since the spring of 1511, had been unable to contain his curiosity; he paid a sneak visit to the property just before Chigi's return.[123]

This "suburban villa," rather than his old palazzo in the bankers' quarter of Parione, now became Chigi's chief residence (Fig. 43). Its open, airy design, set in the middle of gardens, was a far cry from the imposing fortresses that served most powerful people in Rome as their urban residences. Still, for Chigi's purposes, the setting worked: the Vatican was just down the Via della Lungara, and the Ponte Sisto connected him easily with the heart of Rome. Raffaele Riario purchased the land on the opposite side of the street; Alessandro Farnese owned the *vigna* next door. This new settlement of the garden city was no bankers' quarter, and Chigi, clearly enough, was no longer an ordinary merchant. He had good reason to feel that he was different from his fellow bankers; in 1509, Julius adopted Agostino and his brother Sigismondo into the Della Rovere family, allowing them to quarter their arms with his. In Chigi's new abode he flaunted his status by installing a large gilt Della Rovere stemma in the center of his entrance hall. By holding elaborate banquets and cultivating the arts, he inserted himself as best he could into the company of his cardinal neighbors.[124] He also carried on business: his upstairs strongroom eventually held 900,000 ducats' worth of goods in pawn, including, until 1519, the cache of jewels pledged from the Venetian state treasury.

Chigi had entrusted the design of his house to the Sienese architect Baldassare Peruzzi, who, in opting for a suburban villa, re-created a type of building described by Vitruvius, the suburban villa. Like the ancient hybrid that Vitruvius described, Chigi's "Viridario" (Greenhouse) was a clever cross between a country house and an urban palazzo, with a decidedly ancient Roman flavor. Chigi met his clients on its ground floor like an ancient Roman *paterfamilias* rather than receiving them on a conventional upstairs *piano nobile*, as he had in his old house across the river. He filled his Viridario with inlaid furniture, ancient marbles, and Eastern carpets, proof that he really was as rich as Croesus. Paintings and poems proclaimed the general theme that he was a new Augustus, playing on his own given name as well as that of Pope Julius, his obliging Caesar.[125] The conceit seems to have amused them both, for the imperial imagery, even when playful, expressed their sense of a common purpose in promoting the idea of papal Rome and its Christian *imperium*. From the conclave of 1503 to Julius's death in 1513, the two of them had seemed

to battle together for a higher cause, that vision of the universal Church to which Chigi's money made as important a contribution as the frescoes of Raphael and Michelangelo or the verbal fireworks of Fedro Inghirami and Egidio da Viterbo. Only so committed a pope could have put Chigi's extraordinary mind to such a variety of uses as Julius did, and probably only an administrator as fiscally attentive as Julius could have maintained Chigi's respect.

THE NEW ORDER AND "COLOCCI GARDENS"

This was the environment in which Angelo Colocci did his work of drawing up papal proclamations, amassed his own collection of antiquities, wrote his poems, calibrated his weights and measures, and began to inject a new sense of vigor into the old Roman Academy. After Paolo Cortesi's withdrawal from Rome in 1503, he had taken over as the club's driving force, shifting its concerns somewhat as they came to reflect his own.

In the hands of Colocci and his generation of humanists, Pomponio Leto's antiquarian obsession with ancient Rome took on a much more pointed emphasis, spurred by the manifest interests of Pope Julius himself. The pope's search for proof of papal primacy encouraged the Roman Academy of the sixteenth century to scour Rome for traces (*vestigia* again) of Christian Rome's immanent destiny for use in briefs, bulls, speeches, and occasional verse, while Colocci was busily exhorting his friends all the while to try to measure heaven.

The idea that matters of religion could be successfully subjected to quantitative scrutiny or empirical proof seems to have been widely current: we can see the same attitude at work in the sudden resurgence of interest in events like the miracle at Bolsena, which seemed to afford tangible proof that the Eucharist did result in chemical transformations of bread and wine into Christ's body and blood.[126] Above all, however, Julius fostered the conviction that Rome's destiny had been unfolding steadily ever since the Creation; although they might harbor fears of the Apocalypse, humanists were more often paid to predict the advent of a new Golden Age.[127] It was a dream, honored by Julius himself more in the breach than in practice, but it was a glorious dream nonetheless.

Julius hoped to crown that dream with a council on Church reform, the Fifth Lateran Council. He convened its first session at the Basilica of Saint John Lateran on May 3, 1512.[128] (He also hoped to save his skin; a

French-led schismatic council had begun to convene at Pisa in 1511, with the sole purpose of electing an alternative pope). Fedro Inghirami was assigned the coveted post of secretary. Egidio da Viterbo gave the opening address, making a ringing argument for the eternal Church that was much quoted afterward: "Man must be changed by sacred things, not sacred things by man."[129] We will return to the council in Chapter 7.

As the proceedings of Lateran V began their stately progress, Angelo Colocci, by then a papal secretary, and a wealthy one at that, decided to expand his presence in Rome's cultural life. Rather than simply holding forth, as always, in the garden on the Quirinal that had once belonged to Pomponio Leto, he decided to create a garden of his own. In 1513, he bought a piece of property near the Trevi Fountain, which was adorned in those days only by a simple marble basin installed in 1453, possibly designed for Pope Nicholas V by Alberti himself. (It can still be seen today underneath Nicola Salvi's incomparable baroque extravaganza.) Colocci's own property, which he called the "Horti Colotiani" (Colocci Gardens), was graced by an arch of the ancient Aqua Virgo aqueduct, the watercourse that had fed the famous fountain in antiquity. The aqueduct itself had been built in the time of Augustus by Marcus Agrippa to serve his baths near the Pantheon; it took its name from a legend that a young girl (*virgo*) had first showed the water source to thirsty Roman soldiers. Caught up in the spirit of his new refuge, Colocci installed an appropriate centerpiece, a modern fountain in the form of a sleeping nymph, inspired by the story of the original Roman *virgo* of the waters. This nymph looked like the fountain nymph of the *Hypnerotomachia* (described in my Chapter 2), with one difference: Colocci's nymph did not spurt water from her own person; instead, she reclined gracefully among water reeds.[130] A verse inscription carved on a marble plaque at the base of the fountain was included for years in anthologies of ancient epigraphy; in fact, it seems to have been written by the humanist Giannantonio Campano sometime before 1470:

> Here I, the nymph of this place, guard of the sacred fountain,
> Slumber, while gentle water's murmur is what I hear.
> Whoever touches this hollow marble, take care not to wake me;
> Whether you have in mind drinking or bathing, don't speak.[131]

Whereas Agostino Chigi's new house had rated a personal visit from the pope, Colocci's housewarming enlisted a more modest guest of honor: Julius's daughter Felice, who had married a scion of the Orsini

family. The Neapolitan poet Girolamo Borgia composed an eclogue to honor the occasion, in which he suggested, in his most charming Virgilian tones, that the pope's daughter was the very nymph enshrined in Colocci's garden:

> Under a giant oak, the prettiest goddesses gathered:
> Venus, the Graces, the Muses, and Pallas Minerva beside them,
> All to honor Felice, the nymph by the banks of the Tiber,
> Right where the snowy-skinned naiad leapt from her virginal bower.
> She alone tarried behind, bringing water to faltering shepherds;
> There, too, Colocci, my friend, will often prepare an abundant
> Banquet for poets, he, the lord of these crystalline waters.[132]

The occasion was also tinged with melancholy, however, for Julius had died a very short time before the festivities. Borgia's poem continues by having the nymph Felice sing mournfully of what the pope had been undertaking, and what he might have accomplished had he lived longer. Despite its light, occasional tone, Borgia's "Ecloga felix" brings up an important image, for it is one of the contemporary texts in which Julius's transformation of Rome is explicitly described as a rebirth – a renaissance:

> Now she sings Julian praises, bringing up the benefactions
> Of the magnanimous shepherd, how with victorious battles
> Happily Julius increased the Holy City's dominion . . .
> Had Death not snatched him away from Italy's miserable people,
> Great, and attempting great things, readying lofty endeavors,
> Steadfastly driving his flock out of its tottering temples,
> Pondering mighty concerns in his invincible bosom –
> Woe, Death! how often you envy mankind's most fortunate projects,
> Jealous of Rome *reborn* to all her primordial splendor,
> As he built marvelous houses and temples to imitate Heaven.[133]

The arch of the Aqua Virgo has blackened now from automobile exhaust. Today the site of Colocci's garden is paved over and called the "Largo del Nazareno." A sculpted wildcat's head glares down from a nearby door lintel bearing the motto "Cum feris ferus" – "fierce to the fierce," or simply "a beast to the beastly." Somewhere under the pavement below lay the haven in which, from 1513 onward, Angelo Colocci presided as coryphaeus of his gossipy, erudite band (Fig. 44). There Felice, the sculpted nymph, dozed among the water reeds above her forged inscription. Another inscription, this one genuine, mourned Eucharis, a girl of imperial Rome, dead at fourteen but already deeply learned.[134] The

stumpy gravestone of Agathangelus the architect flaunted carved reliefs of the tools of his trade: his *ancon*, or carpenter's set square, his plumb bob, and his foot ruler. Another bas-relief Roman foot stood on a low, gray stone nearby. On sunny days, benches, tables, and books must have been scattered everywhere, occupied by humanists of every size, shape, and quality of clothing, from fat and prosperous Fedro to the skinny hanger-on Pietro Alcionio, who always seemed to hover on the brink of starvation, both physical and intellectual.[135] Lording it over the whole domain there stalked a formidable guardian: Angelo Colocci's cat, Aelurus, he too "Cum feris ferus," with a list of enemies that eventually included Erasmus of Rotterdam among legions of birds and mice.[136] A one-line sketch for a poem about Aelurus tantalized Colocci for years; he never quite knew how to continue beyond the lucid scene drawing of its beginning, in the eleven-syllable Sapphic meter that worked so well for poems of praise or, equally, for cutting invective: "Aelurus fuit in minore sella" (Aelurus was in the small seat).[137]

We can fill in the rest almost as easily as the people who knew cat and master at first hand: large seat, humanists, antiquities, and garden. When the noble animal died, he was buried next to the Trevi Fountain with no fewer than three epitaphs:

> Wander in safety, ye mice; ye birds too, wander in safety,
> So long as Aelurus sleeps next to the Virginal font.

> With the beginning of day – for you, a night neverending –
> Aelurus, I mourn a hero; all's safe and quiet for the mice.

> You, heavy gravestone, lie lightly; Virgin waters, flow softly,
> Thus let Aelurus rest in a more welcoming peace.[138]

THE GREEK ACADEMY IN ROME

Aelurus is the Latinized version of the Greek word for "cat," *ailouros*. Like his fountain nymph, modeled on the ΠΑΝΤΩΝ ΤΟΚΑΣ, Angelo Colocci's cat expressed the humanist's longing to know Greek as well as he knew Latin and Italian, a longing also to be found in such contemporary works as the *Hypnerotomachia Poliphili*, Raphael's *School of Athens*, Battista Casali's oration on the Circumcision, and Aldus Manutius's new Greek press in Venice. Greek studies had first become a focus of acute interest among the Roman humanists through the efforts of the Greek cardinal Bessarion in the mid–fifteenth century; as a result, the Vatican Library of

Sixtus IV featured a separate Biblioteca Graeca to house its Greek manuscripts. Not surprisingly, Pope Julius himself had many Latin translations of Greek works in his private library. Greek was the language of the Gospels and the Septuagint Bible, and there seemed to be cogent reasons for learning to read it.

While Angelo Colocci was negotiating for his garden property by the Trevi Fountain, he also began planning to establish a Greek Academy that would act as the rightful counterpart to the Roman Academy that had now passed under his guidance. This new Greek Academy already had its Plato; about that there was no question from any quarter. It could only be the man who was known to be engaged in harmonizing Plato with standard Christian theology: Egidio da Viterbo. Beside his efforts to spread Christian Neoplatonism, Egidio had also successfully convinced Aldus Manutius to make the printing of Plato a priority for his Venetian publishing house. The Augustinian prelate embodied the educational background, the apostolic zeal, and the spirit of mystic participation that any new Plato for a new academy required. With all his duties as head of the Augustinian order as well as his preaching engagements for Pope Julius, however, it was obvious that Egidio da Viterbo could not manage the actual running of the Greek Academy, whatever form it was to take.

The other obvious candidate to lead the group was Colocci himself, in his capacity as leader of the Roman Academy. Certainly his erudite charm was legendary, but his competence in Greek was another matter. He had studied the language in Rome with the Tuscan humanist Scipione Forteguerri, a pupil of Constantine Lascaris, who had advertised his own mastery of the language by Hellenizing his surname to "Carteromachus." (Both names mean "strong in battle.") "Messer Scipio" Carteromachus was fluent enough in ancient Greek to compose poetry in its various meters, but Colocci always remained at the level of reading knowledge, writing only occasional phrases. Because one of the chief activities of the Roman Academy was to enforce standards of Latin usage, Colocci may have seen his own capacity to direct the corresponding activities of the Academy's Greek branch as fatally limited. He was a sharp critic of Latin and vernacular style, sharp enough to know that his hesitation with Greek would be skewered by some of his fellow clubmen. In a letter of May 15, 1511, he therefore asked his teacher Carteromachus to act as codirector.[139]

May 1511 was not, perhaps, an auspicious time to begin any large-scale project in Rome; for nearly ten months the papal court had been

split between the Vatican and the mobile field headquarters in Bologna, as Pope Julius fought to rid Italy of the French.

Like so many other humanists, Scipio Carteromachus was also caught up in the pope's military maneuvers; he had departed for Bologna in 1510, following in the train of Julius's favorite, Cardinal Francesco Alidosi, appointed as archbishop of Bologna in connection with Julius's attempts to hold that city for the Papal States. As we have noted, a fair number of humanists and cardinals made the same northward trek, and many a letter from 1510–11, written "in corte," was sent from the chill plains of Emilia-Romagna.

By May 1511, the fighting had not gone particularly well for the papal forces; Julius retreated to Ravenna, but with characteristic tenacity he refused to acknowledge defeat. He seems, moreover, to have been giving thought to the state of his projects in Rome. Indeed, the pope himself may have been the ultimate stimulus behind Colocci's renewed activity concerning the Greek Academy. Colocci's letter of May 15, 1511, to Carteromachus described no fewer than three different Grecophile activities: plans to establish a Greek press in Rome under papal sponsorship, plans to activate the Greek branch of the Roman Academy, and plans to lure the Cretan typesetter Zacharias Kalliergês from Venice to Rome. All of these schemes, however, were contingent upon the movements of Pope Julius:

> Jacopo Mazzocchi, at the bookshop formerly belonging to Mercurio, would like to establish the Greek press in Rome, and he's already promised to print the Eustathius commentary on Homer and would like to bring in compositors. Messer Giovanni Antonio Marostico says that he can get hold of that Zacharias who did the *Etymologicon* [a Byzantine dictionary] – find out who he is, so that when the court breaks up, I want you to direct the New Academy with me, especially the Greek part, but nothing can be done without you.
>
> Here the word is that the Venetians can't get peace from the barbarians and that the pope doesn't want to abandon them, and that if he leaves and comes back to Rome, well, if the court breaks up I'm off and running, but if it stays like this then I'm ruined – so we're talking about the Life of Angelo Colocci here, and not about Italy.[140]

The mobile apostolic court did break up shortly after the writing of this letter; against all logic, the pope kept France at bay, Agostino Chigi succeeded in wringing his terms from the Venetians, and a Holy League between Venice and the papacy was already being bruited about. Back

in Rome, Angelo Colocci was indeed off and running – but not in the direction he had anticipated. In July 1511 he acquired his position as apostolic secretary with all its attendant responsibilities. However, the Cretan printer Zacharias Kalliergês did make it to Rome, possibly on the same ship that returned from Venice in August 1511 with Agostino Chigi on board.[141] Meanwhile, Scipio Carteromachus, freed from his obligations to Cardinal Alidosi by the latter's assassination, had retired to his native Pistoia in Tuscany, and the elderly humanist gave no signs of wanting to budge for the still struggling Greek Academy far away in Rome. Still in search of a charismatic chief, Colocci reported to "Messer Scipio" on Christmas Day 1511 about some futile attempts to enlist the services of Egidio da Viterbo. As go-between, he had used Agostino Chigi's chancellor, Cornelio Benigno, whom we first met in Paolo Cortesi's garden in the 1490s. Benigno, like Egidio, was a native of Viterbo, and the two were friends of long standing:

> Honorable Messer Scipio. I've made inquiries with our Cornelio [Benigno] in the past few days about the whole matter with Egidio. Cornelio said that he wanted to speak to Messer Egidio; now what form this conversation took, I don't know, . . . but it seems to me that Egidio had replied coldly. I don't understand . . . My dear Messer Scipio, this is my opinion: come to Rome now, and come here to my house, and if Egidio wants to put you up he'll let me know . . . I've convinced myself that you're in good health – otherwise don't move.[142]

Colocci's crotchety portrait of Egidio da Viterbo is echoed in the prelate's own constant complaints about the demands of his high office: the people to see, the sermons to preach for Pope Julius, the position papers to issue for the Augustinian order. Besides, December of 1511 was a particularly busy time for him. His attention was rivited on the schismatic council in Pisa and the impending plans to counter it by convening the Fifth Lateran Council.[143] The Greek Academy must have seemed at best a peripheral concern for the harried churchman. Furthermore, by Christmas of 1511, Egidio da Viterbo's interest in Greek may have flagged altogether; he had begun to study Hebrew and the Kabbalah in earnest, a course that was to plunge him deeper and deeper into contemplative mysticism focused on the Hebrew alphabet. In his new frame of mind, Greek had exiguous charms when compared with what he had come to regard as the pure language of God.

We hear nothing more about the Greek Academy under Julius II. We

might conclude that the lofty Hellenic ideals formulated in Battista Casali's sermon of 1508 on Rome as the new "School of Athens" and Raphael's paintings on the wall of Julius's library had less to do with Greek studies per se than they did with Greek studies as a stage in human history, a history whose rightful culmination was the sixteenth century or, more specifically, the Julian papacy. Thus, papal sponsorship of more monumental projects such as the Fifth Lateran Council and the rebuilding of Saint Peter's Basilica took precedence over papal sponsorship of a Greek club for the curial humanists. Furthermore, Julius was a pope with an unusually acute grasp of finance; for all his military campaigns and ambitious building programs, he left the papacy solvent at his death in 1513. He may have understood that he could entrust the promotion of Greek studies in Rome to other hands than those of the curial bureaucracy.

JOHANN GÖRITZ (D. 1527)

The members of the Roman Academy – and the potential members of the Greek – acquired another retreat at nearly the same time as the Horti Colotiani, one where Angelo Colocci was also a virtual fixture. In 1512, Johann Göritz, a wealthy apostolic protonotary from Luxembourg, commissioned a clever artistic assemblage for his parish church, Sant' Agostino: a column chapel of the sort that enjoyed considerable popularity in his day (Fig. 45). Along one of the square piers of the central nave, Raphael painted the prophet Isaiah in fresco, a stunning work that still reels from the impact of Michelangelo's new Sistine Chapel ceiling. Beneath the *Isaiah*, a statue of the Virgin, Child, and Saint Anne by Andrea Sansovino was set above an altar which in turn surmounted the patron's family tomb.[144] Every year, on July 26, the feast day of Saint Anne, the chapel and Göritz's *vigna* became the joint focus of a protracted celebration.[145] We have a detailed report of the proceedings from one of the party's chief habitués, a humanist from the Sabine hinterlands west of Rome named Biagio Pallai (d. 1530), whose academic and professional name was Blosio Palladio:

> Were Virgil to come back in your time or you in his, would he have
> been able to keep silent about your festival day, on which you celebrate
> a holy rite to Anne the grandmother of Christ with such ritual and
> honor, first with a sacrifice at your statues, and then at your gardens

with a rich and lavish banquet, together with all good and learned men? For such a cohort of good and erudite men comes together there, and celebrates the day, that in your gardens you can see half of Athens, and an emporium of learning contained there on that day, as well as the Muses, led down from Parnassus and Helicon and transferred to the Tarpeian and Quirinal, hovering over your gardens. Where, here and there, boldly and in great variety, people attach poems, one to your citrus trees, another to the garden walls, another to the wellhead, or the statues scattered all around and lovely to behold, all of ancient manufacture and full of glory; with a single voice together they acclaim the piety and liberality of that day, as regards both gods and men. Ultimately, if I may dare say so, there is no council or banquet in the whole earthly globe that is more noble or illustrious than yours on that day, when, with the sacrifices performed that morning, and divine service, then, after evening has broken, a select crowd of the most learned, the very flowers of literature, are gathered together in your garden, those whom you regard as greater than kings, greater than all satraps, and rightly so.[146]

Göritz had his garden in the environs of Trajan's Forum; it was set, therefore, in the declivity between the Quirinal and the Tarpeian Rock, on whose summits Blosio's description has cleverly placed the Muses. (Moreover, Colocci's bronze tablet honoring Apollo and Clatra, found in the environs, afforded Blosio archaeological grounds for his contention.) It was an appropriate turnabout on Raphael's Vatican fresco of 1511, in which the Greek mountain of Parnassus offered its hospitality to poets of ancient, medieval, and modern Italy, but then Blosio, among the humanists, was particularly sensitive to art.[147]

By dividing his festivities into morning and evening sessions, Göritz created a neat separation between the public Mass and the more esoteric rites of the *litterati*. Latin poems in hand, the invitees would arrive at the evening party by threading down the Via Alessandrina through the standing ruins of the imperial fora, rebuilt over the ages and buried under layers of earth, but still close enough, especially as night fell, to put the ancient world within reach of their imaginations. The sound of Latin poetry, the presence of Roman statues, and a generous flood of wine would do the rest. This in fact was the setting for which the German poet Caius Silvanus composed his poetic description of the humanists in conversation, where earlier we identified Angelo Colocci as the man who spoke about

> the extent of level earth . . .
> Distances between the borders of cities,
> And the extent of land and ocean's circumference.

Now we can also place another of the characters, the one who:

> . . . passed beyond the orbs of Olympus
> in his thoughts, discloses the sacred Scriptures,
> He reveals the reasons why this world's Author
> Wanted to take on a human appearance.

He is almost certainly Egidio da Viterbo, who lived in the convent adjoining Sant' Agostino and was a good friend of Göritz as well as Colocci. When his duties permitted, Egidio took enthusiastic part in gatherings such as these, and his specific preoccupation with the theology of the Incarnation was well known. Göritz's composite chapel commission, in turn, shared something with Egidio da Viterbo; its dedication to the Virgin and Saint Anne reflects the same devotion to the Incarnation, while its assemblage of fresco, statues, and altar played on the same varying levels of reality and representation that we find in Egidio's Neoplatonic writings (or Michelangelo's Sistine Chapel frescoes).[148]

One might expect, in a chapel honoring the Virgin and her mother, that Raphael's marvelous *Isaiah* would hold a scroll with the Hebrew text of the famous passage, "Behold, a virgin shall be with child." But Göritz was a more challenging patron than that; instead he requested that Raphael reproduce Isaiah 26:2–3: "Open the gates, that the righteous nation which keeps faith may enter in. Thou dost keep him . . . whose mind is stayed on thee."[149] Anyone who could read the Hebrew text was forced to think about what it might mean in context with the painted Isaiah and the sculpted Virgin with her mother and son.

That meaning might have revealed itself more or less as follows: by participating in the sacrament of communion at the chapel's altar, both Göritz and his friends could take part in a symbolic reenactment of the results of Christ's Incarnation: His death and Resurrection. Their Christian faith, in turn, held out hope that through Christ's mediation they, too, might one day enter the gates of Zion in accordance with Isaiah's prophecy. Like so many other artistic commissions from the reign of Julius II, the Göritz Chapel was therefore conventional enough to convey a clear message, but just different enough to stimulate thought, and then, ideally, devotion. The humanists who made the annual pilgrimage between the house and garden of the man they called "Janus Corycius" saw

no conflict between their interest in ancient Rome and their work for the Rome of the popes, for they believed that God had always intended for the two to go together. The "righteous nation" could exist quite happily on Mount Parnassus. Accordingly, a poem by the humanist Girolamo Alessandri, alias "Delius," could put "Janus Corycius," his chapel, and his garden into a continuum of cosmic history, much as the Sistine Chapel ceiling (dedicated, after all, in the same year as the Göritz Chapel) did the same on a more epic scale for Pope Julius and the Church:

> At the beginning of time, when atoms wandered at random,
> Nowhere at all in the world was there a recognized god.
> Nowhere the presence of law, for force was the single law binding;
> Animal senses alone acted as leader, as Jove.
> After some one of the gods distinguished these things from each
> other,
> Ordering each to possess the portion that was its due,
> Then our behavior again harked back to the old times of chaos,
> Forcing the Powers on High to contemplate taking to flight.
> Janus, you saw how it was, you pitied the poor race of mortals;
> Now see how safely you bring the gods back to where they
> belong.
> Once more, then, men will believe that somewhere a Thunderer
> rules them,
> He whom all misdeeds offend, he who loves deeds that are good.
> Then you'll see deities pass, strolling the earth at their leisure,
> Then see that banquets are held, both among mortals and gods.[150]

In papal Rome, "Jupiter the Thunderer" was an accepted synonym for Almighty God. Delius's poem thus described not only cosmology and the classical myth of the flight of the gods after the Golden Age but also referred rather specifically to the beneficial effects of the Communion "banquet" in the chapel and of the later banquet in the patron's garden; both bore witness to the infectious enthusiasm of Göritz's piety. Delius further implied that the Luxembourger's activity as a patron demonstrated the power that Rome's educated elite could exert in moving the rest of the population to pious thoughts and deeds. As Delius described it, the Göritz Chapel was not so much a distillation of humanistic thought in Rome as a standing challenge – in concept, in imagery, and in language – to apply that thought to Christian purpose. Julius himself could not have agreed more.

Imitation (1513–1521)

A multis sumpsit Zeusis decora ampla puellis
Una satis nobis Bimbica forma facit
Certe canam, Bimbus tulit omnia, satis in uno
Forma, pudor, flores, Gratia, candor, honos
Si mens scribentis non verba obliqua notatur:
Hunc scripsi formae qui fuit Archetipus.

Zeuxis derived his standard from a bevy of beauties;
For us the Bimbic form sets the standard itself.
Surely I'll sing how Bimbus bears every charm in due measure:
Beauty, grace, modesty, candor, status, and flowering youth.
And if this writer's intent has not been betrayed by his wording,
Here I've described the man who was Beauty's own archetype.

Battista Casali (Vat. Lat. 2836, 188v)

LATERAN V

The Fifth Lateran Council of 1512 opened with Julius in a position of unexpected strength. He was first goaded into action in 1511, when a group of disgruntled French cardinals called a schismatic council in Pisa, but their efforts to turn the Church against Julius never acquired much momentum.[1] Furthermore, by 1512 Julius's tireless opposition to the French presence in Italy was beginning to bear fruit; the French garrisons withdrew from their Italian positions, and French-leaning Ferrara submitted again to papal jurisdiction, pressed by the newly struck Holy League between Venice and the Papal States. Under such circumstances, the Lateran synod opened in a spirit of relieved optimism. With its original task of enforcing papal power no longer so urgent a political necessity, Julius used the synod instead to present his vision of a universal Church

in its most sweeping sense.[2] Egidio da Viterbo, himself a committed re-
former, delivered the council's opening address in the Lateran Basilica;
his classical style of oratory and his burning zeal had already become a
hallmark of the Julian papacy, and his plea for Christian renewal brought
many of his listeners to tears.[3] On the other side of the city, Michelangelo
provided a visual complement to the Augustinian's impassioned speech
in the newly unveiled ceiling of the Sistine Chapel. Here, in a whirl of
brilliant color, titanic muscle, and layered complexity, the delegates could
see the powerful image of the papacy emergent from the first act of
Creation; close by in the Apostolic Palace, Raphael's Stanze assembled
Greek philosophers, Arabic sages, Latin poets, and Hebrew prophets to
prove that the Vatican backed its Christian practice with the sum of
ancient wisdom. The spiritual embrace of a Rome that took in the whole
ancient world could surely take in the delegates to Lateran V, with their
shared religion, their shared language, and their shared purpose. With
paradigmatic force, the art and oratory of Julian Rome pointed the way
toward establishing a common history and a common language among
the delegates by revealing their Christian heritage as immanent, tran-
scending epochs and cultures: Could doctrinal differences possibly impose
greater obstacles than the ones they had already surmounted?

On the most fundamental level, Lateran V presented the essence of
papal art and oratory as the sincere expression of pure faith, as when
Egidio da Viterbo warned, in his opening address, that the text of Scrip-
ture was not to be altered, no matter how raw its language. Ironically, of
course, Egidio's defense of such "pure" expression was itself a highly
stylized performance; he called the prophetic books of the Hebrew Bible
"oracles," as if they came from ancient Greece or Rome rather than Israel:
"I will not dare to upset the style of the oracles, both because it is right
for men to be changed by holy things rather than holy things by men,
and because [here Egidio spoke in Greek before translating into Latin]
'the language of truth is simple.' "[4] At the oration's end, with members
of the audience dabbing their eyes, he let forth another call for primordial
purity, bidding his audience, "Pray to be washed clean from all the stains
you have conceived and to be restored to your ancient splendor and
cleanliness."[5]

However sincere its longing for the purity of the early Church, Julian
Rome could not escape the sophistication with which it expressed that
longing. The oration for session 8 of the council provided a particularly

well-turned version of Roman eloquence. It was delivered by a Rome-based Knight Hospitaller of Saint John named Giovanni Battista Garghi, a friend of Agostino Chigi (as well as the tutor of the great banker's nephew Camillo) and also of Egidio da Viterbo.[6] As the spokesman for his order, Garghi was charged with pledging the fealty of the Knights Hospitallers to the pope; he did so, appropriately enough, in a high classical style that bore an especially close relationship to the emotional intensity and classical correctness of papal orator (and council secretary) Tommaso Inghirami. In one of the oration's high points, a series of striking oxymorons led into Garghi's evocation of two ancient figures of speech: the athlete of virtue and the Christian soldier:

> Let us follow Jesus Christ the King, who wants to have us as participants in His victory. His cross is our victory, his scaffold is our triumph. The earth is not our homeland; rather, Heaven awaits us as its citizens and residents, where we may only hope to hear these words of our Lord: "Well done," He says, "good and faithful servant, who was faithful in such small estate; let me establish great things for you. Well done, I say, stout soldier, imitator of your Lord and comrade to the eternal King, you shall be rewarded with worthy and wished-for prizes. O saving army of Christ, to be sought above all others, that in which the trophies are certain and beyond all price, the trophies in which so many Martyrs and blessed fathers glory in the heavenly Empire and rest in perpetual peace."[7]

Julius intended the Lateran Council to transform what it proclaimed in words into tangible deeds, to knit religious order with religious order, cleric with layman, past with present, and to drive them all toward wholesale reform of the Church's accumulated corruptions. But his universal language was not yet universally intelligible. The opening oration for the council's second session, delivered by the influential Dominican Tommaso de Vio (also known as "Cajetan"), stands, with its scholastic-inspired punctilio, in evident contrast to the speeches of the fiery papal orators: "I thought that I might perform a useful service, welcome to all, if today I first spoke about the Church herself, then about the synods of our time, their differences and their diversity."[8] After Egidio's fireworks, de Vio's clarion call must have sounded a bit soporific. And if Tommaso de Vio's address shows a certain immunity from his fellow speakers' antiquarian rhetoric, another delegate, Gianfrancesco Pico, reacted with scandalized indignation to the omnipresence of the ancient gods in Julian

Rome, writing an outraged poem called "On the Need to Expel Venus and Cupid," after a spin in 1512 around the statue collection of the Belvedere Gardens.[9]

Pico had good reason to be touchy. His life had been, and would continue to be, battered by conflict: political maneuvering, religious wrangling, and personal treachery. He was in Rome, in part, because he had nowhere else to go. He had succeeded his famous paternal uncle, Giovanni Pico, as count of Mirandola upon the latter's death in 1494, but in 1502 his younger brother deposed him, aided by military assistance from the latter's father-in-law, the Milanese mercenary captain Giangiacomo Trivulzi, a formidable soldier long in the service of the king of France.

Like Giovanni Pico della Mirandola (who was only six years older than his nephew, and in many ways more of a brother than an uncle), Gianfrancesco had spent most of his youth in Florence, where they were caught up first in the excitement of Marsilio Ficino's Christian Neoplatonism and then in Giovanni Pico's own extrapolations of that philosophy, which emphasized the universality of ancient wisdom and devoted special attention to the Kabbalah. This idyll ended in 1487, when Giovanni Pico was charged with heresy by a papal commission. He fled briefly to France, where he was first imprisoned but then released by the intervention of Lorenzo de' Medici. By 1488, he had returned to Florence, just as the fiery sermons of Girolamo Savonarola were beginning to draw crowds. The stern Dominican's calls to repentance struck home with the two shaken relatives, as we can see in a letter from Giovanni to Gianfrancesco, written in 1492. There the elder Pico stresses the sovereign importance of Scripture over all other reading in confronting the treacherous uncertainties of the here and now. Gianfrancesco became a still more fervent partisan of Savonarola's thinking.

After his uncle's death and his own expulsion from Mirandola, Gianfrancesco gravitated to the Tuscan community in Rome, where he attracted the eye and the assiduous attentions of Fedro Inghirami and eventually, through Inghirami, of Julius II. In January of 1511, when Julius reconquered Mirandola as part of his campaign against the French, he formally returned it to Gianfrancesco's dominion. By June 6, however, Trivulzi had wrested it back. In 1512, Gianfrancesco Pico was once again an exile in Rome. Languishing in the Belvedere as a guest of Pope Julius, he combined his pious attendance on Lateran V with the search for po-

tential political allies; it may be no wonder that the strange, powerful world of Rome now drove this melancholy character to something near despair.[10]

Pico was not the only desperate man in Rome in 1512. In his peregrinations about the Apostolic Palace, he met another delegate to Lateran V, the Venetian aristocrat Pietro Bembo, who, like Pico, faced the combined burdens of a more famous relative, dismal political failure, and advancing age; at forty-two, Bembo was one year younger than Pico, and both were well into their maturity by the standards of their time.

Pietro Bembo's father, Bernardo, was a man of enviable successes; a distinguished (if unscrupulous) diplomat, he had been elected year after year to various Venetian missions throughout Italy. On two separate missions to Lorenzo de' Medici, he had notoriously charmed the Florentines and struck up a close friendship with Il Magnifico. As he flirted Platonically with the local beauty Ginevra de' Benci, he made underhanded financial arrangements for himself and his family with the Medici bank, arrangements that were to stand him in good stead through the ensuing years. At home in Venice, he maintained an active intellectual life, working closely with the cultivated printer Aldus Manutius and with Pietro; in 1494, the three of them together devised the stately Roman typeface still known as "Bembo" in their honor and also, in the process, invented the semicolon.[11]

With humiliating consistency, however, the Venetians who readily entrusted their diplomatic missions to the father shrank back from something in the son; Pietro Bembo, for all his evident intelligence and still more evident ambition as a writer, lost every election he ever stood for in his native city. Instead, the younger Bembo self-consciously devoted himself to literature and courtly love, working tirelessly at both. Hovering about the small, haughty courts of Mantua, Urbino, and Ferrara, he composed his famous vernacular dialogue, *Gli Asolani*, and emoted on paper and in person with a succession of married women, including the lusty middle-class Venetian Maria Savorgnan and the circumspect duchess of Ferrara, Lucrezia Borgia.[12]

By the time they met in Rome in 1512, both Gianfrancesco Pico and Pietro Bembo were desperately frustrated men, though in profoundly different ways. Pico, darkly pessimistic, sought salvation in a radically reformed Church. Bembo, as unscrupulous and pragmatic as his father,

had come to play the existing system of sold offices and curial benefices. His learned friends in the city doubted that charms like his would escape notice for long:

> By your beauty and by your charm unfeigned,
> By your mien, your company so judicious,
> By your words, your elegance and your habits,
> By your learning you please us, and by your aura . . .
> Bymbus, image of everything that's noble.[13]

All the charming Venetian needed was a foot in the door, and, in September 1512, Gianfrancesco Pico gave Bembo his chance.

At some earlier literary gathering in Rome (or perhaps even in the pope's private library, where both were welcome and where Bembo especially loved to work), the two men had exchanged their views on the way to cultivate a Latin style. Both had had their own reasons for saying their piece on this perennial Roman topic; as delegates to Lateran V, both might hope eventually to deliver an address, while Bembo hoped in addition to accumulate the curial posts that would allow him the income to pursue his real interests as a writer.[14] Their conversation on style apparently garnered them some of the notice they thought they required; in September 1512, however, Pico decided to further their reputation by committing his side of the discussion to writing. He fired off a letter on style to Bembo; it was meant to be a showpiece, and it must have impressed people as such; Angelo Colocci saved a copy among his own papers.[15] Bembo's reply, which he claimed to have composed in the heat of passion, actually took him some four months to complete. He dated it January 1, 1513, or, to be precise, "the kalends of January," just as Cicero might have done.

Pico's letter brought up an aspect of style that had already engaged the Roman curialists for a good quarter century: How, and how much, should a modern fifteenth- or sixteenth-century writer imitate the ancient Latin writers, and which ancients should be held up as models worthy of imitation? Ever since the Middle Ages (and before), the two pillars of the elementary school curriculum had been Cicero and Virgil, authors who had written superbly in a variety of styles on a variety of subjects, and who were also regarded as good moral examples for young readers. As soon as young scholars had acquired a sizable Latin vocabulary to work with, they tried to compose exercises in the style of these two writers, learning elegant writing by doing it.[16]

IMITATION

The humanist movement took this time-honored practice of imitation a step farther: humanists tried to purge contemporary Latin of its medieval accretions, hoping thereby to restore it to the stately *gravitas* of the ancients.[17] Cicero and Virgil, as always, retained pride of place as the supreme masters of style in prose and poetry. For the most radical humanist reformers, true restoration of Latin purity meant discarding words that had not been in the ancient vocabulary, such as the words for "pizza," or "nun," or "violin." To describe such modern novelties, the most devoted purists, from the early fifteenth century onward, resorted to ancient terms, or combinations of ancient words, some of which were virtual synonyms and some of which looked bizarre even to contemporaries: "pizza" became "pita bread," "nun" became "Vestal Virgin," "violin" became "lyre."[18] The Church and all its trappings fell victim to the humanists' linguistic purge, with particularly curious results: church buildings became "temples," the College of Cardinals became the "Sacred Senate," its members "Senators" or "Conscript Fathers," liturgy became "sacrifice," and so on.[19] In this vein, when Leone Battista Alberti wrote his treatise on architecture, *De re aedificatoria*, he attempted to apply the vocabulary of Vitruvius both to ancient and to modern building types; his chapter on basilicas therefore moves abruptly from basilicas in the ancient sense of the term, that is, large assembly halls for lawcourts, to basilicas in the Christian sense, that is, churches.

Rome was always considered the hotbed for this variety of linguistic hypersensitivity; here, a return to ancient linguistic purity went hand-in-hand with other efforts, rhetorical and tangible, to achieve the city's rebirth. Alberti's *De re aedificatoria*, penned in the Vatican about 1450, provides a perfect example of how a Tuscan humanist could be swept up in the local enthusiasm. And if true antiquarians like Pomponio Leto spent their time reading an odd assortment of authors in search of forgotten facts and writing as the spirit moved them, less imaginative humanists refined their style by conforming it with increasing exactitude to that of an inventive ancient writer with a vast stock of words (many of his own creation), Marcus Tullius Cicero.

On the level of elementary education, the imitation of Cicero helped students to assimilate the whole Latin language. The imitation of Cicero by curial humanists aimed at something quite different: to produce an identifying jargon for their inner circle.

If Alberti had been an early exponent of this curial style, one of its first influential practitioners was Paolo Cortesi. Early in his career (perhaps around 1492), well satisfied with his progress in Rome, Cortesi had sent a collection of his Latin letters to Florence for his idol Angelo Poliziano to read. To his shock, Poliziano was loudly unimpressed:

> I am sending back the letters you have collected with such diligence; if I may speak freely, I am ashamed to have wasted my time in reading them, for aside from a very few indeed, they could hardly be said to be worthy of your having collected them, or of reading by any learned person . . . There is something about which I greatly disagree with you in matters of style. As I have understood it, you are not in the habit of approving anything that has not been composed along Cicero's lines. To me, however, the face of a bull, or, for that matter, a lion, is far more noble than that of a monkey, although the latter's is more like a man's . . ."You do not sound like Cicero," someone exclaims. What of it? I am not Cicero; to my knowledge, I sound like myself.[20]

Poliziano, twice rejected for the post of prefect of the Vatican Library, may have been nettled by frustrated ambition as well as by the artificiality of the Latin style practiced in the Curia. Cortesi's collection of letters could only have driven home the size of the gulf between the court language of Rome and the Latin idiom of Medicean Florence.

Cortesi, if stung, was also by this time a personage to reckon with. He sent Poliziano a reply in which he traced the Roman habit of imitating Cicero, as we have, to the process of early education in Latin:

> I would often claim openly that in these times nothing could be said elegantly or movingly except by those who had proposed someone as a model to imitate, just as travelers ignorant of the language can hardly get around foreign places without a guide, and infants of a year cannot walk without their stroller and their nurse. Although there are many who have excelled in every kind of oratory, I recall having fixed my sights upon Marcus Tullius as the single teacher to whom I would recommend that the study of every talented person be directed.[21]

Cortesi had probably been collecting letters to use as examples for a book on Latin style, an appropriate development, in a more mature vein, of the ideas he had begun to explore as a teenager in his dialogue *On Learned Men* (De hominibus doctis), itself a pioneering work of literary criticism. Despite his stout rebuttal, Poliziano's outburst must have been

enough to deter him from pursuing the project further. In 1504, early in the reign of Julius II, he floated another effort to make his mark on humanist Latin studies: this time, he endeavored to transform the plodding scholastic prose of Peter Lombard's twelfth-century theological textbook, the *Sentences* (Sententiae), into a showpiece of classical rhetoric. By this means, Cortesi asserted, both philosophy and theology could be expressed in a language whose aesthetic properties bore full witness to the terrible beauty of God. Couched in a more elegant style, Peter Lombard's work, he claimed, would induce more souls to embrace the Christian faith with greater fervor; it was still the basic theological primer for sixteenth-century readers. However, the preface in which Cortesi outlined his grand plan for a renewed theology fell somewhat sort of hard-hitting apostolic prose:

> Pope Julius, it has been a matter of the greatest contention among philosophers whether they should make use of the luster imparted by the study of Latin eloquence. For there are many philosophers who believe that the ability to create words is a matter of will and judge that they have no less freedom to invent them than did their predecessors, and they would have it that there is no reason why their liberty to invent words should be curtailed by their forerunners.[22]

Here Cortesi has focused attention on one of the reasons that scholastic language attained such precision; where no word existed to describe an idea, the Schoolmen invented one, usually by creating a new compound of common Latin elements (*excommunicare*, *pensionarius*, and *dignificare* are three examples), but also, on occasion, by Latinizing a vernacular term. (The Italian origins of words like *bombarda*, *girandola*, and *castratellus* show clearly through their Latinate endings.)[23] Although precise language had its considerable virtues, its drawbacks were equally clear: proliferating compounds piled quickly into the turgid prose we ourselves recognize as "legalese," "bureaucratese," and "gobbledy-gook," while Latinized vernacular words appeared to graft one language onto another, with results occasionally incongruous or downright ugly. In effect, Cortesi's preface argues that scholastic neologisms acquired their precision at the expense of beauty. Yet the expression of beauty, he contends, is no less important a task for language than the accurate description of ideas; to render the gorgeous realms of theology in awkward prose is its own kind of imprecision – but Cortesi literally speaks of "philosophy" because the word

"theology" is itself a neologism. (Cicero used the term *theologos* [theologian] but had no special word for the science itself; he called speculation about the divine *philosophia*.)

Cortesi's preface to the revamped *Sententiae* therefore suggests that theology – or philosophy – deserves a better medium than the prose of Peter Lombard: "It will be necessary to confess that this kind of philosophy should have an appearance that is literate and artful, and that is based upon the beauty of nature."

Cortesi's ideas were more straightforward than his allusive expression of them might suggest. (This, of course, is the drawback of the lovely style and limited vocabulary of humanistic prose: its loses the scholastics' exactitude.) By artfulness "based upon the beauty of nature," he meant an eloquence whose aesthetic system had a simple rigor comparable to the physical laws that govern, for example, the practice of architecture. A building stood, or it did not; so should a speech or a written text; this analogy was as favored by the ancient Greeks and Romans as it was by Cortesi and his fellow humanists. But writers on rhetoric and on aesthetics concurred that coherent structure was only the beginning. First-rate materials were equally imperative, whether these were a rich treasury of words or the finest building stone. Furthermore, a design could not be called good until it had been finished to its finest detail; in both Greek and Latin, the word for "perfect" (Gr. *teleios*; Lat. *perfectus*) is the same as the word for "finished."

In classical aesthetics, ornament, rather than a superficial adjunct to the underlying structural scheme of a speech or building, is instead that scheme's ultimate natural outgrowth, the final details that constitute *perfectio*, a completed project. Hence Cortesi defended ornamental rhetoric as the most effective, because the most moving, means of communication, just as ornamental buildings were more impressive than spare ones. His arguments went beyond theory, for he was well aware that some of his contemporaries could combine ornate speech and incendiary content with practiced mastery; we have already seen that his later book *De cardinalatu* singles out Mariano da Genazzano, Savonarola, Egidio da Viterbo, and Fedro Inghirami as outstanding examples. Cortesi never quite mustered their skill himself; his observations, however pungent, always seem to bob to the surface of a vast sea of words:

> If the appearance of philosophy is to be called artful, no one should doubt that a pleasing appearance will be more suited for study than a

disjointed one, because that pleasing quality, when it strikes the sense
of understanding, will broaden the interest in philosophy . . . We af-
firm that in preparing a speech, the soundness of our words is not to
be pursued in superficial effects, for elegance follows upon philosophy
as beauty follows upon the build of the body. Thus we deny that those
who believe that eloquence contains cosmetics and rouge will ever
grasp the principles of Rhetoric, because they do not distinguish virtue
from vice; even at close quarters they cannot tell meretricious speech
from healthy speech, like blind men for whom everything seems white,
and who cannot separate marble from pumice because they all seem
to merge in the whiteness.[24]

As Cortesi quickly discovered, Pope Julius already understood the use-
fulness of ornamental language in garnering souls for the Church – but
he also knew who used such language effectively, and called upon their
services with exasperating regularity. Paolo Cortesi was not among them.
Furthermore, Julius understood communication in a larger sense, pro-
jecting his message not only through his orators but also through the
"illiterates" like Michelangelo, Bramante, and Raphael, who imparted
new meaning to visual language and its own repertory of classical imagery.
The idea of Rome's rebirth, as they all knew, could be conveyed in
action, image, and Italian vernacular as well as Latin, and they devoted
much of their waking life to its presentation through these various other
means. Paolo Cortesi, absorbed in his own Latinate world, seems to have
lacked their concentration and almost certainly lacked their ability to share
the pope's fervor. The court of Julius II did not, on the whole, live by
the courtly rules of mannerly banter and incessant in-jokes; it had a larger
job to do in a larger world. In 1503, as Julius first entered upon the papacy,
Cortesi withdrew to his Tuscan villa to write without the continual dis-
tractions of Rome, and there, by and large, he was to stay until his death
in 1510, convinced that a life of retired leisure would produce the best
work.

Julius II seemed to have had other ideas about the wellsprings of human
invention, barking, "When will you finish?" under Michelangelo's Sis-
tine Chapel scaffold, sending a riderless horse to Egidio da Viterbo's sylvan
retreat with an order to ride back and preach, waving his stick at all and
sundry. He kept a copy of Paolo Cortesi's reworked *Sententiae* in his
private library, a deluxe edition printed on vellum, but when his reign
inspired a truly influential revision of Peter Lombard's *Sententiae*, it was
a reworking of content rather than style. In 1506 or so, Egidio da Viterbo

began his own attempt to rework Lombard's *Sentences*, introducing his own brand of Christian Neoplatonism into the venerable scholastic text. Julius himself provided the inspiration, with his drive and his sense of God-given zeal; about this Egidio informs his readers explicitly.[25] Unlike Cortesi's publications, which went largely unread, these manuscript *Sentences According to the Mind of Plato*, though they remained both unfinished and unpublished, nonetheless found a wide reading audience, and Egidio himself returned to these same ideas time and again in his public preaching.

This is not to say that members of the Julian court, especially finely tuned humanists like Fedro Inghirami, were uninterested in matters of style. But Fedro, at least, saw style from a different vantage than Cortesi, who claimed to be raising morals by adjusting the style of Peter Lombard's theological textbook but who was probably really advertising his availability for a choice curial post. Fedro seems with utter sincerity to have perceived his own prominent role within the Church hierarchy as one charged with moral responsibility. He is striking among his contemporaries for the extent to which, long after his school days, he continued to emphasize the importance of Latin letters as an instrument of moral instruction.[26] He professed to admire Cicero less for the great orator's style than for his fortunate combination of expressive language and social commitment:

> It has long been customary to make much of which times, and whose times, are those in which virtue occurs. The sense of this is proven in the case of Marcus Tullius, for whom, had he lived two hundred years previously, the Roman people would have been rude and intractable, or had he happened to have been born just fifty years later when tyranny had invaded everything, beyond doubt he would have been scarcely half what he was.
>
> For you, [Cicero], possessed all the qualities gathered together that are commended individually in others: you had reproduced the vigor of Demosthenes, the jocundity of Isocrates, you had outdone the Gracchi in fierceness, Lelius in levity, Julius in urbanity, Caesar in warmth, Cato in gravity, Calvus in sanctity, Hortensius in memory; it was you alone whom we could put up against the men of Greece in every one of their contests, and you had brought it about that Roman eloquence outstripped their efforts as greatly as had Roman fortune.[27]

Clearly, then, Inghirami regarded Cicero as a powerful symbol of ancient Rome's ascendancy, but to proclaim the rebirth of papal Rome he

mustered a new, personal language. Ironically, when Paolo Cortesi noted his fellow Tuscan's ascendancy, in *De cardinalatu*, he emphasized Fedro's ambition:

> In performing plays we will observe that those who wave their hands about continually or who use their fingers too fussily in their acting tend to attract attention. Indeed, Thomas Phaedrus of Volterra, a man who already as an adolescent could have arrived at supreme elegance, had not the search for greater glory deflected him toward oratory, is said to have given the actors the highest praises when the *Asinaria* of Plautus was performed on the Quirinal for Rome's birthday, reproving them only for overly ornate gestures, particularly of the hands.[28]

As this anecdote shows, Inghirami, however extravagant his persona, knew when to rein in the histrionics. Still, Cortesi, scrupulously correct and increasingly overshadowed by the brilliant Volterran, sensed something giddy about Fedro's success. The giddiness was certainly there to be remarked; characteristically, when imparting a piece of avuncular advice to his young protégé Paolo Riccobaldi Maffei, Fedro sang the praises of imitating Cicero with a crescendo of impassioned rhetoric: "Do not interrupt your literary studies; these will be your true riches, these your honors, these your high offices, but above all cherish and pursue good literature. Do not stray a fingernail's breadth from Marcus Tullius. Imitate him, copy him, plunder him, strip him of his bark; all in all, regard nothing as right except what reeks of him – laugh at the rest."[29]

This passage, surprisingly, has been taken repeatedly as evidence that Fedro himself adopted a radically "Ciceronian" form of the Roman curial lingo. Its piles of Inghiramian hyperbole show vividly that he did no such thing; he reveled quite happily in his own flamboyance. Indeed, Inghirami's epistolary style owed a certain debt to Pliny the Younger along with Marcus Tullius, and he could praise Virgil in the same reverent tones that he used for Cicero – or for Julius II: "Every style, every subject, Virgil will assemble his own eloquence for himself from all of these . . . Let us imitate him, therefore, let us follow him, let us never stray far from him if we wish to pursue Poetry."[30]

Inghirami, in short, was an enthusiast, for ancient Rome, but also for the contemporary Rome in which he lived and prospered. Nor was he wrong to advise Paolo Riccobaldi Maffei that good literature could be so many things to an ambitious young man. In 1516, Raffaele Maffei was to look back over Fedro's career and write to his brother Mario:

Indeed, [Fedro] was a man for whom natural talents piled up in more abundance than anyone I have ever seen or heard tell of. Aside from his elocution, which was his chief point of honor, he had an almost limitless talent, so that whatever he undertook succeeded impressively; thus he entered easily into the favor of princes, and though starting out as a pauper was quickly made a wealthy man, and as we saw, a good Volterran, he had good fortune right to the end of his life. If only he had applied those heavenly gifts to those fields that garner true praise and happiness, there would have been no man more blessed than he.[31]

Consequently, when Pico and Bembo exchanged their own letters on style, their literary exercise was bound to have only a limited effect in Julius's Rome; the pope's dictum "Io non so lettere" effectively relegated debates like theirs to the gatherings where humanists talked exclusively among themselves, and those gatherings were not the ones that shaped the fortunes of the city. Julius's personal secretary, Sigismondo de' Conti, although a humanist himself, shared the pope's scant patience for the fine points of criticism. Asked the difference between Poliziano and another fifteenth-century humanist, Giorgio Merula:

the most literate of all Italians, he is said to have replied that one of them seemed to act like a chameleon, taking the color of whatever he clung to, and the other resembled the bite of a woodworm; however slow its progress it ground away the hardest wood with its tenacity . . . He used to say that as many people knew about eloquence as knew how to judge painting; precious few of them spoke well or painted with any skill. Although it seemed easy to the onlooker, there was nothing more difficult for the person who actually dared attempt it.[32]

Sigismondo de' Conti's own taste in painting can be judged from Raphael's *Madonna of Foligno*, an altarpiece that de' Conti had commissioned for the Church of Santa Maria in Aracoeli at the summit of the Capitoline Hill. Almost exactly contemporary with the chapel of Johann Göritz, the completed Madonna may never have been seen by its patron, who died in February 1512.[33] Sigismondo himself appears in the foreground of what has been laid out as a standard type of devotional painting: the Madonna and Child appearing in glory to a pious donor kneeling in the foreground beneath them (Fig. 46). The holy figures in conventional examples of such paintings are usually shown full-face, whereas the donor appears in profile; sometimes the sizes of saints and mortals differ, and usually they occupy different areas of the composition. Raphael, how-

ever, has begun to transform this standard type into something new, with a striking storm in the background, a sky full of nebulous blue-gray cherubs, and a valiant attempt to make the whole scene occur within a plausible physical space. Sigismondo kneels in the usual donor's position, but he is mirrored by a kneeling Saint Francis, as if the medieval saint and the papal secretary inhabit the same time and place. As fur-clad John the Baptist directs our attention to the Madonna and Child, Saint Francis implores her to look toward us; opposite them, on the painting's right-hand side, Saint Jerome puts a protective hand behind Sigismondo de' Conti's head, commending him to the care of Mary and the infant Christ. Only the expansive folds of Sigismondo's ermine-trimmed red robe connect him to the physical world of the painting's mortal viewers; the painting presents him, in other words, as if he is already dead (not a bad plan for any painting designed to outlast the person who commissioned it). Despite the devotional intensity of the scene and the gaunt features of the donor, Sigismondo de' Conti's spirited face still reveals that he was as distinct a character as the pope he served so closely. This force of personality was not lost on Raphael, for whom the *Madonna of Foligno* marked an important step in his development as an artist. Sigismondo de' Conti had a right to take pride in his connoisseurship.

Why, among this exacting and preoccupied company, would Pico and Bembo have bothered to whip their discussion of literary style into such a public spectacle? Both maintained strong ties with northern Italy, with the courtly world in which such stagy exchanges were an important means by which to gauge the participants' relative social status within a tight community, the intellectual equivalent of rams butting heads to establish their dominance in the herd. Scholarly debates had served both of them all their lives as a cover for more basic battles to secure their positions. Their behavior in Rome must therefore have been virtually instinctive, and it was familiar as well to any number of northern Italians resident in papal Rome.

PICO VS. BEMBO

Pico, at least, had absorbed something of Pope Julius's activism, if not his attitudes. Like his friend Inghirami, he presented imitation of the ancients as a step in the process of moral education and seems, like Fedro, to have regarded moral development as important. His letter to Bembo treated Cicero, with great empathy, as an active participant in the tumultuous

events of first-century Rome. This Cicero was a republican hero, a self-made man, the outspoken foe of tyranny, the champion of duty, the student of philosophy, the invincible lawyer. This Cicero coined words and took tremendous risks with language in order to woo his contemporaries to his points of view, seeking out eloquence as a means of persuasion rather than as an end in itself.[34] Survival in the treacherous conditions of first-century Rome had demanded nothing less, and Pico, who, like Cicero, was to die by a betrayer's sword, understood precariousness at first hand. There was no such thing as a single Ciceronian style, Pico insisted to Bembo, for Cicero's language was compelled to respond to every exigency of Cicero's life:

> Thus it happens that the genre of his writing varies, for he also adopts various levels of expression; the orations of Cicero, his book *On the Orator* dedicated to his brother Quintus, his *On Famous Orators*, and a number of others, are flooded by a great river, not to say an ocean, of eloquence. Yet this same river, broad though it may be, barely waters his books on rhetoric, or those which have been written on the universe and fate – and barely a droplet sprinkles the *Topics*. [His eloquence] also changes as his age changes, and Cicero himself says that his oratory grows gray.[35]

Mastery of style in Pico's terms was a conditional phenomenon, dependent entirely on time, place, and circumstance. In Neoplatonic fashion, he regarded all human attempts at communication as the result of a divine impulse emanating from a higher realm than that of the physical world, for whose imperfection and turmoil he nurtured a profound contempt. Any human attempt to express divinity's ineffable impulse, whether Cicero's or Plato's or his own, would never achieve more than an act of approximation.[36]

Thanks to his early years among the elite of late fifteenth-century Florence and his later years in Rome, Pico also accepted the practical worldly goal of humanist classicism: to refine Latin into a more effective tool of persuasion and, more specifically, as a tool of evangelical persuasion. He bore out the points of his paper debate with Bembo by plying his own classical eloquence to urge his vision of Christian truth; thus in his angry poem "De diis expellendis," mentioned earlier, he adopted classical poetic meter and classical language to insist that Rome expel her pagan gods and give up her devotion to carnal things and replace them with Jesus.[37] In 1517, he addressed a letter to his fellow delegates of

Lateran V, exhorting them, with Savonarolan zeal but in pure classical style, to mend their errant ways. His most virtuosic manipulation of style, however, animated a dialogue on witchcraft, the *Strix*, published in 1523. Here, in the mouths of two humanists, one an enlightened skeptic and the other a firm believer in witches, Pico mustered classical authors and the rhetorical principles of humanist debate to prove that demons, witchcraft, and Satanism had existed ever since classical antiquity. With powerful effect, however, he inserted the formal give-and-take of this learned discussion into the middle of an Inquisitorial trial, suggesting explicitly at the dialogue's end that the legal precision of the Inquisitor's language and the anguished outbursts of the accused witch, an uneducated and terrified plebeian woman, conveyed exactly the same truths as the humanists, albeit with less panache. One wonders whether his view of Cicero's world (and of his own) was as demon-riddled in 1512 as it would be in 1523; certainly Pico already regarded his times as corrupt, pervaded with evil, and saw style as a weapon in the fight for good as he understood it.

Notably, too, Pico was willing to grant that mastery of Latin style in his own day was no longer the exclusive privilege of Italians; he had spent time in Germany himself and corresponded throughout his life – in Latin – with the illustrious friends he had made there. The cosmopolitan microcosm of Lateran V would only have reinforced this opinion. In his letter to Bembo, Pico declared, therefore, that an educated person might emerge from anywhere at all, including countries where a Latinate language was not the native tongue:

> This is what will happen: should our age be granted a person of sound judgment, he might well prefer, and rightly, those who now speak with moderate skill to those who are outstanding, those, that is, who have spent their time among the Goths, Vandals, and Huns, yet retain that ancestral principle of eloquence obliterated by so many centuries, or attempt to retain it by continuous imitation. There's wondrous subtlety in this phenomenon – perhaps too much.[38]

When so enlightened a soul as Egidio da Viterbo was in the habit of calling Germans "barbarians," Pico's assertion stood out for its impartiality. Furthermore, "barbarians" like Erasmus were already in the process of proving him right about their potential for mastering Latin style.

Bembo's reply to Pico had none of his friend's expansive eagerness; it was tightly controlled from beginning to end. His disquisition dealt exclusively with the niceties of style and how to develop them, avoiding

both the larger philosophical problem of human self-expression and the more immediate question of what ends eloquence might serve. This restricted scope is certainly an essential element of his own letter's careful rhetorical structure and its consequent success. But it may as easily have reflected the limited concerns of the man himself. Bembo wrote indefatigably on a certain range of topics: to demonstrate his erudition, to explore his own vagaries in the throes of love, to hand down dicta on good style and good behavior. He was, all in all, a man of staggering self-absorption, and, like many self-absorbed people, he made charming company. By the time he replied to Pico he was a practiced writer and a practiced courtier, his style and his manner gleaming with impeccable polish. All of these qualities made an impression on his contemporaries.

Bembo professed to have chosen two ancient models on which to hone his style: Cicero for prose, and Virgil for poetry. The choice could not have been more conventional; he shared it with every fifteenth- and sixteenth-century student of elementary Latin. However, he absolved these authors of the moral duties they were usually called upon to perform for young students. Bembo's own drive as a writer came from a fierce sense of competition for outside approval, and he seems without reflection to have attributed the same motives to the rest of humanity:

> I most approve those who, when they are about to compose in prose, hold out Cicero alone to be imitated, and in epic poetry, Virgil . . .

> . . . Just as if, when we are making a journey, we are assigned leaders, we take to the road in a more secure state of mind, so, too, in other matters we are more eager in our pursuit if we have teachers and masters. Likewise, we are incited toward every great desire for praise and reputation by nothing so much as by emulation of others. I thought that both in my poetic studies and in the practice of oratory, I should do that which I knew many, many others to have done, namely to choose a leader for each art, illustrious of reputation, whom I might follow, and with whom I might compete; I would set him before me almost as a signpost, toward which all our attempts and our thoughts would be directed.[39]

Rather than searching for examples of ancient moral virtue, Bembo, in other words, scanned his authors for clues to perfect method. Success was his ultimate criterion (one cannot help recalling his own repeated political failure); hence, Cicero and Virgil pointed the way for him be-

cause, of all writers, they had obtained the highest degree of approval by others:

> But all who delight either in oratory or in poetic study ought to hold [their minds] firm, and to rely upon and perfect their own abilities, so that once they have embraced both Cicero and Virgil they will never release them, and never be enticed away by the charms of other writers from the imitation and emulation of these. If they do not abound equally in every brightness of art and talent, if they do not seem to be endowed in heaping proportions with every excellence of writing, still, for excellence, these have been more approved once and for all than any other writers. And so, we say that it is better to follow them alone, and to imitate them, for the reason that we can progress and aspire more nearly to perfect method with them as leaders than with the others.[40]

With chilling virtuosity, the ambitious Venetian thus divorced the cultivation of Latin style from pedagogy, civic responsibility, and moral edification, while at the same time thrusting himself forward in the curial court as an alternative to influential figures like Fedro Inghirami. He wrote with uncommon clarity, just what was needed for an abbreviator, scriptor, or apostolic secretary. All he lacked was the divine spark that would give him something profound to say.

LEO X (1513–1521)

If Pietro Bembo's letter to Gianfrancesco Pico advertised his gifts as a humanist to the Roman Curia, fate turned that advertisement into a manifesto. In March 1513, Julius II died, to be succeeded as pope by Bembo's childhood friend Giovanni de' Medici, son of Lorenzo the Magnificent, who took the pontifical name of Leo X (Fig. 47). When the new pontiff rode out to take formal charge of the Lateran in the solemn procession known as the *possesso*, the humanists, exhilarated at his election, made certain that Pasquino was ready to greet him with appropriate dignity. Decked out as Apollo, the battered old statue sported a new poem pinned to his Grecian robes:

> I used to be an exile, but I'm back in Leo's reign,
> So burn your midnight oil, boys, and follow in my train;
> For no one leaves my Leo without a handsome gain;
> Bards will sing for prizes, and they'll not sing in vain.[41]

Agostino Chigi (with some learned help) put the same sentiment slightly differently on the same occasion. The temporary triumphal arch he had erected next to the main office of his bank bore a verse inscription by the humanist Marcantonio Casanova referring to Leo and his two predecessors as follows:

> Once Venus had her time,
> Once Mars had his.
> Now Pallas [Minerva] has her time.[42]

In other words, the lascivious Alexander VI and the warlike Julius II were to be succeeded by an intellectual. (These brief but vivid characterizations may also serve as a reminder that Chigi's ability to prosper under all three popes was a remarkable feat.)

Giovanni de' Medici, tutored as a boy by Angelo Poliziano, had been a precocious master of improvising clever lines in Latin verse. In his new office he continued to solicit from the humanists, often joining in their games himself. Colocci and his friends never felt so completely at home in the Curia as they did for the nine years of Leo's papacy.

An uncommonly young pontiff (he was thirty-seven at the time of his election), Leo put a new generation in charge of the Vatican. He made Pietro Bembo one of his two personal, or "domestic," secretaries, together with the earnest young prelate Jacopo Sadoleto. Domestic secretary, as we have noted, was a post that stood, like that of Vatican librarian, outside the roster of venal offices; it was a direct papal appointment. Bembo, therefore, immediately commanded far greater influence over the pope than an "apostolic" secretary like Angelo Colocci. And he pressed his advantage immediately.

The ambitious Venetian did not take long to begin imposing his idea of style on the Curia. For Fedro's Latin fireworks, he substituted his own strict cultivation of Ciceronian language, as outlined in his letter to Pico:

> Inasmuch as Cicero is the one Latin author who surpasses all the teachers of good writing who preceded him, whoever they might have been (which was a great and divine thing, to be sure), then certainly someday someone else may come into existence, by whom, along with all the rest, even Cicero himself will be surpassed. There is no easier way for this to happen than for us to imitate him most whom we most want to surpass. It is absurd for us to trust that we will find another, better way than this way, one that Cicero did not so much discover himself as make broader and brighter once it had been discovered by others

. . . so we will follow him whom we have most imitated; then it will be time to turn our attention to whether we can surpass him.[43]

Thanks to his vigilance, the curial cadres put increasing emphasis on how things were said rather than on what things were said; the handsome Bembo's courtly restraint emphasized, by contrast, the flamboyance of Fedro Inghirami, who found himself the victim of scurrilous poems attacking his obesity and his homosexuality. They were quite possibly written by Angelo Colocci, and certainly written to please a pope who was only marginally less corpulent and no less drawn to the company of other men. The most mean-spirited of these is posthumous, written in September 1516:

> Last night, Leo, there perished with the twilight
> That most weighty of orators and poets . . .
> Filling out his family tomb to the limits,
> He's left no more room for his poor descendants.[44]

But Inghirami, who had spent his boyhood in the new pope's Florentine household, was one of Leo X's most longstanding associates; they had both arrived in Rome in their teens, Giovanni de' Medici as a young cardinal, Fedro as a student and aspiring curialist. They had both met with supreme success, for Fedro, as Vatican librarian, canon of Saint Peter's, and secretary of the ongoing Lateran Council, was one of the most powerful figures in Rome. Right up to his death in 1516, he continued to pull his considerable weight in the Vatican.

Furthermore, Pope Leo appreciated Fedro's quick mind and histrionic skill. To the Volterran's hands, therefore (along with those of Inghirami's fellow Roman academician Camillo Porcari), the pope entrusted the first of the many public pageants that would characterize his pontificate; in September 1513 he conferred honorary Roman citizenship on his brother Giuliano, recently restored to power in Florence.[45] The festivities in Rome became a showcase for Tuscan patriots; Tuscans were the largest foreign group in Rome, so much so that they eventually altered the local dialect from a variety of southern Italian to a hybrid of northern and southern elements. For once, Siena, Volterra, and Florence forgot their traditional enmities to trumpet their common "Etruscan" heritage through the streets and squares of Rome.

The Sienese architect Baldassare Peruzzi created a temporary theater on the Campidoglio for Fedro's two-day banquet and variety show; between Tuscan pilasters, painted panels showed various vignettes of the

time-honored relationship between ancient Rome and the Etruscans, to whom the Tuscans of the sixteenth century ostentatiously traced their ancestry, guided as ever by Annius of Viterbo's pseudo-Etruscan mythology. Among other attractions, Lady Roma welcomed Giuliano as her own while pelting him and the bystanders with perfume-filled eggs (more typically the prerogative of Roman courtesans). Happy shepherds recited modernized versions of Virgilian poetry, and, on the second day, Inghirami staged a Latin performance of Plautus's *Poenulus*, during which one of the characters showered the audience with coins minted for the occasion, with Lady Roma on one side and a bust of Giuliano, or Leo, or both, on the other. A splendid time was reportedly had by all.

Egidio da Viterbo, ecstatic at the election of an "Etruscan" pope, once again rehearsed all his ideas about antiquity's prefiguration of keybearers, ships, and Eucharistic elements.[46] He abandoned his Neoplatonic reworking of Peter Lombard, which was only about one-quarter done, and set to work instead on a universal history in which Leo's election featured as the long-awaited fulfillment of Christianity's timeless mission. He called this new work "The History of Twenty Ages" ("Historia XX saeculorum"), using an ancient Etruscan unit of time, the *saeculum* or "age," which lasted roughly one hundred years.[47] The "twenty" of the title was a magic number, and many were the numerological, prophetic, and etymological proofs that Egidio adduced within the twenty previous *saecula* of universal history to herald a new Golden Age that would come into being sometime during Leo's reign. Egidio noted the pope's interest in literature as pointedly as his fellow humanists, whom he singled out for enthusiastic praise:

> And in the [nineteenth] age, religion arrived at true elegance, a level of literary splendor reached by no age since the overthrow of the Golden Age . . . What shall I say of Rome in those same years: at the altar of the Divine Anna erected by Gorycius in my temple [Egidio means S. Agostino] a contest of poets was seen celebrating the sacred rites, such as was once devoted to the scribbling of shameful poetry and obscene. In this flower of writing Venus gives way to the Virgin . . . You, Leo the Tenth, have put the felicity of their writing to work . . . for before, what was written with holiness was written less elegantly, and what was written elegantly was not written with holiness; now the same things are written with holiness and elegance at once.[48]

Rather than deploring the pope's devotion to the hunt, as Serafino Ciminelli had once deplored the hunting expeditions of Cardinal As-

canio Sforza, Egidio's "History of Twenty Centuries" turned the favorite pastime into a metaphorical pursuit of God; an avid huntsman himself, he justified his own forays with Leo into the woods around the papal lodge at Magliana and his own retreat near Viterbo with this religious purpose:

> Leo, most generous of huntsmen, keep your prey, do not let it be snatched from you. Make certain that the evil foot of your ambushers is caught in that hidden snare . . . The lion is the one terror of all the forests, just as earth and heaven depend on you, who alone will not only care for your wounded Bride [the Church] but avenge her where she is insulted, redeem her where she is sold into slavery, wash away her filth, perfume her where she stinks, clothe her where she is ragged, heal her where she has been torn, adorn her where she has been hidden, make her blessed where she has been miserably afflicted, and establish her as perpetually happy, so that, overcome by these favors, she will adore you, her legitimate spouse.[49]

At the same time, however, this great orator of Julian Rome gave evidence of an increasingly powerful mystical streak. The Göritz Chapel in Sant' Agostino probably testified, as we have seen, to his involvement in the study of Hebrew mysticism; soon he was to devote most of his intellectual efforts to more and more intricate contemplation of the Kabbalah. As the exploration of secret lore turned him inward, it made his already allusive language more difficult still to understand:

> That Law which was given to Moses by God, Greatest and Best in words of plain meaning, was exhibited to all the people, and that which was given in the secrets of letters and certain divine names [i.e., the Kabbalah] was handed down to the understanding of Moses alone, and of certain holy men who were truly wise, for them to examine and to ponder deep within. The meaning of the former is common knowledge, of the latter recondite.[50]

He might have said the same in comparing his public orations for Lateran V with the text of the "History of Twenty Centuries." The great preacher had always been an allusive speaker, but it grew harder for him to keep his allusiveness in check.

PARTY POLITICS

From the new pope's lavish *possesso*, its temporary triumphal arches studded with singing boys, to the Capitoline Theater, erected in honor of his

brother Giuliano's election to Roman citizenship, it was evident that festivities were to become an unusually important medium by which the son of Lorenzo the Magnificent intended to convey his political agendas. The humanists were gradually to discover that Leo's true love was music; he also revealed a penchant for rather crude practical jokes.[51] The promising patron of the *litterati* was more easily won over, as it turned out, by song or action.

Thus, in 1514, when King Manuel of Portugal solicited funds from Leo in order to mount a campaign against the Moors, his request came in the form of a gift. His choice of a gift suggests the degree of extravagance that he felt might be necessary to win the pope's notice. Hanno the elephant, fresh from India by way of Lisbon, was disembarked at Porto Ercole near Siena in February 1514, thence making his way southward to Rome in the company of trained leopards, piles of brocades, and his faithful mahout.[52] Unaccustomed to long overland treks, the beast had to be outfitted with two pairs of shoes in papal crimson before his travels were over, but he finally arrived, the first of his species on Italian soil for many centuries. Hanno and his company came, as pilgrims do, through Rome's Porta del Popolo, guided by a Portuguese ambassador, Diego Pacheco, delegated for the express purpose of delivering the pachyderm, and once across the Tiber on Vatican ground, docile Hanno genuflected three times before His Holiness before spraying the populace with water from his trunk. The pope's delight at King Manuel's ingenuity resulted in the pretty and pious present of the Order of the Golden Rose, but a solid gold flower was not enough in itself to sustain armies.

Manuel therefore redoubled his plea for funds, shipping Ganda the rhinoceros early in 1515. This second candidate for Pope Leo's zoo was tragically shipwrecked just off the coast of Civitavecchia, though eventually his stuffed carcass, robbed of its horn, made its way to the Vatican as well.[53] Again the Portuguese king reaped generous praise and little else, for however well he understood the effectiveness of extravagant action in the Leonine court, he could hardly compete with the drains closer to home down which Leo saw fit to pour his money. Spectacle has always been costly, and to the extent that the Leonine papacy marked the triumph of spectacle, it also marked the emptying of the Vatican coffers so carefully restored under Julius II.

Sensitive to the slightest change in the political winds, the humanists quickly noted the difference between the entertainments mounted by Julius and by Leo. A pasquinade written sometime in 1514 referred to

these changes in civic pomp, spurred by the recent memory of the Capitoline Theater and by the advent of Hanno. Pasquino, the insolent talking statue, now spoke as if the chubby pope were taking a ride on the elephant's back:

> Time after time I used to behold such glorious triumphs,
> So long as Julius headed the uttermost ends of Rome.
> Now I look on, as fools mount the Capitol's sacred precinct –
> Leo's after this title, and that bit of lofty prestige.
> Meanwhile the beast that once bore armored towers in battle
> Hauls an unworthy load in the saddle on its back.
> If Rome be compared to a beast, let it be the elephant; surely
> It's the closest of all to the human perception of things.[54]

Although Pasquino's sallies were anonymous, it is not unlikely that the author of these verses was Angelo Colocci's closest friend, the Ferrarese poet Antonio Tebaldeo, a witty man who leavened his humor with a considerable dose of common sense. Tebaldeo was somewhat of a rarity among the *litterati* of Leonine Rome because he continued to express an unabashed nostalgia for the days of Julius II. Another epigram from the time of Hanno's advent suggests, however, that Tebaldeo was not entirely alone in his sentiment: "You who care for the elephant, say, do you worry / Which beast is carrying which? I can't tell them apart."[55]

PRINTERS: PUBLIC, PRIVATE, AND GREEK

Although political relations in Leonine Rome could be cemented on occasion by jungle animals, the pope entrusted mass communication to a more reliable medium: the printed book, which began to outstrip oratory as the chief bearer of tidings in Rome. Here the pope's connection with Pietro Bembo may have been a crucial stimulus, given Bembo's long-standing association with the Venetian press of Aldus Manutius and his superb skill as an editor. In Rome, three printing houses worked under official papal sponsorship as "booksellers to the Roman Academy" (*bibliopolae Academiae Romanae*) or purveyors to the university, each with a slightly different slant, the houses of Étienne Guillery, Jacopo Mazzocchi, and Evangelista Tosini. A fourth house, that of Eucharius Silber, served as official typographer for the Curia.[56] Distinguishing the productions of one house from another is not always easy: Guillery, Silber, and Mazzocchi were also constantly borrowing one another's equipment.

Just to the west of Piazza Navona, Étienne Guillery plied his press from 1506 to 1521, producing bulls and safe-conducts as well as occasional verse in Latin and, to a greater extent than any of his colleagues, in Italian vernacular: together with his Bolognese partner Ercole Nani, he printed each year's official edition of pasquinades, as well as occasional works like Pietro Corsi's Latin "Panegyric of the Treaty between Julius II and the King of Spain" (Panegyris de foedere inter Iulium II et hispan[orum] regem, 1511); Egidio Gallo's *De Viridario Augustini Chigii* (1511), a breathless Latin-hexameter tour of Chigi's suburban villa; Juan de Ortega's vernacular book on *abbaco*, likewise dedicated to Chigi (*Summa de arithmetica*, 1516); and the Italian essay of one "Philomathes" from 1514, entitled *On the Nature, Intellect, and Customs of the Elephant* (Natura intelletto e costumi de lo elephante).[57] Predictably enough, Giangiacomo Penni's *Form, Nature, and Customs of the Rhinoceros* (Forma et natura et costumi de lo rinoceronte) followed from Guillery's press in 1515, just as Ganda's carcass made its sorry way to Rome.

Because Tosini produced the theological and legal texts that served students in those areas, he had the least to do with the curial humanists and had little to do with publishing their works.

From their shop in the Campo de' Fiori, Eucharius Silber (active 1479–1509) and his son Marcello (active 1509–27) served as the official printers for the Curia; not surprisingly, therefore, they specialized in theological tractates, ranging from the *Antiquitates* of Annius of Viterbo through the *Commentaria Urbana* of Raffaele Maffei to treatises on one of Leo's particular concerns, reform of the calendar. When the time came, as it soon would, Marcello Silber also spewed anti-Lutheran tracts on behalf of the papacy.[58]

Yet the Roman printer who may have enjoyed the closest sympathies of Leo X and his two elegant domestic secretaries was Jacopo Mazzocchi. (Active from 1506 to 1521, he was Guillery's exact contemporary.) Closely attuned to the intellectual currents of the papal staff, he printed philosophical works, collections of inscriptions, studies of ancient Rome, and neo-Latin verse, as well as guidebooks like Francesco Albertini's *Little Book of Wonders of Ancient and Modern Rome* (Opusculum de mirabilibus antiquae et novae Urbis Romae) of 1510. His decision to publish the acts of Lateran V was taken in full consciousness that the council had provided a glittering display of papal rhetoric. Mazzocchi was a purist; of 165 books, he published only 2 in Italian and utterly refused to print the classics in translation.[59]

Bembo, at least, did not share Mazzocchi's aversion to the vernacular. Like Angelo Colocci, Pietro Bembo had recognized early on – in his own case, before the turn of the century – that there was a promising connection between printing and the developing world of vernacular literature. Indeed, his first large-scale work, the dialogue on love called *Gli Asolani*, announced at exhaustive length his personal guidelines for cultivating a vernacular style as part of a larger commitment to proper courtly behavior. These convictions were to finally solidify in his lengthy essay on vernacular, *Prose della volgar lingua*, well under way by 1513 but only presented to Pope Clement VII in 1524. Here, as with his cultivation of Virgil and Cicero in Latin, Bembo assumed that Dante and Petrarch had already found the way to "perfect method" in Italian, and that the contemporary writer should develop a personal style by exclusive imitation of these past masters.

Angelo Colocci's linguistic studies took a wholly different view; he placed Italian vernacular within a developing new world of what we call "Romance languages" and Colocci himself called "linguae latianae" (Latinate tongues). Working in Provençal, Spanish, and Portuguese with the same enthusiasm he devoted to his native Picene dialect, he collected and annotated manuscripts in every one of those languages, some of them now national treasures in Lisbon and Paris.[60] His defense of Serafino Aquilano, the unruly wandering practitioner of a new, hybrid lyric form, announced his own sense that the possibilities for novel vernacular creation lay wide open in a world where language, style, and social class seemed to have relaxed their rigid barriers.

Bembo, on the other hand, concentrated with characteristic single-mindedness on bringing his Italian to perfection through imitation. Like Serafino Ciminelli, Bembo was a stylist, but the essence of his style was restrictive – careful emulation of models and carefully controlled social behavior – whereas Serafino's was explosive, upending Petrarch, patronage, and good taste in the service of sovereign self-expression. For Serafino, unkempt and brilliant, there would have been no place among the exquisitely polite ranks of Bembo's *Asolani*, but even an Angelo Colocci, with his incessant drive to speculate about weights, measures, and the order of creation, would have found the conversation at Asolo impossibly confined; in fact, he was no great friend of Bembo's in real life. In one respect, however, Bembo's Procrustean standards for style performed a useful service: the correspondence of the Medici pope, in both Latin and vernacular, was some of the most stately stuff ever to leave the papal chancery.

Another language had yet to make its full impact on the culture of papal Rome: Greek, the second language of every ancient Latin writer and a coveted skill among humanists. As a student of Poliziano, Leo had had some of the best training in Greek available in his own day. He decided, therefore, to establish a Greek Academy once and for all, with the help of Mazzocchi and Angelo Colocci. We have seen that the idea itself had first surfaced during the reign of Julius II, coinciding, not surprisingly, with the painting of Raphael's Greek-inspired frescoes the *School of Athens* and the *Parnassus* on the walls of the Apostolic Palace – that is, in the years 1510–11. Then too, as Colocci reported to Scipio Carteromachus, it was that most *au courant* of Roman printers, Mazzocchi, who had discussed setting up a Greek press with the Cretan printer Zacharias Kalliergês.[61] But when it finally came to printing Greek in Rome, the refined Mazzocchi suddenly lost Kalliergês and his services to a most unexpected rival – Agostino Chigi.[62]

The immediate stimulus behind Chigi's venture into the world of publishing was his chancellor, or head secretary, Cornelio Benigno, one of those humanists in Rome who made their living working for a lay employer. He convinced Chigi to make him a substantial loan (800 ducats) to set up a Greek press in Rome with Kalliergês; in the beginning, at least, Chigi also supplied him with the work space. With Benigno as sponsor and Kalliergês as editor and printer, this press produced a Pindar in 1515, with textual scholarship and printing of very high quality.[63] Benigno claimed to have acted as editor, but the real intellectual force behind the edition was always the printer himself.[64]

Chigi's seven-month stay in Venice in 1511 may also have had some bearing on his decision to back Benigno and Kalliergês in their publishing venture. There he would have seen how Aldus Manutius ran his flourishing press as a private enterprise, driving out talented printers like Kalliergês by the sheer scope of his success. Because Rome was an untested market, with no competitors, Chigi must have been curious about its possibilities and therefore willing to help Benigno with his experiment.

In 1516, a second Greek book appeared, the *Idylls* of Theocritus, another classic work of Greek lyric poetry and as likely a candidate for success among the Roman humanists as any text in that language. And yet, unfortunately for all concerned, the Kalliergês press failed to make money.[65] Chigi, revealing more reverence for profit than for Greek studies in Rome, requested a complete return on his loan when its term expired.[66] Benigno may already have pulled out of association

with Kalliergês in editing the Theocritus; at least, there is no mention of his name in the text.[67] Later in the same year, on September 25, Benigno and Kalliergês were forced to liquidate 778 copies of Pindar and 981 of Theocritus to a bookseller, and in that bookseller's inventory lies another reason why the members of the Greek Academy in Rome failed to pull together at the height of the High Renaissance. From a run of 1,000 books each for Pindar and Theocritus, the Kalliergês Press had sold only 241.[68] Agostino Chigi would surely have recited his Tuscan proverb, "Ove non si pò, non si vole" (Where there's no way, there's no will).

Just as Pindar went to press with Agostino Chigi's blessing, Leo X finally designated some papal funds to favor the development of Greek studies. Appropriately, however, this effort was not a Greek Academy for fully trained humanists but the more modest, and more realistic, project of a Greek gymnasium, a school to instruct the young.[69] Zacharias Kalliergês had already been appointed master ("maestro degli allievi") in 1514; now he could begin to work with students.[70] At this level of instruction, Angelo Colocci was also perfectly comfortable with assuming formal responsibilities as an academician. He lent the project his garden on the Quirinal, the one he may have inherited from Pomponio Leto, and helped to set up a Greek press on the premises. Now Mazzocchi acted as printer, and Cornelio Benigno once again involved himself in the printing of Greek. But the most important aspect of Leo's endowment was the gymnasium itself. Through schools like this Greek gymnasium, Rome eventually produced a population of scholars who could make full use of the Greek manuscripts in the Vatican Library and the printed editions of Greek texts that became increasingly common throughout the sixteenth century. (The undaunted Kalliergês, for instance, produced two anthologies of Greek literature in 1517.)[71] But it would take another generation to build such a community. Rome had a long way to go before it could pretend to be a new Athens in anything but name.

PROJECTS WITH RAPHAEL (1514–1520)

As the plans for the Greek gymnasium went ahead, Angelo Colocci's own research took an exciting new turn. He became an archaeological consultant to Raphael, whose rise in Roman social circles had become virtually irresistible, especially after the removal of Michelangelo and Bramante, the other two commanding artistic talents in the city. Michelan-

gelo, morose by nature and missing Florence, returned to his native city in 1515, after three frustrating years at work on Julius's tomb. Without the importunate old pope to goad him, he changed his mind back and forth, leaving 1,000 ducats' worth of Carrara marble, quarried in 1506, still lying unworked along the docks at the city port of Ripa Grande. While Michelangelo tinkered with successive designs, Agostino Chigi helped himself to some of the stone to use for his own mortuary chapel (and hired Raphael to design it). Bramante survived Pope Julius by only a year; he died in 1514. Under Leo's papacy he retained his position as architect of Saint Peter's, by now a combination of roofless hulk and construction site. Sensibly, the new pope's first intervention was to commission Bramante to build a sturdy shelter for the high altar, under which he and the cardinals could conduct the Mass in relative comfort.[72] This Bramante did in a style that served as a harbinger of his plans for the basilica itself: a Doric frieze topped smooth-sided columns modeled on those from the lowermost story of the Colosseum. In Bramante's hands, the distinctive combination seemed to serve as a hallmark of papal style.

As for the rest of Rome, the bold plans that Bramante and Julius had devised for their garden city were abandoned, bit by bit. Leo authorized cutting the princely properties on the Via Giulia into smaller lots, reduced for quicker sale and less glorious development, so that the garden city on the Tiber was to remain no more than a grandiose vision. Still, as a Medici, Pope Leo knew all about aggressive urban planning. Initially he intended to alter the Roman cityscape as boldly as Pope Julius, entrusting a fellow Tuscan, Giuliano da Sangallo, to create a "Città Medicea" in the long city block between the Piazza Navona and the university. The project, with its patent references to his own passion for books and learning (as well as to his dynastic pride), was meant to rival, and possibly to eclipse, Julius's garden city, now doomed to incompletion.[73] Leo quickly discovered, however, that urban planning required more money than he could part with happily. He settled instead for paper plans.

Upon Bramante's death in 1514, his position as architect of Saint Peter's passed to a team headed by two people: Raphael, Bramante's distant cousin, and the aged scholar-architect Fra Giocondo of Verona, returned to Rome after a quarter century in Venice. Both of these appointments made eminent sense, except for the fact that Raphael was already over-committed and Fra Giocondo was quite elderly. But Bramante had achieved a real coup by bringing Raphael to Rome; as the relationship between mentor and protégé turned into a genuine collaboration, the

younger man, always a quick study, absorbed much of Bramante's approach to design, especially in architecture, as well as his fascination with the ruins themselves. Raphael must have inherited more than drawings from his late mentor, for the elder architect's firsthand study of ancient monuments, his habit of consorting with intellectuals, his penchant for classifying his observations, and his love of beginning new undertakings all seem to have passed along intact. In every sense, Raphael was a true heir to Bramante's legacy.

VITRUVIUS AGAIN

Fra Giocondo, in turn, was an old friend of the Medici family; he had dedicated a manuscript anthology of ancient inscriptions to Lorenzo the Magnificent in his younger days, and his much-touted reconstruction of the Greek passages in his printed Vitruvius of 1511 had been made possible thanks to a Medici manuscript.[74]

As joint heirs to Bramante's plans for Saint Peter's, Raphael and Fra Giocondo also entered into Bramante's spirit of invention, seeking inspiration for an architecture of the future through careful analysis of ancient monuments and texts. Certainly Giocondo's intelligent and visually enticing Vitruvius made that most authoritative of ancient architectural writers more accessible than ever before. Vitruvius, moreover, offered concrete advice that helped fifteenth- and sixteenth-century architects articulate what it was that they found so aesthetically appealing in ancient Roman architecture: on the most fundamental level, Vitruvius insisted that the secret of all good design was a firm basis in the measure of the human body. Columns in Vitruvius have definite tops and bottoms, with different dimensions for each; so do doors, walls, and all the minute components of their ornamentation. Their proportions fall within a restricted range: a column should be somewhere between six and ten times as tall as it is wide at the bottom; a colonnade should have columns placed somewhere between one-half a column width and two columns' width apart. These strictures, which run deeper than the equally evident ornamental systems now known as the classical "orders" (Doric, Ionic, Corinthian, and the like) are what gave classical architecture its distinctive appearance; Romanesque and Gothic columns, for example, put no limits on the proportion between a column's width and height, while a Modernist panel building may be composed of oblong pieces with no distinct ups and downs. Vitruvius also offered advice on the healthy placement

of cities and their buildings, on astronomy, on waterworks, and on siege engines; in the early sixteenth century, much of his scientific information about "veins" in the earth and a chemistry of four elements was still widely accepted.[75] He insisted on the highest quality of building materials and gave detailed instructions on how to select timber, apply stucco, mix paint, and pour concrete under water. The monuments of ancient Rome stood as testimony to the ancient Romans' skill as engineers; the builders of the new Saint Peter's needed all the advice they could get about how to make their own colossal enterprise stand on its foundations.

Raphael decided, sometime after his appointment as architect of Saint Peter's, that he wanted access to *De architectura* in the vernacular.[76] He did not pretend to know Latin (although, like Bramante before him, he probably understood a fair amount). With Fra Giocondo as his partner, however, that fair amount could not have been enough; his subsequent efforts show that Raphael wanted, and eventually acquired, real mastery of the text. He therefore requested a translation from Latin to Italian of the eccentric philologist Marco Fabio Calvo, author of the antiquarian treatise "De numeris," an expert on Pliny the Elder's *Natural History*, and the future translator of Hippocrates.[77] Calvo's readings had given him an unusually concrete grasp of everyday life in ancient times: Pliny's huge encyclopedia ranged from the properties of stone, metal, wood, and animals to a capsule history of ancient art. The medical writings passed down under the name of "Hippocrates" provided detailed accounts of various diseases but also a famous treatise on climate (*Airs Waters Places*). Calvo's familiarity with ancient number symbols enabled him to work with the difficult number symbols in the important tenth book of *De architectura*, on machines. Furthermore, the penurious Calvo quite simply needed the money the work of translation must have brought him. (Raphael may have provided lodging as well.)

There are now two surviving manuscripts of Calvo's translation, one complete and one partial, containing books 1 through 4 and part of book 5. They are both preserved in Munich among a cache of manuscripts that once belonged to the Florentine humanist Pier Vettori, to whom they may have passed at the time of the Sack of Rome in 1527. Both prove unmistakably that Calvo had a partner in his translating enterprise, for both texts are written not in Calvo's hand but in that of Angelo Colocci.

Colocci's presence as a consultant to the project would have made sense under any circumstances; he was an old friend of Calvo's and the owner of a copy of the latter's essay "De numeris." Colocci was also a

close friend of Fra Giocondo, who altered his will to bequeath many of his manuscripts, especially those on mathematics, to the younger man. All three shared a peculiar passion for ancient inscriptions as well as ancient mathematics, and all were meticulous students of the Latin language. What seems a bit more surprising is Colocci's service as scribe; it testifies to more than casual interest in Raphael's project. One of these manuscripts, the complete one, must have been Raphael's working copy; his own notes appear in its margins in a variety of different inks and with his pen trimmed to different sizes (Fig. 48). We do not know whether Raphael and Colocci met through Bramante or Giocondo; we do know that this set of highly distinct personalities, of widely differing backgrounds, shared a similar passion for ancient Rome and its stimulating effect on the production of modern Christian art.

Colocci, moreover, acted as much more than a scribe (a task for which his handwriting was less than ideal anyway). The manuscript is filled with revisions, some involving a reinterpretation of the Latin text of Vitruvius and some involving a refinement of the translation's own literary style; he must have been involved in Calvo's enterprise for quite some time. With his expertise in all the ramifications of "number, weight, and measure" and his superb library, he came prepared for the task of putting Vitruvius into usable Italian.

Colocci's personal copy of Fra Giocondo's printed Latin text of *De architectura* (1511) is a remarkable document in itself. He has systematically compared Giocondo's readings (based largely on manuscripts in Venice) with at least two manuscripts of his own, each indicated in his marginal notes by its own symbol (Fig. 49). His own emendations are carefully labeled "ego." In general, Colocci's is a far more conservative text than Giocondo's boldly conjectural one; Colocci rejects many of the latter's emendations and adheres more closely to the manuscript tradition, though not as closely as Sulpizio da Veroli had done in the 1480s; knowledge of Roman antiquity had made huge strides in two decades, thanks to the generation trained by Sulpizio and Pomponio Leto. Calvo's translation likewise diverges significantly from Giocondo's text at times, but the manuscript also shows its own repeated changes of mind, as the artist and his humanist friends look over Vitruvius again and again, comparing the text with Colocci's manuscripts of the *Agrimensores*, with his Greek treatises on siege warfare and their brilliantly colored illustrations; examine Calvo's beaten-up printed Pliny, its margins dark with notes; and always, incessantly, investigate the ubiquitous ruins around them.

At some point in the process of translation, Colocci and Raphael must have decided to transform the vernacular Vitruvius into a printed book, with Raphael's illustrations. This is what the second, incomplete surviving manuscript of the translation is all about (Fig. 50): it contains Calvo's text, corrected and given a little more flair by Colocci, along with a tentative and oft-revised list of the illustrations that Raphael was supposed eventually to provide.[78] A large, illustrated, vernacular Vitruvius was already in preparation in northern Italy by Bramante's old Milanese associate Cesare Cesariano, who published his annotated, illustrated translation in Como in 1521. Raphael and Colocci must once have hoped to beat him to press.

DRAWING ROME

Raphael and Angelo Colocci extended their collaboration beyond Vitruvius. When Pope Leo's plans for a Città Medicea near Piazza Navona sank into a mire of expenses, the pope fell back on urban planning in miniature: a project to reconstruct imperial Rome on paper. Once again, he drafted Raphael for the job. In Raphael's words,

> Your Holiness commanded that I draw ancient Rome, or as much of it as one can know from what can be seen today, with those buildings which show sufficient preservation to enable infallible reconstruction on true principles of their original state, making those elements which are entirely ruined or barely visible correspond to those still standing and visible.[79]

By this time, perhaps around 1516, Raphael's commitments to the pope already included continuing the fresco cycle begun under Julius in the papal apartments (the Stanze Vaticane) and their adjoining loggia, designing a new tapestry series for the Sistine Chapel, and, of course, doing something about the monumental wreck of Saint Peter's. He was also engaged in several commissions for Agostino Chigi, not to mention a whole series of other patrons, from Leo's friend Cardinal Bibbiena to the king of France. His workshop was large, but there was no doubt that he was beginning to fall hopelessly behind in his work. For the drawing project, with its exacting requirements for "infallible" reconstruction on "true principles," he once again enlisted the help of Angelo Colocci, whose notes indicate that he was working carefully with the measurements of ancient architecture and explain why he felt it was important to

do so: "And because Vitruvius undertook so much work on the proportions of columns, I began to examine buildings."[80]

It is unclear exactly how much of Leo's paper commission was ever completed; Marcantonio Michiel, a Venetian resident in Rome, reported that the drawings of one of the fourteen ancient regions of the city had been finished at the time of Raphael's death in 1520.[81] He must have entrusted a certain amount of the work to assistants, and it is quite possible that some of the drawings of Roman ruins done by Antonio da Sangallo during the period of their collaboration on Saint Peter's may have been destined for Leo's portfolio.[82]

Colocci's distinctive handwriting also proves that he helped draft the letter of dedication meant to accompany the completed set of reconstruction drawings when they were finally presented to Leo. Raphael, whose social connections were virtually unlimited, also sought the help of a second humanist, a commanding presence on Leo's Parnassus, the Mantuan aristocrat Baldassare Castiglione, who arrived in Rome for a brief stay in 1516.[83] Castiglione had known Pietro Bembo from their days as courtiers in Urbino, a tie that bound them as well to Raphael, a native of Urbino and a child of its court. Castiglione shared Bembo's taste for urbane gamesmanship and enshrined both man and manner all too definitively in his series of dialogues on courtly pastimes, the *Book of the Courtier* (Il Cortegiano), whose fictionalized microcosm at the Urbino court has too frequently been taken as an accurate portrayal of the more expansive, and more varied, reaches of sixteenth-century society in a large city like Rome. Important for the reconstruction project, however, was the fact that Castiglione shared Colocci's open-ended opinions about the development of vernacular rather than Bembo's narrowly restrictive *Petrarchismo*, and it was as a vernacular stylist that Raphael drafted Castiglione to work over his presentation letter to Leo X. It was an unusual move for this most genteel of professionals to put so formal a document as a dedication into *volgare*, but the decision was true to Raphael's nature; he did not know Latin well. In a sense, he must have wished to claim implicitly that his expertise in ancient Rome's visual legacy was as impeccable as the humanists' language; the drawings would speak for his skill as an antiquarian. With Castiglione's help, moreover, his preface would make a proud show of vernacular's peculiar elegance. An inveterate fiddler, Castiglione eventually produced several drafts of the text, continuing to work on it when he returned to Mantua in 1517.

MANIERA

Raphael's prefatory letter falls into three sections. Castiglione's touch is most evident in the first of these; indeed, a draft of this initial portion of the text is still preserved in his own hand in the Castiglione family archive in Mantua.[84] The distinguished humanist centered his contribution to Raphael's letter on what he called "maniera," which we may loosely translate, for the moment, as "style."[85] The ancient Romans had had it, the barbarians had lost it, the Germans had begun to recover it, Bramante had brought it back to vibrant life, and Leo, the letter urged, could use it to attract Christian souls to a life of virtue:

> Because Rome was entirely ruined by the barbarians, burnt and de-stroyed, it seems that that great fire and that miserable ruin burnt and ruined, together with the buildings themselves, the very art of building. It followed that, with the fortune of the Romans reversed and with the calamity and misery of slavery following in place of the endless victories and triumphs (as if it were not right for those, who were now subjugated and made the slaves of others, to live in the same manner and with the same grandeur as they did when it was they who had subjugated the barbarians), suddenly, along with Fortune, the way [*modo*] of building and dwelling switched, and each manner [*maniera*] of architecture appeared to be as distant from the other as slavery is from freedom, and Rome was reduced to a manner adapted to its misery, without craftsmanship or proportion, or any grace whatso-ever.[86]

Thanks to Castiglione's help, the letter itself, just as Raphael must have intended, set its own standards for vernacular style; like the building blocks of a classical temple, the subordinate clauses interlock, one after another, to construct the sonorous bulk of Castiglione's monumental run-on sentences. They are modeled explicitly on the periods of Cicero, mus-tered to prove in action that Italian vernacular could rightfully aspire to Ciceronian *gravitas*. The *Hypnerotomachia Poliphili* had reached toward the same goal only twenty years before, but the difference between its pon-derous prose and the fluidity of Castiglione's supple lines bespeaks a whole new level of sophistication:

> Not the least of your thoughts, Holy Father, should be to take care that what little remains of this ancient mother of the glory of the Italian name (through the testimony of those divine souls, who still today

with their memory stimulate the spirits that are among us today and awaken them to virtue) shall not be extirpated altogether and laid waste by the malign and the ignorant . . . Instead, may your Holiness, by keeping alive the challenge of the ancients, endeavor above all else to equal and indeed to surpass them. This you may do with grand buildings, by nurturing and favoring the virtues, reawakening talents, rewarding valiant effort, sowing the holy seed of Peace among Christian princes . . . This is to be a true Clement Pastor, and Father to all the world.[87]

Maniera often meant what we mean by "style," and the letter marks the first recorded instance of a distinction drawn between the various artistic styles of antiquity, as well as the awareness that this difference in *maniera* came about because of a difference in period:

> Architecture was observed and maintained with good method [into late antiquity], and one built in the same *maniera* as before; this was the last of the arts to be lost, and one can recognize this from many examples, among them the Arch of Constantine, the composition of which is well executed in every respect having to do with architecture, but the sculptures on that same arch are utterly clumsy, bereft of art or any decent design. Those that come from the spoils of Trajan and Antoninus Pius are excellent and of a perfect *maniera*.[88]

Maniera also meant something more than style, as its cognate, "manner," suggests: it was also a kind of deportment, a put-togetherness that the ancient Romans called "concinnitas." The Arch of Constantine, in the view put forth by Castiglione and Raphael, exhibited more than stylistic differences: it exhibited gradations of quality ranging from the "perfect *maniera*" of Trajan (A.D. 98–117) to the artless, bad design of Late Antiquity.[89] They reprove the latter, in effect, for behaving badly: "The same thing can be seen in the Baths of Diocletian, for the sculptures of the era are of the worst *maniera* and poorly executed, and the remnants of painting that can still be seen have nothing to do with those from the time of Trajan or Titus. And yet the architecture is noble and well thought out."[90]

Raphael's own painting of the period not only shows his awareness that *maniera* was subject to variation but actively exploits this principle to expressive ends. Depending on context, he adopted a statuesque, marmoreal style evocative of ancient sculpture or reverted to the more gentle lineaments of his Umbrian training. His *Isaiah* of 1512 bore the imprint

of two further visual stimuli: the epic muscularity of Michelangelo's newly unveiled Sistine Chapel ceiling and the soft, suggestive Venetian brushwork of Sebastiano del Piombo. As these various styles became more and more distinct in his art, they became as distinct as the "modes" of composition described by ancient rhetorical writers.

The difference between Raphael's modes, and something of what they might mean, can be seen most strikingly, perhaps, in the two levels of his *Transfiguration*, a painting that draws the contrast between a celestial vision vouchsafed only to Christ's closest disciples and a miracle, the healing of an epileptic boy, wherein God is made manifest through a cruder, more remote terrestrial revelation. As in the *Disputa*, Raphael has created a hierarchy of representations of an ultimately ineffable divinity, but as a fully mature artist he uses his sculptural style to bring out the stony weight (but also the dignity) of the men and women who focus shortsightedly on their earthly affairs, drawing the contrast between them and the ethereal, weightless quality that a looser brushstroke imparts to Christ, the prophets, and the disciples. His *Galatea* of 1514 successfully evoked the shear of wind across water, but the *Transfiguration*'s most spectacular passage of painting is a celestial whirlwind that forces the terrified disciples to the ground, tugging at their robes as it snatches Christ up in its vortex. As in the *Madonna of Foligno*, the epiphany of God rides to earth on a storm.

ORDERS

At a certain point later in its history, Raphael's letter to Leo X changed its orientation: from a personal letter to the pope, it became a more general disquisition on architecture.[91] The agent for this change was apparently Angelo Colocci, and again his presence in Raphael's life involved transforming a manuscript project into a printed book, probably (with a certain degree of shrewd self-interest) well after Castiglione's return to Mantua. Colocci himself wrote the last extant redaction of the letter, perhaps in 1519, ignoring some of Castiglione's later corrections and incorporating new material. This final version of the text shows the effect of collaboration between the artist and the lifelong student of measure (and reflects the influence of their friend Fra Giocondo): in careful detail, it touts a new method for drawing buildings with the help of a magnetic compass mounted on a circular template; the technique, adapted from surveying practice, allowed Raphael to render buildings to scale with their

measurements preserved intact. "And be aware," the letter declares, "that in describing this technique, we are not governed by chance or by practice alone, but by true method [*vera ragione*]." Pietro Bembo's scrutiny of Cicero, as we may remember, was aimed at attaining a similar goal, the *perfecta ratio* of "perfect method." In a sense, accurate drawings of ancient monuments were indeed the visual counterpart of accurate readings of Cicero; they would lead to a clearer understanding of the ancient world. Nor did the task stop there: in both cases, the ultimate goal of such careful study was to penetrate through to the underlying principles by which the ancients had created their marvelous works and then to use those same principles to create new things for a new era.

A second important innovation in this ultimate draft of the letter to Leo X appears on its final page; here Raphael and Colocci address the subject of architectural ornaments: "There is no need to say anything, except that all of them derive from the five orders which the ancients used, that is, Doric, Ionic, Corinthian, Tuscan, and Attic . . . We, as the need arises, shall explain the orders of all [five], presupposing what Vitruvius says."

Four of these columnar types are discussed in Vitruvius (Doric, Ionic, Corinthian, and Tuscan); to the fifth "order," referring to four-sided piers rather than columns, Raphael and Colocci have assigned a properly Hellenic term, "Attic," but they probably made it up. Just as Pietro Bembo called for the refinement of Latin and the Italian vernacular by setting up Cicero, Virgil, Dante, and Petrarch as standards to be imitated rather than as springboards for the development of entirely new styles, so too Raphael and Colocci's establishment of the classical orders signaled the end for a certain kind of inventiveness in the practice of architecture, an inventiveness that had transformed the fifteenth century, ever since Brunelleschi, into a period of unruly, exuberant architectural experimentation.[92]

Ironically, the enshrinement of the orders, like the Ciceronians' enshrinement of Cicero, probably traduced the spirit of Vitruvius as completely as the Ciceronians traduced Cicero's own boundless inventiveness. In the first place, Vitruvius never referred to the "classical orders" in his *De architectura*; rather he wrote that Doric, Ionic, Corinthian, and Tuscan were the four types (*genera*) of columns whose names he knew, asserting at the same time that there was no limit to the development of new types, either by judicious mixing and matching or by sheer play of fancy.[93] Indeed, he professed confidence that Rome's future architects would do no less; his own treatise simply gave them guidelines by which they could

ensure that the results would be attractive and well proportioned. Ancient Romans had in fact created new types of columns with some regularity: the Roman Doric favored by Bramante and Raphael, for example, differed significantly from the Doric architecture of the Greek world. (Roman Doric has smooth columns, with bases as well as capitals; Greek Doric has fluted columns, with no bases.) The melding of Ionic and Corinthian forms now known as "Composite" was a Roman invention of the early Imperial period, but the ancient world also numbered Aeolic, Palmyrene, Nabatean, and a host of more idiosyncratic genera alongside the Doric, Ionic, and Corinthian standards.

Like the ancient Romans, architects of the fifteenth century had crafted their columns with considerable abandon, supplying them with an endless variety of custom capitals, just as their medieval forebears had done with greater freedom still.[94] With Raphael and Colocci's establishment of the "classical orders" in 1519, all that changed, and quickly (Fig. 51). "Order," in papal Rome, was never an entirely neutral word, because in a theological sense order derived from God's first act of creation (in terms of number, weight, and measure) and served to define the trace (*vestigium*) of God's presence.[95] Order had an inescapable finality about it, and that finality probably shaped the direction of Raphael's thinking about architecture. Nor can this artistic idea of imitating a restricted number of classical models be separated entirely from the influence of Pietro Bembo, who sought out Raphael's companionship in precisely this same period, between 1515 and 1520. Bembo's classicism, so clearly defined and so clearly expressed, could be contagious.

And yet, to an extent never reached by Bembo's literary exercises, Raphael's work continued to show that his creative urges overpowered the imitative search for archaeological exactitude. As he scanned the ruins of ancient Rome, he stayed alert to new ideas, and he found them by using a technique that he shared instinctively with Bramante and Michelangelo, one that Bembo advocated without knowing quite how to master it: the search for the underlying structure of *vera ragione, perfecta ratio*, the "true" or "perfect" rational principle. The "orders" were only a step in his artistic pursuit of pure order.

Raphael's late architectural designs moved from accurately reproducing the form and proportion of ancient columns to an exploration of what classical columns meant. From Bramante he had learned that they acted out the architectural story of load and support, for Bramante was the first architect of the age to insist that even engaged columns and pilasters

should exhibit the heft of weight-bearing members; whether or not they actually bore the structural weight of a façade, they ought to look as if they did. A building like the Palazzo Riario conveyed the important idea that its pilasters, like the engaged columns of the Colosseum that served as its inspiration, marked rhythm across a façade, yet the pilasters are almost flush with the vast flat surface of the Palazzo Riario's masonry shell. Bramante, and Raphael after him, drew a distinction between the wall and its articulations by making their engaged columns and pilasters project in distinctly higher relief. They experimented with rhythm by designing façades with a double order, a pair of columns in place of one, setting up the same principle of rhythm but giving that rhythm more variety. Eventually Raphael went still farther: the upper stories of his now-demolished Palazzo Branconio dell' Aquila replaced fictive columns altogether with rhythmic intervals of stucco and bandwork. Yet the principle of order itself was still palpable in the measured lines of the building's novel façade.[96] In his design for the villa of Cardinal Giulio de' Medici, Pope Leo's cousin (the so-called Villa Madama), he bound together a massive façade by means of giant-order, two-story pilasters that cut across the divisions between floors. Vitruvius himself had once used colossal two-story columns to unify the interior of his basilica in the Roman colony of Fano; on a far more lavish scale, Raphael could still see the tremendous columns that had soared inside the now-crumbling halls of the imperial baths. Vitruvius, Bramante, and the ruins taught him that size and number of columns could be adjusted so long as the basic principles of the order – rhythm, sequence, and harmony – held firm.

Unlike Pietro Bembo's restrictive Ciceronian regimen, Raphael's work with his old mentor, Bramante, and his new intellectual collaborators, Castiglione, Calvo, and especially, perhaps, Angelo Colocci, enabled him to lift their discussion of the classical orders – their own invention – to an architectural exploration of fundamental principles, of order absolute. Their scrutiny of the ancient world, Vitruvius in particular, led them toward new "modes and orders" of creation.

ORDER REALIZED: THE LOGGE VATICANE OF LEO X (1518) AND THE CHIGI CHAPEL IN SANTA MARIA DEL POPOLO

Two of Raphael's latest works reveal the true measure of his inventiveness within the strictures of classical architecture and how deeply he came to

understand what he described in his letter to Leo X as its *vera ragione*. For both of these late projects, his role transcended the practice of individual arts; he acted, rather, as general designer, incorporating painting, sculpture, and architecture into grandly comprehensive schemes.

Only one of these commissions was completed; his decorations for the loggia of the papal suite in the Vatican Palace were unveiled in 1518. (These decorations are now known, in the plural, as the Logge Vaticane.) The loggia itself was Bramante's design, part of the renovations he undertook for Julius II, and it gave direct access to the Stanze, where Raphael's workshop was still at work completing for Leo what the young artist had once begun for Julius. To provide the thirteen bays of this glorified corridor, the Logge, with ornamentation that was both visually arresting and somehow coherent was no mean task, but Raphael's managed it handsomely, once again telling the story of Rome's eternal destiny in the process (Fig. 52).

Bramante had outfitted each bay of the loggia with its own groin vault; for each, Raphael provided a fictive architectural frame that held four small fictive panels (known as *quadri riportati*). These were arrayed around a central panel in which a stucco angel carried a yoke: Leo's personal motto was "Suave" (Easy), the first word of one of the biblical verses that Handel's *Messiah* has made famous: "His yoke is easy, his burthen is light." From the first bay to the twelfth, these *quadri riportati* portrayed scenes from the Hebrew Bible; the thirteenth encapsulated Christian Revelation in four scenes: the Annunciation, the Nativity, the Crucifixion, and the Resurrection. The ensemble of biblical vignettes, which comprises only one element of the master design, is now known as "Raphael's Bible." The central bay, the seventh, contains the story of Noah, whose Etruscan nature Leo took to heart as enthusiastically as Egidio da Viterbo. The most ornately executed of all the vaults, it forms the axis of the loggia's entire design, not only thematically but also visually.

The lunettes under the groin vaults, the walls, the piers, and the pilasters of the loggia are all decorated in imitation of ancient Roman painting, the "grotesque" style that artists like "Mr. Perspective" and Pinturicchio had eagerly copied from the ruined interior of Nero's Golden House ever since the 1470s. Raphael entrusted material execution of the grotesques in the Logge Vaticane to his assistant Giovanni da Udine, whose ability as a nature painter was unsurpassed. Giovanni da Udine had also, with the help of Vitruvius, recovered the recipe for an-

cient Roman stucco, and the loggia was the first place in which he could trumpet that discovery in all its glory.[97] Like the original grotesques of Nero's Golden House, the grotesques of Leo's Apostolic Palace were executed in three dimensions. The Logge Vaticane therefore merged painting, sculpture, and architecture in their grand design.

It is clear, despite Giovanni da Udine's marvelous work in the loggia, that the mind behind every aspect of its grotesque decoration was that of Raphael; when later left to his own devices, Giovanni lost both discipline and inventive power. A repeating sequence of four distinctively shaped stucco panels descends down the surface of every exterior pier and its matching internal pilaster: an oblong, an Amazon shield (pelta), a circle, and an almond-shaped mandorla. Only the sequence stays constant; every one of the stucco figures enclosed within these shapes is unique, derived from ancient coins, from nature, or from contemporary life. Taken by themselves, the stucco panels, like Raphael's Bible, provide a virtuoso demonstration of the way in which order can foster invention.

The layers of ordering go on and on: although each bay of the Logge is an entity unto itself, the fundamental decorative elements of the first bay mirror those of the thirteenth, the second mirrors the twelfth, and so on. The fictive architecture in the vaults of the odd-numbered bays is enclosed; that in the even-numbered bays is open to the sky. Like the Sistine Chapel ceiling (which the vignettes of Raphael's Bible quote relentlessly), the Logge Vaticane employ an intricate system of interlocking decorative schemes with impressive mastery. Significantly, however, the basic rhythm of the Logge is carried not on the thirteen bays, which are essentially units of empty space, but on the fourteen sets of piers and pilasters that divide them. Vitruvius called such a range or row of columns an "order," and in working out the decorative plan of the Logge, Raphael has taken him at his word.

Raphael makes this understanding clear in a tiny but telling detail: although no two bays are alike, adjacent bays share an interior pilaster. Because each pilaster is decorated with a design that is axially symmetrical, what may seem to be superficial painted ornament in fact makes a clear announcement that these places are the hinge points not only of the decoration but of the underlying building itself. The pilasters are superimposed on two half pilasters, one on each side, and this feature presents Raphael with a problem: in order to maintain the symmetry of these half pilasters, he must violate the symmetry of the bays. Or, to look at it another way, he has devised a design that compels him demonstrably to

rank the importance of one element, the order, over another, the bay. In formal terms, the Logge Vaticane insist that the design's deepest principle of order is the Tuscan order of its colonnade, and by 1518 "Tuscan order" meant not only a row of columns or pilasters but also the Tuscan (Etruscan!) order of architecture. For an "Etruscan" pope, the successor of "Etruscan" Noah, the conceit was perfect.

What struck Raphael's contemporaries about the Logge Vaticane was not necessarily their compositional sophistication but their boundless exuberance, brilliant color, and glistening white stucco. They agreed that with these Christian grotesques at last the ancients had been surpassed. And yet it is the detail that reveals how thoroughly Raphael had entered into the compositional principles of the ancients and made their *ragione* his own.

If the Logge Vaticane represent Raphael's attainment of ancient style, his design for Agostino Chigi's mortuary chapel moved, like the Sistine Chapel ceiling, into new terrain.[98] Indeed, like the Sistine Chapel ceiling, it was begun under the reign of Julius II, when Chigi's power was at its zenith and Raphael's ambitions were prodded by the genius of his Florentine rival and the fervor of his pope. Chigi chose to be buried in the Church of Santa Maria del Popolo, the Augustinian church at the northernmost gate of Rome that had become a stronghold of the Della Rovere family ever since its reconstruction by Sixtus IV. As an adoptive member of the Della Rovere clan, the great banker meant to make the most of his exalted association. (Appropriately, this was also the church where Chigi had paid for Serafino Aquilano to be buried in state in 1500 and where, five years later, Julius II was to lay Cardinal Ascanio Sforza to rest at papal expense.) Bramante's striking shell canopy over the choir had reverberated on many an occasion with the sounds of Egidio da Viterbo's oratory. Two Raphael panels, the *Portrait of Julius II* and the *Madonna of Loreto*, hung on columns in front of the altar. And in the winter of 1510–11, while the papacy waged war in the north, Martin Luther resided in the adjacent monastery.

Chigi allegedly spent 22,000 ducats on his mortuary chapel, a budget that dwarfed even the 16,000 allotted to Michelangelo by Julius II for his tomb in Saint Peter's – proof, if any were needed, of the scale of Chigi's magnificence. The Chigi Chapel's innovations are difficult to see now, because they were so immediately influential; by contrast, the recent cleaning of the Sistine Chapel ceiling has allowed us a taste of that work's original shock value. Yet in its own day, Agostino Chigi's sepulcher

packed something of the same punch in its sumptuous materials, its Roman *gravitas*, and its powerful sense of movement. For this was the place where, in 1519 or so, Raphael's investigation of architectural order made its transformation from the controlled exuberance of the Logge Vaticane to the propulsive energy that he was simultaneously trying to capture in the central vortex of the *Transfiguration*.[99]

Unraveling the meaning of the Chigi Chapel is difficult for two reasons. First of all, as John Shearman has shown, Raphael changed his plans for its design in 1519. Second, it was never completed. The paintings in the chapel, all sixteenth-century, postdate Agostino's death, and the whole ensemble was remanaged in the seventeenth century by Raphael's baroque analogue, Gianlorenzo Bernini, to the order of Agostino Chigi's descendant, Pope Alexander VII. The baroque alterations wrought some fundamental changes in the chapel's layout, all to answer one paramount concern of its seventeenth-century patron, the former Fabio Chigi: elevating the status, within the chapel's decorative scheme and within the Chigi family itself, of his own great-grandfather, Agostino Chigi's youngest brother Sigismondo, who had no place in the original plan. Thus the cenotaph now identified in bronze letters as Agostino's was originally destined for Agostino's wife, while the place of honor reserved for the great merchant has now been usurped by his sibling. The grille that once led to the chapel's crypt has been replaced by a solid plug of inlaid marble on which a flying skeleton holds aloft the Chigi coat of arms.

It is also true, however, that Fabio Chigi was a patron of unusual sensitivity, not only to family history but especially to art. On the whole, Bernini's interventions in the Chigi Chapel held closely to the grand outlines of its original meaning.

The building blocks of the Chigi Chapel are relatively simple: in form, it imitates, and is meant to evoke, a miniature Pantheon. The distinctive arrangement of its porch pilasters, like the configuration of the pilasters and capitals themselves, is virtually a direct quotation from Hadrian's temple (with some very minor differences). Early in the Christian era, the Pantheon had been reconsecrated to the Virgin Mary; its imposing domed space was an eminently appropriate classical form for a Renaissance Marian chapel to take, and Chigi consecrated the space in his chapel to the Virgin of Loreto (Fig. 53). Rather than an oculus open to the sky, Chigi's miniature Pantheon boasts a mosaic dome (Fig. 54) divided into eight panels. In each, one of the planets, the Sun, or the firmament of the fixed stars appears as a sphere twirled by a guardian angel; these celestial

bodies are also personified in the same panel by the appropriate classical divinity. In the central oculus, God, bearing an uncanny resemblance to Julius II and flanked by angels, beckons imperiously to the realms below.

The chapel dome bears the signature of its Venetian mosaicist, Luigi de Pace, and the date 1517; the Pantheon conceit must have been part of the chapel's original design. So too, presumably, were the plans to have Sebastiano del Piombo paint an Assumption of the Virgin as the altarpiece and the arrangement of four marble statues in niches, two to a side. God's beckoning gesture, therefore, would originally have been directed toward a rising Mary, thematically linking the dome with the lower reaches of the chapel. Only two statues were completed in the sixteenth century, perhaps from some of the marble that Agostino had taken so unceremoniously from Michelangelo. One represents Jonah with the whale; the other may be the prophet Habakkuk, or perhaps Elijah, gazing in awe at the flaming chariot that will bring him to heaven. Jonah is an unequivocal symbol of resurrection, an appropriate theme for the mortuary chapel of a pious Christian; both Elijah and Habakkuk carried similar overtones in contemporary iconographic schemes. The chapel therefore made a neat but hardly original parallel between faithful Christians' expectation of their own bodily resurrection at the end of time and the Virgin's prefiguration of that ultimate journey by her assumption into heaven, accomplished long ago. More unusual is the way in which Raphael knit together the chapel's levels through the idea of movement and metamorphosis, as the Virgin and the souls of all pious Christians prepare to rise at God's command.

Raphael's final changes to this plan projected it into an entirely new sphere of monumentality, and perhaps of hubris. In this last design, Chigi and his wife were to be buried beneath two pyramids with veneers of flame-colored marble; a smaller pyramid stood in the crypt at the head of his leaden casket.[100] The Egyptian overtones of these pyramids are striking, of course, with their suggestions of pharaonic eternity, but there may be a much more specific set of allusions, as Marc Worsdale was first to suggest. Ancient Roman emperors, at their death, were put upon a funeral pyre with eagles tethered to its summit. As flames consumed the emperor's body, the tethers of the eagles were burned and the birds flew upward, a symbol of the dead ruler's immortal soul released in apotheosis. Within the Chigi Chapel, Agostino Chigi's passage from death to eternal life seems to be proceeding along the same lines: eagles are captured in

midflight on the chapel frieze. The playful references to Chigi as Augustus in the humanists' poems are here given boldly concrete form, commending him in that immortal guise *in saecula saeculorum*. More striking still, God's beckoning gesture no longer extends to the Virgin Mary alone but to Agostino Chigi as well.

Raphael expands upon the theme of metamorphosis in the very way he treats the formal elements of the Chigi Chapel: the pyramids slice right through the chapel's frieze course, just as the Virgin and Chigi's soul will slice through the ether to reach heaven. The pyramids' flame-colored marble veneer serves as a reminder that the word "pyramid" itself is derived from the Greek word for fire (*pyr*); these solid stone elements are pretending to be made of bodiless flame as they demonstrate something of flame's power of movement.

Raphael's ability to synthesize Roman imperial imagery with scriptural text and popular devotion shows his harmonic genius at its most acute. His experimentation with materials and textures, and his ability to interweave these with the chapel's symbolic themes, show that he was ready to put Chigi's generous funding to use in radical ways. But Chigi must have contributed more than money to the enterprise. The Chigi Chapel is as rich in imagery as it is expensive – not the bustling, populous imagery of the Logge Vaticane but a deeply thought out meditation on life, death, and salvation. For this overextended and cunning artist, such an outlay of ingenuity would never have happened had not the patron himself captured his interest; Raphael could never bring himself to do anything nearly so complex for Leo X. On a level far deeper than the architectural statements of the Logge Vaticane, Raphael's chapel in Santa Maria del Popolo shows this most responsive of artists warming to the presence of a profoundly intelligent man.

TROUBLE ON PARNASSUS

Ultimately, however, the Rome of Leo X was not Mount Parnassus. This paradise for poets and musicians was also the capital of an ecclesiastical government, charged with running both an organized religion and a temporal state. Julius, for all his faults, had paid close attention both to his religious status and to his treasury. Leo did not, and his lack of concern for both began to show.

The increasing pressure of his monetary worries may also have taken their toll on Leo's judgment. Like Paul II half a century before, he began

to fear that he was the target of a conspiracy, not by the humanists but by a cabal of cardinals with close ties to the world of banking. In 1517, as the Fifth Lateran Council drew to its close, Leo arrested several cardinals and clapped the two youngest of them, Alfonso Petrucci and Bandinello Sauli, as well as some of Petrucci's official family, into Castel Sant' Angelo. He accused them of having conspired to poison him by a particularly repulsive method: the pope had suffered for years from an anal fistula, an imperfection of the spinal column that leaked fluid and subjected him to chronic and embarrassing discomfort. On Petrucci's advice, he had engaged the services of a new doctor, Antonio da Vercelli, whom he came to suspect of poisoning the ointment he applied to the papal posterior.[101] The Genoese cardinal Bandinello Sauli was a teenager, like Petrucci, and the son of the depositor general of the Apostolic Chamber under Julius II; both youths, as everyone knew, held purchased positions urged on Julius by their ambitious fathers. But Leo also fingered two elderly cardinal associates of Julius II as co-conspirators in the plot: the ineffectual humanist Adriano Castellesi and the mighty Raffaele Riario. As various members of Petrucci's household were examined under torture, they revealed the details of the alleged conspiracy and for their pains were condemned to gruesome public punishments; the doctor Antonio da Vercelli and one of Cardinal Petrucci's manservants were carried through Rome in a cart as their flesh was torn with red-hot pincers and killed at the end of the ride; a third alleged participant, a client of the Petrucci family, was merely forced to join them for the parade and to leave the city thereafter. A fourth man, the former captain of the Sienese militia, was hanged in the Tor di Nona prison, and his severed head was impaled on a pike by the Ponte Sant' Angelo. Petrucci himself, as befitted his rank, was strangled with a scarlet cord within his cell; an enormous Moor managed the garrote (for a Christian could not be expected to execute a cardinal). Petrucci may, in fact, have been guilty as charged, for he bore a grudge against Leo: in 1516, a coup had deposed the cardinal's elder brother, Borghese Petrucci, as lord of Siena, and the pope was widely believed to have been responsible.

The remaining three cardinals, whose participation could not be demonstrated (and probably with good reason; they were in all likelihood innocent), were forced to pay enormous fines: Riario's amounted to 150,000 ducats. Stripped of their positions, their properties confiscated, they slunk into exile. Again, the most shocking reversal of fortune was that of Raffaele Riario, deposed as chamberlain of the Apostolic Chamber

after serving for thirty-four years and unseated as well from his positions as dean of the Sacred College and cardinal protector of the Augustinian order.

Thanks to the confiscations, Leo acquired several of Rome's choicest properties, including the magnificent Palazzo Riario (Cancelleria Nuova) and Cardinal Adriano's Bramante-designed travertine palazzo next to the Vatican itself, but he also found himself subject to rumors that he had trumped up the whole affair to make money. Later in the year, Leo further compounded these suspicions by appointing a series of new cardinals, some of whose positions looked transparently purchased. Still, one new cardinal's qualifications were impeccable. Egidio da Viterbo, elevated to the purple, succeeded Raffaele Riario as cardinal protector of the Augustinian order. Modern Italians might call him the "margherita sul letamaio" (the daisy on the dungheap).

AGOSTINO CHIGI BECOMES MAECENAS

Another figure merits a brief mention during the interrogations for the conspiracy trials of 1517; he also happens to be the man whose money had made possible Alfonso Petrucci's initial appointment as cardinal and whose ability to front an immense loan allowed Raffaele Riario to post bail. But Agostino Chigi emerged unscathed from the conspiracy trials of 1517, because it was his maneuvering on behalf of the pope that had precipitated the coup in Siena the year before, the event that had aroused Alfonso Petrucci's wrath in the first place.[102]

Agostino Chigi had been dealing with the Medici at least since the 1490s and may have had a good sense of his future when Julius died and Leo was elected; he seems to have anticipated that his era of creative finance was over. During renegotiation of curial contracts at Leo's accession, Chigi withdrew as chief partner in the Tolfa lease, ceding his place to his longtime associate and quondam brother-in-law Andrea Bellanti.

With the adaptability of a true Roman curialist, Chigi shifted gears, becoming a sixteenth-century version of Maecenas, the eccentric Etruscan who had served the emperor Augustus as an outstanding patron of the arts and sometime political schemer.[103] Under the papacy of Leo X, the proudly Tuscan Agostino Chigi strove to become a cultural force in Rome and, under that cover, continued to meddle with politics in Siena and occasionally Venice.[104] He also dabbled, as we have seen, in publish-

ing, from Juan de Ortega's *Suma de arithmetica* to the printing of Greek.[105] Furthermore, a manuscript astronomical treatise (on recalculating the date of Easter), by the Dalmatian humanist Giorgio Benigno Salviati, bears a letter of dedication to Agostino Chigi, but its text reveals that it had originally been dedicated to Leo X and represents a shameless case of recycling.[106] Above all, however, because Leonine Rome expressed itself mostly in pageantry, Agostino Chigi produced spectacles of his own.

Like the dinners given by such humanist hosts as Johann Göritz and Angelo Colocci, Agostino Chigi's gatherings assembled lute-playing poets, who displayed their mastery of classical Latin in drama and song.[107] Whether Agostino caught all the intricacies of the humanists' recherché art is somewhat beside the point, however they might have chided him for what he missed. Others on his guest list would catch the wordplay and the learned allusions, for the quality of this merchant banker's guests could scarcely be found elsewhere in Rome; it included cardinals, humanists, courtesans, nobles, musicians, dignitaries, and, on occasion, the pope himself. Money brought them running, but the attractions of Chigi's company were always more than that. In the theatrical setting of Leonine Rome there were few performers (aside from Fedro Inghirami) more attuned to a crowd than Agostino Chigi, and few performers with more to hide behind their flamboyant display.

Chigi also continued the support for vernacular verse that he had begun (at least to our knowledge) with his sponsorship of Serafino Aquilano's funeral. A Sienese group known as "I Rozzi" (The Ruffians) made a great hit when they played in Rome, as did the troupe of Venetian dialect performers he engaged to entertain the same Venetian mistress he had brought to Rome in 1511.[108]

Of Chigi's famous parties, stories about three in particular circulated on the Italian gossip network. There was the dinner by the banks of the Tiber in Chigi's riverside loggia, where cardinals and dignitaries were served their own local specialties on golden plates embossed with their coats of arms, the plates cast into the river after each course. Chigi, as well-versed in prudence as his father Mariano, had strung nets beneath the surface of the waters to recover his goods; at a previous party, eleven cardinals had walked out with silver vessels hidden under their skirts. The menu on one of these occasions included a sauce made from parrots' tongues; another included eels from Constantinople. (Chigi himself suffered from digestive trouble and seems to have been a man of simple taste

in food; nothing excited him so much as a few pears and the mild cream cheese called *raveggiolo*.)

Pope Leo came to dinner in 1519, just after Raphael had finished construction of the stables where Chigi housed his prize horses, the most valuable of them a stallion given him by the Turkish sultan. Leo and the other diners sat among a maze of tapestries, which dropped, at a sign from their host, to reveal that the meal had taken place not in the main house but in the new stalls; one assumes that the horses had not yet arrived.

On Agostino's name day, August 28, 1519, Pope Leo came again, to bless Chigi's marriage to his longtime mistress, Francesca Ordeaschi, a greengrocer's daughter brought back as a souvenir from Venice in 1511. While Chigi searched unsuccessfully for a more aristocratic wife, Francesca bore him four children and was soon to be pregnant with a fifth. On the eve of his fifty-third birthday, the groom may have sensed the need to stabilize his affairs; his family was not notable for its longevity, and he may already have begun to feel frail. For his wedding, however, a full complement of cardinals stood by as the pope blessed the rings which he set on the fingers of the newlyweds and declared young Lorenzo Leone, Clarice, Alessandro-Giovanni, and Cassandra Chigi fully legitimate offspring. Immediately afterward Chigi made out his will, in which his new wife was awarded a surprisingly modest annual pension, "provided that she led a chaste life," and the remainder of his fortune was destined to his children. It was an unusual occasion, and one that scandalized more than one visitor to Rome.[109]

Chigi's marriage looked to his contemporaries like a deathbed arrangement, and in fact he was not long for this world. But none of the people who discussed the great banker's continuing intrigues with Venice in late 1519, or the provisions of his will, or the pope's acquiescence in a rich man's flagrantly worldly ways, or even the excruciating progress of Chigi's last illness in March 1520 were prepared for the news that arrived on the sixth of April, 1520: Raphael, the artist with whom Chigi's name had become inextricably associated and who, along with Julius II, seems to have had the most genuine sense of the man Chigi was, took a violent fever and died at the age of thirty-seven. Chigi survived his favorite artist by only four days.

They left behind a dazzling legacy: for the Tiber-side loggia in Chigi's new palazzo, Raphael had frescoed the nymph Galatea riding the waves on a dolphin-drawn half shell outfitted with an incongruous paddle wheel

(Fig. 56).[110] The ceiling of the entrance loggia to his suburban palace showed episodes from the Cupid and Psyche interlude of Apuleius's *Golden Ass* amid diving putti (genius figures that act as emissaries between heaven and earth, much like their compatriots on either side of Raphael's *Isaiah*), bearing the attributes of the various Olympian gods (Fig. 55).[111] The same tight circle of humanists who concocted hymns to the gardens of Johann Göritz and Angelo Colocci also supplied Agostino with versified testimony that the gods could be seen supping among his guests.[112]

At about the same time as he was painting *Isaiah* for Göritz – that is, in 1512 – Raphael was also sketching out a design of prophets and sibyls for Agostino Chigi's chapel in the Church of Santa Maria della Pace, whose cloister had been the site of Bramante's first important Roman commission.[113] But Raphael's most daring design for Agostino Chigi was the great merchant's mortuary chapel in the Church of Santa Maria del Popolo, in many ways his most daring design of all.

Angelo Colocci's collaboration with Raphael did not survive so well; with the death of the artist, their two planned publications foundered. In 1527, Fabio Calvo published a strange little portfolio of engravings called the *Antiquae Urbis Romae simulachrum* (the image of ancient Rome), whose origins may well go back to the years of work with Raphael on translating Vitruvius. Calvo's images of the city, however, are strangely archaic; they are drawn from the schematic images struck on ancient coins and from the illustrations of towns in manuscripts of the *Agrimensores*, long on abstract geometry and short on perspective. Raphael's letter to Leo about his reconstructive drawings, by contrast, emphasized that he would pursue two quite different methods of representation: accurate drawing to scale and perspective rendering.[114] From all that we know of Calvo, it is not surprising that his *Simulachrum* of the city is a willfully archaic one: from his treatise on number to his translation of Hippocrates, he had made a career of anachronism long before he turned to cataloguing the regions of ancient Rome. It seems doubtful that his work sheds much light on what Raphael might have done.[115]

Giulio Romano, Raphael's most gifted successor as an artist, never picked up the momentum of his teacher's intellectual life, which in turn may have received its momentum from the stimulating presence, for a crucial period, of Bramante. Angelo Colocci later said that the best days of his life were those he spent under Leo X, but Leo's Parnassus had already started to crumble well before the end of his reign.

Epilogue: Reformation
(1517–1525)

Cortigiani, vil razza dannata!

Courtiers, godforsaken breed of cowards!

<div align="right">Francesco Maria Piave, libretto for
Giuseppe Verdi, Rigoletto</div>

NINETY-FIVE THESES

The year 1517 was a bad year for Pope Leo X; the alleged conspiracy to poison him was only one irritation among many. News had also trickled down to Rome from Germany that a renegade Augustinian monk had formulated ninety-five theses against current practices of the Church. His name was Martin Luther, and because he had spent the winter of 1510–11 in Rome, at the Convent of Santa Maria del Popolo, he was not an altogether unknown quantity in the city. His superior at the time (now his cardinal protector) had been Egidio da Viterbo, but the two had never met; Luther's stay in Rome had coincided with Julius II's campaign against Ferrara and the French, when Egidio was on the move with the papal court. Had the angry young German been subjected early on to the soothing presence of Rome's famous conciliator, perhaps his subsequent actions might have been different, but as it was, the fermenting Rome of Pope Julius filled him with rage at its ostentation, its corruption, and its hypocrisy.[1]

It was not always easy, in any case, to be a German in Italy; the Italians made it plain to one and all that they were the most civilized people in Europe, if not the whole world. The Germans who came there to study found that their own Latin accent was considered peculiar and that among

Latin speakers, especially those of Ciceronian persuasion, they themselves were liable to be called "barbarians."[2]

What enraged Luther in particular, however, was the power of money to command in the Vatican's version of the Kingdom of God. He knew that the new buildings he could see all around him in Rome owed their proliferation to the sale of indulgences among his own people. To his mind, the Church had long since crossed the line between dignified pageantry and senseless luxury; he could see overelaboration everywhere, in embroidered vestments, polyphonic music, dinner parties with courtesans, and all of it carefully insulated from the ordinary people the Church was supposedly created to serve. The hermetic culture of the humanists and the insular Latin jargon put him off – as, in fact, it was supposed to do – but he understood it well enough to understand the nature of the snubs he received. Unusually for someone in his position, however, he empathized as well with the people who could understand neither a barbed Latin quip from a sharp-tongued curialist nor a passage from the Gospel like "The meek shall inherit the earth" or "The last shall be first." He was to revolutionize both the language of liturgy and its music with terrifying effectiveness.

Luther's experience was far from unique. The international culture of papal Rome had always hung in a precarious balance. The curial staff and the College of Cardinals took scrupulous care to maintain a certain proportion between Italians and non-Italians; the powerful monarchies of Spain, France, and the Holy Roman Empire ensured the continuation of this ecumenism by pushing their own candidates for ecclesiastical preferment.[3] But national fault lines existed nonetheless, especially because the papacy itself functioned as an important sovereign state. It was no accident that when Julius II resolved to drive the French out of Italy it was the French cardinals who called the schismatic Council of Pisa.

Furthermore, Luther's disgust with Roman mores was shared by many Christians.[4] Both Julius II and Egidio da Viterbo were themselves moved by some of his concerns about the state of the Christian Church, not to mention a chronically disgruntled soul like Gianfrancesco Pico or the correct and scrupulous Sadoleto. Egidio da Viterbo's correspondence as prior general of the Augustinians is full of exhortations to his brothers to live a life of poverty, chastity, and obedience; the pattern of his own existence provided an eminent example in most respects.[5] (His main worldly indulgences were partygoing with the humanists and hunting,

which he loved because he claimed to see it, probably in all sincerity, as an allegorical expression of the human soul's quest for God.)[6]

Julius's solution to the ills of the Church was to convene the reforming council of Lateran V, but he died in its early stages. When the proceedings were turned over to Leo X, the concerns of a man like Luther were bound to go unaddressed; the whole curial corps was swept up in more insular matters, and the sickly pope had little energy to drive them harder.

PARODY: ERASMUS AND ARETINO

An earlier barbarian visitor to Rome had been equally disconcerted by the dream world in which the Curia seemed to pass much of its time. Erasmus of Rotterdam passed through Rome in 1507, where he made some good friends, including Fedro Inghirami, and received some very bad impressions. He complained about a sermon that sounded more like an oration at a pagan sacrifice than part of a Christian liturgy, and he was appalled at Julius's militancy. When the pope died, Erasmus wrote a bitterly funny dialogue called *Julius exclusus de caelo* (Julius shut out of heaven), in which the pope storms the Pearly Gates in clanking armor and wonders why Saint Peter refuses to let him in:

Julius: My bile's boiling. I'll knock on the gates. Hey! Hey! Someone open up this portal. What's going on? No one's shown up?

Peter: It's a good thing we have a gate of adamant, otherwise he would have broken it, whatever he is . . . maybe a giant? a satrap? a sacker of cities! But, O, immortal gods, what sewer do I smell here? I won't open the gates just yet, but I'll look out of this barred window and see what kind of a monster it is. Who are you? What do you want? . . . Tell me who you are.

J: As if you couldn't tell.

P: Tell? I see a sight never before seen, not to say a monster!

J: Quit this nattering, if you know what's good for you . . . In case you didn't know, I'm Julius the Ligurian, and unless I'm mistaken, you're familiar with the two letters P.M.

P: I'll bet they mean Pestiferus Maximus.

J: No! Pontifex Maximus!

P: You're like a great king, greater than Thrice Great Hermes, but you're not getting in here; the place is holy.

J: So you won't open up?
P: I'd rather open to anyone but such a pest as you. But do you
 want some good advice? You have a handful of strong men
 and a heap of money. You're a good builder. Make yourself a
 new paradise, but fortify it well so the devils don't take it.[7]

Erasmus's response to the Parnassian reveries of the circle around Leo
X and Pietro Bembo was still more savagely comic; his dialogue called
"The Ciceronian" (*Ciceronianus*) was published in 1525, a vicious parody
of the epistolary exchange between Gianfrancesco Pico and Pietro Bembo
on imitation. The letters had been made widely available in print with
Johann Frobenius's Basel edition of 1518 and may have been available in
manuscript still earlier; Erasmus certainly composed his dialogue after
having read them carefully.[8] He also drew, with still more evident feeling,
on his own memories of life in Rome: "I will report . . . what I heard
with these ears; what I saw with these eyes."

Predictably, however, the most savage of all the parodists of Leonine
Rome was no remote observer like Erasmus but a character who could
usually be found plunged into the thick of the city's activity, a man who
served for three years as Agostino Chigi's Tuscan houseboy, Pietro Are-
tino (1492–1556).[9] He came into Chigi's service in 1517, already gifted
with a sharp tongue and a ready pen, gifts that found ample encourage-
ment in the magnate's Viridario; so did Aretino's propensity for outra-
geous sexual humor. Despite his genuine affection for Chigi, Aretino
came into Rome as part of a diffident new generation, one too young to
have been affected either by Julius II's apostolic zeal or by the more muted
energy generated during the first years of Leo X. Aretino had a rare nose
for decadence, and the later years of Leonine Rome offered it in abun-
dance.

In 1535, after long absence from Rome, Aretino looked back on his
early days in the city, lampooning the humanists' aesthetic strictures by
applying them to sex: his vernacular dialogue, *Sei giornate* (Six days), also
known as the *Ragionamenti*, takes place in two conversations between an
old prostitute and a young protégée, ostensibly to compare the pros and
cons of life as a nun, life as a married woman, and life as a courtesan, but
the conversation all leads toward an obscene sendup of the humanists'
effete attention to letters and manners. Old Nanna, a former courtesan in
papal Rome's glory days, recounts how she spent her days at her window,
flirting with her customers from behind the shutters aptly called "jeal-
ousies" (*gelosie*) before entertaining them more intimately. This passage

of the dialogue takes its point from the contrast between the effete literary language of the courtiers and Nanna's own blunt obscenity; once behind closed doors, of course, these elegant men of words all turn out to want the same thing:

> And I, because I couldn't get enough of watching the courtiers, wore out my eyes gazing through the holes in the shutters at their elegance in those tunics of velvet and satin, with a badge on their cap and a chain around their neck, and on horses that shone as bright as mirrors they approached so gently with their servants right at their stirrups, in which they kept only the very tip of their toe, with their little Petrarch in their hands, charmingly singing, "If this be not love, then what is it I feel?" And this one or that would stop in front of the window where I was spying and say, "Lady, are you so cruel that you will let so many of your servants die?" and raising the shutter just a bit and then bringing it back down with a giggle, I would steal back indoors, and they, with an "I kiss Milady's hand" and an "I swear to God that you are cruel" would take their leave . . . Pretending to the integrity of a nun, looking about me with the sureness of a housewife, I performed the acts of a prostitute.[10]

Aretino's pornography has something of the same frenetic inventiveness as Giovanni da Udine's grotesques for Raphael's Logge Vaticane, where a burgeoning of detail is kept in check by a strongly repetitive underlying structure; by the first day of the six, Aretino has already exhausted virtually every possible sexual conjugation among one to three people. The only way to induce variety is to fly off into wild realms of metaphor, which he mustered for the *Sei giornate* with remarkable skill. Still, the dialogues are rough going; the lowly female protagonists, for all their braggadocio and superabundant amatory experience, tell a tale of unrelieved human misery that belies papal Rome's pretense to a Golden Age; as Aretino shows to pointed effect, that Golden Age was an idyll shared exclusively among a few fortunate men, some of them utterly devoid of merit.

In 1524 or 1525, as Erasmus brought out the *Ciceronianus*, Aretino launched his own variety of attack on the aesthetic sensibilities of the papal court. He did so in order to defend Marcantonio Raimondi, an engraver who worked closely with Raphael and who in 1524 made a series of sixteen pornographic engravings from drawings by Raphael's prize student Giulio Romano.[11] These were known by the high rhetorical title "I Modi," and parody of high style stands at the heart of their essence.

Couples rendered in the Raphael workshop's most statuesque antiquarian style perform sexual acrobatics in sixteen different ways, often surrounded by the attributes of the classical gods, often imitating the poses of ancient statues. Outraged at Raimondi's arrest, Aretino penned a series of pornographic sonnets to accompany the engravings, in which, in a spirit similar to that of the *Modi* themselves, he contrasted the refined strictures of the poetic form with the frank crudity of his language. The pope, Clement VII, was not amused, and Aretino should have known that his sallies would lead him into serious trouble. Once Luther posted his theses in 1517, the papacy had little reason for merriment.

THE TRIAL OF LONGOLIO, 1519

Erasmus saw the change coming; he corresponded regularly with some of Rome's resident intellectuals, and hence it was he who was called upon in 1519 to adjudicate the first issue to cause a serious split among the ranks of the Roman Academy since its inception in 1465. In this argument, every latent hostility of the Roman court suddenly came to the fore: barbarian against Italian nationality, Ciceronian against individualist Latinity, the gathering storm of the Reformation, and, the most central concern of all, relative status among the most ambitious members of the pope's inner circle. It is in the nature of scholars to snipe at one another, but for a half century of existence the Roman Academy had kept its internal sniping to a minimum. It took a confrontation between the complacent Golden Age of Leo X and the uncertainties induced by Luther to bring about an explosion. Not surprisingly, perhaps, Pietro Bembo, that most status-seeking of humanists, was involved in the matter from the outset, he and a man named Longeuil, whom the Italians all called Longolio.[12]

Christophe de Longeuil (1488–1522) was a Belgian humanist of Ciceronian bent and manifest talent, whose family sent him to Paris for his university studies. He was one of those young Europeans for whom the Italian humanist movement exerted an eminently exportable appeal, and once he realized that the faculty at Paris was still in the grip of its scholastic tradition, he moved quickly to the new University of Poitiers (founded in 1431), where he was able to combine his legal studies with *studia humanitatis*. At Poitiers, he had his first taste of academic infighting: on October 11, 1509, he was called upon to give the opening lecture for the university year against the jealous protests of a rival scholar. On the

day of the lecture, Longeuil mounted the narrow, creaking stair to his podium clutching the three-volume legal manuscript on which he planned to focus his inaugural presentation. He looked out onto an un-usually large audience, for the usual academicians were intermingled with thugs hired by his rival to tear him from the lectern. As he began to speak, the strongmen began to murmur; gifted with a stentorian voice, he spoke more loudly. As they grew more unruly, he threw two of the manuscripts down at them, but a last daredevil started up the stairway after him. Longeuil took up his third enormous volume, bound between leather-covered wooden boards and studded with bronze nails, and began pound-ing his assailant on the head, while chairs and books flew among the students and thugs down below. Thanks to his physical prowess, the unflappable scholar was finally able to finish his lecture in peace.[13]

Despite his success in France, Longeuil craved the chance to try his luck in Rome, where he finally arrived in 1516, looking, in the words of Paolo Giovio, "more like a German mercenary than a scholar" and intent on playing the curial marketplace.[14] Pietro Bembo pressed the young foreigner to join his band of hard-core Ciceronians, among whom Longolio emerged as a brilliant success. With a literal-minded fanaticism that left Bembo breathless, the young Longeuil explained how he had held himself for ten years of unrelenting toil to a total immersion in Cicero. This was precisely the kind of educational program that Bembo had recommended to Gianfrancesco Pico in his letter of 1513, a program he claimed in that letter to have undertaken himself. Nothing, however, could have prepared him or any of his fellow humanists for the pitiless self-abnegation of this young Belgian.

Furthermore, the ruthless training seemed to have worked. Longeuil fit comfortably into the group that gravitated around the pope's two domestic secretaries, dazzling them with the classical perfection of his foreign-born eloquence and proving himself a writer of reliable consis-tency. In 1519, after Longeuil delivered a particularly well-turned oration, Pope Leo decided to honor the Belgian humanist with a grant of Roman citizenship. And that is when things exploded.

A hotheaded young Roman named Celso Mellini, the brother of An-gelo Colocci's old friend Pietro, deplored the granting of Roman citi-zenship to a "barbarian" humanist when so many deserving Italians had been ignored. A group of similarly distressed Italians gathered around Mellini to commiserate, among them the genial gossip Blosio Palladio, as well as other minor Parnassians like Lorenzo Grana and Tommaso

Pighinucci di Pietrasanta. Pietro Mellini, too, stood by his brother out of family loyalty. Their grievances seem to have gone beyond the single incident of Longeuil's Roman citizenship; these were men who for the most part occupied the second and third ranks of the humanists' social hierarchy, and their resentments of slights by the pope and his circle, both perceived and real, may have been of long standing. Furthermore, the Lutheran Reformation, perhaps inevitably, was beginning to fuel Italian xenophobia, for despite their lack of political unity the inhabitants of the Italian peninsula were well aware of themselves as a distinct group, especially when they were under siege by barbarians.

Longolio's defenders ranged behind the pope's domestic secretaries – Bembo, the Belgian's chief patron, and Sadoleto. Some less prominent Ciceronians, like Lelio Massimi and Marcantonio Flaminio, also joined their ranks. Angelo Colocci, no friend of Bembo but no fool either, maintained a scrupulous neutrality, as did most of the Roman Academy's stalwarts: Battista Casali, Fausto Capodiferro, Johann Göritz, Egidio da Viterbo, Antonio Tebaldeo, and Baldassare Castiglione (who was absent from Rome much of the time). Many of these men had been friends since the days of Pomponio Leto, and certainly since the days of Julius II; they were old-timers who saw nothing to gain from taking sides with either party.

Somehow, Celso Mellini procured the text of a speech that Longolio had delivered in Poitiers ten years before, an oration in which he had professed that the French, rather than the Italians, were the true heirs and perpetuators of ancient Roman civilization.[15] Taking this document as proof of intellectual treason, the Mellini faction charged Longolio with an ingenious crime they invented for the circumstance: "Romanitas laesa" (injury to Roman honor), and challenged the poor Belgian to appear on that hallowed ground of *Romanitas*, the Campidoglio, to enter his plea before a panel consisting of the pope in person, interested cardinals, and assembled humanists.[16] The date for the trial was to be June 16, 1519, a ripe occasion for Cicero's Gallic disciple to unleash a torrent of Ciceronian rhetoric or at least once again to have at the opposition with a metal-studded manuscript. Pope Leo, whose sense of humor had a cruel streak, looked forward to the occasion with glee. Others sensed that the contest was beginning to take on ugly overtones; as the maelstrom gathered, Pietro Bembo, always a man for self-preservation, slipped north to Venice, leaving Longolio to fend for himself.

Bereft of his chief protector, Longeuil too stole out of Rome one night

and headed after Bembo, professing fear that his "trial" would have degenerated into a riot. (He was not the only scholar of his day to have been a competent fighting man.) From the safety of Padua, just across the lagoon from Venice, he promised to send back a written self-defense in which no phrase would appear that had not been used by Cicero. When the document, containing not one but two orations, arrived late in 1519, as impeccably Ciceronian as its author had promised, most of Rome's humanists regarded it as nothing more than a colossal waste of time: Celso Mellini, the chief agitator in the affair, had drowned (or perhaps killed himself) in 1519, shortly after the scheduled date of the trial that never happened. Longolio died in his Paduan exile in 1522, a sadly diminished man.

In the spring of 1519, before hindsight caught up with them, Rome's *litterati* thought that the rift between Longolio's supporters and his detractors seemed to split the whole world; several of them wrote to tell Erasmus the sorry tale. From his own perspective, far removed from the Longolio maelstrom, Erasmus warned his Roman correspondents that Luther posed a far greater threat to their harmony than some Belgian bookworm's youthful exercise in rhetoric. All too swiftly, the times were to prove Erasmus right.

Signs of tension had already begun to show in Rome when some of the Italian humanists began to suspect their longtime friend and assiduous host, Johann Göritz, of Lutheranism. In 1524, he called off his party on Saint Anne's Day for the first time, aware, perhaps, that the divisions among his erstwhile companions had become too great to keep up the happy Parnassian façade any longer.[17]

For builders, artists, and bankers, the squabbles of the humanists were not yet particularly significant; collaborations as profound as that between Raphael and Fedro Inghirami, or Raphael and Angelo Colocci, were always somewhat unusual. Yet it cannot be fortuitous that one of Raphael's most intellectually challenging works at the end of his life was the design for Agostino Chigi's mortuary chapel. Of all the people in Leo's Rome, Chigi may have been the one who best embodied the charging spirit of Julius II, surrounded in old age by a brigade of young children and still driving bargains with Venice from his deathbed.

Rome in the last years of Leo X was changing, and changing quickly. Egidio da Viterbo's devoted pupil Girolamo Seripando, a future guiding spirit of the Council of Trent, wrote a dejected note in the flyleaf of his copy of Egidio's "Historia XX saeculorum," that protracted hymn to the

reign of Leo X composed in its first flush of Parnassian enthusiasm. Ser-
ipando was still a teenager at the time of Leo's election, in the first stages
of his own illustrious career. He must have shared his mentor's initial
excitement and then lived to watch Egidio turn inward on himself, rapt
in contemplation of the Kabbalah when the realities of the world, and
his own eroding authority, became too much:

> I know that the great hopes he conceived for Leo on that day – and
> not without good reason – all eluded him and fell back to almost
> nothing. Because as of his pontificate, everything began going bad, and
> from bad to worse, whether we're dealing with the war against the
> Turks, or the empire [the Papal States], of which we lost a large part:
> Modena, Reggio Emilia, Parma, Piacenza. Or morals, of which every
> light has gone out, or of reputation, which has never been worse in
> the minds of men. Or authority, which has never been less, to the
> point where it has almost evaporated in a joke.[18]

The papacy never did evaporate in a joke, but it never recovered the
same sense of possibility that animated the first years of the sixteenth
century. Angelo Colocci, who had finally arrived, by 1520, as one of
Rome's most important people and would subsequently rise still farther,
already sensed, and rightly, that the best years of his life were over. Like
the rest of his contemporaries, he grasped that the moment of Rome's
new order was already a memory, and unlike the believers in that new
order, he knew that the past had slipped from his grasp.

Notes

CHAPTER ONE. INITIATION

Note: Angle brackets < > mark letters that have been restored to a text; they do not appear but were certainly intended.

1 For Angelo Colocci's biography, see *Dizionario biografico degli Italiani*, (1982) s.v. *Angelo Colocci*, 105–11; Federico Ubaldini, *Vita di Monsignor Angelo Colocci*, ed. Vittorio Fanelli, Studi e Testi no. 256 (Vatican City: Biblioteca Apostolica Vaticana, 1969); Vittorio Fanelli, *Ricerche su Angelo Colocci e sulla Roma cinquecentesca*, Studi e Testi no. 283 (Vatican City: Biblioteca Apostolica Vaticana, 1979); Samy Lattès, "Récherche sur la bibliothèque d'Angelo Colocci," *Mélanges de l'École Française de Rome* 48 (1931); 308–44; G. F. Lancellotti, *Poesie italiane e latine di monsignor Angelo Colocci, con più notizie intorno alla persona di lui e sua famiglia* (Iesi: P. Bonelli, 1772); *Atti del Convegno di Studi su Angelo Colocci, Jesi, Palazzo della Signoria, 13–14 settembre 1969* (Iesi: Amministrazione Comunale, 1972).

2 The Neapolitan humanist Giovanni Gioviano Pontano had met Colocci at this age; in a treatise he composed between 1499 and 1502 he describes the young man as follows: "In hoc autem ipso iocandi genere comis est admodum ac periucundus A. Colotius noster, tum propter insitam et a natura perraram quandam in dicendo hilaritatem tum propter egregiam litterarum peritiam rerumque multarum usum. Quo fit, ut in explicandis fabellis, in epigrammis comicorumque poetarum dictis referendis ac lusibus, mirifice delectet." (In this kind of playfulness at parties our Angelo Colocci is deft and extremely amusing, both because of a certain rare hilarity of diction instilled by nature and because of his outstanding command of literature and his wide experience. Hence in telling stories, reciting poems, quoting the lines of comic poets, or cracking jokes, he will delight us fantastically.) Iohannes Iovianus Pontanus, *De sermone libri sex*, VI.1, ed. Sergio Lupi and Antonio Risicato (Lugano: Thesaurus Mundi, 1954), 192.

3 The last baronial pope to be elected was Martin V Colonna (1417–1431);

see Peter Partner, *The Papal State under Martin V* (London: British School at Rome, 1958).

4 The classic work on Roman antiquities in the Renaissance is Rodolfo Lanciani, *Storia degli scavi di Roma e notizie intorno le collezioni romane di antichità*, 1st ed. (Rome: Loescher, 1908–12). Annotated rev. ed., ed. Leonello Malvezzi (Rome: Quasar, 1989). English translation, *The Ruins and Excavations of Ancient Rome* (Houghton Mifflin, 1897; reprinted New York: Bell, 1977). See also Phyllis Pray Bober and Ruth Rubinstein, *Renaissance Artists and Antique Sculpture: A Handbook of Sources*, 2nd (rev.) ed. (London: Harvey Miller, 1987); Philip Jacks, *The Antiquarian and the Myth of Antiquity: The Origins of Rome in Renaissance Thought* (Cambridge: Cambridge University Press, 1994).

5 See Nicole Dacos, *La Découverte de la Domus Aurea et la formation des grotesques à la Renaissance* (London: Warburg Institute, 1969).

6 For Leto's biography, see Vladimir Zabughin, *Giulio Pomponio Leto, Saggio critico*, 2 vols. (Rome: Vita Letteraria, 1909); John D'Amico, *Papal Humanism in Renaissance Rome: Humanists and Churchmen on the Eve of the Reformation* (Baltimore: Johns Hopkins University Press, 1981), 91–7.

7 Biblioteca Apostolica Vaticana, Vat. Lat. 4784. Vatican manuscripts will henceforth be identified only by call number.

8 Paolo Cortesi, *Tres libri De cardinalatu ad Julium Secundum Pont[ificem] Max[imum] per Paulum Cortesium Protonotarium Apostolicum*, edited by Lattanzio Cortesi, was published in 1510 on the premises of the Cortesi villa near San Gimignano by the Sienese printer Simeone Nardi (Symeon Nicholaus Nardus); hence the book's colophon reads "in Castro Cortesio." On the work itself, see Nino Pirotta, "Music and Cultural Tendencies in Fifteenth-Century Italy," *Journal of the American Musicological Society* 19 (1966): 127–61; Kathleen Weil-Garris and John F. D'Amico, *The Renaissance Cardinal's Ideal Palace: A Chapter from Cortesi's "De cardinalatu"* (Rome: Elefante, 1980). *De cardinalatu* also provides an important guiding thread for D'Amico's *Papal Humanism*.

 The book's printed pagination after the first forty-five pages becomes confused. Citations therefore give the printed page number first and the real number in parentheses. 59v–60r (65v–66r): "is maxime esset faceta iucunditate *laetus*," a pun on Leto's name.

9 Richard J. Palermino, "The Roman Academy, the Catacombs, and the Conspiracy of 1468," *Archivum Historiae Pontificiae* 18 (1980), 117–55.

10 On Roman rhetoric, see George Kennedy, *The Art of Rhetoric in the Roman World, 300 B.C. – A.D. 300* (Princeton: Princeton University Press, 1972).

11 Paolo Cortesi, *Prohemium in Librum primum sententiarum ad Iulium II Pont. Max.* (Rome: Besicken, 1504): A iiii r: "Erit confiteri necesse eiusmodi

philosophiae speciem litteratam et artificiosam videri, quae ad naturae pul-
chritudinem statuatur."

12 For a vivid characterization of Platina, see Egmont Lee, *Sixtus IV and Men
of Letters* (Rome: Edizioni di Storia e Letteratura, 1978), 111–17. The most
complete biography of the humanist is still to be found in Giacinto Gaida's
introduction to his edition of Platina's Lives of the Popes, *Platynae historici
liber de vita Christi ac omnium pontificum*, Rerum Italicarum Scriptores, vol.
3, pt. 1 (Città di Castello: S. Lapi, 1913–32), ix–xxxiv.

13 Platina, *Life* of Paul II, in *Platynae historici liber* 169: "Ac si nescires omnia
iura in scrinio pectoris nostri collocata esse? . . . Pontifex sum . . ." For
clarity's sake, my translation has elided the royal "we" with which Paul
began his retort, despite the marvelous effect it makes when he suddenly
slips into the first-person "Pontifex sum" of a very angry man.

14 Ibid., 399: "Scripsi itaque epistolam his ferme verbis: Si tibi licuit in dicta
causa spoliare nos emptione nostra iusta ac legitima, debet et nobis licere
conqueri illatam iniuriam iniustamque ignominiam. Reiecti a te, ac tam
insigni contumelia affecti, dilabemur passim ad reges, ad principes, eosque
adhortabimur, ut tibi concilium indicant, in quo potissimum rationem red-
dere cogaris, cur nos legitima possessione spoliaveris."

15 An admirably sober account of the Academy and its vicissitudes is provided
by D'Amico, in *Papal Humanism*, 91–7. See also Platina, *Platynae historici
liber*, xvii–xxvii; A. J. Dunstan, "Pope Paul and the Humanists," *Journal of
Religious History* 7.4 (1973): 287–306; Eugenio Garin, "L' Accademia Ro-
mana, Pomponio Leto, e la congiura," in Emilio Cecchi and Natalino
Sapegno, eds. *Storia della letteratura italiana*, rev. Natalino Sapegno (Milan:
Garzanti, 1988), 3: 144–60; Aulo Greco, "Momenti e figure dell' uma-
nesimo romano," in his *Aspetti dell' umanesimo romano* (Rome: Istituto di
Studi Romani, 1969), 55–72. Full of factual references and overflowing
with moralizing editorial comments are Zabughin, *Leto*, 1: 38–189 and
Ludwig Freiherr von Pastor, *History of the Popes from the Close of the Middle
Ages*, trans. Frederick Ignatius Antrobus and R. F. Kerr (London: Hei-
nemann, 1894–8), 4: 41–57.

16 Platina, *Life* of Paul II, 383. They were apparently tortured by the usual
method of the *strappado*, time-honored (already used in ancient Roman
times), cheap, requiring a minimum of materials, and effective: the victim's
hands are tied behind his back with a rope, which is then flung over a
roofbeam. The torturer pulls the end of the rope until he has hoisted his
victim off the ground or the victim has begun to confess. Platina's right
arm was badly injured in the process of interrogation; torn upper arm
muscles and dislocated shoulders were a common result of the experience.

17 Zabughin, *Leto*, 1:30–37.

18 Thus Gaida's characterization of the group, in Platina, *Platynae historici liber*,

xxv, as "quell' accolta di letterati, pochi di valore, i più rettorelli e poe-
tuncoli boriosi e chiassosi," is not entirely fair, as it fails to take into account
the academics' real duties in the Curia and in Roman society.

19 See esp. Lee, *Sixtus IV*; see also Massimo Miglio, ed., *Un Pontificato e una
città: Sisto IV (1471–1484)* (Rome: Tipografia Editrice Vaticana, 1984);
Eunice Howe, "Sixtus IV and the Ospedale di Santo Spirito," Ph.D. diss.,
Johns Hopkins University, 1977; Fabio Benzi, *Sisto IV, Renovator Urbis:
Architettura a Roma, 1471–1484* (Rome: Officina, 1990).

20 D'Amico, *Papal Humanism*, 96.

21 Federico Ubaldini, *Vita di Mons. Angelo Colocci, Edizione del testo originale
italiano (Barb. lat. 4882)*, ed. Vittorio Fanelli, Studi e Testi, no. 256 (Vatican
City: Biblioteca Apostolica Vaticana, 1969), 13–18:

Seguitò anch' egli l' introduttione di Pomponio Leto di cambiare il proprio
nome con alcuno che sentisse dell' antico Romano, non essendo bastato a vietar
ciò lo sdegno di Paolo II, e chiamossi A. Colotius Bassus. Facevasi questa
mutatione di nome con solennità di cerimonie, cingendosi la testa di lauro e
col consenso degli Accademici scrivendosi nella matricola dagli altri, havendo
prima, con recitar qualche composizione, fatto prova della propria sufficienza;
poscia a un solenne convito ricevuto, gli Accademici cantando versi in sua
lode, col nuovo nome il salutavano, né altrimente che con tal nome si sareb-
bono chiamati, né lasciavansi vedere se non coronati di lauro nelle loro adun-
anze.

22 Cortesi's traditional birth date of 1465, explicitly contradicted in the text
of *De cardinalatu* itself, has been convincingly revised by Maria Teresa Gra-
ziosi, *Paolo Cortesi. De hominibus doctis* (Rome: Bonacci, 1973), vii.

23 This was *De cardinalatu*, cited in note 8 to this chapter.

24 Cortesi's other large work, an adaptation of the *Sententiae* of Peter Lom-
bard, is discussed in Chapter 7 of the present volume.

25 The standard biography of Inghirami is Anna Maria Rugiadi, *Tommaso
Fedra Inghirami umanista volterrano* (Amatrice: Orfanotrofio Maschile, 1933),
but see also the introductory material in Pier Luigi Galletti's editions of
*Thomae Phaedri Inghirami Laudatio in obitu Ludovici Podocathari Cypri S.R.E.
Cardinalis* (Rome: A. Fulgoni, 1773), and *Thomae Phaedri Inghirami Vola-
terrani in Laudem Ferdinandi Hispaniorum Regis Catholici ob Bugiae in Africa
captum oratio* (Rome: A. Fulgoni, 1773), as well as *Thomae Phaedri Inghirami
orationes duae* (Rome: Generoso Salomone, 1777).

26 Raffaele Maffei to Mario Maffei, September 19, 1516, Vat. Lat. 7928, 67v–
68r.

27 Modern editors of Seneca refer to the play as *Phaedra*, to distinguish it from
the *Hippolytus* of Euripides. For the opposite motive, namely to link it to
the legacy of the Greek playwright, the fifteenth-century producers of the
Senecan play called it *Hippolytus*. For the 1486 date and a good selection

of contemporary references, see the two works by Fabrizio Cruciani, "Il Teatro dei Ciceroniani: Tommaso 'Fedra' Inghirami," *Forum Italicum* 14 (1980): 356–77, and *Teatro nel Rinascimento, Roma, 1450–1550* (Rome: Bulzoni, 1983), 219–27. See also Aulo Greco, "Roma e la commedia del rinascimento," *Studi Romani* 22 (1974), 25–35.

28 Unfortunately our only source for this incident is the seventeenth-century forger Curzio Inghirami, in the thousand-page defense by which he strove to authenticate the pseudo-Etruscan documents (called "scarith") which he claimed to have discovered on the grounds of the Inghirami villa near Volterra: *Discorso sopra l' opposizioni fatte all' antichità toscane* (Florence: A. Massi and L. Landi, 1645), 50; see Cruciani, "Il Teatro," 373 n. 9. There is no easy way to judge the quality of this information about Fedro; Curzio's *modus operandi* in a career as a provincial *erudito* involved basing his outrageous fictions on a formidable command of divers facts. As a comic dramatist of real talent, this seventeenth-century Inghirami had more than a little in common with Fedro, who was proposed by many of Curzio's detractors as the real author of the scarith hoax. See Ingrid D. Rowland, *The Scarith of Scornello: An Etruscan Fraud in the Age of Galileo* (forthcoming).

29 D'Amico, *Papal Humanism*, 101.

30 Roman gossip insisted that Alessandro Farnese owed his cardinal's hat to the pope's interest in his sister, but historians point more insistently to the young man's ability. He was elected pope at the conclave of 1534, taking the name Paul III.

31 See Luigi Michelini Tocci, "Dei Libri a stampa appartenuti al Colocci," in *Atti . . . Colocci*, 84. For the tabulation methods of Fabio Calvo, see Chapter 5 of the present volume.

32 Maria Teresa Graziosi, "Pacifico Massimi maestro del Colocci?" in *Atti . . . Colocci*, 157–8 (where she argues that Massimi was not, in fact, Colocci's *maestro*).

33 Ibid., 162–3, from Vat. Lat. 2862, 74r-v:

Vis me vera loqui, quaeque est in mea mente?
Qualem credebam, non mihi talis homo est.
Ore aliud quam mente geris, tua dicta nec illis
Rebus respondent; hoc ais, illud agis.
Te facile et verbis blandus, mitisque videris,
Non item veniunt mens tua, fronsque tua.
Nescio quod gratum vultu promittis amico
Scorpius ut cauda nigra venena refers.
Exstas iras in me velut hostis in hostem
Allatras meum nomen ut ore canis.

34 Vat. Lat. 3351, 59v-60r: "T. Phaedro Ingheramio S[uo]" (extracts):

Longa mora est: ah diminuor mi phaedre morando:
Non sperare fuit poena mihi brevior . . .
Exspectatus morior: prodest sperare: sed haec est
Desperare magis, spes quia clauda venit.

35 Vat. Lat. 3351, 60r: "Alexi eidem phaedromo" (likening Inghirami to the handsome Alexis of Virgil's Eclogue and altering his nickname to that of Phaedromus, a character in a play by Plautus, the *Curculio*):

Ista molossorum sunt apta monilia collo:
Haec regit ardentes copula cauta canes.
Sed quae me retinent vincunt haec vincla cathenae:
Phaedromus has et amor: quilibet ista facit.

36 Scholars of the late nineteenth and early twentieth century could become quite exercised about the question of sexuality in the Roman Academy; see Zabughin, *Leto*, 1: 33: "turpe reato," 37: "un segno dei tempi, una nuova e fosca pennellata del quadro tristissimo d' un' epoca gloriosa ed infame," and Pastor, *History of the Popes*, 5: 98: "if we ask how it was that so many of the Italians of that day became so fearfully depraved, the answer is not far to seek. The cause is to be found in the unrestrained individualism fostered by the pseudo-renaissance." Cf. 131: "there is unmistakeable evidence of the revival of the horrible national vice of the Greeks;" 132: "The advocates of the false renaissance openly and unblushingly extolled the unnatural vices which had been the ruin of the ancient world." Leonard Barkan, *Transuming Passion: Ganymede and the Erotics of Humanism* (Stanford: Stanford University Press, 1991), observes how differently from present mores sexual liaisons were defined in the Italian Renaissance. My thanks to Michael Koortbojian for the reference to Barkan's book.

37 Agostino Vespucci to Niccolò Machiavelli, July 16, 1501, in Niccolò Machiavelli, *Opere*, vol. 6: *Lettere*, ed. Franco Gaeta (Milan: Feltrinelli, 1961), 61–2:

È sul mezzo dí et io spiro del grande chaldo che è a Roma, et per non dormire fo questi pochi versi et *etiam* mosso da Raffaello Pulci che si trastulla con le muse. Spesso alle vigne di questi gran maestri et mercanti dice improviso . . . El Pulcio si trastulla, et sempre è in mezzo di quattro puttane con Sancti Londiano, et emmi detto lui havere qualche dubio, che sendo di lui opinione et certeza di esser poeta, et che l' Academia di Roma lo vuole coronato ad sua posta, non vorria venire in qualche pericolo *circa pedicationem*, perché è qui Pacifico, Phaedro, et delli altri poeti, *qui nisi haberent refugium in asylum nunc huius, nunc illius cardinalis, combusti iam essent. Evenit etiam* che in questi proximi dì in Campo di Fiore fu abrusciata viva una femina, et assai di grado, venitiana, per avere lei pedicato una puctina di 11 in 12 anni, che la si teneva in casa, et

factole etiam altro che taccio, per esser troppo dishonesto, et simile alle cose di Nerone romano.

Quoted from Graziosi, "Pacifico Massimi," 163, her emphasis.

38 Pastor, *History of the Popes*, 5: 460–1. The membership book of the confraternity is preserved at the Ospedale di Santo Spirito, Biblioteca Lancisiana MS 328.

39 Pastor, *History of the Popes*, 5: 43. See also Giovanni Marangoni, *Istoria dell' antichissimo oratorio o cappella di San Lorenzo del Patriarchìo lateranense* (Rome: O. Piccinelli, Stamperia di San Michele, 1747). For the Confraternity of the Gonfalone, see p. 27 and, below, note 50.

40 Donatella Barbalarga, "I Centri di cultura contemporanei: Collegi, studi conventuali e biblioteche pubbliche e private," in Paolo Cherubini, ed., *Roma e lo Studium Urbis: Spazio urbano e cultura dal Quattro al Seicento* (Rome: Quasar, 1989), 17–18.

41 For the later sixteenth-century decorative program of the confraternity's chapel, see Jean S. Weisz, *Pittura e misericordia: The Oratory of San Giovanni Decollato in Rome* (Ann Arbor: UMI Research Press, 1984).

42 Pastor, *History of the Popes*, 5: 44–5; Barbara Wisch, "The Roman Church Triumphant: Pilgrimage, Penance and Processions Celebrating the Holy Year of 1575," in Barbara Wisch and Susan Scott Munshower, eds., *"All the world's a stage . . ."*: *Art and Pageantry in the Renaissance and Baroque*, vol. 1, *Triumphal Celebrations and the Rituals of Statecraft,* Papers in Art History from the Pennsylvania State University, no. 6.1 (University Park: Pennsylvania State University, 1990), 82–117.

43 I am indebted to Katherine Gill and Carolyn Valone for conversations on this subject. Study of women's religious groups and of Italian confraternities outside Florence still depends heavily on anecdotal evidence, but see Nicholas Terpstra, "Women in the Brotherhood: Gender, Class and Politics in Renaissance Bolognese Confraternities," *Renaissance and Reformation* 24 (1990), 193–212; Christopher Black, *Italian Confraternities in the Sixteenth Century* (Cambridge: Cambridge University Press, 1989), 34–8; Gilles Gerard Meersseman, *Ordo fraternitatis: Confraternite e pietà dei laici nel medioevo* (Rome: Herder, 1977), 1, 498–504; Konrad Eisenbichler, ed., *Crossing the Boundaries: Christian Piety and the Arts in Italian Medieval and Renaissance Confraternities,* Medieval Institute Publications. Early Drama, Art, and Music, no. 5 (Kalamazoo: Western Michigan University, 1991). For a slightly later period, see Carolyn Valone, "Women on the Quirinal Hill: Patronage in Rome, 1560–1630," *Art Bulletin* 76 (1994), 129–46. My thanks to Sheryl Reiss for the reference to Terpstra's work.

44 Pastor, *History of the Popes*, 5:41. Juan de Torquemada, a distinguished scholar, was the uncle of the first grand inquisitor of the Spanish Inquisition, Tomás de Torquemada.

45 Two such chapels, the Chigi Chapel in Santa Maria del Popolo and the Göritz Chapel in Sant' Agostino, are discussed in Chapters 7 and 6 of the present volume, respectively.

46 Pastor, *History of the Popes*, 5:44.

47 Luisa Falchi, "Le Accademie Romane tra' 400 e' 600," in Cherubini, *Roma e lo Studium Urbis*, 54–5.

48 Pastor, *History of the Popes*, 5:45; Paolo Portoghesi, *Roma del Rinascimento* (Milan: Electa, 1972), 2:432–3; Christoph Luitpold Frommel, Stefano Ray, and Manfredo Tafuri, eds., *Raffaello architetto* (Milan: Electa, 1984), 127.

49 Simonetta Valtieri, "Sant'Eligio degli Orefici," in Frommel et al., *Raffaello architetto*, 143–56.

50 Pastor, *History of the Popes*, 5:42, 53–5.

51 See the forthcoming article by Barbara Wisch in Barbara Wisch and Diane Ahl, eds., *Ritual, Spectacle, Image: Confraternities and the Visual Arts in Renaissance Italy* (in press). My thanks to Barbara Wisch for the reference.

52 See Weil-Garris and D'Amico, "The Renaissance Cardinal's Palace," Christoph Luitpold Frommel, *Römische Palastbau der Hochrenaissance* (Tübingen: Ernst Wasmuth, 1973).

53 Portoghesi, *Roma del Rinascimento*, 2:429–30.

54 Deborah Brown, "The Apollo Belvedere and the Garden of Giuliano Della Rovere at SS. Apostoli," *Journal of the Warburg and Courtauld Institutes* 49 (1986): 235–8.

55 For the statue of Pasquino, see Cesare D'Onofrio, *Un Popolo di statue racconta storie fatti leggende della città di Roma antica medievale moderna* (Rome: Romana Società Editrice, 1990), 27–43. A lively collection of sixteenth-century pasquinades is to be found in Antonio Marzo, ed., *Pasquino e dintorni* (Rome: Salerno, 1990). See also V. Marucci, A. Marso, and A. Romano, *Pasquinate romane del Cinquecento* (Rome: Salerno, 1983); Giovanni Antonio Cesareo, *Pasquino e pasquinate della Roma di Leone X*, Miscellanea della Reale Deputazione Romana di Storia Patria, no. 11 (Rome: Reale Deputazione Romana di Storia Patria, 1938).

56 The term was still somewhat novel in 1498, when the papal master of ceremonies, Johann Burchard, felt the need to specify its meaning: "cortegiana, hoc est meretrix honesta," cited in Pastor, *History of the Popes*, 5: 129. For courtesans in general, see Domenico Gnoli, "La Lozana andalusa e le cortegiane nella Roma di Leone X," in his *Roma di Leone X* (Milan: Hoepli, 1938), 185–216; Georgina Masson [Marion Johnson], *Courtesans of the Italian Renaissance* (London: Secker and Warburg, 1975); and Margaret Rosenthal, *The Honest Courtesan: Veronica Franco, Citizen and Writer in Sixteenth-century Venice* (Chicago: University of Chicago Press, 1992).

57 Anthony Grafton and Lisa Jardine, "Women Humanists: Education for what?" in their *From Humanism to the Humanities* (Cambridge, MA: Harvard University Press, 1986), 29–57; Margaret King and Albert Rabil, Jr., eds., *Her Immaculate Hand: Selected Works by and about the Women Humanists of Quattrocento Italy* (Binghamton: Center for Medieval and Early Renaissance Studies, 1983).

58 For ancient Roman patronage, see Richard Saller, *Personal Patronage under the Early Empire* (Cambridge: Cambridge University Press, 1982); Peter White, *Promised Verse: Poets in the Society of Augustan Rome* (Cambridge, MA: Harvard University Press, 1993); Andrew Wallace-Hadrill, ed., *Patronage in Ancient Society* (London: Routledge, 1989); Barbara K. Gold, *Literary Patronage in Greece and Rome* (Chapel Hill: University of North Carolina Press, 1987); Barbara K. Gold, ed., *Literary and Artistic Patronage in Ancient Rome* (Austin: University of Texas Press, 1982); P. A. Brunt, *The Fall of the Roman Republic and Related Essays* (Oxford: Oxford University Press, 1988), esp. the articles "Clientela" and "Amicitia." Sociological analyses of the ancient institution can be found in Ernest Gellner and John Waterbury, *Patrons and Clients in Mediterranean Societies* (London: Duckworth,1977); Shmuel N. Eisenstadt and Luis Roniger, *Patrons, Clients, and Friends: Interpersonal Relations and the Structure of Trust in Society* (Cambridge: Cambridge University Press, 1984); Steffen W. Schmidt et al., *Friends, Followers, and Factions: A Reader in Political Clientelism* (Berkeley and Los Angeles: University of California Press, 1977). I am grateful to Peter White for this bibliography.

59 See F. W. Kent and Patricia Simons, eds., *Patronage, Art, and Society in Renaissance Italy* (New York: Oxford University Press, 1987), esp. F. W. Kent and Patricia Simons, "Renaissance Patronage: An Introductory Essay," 1–21; Ronald Weissman, "Taking Patronage Seriously: Mediterranean Values and Renaissance Society," 25–5; Gary Fitch Lytle, "Friendship and Patronage in Renaissance Europe," 47–61; Gary Ianziti, "Patronage and the Production of History: The Case of Quattrocento Milan," 299–311. See also Guy Fitch Lytle and Stephen Orgel, eds., *Patronage in the Renaissance* (Princeton: Princeton University Press, 1981), esp. the bibliographic note at 381–2; Werner L. Gundersheimer, "Patronage in the Renaissance: an Exploratory Approach," 3–26; and Charles Hope, "Artists, Patrons and Advisers in the Italian Renaissance," 293–343. The studies of individual patrons are legion; in the present context see, for example, Janet Cox-Rearick, *Dynasty and Destiny in Medici Art: Pontormo, Leo X, and the Two Cosimos* (Princeton: Princeton University Press, 1984); Sheryl E. Reiss, "Cardinal Giulio de' Medici as a Patron of Art, 1513–1523," Ph.D. diss., Princeton University, 1992; and, on a smaller scale, Edward E. Lowinsky, "Ascanio Sforza's Life: A Key to Josquin's Biography

and an Aid to the Chronology of His Works," in Lowinsky, ed. (with Bonnie J. Blackburn), *Josquin des Prez* (London: Oxford University Press, 1976), 33–75; I. D. Rowland, "Render unto Caesar the things which are Caesar's: Humanism and the Arts in the Patronage of Agostino Chigi," *Renaissance Quarterly* 39 (1986), 673–730.

60 See David S. Chambers, "The Economic Predicament of Cardinals," *Studies in Medieval and Renaissance History* 3 (1966), 289–311. In Cesare Mozzarelli, ed., *"Famiglia" del principe e famiglia aristocratica* (Rome: Bulzoni, 1988), vol. 2, the following: Gigliola Fragnito, " 'Parenti' e 'familiari' delle corti cardinalizie del Rinascimento," 565–88; Pierre Hurtubise, "La 'Familia' del cardinale Giovanni Salviati (1517–1553)," 589–610; Lucinda M. C. Byatt, "Aspetti giuridici e finanziari di una 'familia' cardinalizia del XVI secolo: Un Progetto di ricerca," 611–30; Nicoletta Pellegrino, "Nascita di una 'burocrazia': Il Cardinale nella trattatistica del XVI secolo," 631–77. Also, Gigliola Fragnito, "Cardinals' Courts in Sixteenth-Century Rome," *Journal of Modern History* 65 (1993), 26–56. My thanks to Sheryl Reiss for these references.

61 Lee, *Sixtus IV*, 114–16.

62 The foundation of the library is definitively traced to Sixtus's predecessor Pope Nicholas V by the former prefect, P. Leonard Boyle, "The Vatican Library," in Anthony E. Grafton, ed., *Rome Reborn: The Vatican Library and Renaissance Culture* (New Haven: Yale University Press, 1993), xi–xv; cf. Boyle, "Sixtus IV and the Vatican Library," in his *Rome: Tradition, Innovation and Revival* (Victoria, CAN: University of Victoria, 1991), 65–73. See also Jeanne Bignami Odier and José Ruysschaert, *La Bibliothèque vaticane de Sixte IV à Pie XI* (Vatican City: Biblioteca Apostolica Vaticana, 1973). The library of Nicholas V already numbered 1,143 books; Boyle, "Sixtus IV," 69. Melozzo's fresco "frontispiece" is now detached and displayed in the Pinacoteca Vaticana. Payments are recorded for the artist beginning on January 15, 1477; Boyle, "Sixtus IV," 67.

63 Templa, domum expositis, vicos, fora, moenia, pontes
 Virginem trivii quod repararis aqua.
 Prisca licet nautis statuas dare commoda portus
 Et vaticanum cingere, Sixte, iugum.
 Plus tamen urbs debet; nam quae squalore latebat
 Cernitur in celebri Bibliotheca loco.

64 Another cardinal nephew, Pietro Riario, by all accounts Sixtus's favorite, had died shortly before the Vatican Library opened.

65 Benzi, *Sisto IV*, 15–21; Concetta Bianca, "Francesco della Rovere: Un Francescano tra teologia e potere," in Miglio, *Un Pontificato e una città*, 19–55.

66 The most extensive biography of Raffaele Sansoni Riario is still Francesco

Cancellieri, *Notizie del Cardinale Raffaello Riario* (Rome: De Romanis, 1822). Because he was the son of Pietro Riario's sister, his patronym was "Sansoni," but he was usually known by his mother's far more imposing surname, "Riario." As titular cardinal of the Church of San Giorgio in Velabro, he was known among his contemporaries as "San Giorgio." For his patronage, see also Vincenzo Farinella, *Archeologia e pittura a Roma tra Quattrocento e Cinquecento* (Turin: Einaudi, 1992), 145–8.

67 So Vitruvius, *De architectura libri decem*, 5.9. See also Samuel Ball Platner, *A Topographical Dictionary of Ancient Rome*, revised and completed by Thomas Ashby (Oxford: Oxford University Press, 1929), s.v. *Theatrum Pompei*.

68 Margaret Daly Davis, " 'Opus Isodomum' at the Palazzo della Cancelleria: Vitruvian Studies and Archaeological Antiquarian Interests at the Court of Raffaele Riario," in Silvia Danesi Squarzina, ed., *Roma, Centro ideale della cultura dell' antico nei secoli XV e XVI. Da Martino V al Sacco di Roma, 1417–1527* (Milan: Electa, 1989), 442–57.

69 Vitruvius, *L. Victruvii Pollionis De architectura libri decem*, ed. Iohannes Sulpicius [Giovanni Sulpizio da Veroli], editor's prefatory letter to Cardinal Raffaele Riario, no pagination:

Quicquid curae: studii: vigiliarum et opere: in emendando et vulgando Victruvio posui. Quidquid utilitatis in medium affero. Quicquid forsan et laudis consequar tuae dedico amplitudini Raphael Riarie Ro[manae] Ec[clesiae] dignissime Camerarie: certum litteratorum praesidium: Fotor ingeniorum. Spes publica. Patrocinium populorum [!]: benignitatis delitie: virtutumque plurimarum vivida quaedam effigies: Cum enim hunc aptius possem? Quam cui ego sum deditissimus: et a quo me diligi: et Victruvium in delitiis haberi intelligo? Immo ad quem libentius architectus ipse diriget? quam ad eum qui sua lectione plurimum delectatur. Quique suis praeceptis et saepe et in magnis aedificiis: si vixerit: sit usurus. Quemque praetoria: villas: templa: porticus: arces: et regias: sed prius theatra aedificaturum spe certa colligimus. Tu enim primus Tragoediae quam nos iuventutem excitandi gratia et agere et canere primi hoc aevo docuimus (Nam eius actionem iam multis saeculis Roma non viderat) in medio foro pulpitum ad quinque pedum altitudinem erectum pulcherrime exornasti. Eandemque postquam in Hadriani mole Divo Innocentio spectante est actum: rursus intra tuos penates tanquam in media circi cavea toto consessu umbraculis tecto: admisso populo et pluribus tui ordinis spectatoribus honorifice excepisti. Tu etiam picturatae scaenae faciem quam Pompeiani comoediam agerent: nostro saeculo ostendisti. Quare a te quoque theatrum novum tota urbs magnis votis expectat.

The text is also quoted in Cruciani, *Teatro nel Rinascimento*, 222–4.

70 This manuscript, London, British Library, Harleianus 2767, possibly written for Charlemagne himself, has only two illustrations: a wind rose and a line drawing of Jesus Christ with his hand raised in blessing.

71 Leone Battista Alberti, *L' architettura (De re aedificatoria)*, ed. Giovanni Or-

landi; introduction and notes by Paolo Portoghesi (Milan: Polifilo, 1996), 443 (my translation) (VI.1):

Nanque dolebam quidem tam multa tamque praeclarissima scriptorum monumenta interisse temporum hominumque iniuria, ut vix unum ex tanto naufragio Vitruvium superstitem haberemus, scriptorem procul dubio instructissimum, sed ita affectum tempestate atque lacerum, ut multis locis multa desint et multis plurima desideres. Accedebat quod ista tradidisset non culta: sic enim loquebatur, ut Latini Graecum videri voluisse, Graeci locutum Latine vaticinentur res autem ipsa in sese porrigenda neque Latinum neque Graecum fuisse testetur, ut par sit non scripsisse hunc nobis, qui ita scripserit, ut non intelligamus.

72 Sulpizio da Veroli, letter to readers, in Vitruvius *De architectura*, ed. Sulpicius (no pagination):

ipse tandem effeci . . . ut quantum per plurimas occupationes meas fieri posset: redderem unum imprimendorum archetypum adeo emendatum: ut parvus labor cuius alteri eiusdem rei studioso relinqueretur. Siqua vero in quibusdam graecis quae obscura sane depravataque sunt: interim percunctando meliora potero invenire: ibidem silentio [n]on praeteribo Figurarum descriptionibus quoniam earum exempla habere nequivimus: et sunt rationis difficilis: et artificibus laboriose: sua in imaginibus spatia servabuntur: ut quom vel nostro vel aliorum studio edentur in lucem: suis locis possint affigi. Interim vero litteratos omnes in quorum manus volumina hic auctor emendatissimus: et si suis undique partibus absolutus.

73 Sulpizio da Veroli, to Raffaele Riario in ibid. (no pagination): "Theatro est opus. Quo quid fieri et presentibus et posteris iucundius potest? Si enim post Pompeianum illud marmoreum et capacissimum: minora et incultiora: magnae suis gloriae fuerunt auctoribus. Quantae tibi nunc erit quom nullum integrum extet: si aut dirutum reparaveris: aut novum erexeris?"

74 Simonetta Valtieri, "La Fabbrica del palazzo del Cardinale Raffaele Riario (La Cancelleria)," *Quaderni dell' Istituto di Storia dell' Architettura* 174 (1983), 3–26; Enzo Bentivoglio, "Nel Cantiere del Palazzo del Cardinale Raffaele Riario (La Cancelleria): Organizzazione, materiali, maestranze, personaggi," *Quaderni dell' Istituto di Storia dell' Architettura* 174 (1983), 27–34; Frommel, *Römische Palastbau*, 1:93; Armando Schiavo, *Il Palazzo della Cancelleria* (Rome: Staderini, 1963); Torgil Magnuson, *Studies in Roman Quattrocento Architecture* (Stockholm: Almquist and Wiksell, 1958), 298.

75 Cortesi, *De cardinalatu*, 99r (131r): "itaque Raphael Riarius senator ingenii splendore nitens, ac hominum naturae explorandae cupidus, cum in Theatro Pompei ex symmetriae ratione magnificam metiretur domum, saepe dicebat se iccirco auditorium velle aedificare laxius, quo largiore intervallo adeuntium naturam ex motu corporis notione intuendo posset."

76 See also Marco Nocca, " 'Theatrum novum tota urbs magnis votis expec-

tat': Il teatro della Passione di Velletri, Antonio da Faenza architetto antiquario e Raffaele Riario," in Danesi Squarzina, *Roma, Centro ideale*, 291–302.

77 See Brown, "The Apollo Belvedere."

78 See Christoph Luitpold Frommel, "Kirche und Tempel: Giuliano della Roveres Kathedrale Sant' Aurea in Ostia," in Hans-Ulrich Cain, Hanns Gabelmann and Dieter Salzmann, eds., *Festschrift für Nikolaus Himmelmann*. Beihefte der Bonner Jahrbücher, no. 47 (Mainz: Von Zabern, 1989), 491–505; Silvia Danesi Squarzina and Gabriele Borghini, *Il Borgo di Ostia da Sisto IV a Giulio II* (Rome: De Luca, 1981).

79 See Maria Giulia Aurigemma, "La Rocca è un labirinto. Nascita e sviluppo del presidio ostiense," in Danesi Squarzina and Borghini, *Il Borgo di Ostia*, 60–103; Jarkko Sinisalo, "Le Stufe Romane," in Bruno Contardi and Heinrik Lilius, eds., *Quando gli dei si spogliano. Il Bagno di Clemente VII a Castel Sant' Angelo e le altre stufe romane del primo Cinquecento* (Rome: Romana Società Editrice, 1984), 12–15.

CHAPTER TWO. ALEXANDRIA ON THE TIBER
(1492–1503)

1 For the Borgias in Rome, see Ludwig Freiherr von Pastor, *History of the Popes from the Close of the Middle Ages*, trans. Frederick Ignatius Antrobus and R. F. Kerr (London: Heinemann, 1894–8), vol. 5; Ferdinand Gregorovius, *Lucrezia Borgia*, Italian ed. (Florence: Le Monnier, 1874); Michael Mallett, *The Borgias: Rise and Fall of a Renaissance Dynasty* (London: Bodley Head, 1969); E.R. Chamberlin, *The Fall of the House of Borgia* (New York: Dial, 1974); Marion Johnson, *The Borgias* (London: Macdonald, 1981); Rachel Erlanger, *Lucretia Borgia: A Biography* (New York: McGraw-Hill, 1978), as well as Maria Bellonci's characteristically well-documented historical novel, *Lucrezia Borgia* (Verona: Mondadori, 1960).

2 Niccolò Machiavelli, *The Prince*, bk. 21: "Ognuno vede quello che tu pari; pochi sentono quello che tu se'."

3 Paolo Cortesi, *Tres libri De cardinalatu ad Julium Secundum Ponti[ificem] Max[imum] per Paulum Cortesium Protonotarium Apostolicum* (Castle Cortesi: Symeon Nardi, 1510), 12v: In the passages quoted in the present chapter, my translation has not reproduced Cortesi's habit of calling the College of Cardinals the "Sacred Senate": that peculiarity, and the reasons for it, are discussed at length in Chapter 7 of the present volume.

12v: "non sine causa scientia semper quaedam fuit in senatum obrependi via: siquidem patrum memoria Nicolaus quintus obscuro loco natus ob multarum rerum scientiam, senator est sine adversantium obvaricatione dictus. Nihiloque angustius homini doctissimo Pio secundo aditus in sen-

atum patuit. Nec enim alia causa Sixto quarto quam de Christi cruore disputatio patritiatus adipiscendi fuit.''

4 Ibid., 12v: "Nam cum maxime Senatorum intersit generis humani cura satis intelligi datur eos qui doctrinae altitudine scientiaeque dignitate florent facile posse de inferiorum generum natura iudicare, ac imperandi prohibendique sapientia hominum scire continere genus, quae est maxime propria senatoris virtus.''

5 Ibid., 1r–12r (chapter 1: "De virtutis moralibus"); cf. Machiavelli, *The Prince*, bk. 21.

6 Cortesi, *De cardinalatu*, 79r (101r): "eius gentis homines ambitiosi, blandi, curiosi, avidi, litigiosi, tenaces, sumptuosi, suspitiosi, vafri, ac Barbarorum prope Itali nominari solent: ex quo praeclare doctissimus latinorum Picus inter hos et Italos interesse dicere consuesse ferebatur, quantum inter inventores rerum et confectores excogitatarum . . . ex quorum altero generi Hispanorum generi velox daretur in exquirendo percursio, ex altero Itali nasceretur iudicium in rerum confectione sanius.''

7 Pinturicchio was also sometimes known as "Il Sordino," the "little deaf man." For the decoration of the Borgia Apartments, see Fritz Saxl, "L' Appartamento Borgia," in his *Storia delle immagini* (Bari: Laterza, 1982), 135–63; Federico Hermanin, *L' Appartamento Borgia in Vaticano* (Rome: Danesi, 1934); Franz Ehrle and E. Stevenson, *Gli Affreschi del Pinturicchio nell' Appartamento Borgia del Palazzo Apostolico Vaticano* (Vatican City: Biblioteca Apostolica Vaticana, 1897) ; Ernst Steinmann, *Pinturicchio* (Bielefeld: Velhagen and Klasing, 1898), 41–8; Jürgen Schulz, "Pinturicchio and the Revival of Antiquity," *Journal of the Warburg and Courtauld Institutes* 25 (1962), 35–55; in Silvia Danesi Squarzina, ed., *Roma, Centro ideale della cultura dell' Antico nei secoli XV e XVI. Da Martino V al Sacco di Roma, 1417–1527* (Milan: Electa, 1989): Claudia Cieri, "*Sacrae effigies et signa arcana*: La Decorazione di Pinturicchio e scuola nell' Appartamento Borgia in Vaticano," 185–201, and Maurizio Calvesi, "Il 'Gaio classicismo.' Pinturicchio e Francesco Colonna nella Roma di Alessandro VI," 70–101.

8 See Nicole Dacos, *La Découverte de la Domus Aurea et la formation des grotesques à la Renaissance* (London: Warburg Institute, 1969), 62–9.

9 So Sven Sandström, *Levels of Unreality. Studies in Structure and Construction in Italian Mural Painting during the Renaissance* (Uppsala: Almqvist and Wiksell, 1963), esp. 42.

10 See Ephesians 3:9, "the mystery, which from the beginning of the world hath been hid in God" (King James Version).

11 For *prisca theologia*, see Frances Yates, *Giordano Bruno and the Hermetic Tradition* (Chicago: University of Chicago Press, 1964); D. P. Walker, *Spiritual and Demonic Magic from Ficino to Campanella* (London: Warburg Institute, 1958).

12 An exhaustive bibliography is to be found in Bertrand Jaeger, "La Loggia delle Muse nel Palazzo Te e la reviviscenza dell' Egitto antico nel Rinascimento," in his *Mantova e l' antico Egitto da Giulio Romano a Giuseppe Acerbi. Atti del Convegno di Studi, Mantova, 23–24 maggio 1992*, Accademia Nazionale Virgiliana di Scienze, Lettere, e Arti, Miscellanea no.2 (Florence: Olschki, 1994), 21–40. See also, in the same collection, Enrichetta Leospo, "La *Tabula Bembina*: Un Cimelio 'orientale' dalla Mantova dei Gonzaga alla Torino dei Savoia," 41–52; see also Garth Fowden, *The Egyptian Hermes: A Historical Approach to the Late Pagan Mind* (Princeton: Princeton University Press, 1993).

13 See Acts 7:22: "So Moses was taught all the wisdom of the Egyptians."

14 Anthony Grafton, *Joseph Scaliger: A Study in the History of Classical Scholarship*, vol. 2: *Historical Chronology* (Oxford: Clarendon Press, 1993).

15 Reginald Eldred Witt, *Isis in the Graeco-Roman World* (London: Thames and Hudson, 1971); Anne Roullet, *The Egyptian and Egyptianizing Monuments of Imperial Rome* (Leiden: Brill, 1972); Sarolta Takacs, *Isis in the Greek and Roman World* (Leiden: Brill, 1995).

16 The *Histories* of Ammianus Marcellinus were also important for their description of Rome's obelisks; for the Renaissance interest in Egypt, see Giovanni Cipriani, *Gli Obelischi egizi* (Florence: Olschki, 1993); Karl Giehlow, "Die Hieroglyphenkunde des Humanismus in der Allegorie der Renaissance," *Jahrbuch der Kunsthistorischen Sammlungen des allerhöchsten Kaiserhauses* 23 (1915), 1–232; Erik Iversen, *Obelisks in Exile* (Copenhagen: Gad, 1968), and *The Myth of Egypt and Its Hieroglyphs in European Tradition*, rev. ed. (Princeton: Princeton University Press, 1993); Cesare d' Onofrio, *Gli Obelischi di Roma* (Rome: Bulzoni, 1967); James Stevens Curl, *Egyptomania. The Egyptian Revival: A Recurring Theme in the History of Taste* (Manchester: Manchester University Press, 1994); Jaeger, "La Loggia delle Muse"; see also Leospo, "La *Tabula Bembina*." My thanks as well to Brian Curran for his learned conversation on this subject.

17 See Michael J. B. Allen, *Marsilio Ficino and the Phaedran Charioteer* (Berkeley and Los Angeles: University of California Press, 1981), and *The Platonism of Marsilio Ficino* (Berkeley, Los Angeles, and London: University of California Press, 1984); Arthur Field, *The Origins of the Platonic Academy of Florence* (Princeton: Princeton University Press, 1988); James Hankins, "The Myth of the Platonic Academy of Florence," *Renaissance Quarterly* 44 (1991), 424–75, and *Platonism in the Italian Renaissance* (New York: Columbia University Press, 1990). Cf. Machiavelli, *The Prince*, bk. 21.

18 This was also the room where Pope Julius II kept Cesare Borgia confined after Pope Alexander's death.

19 Discreetly, Pinturicchio avoids developing the story of the most wayward of these scattered members, Osiris's phallus, for which Isis made an ex-

haustive but unsuccessful search. She conscientiously erected tombs in every city where it might have gone astray; Plutarch, *De Iside et Osiride*, 358 A–B.

20 Saxl, "L'Appartamento Borgia," 175–7.

21 In the place of Pinturicchio's decoration, we now see a decorative scheme devised for Pope Leo X (1513–21) by Raphael's assistant Giovanni da Udine with the help of Perino del Vaga.

22 See Johann Burckard, *Liber notarum*, ed. Enrico Celani, Rerum Italicarum Scriptores no. 32, vol. 2 (Città di Castello: s. Lapi, 1906), 235–6, June 29, 1500; cf. Sigismondo Ticci (Tizio), *Historia Senensium*, Chigi G.II.36, 322.

23 For the life and achievements of Giovanni Nanni, who wrote as Annius of Viterbo, see Walter E. Stephens, *Giants in Those Days: Folklore, Ancient History, and Nationalism* (Lincoln: University of Nebraska Press), and "Berosus Chaldaeus: Counterfeit and Fictive Editors of the Early Sixteenth Century" (Ph.D. diss. Cornell University, 1979), as well as "The Etruscans and the Ancient Theology in Annius of Viterbo," in Paolo Brezzi and Maristella de Panizza Lorch, eds., *Umanesimo a Roma nel Quattrocento* (New York: Barnard College, Columbia University, 1984), 309–22; Anthony Grafton, *Forgers and Critics: Creativity and Duplicity in Western Scholarship* (Princeton: Princeton University Press, 1990); E. N. Tigerstedt, "Ioannes Annius and *graecia mendax*," in C. Henderson, Jr., ed., *Classical, Medieval, and Renaissance Studies in Honor of Berthold Louis Ullmann* (Rome: Edizioni di Storia e Letteratura, 1964), 2:293–310; Roberto Weiss, "Traccia per una biografia di Annio da Viterbo," *Italia Medioevale e Umanistica* 5 (1962), 425–41; and "An Unknown Epigraphic Tract by Annius of Viterbo," in *Italian Studies Presented to E. R. Vincent* (Cambridge: Heffer, 1962), 101–20; O. A. Danielsson, "Annius von Viterbo über die Gründungsgeschichte Roms," in *Corolla archaeologica principi hereditario regni sueciae Gustavo Adolpho dedicata* (Lund: Glerup, 1932), 1–16; Edoardo Fumagalli, "Un Falso Tardo-quattrocentesco: Lo Pseudo-Catone di Annio da Viterbo," in Rino Avesani, ed., *Vestigia, Studi in onore di Giuseppe Billanovich* (Rome: Edizioni di Storia e Letteratura, 1984), 337–83; Gigliola Bonucci Caporali, ed., *Annio da Viterbo, Documenti e ricerche*, Contributi alla Storia degli Studi Etruschi ed Italici, no. 1 (Rome: Consiglio Nazionale delle Ricerche, 1981); C. Ligota, "Annius of Viterbo and Historical Method," *Journal of the Warburg and Courtauld Institutes* 50 (1987), 44–56.

24 Giovanni Nanni, O.P., *Ad beatissimum papam Sixtum: et reges ac senatus christianos de futuris christianorum triumphis contra turchos et maomethanos omnes Epistola magistri Joannis viterbiensis* (Genoa: per Reverendum Magistrum Baptistam Cavalum ordinis predicatorum, 1480). For the effect of his preaching on his audience and on the subsequent events in his life, see

Edoardo Fumagalli, "Aneddoti della vita di Annio da Viterbo, O.P., 1. Annio e la vittoria dei genovesi sui sforzeschi; 2. Annio e la disputa sull' Immacolata Concezione," *Archivum Fratrum Predicatorum*, 50 (1980), 167–99; Paola Mattiangeli, "Annio da Viterbo, Ispiratore di cicli pittorici," in Bonucci Caporali, *Annio da Viterbo*, 257 n. 6.

25 Fumagalli, "Annio e la disputa sull' Immacolata Concezione."

26 Annius of Viterbo [Giovanni Nanni], *Commentaria Fratris Joannis Annii Viterbiensis super opera diversorum auctorum de antiquitatibus loquentium* (Rome: Eucharius Silber, 1498); cited from paginated edition of Jehan Petit, Paris 1514, 169v.

27 These marginalia (including the epigraph for this chapter), in an early sixteenth-century hand, are to be found in the copy of Annius's *Antiquitates* held by the Biblioteca Hertziana in Rome.

28 Giehlow, "Die Hieroglyphenkunde," 40–6.

29 Olof August Danielsson, *Etruskische Inschriften in Handschriftlicher Überlieferung*, Skrifter utgivna av Kungl. Humanistiska Vetenskaps–Samfundet i Uppsala, no. 25:3 (Uppsala: Almqvist and Wiksell, 1928); in Mauro Cristofani, ed., *Siena: Le Origini: Testimonianze e miti archeologici* (Florence: Olschki, 1979): Cristofani, "Le Iscrizioni etrusche,"125–6; Marina Martelli Cristofani, "MS Sloane 3524," ibid., 136–43; cf. Adriana Emiliozzi, *Il Museo Civico di Viterbo: Storia delle raccolte archeologiche* (Rome: Consiglio Nazionale delle Ricerche, 1986), 19–35. A superior apograph of the Monte Cipollara inscriptions can be found in Oxford, Bodleian Library, MS Lat. class.e.29, 2r–3v.

30 I. D. Rowland, "L' *Historia Porsennae* e la conoscenza degli Etruschi nel Rinascimento," *Res Publica Litterarum* 9 (1989), 185–93.

31 This point is made by Stephens, "Berosus Chaldaeus," 16.

32 Ibid., and Grafton, *Forgers and Critics*, devote a good deal of attention to Annius's scholarly method.

33 Giehlow, "Die Hieroglyphenkunde," 46–79, 94–102; Ernst Gombrich, "Hypnerotomachiana," cited from his *Symbolic Images* (London: Phaidon, 1972), 102–8; Mattiangeli, "Annio da Viterbo," 257–339.

34 On Roman booksellers, see Francesco Barbieri, *Tipografi romani del Cinquecento: Guillery, Ginnasio Mediceo, Calvo, Dorico, Cartolari* (Florence: Olschki, 1983).

35 Hyperbole seems to have been expected of sixteenth-century autobiographers; Colocci looks positively modest when compared with Benvenuto Cellini.

36 On the *Hypnerotomachia*, see the annotated edition by Giovanni Pozzi and Lucia Ciapponi: Francesco Colonna, *"Hypnerotomachia Poliphili," Edizione critica e commento* (Padua: Antenore, 1980). For the publication history of the book, see Robert G. Babcock and Mark L. Sosower, *Learning from the*

Greeks: An Exhibition Commentary Commemorating the Five-Hundredth Anniversary of the Founding of the Aldine Press (New Haven: Beinecke Rare Book and Manuscript Library, 1994), 44–5; Martin Davies, *Aldus Manutius, Printer and Publisher of Renaissance Venice* (London: British Library, 1995), 37–8. My thanks to Father Thomas Sheehan for this information and for the identification of the Vatican copies of the 1499 *Hypnerotomachia.*

37 The initials to the chapters of the *Hypnerotomachia* form an acrostic: "Frater Franciscus Columna Poliam peramavit" (Brother Francesco Colonna deeply loved Polia), which has usually been accepted as the real author's name. The colophon to the book says "Treviso, 1467," which sounds like a date of composition. There was a Brother Francesco Colonna in the Veneto between 1467 and 1499; in fact, there were several, but one in particular had connections with Treviso and a renegade lifestyle that has induced scholars to identify him as the author of the *Hypnerotomachia*, theorizing that he possibly drafted an early redaction in 1467 and revised it for publication thirty years later. This position is enshrined in Pozzi and Ciapponi's annotated edition of 1980; see also Maria Teresa Casella and Giovanni Pozzi, *Francesco Colonna: Biografia e opere* (Padua: Antenore, 1959); Giovanni Pozzi and Lucia Ciapponi, "La Cultura figurativa di Francesco Colonna e l' arte veneta," *Lettere Italiane* 14 (1962), 151–69. It has been most hotly contested by Maurizio Calvesi, *Il Sogno di Polifilo prenestino* (Rome: Officina, 1980), who identifies the "brother" of the acrostic with the Roman baron Francesco Colonna, prince of Palestrina, and the ruined setting of the *Hypnerotomachia*'s first book as the sanctuary of Fortuna at Palestrina, where the Colonna had a palazzo atop the Roman buildings. The term "brother," according to Calvesi, refers to Colonna's membership in the Roman Academy. See also Silvia Danesi Squarzina, "Francesco Colonna, Principe, letterato, e la sua cerchia," *Storia dell' Arte* 19 (1987), 137–54; Maurizio Calvesi, "*Hypnerotomachia Polifili*. Nuovi riscontri e nuove evidencze di documentazione per Francesco Colonna Signore di Preneste," *Storia dell' Arte* 19 (1987), 85–136, and *La "Pugna d'amore in sogno" di Francesco Colonna romano* (Rome: Lithos, 1996).

Recently, Pietro Scapecchi, following Lucia Ciapponi's lead in volume 2 of the 1980 annotated edition, has taken the novel's second book as a separate work, composed before 1467 by the Servite monk Fra Eliseo da Treviso, which was amplified in the late 1490s for Aldus Manutius by Leonardo Grasso, the book's sponsor, a Venetian envoy to the Holy See whose knowledge of Venice and Rome alike would account for the novel's elements of Venetian dialect and close knowledge of Treviso, as well as for its evocation of a landscape more evocative of ancient Rome. (In Luciana Bigliazzi, Angela Dillon Bassi, Giancarlo Savino, et al., *Aldo*

Manuzio Tipografo, 1494–1515, Firenze, Biblioteca Medicea Laurenziana, 17 giugno–30 luglio 1994 (Florence: Octavo, Franco Cartini, 1994), 68–70. Aldus himself, born in Rome and resident in Venice, had the same kind of knowledge.

In private conversations, Piero Meogrossi of the Soprintendenza alle Antichità di Roma has pointed out that in 1467 Pomponio Leto had left Rome for the Veneto, bringing all his enthusiasm about Roman antiquities with him. Meogrossi believes that the buildings of the first book are based on explorations in the imperial palace on the Palatine and connects the book's environment with the Roman Academy, both the first generation of Platina and his colleagues and the second generation of Paolo Cortesi, Tommaso Inghirami, and Angelo Colocci.

Calvesi, *Il Sogno di Polifilo*; Meogrossi (private communication); and Stefano Borsi, *Polifilo architetto: Cultura architettonica e teoria artistica nel Hypnerotomachia Poliphili di Francesco Colonna, 1499* (Rome: Officina, 1995), are right to emphasize the Roman content of the novel's first book, although the author, as argued here, may have had only a rudimentary sense of ancient architecture and is always in some sense describing a figment of imagination rather than any actual building. Because Palestrina's ruins were not exposed to their present extent until after the Allied bombing of 1944, Calvesi's exclusive emphasis on that site seems misplaced, especially when the Palatine and the Baths of Caracalla were so much more evident to fifteenth-century humanists. It seems unlikely that a book sponsored by a Venetian ambassador to Rome and printed in Venice by an expatriate Roman could be anything but a Romano-Venetian hybrid, and its elaborate art language may have been one way to lift the story out of contemporary regionalisms.

The contention that the book falls into two parts of very different date has much to recommend it. The allegorical fairy story of the second book lacks the archaeological exactitude that humanist culture would have demanded by 1499. However, there are limits to that culture, for writer and audience alike; Pozzo and Ciapponi's erudite commentaries, like Calvesi's essays and Borsi's meticulous architectural study, charitably overestimate the depth of the *Hypnerotomachia*'s learning. As the sixteenth-century bishop Antonio Agustín said of the book's translation into French: "What misspent hours, recording these ineptitudes!" *Antiquitatum romanarum hispanarumque in nummis veterum, Dialogi XI*, Latin translation by Andreas Schott (Antwerp: Henrik Aerts, 1617), 164: "O male collocatas horas in his ineptiis describendis!"

An erudite and insightful overview of the problems is that of Edoardo Fumagalli in his review of Pozzi and Ciapponi's annotated edition of 1980 and of Calvesi's book of the same year, *Aevum* 55 (1981), 571–83.

38 *Hypnerotomachia Poliphili,* ed. Pozzo and Ciapponi, 458: "Cum il delectoso somno celeriuscula dagli ochii mei et cum veloce fuga se tolse, essa dicendo: 'Poliphilo, caro mio amantime, vale.' " All the following quotations from the work are from this edition.

39 *Hypnerotomachia,* 460: "FLOS SIC EXSICCATVS NVNQVAM REVIVISCIT."

40 Title Page: "HYPNEROTOMACHIA POLIPHILI VBI HVMANA OMNIA NON NISI SOMNIVM ESSE DOCET. ATQVE OBITER PLVRIMA SCITV SANE QVAM DIGNA COMMEMORAT." For a more humorous take on the same problem, see e.e. cummings, "Ponder, darling, these busted statues": "consider, lady, this ruined aqueduct / which used to lead something into somewhere."

41 Ibid., 236:

> Diqué la mia eutrapela Polia, solerte del' improbe condictione dil concutiente Amore et accortasi, per mortificare tanto importuno incendio et alquanto sincoparlo et come singulare sospiratrice mia succurrendo, così benignamente me dice: 'Poliphile, di tuti amantissimo mio, già mai non son ignara che le antiquarie opere ad te summamente piaceno di vedere. Aunche commodamente potes tu in questo intervallo che nui il signore Cupidine aspetiamo, ire licentemente queste aede deserte et dalla edace et exoleta vetustate collapse o per incendio assumpte o vero da annositate quassate a tuo solacio mirare et gli fragmenti nobili rimasti, de venerato dignissime, speculare.' . . . Allhora io grandemente avidissimo, cum l' altre commendatissime opere vise etiam queste accuratissimo et multivido di contemplare, levatome dalla foelice sessione . . . solicito perveni.

42 Maurizio Calvesi argues that the sculpted relief that found its way to Colocci's garden was known in 1495 and hence may have inspired the author of the *Hypnerotomachia,* rather than the other way around: see Calvesi, *La "Pugna d' amore,"* 149–51, esp. 245 n. 5. Colocci, however, did not acquire his garden until 1513; he, at least, could not have failed to draw inspiration from, or at least perceive a connection to, the novel. For the nymph fountains, real and fictional, see Otto Kurz, *"Huius nympha loci,"* *Journal of the Warburg and Courtauld Institutes* 6 (1953), 171–7; Elizabeth MacDougall, "The Sleeping Nymph: Origins of a Humanist Fountain Type," *Art Bulletin* 57 (1975), 357–65; Phyllis Pray Bober, "The *Coryciana* and the Nymph Corycia," *Journal of the Warburg and Courtauld Institutes* 40 (1977), 223–39; Ernst Gombrich, "Hypnerotomachiana," *Journal of the Warburg and Courtauld Institutes,* 14 (1951), 119–25, reprinted in his *Symbolic Images,* 102–8; David R. Coffin, *Gardens and Gardening in Papal Rome* (Princeton: Princeton University Press, 1991), 32–46; Millard Meiss, "Sleep in Venice: Ancient Myths and Renaissance Proclivities," in his *Painter's Choice: Problems in the Interpretation of Renaissance Art* (New York: Harper and Row, 1976), 212–40, esp. 214–16 and 240.

43 *Hypnerotomachia,* 63–5:

Hora, questa spectatissima statua l' artifice tanto definitamente la expresse che veramente dubitarei tale Praxitele Venere havesse scalpto, la quale Nichomede, re degli Gnidii, comparandola, come vola la fama, tutto lo havere dil suo populo expose: et quanto venustamente bellissima lui la expresse, tanto che gli homini in sacrilega concupiscentia di quella exarse, il simulachro mastrubando [sic] stuprorono. Ma quanto valeva aestimare, dritamente arbitrai tale imagine mai fusse cusì perfecta, di celte overo di scalpello simulata, che quasi ragione-volmente io suspicavi in questo loco de viva essere lapidata et cusì petrificata . . . Sotto di questa tale et mirabile scalptura, tra le gulature et undule, nella piana fascia, vidi inscalpto questo mysterioso dicto di egregio chractere atthico: ΠΑΝΤΩΝ ΤΟΚΑΔΙ. Per la quale cosa io non saperei definire si la diuturna et tanta acre sete pridiana tolerata, ad bere trahendo me provocasse over il bellis-simo suscitabulo dello instrumento: la frigiditate del quale inditio mi dete che la petra mentiva.

44 Ibid., 110: "La voluptuosa amoenitate poscia degli ordinati vireti, pomarii et irrigui horti, fontane vive, cum rivuli correnti in marmorarii claustri, de incredibile factura contente et septe: herba rosida sempre frescha et flori-gera et aure dolce aestive et veriferi venti cum vario concento di avicule."

45 Ibid., 234: "cum vibrante quale vipera et succulente lingula," "la extrema suavitate dilla saporosa et piciola bucca, spiraculo di odorante aura et mos-coso spirito et freschissimo anhelito"; 68: "le rotunde et elephantine gambe."

46 Ibid., 23:

mirai sopra tutto una bellissima porta tanto stupenda et d' incredibile artificio et di qualunque liniamento elegante, quantomai fabrefare e depolire se potria, che sencia fallo non sento tanto in me di sapere che perfectamente la potesse et assai discrivere, praecipuamente che nella nostra aetate gli vernacoli, proprii, et patrii vocabuli et di l' arte aedificatoria peculiari sono cum gli veri homini sepulti et extincti. O execrabil et sacrilega barbarie, come hai exspoliabonda invaso la più nobile parte dil pretioso thesoro et sacrario latino et l' arte, tanto dignificata, al praesente infuscata da maledicta ignorantia perditamente offensa? La quale, associata inseme cum la fremente, inexplebile et perfida avaritia, ha occaecato quella tanto summa et excellente parte, che Roma fece et sublime et vagabonda imperatrice.

47 The humanist argument has much to be said for it; Roman education followed the legions throughout the empire, and able young provincials could rise either through the ranks of the army or through those of the *litterati.*

48 *Hypnerotomachia,* 23:

Dinanti ad questa egregia porta . . . erano ad libella dui ordini de columnatione cum exquisito intervallo dil' areostylo interiecto, secundo la exigentia oppor-tuna, d' una columna dall' altra; ove il primo corso overo ordine d' ambe due le parte initiavano equali al limbo overo extremo termine dil silicato nel metopa overo fronte dilla magna porta; et tra una et l' altra columnatione era spatio di

275

passi xv. Dilla quale columne alcune et la magiore parte overo numero integre se vedevano, cum li capitelli dorici overo pulvinati, cum gli cortici overo volute cochleate fora degli echini inanulati, cum gli astragali subiecti, dependuli de qui et de lì la tertia parte sua più excedendo lo imo suo, cioè dil capitello, il quale di crassitudine dilla supposta columna semidiametro constava.

Most of this description is lifted wholesale from passages of Vitruvius, *De ar-chitectura*, bks 3–4.

On "Doric, that is, cushion capitals" (li capitelli dorici overo pulvinati) Calvesi, *Il Sogno*, translates *ovvero* as *oppure*, making the passage state that the great gate had both Doric and Ionic columns. But this is not how *ovvero* is used in the *Hypnerotomachia*; repeatedly, in this passage and elsewhere, it furnishes a synonym as a gloss on a difficult word. The text unequivocally specifies that "cushion" capitals (a Vitruvian synonym for "Ionic") are Doric. The mistake is glaring, and cannot be evaded.

49 By 1499, Leone Battista Alberti, who knew both architecture and Latin, was dead; Francesco di Giorgio Martini and Donato Bramante, who knew little Latin, could have caught the architectural errors of the *Hypneroto-machia* if they could have understood the Latinized vernacular in which it is written. Fra Giocondo da Verona, antiquarian, architect, and editor of Vitruvius, would certainly have noted the inaccuracies in the book.

50 *Hypnerotomachia*, 127. Arabic and Greek also appear on a statue base, 29; Hebrew, Greek, and Latin, 30.

51 Davies, *Aldus Manutius*, 37–8.

52 BAV, Incunabulum Rossianum 589: "È una Specie di Romanso noioso," referring the unwary reader to Agustín, *Antiquitatum Dialogi,* Dialogue 11.

53 In the seventeenth century, Pope Alexander VII, whose worn and copi-ously annotated copy of the *Hypnerotomachia* is still preserved in the Vatican Library, suggested to Gian Lorenzo Bernini that a newly discovered obelisk be erected on the back of a stone elephant, like the illustration in the Aldine novel. Such mid–sixteenth-century marvels as Pirro Ligorio's fountains for the Villa D'Este in Tivoli or Vicino Orsini's "parco dei mostri" at Bomarzo also show awareness of the illustrations, if not necessarily the written text, of the *Hypnerotomachia*.

CHAPTER THREE. THE CURIAL MARKETPLACE

1 For the workings of the Curia, see Walter von Hofmann, *Forschungen zur Geschichte der Kurialischen Behörden vom Schisma bis zur Reformation,* Bib-liotheck des Königlich-Preussichen Historischen Instituts zu Rom, 12–13 (Rome: Bibliotheck des Königlich-Preussischen Historischen Instituts zu Rom, 1914); Peter Partner, *The Pope's Men: The Papal Civil Service in the Renaissance* (Oxford: Oxford University Press, 1990), and "The 'Budget'

of the Roman Church in the Renaissance Period," in E. F. Jacob, ed., *Italian Renaissance Studies: A Tribute to the Late Cecilia M. Ady* (London: Faber and Faber, 1960), 256–78, and *The Lands of Saint Peter: The Papal State in the Middle Ages and the Early Renaissance* (Berkeley and Los Angeles: University of California Press, 1972), as well as "Papal Financial Policy in the Renaissance and Counter-Reformation," *Past and Present* 87 (1980), 17–62. Characteristically, D'Amico's discussion, *Papal Humanism in Renaissance Rome: Humanists and Churchmen on the Eve of the Reformation* (Baltimore: Johns Hopkins University Press, 1983), 19–37, is a model of concision and lucidity.

2 In Colocci's lifetime, Cardinals Giulio de' Medici (Clement VII) and Alessandro Farnese (Paul III) made the same transition from the vice-chancellor's office directly into the papacy; von Hofmann, *Forschungen*, 2: 67–71.

3 For a Florentine view, see Lauro Martines, *The Social World of the Florentine Humanists, 1390–1460* (Princeton: Princeton University Press, 1963). For Rome, see esp. Partner, *The Pope's Men*, Charles L. Stinger, *The Renaissance in Rome* (Bloomington: Indiana University Press, 1985), and D'Amico, *Papal Humanism*.

4 Paul Grendler, *Schooling in Renaissance Italy: Literacy and Learning, 1300–1600* (Baltimore: Johns Hopkins University Press, 1989); Van Egmond, "The Commercial Revolution and the Beginnings of Western Mathematics in Renaissance Florence, 1300–1500," Ph.D. diss., Indiana University, 1976; Paul Gehl, *A Moral Art: Grammar, Society and Culture in Trecento Florence* (Ithaca, NY: Cornell University Press, 1993). All three must work, as must the present study, from highly ancedotal evidence. Thus we know, for example, that Machiavelli was trained in *abbaco*; merchants like Stefano Ghinucci, Filippo Strozzi, and Mariano Chigi and his sons were educated in letters.

5 Christine Shaw, *Julius II: The Warrior Pope* (Oxford: Blackwell, 1993), 82–6.

6 In 1517, Riario was forced out of his position by Pope Leo X on the spurious charge that he had conspired with a group of much younger cardinals to assassinate the pope. See Chapter 7 of the present volume.

7 See Jean Delumeau, *Vita economica e sociale di Roma nel Cinquecento* (Florence: Sansoni, 1979), 62–91, 94–5, rev. Italian ed. of *Rome au XVIe siècle* (Paris: Hachette, 1975).

8 For banking families and their relations with the Curia, see, e.g., Ubaldo Morandi, "Gli Spannocchi: Piccoli proprietari terrieri, artigiani, piccoli, medi e grandi mercanti-banchieri," in *Studi in onore di Federigo Melis* (Naples: 1978), 3:103–20; Melissa Meriam Bullard, *Filippo Strozzi and the Medici* (Cambridge: Cambridge University Press, 1980).

9 Barbara McClung Hallman, *Italian Cardinals, Reform, and the Church as Property, 1492–1563* (Berkeley and Los Angeles: University of California, 1985).

10 Some prices will be given later in this chapter; in general, they ranged between 1,000 and 3,000 ducats.

11 A seventeenth-century biography of Agostino Chigi by his brother's great-grandson, Fabio Chigi (the future Pope Alexander VII), "Chisiae Familiae commentarii," is preserved in the Vatican Library, Chigi a.I.1. It was published in an annotated edition by Giuseppe Cugnoni as *Agostino Chigi il magnifico* (Rome: Istituto di Studi Romani, 1878). See also Giuseppe Buonafede, *I Chigi augusti* (Venice: F. Valvasense, 1660); *Dizionario biografico degli Italiani* (1980), s.v. *Agostino Chigi*; Ottorino Montenovesi, "Agostino Chigi, banchiere e appaltatore dell' allume di Tolfa," *Archivio della Reale Società Romana di Storia Patria* 60 (1937), 111–40; Wilde Tosi, *Il Magnifico Agostino Chigi* (Rome: Istituto Bancario di San Paolo, 1970); Felix Gilbert, *The Pope, His Banker, and Venice* (Cambridge, MA: Harvard University Press, 1980); Ingrid D. Rowland, "Render unto Caesar the things which are Caesar's: Humanism and the Arts in the Patronage of Agostino Chigi," *Journal of the Warburg and Courtauld Institutes* 39 (1986), 673–730; Mary Quinlan-McGrath, "The Villa of Agostino Chigi: The Poems and Paintings," Ph.D. diss., University of Chicago, 1983. Vittorio Franchini, "Note sull' attività finanziaria di Agostino Chigi nel Cinquecento," in *Studi in onore di Gino Luzzatto* (Milan: Giuffré, 2: 156–65, 1950) must be revised in light of more recent research; see Ingrid D. Rowland, *The Correspondence of Agostino Chigi in Vatican Cod. Chigi R.V.c: An Annotated Edition*, Studi e Testi (Vatican City: Biblioteca Apostolica Vaticana, in press).

12 For curial merchants, in addition to Partner, *The Pope's Men*, see Gilbert, *The Pope*; Melissa Meriam Bullard, " 'Mercatores florentini romanam curiam sequentes' in the Early Sixteenth Century," *Journal of Medieval and Renaissance Studies* 6 (1976), 51–71, and *Filippo Strozzi*; for conditions in Siena specifically, see David Hicks, "The Education of a Prince: Lodovico il Moro and the Rise of Pandolfo Petrucci," *Studies in the Renaissance* 8 (1968), 88–102; William M. Bowsky, "The Anatomy of Rebellion in Fourteenth-Century Siena: From Commune to Signory?" in Lauro Martines, ed., *Violence and Disorder in Italian Cities, 1200–1500*, (Berkeley and Los Angeles: University of California Press, 1972), 229–72.

13 Sigismondo Ticci, "Historia Senensium," Chigi G.II.36, G.II.37 and G.II.38, details the intricate social relationships among the Sienese; the present analysis relies to a great extent on contracts preserved in the Archivio di Stato, Rome [ASR]: Notai A.C. 4836, 4837, 4838, 7152; and in the Vat-

ican Library: Chigi R.V.b; Chigi R.V.e, i–iii; Vat. Lat. 11171, Archivio Chigi 361, 413, 3666, 11445–55. See also Rowland, *The Correspondence of Agostino Chigi.*

14 In addition to such analytical works as David Hicks, "Sienese Society in the Renaissance," in Charles H. Carter, ed., *From the Renaissance to the Counter-Reformation: Essays in Honor of Garrett Mattingly* (New York: 1968), 75–84; Ann K. Chiancone Isaacs, "Popolo e monti nella Siena del primo Cinquecento," *Rivista Storica Italiana* 86.1 (1970), 32–80; Mario Ascheri, *Siena nel Rinascimento. Istituzioni e sistema politico* (Siena: Leccio, 1985); see Ticci, "Historia Senensium," Chigi G.II.36, 110v, 270r; Archivio di Stato, Siena [ASS], Balìa 49; Rowland, *The Correspondence of Agostino Chigi*, 13–14.

15 Ronald G. Witt, "Medieval *Ars dictaminis* and the Beginnings of Humanism: A New Construction of the Problem," *Renaissance Quarterly* 35 (1985), 1–35, and "Medieval Italian Culture and the Origins of Humanism as a Stylistic Ideal," in Albert Rabil, Jr., ed., *Renaissance Humanism: Foundations, Forms, and Legacy*: vol. 1, *Humanism in Italy* (Philadelphia: University of Pennsylvania Press, 1988), 29–70; as well as "The Origins of Italian Humanism: Padua and Florence," *Centennial Review* 34 (1990), 92–108; Quentin Skinner, "Ambrogio Lorenzetti as Political Philosopher," *Proceedings of the British Academy* 72 (1986), 1–56; Gehl, *A Moral Art*. My thanks to Simone Zurawski for calling my attention to the Skinner article.

16 See Gehl, *A Moral Art*; Grendler, *Schooling*, 306–19; Warren Van Egmond, *Practical Mathematics in the Italian Renaissance: A Catalog of Italian Abbacus Manuscripts and Printed Books to 1600*, Annali dell' Istituto e Museo di Storia della Scienza, suppl. fasc. 1, (Florence: Istitutue Museodi Storia della Scienza, 1980) (hereafter *Practical Mathematics*), 5; and "The Commercial Revolution," 4–6: Frank J. Swetz, *Capitalism and Arithmetic: The New Math of the Fifteenth Century* (La Salle, IL: Open Court, 1987); Raffaella Franci and Laura Toti Rigatelli, *Introduzione all' aritmetica mercantile del Medioevo e del Rinascimento* (Siena: Quattro Venti, 1982).

17 See Leila Arrin, *Scribes, Script, and Books: The Book Arts from Antiquity to the Renaissance* (Chicago: American Library Association, 1991), 194–8.

18 See, e.g., Lucia A. Ciapponi, "A Fragmentary Treatise on Epigraphic Alphabets by Fra Giocondo da Verona," *Renaissance Quarterly* 32 (1979), 18–40.

19 Giuseppe Cugnoni, *Augostimo Chigi il Magnifico*. Archivio della Reale Società Romana di Storia Patoria (Rome: Istituto di Studi Romani, 1878), 14; cf. Buonafede, *I Chigi augusti*, 172.

20 Fabio Chigi reports that Ghinucci was "historiae doctissimus," Chigi a.I.1,18r. The degree of his success as a banker may be gauged by the fact

that one of his sons became a cardinal; in the early sixteenth century that position did not come about gratis. Pandolfo Petrucci spent "60,000 and more" to obtain the cardinal's hat for his son Alfonso, at least according to Sigismondo Ticci, Chigi G.II.37, 139r. See also Barbara McClung Hallman, *Italian Cardinals, Reform, and the Church as Property, 1492–1563* (Berkeley and Los Angeles: University of California, 1985).

21 Chigi a.I.1,18: "Pueritiam, et adolescentiam in litteris peregit, verum xxi aetatis anno patre orbatus negocia prosequi aggressus est."

22 For Lorenzo's literary studies, see Chigi a.I.1, 21r: "Lorenzo non tam domesticis [that is, the family firm], quam literariis, aulicisque negociis operam novaret"; for Angelo, Chigi R.V.c, 10r, and Rowland, *The Correspondence of Agostino Chigi*, 7–9. For Lorenzo's death by fulmination, see Johann Burckard, *Liber notarum*, ed. Enrico Celani, Rerum Italicarum Scriptores, no. 32 (Città di Castello: S. Lapi, 1906), 2: 235–6, June 29, 1500; cf. Ticci, Chigi G.II.36, 322.

23 Cugnoni, *Agostino Chigi il Magnifico*, 14. See also Sigismondo Ticci's comment, "licteris modice conspersus fuerat" (he was moderately versed in letters), Chigi G.II.38, 143v.

24 "Patriis adaugendis divitiis inhians," Cugnoni, *Agostino Chigi*, 14.

25 See Pio Pecchiai, *Roma nel Cinquecento* (Bologna: Licinio Cappelli, 1948), 273–81; Jean Delumeau, *Vita economica e sociale di Roma nel Cinquecento*, (Florence: Sansoni, 1979), rev. Italian ed. of *Rome au XVIe siècle* (Paris: Hachette, 1975), 199–245; Partner, *The Lands of Saint Peter*, Gilbert, *The Pope*. For Chigi's contracts and correspondence, see Rowland, *The Correspondence of Agostino Chigi*, 4, 16–17.

26 See Ubaldo Morandi, "Gli Spannocchi: Piccoli proprietari terrieri, artigiani, piccoli, medi e grandi mercanti-banchieri," in *Studi in onore di Federigo Melis*, Bibliopolis (Naples: 1978), 103–20.

27 See Jean Delumeau, *L' Alun de Rome, XVe–XIXe siècle* (Paris: SEVPEN, 1962), 97–105; Mario di Carlo, Nello di Giulio, Piero Franceschini, et al., eds., *La Società dell' allume: Cultura, materiale economia e territorio di un piccolo borgo* (Rome: De Luca, 1984); G. Zippel, "L' Allume di Tolfa e il suo commercio," *Archivio della Reale Società Romana di Storia Patria* 30 (1907), 389–462; Filippo Maria Mignanti, *Santuari della regione di Tolfa* (Rome: Cremonese, 1936); Ottorino Morra, *Tolfa: Profilo storico e guida illustrata* (Civitavecchia: Cassa di Risparmio di Civitavecchia, 1979); Franchini, "Note sull' attività finanziaria," 167–75; Montenovesi, "Agostino Chigi"; Gilbert, *The Pope*; Rowland, *The Correspondence of Agostino Chigi*. Alum was used as a desiccant to prepare the wool to receive every type of dye except indigo blue.

28 In other words, like Angelo Colocci and Tommaso Inghirami, Sannazaro was a humanist businessman.

29 Chigi R.V.c, 33r, letter of January 30, 1501 from Agostino Chigi in Rome to Mariano Chigi in Siena:

> sopra l' alumeria visto quanto scrivete, e sarà difficile acomodarvi . . . Voi avete le spesi gravi e io credevo il contrario: per avere manchata famiglia bene è vero che io l' ò gravisime, e potete anche essere certo che i' spendo più in uno anno che voi non fate in 4, e queste mie posesioni non mi red[d]ano niente salvo la industria . . . Io vi vegho adirizato a un camino che vi bisogna contentare . . . che io non so fare le mie cose tanto in furia, né con tanta diligienza, e spero in dio che a la giornata mi mostra il meglio.

30 Chigi R.V.c, 28v, Agostino Chigi in Rome to Mariano Chigi in Siena: "Voi sete in nun grande errore se voi credete che io posa atendere a una causa di 100 ducati tignosi che ne laso delle mie che inportano le migliara per non avere a piatire."

31 Ticci, "Historia Senensum," Chigi G.II.36, 374v; Gilbert, *The Pope*, 74–5; Morandi, "Gli Spannocchi," 115; Rowland, *The Correspondence of Agostino Chigi*, 6, and "Render unto Caesar," 680.

32 ASR, Ospedale di San Rocco, Busta 109, 24; cf. Busta 120, 52v–53v: "se non foste stato tanto vantaggioso, le cose fra noi si sariano mosse d' acordo." The date January 5, 1503, is calculated in Sienese style; the year began on March 25.

33 Hofmann, *Forschungen*, 2: 120.

34 D'Amico, *Papal Humanism*, 29; Hofmann, *Forschungen*, 2: 172. (The range is between 1,100 and 1,900 ducats for the first decade of the sixteenth century.)

35 Agostino Chigi's purchase is confirmed by the records of the Chigi bank in ASR, Ospedale di S. Rocco, Busta 110, 43r–v, when the price of the office is returned to the Chigi associate Francesco Tommasi on March 24, 1506; Angelo Chigi, its previous holder, presumably had died shortly before.

36 For the position, see Hofmann, *Forschungen*, 2:120; for its price, see 174. For the office, see D'Amico, *Papal Humanism*, 29–35.

37 Hofmann, *Forschungen*, 2:120.

38 Ibid., 80.

39 He had certainly bought a position as abbreviator before 1499; ibid., 83.

40 D'Amico, *Papal Humanism*, 25.

41 He fought his in-laws stoutly to keep the dowry after her death; see Federico Ubaldini, *Vita di Monsignor Angelo Colocci*, ed. Vitorio Fanelli, Studi e Testi, no. 256 (Vatican City: Biblioteca Apostolica Vaticana, 1969), 29 n. 34.

42 Egmont Lee, *Sixtus IV and Men of Letters* (Rome: Edizioni di Storia e Letteratura, 1978), 111–19; Fabio Benzi, *Sisto IV, Renovator Urbis: Architettura a Roma, 1471–1484* (Rome: Officina, 1990).

CHAPTER FOUR. THE CULTURAL MARKETPLACE

1 Ingrid D. Rowland, *The Correspondence of Agostino Chigi*, in *Vatican Cod. Chigi R.V.c: An Annotated Edition*, Studi e Testi (Vatican City: Biblioteca Apostolica Vaticana, in press), 48.

2 Vat. Lat. 3351, 2r:

> Domenica che fo il primo de octobre 1508, andai a trovare Monsignor Reverendissimo de Medici, cioè Ioanne et pregai soa Reverendissima Sanctità per esser morto il mio Monsignor Reverendissimo della Colonna et io haver facta electione de soa Reverendissima Sanctità Quale è litteratissima et quella li piacesse acceptarme tra li suoi servi et familiari et soa Sanctità Reverendissima con gratioso viso me accepto per familiar et con molte et gratiosissimi parole et offerte. [In a later addition] Questo fu poi creato papa et fù Leone X.

3 For a general overview, see Peter Partner, *Renaissance Rome, 1500–1559: A Portrait of a Society* (Berkeley and Los Angeles: University of California Press, 1976), 131–59.

4 Vat. Lat. 3351, IIr:

> A dì 18 di Julio de martedì 1503 combatterono in prato Mario dastallo et M. Antonio vendectino la differentia era che havendo briga M. Antonio con Marcello fratello de Mario et venendo un dì ad parole M. Antonio con Mario disse chel dicto Marcello non era homo per lui. Mario rispose che nillo haveva mostrato: et questo diceva perchè Marcello haveva assaltato M. Antonio et fattolo fugire: allhora M. Antonio disse: Io te ho: et io te voglio provare che Marcello non è homo per mi: Mario respose: che lui li voleva mantenere che menteva per la gola: M. Antonio hebbe el campo della excellentia dello sempre invicto Caesari duca de valentia. Mario elesse l' arme: queste da defendere: almetto senza visiera con la baviera: queste da offendere. Martelli con lhasta longetta ad un mano et dage, et così el dito [dì] se affrontorno: et menarone circa quattro botte di dicti martelli de ponta Volendo Mario menare un colpo con tutta soa possa et non giongendo comensò a cascare. allhora M. Antonio sopragionse et dettili una sponta et facilmente lo buttò a terra: et fulli sopra con tutto el corpo, et tormentando con le deta per longo spatio locchio mancho et dandogli pugni disse Arrenditi iudio arrenditi. Mario con grandissima constantia sopportando dette de mano alla baviera et cosi sello tirò a dosso: et poi per forza di schena selli voltò sopra et senza far parola pigliò certi pugni de terra et misili in bocca ad M. Antonio et strengendo la gorza et con la sinistra tormentando li coglioni per far miglior presa et metter mano ala daga: Allhora M. Antonio disse piu volte me arendo me arendo me arendo: et così li fu dato presone: et lui lo dunò al duca: al principe: et ad Don Michele. Allhora el principe et Don Michele li pregorno ambidoi volessero essere bon fratelli: et così li ferno basare in labro el duca non fu presente excepto fussi stato travestito. le spoglie del dicto M. Antonio furno sospese ad sancta Maria del Populo . . .

> Ibid., IIv:

In questo laudaremo in Mario animosità nel combattere: patientia in soffrire: forza in superare: consiglio in vencere: liberalità in donarlo presone: pietà in acceptarlo per fratello: humanità in non se superbire della victoria: Relligione in renderne gratie allaltissimo dio."

5 Edith Wharton, *The Age of Innocence* (New York: Appleton, 1920), 122: "Winsett himself had a savage abhorrence of social observances: Archer, who dressed in the evening because he thought it cleaner and more comfortable to do so, and who had never stopped to consider that cleanliness and comfort are two of the costliest items in a modest budget, regarded Winsett's attitude as part of the boring 'Bohemian' pose."

6 See Bruno Contardi and Henrik Lilius, eds., *Quando gli dei si spogliano. Il Bagno di Clemente VII a Castel Sant' Angelo e le altre stufe romane del primo Cinquecento* (Rome: Romana Società Editrice, 1984); Patricia Waddy, *Seventeenth-Century Roman Palaces: Use and the Art of the Plan* (New York: Architectural History Foundation / Cambridge, MA: MIT, 1990), 47–53. For ancient Roman traditions of bathing, see Fikret K. Yegül, *Baths and Bathing in Antiquity* (New York: Architectural History Foundation Cambridge, MA: MIT, 1992).

7 See H. H. Lamb, *Climate, History, and the Modern World*, 2nd ed. (London: Routledge, 1995), 211–41.

8 See Roger Jones and Nicholas Penny, *Raphael* (New Haven: Yale University Press, 1983), 166–71.

9 Thomas Randolph, "On a maide of honor seene by a scholler in Sommerset Garden," in Helen Gardner, ed., *The Metaphysical Poets* (Harmondsworth, UK: Penguin, 1972), 160.

10 The definitive biography of Serafino remains that of his friend Vincenzo Calmeta, "Vita del facondo poeta vulgare Seraphino Aquilano per Vincentio Calmeta composta" in Giovanni Filoteo Achillini, ed., *Collettanee grece-latine-e vulgari per diversi auctori moderni nella morte de lardente Seraphino Aquilano. Per Gioanne Philotheo Achillino bolognese in uno corpo redutte. Et alla Diva Helisabetta Feltria da Gonzaga Duchessa di Urbino dicate* (Bologna: Caligula Bazaliero, 1504). See also *New Grove Dictionary of Music and Musicians*, s.v. *Serafino de' Ciminelli dell' Aquila*; Serafino Aquilano, *Le Rime di Serafino de' Ciminelli dall' Aquila*, ed. Mario Menghini (Bologna, Romagnoli-Dall' Acqua, 1894–6), vol. 75 in *Collezione di Opere Inedite o Rare di Scrittori Italiani dal XIII al XVI Secolo*, ed. Giosuè Carducci; Antonio Rossi, *Serafino Aquilano e la poesia cortegiana* (Brescia: Morcelliano, 1980).

11 See Christopher Reynolds, "Rome: A City of Rich Contrasts," in Iain Fenlon, ed., *The Renaissance from the 1470s to the End of the Sixteenth Century* (Englewood Cliffs, NJ: Prentice-Hall, 1989), 63–101.

12 For Cardinal Ascanio's life, see Edward E. Lowinsky, "Ascanio Sforza's Life: A Key to Josquin's Biography and an Aid to the Chronology of his

Works," in Edward E. Lowinsky and Bonnie J. Blackburn, eds., *Josquin des Prez. Proceedings of the International Josquin Festival–Conference Held at the Juilliard School at Lincoln Center in New York City, 21–25 June 1971* (London: Oxford University Press, 1976), 31–75; Nino Pirrotta, "Music and Cultural Tendencies in Fifteenth-century Italy," *Journal of the American Musicological Society* 19 (1966), 127–61; Reynolds, "Rome," 67; Howard Mayer Brown, *Music in the Renaissance* (Englewood Cliffs, NJ: Prentice-Hall, 1976), 121.

13 Vat. Lat. 5159, 1v:

Non so che voglia il suo Cervel Freneticho:
Che hor mi mostra Riso: & hora Sdegno.
Mo crede ale mie pene: mo pare hereticho
E hora egli è irato, hora benigno.
Quando mi fuge como paraleticho
E quando mostra che di me sia pregio
O ver tu m' ami: o ver m' isclude e serra.
Non mi dare hora pace: et doman guerra.

14 Ibid., 107r:

Morte:che voi: te bramo: echomi apresso
Prendime: a che: che manchi il mio dolore
Non posso: hoimè non poi: non per adesso
Perchè: però che in te non Regna il core
Che facto: hor non sai stulto ove l' ai messo
Ha: ha: anzi si so: n'è causa amore
Ma che farò: fatel restituire
Che chi vita non ha non pò morire.

15 Calmeta, "Vita," + iiii 2r–v:

Et in Casa de uno Cavalero Hyerosolimitano Bolognese chiamato Nestor Malvezzo tanto fece residentia quanto alli servitii de Ascanio Cardinale Sforza fu ammesso, con el quale per tre anni con grandissimo sdegno e fastidio hebbe perseveranza. Imperochè essendo le Nature diverse – haverìa voluto el cardinale (como la più parte de li Principi e non ingiustamente) che Seraphino alli costumi suoi se fusse conformato. E la virtù che mal volontiera può patire subiectione non lo tollerava. Così tuttavia il Signore, con Imperio, e il servo con pigra disposizione erano alle mani. Ma tra molte male conformitati una tutte le altre superava, questa era la caccia, alla quale essendovi il Cardinale tanto dedito che ogni altra cura interlasciava e Seraphino tanto da quella alieno, che a sentirla recordare li porgeva fastidio. Ogni giorno il Cardinale di rabuffarlo e poco existimarlo non desisteva. Trattendolo più domesticamente (in vero) che alla dignità d'un tanto Principe e prelato, et alla Virtù di così pellegrino ingegno non si conveniva. Di qua nacque l' origine che la indignatione di farli componere versi fu la causa primaria. Et imitando più la gratia de la Natura della quale fu dotato che laccidente, cominciò hora a deplorare la sua infelicitate,

hor a lacerare occultamente il Cardinale in sonetti faceti e mordaci (che per trito vocabulo Burchielleschi si chiamano) per modo che mai non trapassava settimana che de lui qualche novitade non se aspetasse. Quando attaccava un sonetto al collo de un cane – quando befava le male spese vigilie de' cortegiani – quando mordeva il Cardinale di pompa et avaritia e quando spesse volte de addormirse o perdere il cane su la caccia li interveniva. A tale che continuando in queste facetie e lacerationi che seco gratia et acutezza portavano, quanto manco da Ascanio era appregiato, tanto più el rumore dil nome suo per Roma se spandeva.

16 Vat. Lat. 5159, 212r (cf. Serafino, *Rime*, ed. Menghini, 125):

Aau, au, au, parlar non so
Intendame: pietà se regna in te.
Ch'io vegno sol per impetrar merzè
De tanta servitù che si ipsa ho.
Bu: bu bu bu bu bu te morderò
Chi vorà del poltron mandar ver me
Qua si dimostra el mio servir con fè
Per le ferite che signato vo.
Non mirar quel ch'io son ma quel ch'io fu
Per ben ch'io sia disposto: più che ma[i]
Se non del corpo: del consiglio più
Perché Signor mio Caro: credo ben sa
Ch'io son sbandito e posto in fondo giù
E di gran bastonate ognun mi da
Questo io non merita
Ma vero è chi in corte el tempo so
More in la paglia disperato po.

17 Calmeta, "Vita" + iiii 3r: "Et essendo Seraphino in Milano prese amicitia con un notabile Gentilhomo Napolitano chiamato Andrea Coscia dil Duca Ludovico Sforza soldato – il quale molto soavemente cantava nel liuto. E tra li alti modi una sonata ne la quale dolcemente strammoti di Charitheo esprime la qual cosa non solo Seraphino il modo li tolse pù limatione aggiungendoli – ma a comporre strammoti con tanto ardore et assiduità se dede che de conseguire gran fama in quello stile hebbe summa felicitade."

18 *New Grove Dictionary of Music and Musicians*, s.v. *Serafino de' Ciminelli dell' Aquila*, and *Frottola*; Brown, *Music in the Renaissance*, 95–112; Nino Pirrotta and Elena Povoledo, *Music and Theatre from Poliziano to Monteverdi*, trans. Karen Eales (Cambridge: Cambridge University Press, 1982), 25–36.

19 Cited from Pirrotta and Povoledo, *Music and Theatre*, 27.

20 Calmeta, "Vita" + iiii 5v:

Essendo al Carnevale propinquo e già in deliberato pensiero de partirse dal Cardinale fece una egloga che comincia – Dimmi Menandro mio etc. Immitando Iacobo sanazaro il qual dil Buccolico verso in quelli tempi otteneva la

Palma, et in quella con artificioso velame lavaricia, et alcuni altri detestandi vitii della corte di Roma lacerava. et recitatela il Carnevale col favore di Gioanne Cardinale Colonna, tuttavia di se stesso piu rendeva ammiratione. Uscito poi de la servitute di Ascanio molti mesi senza havere certo patrone per Roma ando vagando il piu delle volte meco fraternalmente raccogliendose.

21 Vat. Lat. 5159, 244v–245r:

Oymè che può habitar fra tante insidie
Fra tanta servitù: fra tanta inopia
Fra tanta falsità: fra tante invidie
Speso ho gli anni mei qui sì gran copia
A neve: a pioge: al sol ardente e callido
Che ognun diria ch' io naqui in Etiopia.

22 Vat. Lat. 5159, cited from Serafino, *Rime*, ed. Menghini, 242:

Questi patron che d' altrui sangue ingrassano
Caschino tutti in qualche gran voragine
Che quanto d' alto più, più se fracassano.
Come quella superba, alta Cartagine
E la gran Troia già desfatta in cenere.

23 Calmeta, "Vita" + iiii 6v:

Et havendo lui medesimamente provato per experientia che da li Prelati di Roma più presto li erano prestate benignamente le orecchie ad ascoltare le soe compositioni che offertoli le piatose mani a subvenire alli suoi bisogni, deliberò un' altra volta con servitù la soa Fortuna experimentare. E con il Cardinale Ascanio de novo racconciliato alli soi servitii fece ritorno dove con più risguardo e miglior conditione honoratamente li era dato da vivere—poi che un tempo in questo grado hebbe perseverato – di revedere la patria e li parenti soi li venne desiderio.

24 Ibid., A iiii 2r:

Fu Seraphino di statura meno che mediocre, de membri più robusto che delicato, et advenga che fusse alquanto de ossa grossetto era perhò oltra la fortezza de piu agilità che altri non havrìa existimato. Li capilli suoi erano negri, longhi, et destesi, la carne de colore bruno. Li occhi negri, e vivaci, Et ogni soa operatione era con ardore misticata. In facetie, cortesanie, e motti aggratiato, ma spesse volte più licentioso che urbano. Era tanto avido de rumore populare che ad ogni cosa che potesse el vulgo tirare in ammiratione lo ingegno accomodava; faceva diversi giochi di memoria locale, con charti, e nomi, alla palla giocando, et altre cose de industria che non meno chel componere tra vulgari el facevano celebre e famoso. Nel recitare de soi Poemi era tanto ardente, e con tanto giuditio le parole con la Musica consertava, che l' animo de li ascoltanti o dotti, or mediocri, o plebei, o donne equalmente commoveva. Et advenga che con molti Poeti havesse emulatione, niente di meno non fu mai de maligna natura né molto contentioso. Affabile assai in compagnia anchora che havesse molti costumi più per natura che per volunta rusticani. Nel vestire advenga che un

tempo per poco havere il modo, e per naturale pigritia andasse disprezzato, niente di meno fu tanta la soa felicitate che quello andare abietto non a segnitie ma a Philosophica electione da' vulgari li era ascritto. Crescendoli poi nel ultimo insieme le ambitioni con la fama, et anchora havendo meglio il modo, a migliore cultezza et ornato se dede, essendone di quello anchora Amore potissima cagione. Non hebbe in soi Poemi alcuno particulare Amore per oggetto, perchè in ogni loco dove se trovava faceva più presto inamoramento che pigliare casa a pisone. Nel cibo non era temperato, ma alquanto avido . . .

Tutti li soi concetti furno d'havere in vita nome e celebratione anchora che solo tra mediocri e plebei di se fusse restato il rumore. Hebbe in conseguirlo grande felicità.

25 This is in fact Chigi's first known act of patronage. He next figures in 1505, as the dedicatee for two neo-Plautine plays by Egidio Gallo, *Comoediae* (Rome: Besicken, 1505).

26 Achillini, ed., *Collettanee grece-latine-e vulgari,* cited in full in note 10.

27 Calmeta, "Vita," + iiii 4v–5r:

Guarito in poco tempo della ferita (avenga che gran cicatrice li restasse) a Roma insieme col Cardinale fece ritorno. E visitate le consuete compagnie non solo parve novo – ma per haver portato novo modo di cantare – e li strammoti in piu altezza sublimati dede di se a tutta Roma non piccola admiratione. Fioriva medisimamente in Roma a quel tempo la nostra Academia in casa di Paolo Cortese giovene per doctrina – grado et affabilita in la Corte assai reverito. Per modo che non casa di Corteggiano ma officina di eloquentia – e recettaculo dogni inclyta Virtù se potteva chiamare. Concorrevano ivi ogni giorno gran multitutine de elevati ingegni Gioanlorenzo Veneto Petrogravina – Montepiloso Episcopo – Agapyto Gerardino, Manillo, Cornelio, e molti altri eruditi – sotto la cui ombra altri de minore etade che de amplettere la Virtu tuttavia erano desiderosi a soggiornare e prendere delettatione anchora se reducevano. Erano de Poeti vulgari in grandissimo pregio li ardori de lo Aretino – ne anchora de nostri frammenti si faceva poca existimatione. Seraphino adunque il quale più meco che con altra persona vivente hebbe commercio, de frequentare medesimamente questa Accademia prese deliberatione. Il che de non piccolo recreamento a cusi degno consortio fu cagione. Imperho che a tempo con lharmonia di soa Musica – e con largutia di suoi strammoti spesse volte li ardui certami di quelli altri litterati interpellava.

28 Niccolò Machiavelli to Agostino Vespucci, July 16, 1501, in Niccolò Machiavelli, *Opere*, vol. 6: *Lettere*, ed. Franco Gaeta (Milan: Feltrinelli, 1961), 61–2:

Raffaello Pulci . . . si trastulla con le muse. Spesso alle vigne di questi gran maestri et mercanti dice improviso . . . El Pulcio si trastulla, et sempre è in mezzo di quattro puttane con Sancti Londiano . . . Il che etiam conferma decto Raffaello in dovere stare continue per li giardini fra donne, et altri simili ad sé, dove con la lyra loro *suscitent musam tacentem*, diensi piacere e si trastullano. Ma, *bone Deus*, che pasti fanno loro, secondo intendo, *et quantum vini ingurgitant,*

poy che li hanno poetizato! . . . Hanno li sonatori di vari instrumenti, et con quelle damigelle danzano et saltano *in morem Salium vel potius Bacchantium.* Honne loro invidia, et mi bisogna rodere la cathena in camera mia, che è ad tecto, chalda, et con qualche tarantola spesse volte, et moro di chaldo, *ut vix possum ferre aestum.*

The "Salii," ancient Roman priests of Mars, performed a leaping dance that was originally intended to keep soldiers in shape for wearing heavy armor.

29 See Augusto Campana, "Angelo Colocci, Conservatore ed editore di letteratura umanistica," in *Atti del Convegno di Studi Su Angelo Colocci, Jesi, 13–14 settembre 1969, Palazzo della Signoria* (Iesi: Amministrazione Comunale, 1972), 257–72, esp. 261–2.

30 See Aulo Greco, "L' Apologia delle 'Rime' di Serafino Aquilano di Angelo Colocci," in *Atti,* 207–14.

31 They included an anthology of verse by Elisio Calentio. Another anthology, by Benedetto Cingoli, an old client of his uncle's, was also published in 1503, and an undated collection by Agostino Staccoli is probably close in date. Colocci sent the collected vernacular works of Pacifico Massimi to press in Fano in 1506 and those of Pier Francesco Giustolo in Rome in 1510. In the case of Calenzio, Lazzarelli, Massimi, and Giustolo, the printers' copies of the books have survived, with Colocci's notes; see Campana, "Colocci," 262.

32 Angelo Colocci, "Apologia per le rime di Serafino Aquilano," in Serafino, *Rime,* ed. Menghini, 24:

Dico M. Sylvio, che questi che'l nodo nel gionco cercano, la prima cosa li obiectano non haver in tucto familiare la toscana lingua, come che poche rime da singular poeti sian state scripte, ch' alla materna lingua de' toscani non l'habbino accomodate. Et che non ha molto imitato F. Petrarca, né Dante Allegheri, fuor che uno de questi nella simplicità et l' altro nella rotondità del verso. Alla prima questione per noi in questa più abbasso diffusamente gli sarà resposto. All' altra solo diremo non essere securo ne laudabile insistere sempre nelli alieni vestigii. Di novo replicano haver in varie cose imitato nor l' uno hor l' altro, et noi diremo optimi duci haver electi.

Ibid., 26–7:

Pare esser inferiore di grande intervallo della altezza del Petrarca, et questo fa che volendo più facilmente narrare le sue amorose cure monstra gli sensi più aperti, et questi gli affecti che nel pugno del Petrarca erano chiusi nella sua palma ha voluto explicare. Né anchor concederemo che le tumide vene alle volte e i troppo extesi nervi non appariscono fuor delle superfitie, ma lui dicea con la gratia recoprirle.

33 Ibid., 27:

Li concedono el proferir singulare, ma che cercava concordare le parole al leuto per più imprimerle nello animo delle genti et per hor infiamare hora remectere, come Gracco ne' senati la sua lyra adaptava. Dico che come non senza laude sempre sarà Terpandro che agiunse la voce alla musica et Dardano alla tibia, così el Seraphin per haver dato modo et da imprimere et da exprimere in rime le passione d' amore, più ch' alcuno altro mai per adietro sarà da esser celebrato.

34 Ibid., 24 ("la schiera de'stolti," 25, "una secta di puerili ingegni," 30):

Et lor con più pertinacia dicono esser indecoro al cytharista non solo di cose naturale haver parlato, ma anchora al destino et al fato haver l' animo erecto, cantandosi all' orecchi delle donne. Ad cotal obiectione, per lui resisterà el vergiliano Jopa et gli altri antiqui cytharedi, recitando ad Didone el corso delle stelle, le fatiche del sole et della luna, et maxime el nostro Seraphino che ad donne di raro iudicio porgeva le sue parole. Senza che si sforzava ch' a donne et cavalieri el suo dir fusse grato.

35 See Federico Ubaldini, *Vita di Mons. Angelo Colocci, Edizione del testo originale italiano* (Barb.Lat. 4882), ed. Vittorio Fanelli, Studi e Testi, no. 256 (Vatican City: Biblioteca Apostolica Vaticana, 1969), 24; Fanelli, *Ricerche su Angelo Colocci e sulla Roma cinquecentesca*, Studi e Testi, no. 283 (Vatican City: Biblioteca Apostolica Vaticana, 1979), 136–7.

36 Vat. Lat. 4817, 115r: "Gli re di francia scrivero col nativo ydioma / nelle messe nostre sonett / Nelli hinni / le donne picene nelle nenie / li conviti danza piena / le comedie farse: representationi / le balie in cunabulis et neniis canunt ista / le matri / le oratione delle donne."

37 Colocci, "Apologia," 24: "Di novo replicano haver in varie cose imitato hor l' uno hor l' altro, et noi diremo optimi duci haver electi."
 Ibid., 29:

Ad queste cotali obiectioni referiremo solo quel dicto di Afranio scriptor delle togate, che ad alchuni che pur similmente l' imputavano haver pigliato da Menandro comico più et diverse: Confesso – respose – haver preso senza timor de vergogna non pur da Menandro, ma anchor da tucti greci et latini che cose habbino ch' al mio proposito sia expediente, o che da me meglio explicar non si possa. Sí che mi persuado che tale exemplo ne sia bastante ad excusare i fiori coi quali el nostro Seraphino da giardini diversi ha facta la sua ghirlanda, sí come anche Vergilio et altri infiniti scriptori non dai racemi d' un solo poeta hanno facta la loro vendemia copiosa.

38 Vat. Lat. 4817, 9r: "mancando l'imperio romano et la fede christiana surgendo et pigliando forza, li poeti che in christo creduti furono li primi che alli sparse Rhyme cominciassero ad dar forma et latino et vulgare con li san<t>issimi hymni, con li preci, con le canzoni morali et per l'horma di costoro li nobili cavalieri et done amorose exercitandosi hanno dato tal principio che in brieve si spera di posser superare et greci et latini."

39 Ibid., 115r: "li psalmi, la messa, l'officio, le legge non se volgarizzano perché perdono la pressa senza brevità et maestà."

40 Ibid.: "Nui che componemo nella comune lingua de Italia non la latina ma la comuna cercamo imitare."

41 Ibid., 62r:

> Lingua comuna. Dante de comuni aulico. dicas [as often, Colocci is addressing himself] quod hodie magis apparet quod sit illud comune quia est curia romana et dico illud esse comune totius siciliae quod in aula ferdinandi frequentantur et federici. Illud in veneta regione quod venetiis aut ferrara aut mantua celebrantur. Illud comune apud insubres quod mediolani frequens est.
>
> Sed illud comune quod Romae ex istis omnibus componitur. Ubi est universalis Curia vel si magis placet ex dictis aulis singulis fit unum universale inter doctos, quorum consensus factum est communis loquela.

42 The single surviving copy of the book belongs to the Biblioteca Casanatense in Rome, where it is classified as vol. Inc. 1628. The case for Bramante's authorship was first put in 1944 by Guglielmo De Angelis D'Ossat, who did not publish his paper until 1966, as "Preludio romano del Bramante," *Palladio*, n.s. 16 (1966), 92–4. Arnaldo Bruschi accepted this conclusion in *Bramante architetto* (Bari: Laterza, 1967), 22, and it has been seconded authoritatively by Doris D. Fienga, "Bramante autore delle 'Antiquarie prospettiche romane' poemetto dedicato a Leonardo da Vinci," in *Studi Bramanteschi. Atti del congresso internazionale, Milano, Urbino, Roma 1970* (Rome: De Luca, 1974), 417–26. The arguments adduced here in support are largely new, as, surprisingly, is the contention that the poem itself is tongue in cheek.

43 [Donato Bramante (?)], *Antiquarie prospettiche romane*, cited from Gilberto Gori, *Intorno a un opuscolo rarissimo della fine del secolo XV intitolato "Antiquarie prospettiche romane composte per prospettico melanese depictore*: Ricerche," (Rome: Accademia dei Lincei, 1876), reprinted from Atti della Reale Accademia dei Lincei, ser. 2, III, iii (1875–6), 39–66. For the sake of clarity, the passages quoted here have some added word divisions, accents, and punctuation.

> O incognita virtù intellectiva
> La to profondità somma iusticia
> Bagni l' aride labr' al prospectiva
> Acio ch' i' possa dar qualche delitia
> A quei ch' anno fiduci' alla natura
> Per ampliar di Roma so noticia
> Di templi sacri picti et di scultura
> Che ne son parte impie e guasti in toto
> Facendo per piatà pianger le mura.

44 Ibid., stanza 124–9 (4v, col. 1, in the original edition):

Non è sí duro cor che non piangesse
l' ampli palazzi corpi e mura rotte
de Roma triumphante quando resse
Hor son spelonche ruinate grotte
di stucco di rilievo altri colore
di man di cinabuba apelle giotte
Dogni stagion son piene dipintori
più lastate per chel verno infresche
secondo el nome dato da lavori
Andiam per terra con nostre ventresche
con pane con presutto poma e vino
esser più bizarri alle grottesche
El nostro guidarel mastro pinzino
che ben ci fa abbottare el viso e l' ochio
parendo inver ciaschun spaza camino
Et facci traveder botte ranochi
civette e barbarianni e nottoline
rompendosi la schiena cho' ginochi.

45 Ibid., 1r:

Ad te, cordial caro ameno socio
Vinci, mi è caro nol l' aver per vitio
Si a scriver fussi stato colmo di otio
Sopra fluibil del mie sopratifio
Appol ti guardi d' ogni to desastro
Che bramo vederte più che 'l giuditio.

46 Giorgio Vasari, *Life* of Bramante, cited from Bruschi, *Bramante*, XXIX:

Aveva Bramante recato di Lombardia e guadagnati in Roma a fare alcune cose
certi danari, i quali con una masserizia grandissimo spendeva, desideroso poter
vivere del suo, ed insieme, senza avere a lavorare, poter agiatamente misurare
tutte le fabbrishe antiche di Roma. E messovi mano, solitario e cogitativo se
n' andava; e fra non molto spazio di tempo misurò quanti edifizi erano in quella
città e fuori per la campagna; e parimente fece fino a Napoli e dovunque e'
sapeva che fossero cose antiche. Misurò ciò che era a Tiboli e alla Villa Adriana,
e, come si dirà poi a suo luogo, se ne servì assai.

47 Because a woodcut prints a reverse image, "Prospettivo" has become left-
handed in the frontispiece.

48 Cited by De Angelis D' Ossat, *Preludio*, 94, and Fienga, "Bramante," 422.
See also Eugenio Battisti, "Bramante, Piero e Pacioli ad Urbino," *Studi
Bramanteschi*, 267–82.

49 The similarity of pose has also been noted by Fienga, "Bramante," 425–
6. For the identification of Euclid as Bramante, see Giovanni Pietro Bellori,
*Descrizione delle imagini dipinte da Raffaele Sanzio d' Urbino nelle Camere del
Palazzo Apostolico Vaticano* (Rome: Giacomo Komarek, 1695), 11; Hein-

rich Pfeiffer, *Zur Ikonographie von Raffaels Disputa und die Christlich-platonische Konzeption der Stanza della Segnatura*, Miscellanea Historiae Pontificiae, no. 37 (Rome: Università Gregoriana Editrice, 1975).

CHAPTER FIVE. TABULATION

1 Joseph Gies and Frances Gies, *Merchants and Moneymen: The Commercial Revolution, 1000–1500* (London: Barker, 1972); Franco Gaeta, "Dal Comune alla corte rinascimentale," in Alberto Asor Rosa, ed., *Letteratura italiana*, vol. 1: *Il Letterato e le istituzioni* (Turin: Einaudi, 1982), 149–256.

2 For the biography of Leonardo da Pisa, see Richard E. Grimm, "The Autobiography of Leonardo Pisano," *Fibonacci Quarterly* 11 (1973), 99–104; George Sarton, *Introduction to the History of Science* (Baltimore: Williams and Wilkins for the Carnegie Institution, 1927–48), vol. 2, pt. 2, 611–13; Joseph Gies and Frances Gies, *Leonard of Pisa and the New Mathematics of the Middle Ages* (New York: Crowell, 1969). Although designed specifically for "young people," the book is a model of lucidity for adult readers as well.

3 The manuscript, Florence, Biblioteca Nazionale Centrale, Cod. Magliabechianus C.I.616, has been edited with comments by Baldassare Ludovisi Boncompagni, as volume 1 of *Scritti di Leonardo Pisano* (Rome: Tipografia delle Scienze matematiche e Fisiche, 1857), hereafter cited as Fibonacci, *Scritti*.

4 Warren Van Egmond, "The Commercial Revolution and the Beginnings of Western Mathematics in Renaissance Florence, 1300–1500," Ph.D. diss., Indiana University, 1976, 5–6; Francis Pierrepont Barnard, *The Casting-Counter and the Counting-Board: A Chapter in the History of Numismatics and Early Arithmetic* (Oxford: Clarendon Press, 1916); J. M. Pullan, *The History of the Abacus* (New York: Praeger, 1969).

5 Eventually Hindu-Arabic numerals became a crucial element in the writing of algebraic equations; see Van Egmond, *Commercial Revolution*, 323–6; and *Practical Mathematics in the Italian Renaissance: A Catalog of Italian Abbacus Manuscripts and Printed Books to 1600*, Annali dell' Istituto e Museo di Storia della Scienza, suppl. fasc. 1 (Florence: Istituto e Museo di Storia della Scienza, 1980), 11.

6 This "Typus arithmeticae," from Gregorius Reisch, *Margarita philosophica*, was first published in Freiburg in 1503. The woodcut reproduced here is from the 1517 Basel edition of Michael Furterius, 1517, k v 3v. My thanks to Mary Quinlan-McGrath for the reference to Reisch. See also Frank J. Swetz, *Capitalism and Arithmetic: The New Math of the Fifteenth Century* (La Salle, IL: Open Court, 1987), Fig. 1.5.

7 Just as slide rules coexisted with Hindu-Arabic numeration until very re-

cently, the self-portrait of Giovanni Boroni da Piacenza portrays the merchant armed with both counting-stick and slate. Appropriately, the picture adorns Boroni's personal copy of Luca Pacioli, *Summa de arithmetica* (Venice: Paganinus de Paganinis, 1494), pt. 2, 74v, from Newberry Library copy (Incunabulum f5168).

8 Margaret Daly Davis, *Piero della Francesca's Mathematical Treatises: The "Trattato d' abaco" and "Libellus de quinque corporibus regularibus"* (Ravenna: Longo, 1977), 24–5.

9 So Sarton, *Introduction*, vol. 2, pt. 2, pp. 611–13.

10 Fibonacci, *Scritti*, 283:

Quot paria cuniculorum in uno anno ex uno pario germinentur. Quidam posuit unum par cuniculorum in quodam loco, qui erat undique pariete circundatus, ut sciret, quot ex eo paria germinarentur in uno anno: cum natura eorum sit per singulum mensem aliud par germinare; et in secundo mense ab eorum nativitate germinunt. Quia suprascriptum par in primo mense germinat, duplicibus ipsum, erunt paria duo in uno mense. Ex quibus unum, scilicet primum, in secundo mense ge[r]minat; et sic sunt in secundo mense paria 3; ex quibus in uno mense duo pregnantur; et ge[r]minantur in tercio mense paria 2 coniculorum; et sic sunt paria 5 in ipso mense . . .

Potes enim videre in hoc margine, qualiter hoc operati fuimus, scilicet quod iunximus primum numerum cum secundo, videlicet 1 cum 2; et secundum cum tercio; et tercium cum quarto; et quartum cum quinto; et sic deinceps, donec iunximus decimum cum undecimo, videlicet 144 cum 233; et habuimus suprascriptum cuniculorum summam, videlicet 377; et sic posses facere per ordinem de infinitis numeris mensibus.

11 Van Egmond, *Commercial Revolution*, 6. Sarton also notes its towering theoretical character, *Introduction*, vol. 2, pt. 2, pp. 611–12.

12 Richard Goldthwaite, "Schools and Teachers of Commercial Arithmetic in Renaissance Florence," *Journal of European Economic History*, 1 (1972), 418–33; Paul Grendler, *Schooling in Renaissance Italy: Literacy and Learning, 1300–1600* (Baltimore: Johns Hopkins University Press, 1989), 306–19; Van Egmond, *Practical Mathematics*, 5, and *Commercial Revolution*, 4–6; Swetz, *Capitalism and Arithmetic*; Raffaella Franci and Laura Toti Rigatelli, *Introduzione all' aritmetica mercantile del Medioevo e del Rinascimento* (Siena: Quattro Venti, 1982).

13 For the meaning of *abbaco*, see John Florio, *Queen Anna's New World of Words* (London: M. Braidwood for E. Blount and W. Barret, 1511), 1: "*Abbaco*, arithmeticke. Also a deske, a cabinet, or a casket. Also a court-cupboard, or counting-table. Also a chesse-boord, a paire of playing-tables, also a quadrant, or base, or square of a pillar below, which may serve to sit upon. Also a merchants booke of accounts, a shop-booke, or counter."

14 Many *abbaco* books also show a series of hand symbols for the numbers,

units and tens on the left hand, hundreds and thousands on the right, rather like the modern Chinese hand signs, still ubiquitous, or the signs used on mercantile trading floors.

15 Warren Van Egmond has plausibly associated them with the *quadrivium* portion of the university curriculum, *Practical Mathematics*, 9, and *Commercial Revolution*, 313–18.

16 Van Egmond, *Commercial Revolution*, 146.

17 Ibid., 18, 226–7, 306–7; *Practical Mathematics*, 12–13.

18 Daly Davis, *Treatises*, 12–43.

19 Van Egmond attributes this preponderance to the supposed economic supremacy of Florence, which he (along with Florentine historians ever since the Middle Ages) tends to exaggerate. His researches, though fundamental, were inevitably incomplete, and his emphasis on Florence is significantly a matter of where he chose to look. The Vatican's *abbaco* collections, notably the extensive holdings of Angelo Colocci, were unknown to him. It should also be noted that the number of *abbaco* books produced by Italian cities in general does not correlate directly with each city's relative economic importance, suggesting that Florentine social mores may have been at least as important a factor in generating *libri di abbaco* as the Florentine economy.

20 For merchant culture, see Armando Sapori, *Studi di storia economica (secoli XIII XIV XV)* (Florence: Sansoni 1953), 1:53–93, esp. 58–60; Christian Bec, *Cultura e società a Firenze nell' età della Rinascenza* (Rome: Salerno, 1981), and *Les Marchands écrivains, Affaires et humanisme à Florence, 1375–1434* (Paris–La Haye: Mouton, 1967); Federigo Melis, *L' Economia fiorentina del Rinascimento* (Prato: Monnier, 1984); Iris Origo, *The Merchant of Prato: Francesco di Marco Datini, 1335–1410* (New York: Knopf, 1957); Gino Luzzatto, *Breve Storia dell' Italia medievale* (Turin: Einaudi, 1958), 92–210. See also Van Egmond, *Commercial Revolution*, 58–67.

21 About this immense subject, see, with application to the present context, Daly Davis, *Treatises*, on the larger issue, Erwin Panofsky, *Perspective as Symbolic Form* (New York: Zone, 1991) is classic; see also Michael Baxandall, *Painting and Experience in Fifteenth-Century Italy: A Primer in the Social History of Pictorial Style* (Oxford: Oxford University Press, 1972); Martin Kemp, *The Science of Art: Optical Themes in Western Art from Brunelleschi to Seurat* (New Haven: Yale University Press, 1990).

22 Now generally attributed to Jacopo de' Barbari. The most extensive analysis of the painting is that of Daly Davis, *Treatises*, 67–81. See also Martin Kemp's catalogue description in Jay A. Levinson, ed., *Circa 1492: Art in the Age of Exploration* (Washington: National Gallery of Art / New Haven: Yale University Press, 1992), 244–6.

23 Daly Davis calls this figure a "shimmering, crystal icosahexahedron," *Trea-*

tises, 73; Kemp, catalogue description, 244, terms it a "rhombicubocta-hedron," citing his "Geometrical Bodies as Exemplary Forms in Renais-sance Space," in Irving Lavin, ed., *World Art: Themes of Unity in Diversity* (University Park: Pennylvania State University Press, 1989),1: 237–42.

24 Daly Davis, *Treatises*, 71: "in 1495 it was his only printed work."

25 Ibid., 69–70; Kemp, catalogue description, 245.

26 Daly Davis, *Treatises*, 71–2. Pacioli's *De divina proportione*, although only published in 1509, was completed in 1497 and therefore well under way at the time the portrait was painted; ibid., 73.

27 Daly Davis's description is apt: "an uninhibited pedagogue," ibid., 74.

28 Ibid., 61–7, 98–118; Van Egmond, *Practical Mathematics*, 325; Derek Ash-down Clarke, "The First Edition of Pacioli's *Summa de arithmetica* (Venice: Paganinus de Paganinis, 1494)," *Gutenberg-Jahrbuch* 1974, 90–2. The edition was reprinted in 1502 and 1509.

29 Daly Davis provides a detailed analysis of these borrowings from Piero, *Treatises*, 98–118.

30 Giorgio di Lorenzo Chiarini's *Libro che tratta di mercanzie e usanze paesi* was published in Florence by Francesco di Dino in 1481; Van Egmond, *Practical Mathematics*, 325. For Pacioli's *Summa*, see Enrico Narducci, *Intorno a due edizioni della Summa de arithmetica di Fra Luca Pacioli* (Rome 1863); Clarke, "The First Edition," 90–2.

31 Manetti used the phrase in his biography of Filippo Brunelleschi; Daly Davis cites it, *Treatises*, 16 n. 48.

32 His personal copy is not in the Vatican Library, nor has it yet been found elsewhere. For his importance to Colocci's intellectual enterprise, see later in the present chapter.

33 Papinio Cavalcanti, "Libellus de numerandi disciplina," Vat. Lat. 3896, 112r–150r. It is not clear (indeed, it is unlikely) that Colocci's copy, which is certainly from the early sixteenth century, is Cavalcanti's autograph.

34 Van Egmond, who was not aware of Cavalcanti's text, knows only a few other Latin *libri di abbaco*, one of which is that of Fibonacci; see *Commercial Revolution*, 19–20, and *Practical Mathematics*, 19.

35 Cavalcanti, "Libellus de numerandi disciplina," 149v. Sixteenth-century professional copy of a text that probably derives from the late fifteenth century. The book is dedicated to Marcello Capodiferro, of the Roman noble family. The shift between first-person singular and plural is made by Cavalcanti himself:

Dabimus Marcelle capoferre his primis eruditionibus finem qui faustus felixque habeatur. at nescio quod nunc timoris insurget ne locus huic libello apud viros doctos et eloquentes videatur. tunc maxime quom non ad huc nostri studii quarti anni teneamus et in adulescentia ista in qua sum mathematicas: quas latini disciplinarias debent tractare audeam tum vel et nonnulla propterea nobis

portata vocabula quae omnino barbara videbuntur . . . Hic me Florentiae aliquantulum vacasse et ante in ediscendis romanis litteris cupido mihi tanta incesserit: qua triennio huic disciplinae operam dedi: Exercui isto quidem tempore mercaturam biennio ultimo cum patre biennio vero primo cum paulo maximo cive meo.

36 Caius Silvanus Germanicus, "In annales Corycianos," in *Coryciana*, ed. Blosio Palladio (Rome: Lodovicus Vicentinus [Lodovico degli Arrighi] and Leutitius Perusinus, 1524), II–II iiii r:

Felix turba coit peritiorum,
Et docta serit allocutione
Sermones lepidos et elegantes.
Longa stat serie cibis onustae
Mense, dumque sitim aridam Lyaeo,
Sed victo prius Albulae liquore,
Compescunt, Cerere et famem coercent,
Se non inferiora quisque narrant.
Illinc sacra cohors chori perennis
Ad lyram numeros canit suaves,
Quos nec fulmina nec dies futuri
Absument carie vetustiores.
His ultra ingenio globos Olympi
Progressus retegit sacros libellos,
Et causas aperit quid Auctor orbis
Humana voluit tegi figura.
Alter sidereos refert recursus,
Quo vertiginis obviat rotatu
Noctis luna decus tenebricosae
Phoebeis radiis, ut igne semper
Fraterno niteat; quibus laboret
Defectu spaciis, quibusve signis
Portendat pluviam aut serenitatem,
Aut ventos per inane saevientes.
Hinc pensatur humi tenor iacentis,
Quantis oppida terminis recedant,
Quantus circuitus soli salique.
Naturae abdita funditus revellunt,
De rerum ordine disserunt vicissim
Docte, Iuppiter! et simul diserte.

Also discussed and published with a delightful prose translation by Jozef Ijsewijn, "Poetry in a Roman Garden: The *Coryciana*," in Peter Godman and Oswyn Murray, eds., *Latin Poetry and the Classical Tradition: Essays in Medieval and Renaissance Literature* (Oxford: Clarendon Press, 1990), 219–22. See also Chapter 4 of the present volume, where more of the poem is quoted.

37 See Samy Lattès, "A proposito dell' opera incompiuta 'De ponderibus et mensuris' di Angelo Colocci, in *Atti del Convegno di studi su Angelo Colocci, Jesi, 13–14 settembre 1969, Palazzo della Signoria* (Iesi: Amministrazione Comunale, 1972), 97–108; Hubertus Günther, "Die Rekonstruktion des antiken Fußmaßes in der Renaissance," Sitzungsberichte der Kunstgeschichtlichen Gesellschaft zu Berlin, n.s. 30 (December 18, 1981), 8–12. My thanks to Christof Thoenes for the latter reference.

38 Cod. Vat. Lat. 3904, c. 300r–v, 272r (a continuous text; Colocci's papers were rebound in considerable disorder):

principio in templis deorum admiratus sum qui natura essent hi lapides qui aut in aris (300v) aut pro orationes religiosi ostenduntur et primo quod unius coloris ferme omnes essent et quasi ex eodem lapide, et durities immensa et in in aliquibus adhuc insunt cathenae et unci ut facile coniectari possim id esse aut ad mensuras aut ad aliquod aliud organum excogitatum.

Videbam praeterea in sartorum officinis in domo nobilium et textricum plures id genus lapides quibus Romani artifices cilindri loco utuntur ad complanandum id quod consutum est quum unus et alter pannus assuitur sunt enim ut dixi durissimi et politi exactissimi ad unguem Videbam non solum colore conformes sed figura omnes enim absolute rotunditatis sunt nisi quantum et supra et infra de rotundo illo tantum diminutum est, quantum sit satis illi ad sedendum in utrumque partem.

Tractus ulterius ab hac ipsa admiratione selegi nonnullos qui videbantur eiusdem fere magnitudinis et appensis ad saccoma inveni pares mensura et pondere, adhibitis deinde aliis atque aliis repperi esse instrumenta ad res ponderandas.

In nonnullis erat inscriptum Q. AQVIL. in aliis L.TITIUS en ecce tibi antiquarius quispiam heu domine inquit (sciebat enim me vestigare antiquitatum et emptorem), velis emere hanc ex ere pilam? Emi libenter erat erea et superius Duae litterae inscriptae argenteae viz. A.A. statimque (272r) Coniectura percepi unius libre pondus id explere examinatisque prioribus lapidibus uncialibus et libralibus pro comperto huiusmodi id libram esse statimque illud archimedis exclamavi "Comperi comperi"

et ardentior propter id factus universam fere urbem in his lapidibus emendis exhausi, neque laboribus neque impensis parcens.

Appendi omnes qui erant in templis

Et omnes fere ad certam proportionem cum minusculis meis et cum mediocribus respondebant.

"Q. Aquil " and "L. Titus" were the names of two Roman holders of the office of *praefectus urbis*, officials charged with standardizing weights and measures; François Lenormant, *La Monnaie dans l'antiquitè* (Paris: A. Lèvy, 1879), 3: 226–9.

39 Angelo Colocci to Pier Vettori, April 17, 1543, British Library, Additional MS 10265, 271r: "Vorrei hormai riposarmi et attendere alli studii Il che dalla morte di Leone in qua non ho possuto fare." See also Vittorio Fanelli,

"Le Lettere di Mons. Angelo Colocci nel Museo Britannico di Londra," *Rinascimento*, n.s. 6 (1959), 107–35, reprinted (with revisions) in his *Ricerche su Angelo Colocci e sulla Roma cinquecentesca*, Studi e Testi, no. 283 (Vatican City: Biblioteca Apostolica Vaticana), 52, 72–3.

40 See also the classification of the relevant part of Colocci's library in the collected papers gathered as Vat. Lat. 14065, 58r: "Mensura pondera numeri / Forziero bianco da doi chiave all' armario de' panni." My thanks to Rossella Bianchi for drawing my attention to this manuscript.

41 Vat. Lat. 3904, 234r: "Celum ergo et elementa e quanta illis sunt mensuram num[erum] et pondus habent. de quibus nos quandam quasi formula ut Romanis meis prodesse passim nonnulla persequamur."

42 Modern mathematicians often still feel the same way, just as musicians assign personalities to keys and notes. See, e.g., Robert Kanigel, *The Man who knew Infinity: The Life of the Genius Ramanujan* (New York: Scribner, 1991); Alfred Brendel, "Schubert's Last Sonatas," in his *Music Sounded Out* (London: Robson, 1990), 72–141.

43 For the *oeuvre* of Gerardus of Cremona, see Baldassare Boncompagni, "Della vita e delle opere di Gerardo Cremonese," *Atti dell' Accademia Pontificia de' Nuovi Lincei* 4 (1850–1), 412–35; Sarton, *Introduction*, vol. 2, pt. 1, 338–44.

44 For example, Vat. Lat. 3123, a miscellany, mostly of abacus works, owned by Colocci, gives three different lists for the numbers, from an anonymous treatise "De Abaco," 35r–v (Igin, Andras, Boemis, Arbas, Quimas, Cabas, Zenis, Zenenias, Celentis); "Turchillus computista computum ad Simonem de Rotulis," 55v (Igin, Andras, Hormis, Arbas, Quimas, Caletis, Zenis, Temenias, Celentis); and an excerpt "De ratione abaci" attributed to Boethius (Igin, Andras, Oropus, Arbas, Quimas, Caltius, Zenius, Zemenias, Scelentis). "Turchillus computista" asserts that the figures of the numbers come from the Pythagoreans and the names from the Arabs, citing a "Dominus Gualterius Reverendus" as his authority (55v: "Has autem figuras ut dominus Gualt. Rx. testatur a pytagoriis habemus nomina vero ab arabibus").

45 Vat. Lat. 3896, 92r: "Gerardus, versus de integris." Hand of Angelo Colocci.

Ordine primigeno sibi nomen possidet Igin
Andras ecce locum mox vendicat ipse secundum
Ormis post numeros incompositus sibi primus
Denique bis binos succedens indicat Arbas.
Significat quinque facto de nomine Quimas
Sexta tenet Calcus perfecto munere gaudens
At Zemis digne septeno fulget honore
Ordo beatificos Themenias exprimit unus

Hinc sequitur sipos equi rota nempe vocatus
Terque notat trinum celentis nomine Rhithmum

6 *Sexta* scripsit Colotius: *Exa* Cod. *Eya sex* Colotius
7 *Zemis*: *Zenis*
8 *Ordo*: *Octo*
9 *Sipos equi*: *Sipos est*

The origin of these names for the numbers is unknown.

46 Through his researches into *abbaco*, Van Egmond, by training a historian of mathematics, hoped to demonstrate that this transition was more seamless than it turned out to be; he originally had aimed to show specifically that *abbaco* itself contained the roots of sophisticated mathematical thinking. His disappointment is evident from his failure to pursue that research beyond his splendid dis. ("the Commercial Revolution") and the catalogue that derived from it (*Practical Mathematics*).

47 Frances Yates, *The Art of Memory* (London: Routledge and Kegan Paul, 1966), chap. 17, "The Art of Memory and the Growth of Scientific Method." See also Brian Copenhaver, "Lefèvre d' Étaples, Symphorien Champier, and the Secret Names of God," *Journal of the Warburg and Courtauld Institutes* 40 (1987), 189–211.

48 Marco Fabio Calvo, "De numeris," Vat. Lat. 3896. For the manuscript draft of the Hippocrates, see Nancy G. Siriasi, "Life Sciences and Medicine in the Renaissance World," in Anthony E. Grafton, ed., *Rome Reborn: The Vatican Library and Renaissance Culture* (New Haven: Yale University Press, 1993), 183. See also Philip Jacks, "The *Simulachrum* of Fabio Calvo: A View of Roman Architecture *all' antica* in 1527," *Art Bulletin* 72 (1990), 453–81. Some of Jacks' information must be modified in light of more recent work; see Chapter 7 of the present volume.

49 Angelo Colocci, Notes on measure, Vat. Lat. 3906, 230r.

50 Colocci refers to this projected work in a note, ibid., 306r, where in notes to himself he mentions that he plans to insert a paragraph on the invention of music into both treatises: "ego in principio libri de ponderibus ponderum virtute inserendum haec omnia. ego in de opifice mundi dic sub verbo." (Myself. In the beginning of the book on weights all these things should be inserted under the properties of weights. Myself. In "De opifice mundi" say it under the heading ["Music"].)

51 Vat. Lat. 3904, 175r: "in mensura et harmonia versare ingenia Iamb[lichus dixit;] ad sciendam et contemplandum esse naturam. ego divini opificii spectator non solum esse sed contemplator."

52 See Thomas Kuhn, *The Copernican Revolution: Planetary Astronomy in the Development of Western Thought* (Cambridge, MA: Harvard University Press, 1957); Robert Westman, ed., *The Copernican Achievement* (Berkeley and Los Angeles: University of California Press, 1975); David C. Lindberg

and Robert Westman, eds., *Reappraisals of the Scientific Revolution* (Cambridge: Cambridge University Press, 1990); Jean Dietz Moss, *Novelties in the Heavens: Rhetoric and Science in the Copernican Controversy* (Chicago: University of Chicago Press, 1993).

53 Nicolaus Copernicus, *De revolutionibus*, cited by Kuhn, *The Copernican Revolution*, 131, and J. D. Bernal, *Science in History*, vol. 2: *The Scientific and Industrial Revolutions* (Cambridge, MA: MIT [1971] 1985), 48.

54 Vat. Lat. 3904, 161v: "ego de mundo . . . *Pythagoras* primus universorum complexionem *Mundum* vocavit, ob eam nimirum, quae in eo visitur elegantiam rerum *digestionem Thales* et Thaletis studiosi *Mundum unum* esse consue<ue>runt. Democritus Epicurus Metrodorum eorum discipulas Innumerabiles *in infinito mundos* per omnem eius complexum In immensum expatiantum. *Empedocles* circinationem solis circumscriptionem esse mundi hocque eius circumferens lineamentum. *Seleucus* infinibilem Mundum. *Diogenes* universum infinibile Mundum vero finitum. Stoici omne quicquid est ab universo differre. *Omne* enim esse infinitum cum Inani Universum autem abque inani. *Mundum* proinde unum et idem esse universum ac Mundum." (Emphasis in original.)

55 See Linda M. Napolitano Valditara, *Le Idee, i numeri, l' ordine: La dottrina della mathesis universalis dall' Accademia antica al neoplatonismo* (Padua: Bibliopolis, 1988).

56 In translating Philo's works, Lilio produced six volumes in all; Vat. Lat. 180–5.

57 Vat. Lat. 3903, 68r, emphasis in original:

> Philon Deus
> intelligibilis atque incorporeus
> omnibus numeris absolutus

ego ex philone Quodsi partes eius sunt corporeae et corpus *mensurabile est vel sub mensura cadit* tum mundum praecipue quod corpus omnium corporum maximum est quippe quod aliorum corporum congeriem in sinu suo tamquam proprias praeter gerit. generatio ab ipso igitur incipiendum esse divinus ad quem mensurandum devieniemus si a minoris mundi mensura progrediamur. Quos qui in greccia (sic) philos[ophi] sunt ducunt sic. . . . Hos utpote christiani dicimus et . . . Philon 129.

The reference in the first line is to Philo of Alexandria, *De Genesi*, paraphrased.

58 Augustine, *Dialogus Orosianus*, cited in Vat. Lat. 3904, 236r.

59 Ibid., 134r: "ego. Celum ergo et elementa et quae in illis sunt mensuram Numerum et pondus habent. de quibus nos quandam quasi formula ut Romanis meis prodesse passim nonnulla persequantur."

60 Vat. Lat. 3906, 112r, and cf., 42v: "Dic omnia esse finita et mensurabi-

lia, excepto mundi opifice omnia enim aut mensura aut animo finiuntur deo excepto. Deus enim immensus. Sed secundum Stoicos metiri debemur deum ex operum eius admiratione ergo sic incipiendum a mensura orbis et aliis quae in eo sunt et per ea cognoscemus quam immensus sit deus."

61 Vat. Lat. 3903, 48v: "Ego sine pondere celum vacuum diis"; 36r: "Somnia pondus habent et habent quoque signa futuri."

62 See Chapter 6 of the present volume.

63 Egidio Colonna, bishop of Bourges (Giles of Rome), *Egidius Romanus De esse et essentia. De mensura angelorum. et de congnitione angelorum* (Venice: Simon de Luere for Andrea Torresani de Asola, 1503).

64 Raffaele Maffei, *Commentaria Urbana* (Rome: Eucharius Silber, 1506); Luca Pacioli, *Summa de arithmetica* (Venice: Paganino de Paganinis, 1494); Hartmann Schedel, *Liber chronicarum* (Nuremberg: Anton Koberger, 1493).

65 Gregor Reisch, *Margarita philosophica* (Freiburg: Johannes Schottus, 1503).

66 Guillaume Budé, *De asse et eius partibus* (Paris: Iodocus Badius Ascensianus, 1514; also Venice: Aldus Manutius, 1522).

67 Vat. Lat. 3906, 88r: "tu dic [Christus] [nobis] brachia extendisse ut maiorem mensuram efficeret pansis manibus."

68 Vat. Lat. 3904, 300r: "ego has XX furia ope conatus sum in communes utilibus aliquid cudere quod tempus magis in veritate principiorum conscripsi quam in huius voluminis compositione." Vat. Lat. 3906, 104r: "Duo viri doctissimi post me scripsere ut Romanis italis fere omnibus notum est sed horum uterque ante me sua volumina edidit L. Portius prior post Budaeus."

69 Vat. Lat. 3904, 273r: "Florentini et Veneti brachium Romani cannam flandrie elem quae quidem principia in minores mensuras distinctas facile metiuntur."

70 Vat. Lat. 3904, 272v: "Adde quod in monumentis meis in hortulo ad virginis aqueduct[um] erat Agathangeli architecti cupa et in saxo a latere sinistro instrumenta architectonica erant insculpta erat etiam ibi podismi mensura statimque facta copia famulis meis misi ad lateranum columellam et sic in variis."

71 Ibid.:"Et quare bonavum rerum deus occurrit cum gratiabondis haec Jocundo monacho Veronensi mihi per que familiari enarrans statim monuit me ad forum Judeorum in fronte tonsoriae vilissimae esse lapidem quem par certe putabat esse. Ast ego diei citius lapidem magno pretio emi et similem instrumento Agathangeli esse comperi Iterumque archimedium illud exclamavi ευρικα ευρικα." Colocci's misspelling of εὕρηκα shows that he had learned the Byzantine pronunciation of ancient Greek.

72 Flyleaf to Collected papers of Angelo Colocci, Vat. Lat. 4539, IIv: "ecce mihi lapis supra hostium tostrinae harenula in minore campo occurrit in

quibus erat non solum responsus omnium commensuum praedictorum sed deformati palmi digiti semidigiti rotundi quadrati. Tunc clara voce iuxta illus archimedis exclamavi currens ευρικα ευρικα"

73 Giangiacomo Martines, " 'Gromatici veteres' tra antichità e medioevo," *B.S.A. Ricerche di Storia dell' Arte* 3 (1976), 3–23, and "Hygino Gromatico: Fonti antiche per la ricostruzione rinascimentale della città vitruviana," *B.S.A. Ricerche di Storia dell' Arte* 1–2 (1976), 277–84, and "La Scienza dei Gromatici: Un Esercizio di geografia astronomica nel *Corpus agrimensorum*," in Rolando Bussi and Vittorio Vandelli, eds., *Misurare la terra*, vol. 1: *Centuriazione e coloni nel mondo romano, città, agricoltura, commercio: materiali da Roma e dal suburbio* (Modena: Panini, 1984); Pier Nicola Pagliara, "La Roma Antica di Fabio Calvo. Note sulla cultura antiquaria e architettonica," *Psicon* 8–9 (1977), 65–87; James N. Carder, *Art Historical Problems of a Roman Land Surveying Manuscript: The Codex Arcerianus A, Wolfenbüttel* (New York: Garland, 1978); Carl Thulin, "Humanistische Handschriften des *Corpus Agrimensorum romanorum*," *Rheinisches Museum für Philologie*, n.s. 66 (1911), 417–51, esp. 419–22; F. Blume, K. Lachmann, and A. Rudorff, *Schriften der römischen Feldmesser* (Berlin: Reiner, 1848–52); O. A. W. Dilke, *The Roman Surveyors: An Introduction to the "Agrimensores"* (Newton Abbot, UK: David and Charles, 1971), 130. Only the first volume of a projected edition of the *Corpus agrimensorum* has ever been published, edited by Carl Thulin (Leipzig: Teubner, 1913).

74 After a seventeenth-century owner, Iohannes Arcerius, it is now known as the Codex Arcerianus.

75 According to Raffaele Maffei, *Commentaria Urbana*, 56r, 357v, 431v. For steps involved in making this point, see Carder, *Problems*, 18–20. Whether Colocci owned the book, or simply "borrowed" it from the Vatican Library is not clear; usually his own books can be identified by his copious marginalia, but in the case of an old volume he tended to be more sparing.

76 *Pace* Michael Reeve's tantalizing proposal, in L. D. Reynolds, ed., *Texts and Transmission: A Survey of the Latin Authors* (Oxford: Clarendon Press, 1983), s.v. *Agrimensores*, 6, it is likely that the Arcerianus itself was the "codex antiquissimus" to which Colocci refers (Vat. Lat. 3894, [A]r: "codice meo antiquissimo"), rather than "a manuscript quite as venerable as BA, P, and F" to be included among the many books he lost in the Sack of Rome. The Arcerianus is now in the Herzog–August-Bibliothek in Wolfenbüttel; Martines, "Gromatici veteres," 7.

77 For a detailed analysis, see Carder, *Problems*, 221, who summarizes his findings as follows: "the scientific surveying Corpus underwent a pictorialization process which is also evident in other Late Antique and Early Christian illustrated manuscripts. The artistic embellishments added to the surveying Corpus, which include architectural, landscape, and occasionally

figural elements, suggest a date for the first formulation of the Corpus in the second half of the 4th century . . . Significantly, the first redaction of the *Corpus agrimensorum* seems to coincide with the first widespread acceptance of the codex format for the written word and with the probable establishment of artistically-oriented scriptoria to produce the polychromatic illustrations which this book format allowed."

78 Copies of the *Corpus agrimensorum* from Angelo Colocci's library are found in Vat. Lat. 5394, rubricated by Colocci, Vat. Lat. 3893, and Vat. Lat. 3894. The finest copy from Colocci's collection now in the Vatican Library is Vat. Lat. 3132.

79 Vat. Lat. 5394.

80 See the *Oxford Latin Dictionary*, s.v. *podismus*.

81 Vat. Lat. 3906, 92r:

Cum Romae essemus in hortis meis Sallustianis, et Adhibitis ad Cenam/Incidimus in sermone de mundi hiuius partitione, et qua ratione maiores nostri orbem diviserunt et in milliaria et stadia metiti sunt. Hic F. universis nobis scripulum iniecit. Quis nam ordo esset stadiorum quo tam graeci quam latini usi sunt et longitudinem dimensi et omnes affermare stadum constare legitime ex millibus passuum passus autem ex [vacatl] pedibus tamen omnes addubitabant ut quod non esset pedis mensura et quot digitis et quot cubitis palmis

A citation from Pontano immediately afterward points to the influence of that early mentor on the breadth of Colocci's adult interests.

"Order" here might be compared to our "order of magnitude"; a one-word translation is "scale."

82 Hyginus Gromaticus, *Constitutio limitum*, in Thulin, *Corpus agrimensorum romanorum*, 131: "Inter omnes mensurarum ritus sive actus eminentissima traditur limitum constitutio. est enim illi origo caelestis et perpetua continuatio cum quadam latitudine[m] recturae dividentibus ratio tractabilis, formarum pulcher habitus, isporum etiam agrorum speciosa desginatio. constituti enim limites non sine mundi ratione, quanam decumani secundum solis decursum diriguntur, kardines a poli axe."

83 Agennius Urbicus, *De controversiis agrorum*, in Thulin, *Corpus agrimensorum romanorum*, 22 (B 88–9):

Quom autem quaerendum videatur, quid sit ager et ubi sit, ad ordinem mundi partesque revocamur. mundus autem, uti[n] Stoici decer<n>unt, unus esse intelligitur: sed qualis quantus, geometricis spectaminibus aperitur. eo enim elementorum natura terrae aequilibratur huius terrae pars diei fulget, pars nocte fuscatur. dividitur, ut supra diximus, in quattuor partes . . . (B 91) ex his argumentaliter inclinamentorum condicio cognoscetur intra quae ager imperii Romani spatioso fine diffunditur.

Thulin, 22n., believes that this entire passage was probably borrowed from a lost agrimensorial work of Frontinus.

84 Colocci's anonymous biographer in the *Dizionario biografico degli Italiani*, 108, tentatively questions his authorship: "non pare ne sia stato l' autore," but see "De elementorum situ," Vat. Lat. 3353, 265r, 295r; Vat. Lat. 14065, 58r, where the work is called "climata mea."

85 "De elementorum situ," Vat. Lat. 3353, 268r–289r, with notes on 289v. Other notes for this section of the treatise are probably those drawn from Ptolemy and preserved in Vat. Lat. 3353, 290r–297r, with notes on 297r–298r. See also "De mensura orbis terrae," an anonymous treatise preserved in Vat. Lat. 3353, 349r–370r. Pietro and Bernardo Bembo share this view of the composition of the world in the former's dialogue *De Aetna* (Venice: Aldus Manutius, 1494).

86 Raffaello Brenzoni, *Fra Giovanni Giocondo Veronese, Verona 1435–Roma 1515* (Florence: Olschki, 1960); Vincenzo Fontana, *Fra' Giovanni Giocondo, architetto, 1433–c. 1515* (Vicenza: Neri Pozza, 1988).

87 My thanks to Michael Koortbojian for this information on Giocondo and his relationship with Budé and Colocci.

88 Vat. Lat. 3904, 273v: "Et quia magnus labor impendibatur a vitruvio in colu[m]narum proportionibus cepi columnas examinare." For a discussion of this passage, see Chapter 7 of the present volume.

89 Copy of Vitruvius, *De architectura libri decem*, ed. Fra Giovanni Giocondo. (Venice: Giovanni Tridino, 1511), with autograph annotations by Angelo Colocci. BAV, Stampati R.I.III.298.

90 Autograph tabulations form part of the collected notes in Vat. Lat. 3903, 3904, 3906. Vat. Lat. 4059 is a complete tabulation, bound as a separate volume and written in a professional scribe's hand. In every case, the tabulations refer to Giocondo's 1511 edition, and more specifically to Colocci's copy, BAV, Stampati R.I.III.298.

91 Vitruvius, *De architectura libri decem*, IX.1.2.

92 Ibid., III.1. "Sequences": the original term is *ordines*. For its meaning, see Chapter 7 of the present volume and Ingrid D. Rowland, "Raphael, Angelo Colocci, and the Genesis of the Architectural Orders," *Art Bulletin* 76 (1994), 81–104.

CHAPTER SIX. SWEATING TOWARD PARNASSUS (1503–1513)

1 See Ingrid D. Rowland, "A Summer Outing in 1510: Religion and Economics in the Papal War with Ferrara," *Viator* 18 (1987), 347–59.

2 Luigi Frati, *Le Due Spedizioni militari di Giulio II, tratte dal diario di Paride Grassi Bolognese* (Bologna: Tipografia Regia, 1886).

3 Chigi G.II.37, 26v.

4 The proceeds from Tolfa alum were destined, from the mines' discovery

in 1460, for a war chest to finance Crusade, but Chigi and Julius II were the first to dare apply the idea to excommunication; see Felix Gilbert, *The Pope, His Banker, and Venice* (Cambridge, MA: Harvard University Press, 1980), 59, 82–3, 105–9; further documentation of the practice in ASR, Ospedale di S. Rocco, Busta 110, 47r; Chigi R.V.c, 40r.

5 I. D. Rowland, *The Correspondence of Agostino Chigi: An Annotated Edition* (Vatican City: Biblioteca Apostolica Vaticana, in press), 131–5; Gilbert, *The Pope*, 78–85; Vittorio Franchini, "Note sull' attività finanziaria di Agostino Chigi nel Cinquecento," in *Studi in onore di Gino Luzzatto* (Milan: Giuffré, 1950), 156–65; Ottorino Montenovesi, "Agostino Chigi, banchiere e appaltatore dell' allume di Tolfa," *Archivio della Reale Società Romana di Storia Patria* 60 (1937), 111–40.

6 Gilbert, *The Pope*, esp. 88–91; Rowland, *The Correspondence of Agostino Chigi*, 57–151.

7 Though Riario also fled Rome for a brief period in 1499, after Cesare Borgia's slaying of Girolamo Riario and the subsequent capture of Imola (despite Caterina Sforza's remarkable efforts to keep Borgia at bay), he had returned by 1500.

8 See John W. O' Malley, *Praise and Blame in Renaissance Rome: Rhetoric, Doctrine, and Reform in the Sacred Orators of the Papal Court, c. 1450–1521* (Durham, NC: Duke University Press, 1979); John M. McManamon, *Funeral Oratory and the Cultural Ideals of Humanism* (Chapel Hill: University of North Carolina Press, 1989).

9 See Iris Origo, *The World of San Bernardino* (New York: Harcourt, Brace, and World, 1962).

10 Angelo Poliziano to Tristano Calchi, April 1489, cited and translated by Francis X. Martin, *Friar, Reformer, and Renaissance Scholar: Life and Work of Giles of Viterbo, 1469–1532* (Villanova, PA: Augustinian Press, 1992), 39. See also Sigismondo Ticci, Chigi G.II.36, 57v.

11 Paolo Cortesi, *De Tres libri Cardinalatu ad Julium Secundum Pont[ificeum] Max[imum] per Paulum Cortesium Protonotarium Apostolicum* (Castel Cortesi: Symeon Nardi, 1510), 134r: "Nec item minus illa genera reprehendi solent quibus inest fucatus sine dignitate candor: qualis nobis pueris Mariani Ghinazzanensis est locutio quotidiana visa: quae ita nimii artificii diligentia nimioque calamistrorum usu compta ferrent, ut et rei auctoritatem adimeret et sermonis expositioni fidem."

12 See Martin, *Friar*, 37–59.

13 See Sigismondo Ticci, "demulcebat aures," Chigi G.II.37, 163v; "Predicatio Egidii delectabilis," Chigi G.II.37, 163v; "etsi longum, luculentum tamen," Chigi G.II.36, 370v. It must be admitted that in a later marginalum Ticci repents of this last judgment, appending, "Verum ita longum ut universum populum tedio afficeret atque fastidio" (In fact, it was so long

that it affected the entire audience with boredom and disgust). His opinion of Egidio declined still farther as he grew older. Cortesi, *De cardinalatu*, S2r cites Egidio, along with Mariano da Genazzano, as the foremost Augustinian preachers of the day.

14 See his oration for the Fifth Lateran Council, in *Acta Concilii Lateranensis V*, ed. Jacopo Mazzocchi (Rome: Jacopo Mazzocchi, 1521), A iii v: "Nam cum annis ab hinc circiter viginti: quantum in me fuit: et per exiguae vires tulere: Evangelia populis interpretatus sim."

15 Jacopo Sadoleto to Pietro Bembo, in *Acta Concilii*, Aii v (the introduction of the transcript of Egidio's opening address): "Nec vero quicquid interfuit illo dicente inter doctos homines: et idiotas: non senex ab adolescente, vir a muliere: princeps ab infimo homine potuit dignosci: sed omnes pariter vidimus praecipites ferri impetu animos audientium: quocumque eos oratori impellere libuisset: tanta vis orationis: tantum flumen lectissimorum verborum: pondus optimarum sententiarum ex eo ferebatur."

16 Cortesi, *De cardinalatu*, 103r: "Quid item modo de Egidio Viterbense dicam? qui unus inter multos videri potest ad Italorum ingenia flectenda et mitiganda natus, cuius sermo ita litteratioris elegantiae sale conditur? ut in summa verborum concinnitate omnis adsit sententiarum succus, ac ita suaviter et numerose fluit, ut in vocis varietate et flexu plectri similes exaudiantur soni?" See also, e.g., a letter of Crisostomo Colonna to Egidio of October 1, 1500: "incredibili . . . voluptate perfundebatur animus meus, cum te vel sacras habentem conciones vel intra privatos parietes aut disserentem aliquid familiariter aut confabulantem audire licebat"; Egidio da Viterbo, *Lettere familiari*, ed. Anna Maria Voci Roth, no. 18 *Fontes Historiae Ordinis Sancti Augustini* (Rome: Institutum Historicum Augustinianum, 1990), 1:107.

17 Sadoleto, in *Acta Concilii* A ii v: "Ergo illa [eloquentia] in sacris concionibus divina semper, et ad miracula flectere arbitrio suo hominum mentes: refrenare incitatas: languentis accendere: vel inflammare potius ad Virtutis: Iustitiae: Temperantiae studium: summi Dei veneratione: sanctae religionis observantiam [videtur]."

18 For a history of the composition of the *Sententiae*, see Daniela Gionta, " 'Augustinus Dux meus': La Teologia Poetica 'Ad mentem Platonis' di Egidio da Viterbo OSA," in *Atti del Congresso Internazionale su S. Agostino nel XVI centenario della conversione, Roma, 15–20 settembre 1986*, Studia Ephemerdis "Augustinianum," nos. 24–6 (Rome: Institutum Patristicum "Augustinianum," 1987), 3:187–201.

19 Vat. Lat. 6325, 57v: "[Angelorum] praestantiam docuit [Augustinus], quorum opem posuit mortalibus necessarium ad Deum cognoscendum, vel amandum, Qua propter in Critia Plato Deos statuit terrarum orbem sortitos, atque optimos esse mortalium curatores: Quae res adduxit et Hom-

erum, ut Ulixi Minervam, et Maronem Aeneae Venerem praeficeret Ducem, quarum opera, studioque, factum est, ut illi et discrimina evaderent, et summam sibi gloriam compararent."

For John Duns Scotus, the angels and the human soul have the same nature but differ in *officium* and *species*. Egidio diverges from all his predecessors in the extent to which he embodies *imago* in dramatic personifications.

20 Egidio was not entirely original here; both Augustine and Peter Lombard also connected *vestigium* to measure, number, and weight.

21 Vat. Lat. 6325, 25r: "Nam cum mundi huius pulcritudo, atque ordo videtur, statim occurrit esse totius, vel mundi, vel certe ordinis auctorem, qui parens rerum sit, aut rector, administratorque naturae." Here, as often, Egidio's own position as "rector, administratorque" of the Augustinian order seems implicit in his choice of words to describe God.

22 See Martin, *Friar*, 162–9, esp. 175.

23 Ibid., 163–4, John O'Malley, *Giles of Viterbo on Church and Reform: A Study in Renaissance Thought* (Leiden: Brill, 1968), 84–9; François Secret, *Les Kabbalistes chrétiens de la Renaissance* (Paris: Dunod, 1964), esp. 106–26.

24 This number is supplied by Martin, *Friar*, 93; see 61–118 for Egidio's appointment and reform efforts. David Gutierrez, *Historia de la Orden de San Agustín*, vol.1, pt. 2: *Los Agustinos en la edad media, 1357–1517* (Rome: Institutum Historicum Ordinis Fratrum Sancti Augustini, 1977), estimates the number of Augustinians in 1517 as eight thousand; 109.

25 So Sigismondo Ticci, Chigi G.II.37, 95r; see Ingrid D. Rowland, "Egidio da Viterbo's Defense of Julius II, 1509 and 1511," in Thomas L. Amos, Eugene A. Green, and Beverly Mayne Kienzle, eds., *De Ore Domini: Preacher and Word in the Middle Ages,* Studies in Medieval Culture, no. 27 (Kalamazoo: Western Michigan University, 1989), 238. A subsequent sermon on a similar topic is detailed in Florence, Biblioteca Medicea-Laurenziana, Ashburnham 287, 22v. Written without knowledge of that manuscript, my "Summer Outing in 1510" erroneously states that Egidio remained out of Rome for the entire summer.

26 See Rowland, "Egidio da Viterbo's Defense," 241–60, and "Abacus and Humanism," *Renaissance Quarterly*, 48 (1995), 695–727; Ticci, G.II.37: 163v: "propositis autem arithmeticae termini[bu]s quibusdam, tum circularis lineae quam referebat in deum: brevi se expedivit praedicatione populum vero alliciens die postera nunciaturum se magis ad senenses pertinentia est pollicitus."

27 Christine Shaw, *Julius II: The Warrior Pope* (Oxford: Blackwell, 1993), 157.

28 Egidio delivered the sermon with figs in Siena in April 1508, with Sigismondo Ticci in the audience; Chigi G.II.37, 37r.

29 See O'Malley, *Giles of Viterbo*, 30–2, 123–5, and "Fulfillment of the

Golden Age under Julius II: Text of a Discourse of Giles of Viterbo, 1507," *Traditio* 25 (1969), 272. Egidio's Etruscological theories are prominent in his *"Sententiae" ad mentem Platonis* (Vat. Lat. 6325) and *Historia XX Saeculorum* (Rome, Biblioteca Angelica, MS 351).

30 The acclamation "Salve, o Iani sedes, nunc vere Ianiculum!" is quoted in John W. O'Malley, "Man's Dignity, God's Love, and the Destiny of Rome: A Text of Giles of Viterbo," *Viator* 3 (1972), 413.

31 For Annius's philological method, see Anthony Grafton, *Forgers and Critics: Creativity and Duplicity in Western Scholarship* (Princeton: Princeton University Press, 1990); Walter E. Stephens, "Berosus Chaldaeus: Counterfeit and Fictive Editors of the Early Sixteenth Century," Ph.D. diss., Cornell University, 1979.

32 Valdimir Zabughin, *Giulio Pomponio Leto, Saggio critico* (Rome: Vita Letteraria, 1909), vol. 2, is entirely concerned with Leto's method.

33 O'Malley, "Golden Age," 285–6 (my translation changes some passive periphrastics to active constructions):

Sed ante [Saturni adventum] Ianum in altera Tyberis parte aureis legibus Hetruriae imperasse aiunt, cuius quidem instituta alias latius disserere licebit . . . Quid enim divina factum providentia est ut una cum Iano navis imago aere celaretur, nisi quod Hetrusca Iani sedes, quam ipse obtines, foelicibus institutis assueta, foelicibus Christianae naviculae legibus dedicanda erat, eratque sanctissemas Christi leges foelicis regis navibus usque ad extremum terrae comportatura.

34 Julius's attention was all the more extraordinary because Egidio was so notoriously long-winded. See O'Malley, "Fulfillment," 269.

35 This was the assessment of his friend Paolo Cortesi, *De cardinalatu*, 221r. For Fedro, see Anna Maria Rugiadi, *Tommaso Fedra Inghirami umanista volterrano* (Amatrice: Tipografia Orfanotrofio Maschile, 1933); Fabrizio Cruciani, "Il Teatro dei Ciceroniani: Tommaso 'Fedra' Inghirami," *Forum Italicum* 14 (1980), 356–77; and *Teatro nel Rinascimento*, 219–27; Aulo Greco, "Roma e la commedia del Rinascimento," *Studi Romani* 22 (1974), 25–35; Luca d' Ascia, *Erasmo e l'umanesimo romano* (Florence: Olschki, 1991), 188–196; Deoclecio Redig de Campos, "L' Ex-Voto del Inghirami al Laterano," *Rendiconti della Pontificia Accademia Romana di Archeologia* 29 (1956–7), 171–9.

36 Andrea Fulvio, *Antiquaria Urbis* (Rome: Mazzocchi, 1513), E ii 2v: "magni vinea Phedri."

37 For Inghirami's offices, see W. von Hofmann, *Forschungen zur Geschichte der kurialen Behörden von Schisma bis zur Reformation*. Bibliothek des Königlichen-Preussischen Historischen Instituts in Rom, nos. 12–13 (Rome: Van Loescher, 1914), 183. The portrait exists in two copies, one from the Inghirami family that is now in the Isabella Stewart Gardner Museum,

Boston, and one from the Medici collection, now in the Galleria Palatina of the Pitti Palace in Florence. Opinions as to which is the "original" differ.

38 See Redig de Campos, "L' Ex-Voto," 171–9, and Fabrizio Mancinelli, "I Personaggi del mondo culturale nell' ambito della Curia papale," in Mancinelli, ed., *Raffaello in Vaticano, Città del Vaticano, Braccio di Carlo Magno, 16 ottobre 1984–16 gennaio 1985* (Milan: Electa, 1984), 56.

39 This point is made in Mancinelli, "I Personaggi," 56.

40 The oration is preserved in Paris, Bibliothèque Nationale, MS 7352B. See also Luca d'Ascia, "Una 'Laudatio Ciceronis' inedita di Tommaso 'Fedra' Inghirami," *Rivista di Letteratura Italiana* 5 (1987), 479–501; Lucia Gualdo Rosa, "Ciceroniano o cristiano? A proposito dell' orazione 'De morte Christi' di Tommaso Fedra Inghirami," *Humanistica Lovaniensia* 34 (1985), 52–64; O'Malley, *Praise and Blame*, 67.

41 Cited in Gualdo Rosa, "Ciceroniano," 58: "Dirum facinus, et post homines natos ne apud penitissimos quidem barbaros extra omnem humanitatem positos auditum . . . ad te defero, Pater Beatissime."

42 Ibid., 61: "En dispessas habet manus ut te excipiat; en caput deflexit, ut osculum porrigat . . . Plura ne dicam lacryme me impediunt." See also O'Malley, *Praise and Blame*, 67.

43 Vat. Lat. 7928, 11r–17v; see also Tommaso Fedro Inghirami, *Thomae Phaedri Inghirami Volaterrani in laudem Ferdinandi Hispaniarum Regis Catholici ob Bugiae in Africa captum oratio,* ed. Pier Luigi Galletti (Rome: A. Fulgoni, 1773). Bougea was the city where Fibonacci claimed to have learned the "nine figures of the Indians"; see Chapter 5 of the present volume.

44 From Vat. Lat. 7928, 46v we learn that Fedro's allotted time for the funeral oration of Julius II was half an hour. The oration in praise of Ferdinand comes from the same manuscript.

45 The following citation is taken from the Vatican Library's miscellany of contemporary pamphlets issued during Lateran V, Stampati R.I.IV.2107. The pamphlet with Egidio's oration was published as "Romae . . . apud Sanctum Eustachium per Ioannem Beplin Alemanum [de Argentina]," with Jacopo Sadoleto's prefatory letter to Pietro Bembo, A 2 v: "calor ille, et vis in dicendo oratoria spiritusque ζωσηs, ut aiunt φωνηs: quo tantum potuit Egidius, ut omnium adstantium animos primum suavissime demulserit, deinde ad extremum vehementissime commoverit."

46 Janus Parrhasius, letters, Vat. Lat. 5233, 162v–163r: "Silet (heu) T. Phaedrae vox illa tua iucunde sonora: Illa argutae linguae suadela: quae mentes hominum in omnes affectus impellebat. Quae romanam facundiam a Goticis usque temporibus amissam restituit. Ubi nunc est ille gestus cum sententiis congruens? Ubi illa incorrupta latini sermonis integritas?"

47 The position was awarded for life, and despite the fact that Inghirami's

predecessor, Giuliano Maffei, was doing little work by the end of his ten-
ure, he nonetheless retained the right to his office. His death in 1510 finally
opened the position to Fedro.

48 Redig de Campos, "L' Ex-Voto del Inghirami," 175–6, noting that In-
ghirami's connection with the library dates at least from 1505.

49 See Chapter 7 of the present volume.

50 See the records in Vat. Lat. 3966, and Maria Bertòla, *I Due Primi Registri
di prestito della Biblioteca Apostolica Vaticana, Codices Vaticani Latini 3964,
3966* (Vatican City: Biblioteca Apostolica Vaticana, 1942).

51 Tommaso Fedro Inghirami, *Thomae Phaedri Inghirami Volaterrani orationes
duae altera in funere Galeotti Franciotti Card. Vicecancellarii altera item funeris
Pro Julio II Pont[ifice] Max[imo]*, ed. Pier Luigi Galletti (Rome: Generoso
Salomone, 1777), 96: "Bone Deus! quod illius ingenium fuit, quae pru-
dentia, quae regendi, administrandique imprii peritia? quod excelsi, in-
fractique animi robur? nulla illi quies, nullus somnus, nulla aletitia fuit,
quousque contumaciam omnium repressisset, parendi voluntatem ad ob-
sequium revocasset, tyrannides exintinxisset, civiles dissensiones, intesti-
naque odia, non armis, sed consilio, atque auctoritate sua abolevisset."

52 The translation of the bull *Ad decorem* of 1475 is by Leonard Boyle, "The
Vatican Library," in Anthony E. Grafton, ed., *Rome Reborn: The Vatican
Library and Renaissance Culture* (New Haven: Yale University Press, 1993),
xiii ("Ad decorem militantis ecclesiae, fidei catholice augmentum, erudi-
torum quoque ac litterarum studiis insistentium virorum commodum et
honorem").

53 For *prisca theologia* in general, see Frances A. Yates, *Giordano Bruno and the
Hermetic Tradition* (Chicago: University of Chicago Press, 1964); Anthony
Grafton, "The Ancient City Restored: Archaeology, Ecclesiastical History,
and Egyptology," in Grafton, *Rome Reborn*, 87–124. For Etruscan studies
in particular, see O'Malley, *Giles of Viterbo,* 31; W. Stephens, Jr., "The
Etruscans and the Ancient Theology in Annius of Viterbo," in P. Brezzi,
ed., *Umanesimo a Roma*, 309–22.

54 Bertòla, *I Due Primi Registri*, shows Philo and Hermes in circulation from
the time of Platina. Inventories to the library can be found in Eugène
Müntz and Paul Fabre, *La Bibliothèque du Vatican au XVe siècle* (Paris:
Thorin, 1887; reprint, Amsterdam: Van Heusden, 1970).

55 The significance of these frescoes to Giuliano Della Rovere's relationship
with the Vatican Library is taken up by Egmont Lee, *Sixtus IV and Men of
Letters* (Rome: Ediziani di Storia e Letteratura, 1978), 114–16.

56 O'Malley, *Praise and Blame*, 114–15.

57 The Latin text is published by John O'Malley, "The Vatican Library and
the Schools of Athens: A Text of Battista Casali, 1508," *Journal of Medieval
and Renaissance Studies* 7 (1977), 271–87. The passages cited come from

286–87. The "shipwreck" refers to conquest of Constantinople by the Ottoman Turks in 1453.

58 Shaw, *Julius II*, 203. Raffaele Maffei agreed heartily with the pope's self-assessment; see John D' Amico, "Papal History and Curial Reform in the Renaissance: Raffaele Maffei's *Brevis historia* of Julius II and Leo X," *Archivum Historiae Pontificiae* 18 (1980), 175–6, but Maffei was writing for Leo X, who, with his two secretaries, Pietro Bembo and Jacopo Sadoleto, belonged to a generation for whom the political concerns of Julius and his generational contemporaries posed an unnecessary distraction from their own overriding (and strikingly selfish) interest in personal cultural development. It is Bembo and Sadoleto who created the myth of a Golden Age of art and letters under Leo X and who had to do so specifically at the expense of Julius II. Erasmus's vicious posthumous caricature of *Julius Excluded from Heaven* did the rest; see Chapter 8 of the present volume.

59 Shaw, *Julius II*, 206. Shaw's polemic against art historians in her analysis of Julian patronage, 189–208, centers puzzlingly on the work of the distinguished historian Charles Stinger, which is not art history at all.

60 He had also engaged Pollaiuolo to do a series of bronze reliefs for the high altar of his titular church, San Pietro in Vincoli. See Leopold D. Ettlinger, "Pollaiuolo's Tomb of Pope Sixtus IV," *Journal of the Warburg and Courtauld Institutes* 16 (1953), 239–74, and *Antonio and Piero Pollaiuolo: Complete Edition with a Critical Catalogue* (London: Phaidon, 1978), esp. 148–51.

61 The possibility that Pollaiuolo drew from ancient Greek vase painting was first raised by Fern Rush Shapley, "A Student of Ancient Ceramics, Antonio Pollaijuolo," *Art Bulletin* 2 (1919), 78–86. The hypothesis is rejected in no uncertain terms by Ettlinger, *Antonio and Piero del Pollaiuolo*, 36, 145–6; but see now Michael Vickers, "A Greek Source for Antonio Pollaiuolo's *Battle of the Nudes* and *Hercules and the Twelve Giants*," *Art Bulletin* 59 (1977), 182–7.

62 Howard Hibbard, *Michelangelo* (New York: Harper and Row, 1974), 38.

63 Ibid., 36–48. See also Vincenzo Farinella, *Archeologia e pittura a Roma tra Quattrocento e Cinquecento* (Turin: Einaudi, 1992),145–7.

64 See Charles Seymour, Jr., ed., *Michelangelo: The Sistine Chapel Ceiling* (New York: Norton, 1972); Charles de Tolnay, *Michelangelo*, vol. 2: *The Sistine Ceiling* (Princeton: Princeton University Press, 1945); Malcolm Bull, "The Iconography of the Sistine Chapel Ceiling," in Marjorie Reeves, ed., *Prophetic Rome in the High Renaissance Period* (Oxford: Clarendon Press, 1992), 307–19; Esther Gordon Dotson, "An Augustinian Interpretation of Michelangelo's Sistine Ceiling," *Art Bulletin* 61 (1979), 223–56, 405–29.

65 See Leopold D. Ettlinger, *The Sistine Chapel before Michelangelo* (Oxford: Clarendon Press, 1965); Carol F. Lewine, *The Sistine Chapel Walls and the*

Roman Liturgy (University Park: Pennsylvania State University Press, 1993).

66 Michelangelo says this himself; see Shaw, *Julius II*, 197–8.

67 John O' Malley, "The Theology behind Michelangelo's Ceiling," in Massimo Giacometti, ed., *The Sistine Chapel: The Art, the History, and the Restoration* (New York: Harmony, 1986), 92–148. See also, sometimes *cum grano salis*, Dotson, "An Augustinian Interpretation."

68 Peter Lombard made one exception: the persons of the Trinity had order but not sequence, and much ingenuity was expended by Lombard and his later commentators in attempting to explain what ultimately defied explanation.

69 Charles L. Stinger, *The Renaissance in Rome* (Bloomington: Indiana University Press, 1985), 308–314. There is also explicit continuity with the earlier plan for the chapel's iconography; see Ettlinger, *The Sistine Chapel before Michelangelo*; Lewine, *The Sistine Chapel Walls*; D. S. Chambers, "Papal Conclaves and Prophetic Mystery in the Sistine Chapel," *Journal of the Warburg and Courtauld Institutes* 41 (1978), 322–6.

70 See the brilliant analysis by Sven Sandström, *Levels of Unreality: Studies in Structure and Construction in Italian Mural Painting during the Renaissance* (Uppsala: Almqvist and Wiksell, 1963).

71 John Shearman, "The Vatican Stanze: Functions and Decoration," *Proceedings of the British Academy* 57 (1971): 371.

72 Ibid., 372.

73 Ibid., 379.

74 Ibid. Following the lead of Léon Dorez, "La Bibliothèque privée de Jules II," *Révue des Bibliothèques* 6 (1896), 97–124, Shearman's article makes a strong case for the room's identification as a library, seconded by Giovanni Morello, "La Biblioteca di Giulio II" in his *Raffaello e la Roma dei papi* (Rome: Palombi, 1986), 51–3. A contrary opinion is voiced by Ernst Gombrich, "Raphael's Stanza della Segnatura and the Nature of its Symbolism," in his *Symbolic Images: Studies in the Art of the Renaissance* (London: Phaidon, 1972), 85–101, on the basis that the private library was decorated with planets and constellations, and the Stanza della Segnatura is not, but in fact there are planets on the Stanza della Segnatura's ceiling.

75 "Ad praescriptum Julii pontificis," cited in Deoclecio Redig de Campos, *Le Stanze di Raffaello* (Florence, 1950), 8.

76 G. P. Bellori, *Descrizione delle imagini dipinte da Raffaele Sanzio d' Urbino nelle camere del Palazzo Apostolico Vaticano* (Rome: Giacomo Komarek, 1695), remains a fundamental text in discussing the Stanze.

77 A detailed argument for Inghirami's participation in the design of the Stanze is made by Paul Künzle, "Raffaels Denkmal für Fedro Inghirami auf dem letzten Arazzo," *Mélanges Eugène Tisserant*, Studi e Testi, no. 236

(Rome: Biblioteca Apostolica Vaticana, 1964), 6:511–49. As its title suggests, his article seeks to demonstrate that there is a portrait of Fedro in Raphael's tapestry design for *Saint Paul Preaching to the Athenians,* now in the Victoria and Albert Museum, London. That likeness, however, almost certainly belongs to Pope Leo X. See also Konrad Oberhuber, *Porträt und Synthese in Raffaels Schule von Athen* (Stuttgart: Urachhaus, 1983).

78 Frequently this division is associated with the division of university faculties in the early sixteenth century. Dorez, "La Bibliothèque privée de Jules II," 101–2, points out that university faculties maintained chairs in medicine rather than poetry and identifies the organization of the Stanza della Segnatura with the literary interests of humanism, beginning, significantly, with the system installed by Tommaso di Sarzana, the future Nicholas V (and therefore founder of the Vatican Library), for the Dominican Library of San Marco endowed by Cosimo de' Medici. A chair in poetry became characteristic of universities with a humanistic curriculum, however.

79 See Heinrich Pfeiffer, *Zur Ikonographie von Raffaels Disputa: Egidio da Viterbo und die christlich-platonische Konzeption der Stanza della Segnatura,* Miscellanea Historiae Pontificiae, no. 37 (Rome: Tipografia Gregoriana, 1975) and "Die Predigt des Egidio da Viterbo über das goldene Zeitalter und die Stanza della Segnatura," in J. A. Schmoll Eisenwerth, Marcell Restle, and Herbert Weiermann, eds., *Festschrift Luitpold Dussler. 28 Studien zur Archäologie und Kunstgeschichte* (Munich: Deutscher Kunstverlag, 1972), 237–54; Matthias Winner, "Disputa und Schule von Athen," in Christoph Luitpold Frommel and Matthias Winner, eds., *Raffaello a Roma: Il Convegno del 1983* (Rome: Elefante, 1986), 29–45; Christiane L. Joost-Gaugier, "Some Considerations on the Geography of the Stanza della Segnatura," *Gazette des Beaux-Arts* 124 (1994), 223–32.

80 On the subject of Julius and his beard, see M. J. Zucker, "Raphael and the Beard of Pope Julius II," *Art Bulletin* 59 (1977), 524–33.

81 See Matthias Winner, "Disputa und Schule von Athen," 29–45; Daniel Orth Bell, "New Identifications in Raphael's *School of Athens,*" *Art Bulletin* 77 (1975), 639–46; Ingrid D. Rowland, "The Intellectual Background of the *School of Athens,*" in Marcia Hall, ed., *Raphael's "School of Athens"* (Cambridge: Cambridge University Press, 1996), 130–70. I am also indebted to Glenn Most for a preview of his own work on the *School of Athens,* now in press.

82 Stinger, *Rome,* 199–200; Christiane L. Joost-Gaugier, "Pindar on Parnassus: A Neopythagorean Impulse in Raphael's Stanza della Segnatura," *Gazette des Beaux-Arts* 127 (1996), 63–80, and "Sappho, Apollo, Neopythagorean Theory, and *Numine afflatur* in Raphael's Fresco of the Parnassus," *Gazette des Beaux-Arts* 122 (1993), 123–34.

83 Tommaso Fedro Inghirami, "Commentaria in artem poeticam," Vat. Lat.

2742, 48v: "[poeti lirici] sunt qui primum deorum immortalium laudes cecinere." The sentiment is a well-worn one, but his choice of poets closely reflects the roster in the *Parnassus*.

84 For the instruments of the *Parnassus*, see Emanuele Winternitz, "Archeologia musicale del Rinascimento nel Parnaso di Raffaello," *Rendiconti della Pontificia Accademi di Archeologia* 27 (1951), 358–88. For the painting as a whole, see Stinger, *Rome*, 199–200; Luisa Becherucci, "Le Pitture," in *Raffaello: L' Opera, le fonti, la fortuna* (Novara: Istituto Geografico De Agostini, 1968), 1: 135–59.

85 The inscription is CIL [Corpus Inscriptionum Latinarum] VI.XI, 350. See Vittorio Fanelli, *Ricerche su Angelo Colocci e sulla Roma cinquecentesca*, Studi e Testi, no. 283 (Vatican City: Biblioteca Apostolica Vaticana, 1979), 133–4; Federico Ubaldini, *Vita di Mons. Angelo Colocci, Edizione del testo originale italiano (Barb. Lat. 4882)*, ed. Vittorio Fanelli, Studi e Testi, no. 256 (Vatican City: Biblioteca Apostolica Vaticana, 1969), 48 n. 58. T. Hackens, "Mons Apollinis et Clatrae," *Rendiconti della Pontificia Accademia Romana di Archeologia* 33 (1961), 185–96, notes that Pomponio Leto inserted a "Mons Apollinis et Clatrae" into the ancient Roman regionary list of "Publius Victor"; for the latter, see Ingrid D. Rowland, "Raphael, Angelo Colocci, and the genesis of the Architectural Orders," *Art Bulletin* 76 (1994), 81–104.

86 Stinger, *Rome*, 199 and n. 125; Elisabeth Schröter, *Die Ikonographie des Themas Parnass vor Raffael. Die Schrift- und Bildtraditionen von der Spätantike bis zum 15. Jahrhundert* (Hildesheim: Georg Olms, 1977).

87 Heinrich Pfeiffer, "Die Drei Tugenden und die Übergabe der Dekretalen in der Stanza della Segnatura," in Frommel and Winner, *Raffaello a Roma*, 47–58; Christiane L. Joost-Gaugier, "The Concord of Law in the Stanza della Segnatura," *Artibus et Historiae* 29 (1994), 85–98.

88 Shearman, "The Vatican Stanze," 383.

89 See John Shearman, "The Expulsion of Heliodorus," in Christoph Luitpold Frommel and Matthias Winner, *Raffaello a Roma: Il Convegno del 1983* (Rome: Edizioni dell' Elefante, 1986), 75–88.

90 Stinger, *Rome*, 218; Jörg Träger, "Raffaels Stanza d' Eliodoro und ihr Bildsprogramm," *Römisches Jahrbuch für Kunstgeschichte* 13 (1971), 29–99.

91 For the general theological background of Julian Rome, see, e.g., Pfeiffer, *Zur Ikonographie von Raffaels Disputa*. Walter Stephens's forthcoming book on witchcraft discusses humanist analysis of the sacraments; I am indebted to him for several oral presentations and conversation on this point.

92 Shaw, *Julius II*, 172.

93 Pierluigi De Vecchi, "La Liberazione di San Pietro dal carcere," in Frommel and Winner, *Raffaello a Roma*, 89–96.

94 As cardinal, Giuliano Della Rovere had also commissioned Pollaiuolo's bronze reliefs to surround the reliquary there.

95 BAV, Cappella Sistina 46, [Heinrich Isaac] Motet, "O claviger regni ce-
 lorum," 104v–107r:

O claviger regni celorum et princeps apostolorum Dignare pro nobis pium
exorare Ihesum christum dominum nostrum Ut precum votis tuarum diluat
sordes culparum tribuatque post obitum paradisi celestis introitum primorum
princeps et athleta potentissime Petre. Ora pro nobis dominum et magistrum
tuum Ut precum votis tuarum diluat sordes culparum tribuatque post obitum
paradisi celestis introitum. Qui regni claves et curam tradit ovibus qu[i] celi
terreque petro conmisit habenas Ut reseret clausis et solvat vincla ligatis Ipse
tua petre iussit vincula solvi qu[i] te mundanos constituit solvere nexus qu[i]
celi terreque petro conmisit habenas ut solvat vincla ligatis. Pastoris nostri mer-
itis ac prece salutifera Nos a peccatis debitis eterne pastor libera.

Jeff Dean first called this motet to my attention in 1982. A facsimile edition
of the manuscript, entitled "Biblioteca Apostolica Vaticana, Cappella Sis-
tina MS 46," can be found in *Renaissance Music in Facsimile*, vol. 21 (New
York: Garland, 1986).

96 This is what Doris Fienga surmises, "Bramante autore delle *Antiquarie pros-
 pettiche romane*, poemetto dedicato a Leonardo da Vinci," in *Studi Braman-
 teschi, Atti del congresso internazionale, Milano, Urbino, Roma 1970* (Rome:
 De Luca, 1974), 425–36.
97 Christoph Luitpold Frommel, "Die Peterskirche unter Papst Julius II,"
 Römische Jahrbuch für Kunstgeschichte 16 (1976), 57–136.
98 Arnaldo Bruschi, *Bramante architetto* (Bari: Laterza, 1967), 885.
99 See John Shearman, "Il 'Tiburio' di Bramante," in *Studi Bramanteschi*, 567–
 74.
100 Bruschi, *Bramante*, 883–99, Christoph Luitpold Frommel, " 'Cappella Iu-
 lia': Die Grabkapelle Papst Julius II in Neu-St. Peter," *Zeitschrift für Kun-
 stgeschichte* 40 (1977), 26–62.
101 See Giovanni Cipriani, *Gli Obelischi egizi: Politica e cultura nella Roma barocca*
 (Florence: Olschki, 1993), 9–75.
102 This is proven unequivocally in the postscript to James S. Ackerman,
 "The Belvedere as a Classical Villa," *Journal of the Warburg and Courtauld
 Institutes* 14 (1951), 70–91; reprinted with postscript in his *Distance
 Points: Essays in Theory and Renaissance Architecture* (Cambridge, MA:
 MIT, 1991), 325–59.
103 Egidio da Viterbo, "Historia XX saeculorum," Rome, Biblioteca Angel-
 ica, MS 351, 245r:

Conatus Bramantes, architectus huius temporis princeps . . . conatus . . . est
ille persuadere Julio apostoli sepulcrum ut commodiorum in templi transfer-
retur, templi frons, non ad orientem solem, ut nunc vergit, set uti in meri-
diem nothumque converteretur, ut obeliscus magna in templi area templum
ascensuris occurreret; negare id Julius, immota oportere esse sacra dictitare,

movere non movenda prohibere; contra instare Bramantes, rem omnium ac-
commodatissimum futurum pollicere, si Julii pont[ificis] is templum, augus-
tissimum Julii Caesaris monumentum, [quod] vulgo putant, in vestibulo et
ipso templi aditu haberet, ad religionem facere ut templum ingressurus fac-
turusque rem sacram non nisi commotus attonitusque novae molis aspectu
ingrediatur; saxa montibus herentia difficile moveri; mota loca in ima facile
ferri; animos quoque affectuum expertes immotos perstare, affectu concitos
facile se ad templa arasque prosternare; tumuli proinde transferendi sibi
curam sumere; nihil motum iri, sed tumulum cum vicina soli parte quomi-
nus quequam fatiscat integre se convecturum polliceri. Nihilo serius Julius in
sententiam perstat, nihil ex vetere templi situ inverti, nihil et primi pontificis
tumulo attrectari se passurum dicit; quid Caesaris obeliscum deceat, ipse vi-
derit, se sacra prophanis, religionem splendori, pietatem ornamentis esse
praepositurum.

104 James S. Ackerman, *The Cortile of the Belvedere*, Studi e Documenti per la
 Storia del Palazzo Apostolico Vaticano, no. 3 (Vatican City: Biblioteca
 Apostolica Vaticana, 1954); and, "The Belvedere as a Classical Villa";
 Christoph Luitpold Frommel, "Il Palazzo Vaticano sotto Giulio II e Leone
 X: Strutture e funzioni," in *Raffaello in Vaticano*, 122–32; Deoclecio Redig
 de Campos, "Bramante e le logge di San Damaso," in *Studi Bramanteschi*,
 517–22; Hans Brummer, *The Statue Court in the Vatican Belvedere* (Stock-
 holm: Almqvist and Wiksell, 1970).

105 See Samuel Ball Platner, *A Topographical Dictionary of Ancient Rome*, com-
 pleted and revised by Thomas Ashby (Oxford: Oxford University Press,
 1929), 473–75, s.v. *Septizonium*. (The entry argues for the correctness of
 the term "Septizodium.")

106 Cited from Ernst Gombrich, "Hypnerotomachiana," in his *Symbolic Im-
 ages* (London: Phaidon, 1972), 102. It is worth noting here that in the
 seventeenth century Francesco Borromini produced just such a "hiero-
 glyph" over one of the portals to the Church of S. Ivo alla Sapienza, the
 official chapel of the University of Rome and dedicated to the patron
 saint of lawyers. A lawbook and scales denote Juris, while a snake smil-
 ing into a mirror (with a toothily grinning reflection smiling back) rep-
 resents Prudentia; the whole wittily announces the faculty of
 Jurisprudentia.

107 Gombrich, "Hypnerotomachiana." See also Stefano Borsi, *Polifilo architetto:
 Cultura architettonica e teoria artistica nell' Hypnerotomachia Poliphili, 1499*
 (Rome: Officina, 1995), 224–6.

108 Giorgio Vasari, *Life* of Bramante, in *Le Vite de' più eccellenti pittori scultori
 e architettori, nelle redazioni del 1550 e 1568*, ed. Rosanna Bettarini, with
 a commentary by Paola Barocchi (Florence: Sansoni, 1966–1984), 4:
 79.

109 Vat. Lat. 2742, 9v: "Bene poeticam picturae comparat: quam poeta nihil

aliud sit quam pictor loquens et pictor mutus poeta. Uterque hominum ferarumque motus effingit." 12v:

Recte post totius operis convenientia: dispositionem ordinemque collocat. nihil enim est quod tam faciat a proposito discedere nec in incepto persistere quam non omnia convenientiae praecepta mente cogitationeque complecti. Natura rerum nihil habet ordine praestantius quo sublato omnia haec pereant necesse est, et in veterem confusionem antiquumque chaos revolvantur . . . Statuam si effingas nequaquam membra suis locis disponas prodigium facias. Poema hoc ipso carens ordinem fluitat et tumultuatur. qui sunt hedificatum licet saxa har-enam et quae ad opus sunt necessaria congesserint, nisi illis collocandis dispo-nendisque adhibuerint aedificium, nihil praeclari operis surget: si pro vestibulo cubiculum, pro aula lararium collocarint non hec solum membra sed omnem decorem perturbabunt. Sic poeta meditetur quantumlibet magnas afferat cog-itationes et divina congerat inventa nisi magno ordine suis queque locis sta-tuerit, meditata digesserit, et ni in se commissa coniuncta devinxerit cumulum rerum faciet atque congestum.

110 See Pier Nicola Pagliara, "Vitruvio: Da testo a canone," in Salvatore Settis, ed., *Memoria dell' antico nell' arte italiana* (Turin: Einaudi, 1986), 3: 5–85, esp. 32–8; Lucia Ciapponi, "Fra Giocondo da Verona and his Edition of Vitruvius," *Journal of the Warburg and Courtauld Institutes* 47 (1984), 72–90.

111 For both these manuscript traditions, see Chapter 5 of the present volume and Giangiacomo Martines, " 'Gromatici veteres' tra antichità e me-dioevo," *B.S.A Ricerche di Storia dell' Arte* 3 (1976), 277–84.

112 Giocondo's emendations mostly involve the adjustment of one or two letters, like reading "suculis" at 1.i.8 when all the manuscript texts read "surculis," or "Carya" for the manuscript's "Caria" at 1.i.5 (in the tale of the caryatids), or "Thesbiae" at 1.i.7 for the manuscripts' "cum thesbia." Modern editors now read "Ctesibii" for "Thesbiae" but accept the other two emendations. Sometimes more hangs on an emendation than a detail of vocabulary; Vitruvius's discussion of the Tuscan temple at 4.vii.2 speaks of a central chamber (*cella*) with "others" on each side (*aliae*), implying that Tuscan temples all have three cellas. Giocondo emends *aliae* to read "wings" (*alae*), suggesting a temple with a single central cella flanked on each side by partially enclosed spaces. An archaeologist excavating with Vitruvius in hand will expect to find a one-room temple if that Vitruvius is a Giocondo text, whereas a text that adheres more strictly to manuscript readings will prompt the search for a three-room temple. Giocondo's sub-stitution of "rationes" for the manuscripts' "ratiocinationes" at 1.iii.2 sub-stitutes a philosophical word that means "principles" for one that means the more mundane process of "reckoning." In Giocondo's own day, the distinction in social status between practitioners of philosophy and prac-

titioners of craftsmanship was as marked as it was in the time of Vitruvius; it was more befitting the dignity of an ancient author to speak of lofty principle than of an everyday technique.

113 For Giocondo's legacy to Angelo Colocci, see Chapter 7 in the present volume.

114 See Christof Thoenes, "Gli Ordini architettonici: Rinascita o invenzione? Parte prima," in Marcello Fagiolo, ed., *Roma e l' antico nell' arte e nella cultura del Cinquecento* (Rome: Istituto dell' Enciclopedia Italiana, 1983); Hubertus Günther, "Gli Ordini architettonici: rinascita o invenzione? Parte seconda," in ibid., 272–310; Christiane Denker Nesselrath, *Die Säulenordnungen bei Bramante* (Worms: Wernersche Verlagsgesellschaft, 1990); Thomas N. Howe, "Composizione retorica e composizione architettonica nell' ambiente del Poliziano," in Luisa Secchi Tarugi, ed., *Poliziano e il suo tempo: Atti del VI Congresso Internazionale di Studi Umanistici* (Florence: Cesati, in press).

115 Christoph Luitpold Frommel, "Papal Policy: The Planning of Rome during the Renaissance," in Robert I. Rotberg and Theodore K. Rabb, eds., *Art and History: Images and their Meaning* (Cambridge: Cambridge University Press, 1988), 39–66, esp. 50–3; Frommel, *Die Farnesina*, 163–70; Luigi Salerno, Luigi Spezzaferro, and Manfredo Tafuri, *Via Giulia: Una Utopia urbanistica del '500* (Rome: Staderini, 1973).

116 Christoph Luitpold Frommel, "Il Palazzo dei Tribunali in Via Giulia," in *Studi Bramanteschi*, 523–34.

117 Felix Gilbert, *The Pope, His Banker, and Venice* (Cambridge, MA: Harvard University Press, 1980), 1–92.

118 Giuseppe Cugnoni, *Agostino Chigi in Magnifico*, Archivio della Reale Società Romana di Storia Patria (Rome: Istituto di Studio Romani, 1878), 39–41; Gilbert, *The Pope*, 78–9; Rowland, *The Correspondence of Agostino Chigi*, 52, 82, 109–14.

119 Gilbert, *The Pope*, 85–96; Pastor, Ludwig Freiherr von Pastor, *History of the Popes from the Close of the Middle Ages*, trans. Frederick Ignatius Autrobus and R. F. Kerr (London: Heinemann, 1894–98), 6:308–12. See also Nelson Minnich, "The Healing of the Pisan Schism (1511–13), *Annuarium Historiae Conciliorum* 16 (1984), 59–192; printed with revisions in his *Fifth Lateran Council (1512–17): Studies on Its Membership, Diplomacy, and Proposals for Reform* (Aldershot: Variorum, 1993), 59–197.

120 Shaw, *Julius II*, 209–78; Rowland, *The Correspondence of Agostino Chigi*, 63–71.

121 Gilbert, *The Pope*, 66–9, 88–90; Pecchiai, *Roma nel Cinquecento*, 267–8, 273–8; Rowland, "A Summer Outing in 1510," 347–59, and *The Correspondence of Agostino Chigi*, 65–7.

122 Gilbert, *The Pope*, 17–26; Rowland, *The Correspondence of Agostino Chigi*, 87–157.

123 See Christoph Luitpold Frommel, *Die Farnesina und Peruzzis architekton-isches Frühwerk* (Berlin: De Gruyter, 1961), 6–7; Mary Quinlan-McGrath, "The Villa of Agostino Chigi: The Poems and Paintings," Ph.D. diss., University of Chicago, 1983.

124 See Cugnoni, *Agostino Chigi*, 63–6; Quinlan-McGrath, "The Villa"; Frommel, *Die Farnesina*, 7–15; Rowland, "Render unto Caesar the Things Which are Caesar's: Humanism and the Arts in the Patronage of Agostino Chigi," *Renaissance Quarterly* 39 (1986), 683–93; and "Some Panegyrics to Agostino Chigi," *Journal of the Warburg and Courtauld Institutes* 47 (1984), 194–9.

125 See Rowland, "Render unto Caesar."

126 This was the period when Cardinal Giovanni de' Medici commissioned a new façade for the cathedral of Bolsena, site of the miracle.

127 See Reeves, *Prophetic Rome.*

128 See Minnich, *The Fifth Lateran Council.*

129 "Homines per sacra immutari fas est, non sacra per homines." An English translation of the oration by Joseph C. Schnaubelt, O.S.A., is now available in Martin, *Friar*, 285–96. The Latin text has been edited with commentary by Clare O'Reilly, " 'Without councils we cannot be saved': Giles of Viterbo addresses the Fifth Lateran Council," *Augustiniana* 27 (1977), 166–204. Also see Nelson Minnich, "Concepts of Reform Proposed at the Fifth Lateran Council," *Archivum Historiae Pontificiae* 7 (1969), 169–73, reprinted in his *Fifth Lateran Council*, 4:169–73.

130 Ubaldini, *Vita*, 38–60; Fanelli, "Aspetti della Roma cinquecentesca: Le Case e le raccolte archeologiche del Colocci," in his *Ricerche*, 115–25; Elizabeth MacDougall, "The Sleeping Nymph: Origins of a Humanist Fountain Type;" *Art Bulletin* 57 (1975), 357–65; Domenico Gnoli, "Orti letterari nella Roma di Leon X," *Nuova Antologia* 347 (1930), 3–19, 137–48; David R. Coffin, *Gardens and Gardening in Papal Rome* (Princeton: Princeton University Press, 1991), 33–4, 233–6; Millard Meiss, "Sleep in Venice: Ancient Myths and Renaissance Proclivities," in his *Painter's Choice: Problems in the Interpretation of Renaissance Art* (New York: Harper and Row, 1976), 212–40, esp. 214–16 and 240. I had once toyed with the idea that the Diana of Palazzo Odescalchi in Piazza Santissimi Apostoli (Meiss, "Sleep in Venice," 240) was the nymph from Colocci's fountain, but the attributes make this impossible. The resemblance is striking none-theless.

131 The poem's antiquity is called into question (convincingly) by Otto Kurz, "Huius nympha loci," *Journal of the Warburg and Courtauld Institutes* 6 (1953), 171–7; see also MacDougall, "The Sleeping Nymph," 357–65; Bober, "The *Coryciana* and the Nymph Corycia," *Journal of the Warburg and Courtauld Institutes* 40 (1977), 223–39; Coffin, *Gardens and Gardening,*

34. In meter and subject, if not in language, the Latin poem evokes the three Greek verses about water springs quoted in book 8 of Vitruvius's *De architectura*, verses restored to the Vitruvian text, as recounted previously, by Fra Giocondo in his printed edition of 1511:

Huius nympha loci, sacri custodia fontis
Dormio, dum blandae sentio murmur aquae.
Parce meum, quisquis tangis cava marmora, somnum
Rumpere: sive bibas, sive lavere, tace.

132 Girolamo Borgia, "Ecloga felix," Vat. Lat. 5225, IV, 1014r:

Forte sub ingenti pulcherrima numina quercu
Alma Venus charitesque sua cum pallade musae
Felicem ornabant tyberina ad flumina nympham:
Qua de virgineo salit antiro candida nais
Una superstes aquas praebens pastoribus aegris:
Quaque meus sociis convivia lauta poetis
Saepe parat dominus purae Colotius undae.

133 Ibid., 1015r:

Addit iulaeas laudes: benefacta parentes
Magnanimi pastoris: uti victricibus armis
Imperium sanctae feliciter auxerit urbi
Julius . . .
Ni mors heu miseris italis rapuisset iulum
In magnis magnum conatibus: alta parantem
Deque suo grege sollicitum, templisque caducis
Semper: et invicto meditantem pectore summa.
Heu mors saepe virum felicibus invida coeptis
Inde *renascentem* decora in sua pristina Romam:
Utque domos miras ac templa imitantia coelum
Aedificavit.

Emphasis added.

134 CIL VI,2, 10096; Vittorio Fanelli, "Le raccolte archeologiche di Angelo Colocci," in his *Ricerche su Angelo Colocci e sulla Roma cinquecentesca*, Studi e Testi, no. 283 (Vatican City: Biblioteca Apostolica Vaticura, 1979), 191; see a copy of the text in the Houghton Library, Harvard University, MS Lat. 358, 144: "In hortis A. Colotii romae Eucharis Liciniae libertae docta erudita omnes artes virgo vix[it] an[ni] xiiii." The manuscript, described in the library's catalogue as possibly from Ferrara, is more probably from Rome.

135 For Alcionio's life and times, see Kenneth Gouwens, "Redefinition and Reorientation: The Curial Humanist Response to the 1527 Sack of Rome," Ph.D. diss., Stanford University, 1991.

136 Aelurus is instructed to attack Erasmus in a poem written in response to

the latter's *Adagia*, in which the Dutch humanist criticized Italian coward-
ice in battle. Colocci's friend Pietro Corsi had composed a response, and
Antonio Tebaldeo suggested in the following poem that there were more
effective ways to deal with the "barbarian" from Rotterdam, Vat. Lat.
2835, c. 187r; cf. Ott. 2860, c. 87r. The "Samian sage" is Pythagoras, with
his belief in reincarnation.

Credendum est samio seni putavit
Qui nos in varias redire formas.
Eras mus, vitium tibi remansit
Turpe, rodis adhuc maligne, rodis
Magnorum monumenta tot virorum.
In te non opus est ciere Petrum [petram, Cod. Ott. 2860]
Aelurus veniat, petes latebras.

It's all true what the Samian sage reported:
Namely, that we've had other incarnations.
You once were a mouse, Erasmouse, and kept its
Ugly habit of gnawing; still you're gnawing
All those monuments left by our great forebears.
There's no need to send in a Rock to scare you; [*Petrum*, meaning Pietro
 Corsi, replaces *petram*]
Just let Aelurus come, you'll seek your mouseholes!

137 See Vat. Lat. 3388, 234r, a series of disconnected notes in Angelo Colocci's
 worst hand: "Aelurus fuit in minore sella"; "Puerum ipsius inquiratur
 ossa"; "Maximus simulator hadrianus"; "Dignus imperio nisi imperasset."
 Cf. 84r: "Aelurus fuit in minore sella."

138 See Marina Fava, "I Cagnolini dell' epigrammatario colocciano," in *Atti*,
 231–42, esp. 235, 242: "Securi mures, tutaeque errate volucres / Virge-
 neam Aelurus dum prope dormit aquam; Exoriente die tibi nox Aelure
 perennis / Maeror hero, tuta est muribus quies; Dure lapis levis incumbas:
 tuque efflue Virgo / Lenis ut Aeluro sit mage grata quies." The epitaphs
 are found in Vat. Lat. 3353, 61r, 77r; Houghton Library, MS 358, 194,
 222–3.

139 Vat. Lat. 4104, 41r–42r:

 A presso Jac[op]o mazzocchio già mercurio vol condurre la stampa graeca in
 Roma et già promecte stampare lo Eustathio sopra homero et vorria condurre
 compositori. Missere Johanni Antonio Marostico dice che lui pò disponere di
 quello Zacharia che fece lo ethymologicon; informateve chi è quello, che
 quando la corte si rassecte voglio che vui et Io derizzamo in roma la neacademia
 presertim del greco, ma nisuna cosa si pò fare senza di vui.

 Qui se dice che venetiani non possono haver pace da' barbari et che'l papa
 non li vole abandonare et che se parte et torna in roma: se la corte si rassecta
 Io so' a cavallo; se sta così Io so ruinato sicché Agitur de summa rerum col-
 occiarum non de Italia.

140 Text cited in previous note. See Francesco Barberi and Emidio Cerulli, "Le Edizioni greche 'In Gymnasio mediceo ad Caballinum montem,' " in *Atti*, 61–76; Vittorio Fanelli, "Il Ginnasio greco di Leone X a Roma," *Studi Romani* 9 (1961), 379–93, reprinted in his *Ricerche*, 91–110.

141 This is the surmise of F. J. Norton, *Italian Printers, 1501–1520* (London, 1958), 91.

142 Vat. Lat. 4104, 46r:

> D[omine] Scipio hon[orande] ho indugiato per haver dextramente risolutione dal tucto con egidio alli dì passati con cornelio nostro el quale dixe voler parlare con magistro egidio in che forma ne parlasse io non la so . . . parme respondasse freddamente. Io non la intendo . . . Misser scipion mio io so' de questo parere che vui veniate adesso in roma; et venitene qui in casa, et se egidio vorrà covella da vui ne lo farà intendere, una volta è stato avisato. Io me persuado state sano alias non mutate aere.

143 Shaw, *Julius II*, 281–6; Minnich, " Healing," 59–192.

144 The statue niche was brought to light in a remarkable above-ground archaeological investigation conducted in the course of her doctoral research by Virginia Anne Bonito, "The Saint Anne Chapel in Sant' Agostino," Rome, Ph.D. diss., New York University, 1984. Bonito dates the entire complex between the contract of commission on December 13, 1510, and the dedication on July 26, 1512. See also the summary versions of this work in her "St. Anne Altar in Sant' Agostino in Rome: A New Discovery," *Burlington Magazine* 122 (1980), 805–12, and "St. Anne Altar in Sant' Agostino: Restoration and Interpretation," *Burlington Magazine* 124 (1982), 268–76.

145 See Julia Haig Gaisser, "The Rise and Fall of Göritz's Feasts," *Renaissance Quarterly* 48 (1995), 41–57.

146 Blosio Palladio, ed., preface to *Coryciana* (Rome: Lodovicus Vicentinus [Lodovico degli Arrighi],1524):

> An vero ille illum tuum solennem diem tacere potuisset, quo tu Annae Christi Aviae sacrum, tanto cultu et honore, ad tuas primum statuas stato sacrificio, inde ad hortos, pingui et lauto epulo, atque adeo omnibus bonis, omnibus doctis, indicto, concelebras? Nam eo bonorum atque eruditorum virorum ea cohors coit, ac diem celebrat, ut in tuis hortis medias Athenas, emporiumque doctrinarum possis videri illo die includere, et musas de Helicone et Parnasso deductas, in Tarpeium et Quirinalem tuis hortis imminentes, transferre. Ubi alius ad arbores citrias, alius ad hortenses parietes, alius ad puteos, aut signa, quae illic plurima sunt et speciosa, omnia antiqui operis, et gloriae plena, hac illac temere et varie, carmina affigiunt tuas statuas, tuam pietatem, liberalitatemque eius diei, tam in Deos quam in homines tantam, uno ore concelebrant. Denique nullum in orbe terrarum (ausim hoc dicere) concilium aut convivium est, illo tuo illius diei, nobilius atque illustrius, quum praeeuntibus mane sacrificiis, et re divina, post vergente vespera, selecta doctissimorum turba, et quasi

flores litterarum, in hortos tuos coacervantur: quos tu quidem plurisquam reges, plurisquam Satrapas universos aestimas et iure aestimas.

147 Blosio had some experience of writing about artistic programs; his single published work, aside from the *Coryciana*, is a long description of Agostino Chigi's suburban palazzo, printed in January 1512, in which he evinces his grasp of the symbolism displayed in the art and architecture of Chigi's new showcase; see Michael J. Dewar, "Blosio Palladio and the *Silvae* of Statius," *Res Publica Litterarum* 13 (1990), 59–64, and "Encomium of Agostino Chigi and Pope Julius II in the 'Suburbanum Augustini Chisii,' of Blosio Palladio," *Res Publica Litterarum* 14 (1991), 61–8; Mary Quinlan-McGrath, "Blosius Palladius, Suburbanum Augustini Chisii," *Humanistica Lovaniensia* 39 (1990), 93–156.

148 See Ingrid D. Rowland, "The Göritz Chapel in Sant' Agostino and the *Vestigium Dei*," *Augustiniana* (forthcoming).

149 Isaiah 25:6–8; 26:1–3, Revised Standard version. Bonito's analysis of this passage in her dissertation "The Saint Anne Chapel," is misleading in two respects. Her interpretation relies upon the assumption that Egidio da Viterbo has supplied Raphael with a text that diverges significantly from the canonical biblical wording in order to bring in references to Psalm 118 (119 Vulgate) and to the Crucifixion. The most significant textual variant, an alternative word for "gates," present in 1 Samuel 17:57 as well as the psalter, simply reflects the consequences of a scholar supplying a citation from memory, as often happens during this period (and most others). The reference to the Crucifixion depends upon an overly subtle reading of Raphael's Hebrew script, arguing that the text has replaced the word "stayed" in "stayed on thee" with "nailed." However, Raphael's letter forms throughout the scroll are somewhat approximate; this approximation may have been exacerbated by the fact that he was working not from a printed Bible but from handwritten instructions. Raphael, to the best of his ability, has copied enough of Isaiah 26:2–3 for humanists learned in Hebrew to identify the biblical verses.

Bonito plausibly suggests Egidio da Viterbo as the supplier of Isaiah's text to Raphael but proceeds to interpret that text on the basis of work that comes very late in Egidio's career, following upon his contacts with Rabbi Elias Levita. Elias Levita first came to Rome in 1515 – that is, three years after the completion of the chapel. In 1512, Egidio da Viterbo's interest in Hebrew had yet to take the obsessive turn that characterized his writing from 1515 onward; he probably had not yet mastered the language thoroughly and was still completely embroiled in the maneuverings, political and theological, of Pope Julius II, with whom he was even then setting the course of the Fifth Lateran Council. During the Julian papacy he looked to Greco-Roman antiquity, not Hebrew studies, as the most

fruitful place in which to trace the patterns of divine inspiration working through history. Therefore, rather than looking at Egidio's increasingly hermetic later writings for enlightenment about Raphael's *Isaiah*, it is more realistic to interpret the prophet's scroll in light of what was generally available to a competent general hebraist (not necessarily a cabalist) in 1512. Moreover, like most of the texts shown in Renaissance art, this is a citation that invites its readers to recall more than the excerpt that appears; those who catch the reference in the first place are fully expected to supply its context as well, a natural enough process for practitioners of the mnemonic art.

150 *Coryciana*, V ii r:

Delius Hier[onymus] Alex[andrius]:

Tempore quo huc illuc errabant corpora primum,
Nullus erat toto notus in orbe Deus.
Nullae aderant leges, leges erat una voluntas.
Unus dux sensus, Iuppiter unus erat.
Ast ubi digessit quisquis fuit ille Deorum
Haec, et quoque modium iussit habere suum,
Nunc eadem rursus facientes tempora mores
Compulerant Superos consuluisse fugam,
Esse ita sed mortale genus miserate, vederis
Iane tuos tute restituisque Deos.
Credere tunc homines aliquem regnare Tonantem
Quem scelera offendant, quem benefacta iuuent,
Numina tunc passim terras peragrare videres,
Convivias homines atque habuisse Deos.

CHAPTER SEVEN. IMITATION

1 See Nelson Minnich, "The Healing of the Pisan Schism (1511–1513)," *Annuarium Historiae Conciliorum* 16 (1984), 59–192; reprinted with new appendices in his *Fifth Lateran Council (1512–17): Studies on Its Membership, Diplomacy, and Proposals for Reform* (Aldershot: Variorum, 1993), 59–197.

2 For this reason Nelson Minnich finds the council's pronouncements, beginning with Julius's opening statement, remarkably indefinite. See "Concepts of Reform Proposed at the Fifth Lateran Council," *Archivum Historiae Pontificiae* 7 (1969), 163–251, reprinted in *The Fifth Lateran Council*, 163–253. See also *Dizionario biografico degli Italiani*, s.v. *Pietro, Bembo*.

3 Minnich, "Concepts of Reform," 169.

4 The following excerpts from the sessions of Lateran V are taken from a collection of contemporary pamphlets now in the Vatican Library as Stampati R.I.IV.2107. Pagination and details about publication are sometimes lacking. Most of this material can also be found in Jacopo Mazzocchi, ed.,

Acta Concilii Lateranensis (Rome: Mazzocchi, 1521). The passage quoted is Egidio da Viterbo, Oration for Lateran V, session 1 (Rome: Johnn Beplin, 1512), A 2 2r: "Dicam . . . oraculorum stilum me invertere non ausurum esse: tum quod homines per sacra immutari fas est: non sacra per homines: tum quod. ἁπλὸς ὁ μῦθος τῆς ἀληθείας ’έφυ Simplex sermo veritatis est."

5 Ibid., B2 4v: "Ablui ab omnibus conceptis maculis et in antiquum splendorem munditiamque restitui."

6 As often happened in this period, Garghi's name is rendered differently by different records; he is also known as Gargha, Gargius, etc. I have given his name as it appears in some of Agostino Chigi's letters and contracts (although Chigi often spells it "gharghi.") For Garghi himself, see Minnich, "Concepts of Reform," 190; Rowland, "A Summer Outing in 1510: Religion and Economics in the Papal War with Ferra," *Viator* 18 (1987), 347–59.

7 Giovanni Battista Garghi, Oration for Lateran V, session 8. Pamphlet version, a ii 2v:

Victorem Christum Regem sequamur: qui nos vult victoriae suae habere participes: Crux illius nostra est victoria: cuius Patibulum noster est triumphus. Terra non nobis Patria est: sed Coelum nos Cives et incolas expectat: Ubi haec utinam verba domini audiamus. Euge inquit serve bone et fidelis: quia in pauco fuisti fidelis: supra multa te constituam. Euge inquam Miles strennue [sic], imitator domini tui: et Regis aeterni comes, dignis et optatis remuneraberis praemiis. O salutifera: et prae omnibus expetenda Christi militia: in qua certa et pretiosissima sunt trophea: quibus tot Martyres ac beati Patres coelesti imperio gloriantur: ac perpetua pace quiescunt.

8 Tommaso de Vio (Cajetan), Oration for Lateran V, session 2: "Existimavi me facturum rem et utilem et omnibus gratam si hodierno die primum de ecclesia ipsa, deinde de synodis huius temporis illarumque differentia et diversitate dicerem." See also Minnich, "Concepts of Reform," 175–9.

9 Ernst Gombrich, "Hypnerotomachiana," *Journal of the Warburg and Courtauld Institutes* 14 (1951), 121–2; James S. Ackerman, *The Cortile of the Belvedere*, Studi e Documenti per la Storia del Palazzo Apostolico Vaticano, no. 3 (Vatican City: Biblioteca Apostolica Vaticana, 1954).

10 For the life of Gianfrancesco Pico, see the preface to his *Opera omnia* (Basel: Sebastianus Henricpetrus, 1601); Charles B. Schmitt, *Gianfrancesco Pico della Mirandola (1469–1533) and His Critique of Aristotle* (The Hague: Martinus Nijhoff, 1967); Giorgio Santangelo, ed., *Le Epistole "De imitatione" di Giovanfrancesco Pico della Mirandola e di Pietro Bembo* (Florence: Olschki, 1954), 1–19.

11 *Dizionario biografico degli Italiani*, s.v. *Bernardo, Bembo.*

12 Bembo kept his correspondence with his mistress Maria Savorgnan and

that with Lucrezia Borgia, reworking his own contributions. These exchanges of letters may now be read in modern editions: Pietro Bembo, *Lettere* (Bologna: Commissione per i Testi di Lingua, 1987), ed. Ernesto Travi; Lucrezia Borgia, *Lucrezia Borgia, La Grande Fiamma, lettere 1503–1517*, ed. Giulia Raboni (Milan: Rosellina Archinto, 1989).

13 BAV, Vat. Lat. 3353:

> Forma simplicitate gratiaque
> Incessu probitate comitate
> Verbis moribus elegantiaque
> Doctrinaque simul places et nitore
> . . . Bymbus nobilitatis omnis instar.

14 Pico eventually did write a letter to the council on December 12, 1516; see Minnich, "Concepts of Reform," 202–5.

15 Pico's letter to Bembo is found in Vat. Lat. 2847, 176r–179r.

16 Paul F. Gehl, *A Moral Art: Grammar, Society and Culture in Trecento Florence* (Ithaca, NY: Cornell University Press, 1993), 107–134.

17 See the introduction to Angelo Gambaro, *Erasmo da Rotterdam, Il Ciceroniano o dello stile migliore* (Brescia: La Scuola, 1965); John D'Amico, *Papal Humanism in Renaissance Rome: Humanists and Churchmen on the Eve of the Reformation* (Baltimore: Johns Hopkins University Press, 1983), 115–43; Luca D'Ascia, *Erasmo e l' umanesimo romano* (Florence: Olschki, 1991), esp. 105–49 and the extensive bibliography at 106 n. 2; Izora Scott, *Controversies over the Imitation of Cicero in the Renaissance as a Model for Style and Some Phases of their Influence on the Schools of the Renaissance* (New York: Teachers College, Columbia University, 1910; reprinted Davis, CA: Hermagoras Press, 1991); Andrea Bolland, "Art and Humanism in Early Renaissance Padua: Cennini, Vergerio, and Petrarch on Imitation," *Renaissance Quarterly* 49 (1996), 469–87.

18 Poggio Bracciolini's use of *pita* for "pizza" was perfectly correct from an etymological standpoint, despite Lorenzo Valla's protests in his own *Elegantiae*.

19 Remigio Sabbadini, *Storia del Ciceronianismo e di altre questioni letterarie nell' età della Rinascenza* (Turin: Ermanno Loescher, 1885), esp. 1–80; Donato Gagliardi, *Il Ciceronianismo nel primo Cinquecento e Ortensio Lando* (Naples: Morra, 1967).

20 Angelo Poliziano to Paolo Cortesi, in Eugenio Garin, ed., *Prosatori latini del Quattrocento* (Milan: Ricciardi, 1952), 902:

> Remitto epistolas diligentia tua collectas, in quibus legendis, ut libere dicam, pudet bonas horas male collocasse. Nam praeter omnino paucas, minime dignae sunt quae vel a docto aliquo lectae vel a te collectae dicantur . . . Est in quo tamen a te dissentiam de stylo nonnihil. Non enim probare soles, ut accepi, nisi qui lineamenta Ciceronis effingat. Mihi vero longe honestior tauri facies

aut item leonis quam simiae videtur, quae tamen homini similor est . . . Non exprimis, inquit aliquis, Ciceronem. Quid tum? Non sum enim Cicero; me, tamen, ut opinor, exprimo.

Ibid., 904:

Sed cum Ciceronem, cum bonos alios multum diuque legeris, contriveris, edidiceris, concoxeris et rerum multarum cognitione pectus impleveris, ac iam componere aliquid ipse parabis, tum demum velim quod dicitur sine cortice nates, atque ipse tibi sis aliquando in consilio, sollicitudinemque illam morosam nimis et anxiam deponas effingendi tantummodo Ciceronem tuasque denique vires universas pericliteris.

21 Cortesi to Plisiano, in ibid.,906:

Et primum de iudicio libenter fatebor, cum viderem eloquentiae studia tamdiu deserta iacuisse, et sublatum usum forensem, et quasi nativam quandam vocem deesse hominibus nostris, me saepe palam affirmassse nihil his temporibus ornate varieque dici posses, nisi ab iis qui aliquem sibi praeponerent ad imitandum, cum et peregrini expertes sermonis alienas regiones male possint sine duce peragrare, et anniculi infantes non nisi in currculo aut nutrice praeeunte inambulent. Cum autem multi in omni eloquentiae genere floruerint, memini me unum Marcum Tullium ex doctorum acie abduxisse, in quem omnium ingeniosorum hominum studia conferenda putarem . . . Ausim nunc etiam affirmare idem quod saepe: neminem post Marcum Tullium in scribendo laudem consecutum praeter unum aut alterum, qui non sit ab eo eductus et tamquam lactis nutrimento educatus.

22 Paolo Cortesi, *Prohemium in Librum primum sententiarum ad Iulium II Pont. Max.* (Rome: Besicken, 1504): A iiii r:

Iu[li] Pont[ifex] Max[ime] summa est hominum contentione certatum Philosophorum ne esset studiis latini sermonis adhibendus nitor. Sunt enim multi philosophi qui cum facultatem verborum faciendorum voluntariam esse opinentur nihiloque minus eis in pariendo licere quam priscis illis licitum fuerit arbitrentur negant quicquam esse causae cur verborum pariendorum licentiam priscorum angustiis praefiniri velint . . . Ex quo erit confiteri necesse eiusmodi philosophiae speciem litteratam et artificiosam videri, quae ad naturae pulchritudinem statuatur.

23 These examples are all taken from Sabbadini, *Storia del Ciceronianismo*, 32, 44, 77.

24 Cortesi, *Prohemium*, A iiii r:

Quod si artificiosa dicatur, nemini dubium esse debet eam speciem philosophiae studiis esse aptiorem quae suavis quam quae absona feratur, propterea quod suavitas cum in intelligendi sensum irrepat philosophiae studia amplificat. Nam qui in aliquo doctrinarum genere diiudicant ut qui cytharae artifici[o] delectantur perfacile cytharedi boni fiunt ob eamque causam affirmamus in orationis ornatu verborum salubritatem non consectandum esse fucum quan-

doquidem elegantia philosophiam tanquam pulchritudo habitum corporis se-
quatur. Itaque his qui eloquentiam concinnis et fuco contineri credunt iure
negemus eos nunquam Rethorum praecepta attigisse cum virtutum et vitiorum
vicinitate non internoscant, quantum intersit inter orationem fucatam et sanam
ut lippi quibus omnia alba apparent marmor a topho non secernunt, quod
congruere in candore videantur.

25 Egidio da Viterbo, *Sententiae ad mentem Platonis*, Vat. Lat. 6325, 172r:
"Nobis solis scripsimus." For a history of the composition of Egidio's *Sen-
tentiae*, see Daniela Gionta, " 'Augustinus dux meus': La Teologia poetica
'Ad mentem Platonis' di Egidio da Viterbo OSA," in *Atti del Congresso
Internazionale su S. Agostino nel XVI centenario della conversione, Roma, 15–
20 settembre 1986* Studia Ephemeridis "Augustinanum" (Rome: Institutum
Patristicum "Augustinianum," 1987), 3:187–201.

26 Fedro did, however, continue to teach at the university and to produce
plays with young men in the cast; his emphasis on the moral virtues of
Latin may have been stimulated by this didactic side of his life.

27 Machiavelli, in book 21 of *The Prince*, shows Inghirami's same sense that
timing is crucial to the development of virtue. For Inghirami, see Vat. Lat.
7928, 3r: "Pervetustum est illud multum referre in quae cuiusque tempora
virtus inciderit: Id ipsum in Marco Tullio est comprobatum, cui si ducentis
antea annis eum rudis et intractabilis Populus Romanus esset vel quinqua-
ginta saltem postea nasci contigisset cum tirannis omnia invaserat, procul-
dubio dimidio longe minor extitisset." Ibid., 9v: "Tu enim omnes virtutes
congestas habebas quae in alii singulae commemorantur; tu vim Demos-
thenis, iucunditatem Isocratis affinxeras Tu Gracchos inpetu, Lelium lev-
itate, Julium urbanitate Caesarem calore, Catonem gravitate, Calvum
sanctitate, Hortensium memoria superaveras, unusque fueras quem pos-
semus Graecis hominibus ad omnem comparationem illorum obponere,
fecerasque ut illorum studia tantum antecederet Romana eloquentia quan-
tum fortuna . . .' "

28 Cortesi, *Tres Libri de cardinalatu* and *Julium Secundum Pont[ificem] Max[imum]
per Parlum Cortesium Protonotarium Apostolicum* (Castel Cortesi: Symeon
Nardi, 1510), 98v: "Ideoque in comediis etiam videmus notari solere eos,
qui aut crebrius proiciant manus, aut nimis digitorum argutiis in agendo
utantur. T. quidem Phedrus Volaterranus, homo qui in adolescentia cel-
erior ad absolutam ethologiam pervenire potuisset, nisi enim ad eloquen-
tiam abstraxisset gloria expetita maior, cum Parilibus in Quirinali Plauti
Poetae Asinaria ageretur, in summis actorum laudibus, gestarum tantum et
manuum nimias argutias excepisse dicitur."

29 Tommaso Fedro Inghirami to Paolo Riccobaldi Maffei, Ott. Lat. 2413,
3r: "Studio litterarum ne intermittas: hae tibi erunt verae divitiae, hi ho-
nores, his magistratus, sed imprimis ama, et sectare bonas litteras: à Marco

Tullio ne latum quidem unguem absis. Illum imitare, effinge, expila, glube, nihil denique rectum puta, nisi quod illum oleat: ride reliqua." On Paolo Maffei, see José Ruysschaert, "Récherche des deux bibliothèques romaines Maffei des XVe et XVIe siècles," *La Bibliofilia* 60 (1958), 305–55.

30 Vat. Lat. 2742, 28v: "omnes stilos omnia et ex omnibus suam sibi eloquentiam conflabit Vergilius . . . hunc ergo imitemur, hunc sequamur, ab hoc ne latum quidem unquam digrediamur si poeticam assequi desideramus."

31 Raffaele Maffei to Mario Maffei, September 19, 1516, Vat. Lat. 7928, 67v–68r:

> Vir profecto cui nature dotes quantas nemini hoc tempore viderim, aut audiverim cumulatim obvenerant, praeter enim pronuntiationem, quae primus eius honos fuerat, ingenium innumerato quodammodo habebat, ita ut omnia quae tentaret ei magnopere succederent, unde gratiam ille principum facile inierat et ex paupere dives velociter est factus, denique fortunam ut homo Volaterranus secundam usque ad extremum ut vidimus habuit. Atque utinam haec dona caelestia caeteris artibus in quibus vera est laus ac felicitas coniunxisset, nihil eo beatius.

32 The anecdote is given, not without some gloating, by Cortesi, *De cardinalatu*, 124v: "litteratissimus Italorum . . . respondisse dicitur, eorum alterum non multo ac Chamaeleontem facere videri secus, qui eum colorem reddat imitando, quem adhaerescendo contingat, ab altero teredinis repraesentati morsum, quae quamquam sit in progrediendo lenta durum tamen lignum terendi assiduitate potest."

33 Roger Jones and Nicholas Penny, *Raphael* (New Haven: Yale University Press, 1983), 88–9.

34 In other words, Cicero was not a Ciceronian, just as Vitruvius was not a Vitruvian, and ancient Rome lacked Roman planning.

35 Santangelo, *Le Epistole "De imitatione"* 34:

> Huc accedit scripti genus varium, quod variam quoque sibi vendicat phrasin: Ciceronis enim Orationes, libri De Oratore ad Quintum fratrem, De claris oratoribus, et alii plerique, magno eloquentiae inundantur flumine, si non potius Oceano: sed ille ipse tam vastus fluvius vix irrigat Rhetoricos libros, eos qui de universitate, et de fato inscribuntur: idemque ipse vix stillat in Topicis. Mutatur quoque aetate mutata: et ab eodem Cicerone dicta est canescere oratio.

> English translations (somewhat abridged) and a brief outline of the controversy over Ciceronianism can be found in Scott, *Controversies*. All translations here are my own.

36 See Santangelo, *Le Epistole,* 27–28.

37 See also Pico della Mirandola, *Examen vanitatis doctrinae gentium* (Examination of the vanity of pagan teaching) of 1520.

38 Santangelo, *Le Epistole,* 32: "inde fiet, aequum rerum aestimatorem si sor-

tiatur nostra aetas, posse eos, qui nunc mediocriter loquuntur, praecipuis illis et antesignanis iure praeferri: qui sciliciet inter Gothos, Vandalos, Hunnosque versati priscam illam, et tot saeculis abolitam dicendi rationem aut teneant, aut tenere conentur imitatione continua: qua etiam in re mira subtilitas et forte nimia."

39 Ibid., 49, 51:

Venio igitur ad illam partem sermonis nostri, in qua ea mea sententia fuit; ut dicerem, eos mihi vehementer probari, qui prosa oratione scripturi, Ciceronem sibi unum ad imitandum proponerent; heroicis carminibus Virgilium . . .

 . . . Itaque sive ut in itinere conficiendo cum duces nacti sumus, securiore animo viam ingredimur, sic in reliquis rebus alacriores ad illa sumus, quorum doctores et magistros habemus: sive etiam ad omnem excellentem laudis et gloriae cupiditatem nulla re magis, quam aliorum aemulatione incitamur: mihi quoque idem faciendum putavi, cum poeticis in studiis, tum in oratoria disciplina; quod permultos fecisse intelligebam, ut in utraque earum artium et ducem, quem sequerer, et gloria illustrem, quem aemularer, eligerem; mihique ipse quasi signum proponerem, ad quod quidem conatus omnes nostri cogitationesque dirigerentur.

40 Ibid., 54:

Sed illud tenere omnes debebunt; et quantum in quoque est, niti atque perficere, qui aut oratoriae, aut poetices studiis delectabuntur: ut cum Ciceronem, tum Virgilium semel complexi nunquam dimittant: nunquam ullis aliorum scriptorum illecebris ab eorum imitatione aemulationeque revocentur. Qui si non in omnibus artis atque ingenii luminibus abundarent; si non universis scribendi virtutibus praediti cumulatique conspicerentur: essent autem ipsi caeteris una tantum virtute probatiores: tamen eos nos unos sequi tantummodo imitarique dicerem oportere propterea quod vicinius ad perfectam rationem illis ducibus, quam ullis aliis, progredi et pertendere possumus.

41 Translation by Julia Haig Gaisser in "The Rise and Fall of Göritz's Feasts," *Renaissance Quarterly* 48 (1995), 41.

42 The poem is frequently cited in contemporary verse anthologies; this transcript comes from the Archivio Chigi of the Vatican Library, MS 11450, 266:

Olim habuit Cypris sua tempora
Sua tempora Mavors olim habuit
Sua nunc tempora Pallas habet.

See Francesco Cancellieri, *Storia de' solenni possessi de' sommi pontefici detti anticamente processi o processioni dopo la loro coronazione dalla basilica vaticana alla lateranense* (Rome, 1802), 72–4. For the ceremony itself, aside from Cancellieri's book, see Ludwig Freiherr von Pastor, *History of the Popes from the Close of the Middle Ages*, trans. Frederick Ignatius Antrobus and R.F. Kerr (London: Heinemann, 1894–8), 7: 35–43; John Shearman, *Raphael's*

Cartoons in the Collection of Her Majesty the Queen and the Tapestries for the Sistine Chapel (London: Phaidon, 1972), 17–18; Richard Ingersoll, "The Ritual Use of Public Space in Renaissance Rome," Ph.D. diss., University of California at Berkeley, 1985, 201ff.; A. Cummings, *The Politicized Muse: Music for Medici Festivals, 1512–1538* (Princeton: Princeton University Press, 1992), chapter 3. My thanks to Sheryl Reiss for these latter references.

43 Pietro Bembo to Gianfrancesco Pico, in Santangelo, *Le Epistole,* 56:

Etenim quemadmodum Cicero inter Latinos extitit, qui unus omnes, quicunque ante illum boni scribendi magistri fuerunt, excelleret; quod quidem magnum atque divinum fuit: sic profecto alius existere aliquando poterit, a quo cum reliqui omnes, tum etiam ipse Cicero superetur. Id autem nullo modo accidere facilius potest, quam si, quem anteire maxime cupimus, eum maxime imitemur. Absurdium est enim confidere nos aliam invenire viam posse, quae melior sit, quam est illa via; quam Cicero non tam quidem invenit ipse, quam ab aliis inventam ampliorem et illustriorem reddidit: praesertim, cum quo tempore id fieri necesse est, quantum ipsi plane possumus, nondum exploratum habeamus. Quod si, quem maxime imitati fuerimus, etiam assequemur: tum adhibenda cura erit, ut illum anteire valeamus.

44 Vat. Lat. 3388, 68r, 274v: "Ad Leonem de phedri corpulentia":

Hesterna Leo luce cum perisset
Orator gravis et gravis poeta
Verum is sic tumulum replevit unus
Posteros monumenta ne sequantur.

45 See Fabrizio Cruciani, *Il Teatro del Campidoglio e le feste romane del 1513* (Milan: Polifilo, 1969), and *Teatro nel Rinascimento,* 406–33; Hubert Janitschek, "Das capitolinishe Theater vom Jahre 1513," *Repertorium für Kunstwissenschaft* 5 (1882), 259–70; Giovanni Cipriani, *Il Mito etrusco nel rinascimento fiorentino* (Florence: Olschki, 1980), 51–2.

46 See Cipriani, *Il Mito etrusco,* 48–66; John W. O'Malley, *Giles of Viterbo on Church and Reform* (Leiden: Brill, 1967), 30–2, 123–5.

47 See O'Malley, *Giles of Viterbo,* 122–6; F. X. Martin, *Friar, Reformer, and Renaissance Scholar: Life and Work of Giles of Viterbo, 1469–1532* (Villanova, PA: Augustinian Historical Institute, 1992), 133–4; Cipriani, *Il Mito etrusco,* 53–4. There are two copies of this text in the Biblioteca Angelica, Rome: MS 351 and MS 502.

48 The text actually refers to the ninth Christian age; there are ten *saecula* before Christ, and ten after. Egidio da Viterbo, "Historia XX saeculorum," Biblioteca Angelica, MS Lat. 351, 248 (245)r–v:

At nono saeculo: excultus: eo in dicendo splendoris ventum est: quo post eversum aurei saeculi veram elegantiam: nulla aetas pervenit . . . Quid dicam Romae his ipsis annis: ad Divae An[n]ae aram meo in templo per Goryciam

erectam: certamen poetarum visum: in sacris celebrandis: quale olim in turpi carmine fuit: in oscenis: scriptitandis: in scribendi flore fere eodem: cessit Venus Virgini . . . Quorum in scribendo foelicitate tu usus Leo Decime . . . Quae enim sancte prius: minus eleganter: quae eleganter non sancte scribebantur: nunc eadem simul sancte eleganterque scripta sunt.

49 Ibid., 22v:

Venatorum generosissime Leo, serva tibi predam tuam, ne eripi tibi illam patiare: fac ut in laqueo isto, quem asconderunt, pes male insidiantium comprehendatur . . . [leo]: silvarum [terror unicus]: tanquam tellus a te, celumque pendeat: qui unus sponsam tuam non modo cures sauciam sed iniuria affectam ulcisceris, venditam redimas, sorditatem laves: male olentem ungas: exutam induas: laceram reficias: pannosam exornes, afflicatam, ac miseram beatam, ac felicem perpetuo statuas: faciasque ut his beneficiis affecta legitimum sponsum te adoret.

50 Ibid., 2v: "Lex a Deo Opt[imo] Max[imo] data Mosi in apertis dictionum significationibus, populo est exposita, in arcanis litterarum, et quorundam divinorum nominum intellectibus soli Mosi, sanctisque, ac vere sapientibus introspicienda, ac penitus rimanda tradita est. Sensus ille est vulgaris, hic reconditus."

51 See Bonner Mitchell, *Rome in the High Renaissance: The Age of Leo X* (Norman: University of Oklahoma Press, 1972).

52 See Matthias Winner, "Raffael malt einen Elefanten," *Mitteilungen des Kunsthistorischen Instituts in Florenz* 11 (1965), 71–109; Silvio Bedini, "The Papal Pachyderms," *Proceedings of the American Philosophical Society*, 125.2 (1981), 75–90; Ingrid D. Rowland, *The Correspondence of Agostino Chigi, in Vatican Cod. Chigi R.V.c: An Annotated Edition*, Studi e Testi (Vatican City: Biblioteca Apostolica Vaticana, in press), 185–9. For my information on the papal pachyderms I am greatly indebted to Professor Hermann Walter.

53 See Hermann Walter, "Un Ritratto sconosciuto della 'Signorina Clara' in Palazzo Ducale di Venezia. Nota sulle mappe geografiche di Giambattista Ramusio e Giacomo Gastaldi," *Studi Umanistici Piceni* 14 (1994), 207–28; and "Contributi alla recezione umanistica della zoologia antica. Nuovi documenti per la genesi del '1515 RHINOCERVS' di Albrecht Dürer," *Res Publica Litterarum* 12 (1989), 267–77; A. Fontoura da Costa, *Deambulations of the Rhinoceros (Ganda) of Muzafar, King of Cambaia, from 1514–1516* (Lisbon: Division of Publications and Library Agency for the Colonies, 1937), 27–30.

54 Vat. Lat. 3353, 203v:

Ille ego tot celebres solitus spectare triumphos
Iulius extremae dum caput Urbis erat.
Scandentes sacra aspicio capitolia stultos

Hos quaerit titulos haec decora alta Leo.
Quaeque olim armatas turres in bella ferebat
Getula indignum bellua portat onus.
Patendum est, est Roma feris, pateto elephanti
Proximus humanis sensibus ille magis.

55 Vat. Lat. 3353, 204r, "Ad magistros elephantis": "Vos quibus est Elephas curae sit, dicite quaeso / Qui vehit, an vectus bellua, nam dubito."

56 Francesco Barbieri, *Tipografi romani del Cinquecento: Guillery, Ginnasio Mediceo, Calvo, Dorico, Cartolari* (Florence: Olschki, 1983), 16.

57 Ibid., 48.

58 Ibid., 19–20.

59 Ibid., 16–20.

60 Impressive testimony of Colocci's work in this regard can be seen in the eight-volume facsimile edition of what was once his own Portuguese *cancioneiro*, a huge collection of lyric poetry; Elza Paxeco Machado and José Pedro Machado, eds., *Cancioneiro da Biblioteca Nacional Antigo Colocci-Brancuti* (Lisbon: Edição da *Revista de Portugal*, 1949–64). The modern edition, appropriately and movingly, is dedicated to Colocci's memory.

61 See Chapter 6 of the present volume.

62 Fernanda Ascarelli, *Annali tipografici di Giacomo Mazzocchi* (Florence: Sansoni, 1960).

63 See Vittorio Fanelli, "Il ginnasio greco di Leone X a Roma," in his *Ricerche su Angelo Colocci e sulla Roma cinquencentesca*, Studi e Testi, no. 283 (Vatican City: Biblioteca Apostolica Vaticana, 1979), 91–110; Francesco Barberi and Emidio Cerulli, "Le Edizioni greche 'In Gymnasio mediceo ad Caballinum monteur," in *Atti del carvegno di Studi su Angelo Colocci, Iesi, 13–14 settembre 1969, Palazzo della Signoria* (Iesi: Amministraziare Comunale, 1972), 61–76; José Ruysschaert, "Trois Recherches sur le XVIe siècle romain," *Archivio della Società Romana di Storia Patria* 94 (1971), 17–29, as well as Rowland, "Render unto Caesar the Things Which Are Caesar's: Humanism and the Arts in the Patronage of Agostino Chigi," *Renaissance Quarterly* 39 (1986), 714–15, with the following corrections, for which my thanks are due to Staffan Fogelmark: Kalliergês, not Benigno, must have edited the Greek texts of the Pindar and the Theocritus; the colophon has a correct accusative tense rather than what I have read as an anomalous dative, n. 142; Benigno is not mentioned in the Theocritus. However, Benigno's financial affairs were still closely linked to those of Kalliergês, see Ruysschaert, "Trois Recherches," 21–2.

64 Staffan Fogelmark, private communication, 1994.

65 Ibid., "Trois Recherches," 21–2.

66 Ibid., 21 n. 37.

67 Ibid., 21.

68 Vat. Lat. 11173, 112v–113r; see Ruysschaert, "Trois Recherches," 22.

69 Fanelli, "Il Ginnasio greco," 98–103.

70 Barbieri and Cerulli, "Le edizioni greche," 63.

71 Ibid.

72 John Shearman, "Il 'Tiburio' di Bramante," in *Studi Bramanteschi*, 567–74.

73 Frommel, "Papal Policy: The Planning of Rome during the Renaissance," in Robert I. Rotberg and Theodore K. Rabb, eds., *Art and History: Images and Their Meaning* (Cambridge: Cambridge University Press, 1988), 55–9; Manfredo Tafuri, *Ricerca del Rinascimento* (Turin: Einaudi, 1992), 97ff. ("Un Princeps christianus: Leone X e la nuova Roma"). My thanks to Charles Stinger for the latter reference.

74 Vat. Lat. 10228. My thanks to Michael Koortbojian for this reference.

75 Some of Vitruvius's "scientific" information still holds up: he was the first writer to call attention to lead poisoning and its symptoms, and on that basis deplored the Romans' use of lead for their plumbing.

76 Ingrid D. Rowland, "Raphael, Angelo Colocci, and the Genesis of the Architectural Orders," *Art Bulletin* 76 (1994), 81–104; the edition by Vincenzo Fontana and Paolo Moracchiello, *Vitruvio e Raffaello. Il "De architectura" di Vitruvio nella traduzione inedita di Fabio Calvo ravennate* (Rome: Officina, 1975), has not done an accurate job of transcribing Colocci's admittedly difficult handwriting.

77 See Pier Nicola Pagliara, "La Roma Antica di Fabio Calvo: Note sulla cultura antiquaria e architettonica," *Psicon* 8–9 (1977), 65–87; Philip Jacks, "The *Simulachrum* of Fabio Calvo: A View of Roman Architecture all' antica in 1527," *Art Bulletin* 72 (1990), 453–81, and *The Antiquarian and the Myth of Antiquity: The Origins of Rome in Renaissance Thought* (Cambridge: Cambridge University Press, 1994), 183–204.

78 Arnold Nesselrath plausibly identifies a set of illustrations for Vitruvius in the anonymous Fossombrone sketchbook as copies from Raphael's own drawings for the projected publication; see his "Raphael's Archaeological Method," in Frommel and Winner, *Raffaello a Roma*, 362 and pl. 146, Figs. 12–13. Cf. Nesselrath, *Das fossombroner Skizzenbuch* (London: Warburg Institute, 1993), 171–4, Figs. 50–1.

79 The most recent work on the subject is Francesco P. de Teodoro's meticulous *Raffaello, Baldassar Castiglione e la lettera a Leone X* (Bologna: Nuova Alfa, 1994), which takes into account Colocci's participation in Raphael's archaeological studies. See also John Shearman, "Castiglione's Portrait of Raphael," *Mitteilungen des Kunsthistorischen Instituts zu Florenz* (1994), 69–97.

 Though this letter from an artist to a pope explicitly mentions neither by name, its attribution to Raphael and Leo X has been generally accepted for a long time. With the discovery of an autograph *minuta* of the first parts

of the text in the hand of Baldassare Castiglione (in the Castiglione family archive!), that humanist's contribution to its redaction, also a matter of general consensus, was made entirely secure. As we shall see, Raphael's autograph correction to one text of the letter confirms what was already an exceedingly strong case for his authorship.

The letter is published (with some inaccuracies) by Vincenzo Golzio, *Raffaello nei documenti nelle testimonianze dei contemporanei e nella letteratura del suo secolo* (Vatican City: Pontificia Insigne Accademia dei Virtuosi del Pantheon, 1936), 78–92, and in an extremely useful annotated edition (though still with significant textual inaccuracies) by Renato Borelli, "Lettera a Leone X," in *Scritti rinascimentali di architettura* (Milan: Polifilo, 1978), pp. 459–84. A new transcript of the Munich version of the letter is supplied in Rowland, "Raphael, Angelo Colocci." For the history of the letter and the identification of its authors, see that article and also Christof Thoenes, "La 'Lettera' a Leone X," in Frommel and Winner, *Raffaello a Roma*, 373–81; Gabriele Morolli, *"Le Belle Forme degli edifici antichi": Raffaello e il progetto del primo trattato rinascimentale sulle antichità di Roma* (Florence Alinea, 1984), 51–64. For the identification of Angelo Colocci as scribe, see Ingrid D. Rowland, "Angelo Colocci ed i suoi rapporti con Raffaello," *Res Publica Litterarum* 11 (1991), 217–25. I am much indebted to Professor Christof Thoenes for discussing the letter with me; he intends to produce an annotated edition of all three versions.

80 Vat. Lat. 3904, 272v: "Et quia magnus labor impendibatur a vitruvio in colu[m]narum proportionibus cepi columnas examinare."

81 Cited in Golzio, *Raffaello nei documenti*, 113; see also Nesselrath, "Raphael's Archaeological Method," 363.

82 So Thoenes, "La 'Lettera,' " 373–81.

83 De Teodoro, *Raffaello, Castiglione e la lettera a Leone X*.

84 In addition to the bibliography mentioned in note 79, see also Arnold Nesselrath and Howard Burns, "Raffaello e l' antico," in Christoph Frommel, Stefano Ray, and Manfredo Tafuri, eds., *Raffaello architetto* (Milan: Electa, 1984), 379–452.

85 See John Shearman, "Maniera as an Aesthetic Idea," in *Acts of the Twentieth International Congress of the History of Art* (Princeton: Princeton University Press, 1963), 2:200ff., and *Mannerism* (Harmondsworth, UK: Penguin, 1967), 15–22.

86 This and all subsequent citations are taken from my transcription of the latest (Munich) version of the letter to Leo X, MS It. 37b (discussed in note 79 to this chapter).

Ma, poichè Roma in tutto dalli barbari fu ruinata, arsa et distrutta, parve che quello incendio et quelle misera ruina ardesse et ruinasse, insieme con li edifici, anchora l' arte dello edificare. Onde, essendosi tanto mutata la fortuna de'

Romani Et succedendo, in luoco delle infinite victorie e triomphi, la calamitate et la miseria della servitù, Come non si convenisse a quelli, che già erano subiugati et fact servi altrui, habitar di quel modo e con quella grandezza che facevano quando esse haveano sugiogati li barbari, Subito – con la fortuna – si mutò el modo dello edificare et abitare, et apparve uno extremo tanto lontano da l' altro, quanto è la servitute dalla libertate; e ridusse a maniera conforme alla sua miseria, senza arte, o misura, o gratia alcuna.

87 Ibid.:

Non debbe adunche, Padre Santo, esser tra gli ultimi pensieri di Vostra Santità lo haver cura che quello poco che resta di questa anticha matre della gloria et nome italiano, per testimonio di quelli Animi divini, che pur thalhor con la memoria loro excitano e destano alla virtù li spiriti che hoggidì sono tra noi, non sia extirpato in tutto e guasto delli maligni e ingnoranti, che purtroppo si sono insino a qui facte ingiurie a quelli animi che sol sangue loro parturirono tanta gloria al mondo, et a questa patria et a noi; ma più presto cerchi Vostra Santità, lassando vivo el paragone de li antichi, aguagliarli et superarli, Come ben fa con magni edifici, col nutrire et favorire le virtuti: et risvegliare gl' ingegni: dar premio alle virtuose fatiche, spargendo el santissimo seme della pace tra li principi cristiani.

88 Ibid.:

E benché le lettere; la scultura, la Pictura et quasi tutte l' altre arti fossero longamente ite in declinatione, et peggiorando fino al tempo degli ultimi Imperatori, Pur l' architectura si osservava et manteneasi con bona ragione, et edificavasi con la medesima maniera che prima; E fu questa, tra le altre arti, l' ultima che si perse, e questo cognoscier si può da molte cose, e tra l' altre, da l' arco di Costantino, il componimento del quale è bello et ben fatto in tutto quel che appartiene all' architettura, ma le sculture del medesimo archo sono schiochissime, senza arte o disegno alcuno, buono, Quelle che vi sono delle spogle di Traiano e di antonino Pio sono excellentissime e di perfetta maniera.

89 See Nesselrath, "Raphael's Archaeological Method," 364–6.

90 Raphael, Letter to Leo X: "Il simile si vede nelle therme Diocletiane, ché le sculture del tempo suo sono di malissima maniera e mal facte, e le reliquie di pictura che si vegono non hanno che fare con quelle del tempo di Traiano et di Tito. E pur l' architectura è nobile et ben intesa."

91 So Thoenes, "La 'Lettera,' " 374–5; see also Morolli, "La Belle Forme," 51–2, n. 70; Rowland, "Raphael, Angelo Colocci," 92–3.

92 See Christoph Thoenes and Hubertus Günther, "Gli Ordini architettonici: Rinascita o invenzione?" in Marcello Fagiolo, ed., Roma e l'antico nell' arte e nella cultura del Cinquecento (Rome: Istituto di Studi Romani, 1985), 261–310; Christof Thoenes, "Bramante und die Säulenordnungen," Kunstchronik 30 (1977), 62–63; Arnaldo Bruschi, "L' Antico e la riscoperta degli ordini architettonici nella prima metà del Quattrocento: Storia e problemi," in Silvia Danesi Squarzina, ed., Roma, Centro ideale della cultura

dell' Antico nei decoli XV e XVI. Da Martino V al Sacco di Roma, 1417–1527 (Milan: Electa, 1989), 410–34; Christiane Denker-Nesselrath, *Die Säulenordungen bei Bramante* (Worms: Wernersche Verlagsgesellschaft, 1990). Joseph Rykwert's *Dancing Column* was not yet available at the time of writing.

93 Vitruvius, *De architectura libri decem*, 4.8.4–6.

94 See Simonetta Valtieri, "L'Architettura a Roma nel XV secolo: L' Antico come 'imitazione' e come 'interpretazione' nel suo processo formativo e evolutivo," in Danesi Squarzina, *Roma, centro ideale*, 257–68.

95 See Rowland, "Raphael, Angelo Colocci," 97–9.

96 See Pagliara, "Vitruvio da testo a canone," in Salvatore Settis, ed., *Memoria dell' antico nell' arte italiana* (Turin: Einaudi, 1986), 3:38–57.

97 Giorgio Vasari reports in his Life of Giovanni da Udine that Giovanni's stucco was white whereas Bramante's was gray; see Nesselrath, "Raphael's Archaeological Method," 364.

98 On the Chigi Chapel, see John Shearman, "The Chigi Chapel in Santa Maria del Popolo," *Journal of the Warburg and Courtauld Institutes* 24 (1961), 129–60; Enzo Bentivoglio, "La Cappella Chigi," in Enzo Bentivoglio and Simonetta Valtieri, *Santa Maria del Popolo* (Rome: Bardi, 1976), 104–20; Christoph Luitpold Frommel, "Das Hypogäum Raffaels undter der Chigi Kappelle," *Kunstchronik* 27 (1974), 128–47, 307–10; and "Il Sepolcreto della cappella Chigi e altre note raffaelesche," *Bollettino del Centro di Studi per la Storia dell' Architettura* 24 (1979), 89–92; Kathleen Weil-Garris Brandt, "Cosmological Patterns in Raphael's Chigi Chapel in S. Maria del Popolo," in Frommel and Winner, *Raffaello a Roma*, 127–57; Stefano Ray, "La Cappella Chigi: Significato e cultura," and 315–22; idem, *Raffaello architetto*, 125–42; Giuseppe Marchini, "Le Architetture"; John Shearman, *Only Connect: . . . Artist and Spectator in the Italian Renaissance: The A. W. Mellon Lectures in the Fine Arts, 1988* (Washington, DC: National Gallery of Art / Princeton: Princeton University Press, 1992), 178–81. I am also greatly indebted to a long series of conversations *in situ* with the late Marc Worsdale in the early 1980s.

99 For the revision of the Chigi Chapel's scheme late in Raphael's career, see John Shearman, "Pentimenti in the Chigi Chapel," in Moshe Barasch and Lucy Freeman Sandler, eds., *Art the Ape of Nature: Studies in Honor of H. W. Janson* (Englewood Cliffs, NJ: Prentice-Hall, 1981), 219–22.

100 See Shearman, "The Chigi Chapel"; Rowland, "Render unto Caesar," 694–711; Anna Maria Odenthal, "Zur architektonischen Planung der Cappella Chigi bei S. Maria del Popolo," in Frommel and Winner, *Raffaello a Roma*, 305–8; Enzo Bentivoglio, "La Cappella Chigi," in Frommel and Winner, *Raffaello a Roma*, 309–14; Ray, "La Cappella Chigi," 315–22.

101 See Fabrizio Winspeare, *La Congiura dei cardinali contro Leone X* (Florence: Olschki, 1957), and Alessandro Ferraioli, *La Congiura dei cardinali contro Leone X* (Rome: Reale Società di Storia Patria, 1919).

102 Rowland, *The Correspondence of Agostino Chigi,* 214–21, 253.

103 Still an enigmatic figure in ancient Rome, Maecenas came to grief in connection with the fall from grace, between 23 and 22 B.C., of his brother-in-law Licinius Murena (Dio Cassius 54.3.1–5), put to death for his connection with the conspiracy of Caepio; see Robin Nisbet and Margaret Hubbard, *A Commentary on Horace's Odes, Book I* (Oxford: Oxford University Press, 1970), xxxvi–xxxvii, with bibliography.

104 Gilbert, *The Pope, His Banker, and Venice* (Cambridge, MA: Harvard University Press, 1980), 95–109; Rowland, *The Correspondence of Agostino Chigi,* 184–276.

105 Juan de Ortega, *Suma de arithmetica: Geometria: Pratica utilissima: Ordinata per Johane de Ortega Spagnolo Palentino* (Rome: Stefano Guilleri di Lorena, 1516).

106 "Correctio erroris qui ex equinoctio vernali in kalendario procedere solet," Vat. Lat. 8846. For Benigno Salviati, see Cesare Vasoli, "Giorgio Benigno Salviati (Dragisic)," in Marjorie Reeves, *Prophetic Rome in the High Renaissance Period* (Oxford: Clarendon Press, 1992), 121–56.

107 See Giuseppi Cugnoni, *Agostino Chigi il Magnifico,* Archivio della Reale Società Romana di Storia Patria (Rome: Istituto di Studi Romani, 1878); Mary Quinlan-McGrath, "The Villa of Agostino Chigi: The Poems and the Paintings," Ph.D. diss., University of Chicago, 1983; Christoph Luitpold Frommel, *Die Farnesina und Peruzzis Architektonisches,* Frühwerk (Berlin: De Gruyter, 1961); Stefano Ray, *Raffaello architetto: Linguaggio artistico e ideologia nel Rinascimento romano* (Bari: Laterza, 1974); Rowland, "Render unto Caesar," 683–93, and "Some Panegyrics to Agostino Chigi," *Journal of the Warburg and Courtauld Institutes* 47 (1984), 194–9.

108 Cugnoni, *Agostino Chigi,* 63–6.

109 Frommel, *Die Farnesina,* 9–10; Gilbert, *The Pope,* 99; Cugnoni, *Agostino Chigi,* 63–6; Frommel and Winner, *Raffaello a Roma.*

110 See Christof Thoenes, "Galatea: Tentativi di avvicinamento," in Frommel and Winner, *Raffaello a Roma,* 59–74; Millard Meiss, "Raphael's Mechanized Seashell: Notes on a Myth, Technology, and Iconographic Tradition," in his *Painter's Choice: Problems in the Interpretation of Renaissance Art* (New York: Harper and Row, 1976), 203–11.

111 Michaela J. Marek, "La 'Loggia di Psyche' nella Farnesina: Per la ricostruzione ed il significato," in Frommel and Winner, *Raffaello a Roma,* 209–16; Konrad Oberhuber, "Raphael's Drawings for the Loggia of Psyche in the Farnesina," in ibid., 189–208.

112 Quinlan-McGrath, "The Villa of Agostino Chigi"; Rowland, "Some Pan-egyrics"; Rowland, "Render unto Caesar," 726–7.

113 See Michael Hirst, "The Chigi Chapel in Santa Maria della Pace," *Journal of the Warburg and Courtauld Institutes* 24 (1961), 161–85.

114 Arnold Nesselrath persuasively traces the choice of methods – plan, or-thogonal elevation, and perspective rendering – to Fra Giocondo's Vitru-vius; see "Raphael's Archaeological Method," 361.

115 On the *Simulachrum*, see Philip Jacks, "The *Simulachrum*," 453–81; and *The Antiquarian and the Myth of Antiquity*, 183–204; Pagliara, "La Roma An-tica," 65–87.

EPILOGUE: REFORMATION (1517–1525)

1 See John W. O'Malley, "Erasmus and Luther: Continuity and Disconti-nuity as Key to Their Conflict," *Sixteenth Century Journal* 5.2 (1974), 47–65, reprinted in his *Rome and the Renaissance* (London: Variorum, 1981), 12:47–65.

2 See Ingrid D. Rowland, "Revenge of the Regensburg Humanists," *Six-teenth Century Journal*, 25 (1994), 307–22.

3 Peter Partner, *The Pope's Men: The Papal Service in the Renaissance* (Oxford: Oxford University Press, 1990), 8–13, 188–9, 207–9.

4 John W. O'Malley, "Historical Thought and the Reform Crisis of the Early Sixteenth Century," *Theological Studies* 28 (1967), 531–48, reprinted in his *Rome and the Renaissance*, 2:531–48.

5 Egidio's official correspondence has been edited by Clare O'Reilly as *Giles of Viterbo: Letters as Augustinian General* (Rome: Institutum Historicum Au-gustinianum, 1992). See also F. X. Martin, *Friar, Reformer, and Renaissance Scholar: Life and Work of Giles of Viterbo, 1469–1532* (Villanova, PA: Au-gustinian Press, 1992), 73–118.

6 See Paolo Giannini, "L' Amore per la solitudine del cardinale Egidio An-tonini ed il Convento della Santissima Trinità in Soriano," *Biblioteca e Società* 4.1–2 (Viterbo, June 30, 1982), 39–40; Anna Maria Voci [Roth], "Idea di contemplazione ed eremitismo in Egidio da Viterbo," in Carlos Alonso, ed., *Egidio da Viterbo, O.S.A. e il suo tempo, Atti del V Convegno del Istituto Stovico Agostiniano, Roma–Viterbo, 20–23 ottobre 1982* (Rome: Analecta Augustiniana, 1983), 107–16; Rowland, "A Summer Outing in 1510: Religion and Economics in the Papal War with Ferrara," *Viator* 18 (1987), 355.

7 A facsimile edition of *Julius exclusus* is available at the beginning of Carl Stange, *Erasmus und Julius II: Eine Legende* (Berlin: Töpelmann, 1937); there is also a Latin text edited by Wallace K. Ferguson in *Erasmi opuscula* (The Hague: Nijhoff, 1933). Lively English translations with introductory

essays have been produced by Paul Pascal (with introduction and critical notes by J. Kelley Sowards), *The "Julius Exclusus" of Erasmus* (Blooming- ton: Indiana University Press, 1968), and by Michael J. Heath, in Erasmus, *Collected Works*, ed. A.H.T. Levi (Toronto: University of Toronto Press, 1986), 27:168–97. The translation here is my own.

8 On the *Ciceronianus* and the circumstances on which it comments, see the edition with Italian translation by Angelo Gambaro, *Erasmo da Rotterdam, Il Ciceroniano o dello stile migliore* (Brescia: La Scuola, 1965). See also John D'Amico, *Papal Humanism in Renaissance Rome: Humanists and Churchmen on the Eve of the Reformation* (Baltimore: Johns Hopkins University Press, 1983), 138 and n. 112; Luca d' Ascia, *Erasmo e l'umanesimo romano* (Flor- ence: Olschki, 1991). For the publishing history of the letters of Pico and Bembo, see Giorgio Santangelo, ed., *Le Epistole 'de Imitatiare' di Giovan- francesco Pico della Mirandola e di Pietro Bembo* (Florence: Olschki, 1954), 6– 18.

9 Aretino's sojourn with Chigi appears in three of his letters, nos. 162, 619, and 626.

10 Pietro Aretino, *Sei giornate*, ed. Angelo Romano (Milan: Mursia, 1991), 118–19:

E io, non mi potendo saziare di vedere i cortigiani, perdea gli occhi per i fori della gelosia vagheggiando la politezza loro in quei sai di velluto e di raso, con la medaglia nella berretta e con la catena al collo, e in alcuni cavalli lucenti come gli specchi, andando soavi soavi con <i> loro famigli alla staffa, nella quale teneano solamente la punta del piede, col petrarchino in mano, cantando con vezzi: "Se amor non è, che dunque è qual ch' io sento?" E fermatosi questo e quello dinanzi alla finestra dove io facea baco baco, dicevano: "Si- gnora, sarete voi sì micidiale che lasciate morire tanti vostri servidori?"; e io alzato un pocolino la gelosia e con un risetto rimandatola giuso, mi fuggiva dentro; ed eglino, con un "bascio la mano a vostra Signoria" e "con un giuro a Dio che sète crudele," si partivano . . . Fingeva onestà di monica, e guardando con sicurtà di maritata, faceva atti di puttana.

11 See Pietro Aretino, *Sonetti sopra i "XVI modi,"* ed. Giovanni Aquilecchia (Rome: Salerno, 1992), esp. Aquilecchia's notes and bibliography, which recapitulate his earlier work and cast light, positive and negative, on other recent scholarship.

12 For the life of Longueil, see Théophile Simar, *Christophe de Longueil, Hu- maniste (1488–1522)* (Louvain: Peeters, 1911).

13 Ibid., 30–3.

14 Ibid., 51, cites Giovio's *Elogia virorum literis illustrium.*

15 Simar, *Longueil*, 14–30.

16 See Domenico Gnoli, *Un Giudizio di lesa romanità nella Roma di Leone X* (Rome: Hoepli, 1891); D'Amico, *Papal Humanism*, 110–11; Julia Haig

Gaisser, "The Rise and Fall of Göritz's Feasts," *Renaissance Quarterly* 48 (1995), 48–51.

17 Gaisser, "The Rise and Fall," 41–57.

18 Girolamo Seripando on Leo X, Ang. 351, 398r:

Hoc scio ad hanc diem spes illas magnas, quas de leone, non absque magna ratione conceperat, elusas fuisse, ac pene in nihilum recidisse. Cum ab eius Pontificatu in peius omnia ruere ceperint, ac retro sublapsa referri, sive de bello contra Turchas agamus, sive de imperio, cuius magna pars amissa est, Mutina, Rhegium, Parma, Placentia. Sive de moribus, quorum lumen omne extinctum est, Sive de existimatione, quae nunquam fuit in hominum mentibus deterior. Sive de auctoritate, quae nunquam fuit minor, adeo ut in lusum fere abierit. Dux Urbini pulsus. Post legatos ad reges missos pro bello contra Turchas. Bellum Mediolanense contra Gallos. Monstrum gemellorum ad umbilicum alterius affixus erat.

Bibliography

PRIMARY SOURCES

Manuscripts

Cambridge, Massachusetts, Houghton Library, Harvard University
MS Lat. 358. Collected verse, probably by a friend of Angelo Colocci. 16th c.

Florence, Biblioteca Nazionale Centrale
MS Magliabechianus C.I.616. Leonardo da Pisa (Fibonacci), "Liber Abaci." 13th c.

London, British Library
Additional MS 10265. Papers of Pier Vettori, including letters from Angelo Colocci. 16th c.

Rome, Archivio di Stato
Notai A.C. 4836– 38. Notarial records of Filippo Pagni and Cristofano Pagni. 16th c.
Notai A.C. 7152. Notarial records of Francesco Vigorosi. 16th c.
Ospedale di San Rocco, buste 109–111, 120. Papers of Francesco Tommasi, bank books of Banco Chigi. 16th c.

Rome, Biblioteca Angelica
MS 351. Egidio da Viterbo. "Historia XX saeculorum." 16th c.
MS 502. Egidio da Viterbo. "Historia XX saeculorum." (Girolamo Seripando's copy). 16th c.
MS 1001. Egidio da Viterbo. Correspondence. 16th c.

Rome, Biblioteca Lancisiana

MS 328. Rolls of the Confraternity of Santo Spirito in
 Sassia. 15th c.

Siena, Archivo di Stato

Balía 49. Deliberations of the City Council. 16th c.

Vatican City, Biblioteca Apostolica Vaticana

Archivio Chigi 361. Chigi family papers. 16th c.
Archivio Chigi 413. Copies of Chigi family papers from Roman ar-
 chives. 17th c.
Archivio Chigi 3666. Chigi family documents on parchment. 14th–
 16th c.
Archivio Chigi 11445–55. Copies of Chigi family papers. 17th c.
Cappella Sistina 46. Music for the Sistine Chapel choir. 16th c.

Chigi a.I.1. Fabio Chigi. "Chisiae familiae commentarii."
 17th c.
Chigi G.I.31–G.II.40. Sigismondo Ticci. "Historia senensium." 16th
 c.
Chigi R.V.b. Chigi family contracts. 15th–16th c.
Chigi R.V.c. Agostino Chigi et al. Correspondence. 16th c.
Chigi R.V.e, i-iii. 16th–17th c. Chigi family documents and 17th-
 century copies.
Ott. Lat. 2413. Maffei family letters. 16th c.
Ott. 2860. Humanistic verse collected by Angelo Colocci.
 16th c.
Vat. Lat. 180–185. Philo of Alexandria. "Opera omnia." Trans.
 into Latin by Egidio Lilio. 15th c.
Vat. Lat. 2742. Tommaso Fedro Inghirami. "Commentaria in
 Artem poeticam." (Commentary on the
 Ars poetica of Horace.) 16th c.
Vat. Lat. 2835. Humanistic verse collected by Angelo Colocci.
 16th c.
Vat. Lat. 2862. Pacifico Massimi. Collected verse. 16th c.
Vat. Lat. 3123. "Corpus Agrimensorum." Copied by Basilio
 Zanchi, 1530s.
Vat. Lat. 3129. Luca Pacioli. "Samma de Arithmetica. 15th c.
Vat. Lat. 3351. Fausto Capodiferro. Colonna family accounts,
 news, verse. 16th c.

Vat. Lat. 3353.	Humanistic verse collected by Angelo Colocci, metrological notes, "De Elementorum Situ." 16th c.
Vat. Lat. 3388.	Humanistic verse collected by Angelo Colocci. 16th c.
Vat. Lat. 3896.	Papinio Cavalcanti. "Libellus de numerandi disciplina." 112r-150r. 16th c.
Vat. Lat. 3892.	Marco Fabio Calvo. "De numeris." 16th c.
Vat. Lat. 3904.	Autograph notes on measure by Angelo Colocci. 16th c.
Vat. Lat. 3906.	Autograph notes on measure by Angelo Colocci. 16th c.
Vat. Lat. 3909.	Collected letters of Vincenzo Calmeta. 16th c.
Vat. Lat. 4784.	Petrarch. "Rime." Colocci family copy with family records. 15th c.
Vat. Lat. 4817.	Angelo Colocci. Notes on language, esp. vernacular. 16th c.
Vat. Lat. 5159.	Serafino Ciminelli Aquilano. "Rime." 15th–16th c.
Vat. Lat. 5233.	Janus Parrhasius. Correspondence. 16th c.
Vat. Lat. 6325.	Egidio da Viterbo. "Sententiae ad mentem Platonis." 16th c.
Vat. Lat. 7928.	17th-c. copies of 16th-c. Maffei family letters.
Vat. Lat. 11177	Miscellaneous contracts stolen in 19th c. from Archivio di Stato, Rome, by Girolamo Amati, several involving Agostino Chigi. 16th c.
Vat. Lat. 14065.	Miscellaneous papers of Angelo Colocci. 16th c.

Printed Books

Achillini, Giovanni Filoteo. *Collettanee grece-latine-e vulgari per diversi auctori moderni-nella morte de lardente Seraphino Aquilano. Per Gioanne Philotheo Achillino bolognese in uno corpo redutte. Et alla Diva Helisabetta Feltria da Gonzaga Duchessa di Urbino dicate.* Bologna: Caligula Bazaliero: 1504.

Acta Concilii Lateranensis V. Rome: Jacopo Mazzocchi, 1521.

Acta Concilii Lateranensis V. Biblioteca Apostolica Vaticana, Stampati R.I.IV.2107. Collection of contemporary pamphlets from the Fifth Lateran Council. 1512–21.

Agustín, Antonio. *Antiquitatum romanarum hispanarumque in nummis veterum dialogi xi.* Latin translation by Andreas Schott. Antwerp: Henrik Aerts, 1617.

Alberti, Leone Battista. *L'Architettura (De re aedificatoria)*. Ed. Giovanni Orlandi, introduction and notes by Paolo Portoghesi. Milan: Polifilo, 1966.

Annius of Viterbo. *See* Giovanni Nanni.

Annius Viterbiensis. *See* Giovanni Nanni.

Antiquitates. See Giovanni Nanni, *Commentaria* . . .

Aretino, Pietro. *Sei giornate*. Ed. Angelo Romano. Milan: Mursia, 1991.

 Sonetti sopra I "XVI modi." Ed. Giovanni Aquilecchia Rome: Salerno, 1992.

Arrighi, Lodovico degli. *Essemplario de' scrittori*. Rome: Ugo da Carpi. 1522.

Bembo, Pietro. *De Aetna*. Venice: Aldus Manutius, 1494.

 Lettere. Ed. Ernesto Travi. Bologna: Commissione per i Testi di Lingua, 1987.

Bertóla, Maria. *I Due Primi Registri de prestito della Biblioteca Apostolica Vaticana, Codices Vaticani Latini* 3964, 1966. Vatican City: Biblioteca Apostolica Vaticana, 1942.

Boethius. *Ars geometriae*. Ed. Gottfried Friedlein. Leipzig: Teubner, 1867.

Borgia, Lucrezia. *Lucrezia Borgia, la grande fiamma, lettere, 1503–1717*. Ed. Giula Raboni. Milan: Rosellina Archinto, 1989.

[Bramante, Donato (?).] *Antiquarie prospettiche romane composte per prospettico melanese depictore*. Reprinted in Gori, *Intorno a un opuscolo rarissmo*.

Budé, Guillaume. *De asse et eius partibus*. Paris: Iodocus Badius Ascensianus, 1514; also Venice: Aldus Manutius, 1522.

[Burchard, Johann.] Johannes Burckardus. *Liber notarum*. Ed. Enrico Celani. Rerum Italicarum Scriptores, no. 32. Città di Castello: s. Lapi, 1906.

Calmeta, Vincenzo. *Vita del facondo poeta vulgare Seraphino Aquilano per Vincentio Calmeta composta*. In Achillini, *Collettanee grece-latine-e vulgari*. + iiii 2r– v.

Ciminelli, Serafino. *See* Serafino Aquilano.

Colocci, Angelo. *Apologia per le rime de Serafino Aquilano*. In Menghini, ed., *Le Rime de Serafino de' Ciminelli dall'Aquila*.

Colonna, Egidio, bishop of Bourges. [Giles of Rome]. *Egidius Romanus De esse et essentia. De mensura angelorum. et de cognitione angelorum*. Venice: Simon de Luere for Andrea Torresani de Asola, 1503.

Colonna, Francesco. Pseud. (?) See *Hypnerotomachia*.

Corpus agrimensorum Romanorum. Ed. Carl Thulin. Leipzig: Teubner, 1913.

Cortesi, Paolo. *De hominibus doctis*. Ed. Maria Teresa Graziosi. Rome: Bonacci, 1973.

 Prohemium in Librum primum sententiarum ad Iulium II Pont. Max. Rome: Besicken, 1504.

 Tres libri De cardinalatu ad Julium Secundum Pont[ificem] per Paulum Cortesium Protonotarium Apostolicum. Castel Cortesi: Symeon Nardi, 1510.

Coryciana. Ed. Blosio Palladio. Rome: Lodovicus Vicentinus [Lodovico degli Arrighi] and Leutitius Perusinus, 1524.

Egidio da Viterbo. [Giles of Viterbo.] *Lettere familiari*. Ed. Anna Maria Voci Roth.

Fontes Historiae Ordinis Sancti Augustini, no. 18. Rome: Institutum Historicum Augustinianum, 1990.

Giles of Viterbo. Letters as Augustinian General. Ed. Clare O'Reilly. Rome: Institutum Historicum Augustininaum, 1992.

Erasmus, Desiderius. *Julius exclususo.* Trans. Michael J. Heath. Vol. 27 in A. H. T. Levi, ed., *Collected Works of Erasmus.* Toronto: University of Toronto Press, 1986. 168–97.

The Julius Exclusus of Erasmus. Trans. Paul Pascal. Intro. and critical notes by J. Kelley Soward. Bloomington: Indiana University Press, 1968.

Julius exclusus de caelo. Erasmi opuscula. Ed. Wallace K. Ferguson. The Hague: Nijhoff, 1933.

Fibonacci. [Leonardo da Pisa]. *Scritti di Leonardo Pisano.* Ed. Baldassare Ludovisi Boncampagni. Rome: Tipografia della Scienze matematiche e Fisiche, 1857.

Florio, John. *Queen Anna's New World of Words.* London: M. Braidwood for E. Blount and W. Barret, 1511.

Fulvio, Andrea. *Antiquaria Urbis.* Rome: Mazzocchi, 1513.

Garghi, Giovanni Battista. Oration for the Fifth Lateran Council, session 8. Contemporary pamphlet, now contained in Biblioteca Apostolica Vaticana, Stampati R.I.IV.2107.

Garin, Eugenio, ed. *Prosatori latini del Quattrocento.* Milan: Ricciardi, 1952.

Giles of Rome. *See* Egidio Colonna.

Giles of Viterbo. *See* Egidio da Viterbo.

Hypnerotomachia Poliphili. By "Francesco Colonna" (pseud. ?). Venice: Aldus Manutius, 1499.

Francesco Colonna, *"Hypnerotomachia Poliphili," Edizione critica e commento.* Ed. Giovanni Pozzi and Lucia Ciapponi. Vol. 1. Padua: Antenore, 1980.

Inghirami, Curzio. *Discorso sopra l'opposizioni fatte all' antichità toscane.* Florence: A. Massi and L. Landi, 1645.

Inghirami, Tommaso Fedro. *Thomae Phaedri Inghirami laudatio in obitu Ludovici Podocathari Cypri S.R.E. cardinalis.* Ed. Pier Luigi Galletti. Rome: A. Fulgoni, 1773.

Thomae Phaedri Inghirami orationes duae. Ed. Pier Luigi Galletti. Rome: Generoso Salomone, 1777.

Thomae Phaedri Inghirami volaterrani in laudem Ferinandi Hispaniorum Regis Catholici ob bugiae in Africa captum oratio. Ed. Pier Luigi Galletti. Rome: A. Fulgoni, 1773.

Leonardo da Pisa. *See* Fibonacci.

Machiavelli, Niccolò. Vol. 6 in *Opera. Lettere.* Ed. Franco Gaeta. Milan: Feltrinelli, 1961.

Maffei, Raffaele. *Commentaria Urbana.* Rome: Eucharius Silber, 1506.

Nanni, Giovanni, O.P. [Annius of Viterbo/Annius Viterbiensis]. *Ad beatissimum papam Sixtum: et reges ac senatus christianos de futuris christianorum triumphis*

contra turchos et maomethanos omnes epistola magristri Joannis viterbiensis. Genoa: per Reverendum Magistrum Baptistam Cavalum ordinis predicatorum, 1480.

Commentaria Fratris Joannis Annii Viterbiensis super opera diversorum auctorum de antiquitatibus loquentium. Rome: Eucharius Silber, 1498.

de Ortega, Juan. *Suma de arithmetica: Geometria: Pratica utilissima: ordinata per Johane de Ortega Spagnola Palentino.* Rome: Stefano Guilleri di Lorena, 1516.

Pacioli, Luca. *Summa de arithmetica.* Venice: Paganinus de Paganinis, 1494.

Pico, Giovanni Francesco. *Opera ominia.* Basel: Sebastianus Henricpetrus, 1601.

Platina. *Platynae historici liber de vita Christi ac omnium pontificum.* Ed. Giacinto Gaida, Rerum Italicarum Scriptores, III.1. Città di Castello: Lapi. 1913–32.

Plutarch. *De Iside et Osiride.*

Pontano. Iohannes Iovianus Pontanus. *De sermone libri sex.* Ed. Sergio Lupi and Antonio Risicato. Lugano: Thesaurus Mundi, 1954.

Randolph, Randolph. "On a maide of honor seene by a scholler in Sommerset Garden." In *The Metaphysical Poets,* ed. Helen Gardner. Harmondsworth, UK: Penguin, 1972.

Reisch, Gregor. *Margarita philosophica.* Freiburg: Johannes Schottus, 1503.

Santangelo, Giorgio, ed. *Le Epistole "De imitatione" de Giovanfrancesco Pico della Mirandola e di Pietro Bembo.* Florence: Olschki, 1954.

Schedel, Hartmann. *Liber chronicarum.* Nuremberg: Anton Koberger, 1493.

Scriptores metrologici. Ed. F. Hultsch. Stuttgart: Teubner, 1971. Reprint of Leipzig: Teubner, 1864–66.

Serafino Aquilano [Serafino Ciminelli]. *Le Rime di Serafino de' Ciminelli dall' Aquila.* Ed. Mario Menghini. Vol. 75 in *Collezione di opere inedite o rare di scrittori italiani dal XIII al XVI secolo,* ed. Giosuè Carducci. Bologna: Romagnoli–Dall'Acqua, 1894–96.

Ubaldini, Federico. *Vita di Mons. Angelo Colocci, Edizione del testo originale italiano (Barb. lat. 4822).* Ed. Vittorio Fanelli. Studi e Testi, no. 256. Vatican City: Biblioteca Apostolica Vaticana, 1969.

Vasari, Giorgio. *Le Vite de' più eccellenti pittori, scultori e architettori, nelle redazoni del 1550 e 1568,* ed. Rosanna Bettarini, with commentary by Paola Barocchi. Florence: Sansoni, 1966–84.

Vitruvius. *L. Victruvii Pollionis De architectura libri decem.* Ed. Iohannes Sulpicius [Giovanni Sulpizio da Veroli]. Rome, 1486(?).

M. Vitruvius per Iocundum solito castigatior factus cum figuris et tabulis ut iam legi et intelligi possit. Venice: [G]io[v]anni Tacuino de Tridino, 1511.

SECONDARY SOURCES

Ackerman, James S. "The Belvedere as a Classical Villa." *Journal of the Warburg and Courtauld Institutes* 14 (1951), 70–91. Reprinted with postscript in *Dis-*

tance Points: Essays in Theory and Renaissance Architecture. Cambridge, MA: MIT, 1991. 325–59.

The Cortile of the Belvedere. Studi e Documenti per la Storia del Palazzo Apostolico Vaticano, no. 3. Vatican City: Biblioteca Apostolica Vaticana, 1954.

Allen, Michael J. B. *Marsilio Ficino and the Phaedran Charioteer*. Berkeley and Los Angleles: University of California Press, 1981.

The Platonism of Marsilio Ficino. Berkeley and Los Angeles: University of California Press, 1984.

Alonso, Carlos, ed. *Egidio da Viterbo, O.S.A., e il suo tempo. Atti del V Convengno del Istituto Storico Agostiniano, Roma–Viterbo, 20–23 ottobre 1982*. Rome: Analecta Augustiniana, 1983.

Arrin, Leila. *Scribes, Script, and Books: The Book Arts from Antiquity to the Renaissance*. Chicago: American Library Association, 1991.

Ascarelli, Fernanda. *Annali tipografici di Giacomo Mazzocchi*. Florence: Sansoni, 1960.

Ascheri, Mario. *Siena nel Rinascimento. Istituzioni e sistema politico*. Siena: il Leccio, 1985.

Atti del Convegno di Studi su Angelo Colocci, Jesi, 13–14 settembre 1969, Palazzo della Signoria. Iesi-Amministrazione Comunale, 1972.

Atti del Congresso Internazionale su S. Agostino nel XVI centenario della conversione, Roma, 15–20 settembre 1986. Studia Ephemeridis "Augustinianum," nos. 24–6. Rome: Institutum Patristicum Augustinianum, 1987.

Aurigemma, Maria Giulia. "La Rocca è un labirinto. Nascita e sviluppo del presidio ostiense." In Danesi Squarzina and Borghini, eds., *Il Borgo di Ostia*. 60–103.

Babcock, Robert G., and Mark L. Sosower. *Learning from the Greeks: An Exhibition Commentary Commemorating the Five-Hundredth Anniversary of the Founding of the Aldine Press*. New Haven: Beinecke Rare Book and Manuscript Library, 1994.

Barbalarga, Donatella. "I Centri di cultura contemporanei: Collegi, studi conventuali e biblioteche pubbliche e private." In Cherubini, ed., *Roma e lo Studium Urbis*. 17–27.

Barberi, Francesco, and Emidio Cerulli. "Le Edizioni Greche in gymnasio mediceo ad Caballinum montem." In *Atti del Convegno di Studi su Angelo Colocci*. 61–76.

Barbieri, Francesco. *Tipografi romani del Cinquecento: Guillery, Ginnasio Mediceo, Calvo, Dorico Cartolari*. Florence: Olschki, 1983.

Barkan, Leonard. *Transuming Passion: Ganymede and the Erotics of Humanism*. Stanford: Stanford University Press, 1991.

Barnard, Francis P. *The Casting-Counter and the Counting-Board*. Oxford: Clarendon Press, 1916.

Battisti, Eugenio. "Bramante, Piero e Pacioli ad Urbino." *Studi Bramanteschi.* 267–82.

Baxandall, Michael. *Painting and Experience in Fifteenth-Century Italy: A Primer in the Social History of Pictorial Style.* Oxford: Oxford University Press, 1972.

Bec, Christian. *Cultura e società a Firenze nell' età della Rinascenza.* Rome: Salerno, 1981.

Les Marchands Écrivains, affaires et humanisme à Florence, 1375–1434. Paris–La Haye: Mouton, 1967.

Becherucci, Luisa. "Le Pitture." In *Raffaello: L'Opera, le fonti, la fortuna.* 1: 135–59.

Bedini, Silvio. "The Papal Pachyderms." *Proceedings of the American Philosophical Society.* 125.2 (1981), 75–90.

Bell, Daniel Orth. "New Identifications in Raphael's *School of Athens.*" *Art Bulletin* 77 (1975), 659–46.

Bellonci, Maria. *Lucrezia Borgia.* Verona: Mondadori, 1960.

Bellori, G. P. *Descrizione delle imagini dipinte da Raffaele Sanzio d'Urbino nelle Camere del Palazzo Apostolico Vaticano.* Rome: Giacomo Komarek, 1695.

Bentivoglio, Enzo. "Nel cantiere del Palazzo del Cardiale Raffaele Riario (La Cancelleria): Organizzazione, materiali, maestranze, personaggi." *Quaderni dell' Instituto di Storia dell' Architettura* 174 (1983), 27–34.

"La Cappella Chigi." In Enzo Bentivoglio and Simonetta Valtieri, *Santa Maria del Popolo.* Rome: Bardi 1976. 104–20.

Benzi, Fabio. *Sisto IV, Renovator Urbis: Architettura a Roma, 1471–1484.* Rome: Officina, 1990.

Bertóla, Maria. *I Due Primi Registri di prestito della Biblioteca Apostolica Vaticana, Codices Vaticani Latini 3964, 1966.* Vatican City: Biblioteca Apostolica Vaticana, 1942.

Bianca, Concetta. "Francesco della Rovere: Un Francescano tra teologia e potere." In Miglio, ed., *Un Pontificato e una città.* 19–55.

Bigliazi, Luciana, and Angela Dillon Bassi, Giancarlo Savino, et al. *Aldo Manuzio Tipografo, 1494–1515. Firenze, Biblioteca Medicea Laurenziana, 17 guigno–30 luglio 1994.* Florence: Octavo, Franco Cartini, 1994.

Bignami Odier, Jeanne, and José Ruysschaert. *La Bibliothèque vaticane de Sixte IV à Pie XI.* Vatican City: Biblioteca Apostolica Vaticana, 1973.

Black, Christopher. *Italian Confraternities in the Sixteenth Century.* Cambridge: Cambridge University Press, 1989.

Blume, F., K. Lachmann, and A. Rudorff. *Schriften der römischen Feldmesser.* Berlin: Reiner, 1948–52.

Bober, Phyllis Pray. "The *Coryciana* and the Nymph Corycia." *Journal of the Warburg and Courtauld Institutes* 40 (1977), 223–39.

Bober, Phyllis Pray, and Ruth Rubinstein. *Renaissance Artists and Antique Sculpture: A Handbook of Sources.* Second, rev. ed. London: Miller, 1987.

Bolland, Andrea. "Art and Humanism in Early Renaissance Padua: Cennini, Vergerio, and Petrarch on Imitation." *Renaissance Quarterly* 49 (1966), 469–87.

Boncompagni, Baldassare Ludovisi. "Della vita e delle opere di Gerardo Cremonese." *Atti dell' Accademia Pontificia de' Nuovi Lincei* 4 (1850–1), 412–35.

Bonito, Virginia Anne. "The St. Anne Altar in Sant' Agostino in Rome: A New Discovery." *Burlington Magazine* 122 (1980), 805–12.

 "The St. Anne Altar in Sant' Agostino: Restoration and Interpretation." *Burlington Magazine* 124 (1982), 268–76.

"The Saint Anne Chapel in Sant' Agostino, Rome." Ph.D. diss., New York University, 1984.

Bonucci Caporali, Gigliola, ed. *Annio da Viterbo, Documenti e ricerche. Contributi alla Storia degli Studi Etruschi ed Italici*, 1. Rome: Consiglio Nazionale delle Ricerche, 1981.

Borsi, Stefano. *Polifilo architetto: Cultura architettonica e teoria artistica nel Hypnerotomachia Poliphili di Francesco Colonna, 1499*. Rome: Officina, 1995.

Bowsky, William M. "The Anatomy of Rebellion in Fourteenth-Century Siena: From Commune to Signory?" In Martines, ed., *Violence and Disorder in Italian Cities, 1200–1500*. 229–72.

Boyle, Leonard E., "Sixtus IV and the Vatican Library." In *Rome: Tradition, Innovation and Revival*. Victoria, CAN: University of Victoria, 1991. 65–73.

"The Vatican Library." In Grafton, *Rome Reborn*. xi–xv.

Brendel, Alfred. *Music Sounded Out*. London: Robson, 1990.

Brenzoni, Raffaello. *Fra Giovanni Giocondo Veronese, Verona 1435–Roma 1515*. Florence: Olschki, 1960.

Brown, Deborah. "The Apollo Belvedere and the Garden of Guiliano Della Rovere at SS. Apostoli." *Journal of the Warburg and Courtauld Institues* 49 (1986), 235–8.

Brown, Howard Mayer. *Music in the Renaissance*. Englewood Cliffs, NJ: Prentice-Hall, 1976.

Brummer, Hans. *The Statue Court in the Vatican Belvedere*. Stockholm: Almqvist and Wiksell, 1970.

Brunt, P. A. *The Fall of the Roman Republic and Related Essays*. Oxford: Oxford University Press, 1988.

Bruschi, Arnaldo. *Bramante architetto*. Bari: Laterza, 1967.

Bull, Malcolm. "The Iconography of the Sistine Chapel Ceiling." In Reeves, ed., *Prophetic Rome in the High Renaissance Period*. 307–19.

Bullard, Melissa Meriam. *Filippo Strozzi and the Medici*. Cambridge: Cambridge University Press, 1980.

Buonafede, Giuseppe. *I Chigi Augusti*. Venice: F. Valvasense, 1660.

Byatt, Lucinda M. C. "Aspetti giuridici e finanziari di una 'familia' cardinalizia

del XVI secolo: Un Progetto di ricerca." In Mozzarelli, *"Famiglia" del principe e famiglia aristocratica*. 2: 611–30.

Calvesi, Maurizio. "Il 'Gaio classicismo.' Pinturicchio e Francesco Colonna nella Roma di Alessandro VI." In Danesi Squarzina, ed., *Roma, Centro ideale della cultura dell' Antico*. 70–101.

 "*Hypnerotomachia Polifili*. Nuovi riscontri e nuove evidencze di documentazione per Francesco Colonna Signore di Preneste." *Storia dell'Arte* 19 (1987), 85–136.

 La "Pugna d'amore in sogno" di Francesco Colonna romano. Rome: Lithos, 1996.

 Il Sogno di Polifilo prenestino. Rome: Officina, 1980.

Campana, Augusto. "Angelo Colocci, conservatore ed editore di letteratura umanistica." In *Atti del Convegno di Studi su Angelo Colocci*. 257–72.

Cancellieri, Francesco. *Notizie del Cardinale Raffaello Riari*. Rome: De Romanis, 1822.

Carder, James N. *Art Historical Problems of a Roman Land Surveying Manuscript: The Codex Arcerianus A, Wolfenbüttel*. New York: Garland, 1978.

Casella, Maria Teresa, and Giovanni Pozzi. *Francesco Colonna: Biografia e opere*. Padua: Antenore, 1959.

Chamberlin, E. R. *The Fall of the House of Borgia*. New York: Dial, 1974.

Chambers, David S. "The Economic Predicament of Cardinals." *Studies in Medieval and Renaissance History* 3 (1966), 289–311.

 "Papal Conclaves and Prophetic Mystery in the Sistine Chapel." *Journal of the Warburg and Courtauld Institutes* 41 (1978), 322–6.

Cherubini, Paolo, ed. *Roma e lo Studium Urbis: Spazio urbano e cultura dal quattro al Seicento*. Rome: Quasar, 1989.

Chiancone Isaacs, Ann K. "Popolo e monti nella Siena del primo Conquecento." *Rivista Storica Italiana* 86.1 (1970), 32–80.

Ciapponi, Lucia. "Fra Giocondo da Verona and His Edition of Vitruvius." *Journal of the Warburg and Courtauld Institutes* 47 (1984), 72–90.

Cieri, Claudia. "*Sacrae Effigies et signa arcana*: La Decorazione di Pinturicchio e scuola nell' Appartamento Borgia in Vaticano." In Danesi Squarzina, ed., *Roma, Centro ideale della cultura dell' Antico*. 185–201.

Cipriani, Giovanni. *Il Mito etrusco nel Rinascimento fiorentino*. Florence: Olschki, 1980.

 Gli Obelischi egizi: Politica e cultura nella Roma barocca. Florence: Olschki, 1993.

Coffin, David R. *Gardens and Gardening in Papal Rome*. Princeton: Princeton University Press, 1991. 32–46.

Contardi, Bruno, and Heinrik Lilius, eds. *Quando gli dei si spogliano. Il Bagno di Clemente VII a Castel Sant' Angelo e le altre stufe romane del primo Cinquecento*. Rome: Romana Società Editrice, 1984.

Copenhaver, Brian. "Lefèvre d' Étaples, Symphorien Champier, and the Secret

Names of God." *Journal of the Warburg and Courtauld Institutes* 40 (1987), 189–211.

Cox-Rearick, Janet. *Dynasty and Destiny in Medici Art: Pontormo, Leo X, and the Two Cosimos.* Princeton: Princeton University Press, 1984.

Cristofani, Mauro, ed. *Siena: Le Origini: Testimonianze e miti archeologici.* Florence: Olschki, 1979. 125–6.

Cruciani, Fabrizio. "Il Teatro dei Ciceroniani: Tommaso 'Fedra' Inghirami." *Forum Italicum* 14 (1980), 356–77.

Teatro nel Rinascimento, Roma, 1450–1550. Rome: Bulzoni, 1983.

Cugnoni, Giuseppe. *Agostino Chigi il Magnifico.* Archivio della Reale Società Romana di Storia Patria. Rome: Istituto di Studi Romani, 1878.

Curl, James Stevens. *Egyptomania: The Egyptian Revival, A Recurring Theme in the History of Taste.* Manchester, UK: Manchester University Press, 1994.

Dacos, Nicole. *La Découverte de la Domus Aurea et la formation des grotesques à la Renaissance.* London: Warburg Institute, 1969.

Daly Davis, Margaret. *Piero della Francesca's Mathematical Treatises: The "Trattato d'abaco" and "Libellus de quinque corporibus regularibus."* Ravenna: Longo, 1977.

" 'Opus isodomum' at the Palazzo della Cancelleria: Vitruvian Studies and Archaeological Antiquarian Interests at the Court of Raffaele Riario." In Danesi Squarzina, ed., *Roma, Centro ideale della cultura dell' Antico.*

D'Amico, John F. "Papal History and Curial Reform in the Renaissance: Raffaele Maffei's 'Brevis historia' of Julius II and Leo X." *Archivum Historiae Pontificiae* 18 (1980), 157–210.

Papal Humanism in Renaissance Rome: Humanists and Churchmen on the Eve of the Reformation. Baltimore: Johns Hopkins University Press, 1983.

Danesi Squarzina, Silva. "Francesco Colonna, Principe, letterato, e la sua cerchia." *Storia dell'Arte* 19 (1987), 137–54.

Danesi Squarzina, Silvia, ed. *Roma, Centro ideale della cultura dell' antico nei secoli XV e XVI. Da Martino V al Sacco di Roma, 1417–1527.* Milan: Electa, 1989.

Danesi Squarzina, Silvia, and Gabriele Borghini, eds. *Il Borgo di Ostia da Sisto IV a Giulio II.* Rome: De Luca, 1981.

Danielsson, O. A. "Annius von Viterbo über di Gründungsgeschichte Roms." In *Corolla archaeologica principi hereditario regni sueciae Gustavo Adolpho dedicata.* Lund: Glerup, 1932. 1–16.

Etruskische Inschriften in handschriftlicher Überlieferung. Skrifter utgivna av Kungl. Humanistika Vetenskaps-Samfundet I Uppsala. Uppsala: Kungl. Humanistika Vetenskaps-Samfundet; Uppsala, 1928.

D'Ascia, Luca. *Erasmo e l'Umanesimo romano.* Florence: Olschki, 1991.

"Una 'Laudatio Ciceronis' inedita di Tommaso 'Fedra' Inghirami." *Rivista di Letteratura Italiana* 5 (1987), 479–501.

Davies, Martin. *Aldus Manutius: Printer and Publisher of Renaissance Venice*. London: British Library, 1995.

De Angelis D'Ossat, Guglielmo. "Preludio romano del Bramante." *Palladio*, n.s. 16 (1966), 92–4.

Delumeau, Jean. *L'Alun de rome, XVe–XIXe siècle*. Paris: SEVPEN, 1962.

Vita economica e sociale di Roma nel Cinquecento. Florence: Sansoni, 1979. Rev. Italian ed. of *Rome au XVIe siècle*. Paris: Hachette, 1975.

Denker Nesselrath, Christiane. *Die Säulenordnungen bei Bramante*. Worms: Wernersche Verlagsgesellschaft, 1990.

De Teodoro, Francesco P. *Raffaello, Baldassar Castiglione e la lettera a Leone X*. Bologna: Nuova Alfa, 1994.

De Tolnay, Charles. *The Sistine Ceiling*. Vol. 2 of *Michelangelo*. Princeton: Princeton University Press, 1945.

Dewar, Michael J. "Blosio Palladio and the *Silvae* of Statius." *Res Publica Litterarum* 13 (1990), 59–64.

"Encomium of Agostino Chigi and Pope Julius II in the *Suburbanum Augustini Chisii* of Blosio Palladio." *Res Publica Litterarum* 14 (1991), 61–8.

DeCarlo, Mario, Nello di Giulio, Piero Franceschini, et al., eds. *La Società dell' allume: Cultura, materiale econimia e territorio di un piccolo borgo*. Rome: De Luca, 1984.

Dilke, O. A. W. *The Roman Surveyors: An Introduction to the "Agrimensores."* Newton Abbot, UK: David and Charles, 1971.

Dionisotti, Carlo. *Dizionario biografico degli Italiani*. 1966. s.v. *Pietro Bembo*.

D'Onofrio, Cesare. *Un Popolo di statue racconta storie fatti leggende della città di Roma antica medievale moderna*. Rome: Romana Società Editrice, 1990.

Gli Obelischi di Roma. Rome: Bulzoni, 1967.

Dorez, Léon. "La Bibliothèque privée de Jules II." *Révue des Bibliothèques*, 6 (1896), 97–124.

Dotson, Esther Gordon. "An Augustinian Interpretation of Michelangelo's Sistine Ceiling." *Art Bulletin* 61 (1979), 223–56, 405–29.

Dunstan, A. J. "Pope Paul and the Humanists." *Journal of Religious History* 7.4 (1973), 287–306.

Eisenbichler, Konrad, ed. *Crossing the Boundaries: Christian Piety and the Arts in Italian Medieval and Renaissance Confraternities*, Medieval Institute Publications, Early Drama, Art, and Music, no. 5. Kalamazoo: Western Michigan University, 1991.

Eisenstadt, Shmuel and Luis Roniger. *Patrons, Clients, and Friends: Interpersonal Relations and the Structure of Trust in Society*. Cambridge: Cambridge University Press, 1984.

Emiliozzi, Adriana. *Il Museo civico di Viterbo: Storia della raccolte archeologiche*. Rome: Consiglio Nazionale delle Ricerche, 1986.

Erlanger, Rachel. *Lucretia Borgia*. New York: McGraw-Hill, 1978.

Ettlinger, Leopold D. *Antonio and Piero Pollaiuolo: Complete Edition with a Critical Catalogue*. London: Phaidon, 1978.

"Pollaiuolo's Tomb of Pope Sixtus IV." *Journal of the Warburg and Courtauld Institutes* 16 (1953), 239–74.

The Sistine Chapel before Michelangelo: Religious Imagery and Papal Primacy. Oxford: Clarendon Press, 1965.

Falchi, Luisa. "Le Accademie Romane tra '400 e '600." In Cherubini, ed., *Roma e lo Studium Urbis*. 49–55.

Fanelli, Vittorio. "Il Ginnasio greco di Leone X a Roma." *Studi Romani* 9 (1961), 379–393. Reprinted in Fanelli, *Ricerche su Angelo Colocci*. 91–110.

"Le Lettere di Mons. Angelo Colocci nel Museo Britannico di Londra." *Rinascimento*, n.s. 6 (1950), 107–35. Reprinted in Fanelli, *Ricerche su Angelo Colocci*. 45–90.

"Momenti e figure dell' umanesimo romano." In *Aspetti dell' umanesimo romano* (Rome: Istituto di Studi Romani, 1969), 55–72.

Ricerche su Angelo Colocci e sulla Roma cinquecentesca. Studi e Testi, no. 283. Vatican City: Biblioteca Apostolica Vaticana, 1979.

Farinella, Vincenzo. *Archeologia e pittura a Roma tra Quattrocento e Cinquecento*. Turin: Einaudi, 1992.

Fava, Marina. "I Cagnolini dell' epigrammatario colocciano." In *Atti del Convegno di Studi su Angelo Colocci*. 231–42.

Fenlon, Iain, ed. *The Renaissance from the 1470s to the End of the Sixteenth Century*. Englewood Cliffs, NJ: Prentice-Hall, 1989.

Field, Arthur. *The Origins of the Platonic Academy of Florence*. Princeton: Princeton University Press, 1988.

Fienga, Doris D. "Bramante, autore dell' *Antiquarie prospettiche romane*, poemetto dedicato a Leonardo da Vinci." In *Studi Bramanteschi*. 417–26.

Fontana, Vincenzo. *Fra'Giovanni Giocondo, architetto, 1433–c. 1515*. Vicenza: Neri Pozza, 1988.

Fontoura da Costa, A. *Deambulations of the Rhinoceros (Ganda) of Muzafar, King of Cambaia, from 1514–1516*. Lisbon: Division of Publications and Library Agency for the Colonies, 1937.

Fowden, Garth. *The Egyptian Hermes: A Historical Approach to the Late Pagan Mind*. Princeton: Princeton University Press, 1993.

Fragnito, Gigliola. "Cardinals' Courts in Sixteenth-Century Rome." *Journal of Modern History* 65 (1993), 26–56.

" 'Parenti' e 'familiari' delle corti cardinalizie del Rinascimento." In Mozzarelli, ed., *"Famiglia" del principe e famiglia aristocratica*. 2:565–88.

Franchini, Vittorio. "Note sull' attività finanziaria di Agostino Chigi nel Cinquecento." In *Studi in onore di Gino Luzzatto*. Milan: Giuffré, 1959. 2:156–75.

Franci, Raffaella, and Toti Rigatelli. *Introduzione all' aritmetica mercantile del Medioevo e del Rinascimento*. Siena: Quattro Venti, 1982.

Frati, Luigi. *Le Due Spedizioni militari di Guilio II, tratte dal diario di Paride Grassi Bolognese*. Bologna: Tipografia Regia, 1886.

Frommel, Christoph Luitpold. " 'Cappella Iulia': Die Grabkapelle Papst Julius II in Neu-St. Peter." *Zeitschrift für Kunstgeschichte* 40 (1977), 26–62.

——. *Die Farnesina und Peruzzis architektonisches Frühwerk*. Berlin: De Gruyter, 1961.

——. "Das Hypogäum Raffaels unter der Chigi Kappelle." *Kunstchronik* 27 (1974), 128–47, 307–10.

——. "Kirche und Tempel: Giuliano della Roveres Kathedrale Sant' Aurea in Ostia." In Hans-Ulrich Cain, Hanns Gabelmann, and Dieter Salzmann, eds., *Festschrift für Nikolaus Himmelmann*. Beihefte der Bonner Jahrbücher, no. 47. Mainz: Von Zabern, 1989. 491–505.

——. "Il Palazzo dei Tribunali in Via Giulia." In *Studi Bramanteschi*. 523–34.

——. "Il Palazzo Vaticano sotto Giulio II e Leone XI: Strutture e funzioni." In *Raffaello in Vaticano*. 12–32.

——. "Papal Policy: The Planning of Rome during the Renaissance." In Robert I. Rotberg and Theodore K. Rabb, eds., *Art and History: Images and Their Meaning*. Cambridge: Cambridge University Press, 1988. 39–66.

——. *Römische Palastbau der Hochrenaissance*. Tübingen: Wasmuth, 1973.

——. "Il Sepolcreto della cappella Chigi e altre note raffaelesche." *Bollettino del Centro di Studi per la Storia dell' Architettura* 24 (1979), 89–92.

Frommel, Christoph Luitpold, and Mathias Winner, eds. *Raffaello a Roma: Il Convegno del 1983*. Rome: Elefante, 1986.

Fumagalli, Edoardo. "Aneddoti della vita di Annio da Vietro, O.P. 1. Annio e la vittoria dei genovesi sui sforzeschi. 2. Annio e la disputa sull' Immacolata Concezione." *Archivum Fratrum Predicatorum* 50 (1980), 167–99.

——. "Un Falso Tardo-Quattrocentesco: Lo Pseudo-Catone di Annio da Viterbo." In Rino Avesani, ed., *Vestigia: Studi in onore di Giuseppe Billanovich*. Rome: Edizioni di Storia e Letteratura, 1984. 337–83.

——. Review of Pozzi and Ciapponi, *Francesco Colonna*. *Aevum* 55 (1981), 571–83.

Gaeta, Franco. "Dal Comune alla corte rinascimentale." In Alberto Asor Rosa, ed., *Letteratura italiana*. Vol. 1: *Il Letterato e le istituzioni*. Turin: Einaudi, 1982. 149–256.

Gagliardi, Donato. *Il Ciceronianismo nel primo Cinquecento e Ortensio Lando*. Naples: Morra, 1967.

Gaisser, Julia Haig. "The Rise and Fall of Göritz's Feasts." *Renaissance Quarterly* 48 (1995), 41–57.

Garin, Eugenio. "L' Accademia Romana, Pomponio Leto, e la congiura." In *Storia della letteratura italiana*. Milan: Garzanti, 1966. 3:142–58.

Garin, Eugenio, ed. *Prosatori latini del Quattrocento*. Milan: Ricciardi, 1952.

Gehl, Paul F. *A Moral Art: Grammar, Society, and Culture in Trecento Florence.* Ithaca, NY: Cornell University Press, 1993.

Gellner, Ernest, and John Waterbury. *Patrons and Clients in Mediterranean Societies.* London: Duckworth, 1977.

Giacometti, Massimo, ed. *The Sistine Chapel: The Art, the History, and the Restoration.* New York: Harmony, 1986.

Giannini, Paolo. "L' Amore per la solitudine del Cardinale Egidio Antonini ed il Convento della Santissima Trinità in Soriano." *Biblioteca e Società* 4.1–2 (1982), 39–40.

Giehlow, K. "Die Hieroglyphenkunde des Humanismus in der Allegorie der Renaissance." *Jahrbuch der kunsthistorischen Sammlungen des allerhöchsten Kaiserhauses* 23 (1915), 1–232.

Gies, Joseph, and Frances Gies. *Leonard of Pisa and the New Mathematics of the Middle Ages.* New York: Crowell, 1969.

Merchants and Moneymen: The Commercial Revolution, 1000–1500. London: Barker, 1972.

Gilbert, Felix. *The Pope, His Banker, and Venice.* Cambridge, MA: Harvard University Press, 1980.

Ginzburg, Carlo. *The Enigma of Piero: Piero della Francesca, "The Baptism," the Arezzo Cycle, "The Flagellation."* Trans. Martin Ryle and Kate Soper. London: Verso, 1985.

Gionta, Daniela. " 'Augustinus dux meus': La Teologia Poetica 'Ad Mentem Platonis' di Egidio da Viterbo, O.S.A.." In *Atti del Congresso Internazionale su S. Agostino* 3:187–201.

Gnoli, Domenico. *Un Giudizio di lesa romanità nella Roma di Leone X.* Rome: Hoepli, 1891.

"La Lozana andalusa e le cortegiane nella Roma di Leone X." in *La Roma di Leone X.* Milan: Hoepli, 1938. 185–216.

Godman, Peter, and Oswyn Murray, eds. *Latin Poetry and the Classical Tradition: Essays in Medieval and Renaissance Literature.* Oxford: Clarendon Press, 1990.

Gold, Barbara K. *Literary Patronage in Greece and Rome.* Chapel Hill: University of North Carolina Press, 1987.

Gold, Barbara K., ed. *Literary and Artistic Patronage in Ancient Rome.* Austin: University of Texas Press, 1982.

Goldthwaite, Richard. "Schools and Teachers of Commercial Arithmetic in Renaissance Florence." *Journal of European Economic History* 1 (1972), 418–33.

Golzio, Vincenzo. *Raffaello nei documenti nelle testimonianze dei contemporanei e nella letturatura del suo secolo.* Vatican City: Pontificia Insigne Accademia dei Virtuosi del Pantheon, 1936.

Gombrich, Ernst. "Hypnerotomachiana." *Journal of the Warburg and Courtauld*

Institutes 14 (1951), 119–125. Reprinted in *Symbolic Images* (London: Phaidon, 1972). 102–8.

"Raphael's Stanza della Segnatura and the Nature of Its Symbolism." In *Symbolic Images: Studies in the Art of the Renaissance*. London: Phaidon, 1972. 85–101.

Gori, Gilberto. *Intorno a un opuscolo rarissimo della fine del secolo XV initolato "Antiquarie prospettiche romane composte per prospettico melanese depictore": Ricerche*. Rome: Accademia dei Lincei, 1876. Offprint from *Atti della Reale Accademia dei Lincei,* ser. 2, III, iii (1875–6). 39–66.

Gouwens, Kenneth. "Redefinition and Reorientation: The Curial Humanist Response to the 1527 Sack of Rome." Ph.D. diss., Stanford University, 1991.

Grafton, Anthony. *Forgers and Critics: Creativity and Duplicity in Western Scholarship*. Princeton: Princeton University Press, 1990.

Joseph Scaliger: A Study in the History of Classical Scholarship. Vol. 2: *Historical Chronology*. Oxford: Clarendon Press, 1993.

Grafton, Anthony E., ed. *Rome Reborn: The Vatican Library and Renaissance Culture*. New Haven: Yale University Press, 1993.

Grafton, Anthony, and Lisa Jardine. "Women Humanists: Education for what?" In *From Humanism to the Humanities*. Cambridge, MA: Harvard University Press, 1986. 29–57.

Graziosi, Maria Teresa. "Pacifico Massimi, Maestro del Colocci?" In *Atti del Convegno di Studi su Angelo Colocci*. 157–68.

Greco, Aulo. "L'Apologia delle Rime di Serafino Aquilano." In *Atti del Convegno di Studi su Angelo Colocci*. 205–20.

"Momenti e figure dell' umanesimo romano." In *Aspetti dell' umanesimo romano*. Rome: Istituto di studi Romani, 1969. 55–72.

"Roma e la commedia del rinascimento." *Studi Romani* 22 (1974), 25–35.

Gregorovius, Ferdinand. *Lucrezia Borgia*. Florence: Monnier, 1874. (In Italian.)

Grendler, Paul. *Schooling in Renaissance Italy: Literacy and Learning. 1300–1600*. Baltimore: Johns Hopkins University Press, 1989.

Gualdo Rosa, Lucia. "Ciceroniano o cristiano? A proposito dell' orazione 'De morte Christi' di Tommaso Fedra Inghirami." *Humanistica Lovaniensia* 34 (1985), 52–64.

Gundersheimer, Werner L. "Patronage in the Renaissance: An Exploratory Approach." In Guy Fitch Lytle and Stephen Orgel, eds., *Patronage in the Renaissance*. Princeton: Princeton University Press, 1981. 3–26.

Gutierrez, David. *Historia de la Orden de San Augustín. Vol. 1, pt. 2: Los Agustinos en la edad media, 1357–1517*. Rome: Institutum Historicum Ordinis Fratrum Sancti Augustini, 1977.

Hackens, T. "Mons Apollinis et Clatrae." *Rendiconti della Pontificia Accademia Romana di Archeologia* 33 (1961), 195–6.

Hallman, Barbara McClung. *Italian Cardinals, Reform, and the Church as Property, 1492–1563.* Berkeley and Los Angeles: University of California Press, 1985.

Hankins, James. "The Myth of the Platonic Academy of Florence." *Renaissance Quarterly* 44 (1991); 424–75.

 Platonism in the Italian Renaissance. New York: Columbia University Press, 1990.

Hermanin, Federico. *L'Appartamento Borgia in Vaticano.* Rome: Danesi, 1934.

Hibbard, Howard. *Michelangelo.* New York: Harper and Row, 1974.

Hicks, David. "The Education of a Prince: Lodovico il Moro and the Rise of Pandolfo Petrucci." *Studies in the Renaissance* 8 (1968), 88–102.

 "Sienese Society in the Renaissance." In Charles H. Carter, ed., *From the Renaissance to the Counter-Reformation: Essays in Honor of Garrett Mattingly.* New York: 1968. 75–84.

Hofmann, Walter von. *Forschungen zur Geschichte der kurialischen Behörden vom Schisma bis zur Reformation.* Bibliothek des Königlich-Preussischen Historischen Instituts zu Rom, nos. 12–13. Rome: Von Loescher, 1914.

Hope, Charles. "Artists, Patrons and Advisers in the Italian Renaissance." In Lytle and Orgel, eds., *Patronage in the Renaissance.* 293–343.

Howe, Eunice. "Sixtus IV and the Ospedale di Santo Spirit." Ph.D. diss., Johns Hopkins University, 1977.

Hülsen, Christian. "Morto da Feltre." *Mitteilungen des Kunsthistorischen Instituts in Florenz* 2 (1912–17), 81–9.

Hurtubise, Pierre. "La 'Familia' del Cardinate Giovanni Salviati (1517–1553)." In Mozzarelli, ed., *"Famiglia" del principe e famiglia aristocratica.* 2:589–610.

Ianziti, Gary. "Patronage and the Production of History: The Case of Quattrocento Milan." In Kent and Simons, eds., *Patronage, Art, and Society in Renaissance Italty.* 299–311.

Ijsewijn, Jozef. "Poetry in a Roman Garden: The *Coryciana.*" In Godman and Murray, eds., *Latin Poetry and the Classical Tradition.*

Inghirami, Curzio. *Discorso sopra l'opposizioni fatte all' antichità Toscane.* Florence: Massi and Landi, 1645.

Iversen, Erik. *The Myth of Egypt and Its Hieroglyphs in European Tradition.* Rev. ed. Princeton: Princeton University Press, 1993. Originally published 1961.

 Obelisks in Exile. Copenhagen: Gad, 1968.

Jacks, Philip. *The Antiquarian and the Myth of Antiquity: The Origins of Rome in Renaissance Thought.* Cambridge: Cambridge University Press, 1994.

 "The 'Simulachrum' of Fabio Calvo: A View of Roman Architecture *All' Antica* in 1527." *Art Bulletin* 72 (1990), 453–81.

Jaeger, Bertrand. "La Loggia delle Muse nel Palazzo Te e la revivescenza dell' Egitto antico nel Rinascimento." In *Mantova e l'antico Egitto da Giulio Romano a Giuseppe Acerbi,* 21–40.

Janitschek, Hubert. "Das capitolinische Theater vom Jahre 1513." *Repertorium für Kunstwissenschaft* 5 (1881), 259–70.

Johnson, Marion. [Georgina Masson]. *The Borgias*. London: Macdonald, 1981.

Jones, Roger, and Nicholas Penny. *Raphael*. New Haven: Yale University Press, 1983.

Joost-Gaugier, Christiane L. "The Concord of Law in the Stanza della Segnatura." *Artibus et Historiae* 29 (1994), 85–98.

"Pindar on Parnassus: A Neopythagorean Impulse in Raphael's Stanza della Segnatura." *Gazette des Beaux-Arts* 127 (1996), 63–80.

"Sappho, Apollo, Neopythagorean Theory, and Numine Afflatur in Raphael's Fresco of the Parnassus." *Gazette des Beaux-Arts* 122 (1993), 123–34.

"Some Considerations on the Geography of the Stanza della Segnatura." *Gazette des Beaux-Arts* 124 (1994), 223–32.

Kanigel, Robert. *The Man Who Knew Infinity: The Life of the Genius Ramanujan*. New York: Scribners, 1991.

Kemp, Martin. "Geometrical Bodies as Exemplary Forms in Renaissance Space." In Irving Lavin, ed., *World Art: Themes of Unity in Diversity*. University Park: Pennsylvania State University Press, 1989. 1:237–42.

The Science of Art: Optical Themes in Western Art from Brunelleschi to Seurat. New Haven: Yale University Press, 1990.

Kennedy, George. *The Art of Rhetoric in the Roman World, 300 B.C.–A.D. 300*. Princeton: Princeton University Press, 1972.

Kent, F. W., and Patricia Simons. "Renaissance Patronage: An Introductory Essay." In Kent and Simons, eds., *Patronage, Art, and Society in Renaissance Italy*. 1–21.

Kent, F. W., and Patricia Simons, eds., *Patronage, Art, and Society in Renaissance Italy*. New York: Oxford University Press, 1987.

King, Margaret, and Albert Rabil, Jr., eds. *Her Immaculate Hand: Selected Works by and about the Women Humanists of Quattrocento Italy*. Binghamton: Center for Medieval and Early Renaissance Studies, 1983.

Kuhn, Thomas. *The Copernican Revolution: Planetary Astronomy in the Development of Western Thought*. Cambridge, MA: Harvard University Press, 1957.

Künzle, Paul. "Raffaels Denkmal für Fedro Inghirami auf dem letzten Arazzo." Vol. 6 in *Mélanges Eugène Tisserant*. Studi e Testi, no. 236. Rome: Biblioteca Apostolica Vaticana, 1964. 511–49.

Kurz, Otto. "Huius nympha loci." *Journal of the Warburg and Courtauld Institutes* 6 (1953), 171–7.

Lamb, H. H. *Climate, History, and the Modern World*. 2nd ed. London: Routledge, 1995.

Lancellotti, G. F. *Poesie italiane e latine di monsignor Angelo Colocci, con più notizie intorno alla persona di lui e sua famiglia*. Iesi: P. Bonelli, 1772.

Lanciani, Rodolfo. *Storia degli scavi di Roma e notizie intorno le collezioni romane di*

antichità. 1st ed., Rome: Loescher, 1908–12; annotated, rev. ed., ed. Leonello Malvezzi, Rome: Quasar, 1989. English translation, *The Ruins and Excavations of Ancient Rome.* New York: Houghton Mifflin, 1897; reprinted New York: Bell, 1977.

Lattès, Samy. "A proposito dell' opera incompiuta 'De ponderibus et mensuris' di Angelo Colocci." In *Atti del Convegno di Studi su Angelo Colocci.* 97–108. "Récherche sur la bibliothèque d'Angelo Colocci." *Mélanges de l' École Française de Rome* 48 (1931), 308–44.

Lee, Egmont. *Sixtus IV and Men of Letters.* Rome: Edizioni di Storia e Letteratura, 1978.

Leospo, Enrichetta. "La Tabula Bembina: Un Cimelio 'orientale' dalla Mantova dei Gonzaga alla Torino dei Savoia." In *Mantova e l'antico Egitto da Guilio Romano a Giuseppe Acerbi.* 41–52.

Levinson, Jay A. ed. *Circa 1492: Art in the Age of Exploration.* Washington: National Gallery of Art / New Haven: Yale University Press, 1992.

Lewine, Carol F. *The Sistine Chapel Walls and the Roman Liturgy.* University Park: Pennsylvania State University Press, 1993.

Ligota, C. "Annius of Viterbo and Historical Method." *Journal of the Warburg and Courtauld Institutes* 50 (1987), 44–56.

Lindberg, David C., and Robert Westman, eds. *Reappraisals of the Scientific Revolution.* Cambridge: Cambridge University Press, 1990.

Lowinsky, Edward E. "Ascanio Sforza's Life: A Key to Josquin's Biography and an Aid to the Chronology of his Works." In Lowinsky and Bonnie J. Blackburn, eds., *Josquin des Prez: Proceedings of the International Josquin Festival–Conference held at Juilliard School at Lincoln Center in New York City, 21–25 June 1971.* London: Oxford University Press, 1976. 33–75.

Luzzatto, Gino. *Breve storia dell' Italia medievale.* Turin: Einaudi, 1958.

Lytle, Guy Fitch. "Friendship and Patronage in Renaissance Europe." In Kent and Simons, eds., *Patronage, Art, and Society in Renaissance Italy.* 47–61.

Lytle, Guy Fitch, and Stephen Orgel, eds. *Patronage in the Renaissance.* Princeton: Princeton University Press, 1981.

MacDougall, Elizabeth. "The Sleeping Nymph: Origins of a Humanist Fountain Type." *Art Bulletin* 57 (1975), 357–65.

Machado, Elza Paxeco, and José Pedro Machado. *Cancioneiro da Biblioteca Nacional Antigo Colocci–Brancuti.* Lisbon: Edição da *Revista de Portugal.* 1949–64.

McManamon, John M. *Funeral Oratory and the Cultural Ideals of Humanism.* Chapel Hill: University of North Carolina Press, 1989.

Magnuson, Torgil. *Studies in Roman Quattrocento Architecture.* Stockholm: Almqvist and Wiksell, 1958.

Mallett, Michael. *The Borgias: Rise and Fall of a Renaissance Dynasty.* New York: 1969.

Mancinelli, Fabrizio, ed. *Raffaello in Vaticano. Città del Vaticano, Braccio di Carlo Magno, 16 ottobre 1984–16 gennaio 1985*. Milan: Electa, 1984.

Mantova e l'antico Egitto da Giulio Romano a Giuseppe Acerbi. Atti del Convegno di Studi, Mantova, 23–24 maggio 1992. Accademia Nazionale Virgiliana di Scienze, Lettere, e Arti, Miscellanea no. 2. Florence: Olschki, 1994.

Marangoni, Giovanni. *Istoria dell' antichissimo oratorio o cappella di San Lorenzo del Patriarchìo lateranense*. Rome: O. Piccinelli, Stamperia di San Michele, 1747.

Marchini, Giuseppe. "Le Architetture." In *Raffaello*. 442–92.

Marek, Michaela J. "La 'Loggia di Psyche' nella Farnesina: Per la ricostruzione ed il significato." In Frommel and Winner, eds., *Raffaello a Roma*. 209–16.

Martin, Francis X. *Friar, Reformer, and Renaissance Scholar: Life and Work of Giles of Viterbo, 1469–1532*. Villanova, PA: Augustinian Press, 1992.

Martines, Giangiacomo. " 'Gromatici veteres' tra antichità e medioevo." *B.S.A. Ricerche di Storia dell' Arte* 3 (1976), 3–23.

"Hygino Gromatico: Fonti antiche per la ricostruzione rinascimentale della città vitruviana." *B.S.A. Ricerche di Storia dell' Arte* 1–2 (1976), 277–84.

"La Scienza dei Gromatici: Un Esercizio di geografia astronomica nel Corpus Agrimensorum." In *Misurare la terra*. Vol. 1: *Centuriazione e coloni nel mondo romano, città, agricoltura, commercio: materiali da Roma e dal suburbio*. Modena: Panini, 1984.

Martines, Lauro, ed. *Violence and Disorder in Italian Cities, 1200–1500*. Berkeley and Los Angeles: University of California Press, 1972.

Marucci, V., A. Marzo, and A. Romano. *Pasquinate romane del Cinquecento*. Rome: Salerno, 1983.

Marzo, Antonio. *Pasquino e dintorni*. Rome: Salerno, 1990.

Masson, Georgina. [Marion Johnson]. *Courtesans of the Italian Renaissance*. London: Secker and Warburg, 1975.

Mattiangeli, Paola. "Annio da Viterbo, Ispiratore di cicli pittorici." In Bonucci Caporali, ed., *Annio da Viterbo*. 257–339.

Meersemann, Gilles Gerard. *Ordo fraternitatis: Confraternite e pietà dei laici nel medioevo*. Rome: Herder, 1977.

Meiss, Millard. "Raphael's Mechanized Seashell: Notes on a Myth, Technology, and Iconographic Tradition." In *The Painter's Choice: Problems in the Interpretation of Renaissance Art*. New York: Harper and Row, 1976. 203–11.

"Sleep in Venice: Ancient Myths and Renaissance Proclivities." In *The Painter's Choice: Problems in the Interpretation of Renaissance Art*. New York: Harper and Row, 1976. 212–40.

Melis, Federigo. *L'Economia fiorentina el Rinascimento*. Florence: Monnier, 1984.

Michelini Tocci, Luigi. "Dei Libri stampati appartenuti al Colocci." In *Atti del Convegno di Studi su Angelo Colocci*. 76–7.

Miglio, Massimo, ed. *Un Pontificato e una città: Sisto IV (1471–1484)*. Vatican City: Scuola Vaticana di Paleografia, Diplomatica, e Archivistica, 1984.

Minnich, Nelson H. "Concepts of Reform Proposed at the Fifth Lateran Council." *Archivum Historiae Pontifiae* 7 (1969), 163–251; reprinted, with new appendices, in *The Fifth Lateran Council* 4:163–251.

The Fifth Lateran Council (1512–17): Studies on Its Membership, Diplomacy, and Proposals for Reform. Aldershot, UK: Variorum, 1993.

"The Healing of the Pisan Schism (1511–13). *Annuarium Historiae Conciliorum* 16 (1984), 59–192. Revised version in *The Fifth Lateran Council*. Articles 59–197.

Mitchell, [Marion] Bonner. *Rome in the High Renaissance: The Age of Leo X.* Norman: University of Oklahoma Press, 1972.

Montenovesi, Ottorino. "Agostino Chigi, banchiere e appalatore dell'allume di Tolfa." *Archivio della Reale Società Romana di Storia Patria* 60 (1937), 111–40.

Morandi, Ubaldo. "Gli Spannocchi: Piccoli proprietari terrieri, artigiani, piccoli, medi e grandi mercanti-banchieri." In *Studi in onore di Federigo Melis*. Naples: 1978. 3:103–20.

Morra, Ottorino. *Tolfa: Profilo storico e guida illustrata*. Civitavecchia: 1979.

Moss, Jean Dietz. *Novelties in the Heavens: Rhetoric and Science in the Copernican Controversy*. Chicago: University of Chicago Press, 1993.

Mozzarelli, Cesare, ed. *"Famiglia" del principe e famiglia aristrocratica*. Rome: Bulzoni, 1988.

Napolitano Valditara, Linda M. *Le Idee, I numeri, l' ordine: La Dottrina della mathesis universalis dall' Accademia antica al neoplatonismo*. Padua: Bibliopolis, 1988.

Nesselrath, Arnold. *Das Fossombroner Skizzenbuch*. London: Warburg Institute, 1993.

"Raphael's Archaeological Method." In Frommel and Winner, eds., *Raffaello a Roma*. 357–72.

Nesselrath, Arnold, and Howard Burns. "Raffaello e l'antico." In Frommel, Ray, and Tafuri, *Raffaello architetto*.

Nocca, Marco. " 'Theatrum novum tota urbs magnis votis expectat': Il Teatro della Passione di Velletri: Antonio da Faenza architetto antiquario e Raffaele Riario." In Danesi Squarzina, ed., *Roma, Centro ideale della cultura dell' Antico*. 198, 291–302.

Oberhuber, Konrad. *Porträt und Synthese in Raffaels Schule von Athen*. Stuttgart: Urachhaus, 1983.

"Raphael's Drawing for the Loggia of Psyche in the Farnesina." In Frommel and Winner, eds., *Raffaello a Roma*. 189–208.

Odenthal, Anna Maria. "Zur architektonischen Planung der Cappella Chigi bei S. Maria del Popolo." In Frommel and Winner, eds., *Raffaello a Roma*. 305–8.

O'Malley, John W. "Erasmus and Luther: Continuity and Discontinuity as Key

to their Conflict." *Sixteenth Century Journal* 5.2 (1974), 47–65. Reprinted in *Rome and the Renaissance*. London: Variorum, 1981.

"Fulfillment of the Golden Age under Julius II: Text of a Discourse of Giles of Viterbo, 1507." *Traditio* 25 (1969), 265–338.

Giles of Viterbo on Church and Reform: A Study in Renaissance Thought. Leiden: Brill, 1968.

"Historical Thought and the Reform Crisis of the Early Sixteenth Century." *Theological Studies* 28 (1967), 531–48.

"Man's Dignity, God's Love, and the Destiny of Rome: A Text of Giles of Viterbo." *Viator* 3 (1972), 389–416.

Praise and Blame in Renaissance Rome: Rhetoric, Doctrine, and Reform in the Sacred Orators of the Papal Court, c. 1450–1521. Durham, NC: Duke University Press, 1979.

"The Theology behind Michelangelo's Ceiling." In Giacometti, ed., *The Sistine Chapel*. 92–148.

"The Vatican Library and the Schools of Athens: A Text of Battista Casali, 1508." *Journal of Medieval and Renaissance Studies* 7 (1977), 271–87.

O'Reilly, Clare. " 'Without Councils we cannot be saved': Giles of Viterbo addresses the Fifth Lateran Council." *Augustiniana* 27 (1977), 166–204.

Origo, Iris. *The Merchant of Prato: Francesco di Marco Datini, 1335–1410*. New York: Knopf, 1957.

The World of San Bernardino. New York: Harcourt, Brace, and World, 1962.

Pagliara, Pier Nicola. "La Roma Antica di Fabio Calvo: Note sulla cultura antiquaria e architettonica." *Psicon* 8–9 (1977), 65–87.

"Vitruvio: Da testo a canone." In Savatore Settis, ed., *Memoria dell' antico nell' arte italiana*. Turin: Einaudi, 1986. 3:5–85.

Palermino, Richard J. "The Roman Academy, the Catacombs, and the Conspiracy of 1468." *Archivum Historiae Pontificae* 18 (1980), 117–55.

Panofsky, Erwin. *Perspective as Symbolic Form*. New York: Zone, 1991.

Partner, Peter. "The 'Budget' of the Roman Church in the Renaissance Period." In E. F. Jacob, ed., *Italian Renaissance Studies: A Tribute to the Late Cecilia M. Ady*. London: Faber and Faber, 1970.

The Lands of Saint Peter: The Papal State in the Middle Ages and the Early Renaissance. Berkeley and Los Angeles: University of California Press, 1972.

"Papal Financial Policy in the Renaissance and Counter-Reformation." *Past and Present* 87 (1980), 17–62.

The Papal State under Martin V. London: British School at Rome, 1958.

The Pope's Men: The Papal Civil Service in the Renaissance. Oxford: Oxford University Press, 1990.

Renaissance Rome, 1500–1559: A Portrait of a Society. Berkeley and Los Angeles: University of California Press, 1976.

von Pastor, Ludwig Freiherr. *History of the Popes from the Close of the Middle Ages*.

Trans. Frederick Ignatius Antrobus and R. F. Kerr. London: Heinemann, 1894–8.

Pecchiai, Pio. *Roma nel Cinquecento*. Bologna: Licinio Cappelli, 1948.

Pellegrino, Nicoletta. "Nascita di una 'burocrazia': Il Cardinale nella trattatistica del XVI secolo." In Mozzarelli, ed., *"Famiglia" del principe e famiglia aristocratica*. 2:631–77.

Petrucci, Armando. *La Scrittura: Ideologia e rappresentazione*. Turin: Einaudi, 1986.

Pfeiffer, Heinrich. "Die drei Tugenden und die Übergabe der Dekretalen in der Stanza della Segnatura." In Frommel and Winner, eds., *Raffaello a Roma*. 47–58.

Pfeiffer, Heinrich. *Zur Ikonographie von Raffaels Disputa: Egidio da Viterbo und die christlich-platonische Konzeption der Stanza della Segnatura*. Miscellanea Historiae Pontificiae, no. 37. Rome: Tipografia Gregoriana, 1975.

"Die Predigt des Egidio da Viterbo über das goldene Zeitalter und die Stanza della Segnatura." *Festschrift Luitpold Dussler. Acht-und-zwanzig Studien zur Archäologie und Kunstgeschichte*. Munich: Deutsche Kunstverlag, 1972. 237–54.

Pirrotta, Nino. "Music and Cultural Tendencies in Fifteenth-Century Italy." *Journal of the American Musicological Society* 19 (1966), 127–61.

Pirotta, Nina, and Elena Povoledo. *Music and Theatre from Poliziano to Monteverdi*. Trans. Karen Eales. Cambridge: Cambridge University Press, 1982. Originally published as *Li due Orfei, da Poliziano a Monteverdi*. Turin: ERI, 1969.

Platner, Samuel Ball. *A Topographical Dictionary of Ancient Rome*. Revised and completed by Thomas Ashby. Oxford: Oxford University Press, 1929.

Portoghesi, Paolo. *Roma del Rinascimento*. Milan: Electa, 1972.

Pozzi, Giovanni, and Lucia Ciapponi. *Francesco Colonna, "Hypnerotomachia Poliphili," Edizione critica e commento*. Vol. 2. Padua: Antenore, 1980.

Pullan, J. M. *The History of the Abacus*. New York: Praeger, 1969.

Quinlan-McGrath, Mary. "Blosius Palladius, Suburbanum Augustini Chisii." *Humanistica Lovaniensia* (1990), 93–156.

"The Villa of Agostino Chigi: The Poems and Paintings." Ph.D. diss., University of Chicago, 1983.

Raffaello: L'Opera, le fonti, la fortuna. Novara: Istituto Geografico de Agostini, 1968.

Ray, Stefano. *Raffaello architetto: Linguaggio artistico e ideologia nel Rinascimento romano*. Bari: Laterza, 1974.

"La Cappella Chigi: Significato e cultura." In Frommel and Winner, eds., *Raffaello a Roma*. 315–22.

Redig de Campos, Deoclecio. "Bramante e le logge di San Damaso." In *Studi Bramanteschi*. 517–22.

"L'Ex Voto del Inghirami al Laterano." *Rendiconti della Pontificia Accademia Romana di Archeologia* 29 (1956–7), 171–9.

Le Stanze di Rafaello. Florence: Del Turco, 1950.

Reeves, Marjorie, ed. *Prophetic Rome in the High Renaissance Period.* Oxford: Clarendon Press, 1992.

Reiss, Sheryl E. "Cardinal Giulio de' Medici as a Patron of Art, 1513–1523." Ph.D. diss., Princeton University, 1992.

Reynolds, Christopher. "Rome: A City of Rich Contrasts." In Iain Fenlon, ed., *The Renaissance from the 1470s to the End of the Sixteenth Century.* Englewood Cliffs, NJ: Prentice-Hall, 1989. 63–101.

Reynolds, L. D., ed. *Texts and Transmission: A Survey of the Latin Authors.* Oxford: Clarendon Press, 1983.

Rosenthal, Margaret. *The Honest Courtesan: Veronica Franco, Citizen and Writer in Sixteenth-Century Venice.* Chicago: University of Chicago Press, 1992.

Roullet, Anne. *The Egyptian and Egyptianizing Monuments of Imperial Rome.* Leiden: Brill, 1972.

Rowland, Ingrid D. "Abacus and Humanism." *Renaissance Quarterly* 48 (1995), 695–727.

The Correspondence of Agostino Chigi in Vatican Cod. Chigi R.V.C.: An Annotated Edition. Studi e Testi. Vatican City: Biblioteca Apostolica Vaticana, in press.

"Egidio da Viterbo's Defense of Julius II, 1509 and 1511." In Thomas L. Amos, Eugene A. Green, and Beverly Mayne Kienzle, es., *De ore domini: Preacher and Word in the Middle Ages.* Studies in Medieval Culture, no. 27. Kalamazoo: Western Michigan University, 1989. 235–60.

"L' *Historia Porsennae* e la conoscenza degli Etruschi nel Rinascimento." *Res Publica Litterarum* 11 (1989), 185–93.

"Raphael, Angelo Colocci, and the Genesis of the Architectural Orders." *Art Bulletin* 76 (1994), 81–104.

"Render unto Caesar the things which are Caesar's: Humanism and the Arts in the Patronage of Agostino Chigi." *Renaissance Quarterly* 39 (1986), 673–730.

"Revenge of the Regensburg Humanists." *Sixteenth Century Journal* 25 (1994), 307–22.

"Some Panegyrics to Agostino Chigi." *Journal of the Warburg and Courtauld Institutes* 47 (1984), 194–9.

Rugiadi, Anna Maria. *Tommaso Fedra Inghirami, Umanista volterrano.* Amatrice: Tipografia Orfanotrofio Maschile, 1993.

Ruysschaert, José. *Récherche des deux bibliothèques romaines Maffei des Xve et XVIe siècles."* *Bibliofilia* 60 (1958), 305–55.

Sabbadini, Remigio. *Storia del Ciceronianismo e di altre questioni letterarie nell' età della Rinascenza.* Turin: Ermanno Loescher, 1885.

Saller, Richard. *Personal Patronage under the Early Empire*. Cambridge: Cambridge University Press, 1982.

Sapori, Armando. *Studi di Storia economica (secoli XIII XIV XV)*. Florence: Sansoni, 1953.

Sandström, Sven. *Levels of Unreality: Studies in Structure and Construction in Italian Mural Painting during the Renaissance*. Uppsala: Almqvist and Wiksell, 1963.

Sarton, George. *Introduction to the History of Science*. Baltimore: Williams and Wilkins for the Carnegie Institution, 1927–48.

Saxl, Fritz. "The Appartamento Borgia." In *Lectures*. London: Warburg Institute, 1957. 1:174–88.

Schiavo, Armando. *Il Palazzo della Cancelleria*. Rome: Staderini, 1963.

Schmidt, Steffen W. et al. *Friends, Followers, and Factions: A Reader in Political Clientelism*. Berkeley and Los Angeles: University of California Press, 1977.

Schmitt, Charles B. "Gianfrancesco Pico della Mirandola and the Fifth Lateran Council." *Archiv für Reformationsgeschichte* 61 (1970), 161–78.

 Gianfrancesco Pico della Mirandola (1469–1533) and His Critique of Aristotle. International Archives of the History of Ideas, no. 23. The Hague: Martinus Nijhoff, 1967.

Schulz, Jürgen. "Pinturicchio and the Revival of Antiquity." *Journal of the Warburg and Courtauld Institutes* 25 (1962), 35–55.

Scott, Izora. *Controversies over the Imitation of Cicero in the Renaissance as a Model for Style and Some Phases of their Influence on the Schools of the Renaissance*. New York: Teachers College, Columbia University, 1910; reprinted Davis, CA: Hermagoras Press, 1991.

Schröter, Elisabeth. *Die Ikonographie des Themas Parnass vor Raffael. Die Schrift- und Bildtraditionen von der Spätantike bis zum 15. Jahrhundert*. New York: Olms, 1977.

Secret, François. *Les Kabbalistes Chrétiens de la Renaissance*. Paris: Dunod, 1964.

Seymour, Charles, Jr., ed. *Michelangelo: The Sistine Chapel Ceiling*. New York: Norton, 1972.

Shapley, Fern Rush. "A Student of Ancient Ceramics, Antonio Pollajuolo." *Art Bulletin* 2 (1919), 78–86.

Shaw, Christine. *Julius II: The Warrior Pope*. Oxford: Blackwell, 1993.

Shearman, John. "Castiglione's Portrait of Raphael." *Mitteilungen des Kunsthistorischen Instituts zu Florenz* (1994), 69–97.

 "The Chigi Chapel in Santa Maria del Popolo." *Journal of the Warburg and Courtauld Institutes* 24 (1961), 129–60.

 "Maniera as an Aesthetic Idea." In *Acts of the Twentieth International Congress of the History of Art*. Princeton: Princeton University Press, 1963. 2:200ff.

 Mannerism. Harmondsworth, UK: Penguin, 1967. 15–22.

 Only Connect . . . Artist and Spectator in the Italian Renaissance. The A. W. Mellon

Lectures in the Fine Arts, 1988. Washington, DC: National Gallery of Art / Princeton: Princeton University Press, 1992.

"Pentimenti in the Chigi Chapel." In Moshe Barasch and Lucy Freeman Sandler, eds., *Art the Ape of Nature: Studies in Honor of H. W. Janson.* Englewood Cliffs, NJ: Prentice-Hall, 1981. 219–22.

Raphael's Cartoons in the Collection of Her Majesty the Queen and the Tapestries for the Sistine Chapel. London: Phaidon, 1972.

"Il 'Tiburio' di Bramante." In *Studi Bramanteschi.* 567–74.

"The Vatican Stanze: Functions and Decoration." *Proceedings of the British Academy* 57 (1971), 367–472.

Sinisalo, Jarkko. "Le Stufe romane." In Bruno Contardi and Heinrik Lilius, eds., *Quando gli dei si spogliano. Il bagno di Clemente VII a Castel Sant' Angelo e le altre stufe romance del primo Cinquecento.* Rome: Romana Società Editrice, 1984. 12–15.

Siriasi, Nancy G. "Life Sciences and Medicine in the Renaissance World." In Grafton, *Rome Reborn.* 169–98.

Skinner, Quentin. "Ambrogio Lorenzetti as Political Philosopher." *Proceedings of the British Academy* 72 (1986), 1–56.

Stange, Carl. *Erasmus und Julius II: Eine Legende.* Berlin: Töpelmann, 1937.

Steinmann, Ernst. *Pinturicchio.* Bielefeld: Velhagen and Klasing, 1898.

Stephens, Walter E. "Berosus Chaldaeus: Counterfeit and Fictive Editors of the Early Sixteenth Century." Ph.D. diss., Cornell University, 1979.

"The Etruscans and the Ancient Theology in Annius of Viterbo." In Paolo Brezzi and Maristella de Panizza Lorch, eds., *Umanesimo a Roma nel Quattrocento.* New York: Barnard College (Columbia University), 1984. 309–22.

Giants in Those Days: Folklore, Ancient History, and Nationalism. Lincoln: University of Nebraska Press, 1989.

Stinger, Charles L. *The Renaissance in Rome.* Bloomington: Indiana University Press, 1985.

Studi Bramanteschi. Atti del congresso internazionale, Milano, Urbino, Roma, 1970. Rome: De Luca, 1974.

Swetz, Frank J. *Capitalism and Arithmetic: The New Math of the Fifteenth Century.* LaSalle, IL: Open Court, 1987.

Takacs, Sarolta. *Isis in the Greek and Roman World.* Leiden: Brill, 1995.

Terpstra, Nicholas. "Women in the Brotherhood: Gender, Class and Politics in Renaissance Bolognese Confraternities." *Renaissance and Reformation* 24 (1990), 193–212.

Thoenes, Christof. "Galatea: Tentativi di avvicinamento." In Frommel and Winner, eds., *Raffaello a Roma.* 59–74.

"La 'Lettera' a Leone X." In Frommel and Winner, eds., *Raffaello a Roma.* 373–81.

Thulin, Carl. "Humanistische Handschriften des Corpus Agrimensorum roma-norum." *Rheinishes Museum für Philologie*, n.s. 66 (1911), 417–51.

Tigerstedt, E. N. "Ioannes Annius and *Graecia Mendax.*" In C. Henderson, Jr., ed., *Classical, Medieval, and Renaissance Studies in Honor of Berhold Louis Ullmann.* Rome: Edizioni di Storia e Letteratura, 1964. 2:293–310.

Tosi, Wilde. *Il Magnifico Agostino Chigi.* Rome: Istituto Bancario di San Paolo, 1970.

Valtieri, Simonetta. "L'Architettura a Roma nel XV secolo: L' Antico come 'imitazione' e come 'interpretazione' nel suo processo formativo e evolutivo." In Danesi Squarzina, ed., *Roma, Centro ideale della cultura dell' Antico.* 257–68.

———. "La Fabbrica del Palazzo del Cardinale Raffaele Riario (La Cancelleria)." *Quaderni dell' Istituto di Storia dell' Architettura* 174 (1983), 3–26.

———. "Sant'Eligio degli Orefici." In Frommel, Ray, and Tafuri, eds., *Raffaello architetto.* 143–56.

Van Egmond, Warren. "The Commercial Revolution and the Beginnings of Western Mathematics in Renaissance Florence, 1300–1500." Ph.D. diss., Indiana University, 1976.

———. *Practical Mathematics in the Italian Renaissance: A Catalog of Italian Abbacus Manuscripts and Printed Books to 1600.* Annali dell' Istituto e Museo di Storia della Scienza. Suppl. fasc. 1. Florence: Instituto e Museo di Storia della Scienza, 1980.

Vasoli, Cesare. "Giorgio Benigno Salviati (Dragisic)." In Reeves, ed., *Prophetic Rome.* 121–156.

Vickers, Michael. "A Greek Source for Antonio Pollaiuolo's Battle of the Nudes and *Hercules and the Twelve Giants.*" Art Bulletin 59 (1977), 182–77.

Voci [Roth], Anna Maria. "Idea di contemplazione ed eremitismo in Egidio da Viterbo." In *Egidio da Viterbo, O.S.A., e il suo tempo.* 107–16.

Waddy, Patricia. *Seventeenth-Century Roman Palaces: Use and the Art of the Plan.* New York: Architectural History Foundation/Cambridge, MA: MIT, 1990.

Walker, D. P. *Spiritual and Demonic Magic from Ficino to Campanella.* London: Warburg Institute, 1958.

Wallace-Hadrill, Andrew, ed. *Patronage in Ancient Society.* London: Routledge, 1989.

Walter, Hermann. "Contributo alla recezione umanistica della zoologia antica. Nuovi documenti per la genesi del '1515 RHINOCERVS' di Albrecht Dürer." *Res Publica Litterarum* 12 (1989), 267–77.

———. "Un Ritratto sconosciuto della 'Signorina Clara' in Palazzo Ducale di Venezia. Nota sulle mappe geografiche di Giambattista Ramusio e Giacomo Gastaldi." *Studi Umanistici Piceni* 14 (1994), 207–28.

Weil-Garris, Kathleen, and John F. D'Amico. *The Renaissance Cardinal's Ideal Palace: A Chapter from Cortesi's* "De Cardinalatu." Rome: Elefante, 1980.

Weil-Garris Brandt, Kathleen. "Cosmological patterns in Raphael's Chigi Chapel in S. Maria del Popolo." In Frommel and Winner, eds., *Raffaello a Roma*. 127–57.

Weiss, Roberto. "Traccia per una biografia di Annio da Viterbo." *Italia Medioevale e Umanistica* 5 (1962), 425–41.

——— "An Unknown Epigraphic Tract by Annius of Viterbo." In *Italian Studies Presented to E. R. Vincent*. Cambridge: Heffer, 1962. 101–20.

Weissman, Ronald, "Taking Patronage Seriously: Mediterranean Values and Renaissance Society." In Kent and Simons, eds., *Patronage, Art, and Society in Renaissance Italy*. 25–45.

Weisz, Jean S. *Pittura e misericordia: The Oratory of San Giovanni Decollato in Rome*. Ann Arbor: UMI Research, 1984.

Westman, Robert, ed. *The Copernican Achievement*. Berkeley and Los Angeles: University of California Press, 1975.

Wharton, Edith. *The Age of Innocence*. New York: Appleton, 1920.

White, Peter. *Promised Verse: Poets in the Society of Augustan Rome*. Cambridge, MA: Harvard University Press, 1993.

Winner, Matthias. "Disputa und Schule von Athen." In Frommel and Winner, eds., *Raffaello a Roma*. 29–45.

——— "Raffael malt einen Elefanten." *Mitteilungen des Kunsthistorischen Instituts in Florenz* 11 (1964), 71–109.

Wisch, Barbara. "The Roman Church Triumphant: Pilgrimage, Penance and Processions Celebrating the Holy Year of 1575." In Barbara Wisch and Susan Scott Munshower, eds., *"All the world's a stage . . ." Art and Pageantry in the Renaissance and Baroque*. Vol 1: *Triumphal Celebrations and the Rituals of Statecraft, Papers in Art History from the Pennsylvania State University* 6.1 (University Park: Pennsylvania State University Press, 1990), 82–117.

Witt, Reginald Eldred. *Isis in the Graeco-Roman World*. London: Thames and Hudson, 1971.

Witt, Ronald G. "Medieval *Ars dictaminis* and the Beginnings of Humanism: A New Construction of the Problem." *Renaissance Quarterly* 35 (1985), 1–35.

——— "Medieval Italian Culture and the Origins of Humanism as a Stylistic Ideal." In Albert Rabil, Jr., ed., *Renaissance Humanism: Foundations, Forms, and Legacy*. Vol 1: *Humanism in Italy*. Philadelphia: University of Pennsylvania Press, 1988. 29–70.

——— "The Origins of Italian Humanism: Padua and Florence." *Centennial Review* 34 (1990), 92–108.

Yates, Frances. *The Art of Memory*. London: Routledge and Kegan Paul, 1966.

Giordano Bruno and the Hermetic Tradition. Chicago: University of Chicago Press, 1964.

Yegül, Fikret K. *Baths and Bathing in Antiquity.* New York: Architectural History Foundation / Cambridge, MA : MIT, 1992.

Zabughin, Vladmir. *Guilio Pomponio Leto, Saggio critico.* Rome: Vita Letteraria, 1909.

Zippel, G. "L'Allume di Tolfa e il suo commercio." *Archivio della Reale Società Romana di Storia Patria* 30 (1907), 389–462.

Zucker, M. J. "Raphael and the Beard of Pope Julius II." *Art Bulletin* 59 (1977), 524–33.

Index